Australian Art in the National Gallery of Australia

Australian Art

in the National Gallery of Australia

Anne Gray editor

■ national gallery of **australia**

© National Gallery of Australia, 2002.
All rights reserved. No part of this publication may be reproduced or transmitted in any form or by any means, electronic or mechanical (including photocopying, recording or any information storage and retrieval system), without permission from the publisher.

Produced by the Publications Department
of the National Gallery of Australia

nga.gov.au

Designer: Kirsty Morrison
Editor: Susan Hall
Printer: Lamb Print
Prepress: ColourboxDigital

Cataloguing-in-Publication data

Australian art in the National Gallery of Australia.

Bibliography.
Includes index.

ISBN 0 642 54142 6 (hbk)

ISBN 0 642 54148 5 (pbk)

1. Australian National Gallery – Catalogs. 2. Art, Australian – Catalogs. I. Gray, Anne, 1947– . II. Australian National Gallery.

709.94

Distributed in Australia by
Thames and Hudson
11 Central Boulevard Business Park
Port Melbourne, Victoria 3207

Distributed in the United Kingdom by
Thames and Hudson
181A High Holborn
London WC1V 7QX, UK

Distributed in the United States of America by
University of Washington Press
1326 Fifth Avenue, Ste 555
Seattle, WA 98101-2604

The following works are reproduced as details:

Mount Wellington and Hobart Town from Kangaroo Point 1831-33
 John Glover p.33
Ferntree Gully in the Dandenong Ranges 1857 Eugene von Guérard p.52
Mount Arapiles and the Mitre Rock 1863 Nicholas Chevalier pp.20-21
Allegro con brio, Bourke Street West c.1885-86 Tom Roberts p.79
Golden summer, Eaglemont 1889 Arthur Streeton p.86
Pastoral c.1893 Rupert Bunny p.93
Afterglow 1912 Frederick McCubbin pp.72-73
The squatter's daughter 1923-24 George Lambert p.137
Christian Waller with Baldur, Undine and Siren at Fairy Hills 1932
 Napier Waller pp.128-29
The drover's wife c.1945 Russell Drysdale p.196
The trial 1947 Sidney Nolan pp.182-83
A south coast road 1951 Lloyd Rees p.217
Turtle and temple gong 1965 Ian Fairweather p.261
Sydney sun 1965 John Olsen p.266
Fidgeting with infinity 1966 Brett Whiteley p.271
Latin American Grand Final 1969 John Brack p.281
Pear – version number 2 1973 George Baldessin p.295
Cream filling; phew, finger ring 1971 Richard Larter pp.246-47
Corrugated Gioconda 1976 Jeffrey Smart p.310
Cones 1982 Bert Flugelman pp.302-03
Mount Analogue 1985 Imants Tillers p.339
The Aboriginal Memorial 1987-88 Ramingining Artists p.359
All that big rain coming from top side 1991 Rover Thomas p.379
The Alhalker suite 1993 Emily Kam Kngwarray p.385
Suddenly the Lake 1995 Rosalie Gascoigne p.391
Rendez-vous 2000 Robert Boynes pp.374-75

Cover: **Sidney Nolan** *Glenrowan* 1946 (detail)
enamel on composition board 90.9 x 121.2 cm Gift of Sunday Reed 1977 76.299

Contents

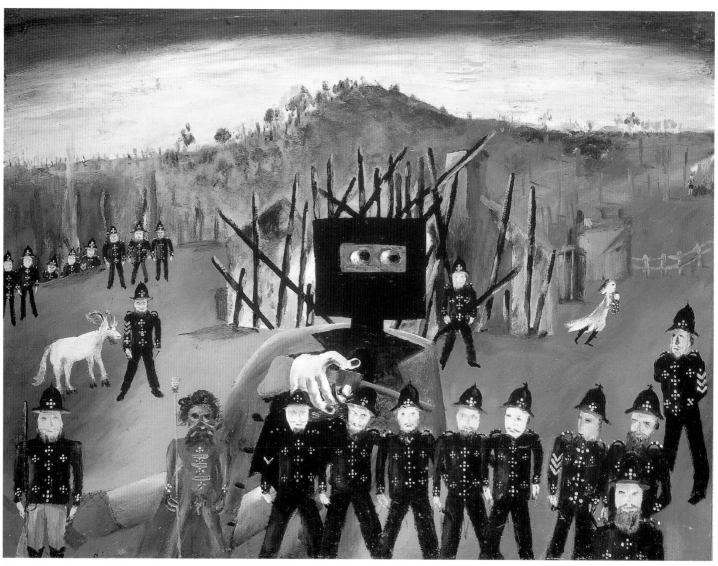

Sidney Nolan *Glenrowan* 1946 enamel on composition board 90.9 x 121.2 cm Gift of Sunday Reed 1977 76.299 (see page 202)

Foreword

The story of Australian art is central to the foundation of the National Gallery of Australia – and to the National Capital, Canberra. The idea of a national collection of Australian art, and a national gallery in which to house it, grew as the idea for a national capital developed. Some of those who first helped to build our National Collection were the directors of state galleries in Sydney and Melbourne who, as members of the Commonwealth Art Advisory Board, were keen to create a national institution that would complement theirs, by promoting the story of Australian art and the history and culture of our country in the national and international arena.

We are rightly proud of the Australian art collections of the National Gallery of Australia, which are among the finest and most representative in existence. The Australian collections are deep and broad ranging, with a substantial collection of Australian paintings, sculptures, prints and drawings, photographs, decorative arts, theatre designs and posters, as well as a collection of Aboriginal and Torres Strait Islander art of the highest artistic merit. The collection is truly national in that it includes the activities of artists representative of the whole country.

This book includes a selection of the highlights of the Australian art collection and seeks to show the range of material collected by the National Gallery. There are, of course, many fine works that have not been included. Nevertheless, the book indicates something of the unique character of the National Gallery's collection of Australian art.

To a great extent, the riches of the National Gallery of Australia's Australian art collection reflect the excellent connoisseurship of the foundation Director James Mollison and his staff, and that of the subsequent directors and their staff. It also reflects a long-held, and thankfully growing, philanthropic tradition of which Australia can be proud. Among the earliest donors were George Wagstaff Booth, John Pye and Oscar Paul, who gave significant works by Tom Roberts, Rupert Bunny, Arthur Streeton and George Lambert, which were presented to the Commonwealth of Australia in trust for a future National Gallery.

The roll call of major donors to the Gallery shows how indebted we are to private individuals. In 1975, the Gallery received a gift from Arthur Boyd that included works across a range of mediums, from paintings to tapestries. In 1977, Sunday Reed gave to the Gallery Sidney Nolan's seminal Ned Kelly series. In 1989, Gordon Darling endowed the Gallery with a purchase fund to buy contemporary Australian prints. James O. Fairfax has given major paintings to the Australian collection, as have Joseph Brown and Benno Schmidt.

The National Collection belongs to the people of Australia. The Collection is held for all to enjoy, and cherish. It provides a splendid opportunity for learning. From its beginnings, the Gallery has been aware of the need to provide access to the Collection. We make it available for use in many places outside Canberra – as loans or travelling exhibitions. We have also developed an extensive Internet site at nga.gov.au. It is our intention to continue to offer the collections to the widest possible audience, both in Australia and overseas.

The Assistant Director of Australian Art, Anne Gray, and the Publisher's Editor, Susan Hall, together with staff in the Australian art program, have conceived this volume, and to them we express our appreciation. Dr Gray is not only a distinguished scholar but also a splendid motivator who has coaxed and teased fascinating texts from many friends and colleagues in her efforts to make this book a significant one. Her commitment has been beyond the call of any duty, and is testament to her passion for Australian art. Without Susan Hall's highly skilled editing, her most agreeable manner, persistence and determination, this publication would have been a very different one indeed. She has been a tower of strength. Special thanks are due to the artists who have permitted us to reproduce their works and written texts, and to the authors who have contributed essays, including past and present staff of the Gallery. I particularly acknowledge former Director, Betty Churcher; the Visiting Curator of Australian Art 1976–79, James Gleeson; and the inaugural Head of Australian Art, Daniel Thomas, for their contributions and ongoing interest in the Gallery. Thanks, too, to the photographic, registration, exhibition, and library staff, who provided invaluable assistance in the preparation of this book. I also extend my appreciation to the copyright holders for their cooperation. My very special thanks go to Kirsty Morrison, for her characteristic style and design flair, which has made this book a delight.

Brian Kennedy
Director

Editor's Note

This book provides an introduction to the National Gallery of Australia's expansive collection of paintings, sculptures, drawings, prints, photographs, decorative arts and design, by non-Indigenous and Indigenous Australians. It is intended to create enthusiasm and to encourage further exploration of the substantial holdings of the Gallery that have been carefully developed by a succession of directors, curators and benefactors.

The book contains insightful essays by over 50 of the artists who made the works, as well as many by curators and writers. The authors include past and present staff, as well as colleagues from other Canberra institutions and those who have had a strong connection with the National Gallery of Australia. We are particularly delighted to include essays by the current Director, Brian Kennedy, former Director, Betty Churcher (1990–97), the National Gallery's Visiting Curator of Australian Art, James Gleeson (1976–79), and the first head of the Australian Art Department, Daniel Thomas (1978–84), each of whom has played such a crucial role in developing the Australian art collection. The remarkable work of the founding Director, James Mollison, in building the Gallery's collection of Australian art shines through the entire publication.[1]

Our artists and authors were generally given the same flexible brief: to write on their nominated works in 250 to 750 words and to keep the general reader in mind. The result is as varied as art writing itself has become over recent years. Some are intense, personal reflections on individual works; others are more discursive and place the works in their art historical or historical contexts. A small number of essays are edited versions of material previously published by the Gallery. In re-publishing selected texts by previous Gallery staff, we acknowledge their considerable contribution to the development of, and research into, the collection.

This book reproduces more than 400 works from the Australian art collection from 1770 to 2002. It includes perennial favourites, like Nolan's 'Ned Kelly' series, as well as important lesser-known works and newer acquisitions. The process has been inclusive, the selection being made in collaboration with the curators of Australian Art, with the aim of showing a representative sample from the collection, incorporating the major mediums acquired. It does not reflect one taste or one view, but covers a variety of subjects, shown through different approaches by a range of artists. Inevitably, there are many works that we would have liked to include but, for space reasons, could not.

While this book reflects the range of material collected, the focus is principally on paintings by non-Indigenous artists.

This is because we have already produced – and are planning to publish in the future – publications on other aspects of the Australian art collection.[2] Although we have included a substantial representation of work by contemporary artists, one of our biggest regrets is that we have not been able to include more, to emphasise the extent to which the Gallery endorses and encourages art by living artists. However, our support for contemporary art is multifaceted: it is also demonstrated through the Gallery's biannual survey exhibitions of contemporary Australian art, such as *Uncommon world* and *Tales of the Unexpected*, our *National Sculpture Prize*, supported by Macquarie Bank, and exhibitions of prints like *My Head is a Map* and of contemporary decorative arts like *Transparent Things*.

This is primarily a visual survey of Australian art. For additional information, we refer you to previously published histories of Australian art, dictionaries of artists, and the National Gallery's detailed catalogues of segments of its Australian art collection.[3] This book aims to complement these by providing a wealth of images from the National Gallery of Australia's collection.

In this book we have necessarily adopted a structure: we have arranged the works, broadly speaking, chronologically, from earliest to most recent, and grouped them into periods. The first section, *Pre-colonial and Colonial (1770–1884)*, covers the period which dates from Captain James Cook's discovery of the eastern coast of Australia in 1770. It begins with an engraving of a kangaroo after George Stubbs's noted painting – his model was a specimen taken back to Britain by Joseph Banks on the *Endeavour*. The next section, *Nationalists and Expatriates (1885–1914)*, covers a period of nationalism, in which artists sought to develop an Australian school of painting and to paint the national life of Australia, as well as a time of expatriatism, when a large number of Australian artists lived and worked overseas. The starting date, 1885, is the year in which the artist Tom Roberts returned to Australia with new ideas about making Australian art. It begins with Wurundyeri artist William Barak's important drawing, *Corroboree (Figures in possum skin cloaks)*, which acknowledges the prior ownership of the land by Indigenous Australians (a fact largely overlooked in the 1888 celebrations of 100 years of non-Indigenous settlement in Australia).

The third section, *Modernism and Feminism (1915–1939)*, covers the period of the First World War and the interwar years (until the start of the Second World War). It was a period of modernisms (formalism and Art Deco) and of the greater emancipation of women. Half the chapter consists of work by women artists, beginning with Jessie Simpson's *Magpie vase* and ending with paintings by four women artists: Grace Crowley's *Woman (Annunciation)*, Elise Blumann's *Charles, morning on the*

Swan, Olive Cotton's *Papyrus*, and Kathleen O'Connor's *In my studio, Paris*. The fourth section, *Figurative Debate (1940–59)*, covers the period of the Second World War and continues until 1959, the year of the significant *Antipodeans* exhibition that asserted the importance of figurative art as opposed to abstract art. The majority of the works in this chapter are expressive figuration, including images by the Social Realists, the Angry Penguins and the Antipodeans. Works by artists who studied at the Bell-Shore school and developed a more classical modernist form of figuration provide a contrast to these images. A small group of works indicate an interest in non-figurative art.

The fifth section, *Abstraction and Social Change (1960–74)*, covers a period of social change and sexual liberation, with renewed support for the arts led by Prime Minister Gough Whitlam. It includes some works reflecting the sexual attitudes of the period. However, this chapter is essentially concerned with abstraction – the expressive abstraction of artists such as Stanislaus Rapotec, Henry Salkauskas, Peter Upward, and the hard-edge colour-field abstraction of the artists who were included in *The Field* exhibition of 1968. It ends with one of Boyd's most significant works, *Paintings in the studio*, from his magnificent gift to the nation in 1975. The sixth section, *Anything Goes (1975–89)*, reflects the diversity in Australian art over this period – in medium and stylistic approach. It was a period of renewed interest in sculpture, prints and the crafts, a time of installation art and Postmodernism. The Australian Centre for Photography was established in 1974 and this section appropriately begins with photographs by Roger Scott and Carol Jerrems. In 1971, the Papunya painting movement began and this section includes the work of a range of Indigenous artists who expressed their relationship to the land through their art. There was an increasing interest in sculpture during this period, and the section ends with a work of one of the foremost sculptors of the period, Robert Klippel.

The seventh and final section, *Art Now (1990–2002)*, covering the last years of the 20th century and the first years of the 21st, continues to reflect diversity in Australian art. It highlights the changing nature of Australian society through the varied cultural backgrounds of the artists. It begins with works by Iranian-born Hossein Valamanesh and Kukatja artist Rover Thomas and ends with works by Hong Kong-born John Young and Bidjara artist Christian Thompson.

Artists are identified by the working names by which they are best known. Measurements have been given in centimetres, height before width. Unless otherwise stated, the measurements with paintings refer to stretcher dimensions in the case of canvases, support dimensions in the case of works on rigid supports, sheet size in the case of watercolours and drawings, plate size in the case of etchings and image size in the case of lithographs, linocuts and woodcuts. The numbers following the purchase details refer to the Gallery's accession numbers. Within the main text, dates of works are given after titles for those not included in this book

Anne Gray
Assistant Director, Australian Art

1 For a detailed discussion of James Mollison's achievements see Anne Gray, 'Truly National' in Pauline Green (ed.), *Building a National Collection*, Canberra: National Gallery of Australia, 2002.
2 In 1988, Gael Newton's *Shades from Light* was published, a substantial catalogue highlighting the Gallery's photographic collection, and next year Peter Conrad's selection of some 250 images from the Gallery's Australian photography collection, *At Home in Australia*, will be released. In 1989 Andrew Sayers's *Drawing in Australia* was published, a major book focusing on the Gallery's significant drawing collection. Much of Roger Butler's vast research into Australian prints is now readily available on the website, sponsored by the Gordon Darling Australasian Print Fund, at www.australianprints.gov.au. And in the near future Brenda L. Croft will edit a major publication on the Gallery's Aboriginal and Torres Strait Island collection, following Wally Caruana's important *Aboriginal Art*.
3 Most recently we have published Robert Bell's survey of functional and decorative objects, *Material Culture – Aspects of contemporary Australian craft and design*, Roger Butler's review of prints by Indigenous artists of Australia and the Australasian region, *Islands in the Sun*, Deborah Hart's focused study, *Joy Hester and Friends* and Anne McDonald's exploration of the creative output of Douglas Annand, *Douglas Annand: The art of life*.

Introduction

At the heart of every great work of art lies an area of darkness that defies analysis. Theorists try, but something of the greatest works always elude the pursuer … It is not whether you have understood exactly what the artist had in mind, but whether or not it has stirred your imagination into a creative act. *James Gleeson*.[1]

Australian art enriches our understanding of our cultural history; it provides opportunities to know ourselves better and to understand more fully those who came before us. It is constantly changing as we and our environment are continually evolving. In the 1960s, however, when the Commonwealth Art Advisory Board began seriously to form the National Collection, it was thought that the story of Australian art was 'one', that there were key movements and artists, and that works could be purchased to represent these. Now we know Australian art tells many important and interesting stories and that the narrative is diverse; we understand that the story continually grows with our responses to it and that it can be viewed from different perspectives. Likewise, we know that many artists who have disappeared into obscurity, or have been overlooked, will be rediscovered and will add to the overall picture of our artistic heritage.

Since the National Gallery of Australia officially opened in 1982, there have been dedicated exhibitions and publications focusing on women artists, others looking at the work of artist refugees from Europe, as well as those discussing the work of artists of Asian and Middle Eastern origin.[2] Most significantly, there has been a complete revision of the non-Indigenous Australian thinking about Aboriginal and Torres Strait Islander art – including Andrew Sayers's research into Indigenous artists of the 19th century.[3] Non-Indigenous Australians now recognise the importance of re-telling the story of Australian art according to their new understanding of their relation to the Indigenous peoples and to the land. As Daniel Thomas has observed:

We now see nineteenth-century Australia's story as a story of land-taking. Land filled with Aboriginal myth and spirituality, land formed by Aboriginal agricultural practice ... A revised understanding of colonial art finds that it often embodies our present-day hopes for indigenous reconciliation, and our fears of ecological disaster.[4]

We continually re-view our art and the stories it tells and discover new aspects in familiar images.

This book is intentionally broad in its scope, reflecting the expansive collection of Australian art in the National Gallery of Australia. It tells a range of stories through its images. Some are evident by looking at the individual works and the comment accompanying them. Others are revealed by conjunctions of works, side by side or throughout sections.

The art historian, Bernard Smith, paid due respect to colonial art in his histories, but for many years most art museums dismissed much of earlier Australian art as being merely topographical or historical and the province of libraries rather than art museums.[5] By the 1960s, however, when the National Gallery of Australia began to develop its collection under the guidance of its first Director, James Mollison, this attitude had changed and curators had begun to collect colonial art and, by the 1970s, to mount serious exhibitions such as *The Colonial Eye*, *Australian Colonial Portraits* and *Eugen von Guérard*.[6] Daniel Thomas, inaugural head of the Australian Art Department at the Gallery (1978–84), not only acknowledged the aesthetic merit of colonial art but also sought to emphasise the cultural unity in the differing forms of creative endeavour within the Gallery's collection and displays. During his period, and in subsequent years, the Gallery has sought to present 'a visual culture intact and complete, instead of fragmented by technological and media classifications'.[7] To this end, Thomas drew attention to the fern fever of the mid-1800s, with the motif of Australian tree ferns used in works in a variety of mediums:

A picture frame by Isaac Whitehead, on a painting by Louis Buvelot, is ornamented with fern fronds and appears near a silver presentation centre-piece with palms and ferns by an English maker, and a painting by Eugene von Guérard of a fern-tree gully and lyrebirds. Lithographs by John Skinner Prout and Nicholas Chevalier of fern gullies will accompany a costume drawing by the latter artist for a fern-decorated ball-gown 'emblematic of the colony of Victoria', to be worn by a Governor's lady. There will be a Fairy Scene at Fernshaw by the artist photographer Nicholas Caire. Folk-art furniture decorated with stencilled spatter-work of ferns accompanies commercial pottery from Lithgow, New South Wales, decorated with moulded fern motifs.[8]

Evidence of fern fever can be seen in John Skinner Prout's *Fern Tree Valley, Mount Wellington*, Eugene von Guérard's *Ferntree Gully in the Dandenong Ranges* and the *Table garniture* of Stephen Smith and William Nicholson. In Fiona Hall's magnificent 20th-century homage to 19th-century fern mania, *Fern garden*, the artist, not nature, has arranged the ferns and, in doing so, has created a magical site for contemplation and regeneration.

Early colonists in Australia wanted to record their success and sought to do so along conventional lines by having their portraits painted. It is therefore not surprising that approximately one third of the images in the first section of this book, *Pre-colonial*

and Colonial (1770–1884), are portraits. Augustus Earle painted the first large-scale professional portraits of the early European settlers in Sydney, including those of *Captain John Piper* and *Mrs John Piper*. Thirty years later, in the Western District of Victoria, Robert Dowling took a more adventurous approach to portraiture in his engaging mourning tableau, *Mrs Adolphus Sceales with Black Jimmie on Merrang Station*.

A number of non-Indigenous artists portrayed Indigenous Australians during the early days of the colony, including the convict artist Charles Rodius, the sculptors Benjamin Law and Theresa Walker, and the photographer J.W.Lindt. Rodius gave his subjects a sense of dignity, as did Law in his sculpted busts of *Woureddy* and *Trucanniny*, the first significant sculptures in Australian art. John Glover portrayed Tasmanian Aboriginal people singing and dancing, fishing and swimming, living freely and at ease in the natural environment. Benjamin Duterrau, on the other hand, in *Mr Robinson's first interview with Timmy*, created one of the first Australian history paintings by representing the missionary 'conciliator' George Augustus Robinson with some of the Tasmanian Aboriginal people he endeavoured to 'save'. Duterrau glorified Robinson as a heroic missionary but, in 1840 when he painted this picture, more than half of the Tasmanian Aboriginal people who had been moved to Flinders Island as a result of Robinson's efforts had died. Duterrau knew this and ignored it. Some of us now cannot ignore it and, because of this knowledge, read the painting differently from the way Duterrau intended.

As well as sharing similar subject matter, artists also adopted common stylistic approaches, such as the neoclassical style seen during the 1820s to 1840s. As Daniel Thomas observed:

> a heavy Neo-classical style, characteristic of colonial art from the 1820s to the 1840s is clear enough in the large history-paintings by Benjamin Duterrau, in which an Aborigine might be given a pose taken from Greco-Roman statuary, and in the portrait busts of Aborigines by Benjamin Law, in which kangaroo-skin cloaks replace Roman drapery … it is the more obviously Neo-classical forms of a lyre-shaped sofa and the vase-shapes of a silver tea-service by Alexander Dick that most sharply point up the stylistic unity of the period.[9]

All these works discussed by Daniel Thomas are reproduced in this book.

In addition to similarity in subjects and styles, there are also contextual links between artists – such as their common heritage. For instance, German migrant Ludwig Becker, Prussian-born William Blandowski and Swiss-trained Nicholas Chevalier came to Australia from Europe with an interest in exploration. Becker's *Blow-hole, Tasman's Peninsula, Van Dieman's Land*, Blandowski's *Pattowatto* and Chevalier's *Mount Arapiles and the Mitre Rock*

Tom Roberts 1856–1931 *In a corner on the Macintyre* 1895 oil on canvas 71.1 x 86.4 cm purchased 1971 71.109

combine a scientific with an artistic vision. The artists created precise and descriptively-real images that convey the wonder of nature. They show, moreover, the important contribution that artists from Europe made to our understanding of the Australian landscape.

In 1895, a critic for the *Argus* suggested that 'there can be no doubt that an Australian School of painting is in process of birth'.[10] He was referring to the work of Frederick McCubbin, Tom Roberts and Arthur Streeton and their colleagues. His vision of their paintings as forming an Australian school was in part the consequence of the spirit of the times and a drive for a specifically Australian subject matter from writers as diverse as the Sydney artist Julian Ashton and the Melbourne University Professor of Moral Philosophy Henry Laurie.[11] Such ideas were the inevitable consequence of the non-Indigenous Australian's Centennial celebrations of 1888 and the preparations for Federation. Roberts and his colleagues took advantage of this emotional climate by drawing attention to themselves in their *succès de scandale*, their *9 by 5 Impression Exhibition* of 1889. They declared in the accompanying catalogue that their aim was to develop 'what we believe will be a great school of painting in Australia'.[12] Conder's *Herrick's Blossoms* and *Impressionists' camp*, Roberts's *Going home* and Streeton's *Hoddle St., 10 p.m.*, were all shown in this exhibition.

Following this, Roberts urged his friends to leave 'the suburban bush and paint the national life of Australia',[13] which he himself proceeded to do in works such as *Shearing the rams* (National Gallery of Victoria) and *In a corner on the Macintyre*. Streeton did so too, in works like *Fire's On, Lapstone Tunnel* (Art Gallery of New South Wales) and *The selector's hut (Whelan on the log)*.

Early artists by and large worked independently, following their individual vision. Artists of the 1880s and 1890s, however, frequently worked together – often in painting camps such as that at Eaglemont near Heidelberg or at Sirius Cove on Sydney Harbour. They had a common exuberant response to the Australian landscape and exchanged ideas about how and what to paint. Streeton's *The selector's hut* and Conder's similar *Under a southern sun* together provide an opportunity to compare the approaches of these two artists who readily shared information about painting techniques. On the surface the images are alike – both were painted at Heidelberg in the summer of 1890 in a palette of yellow, blue and pink. But the works are also clearly by two distinct artists: Conder adopted a more decorative elongated format, a more domestic subject and created the appearance of a softer light, while Streeton took a greater interest in creating a (fictional) image of the heroic pioneer and in presenting his scene under a more dramatic glaring light.

Whereas earlier artists were fascinated by tree ferns, artists at the turn of the century were more interested in giant trees and debates about whether Australia or America had the largest examples. Artists working in different mediums paid homage to these trees. Conder's *Under a southern sun* and Streeton's *The selector's hut* both depict the tall tree and the felled log. This is also the subject of Nicholas Caire's photograph, *Giant tree at Neerim, forty feet girth*. Conder and Streeton, however, would appear to have supported cutting down the giant trees in the name of progress (although Streeton later actively campaigned against this); Caire sought their preservation. He took his photographs in order to document the endangered trees, in the hope that this would at least provide future generations with a record of their existence. He worked with fellow photographer, J.W.Lindt, to produce a tourist guide to encourage people to visit the tall trees, to develop a love and admiration for them and so to save the forests.[14] A contemporary work, Narelle Jubelin's *A fallen monarch*, refers to Caire's photographs of tall trees. Jubelin selected one of his photographs of large fallen trees and recast it in petit point embroidery in order to comment on the present-day destruction of the natural environment.

During the 1970s, when James Mollison began to develop the Gallery's Australian art collection, there was a renewed interest in research and publication on the work of the 'Heidelberg School' artists, both as a group and as individuals.[15] The 1970s was a period of enthusiastic nationalism that looked back to this earlier era to help construct an Australian identity. It was the time of the Whitlam government, the formation of the Australia Council and substantial support for the arts. It was when Australian Broadcasting Commission newsreaders began to speak with an Australian accent. It was when the Australian film industry was re-born, with films that looked back to a mostly non-Indigenous Australian past (*Picnic at Hanging Rock (1975)*, *The Getting of Wisdom (1977)*, *The Chant of Jimmie Blacksmith (1978)* and *My Brilliant Career (1979)*). The new recognition in the 1970s of the Australian Impressionists as the founders of a national school of painting was part of this trend of seeking foundations on which to build a cultural tradition.

The friendship between Conder, Roberts and Streeton and the way they worked together is well known and a similarity in their work is expected. Less predictable, although understandable given their mutual interest in the French modern style of painting, is the way in which E. Phillips Fox and John Peter Russell, located in different areas of France around the same time, used bright intense colours to create light-filled scenes such as *Sunlight effect* and *In the morning, Alpes Maritimes from Antibes*, shown side by side in this book. Hilda Rix Nicholas also used a similar palette a few years later in her *In the fields by the sea*.

As with the colonial period, in Edwardian times people were keen to have their portraits painted and sculpted to establish

Hugh Ramsay 1877–1906 *Portrait of Miss Nellie Patterson* oil on canvas 122.3 x 92.2 cm purchased 1966 66.99

themselves in society, and thus many of the images in the second section of this book, *Nationalists and Expatriates (1885–1914)*, are also portraits. Artists such as Tom Roberts and George Lambert earned their living mostly from portraits. George Lambert, Max Meldrum, Ambrose Patterson and Hugh Ramsay also created images of themselves, their families and their friends. They painted these works as explorations in technique and as works to exhibit in the Royal Academy in London and other exhibitions, to show off their talents to prospective clients. They were influenced by the aestheticism of Whistler and the tonalism of Velázquez. Both Meldrum and Patterson based their very different works – *The yellow screen (Family group)* and *Self-portrait* – on Velázquez's famous group portrait *Las Meninas*. In doing so, they were following another trend of the time, that of appropriating details from earlier works of art and giving them new energy. Working in quite distinct mediums, both Harold Parker in *Orpheus* and Violet Teague in *Boy with the palette* turned independently to the sculpture of the Greek artist Lysippus (his *Apoxyomenus*, 4th-century BC) as an inspiration for the poses in their works (with Teague fusing this with a painterly approach learned from looking at Manet's paintings).

At the turn of the century and during the interwar years, there was an increase in the number of women artists. This book includes the work of about 100 women artists – painters, printmakers, photographers, textile artists and ceramicists. Their subjects included the New Woman of the turn of the century and the 'modern woman' of the 1920s and 1930s. Artists such as Hilda Rix Nicholas portrayed strong independent working women, an alternative to the elegant portraits of ladies, emblems of their husbands' wealth, that were often painted at this time. May and Mina Moore, on the other hand, represented the stylish 'modern woman' with her jazzy lifestyle in *Portrait of an actress*, as did Margaret Preston in her painting, *Flapper*.

Women artists made a reputation for themselves as printmakers and designers. Margaret Preston and Thea Proctor promoted prints as being the perfect form of decoration for the modern home. Both insisted on the importance of design and created images that have a tension between flat colour and illusionistic space. They supported each other's work and promoted women's activities in the arts. Together with Adelaide Perry, Dorrit Black, Eveline Syme and Ethel Spowers, they used woodcuts and linocuts as a means of communicating modernist ideas – the simplification of form and colour. Their bold, vigorously delineated works expressed 'vitality', but the subject matter of many of their images reflected a leisured lifestyle, a space free from the financial pressures or social inequalities of the real world – views of the harbour and of people dancing and skating. In *The works, Yallourn*, however, Ethel Spowers,

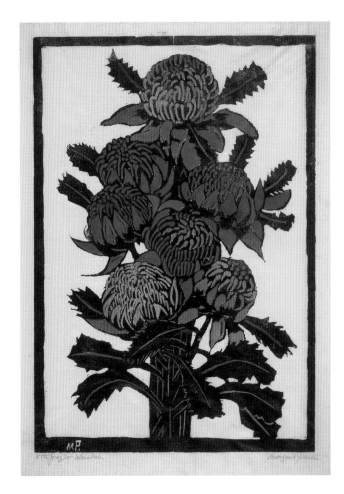

Margaret Preston 1875–1963 *Waratahs* 1925 woodblock
42.5 x 30.0 cm purchased 1976 76.939

like her male counterparts, Harold Cazneaux and Frank Hinder, found inspiration in the industrial world.

George Lambert actively supported the work of Thea Proctor and Margaret Preston and other modernist artists working in Sydney. During the interwar years, he and his painting *The squatter's daughter* played a significant role in directing Australian artists away from the intuitive approach to landscape that had been promoted by Streeton, towards a more controlled method that conveyed the definite forms and clear contours of a scene. This can be seen in the landscapes of Lloyd Rees, Elioth Gruner and Kenneth Macqueen.

A number of artists adopted an art deco style during the 1920s and 1930s. This is evident in a vase painted by Jessie Simpson with a decorative magpie frieze, a brass casket featuring a stylised cloisonné ibis by James W.R. Linton, a painting by Dorothy Thornhill, *Resting Diana*, in which the woman's figure and the surrounding trees are portrayed in precise, hard contours, and a painting by Napier Waller of his wife and dogs, *Christian Waller with Baldur, Undine and Siren at Fairy Hills*, which is a mix of the stylised and the real. It is also seen in a woodcut

by Christian Waller, *The Lords of the flame*, in which the figures are reduced to decorative outlines, and in a severe, austere sculpture by Rayner Hoff, *Theseus*. Classical subjects are also present in some of these works, in Thornhill's Diana of Roman mythology and in Hoff's Greek hero.

As well as adopting similar stylistic approaches, artists shared ideas that were prevalent at the time. Arthur Murch celebrated the idea of vitalism, of a healthy body and an idyllic Australian way of life, in his modern day image of the Madonna and child, *The calf*. So too did Thornhill with her lean, muscular Diana. Max Dupain paid homage to the male body in his sensuous image of a sunbaker. This was an era in which the government was conservative and isolationist, supported the White Australia policy, a high standard of living and was concerned with keeping Australia healthy and wholesome. It was the period in which the myth of the bronzed Anzac developed. These artists portrayed the wholesome ideas of their times – using imagery which, with hindsight, comes uncomfortably close to Nazi images of an Aryan master race.

A different form of Modernism was introduced at the end of the 1930s, when many migrants came to Australia to escape the turmoil in Europe and Nazi persecution. Yosl Bergner and Sali Herman arrived in Melbourne in 1937 and Elise Blumann in Perth in 1938. Ludwig Hirschfeld Mack fled from Germany in 1936 but was interned in Britain in 1940 and in that year sent to a detention camp in Australia. They brought with them new European approaches to art and created works that fused their European background and Australian experience. Bergner, in works such as *Pumpkins*, focused on the dispossessed, showing them as victims or outcasts. Together with other left-wing artists in Melbourne, such as Noel Counihan, he used a social realist approach to expose political corruption and social inequities. Some contemporary commentators had difficulty accepting these newcomers' work. Blumann was regarded as a rebel in Perth because she simplified and abstracted the shapes of her figures and her landscapes. Critics dubbed Sali Herman's paintings of Paddington houses 'slumscapes' and suggested they presented squalor and decay rather than, as their artist intended, creating a harmony through balanced juxtaposition of forms and textures.[16]

George Bell and Arnold Shore played an important role in increasing the understanding of a more modern approach to art in Melbourne in the 1930s and 1940s. At the George Bell School (which Bell and Shore started in 1932) their teaching influenced a range of artists such as Frances Burke, Russell Drysdale, Sali Herman, Mary Cockburn Mercer, Peter Purves Smith, David Strachan and Eric Thake. Mary Cecil Allen visited the school to teach. Bell promoted strong design and a serene mood,

a concern with geometrical structure and with selecting and reducing nature to its essential forms. In this book, Burke's fabric design with the phoenix and flower motif, with its simplified shapes and bright colour, is shown alongside Cecil Allen's screen with its decorative arrangement of kangaroos.

A number of artists broke new ground by taking an interest in the far-flung areas of Australia during the 1940s. In 1944, Drysdale travelled to New South Wales to record the drought there. He portrayed scenes of devastation as well as the lives of people like the woman in *The drover's wife*. While located at army camps in the Wimmera district during the Second World War, Nolan discovered the space, heat and clear light of the landscape of this region. His Kelly series arose out of this experience. By 1950 he had made several outback journeys, which resulted in images such as *Burke at Cooper's Creek*, a poignant view of a non-Indigenous Australian's relationship with the harsh land that eventually killed him. It is placed side by side with the harmonious representation of Central Australia by Western Aranda/Arrernte artist, Albert Namatjira, in his watercolour *Mount Hermannsburg, Finke River*. Namatjira's vision of the fertile valley of his traditional homeland challenges the non-Indigenous Australian view of this land as an empty desert.

Non-Indigenous Australians enthusiastically purchased Namatjira's paintings. In 1924, Margaret Preston had suggested that Australian artists should take into account the work of Indigenous art in order to achieve a national style.[17] This culminated in her Indigenous-inspired works of the 1940s such as *Flying over the Shoalhaven River* and *Shoalhaven Gorge, N.S.W.* But she also championed Modernism in art and in life, promoting the advantages of a new technological age and a world that was despoliating the Indigenous way of life – the culture that gave Indigenous art its meaning.

Arthur Boyd visited Central Australia in 1951 and observed the Indigenous people's isolation from the non-Indigenous population. In images such as *Reflected Bride I (Bride reflected in a creek)*, from his 'Love, marriage and death of a half-caste' series of 1957–58, he commented on the then non-Indigenous Australian's unthinking attitude towards assimilation and cohabitation. This book also includes Budamiya artist Julie Dowling's more recent comment on the cruel relationships between non-Indigenous and Indigenous people in her work *Her father's servant*. Dowling has used techniques of painting borrowed from European culture to create a socio-political narrative that portrays members of her own family involved in a mixed-race marriage, as well as children separated from their parents.

During the war years, and those immediately afterwards, many artists remained determinedly figurative. Boyd and Nolan,

Joy Hester, John Perceval, Albert Tucker and Danila Vassilieff were principally concerned with creating expressive images that told stories. Perceval's disturbing image *Boy with cat 2*, placed opposite Tucker's savage *Victory girls*, conveys the collective anxiety of the war years as well as a universal potential for violence and suffering. Charles Blackman, John Brack and Robert Dickerson were interested in portraying people engaged in everyday activities – conveying their emotional responses to contemporary life. They created metaphors of modern life: the daydreams, fears and vulnerabilities of ordinary men and women. Along with the Heidelberg artists, these artists were selected for renewed attention in the 1970s as part of the search for a new national identity. As with the earlier artists, there was an interest in researching their work, and the myths and tales they depicted, as well as the stories of their lives.[18] It was at this time too – in 1975 – that Arthur Boyd gave the Gallery an extensive group of works from his private collection that covered a period of almost 40 years. This gift demonstrated Boyd's complex and singular vision through a broad range of images – from his beasts and cripples to his religious scenes, from landscapes to mythological images, and included works such as *Paintings in the studio: 'Figure supporting back legs' and 'Interior with black rabbit'*. This magnificent donation was followed in 1977 by Sunday Reed's gift of Sidney Nolan's Ned Kelly paintings. Nolan had painted these highly inventive images and given them to Sunday Reed when he was living at Heide with the Reeds in the 1940s, and Sunday wanted the paintings to go to the National Collection because of their importance and because she approved of the way the collection was developing.[19]

Boyd, Blackman, Brack, Dickerson, Perceval and Clifton Pugh exhibited together in the *Antipodeans* exhibition in 1959. Bernard Smith wrote an introduction to the catalogue for this exhibition, in which he placed figurative art in opposition to abstract art, explicitly attacking non-objective art. Now, in a more pluralist time, when various approaches coexist, the intensity of the debate becomes hard to comprehend. We observe the abstract aspects of figurative art, and the representational elements of some abstract work. Artists who might be regarded as working in the figurative tradition, such as Blackman and Dickerson, simplified and abstracted the real world in their images, paring away superfluous detail. Blackman's *The cigarette shop (Running home)*, placed in this book alongside Ralph Balson's *Constructive painting*, shows how each artist in his own way based his composition on juxtaposed geometrical forms. Some artists moreover, who might be regarded as working in the abstract tradition can not be so categorised in a strict sense. For example, Yvonne Audette's apparently pure abstract *Cantata no. 8* is based on the textures of the ancient walls of Europe. Robert Rooney's

Superknit 5 derives from a knitting pattern and Ron Robertson-Swann's *Australia* is a response to the Australian landscape.

The 1960s and 1970s were periods of individualism, in which the art was broad-ranging, with artists adopting a wide range of styles and subjects. Expressionism, Pop, hard-edge and colour-field painting attracted many artists. Nonetheless, alongside these movements, more traditional forms continued. When the American avant-garde critic Clement Greenberg came to Australia in 1968, he noticed this variety of approach but found Australians 'too partisan regarding schools of Australian painting, the abstract as against the representationalist and so on'.[20] He saw danger in this and suggested that Australians should enjoy their diversity, if not celebrate it. We have sought to do just this in this book, to emphasise the diversity of Australian art, to include abstract and realist, iconoclastic and traditional, from 1770 to the present – as well as to suggest some common threads running through it.

James Mollison had a feeling for the art of his time and recommended that the National Gallery of Australia purchase a selection of works by the Australian hard-edge Abstractionists who had been included in *The Field* exhibition of 1968.[21] Among the works that Mollison purchased were Dale Hickey's *Atlantis wall*, a reference to the patterns in modern urban construction; Robert Hunter's sophisticated minimal *Untitled* 1970–76; Alun Leach Jones's *Noumenon XXXII: Red square* showing expressive

Alun Leach-Jones b.1937 *Noumenon XXXII, Red Square* 1968
synthetic polymer paint on canvas 168.5 x 168.5 cm purchased 1969 69.91

use of colour, and Paul Partos's *Yellow screen with yellow,* an exploration of the boundaries between painting and sculpture. These artists used flat areas of colour with hard-edged abstract designs, sometimes with an optical play of colour and form.

During this period, a number of non-Indigenous artists became interested in expressing spiritual ideas. Indigenous artists such as Dawidi Djulwark were well practised in expressing their spiritual response to the land – as in his *Wagilag Creation Story,* in which he presented the climactic events of the encounter between the Wagilag Sisters and Wititj the Olive Python. Placed opposite Roger Kemp's *Equilibrium,* it emphasises Kemp's interest in conveying the rhythms of life as well as his distinct Christian symbolism. Others sought to represent the spiritual through a more representational approach. Grace Cossington Smith remarked: 'art is … the golden thread running through time'.[22] Lloyd Rees said: 'I'm constantly thinking of the miracle of endlessness, and I look upon every bit of nature as a symbol of eternity'.[23]

The 1960s and 1970s were a time of sexual liberation and debate, a period when the musical *Hair* shocked audiences by revealing naked bodies on stage – when the Sydney Vice Squad investigated Mike Brown's solo exhibition and the *Oz* obscenity trial took place. The sexual attitudes of this time are revealed in the art, including a number of provocative images of female nudes. A painting by Vivienne Binns, *Vag Dens,* focuses on a woman's 'toothed' vagina, an image by fashion photographer Henry Talbot, *Fibremakers Australia fashion study,* looks up the legs of a model, a composite work by Brett Whiteley, *Fidgeting with infinity,* exposes a woman's breasts and vulva, a painting by Richard Larter, *Cream filling; phew, finger ring,* presents several provocatively posed women, and a photograph by Carol Jerrems, *Vale Street,* also shows a half-naked woman. In a slightly different vein, a work by John Brack of professional ballroom dancers, *Latin American Grand Final,* painted in bright pinks and reds, is full of sexual suggestion. These images were intentionally challenging, aimed to undermine traditional ways of imaging and thinking about women and sexuality.

At this time, Australians began to redefine themselves. It was a period of hope, of political and cultural change, when people thought they could make a difference, and did so. Artists addressed a variety of issues such as nuclear explosions in the Pacific, injustices and social inequalities, and the inadequacies of the consumer culture. Aleks Danko wanted to parody the way in which the streetlights were restrictively turned off at 1am in Adelaide. Poster artists Toni Robertson and Chips Mackinolty wanted to change attitudes through their image about the consequences of radiation, and Anne Newmarch sought to do so through her comment on the dangers of guns. The performance

artist, Jill Orr, half buried herself in the earth to express her alarm at the desecration of the environment. And to dramatise his concerns about the way we kill animals, Ivan Durrant created five lifelike three-dimensional severed pigs' heads.

This interest in recording and commenting on issues of concern has continued into present-day art. Dennis Del Favero has visualised the breakdown of social bonds and Ian Howard has created dramatic images about the way we are complicit in 'the militarisation of planet earth'. William Yang has taken moving photographs about the way the gay community lobbied for better conditions for AIDS sufferers in his *Vigil* photographs. Badtjala artist Fiona Foley has created a powerful installation that comments on the forcible dispossession of Indigenous people's traditional land. Budawia/Budimaya artist Julie Dowling, as already noted, has created a socio-political image about mixed heritage and separated children.

Artists have traditionally looked to their predecessors as a point from which to learn and develop. This was as much so in the 1970s and 1980s as at other times, with a range of artists showing an interest in earlier art – referring to it, quoting from it, playing with it. Some artists turned to past art as inspiration. Jeffrey Smart re-cast Leonardo's famous portrait, *Mona Lisa,* as a poster on a corrugated iron fence in *Corrugated Gioconda.* William Delafield Cook turned to an early photograph by Fox Talbot to create his painted version *A haystack,* and Brett Whiteley reworked a variation of Piero della Francesca's *Baptism of Christ* in his painting *Fidgeting with infinity.* In their poster *Daddy what did you do in the nuclear war?,* Toni Robertson and Chips Mackinolty re-cast a well-known poster to make their comment about nuclear war and First World War recruiting campaigns.

Other artists adopted a more postmodernist aesthetic, making interventions in works quoted, and critiquing them. Miriam Stannage placed Australian icons such as Drysdale's *Emus in a landscape* and Nolan's *Ned Kelly* within television sets in her print *Letter from Australia,* to locate these paintings within an everyday public context – contrasting 'high art' and mass culture – and in that way constructing a new way of looking at them. John Nixon was inspired by Russian Constructivist artists Kasimir Malevich and Alexandra Exter in making his *Eleven heads.* Imants Tillers turned to Eugene von Guérard's *North-east view from the northern top of Mount Kosciusko* when painting *Mount Analogue,* breaking it up into 165 elements.

Raymond Arnold looked to the work of 17th-century Dutch artist Hercules Seghers when making his print *Imaginary landscape,* and Ken Orchard used and adapted fragments from illustrations in a children's book and a 19th-century oil painting to create his woodcut, *Three textures.* Anne Zahalka turned to the tradition of Dutch still life in setting up the scene of her

Russell Drysdale 1912–81 *Emus in a landscape* 1950 oil on canvas
101.6 x 127.0 cm purchased 1981 81.1929

photograph, *Die Putzfrau (The cleaner)*, while deliberately including anachronistic elements to disrupt a nostalgic reading of the image.

Fiona Hall referred to John Parkinson's 17th-century florilegium and Robert John Thornton's 19th-century *The Temple of Flora* in her witty and erotic *'Paradisus Terrestris'* series, and Helen Wright also looked at *The Temple of Flora*, as well as at Paul Hermann's 17th-century *Herbarium of Plants* in creating her journey into an imaginary continent in 'The impossible' suite of prints.

Neil Roberts appropriated the imagery of 20th-century American glassmaker Louis Tiffany in his sculpture *Half ether, half dew mixed with sweat*. Narelle Jubelin, as already noted, referred to photography of Nicholas Caire in creating her embroidery, *A fallen monarch*, and Julie Dowling to de Hooch and the Dutch school of painting in her painting, *Her father's servant*.

As more and more Australians have become urban, living in cities close to the sea, and as the economy has become less and less dependent on the rural sector, our attitudes towards our land and our landscape have changed. Our art has moved from being one principally concerned with painting the landscape and has become as much interested in city life, and in broader experiences. Artists, nonetheless, continue to seek new ways of viewing nature and the Australian landscape. A wide range of Indigenous artists, including Kukatja/Wangkajungka artist Rover Thomas and Anmatyerr artist Emily Kam Kngwarray, each in their own way, have totally altered the non-Indigenous way of looking at and understanding place. John Olsen has taken his paintbrush for a walk over the canvas to suggest a sense of journeying over the land, and incorporated multiple viewpoints in paintings such as *Sydney sun*. Fred Williams has given us new ways of looking at Australia – landscapes with an array of lush, thick dabs of paint denoting scrubby trees and other vegetation, landscapes without a horizon, views of the land seen from above, as well as strip gouaches which capture different aspects of a scene within one image.

In his painting, *A journey near Ormiston Gorge in search of rare grasshoppers*, John Wolseley wanted to break away from earlier images of central Australia such as those by Drysdale and Nolan and create a kind of stream of consciousness image of this trip, a map of the terrain – an expression of his interaction with the landscape. More recently, Ah Xian has explored the way humans relate to nature, the way our environment reflects us and we reflect it, drawing from both classical western sculpture and oriental art in his *China china bust 15*. And William Robinson has created the sense of being surrounded by a landscape, being within a landscape, in *Springbrook with lifting fog*.

Some artists have used found materials as essential ingredients of their images. In his sculpture, *Suspended stone wallpiece*, Ken Unsworth expressed a personal response to natural materials and sought to conjure up memories of the stony landscapes or ritual places using actual objects suspended in the air. In installation works such as *Feathered fence*, Rosalie Gascoigne used objects that she had found in the landscape to conjure up the experience of being there, of feeling a sense of the sun and the wind, of interacting with the place.

We live in a world in which truth is malleable and where dinosaurs, mythical creatures and extraterrestial characters are readily visualised and can enter our living rooms through our television sets. It is hardly surprising then, that contemporary artists have explored the realm of fantasy, illusion and reverie, a realm out of time and space. In his painting, *Conference at the caldera*, James Gleeson has presented an alternative reality, a vital landscape with a purpose of its own, while in her painting, *The sublime and the ridiculous*, Susan Norrie has constructed a dark, menacing imaginary place that conjures up internal states of confusion and fear. In a photograph by Bill Henson, a figure has a shadowy existence, as if she hovers in another world. In a staged (but not digitally manipulated) photograph by Rosemary Laing, *flight research #6*, a bride is splendidly empowered with the freedom of flight, while in a painting by Louise Hearman a child appears to be frightened by unseen things. Such images and worlds can seem as real to us as the one we walk about in – and certainly as potent.

We live in a time when we look at events from a variety of perspectives and when we recognise the limits of objective reality and the power of a psychological one. In Sally Smart's *Spider Artist (sew me)*, a woman wears layers of different clothes,

while sewing on additional fragments of clothing, constructing her persona as she does so. And in her installation, *High bed*, Rosslynd Piggot expanded a bed into an impossible unreachable height to express her emotional experience of living in a Paris studio.

Non-Indigenous art in Australia is the product of a continuous stream of people coming to this land and interacting with what they discovered here. The art was initially produced by European artists on voyages of exploration, then by convicts and settlers from Britain and elsewhere. They brought with them a range of ways of seeing, and looked at people and place through these perspectives – as well as through their own individual vision. By the 1890s, a sufficient number of non-Indigenous Australians had been born in this country to foster what was thought of as a 'national school of painting' (which was as much based on the European tradition as the art of earlier artists). Before and after the Second World War, many émigrés came to Australia and brought with them new approaches to painting, including social realism and gestural expressionism. More recent migrants have produced a range of works that consider cross-cultural sensibilities. Guan Wei has explored the processes of being human in a society of mixed cultures in *Efficacy of medicine*. Kate Beynon has commented on the experiences of Asian migrants living in Australia and some of the difficulties in communication in *Excuse Me!*. Liu Xiao Xian has created a wall piece consisting of 100 prints to convey the multi-levels of existence, the Yin and Yang of the cosmos, in *Reincarnation – Mao, Buddha & I*. John Young has addressed issues of displacement, the difficulties of severing from an old situation and the anxiety experienced in a new one, in *Give and take*. Such works increase our understanding of our changing culture and the complexities of present-day life.

By collecting works in different mediums and displaying these together, the National Gallery of Australia has sought to show interconnections of various kinds. Many artists use their drawings to begin to explore their ideas for paintings, sculpture and work in other areas. They also turn to drawing to work freely, in an experimental – and sometimes atypical – fashion. In this book we have for example, illustrated a drawing by Louis Buvelot, *Macedon*, made on one of his sketching trips as a basis for a painting in the studio, alongside one of his oil paintings, *Near Lilydale*. Fred Williams continually made etchings from his paintings and paintings from his etchings, as he did with his etching, *Yellow landscape '74*, made in conjunction with the painting *Landscape '74*.

The National Gallery of Australia's position in the National Capital makes the collection and display of Aboriginal and Torres Strait Islander art of particular importance – as a statement about its vital place within Australian visual culture. For many years

Fred Williams 1927–1982 *Landscape 74* 1974–75 oil on canvas 200.5 x 373.0 purchased 1975 75.39

Indigenous art was considered ethnographical, to be collected by natural science museums rather than art musuems, and in Canberra collecting in this area was the province of the Australian Institute of Aboriginal and Torres Strait Islander Studies. James Mollison instigated serious collecting in this field and in 1972–73 purchased the National Gallery of Australia's first bark paintings. With Mollison's active encouragement, and that of subsequent Directors, the Gallery has developed one of the finest collections of contemporary Indigenous art in the country. Among the most significant acquisitions was the Gallery's commission in 1987, to 43 artists from Ramingining in central Arnhem Land, to create *The Aboriginal Memorial*, a monument to honour the many thousands of Indigenous people who died defending their land, their beliefs and their law, with each of the two hundred log coffins representing one year of Indigenous deaths from European colonisation to 1988.

There can be no doubt that the National Gallery of Australia's achievements in developing a National Collection of Australian art are considerable. Broadly speaking, from the 1960s until the present day, the goals for the National Collection of Australian art have remained the same. They are to build a collection of works of art of outstanding aesthetic merit in all mediums, and to build on strengths in the collection; to acquire an historical collection from all periods and approaches, as well as a broad range of work by living artists. James Mollison refined this into two groups, the display collection and the repository collection. We now talk about premium works, and works that strengthen the existing collection; the terminology is different, but the intent is much the same.

The creation of a National Collection of Australian art is part of the on-going history of our country. As Director, Brian Kennedy, has commented:

A national gallery can make a major contribution to public debate, about art, culture and society.[24]

We need constantly to improve our understanding of our past and renegotiate our relationship to the present and, consequently, continually to re-think what works should be acquired for the National Collection to tell the story of Australia and Australian art as present-day Australians understand it.

Anne Gray
Assistant Director, Australian Art

1 James Gleeson, quoted in Renee Free, *James Gleeson: Images from the shadows*, Sydney: Craftsman House, 1993, p.13.
2 For instance, Joan Kerr (ed.), *Heritage: The national women's art book*, Sydney: Craftsman House, 1995; Roger Butler, *The Europeans: Émigré artists in Australia 1930–1960*, Canberra, National Gallery of Australia, 1997.
3 Andrew Sayers, *Aboriginal Artists of the Nineteenth Century*, Melbourne: Oxford University Press in association with the National Gallery of Australia, 1994.
4 Daniel Thomas, 'Colonial English Eyes: New Worlds from Old and the idea of Colonial art' in *Like, Art Magazine*, no. 7, 1998/99, pp.20–26 (p.26).
5 Bernard Smith, *Place, Taste and Tradition: A study of Australian art since 1788*, Sydney: Ure Smith, 1945, and *Australian Painting 1788–1960*, Melbourne: Oxford University Press, 1962.
6 Barbara Chapman, *The Colonial Eye*, Perth: Art Gallery of Western Australia, 1979; Eve Buscombe, *Australian Colonial Portraits*, Hobart: Tasmanian Museum and Art Gallery, 1979; Candice Bruce, *Eugen von Guérard*, Sydney: Australian Galleries Directors Council; Canberra: AGDC/Australian National Gallery, 1980.
7 Daniel Thomas, 'Australian Art' in *Art and Australia*, vol.20, no.1, Spring 1982, pp.66–67.
8 ibid., p.67. See also Tim Bonyhady, *The Colonial Earth*, Melbourne: Miegunyah Press, 2000, pp.102–125.
9 ibid., p.67.
10 Editorial, *Argus*, 24 August 1895, p.6.
11 Julian Ashton, 'Art in Australia and its Possibilities' in *Table Talk*, 27 January 1888, p.3 and 'An Aim for Australian Art' in *The Centennial Magazine*, no.1, August 1888, pp.31–2; Henry Laurie, speech to the Victorian Artists' Society in *Table Talk*, 7 June 1889, p.5.
12 Tom Roberts, Charles Conder and Arthur Streeton, 'Concerning "Impressions" in Painting', letter to the *Argus*, 3 September 1889, p.7.
13 Robert Croll, *Tom Roberts: Father of Australian landscape painting*, Sydney: Robertson and Mullens, 1935, p.16.
14 Tim Bonyhady, *The Colonial Earth*, Melbourne: Miegunyah Press, 2000, pp.248–252, 275–9.
15 For instance, James Gleeson, *Impressionist Painters 1881–1930*, Melbourne: Lansdowne, 1971; Alan McCulloch, *The Golden Age of Australian Painting: Impressionism and the Heidelberg school*, Melbourne: Lansdowne, 1969 (2nd ed. 1977); Ann Galbally, *Arthur Streeton*, Melbourne: Lansdowne, 1969 (rev. ed. 1979); Ursula Hoff, *Charles Conder*, Melbourne: Lansdowne, 1972; Virginia Spate, *Tom Roberts*, Melbourne: Lansdowne, 1972 (rev. ed. 1978).
16 See Barry Pearce, *Sali Herman Retrospective*, Sydney: Art Gallery of New South Wales, 1981, p.9 and Anne Gray, 'Elise Blumann' in *Art and Australia*, vol.16, no.4, June 1979, pp.369–371 (p.369).
17 Margaret Preston, 'Art for Crafts: Aboriginal art artfully applied' in *Home*, December 1924, pp.30–31. See also, 'The Indigenous Art of Australia' in *Art in Australia*, series 3, no.11, March 1925, pp.32–45; 'What is to be our National Art?' in *Undergrowth*, March–April 1927; 'The Application of Aboriginal Designs' in *Art in Australia*, series 3, no.31, March 1930, pp.44–58.
18 Kenneth Clark, Bryan Robertson, Colin MacInnes, *Sidney Nolan*, London: Thames and Hudson, 1961; Franz Philipp, *Arthur Boyd*, London: Thames and Hudson, 1967; Elwyn Lynn, *Sidney Nolan: Myth and imagery*, London: Macmillan, 1967; Christopher Uhl (ed.), *Albert Tucker*, Melbourne, Lansdowne, 1969; Margaret Plant, *John Perceval*, Melbourne: Lansdowne, 1971; Elwyn Lynn and Sidney Nolan, *Sidney Nolan – Australia*, Sydney: Bay Books, 1979; *Arthur Boyd's Australia; Sidney Nolan: Paradise Garden*, Melbourne: National Gallery of Victoria, 1970.
19 When the Gallery enquired about a credit line for the gift, it was suggested that the following be used: 'In 1977 these paintings were given with love to the Australian National Gallery by Sunday Reed. Nolan painted them and gave them to her when he was living with her and her husband, John Reed, at Heide, Heidelberg, Victoria.'
20 Editorial, *Art and Australia*, vol.6, no.1, June 1968, p.21.
21 This exhibition marked the opening of the new National Gallery of Victoria on St Kilda Road in 1968.
22 Grace Cossington Smith, quoted in Daniel Thomas's essay, *Interior in yellow* 1962/64, p.256 of this publication.
23 Lloyd Rees, quoted in Janet Hawley, 'Lloyd Rees' in *Encounters with Australian Artists*, Brisbane: University of Queensland Press, 1993, p.23.
24 Brian Kennedy, 'The Purpose of a National Gallery', speech delivered at Wellington City Art Gallery, 23 February 2002 (see www.nga.gov.au/press/purpose).

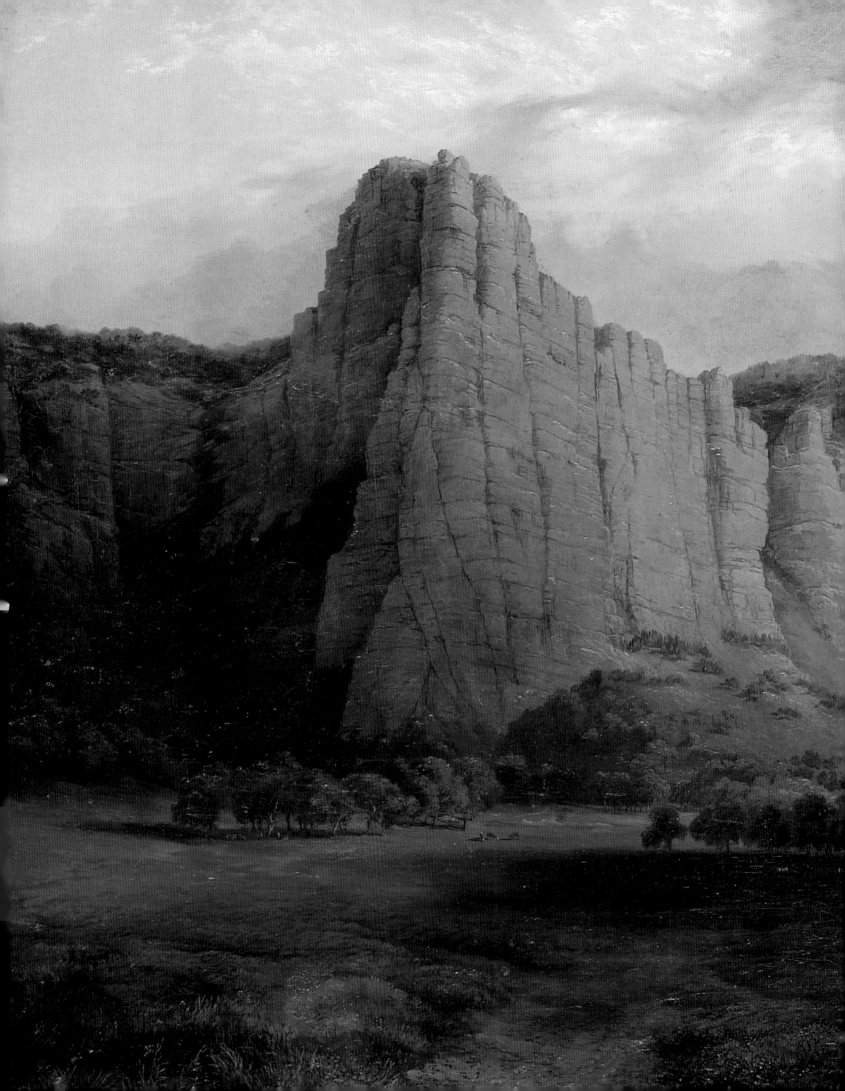

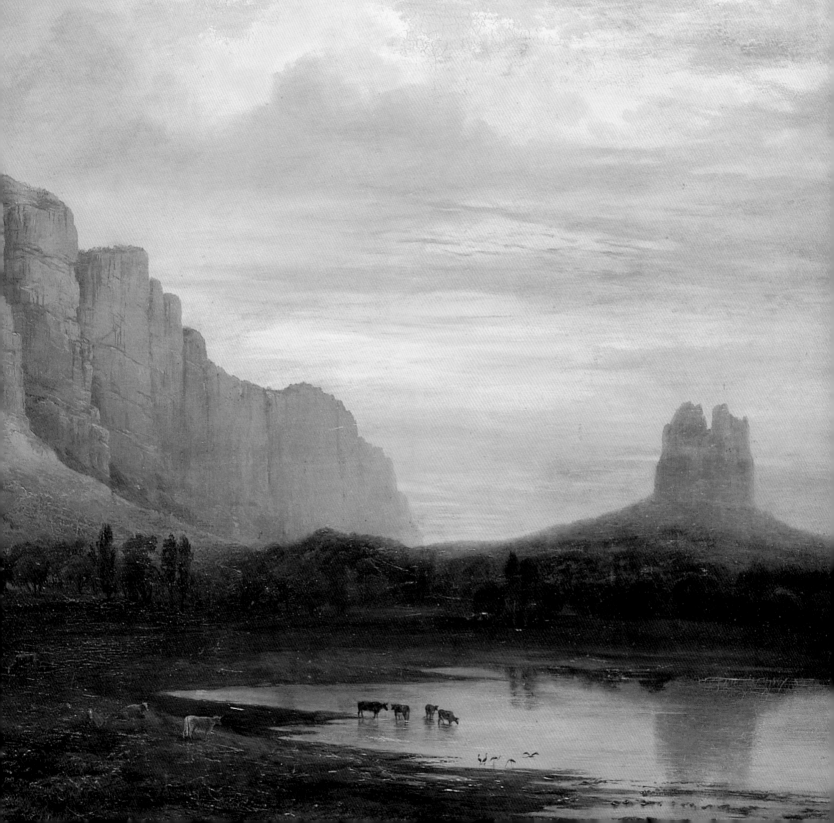

Pre-colonial and Colonial
1770–1884

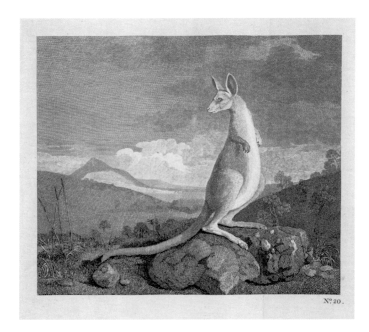

after George Stubbs 1724–1806
An animal found on the coast of New Holland called Kanguroo
from John Hawkesworth, *An Account of the Voyages Undertaken …*
for Making Discoveries in the Southern Hemisphere … London: 1773
line engraving, printed in black ink, from one copper plate on paper
19.8 x 24.3 cm
purchased 1985 85.1699

The Sydney Bird Painter active Sydney c.1790s
The white gallinule 1791–92
watercolour, brush and ink on paper 47.5 x 30.2 cm
purchased 2000 2000.461

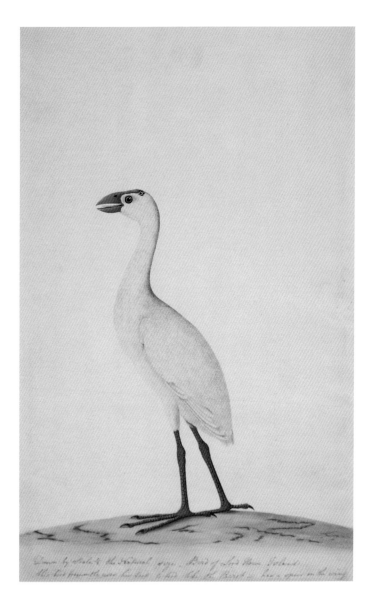

Following his 'discovery' of the eastern coast of Australia in 1770, Captain James Cook returned to England to a scientific community amazed by his expeditions and by the extraordinary birds, plants and animals collected during the *Endeavour*'s voyage.

One of the most peculiar specimens of all was a kangaroo, depicted in this engraving based on the celebrated painting by British animal painter and etcher George Stubbs. Painted from a specimen and from drawings by ship's artist Sydney Parkinson, Stubbs's image aroused great curiosity when it was first shown in London at the Society of Artists. It appeared in 1773 as an engraving in Hawkesworth's first official account of Cook's voyages. Hawkesworth described his first sighting of a kangaroo:

> it was of a light mouse colour, and in size and shape very much resembling a greyhound … and I should have taken it for a wild dog, if instead of running, it had not leapt like a hare or deer.[1]

The first white settlers who followed Cook also documented the curious wildlife of their new home. This skilfully rendered watercolour of a white gallinule was probably painted by the Sydney Bird Painter, a name attributed to possibly three different unknown artists, who may have arrived with the First Fleet in 1788.

Richard Neville wrote of the history of the white gallinule in a recent Sotheby's catalogue:

> A peculiar bird, the White Gallinule was one of a multitude of fauna first discovered on Lord Howe Island when Lieutenant Ball landed there in the *Supply* in March 1788. Like the unfortunate Mount Pitt bird of Norfolk Island that the Sydney Bird Painter also depicted, the White Gallinule was flightless and tragically hunted to extinction. The skin of only one White Gallinule has survived white settlement, enhancing the poignancy of this rare contemporary drawing.[2]

Anne McDonald

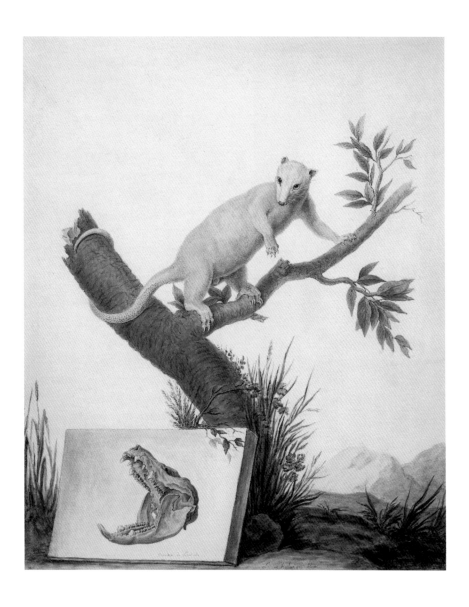

Attributed to **Peter Brown** active c.1758–99

The white phalanger (Phalanger orientalis) c.1770s–90s

watercolour, gouache on vellum 33.2 x 27.0 cm

purchased 1986 86.1139

This highly finished work, executed in watercolour on vellum, has not been traced to a published illustration, but it was almost certainly intended as the basis of an engraved plate for a natural history text. The image conforms to all of the natural history illustration conventions of the late 18th century and the pose of the animal suggests the taxidermist's hand. The artist almost certainly worked from a preserved specimen, yet he managed skilfully to give the creature a sense of life. The phalanger is observed in remarkable detail and imagined with real vitality. The tree and the suggested landscape are entirely conventional, yet the skill of the artist has brought out the softness of the animal's fur, suggested agile movement and convincingly portrayed its liveliness of eye.

The identity of the artist is unclear, the most likely candidate being Peter Brown, a natural history painter active in Britain in the latter part of the 18th century. Brown is best known for his 1776 publication, *New Illustrations of Zoology*, which had texts in English and French. Little is known of him besides a fleeting reference in the memoirs of the naturalist Thomas Pennant, who described him as 'a Dane by birth, and a very neat limner'.[3] Pennant's use of the word 'neat' to sum up Brown's style certainly fits with the precise and finely observed image presented in this natural history drawing.

The white phalanger is more commonly known as the grey phalanger, or cuscus. It is a marsupial, native to a small area of Cape York, Queensland, as well as parts of Indonesia, Timor and New Guinea. Most of the specimens described in European texts in the late 18th century were collected in Timor.

Andrew Sayers

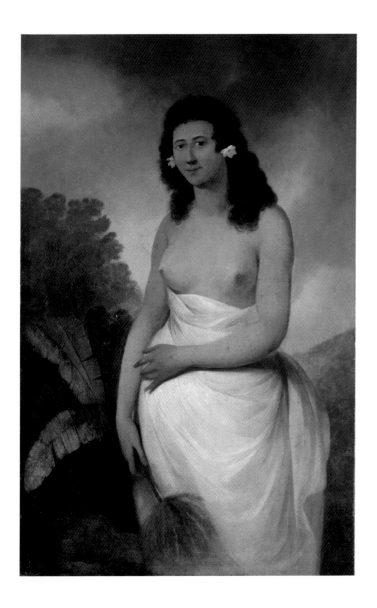

John Webber 1752–93

Poedooa, daughter of Orea, King of Ulietea, Society Islands c.1782–85
oil on canvas 144.8 x 93.5 cm
Rex Nan Kivell Collection. National Library of Australia
and National Gallery of Australia

Poedooa, daughter of Orea, King of Ulietea, Society Islands is one of
a number of works produced as a result of Captain James Cook's
voyages to the South Pacific. John Webber first painted Poedooa's
portrait in 1777 during the three days when she, her husband and
her brother were hostages on board the *Discovery* as Cook
pressured her father into returning two deserters. She was
15 at the time, and pregnant.

John Webber served as official draughtsman on Cook's third
Pacific voyage, which he made to search for a navigable North-
West Passage between the Pacific and Atlantic oceans. Artists
had accompanied Cook on each of his earlier Pacific voyages,
but Webber – trained at Bern and Paris in both landscape painting
and portraiture – was his closest collaborator, supplying images
to correct 'the unavoidable imperfections of written accounts …
to preserve, and to bring home, such drawings of the most
memorable scenes' so that the voyage could be made
'entertaining to the generality of readers'.[4]

Between 1776 and 1780, Webber produced nearly 200 works
of art and numerous coastal profiles and natural history subjects.
Amongst these works were 19 oil portraits, including one of
Poedooa. In all, three portraits of Poedooa are known to exist,
and the coarse canvas and thinly applied paint of the version in
the National Maritime Museum, Greenwich, England suggests
that it is the original, delivered to the Admiralty in fulfilment
of Webber's commission. This version, painted after Webber's
return to England, concentrates on Poedooa's exotic physical
charms but fails to reproduce the complex and challenging gaze
of the original. It was shown at the Royal Academy in 1785.

Rex Nan Kivell purchased this painting in 1965 for his
magnificent 'Australasian' Collection. It is one of a number of
highly significant paintings from the collection that have been
shown at the National Gallery of Australia since 1994.

Michelle Hetherington

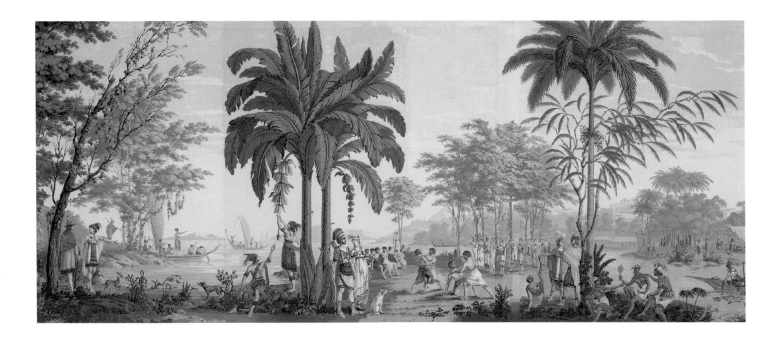

Joseph Dufour et Cie manufacturer Mâcon 1797–1835
Jean-Gabriel Charvet designer 1750–1829

Les Sauvages de la Mer Pacifique c.1805
woodblock, printed in colour, from multiple blocks; hand-painted
gouache through stencils on paper 170.0 x 1060.0 cm (overall)
purchased from Gallery admission charges 1982–83 83.1524

Panoramic wallpapers were popular as a form of decoration for
the European middle class in the early years of the 19th century –
for those who would have liked a painted mural but were unable
to afford the services of an artist. The views were mainly of exotic
lands, 'discovered' during the great voyages undertaken by the
dominant European powers during the 17th and 18th centuries.

Les Sauvages was designed by the French artist Jean-Gabriel
Charvet, who freely appropriated images from the published
accounts of various voyages, the two main sources being the
voyages of Captain James Cook (whom the French greatly
admired) and Jean-Francois de la Pérouse.

When viewing *Les Sauvages de la Mer Pacifique*, it is important
to remember that these panels are wallpaper and that the original
function determined the form of the imagery. The finished design
was translated into wallpaper by Joseph Dufour at his printing

workshop in Mâcon, near the city of Lyon in southern Burgundy,
France. Here, thousands of individual woodblocks were cut,
inked (in about 31 colours) and accurately printed and overprinted
on the 100 sheets of paper that were needed to make up the
complete image. These sheets were then glued together to form
20 vertical strips.

In its grand scale and conception, the wallpaper reveals
an extraordinary juxtaposition of Pacific peoples, cultures,
landscapes, fauna and flora. Although the viewer today may
perceive the wallpaper as having a purely decorative function,
at the time of its production the emphasis was on the educational
nature. This was post-revolutionary France and the world's first
public art gallery – the Louvre – had opened its doors in 1793.
The 48-page book which was issued with the wallpaper
explained: 'This decoration has been designed with the object
of showing to the public the peoples encountered by the most
recent explorers'.[5] Each of the 20 panels which make up the
panorama has a specific Pacific Island location, which was briefly
described in the accompanying booklet.

Roger Butler

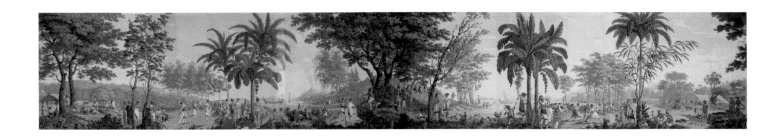

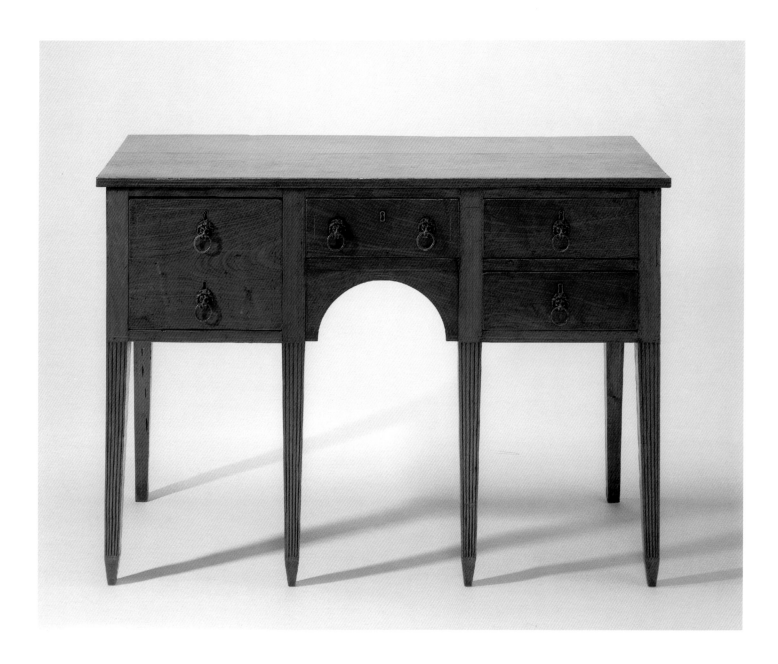

Maker unknown

Sideboard c.1810

blackwood and pine 91.0 x 131.4 x 52.0 cm

purchased from Gallery admission charges 1986 86.997

This sideboard was made in Tasmania in about 1810 and is one of the earliest known to have been made on the island, which was first settled as a penal colony in 1803. While its maker has not been identified, its design reflects the refined neoclassical style of English furniture of the late 18th century which remained popular through the early decades of colonial life in Australia. The restraint and simplicity that was characteristic of furniture design of this period made it possible for colonial furniture makers to interpret English designs, despite their limited resources and tools and unfamiliarity with local timbers.

Tasmania's isolation encouraged the development of locally-produced furniture which, as a result, became closely integrated with the simple and elegant design of the island's domestic architecture. This sideboard with its reeded, square-tapered legs and arched lunette front was made from native blackwood, with the decorative geometric double stringing on the drawer fronts made from unidentified pine.

Robert Bell

The Mountain Pheasant.

John Lewin 1770–1819

Blue face honeysucker

from his *Birds of New South Wales with their Natural History*

Sydney: G. Howe, 1813

etching, printed in black ink, from one copper plate;

hand-coloured on paper 28.0 x 21.8 cm

purchased 1996 96.916.15

Richard Browne 1776–1824

The mountain pheasant 1819

watercolour, pen and ink over pencil on paper 33.4 x 27.8 cm

purchased 1973 73.661

John Lewin, a natural history illustrator, arrived in New South Wales from England in 1801, the first professional artist to come to the new colony as a free settler. Richard Browne was also an artist, but arrived in the colony as a convict in 1811, completing his sentence in Newcastle in 1817. Their illustrations of the exotic bird life of Australia are today recognised as some of the most significant in colonial art.

Lewin's *Birds of New South Wales with their Natural History* was the first non-government book published in the colony.

He finished the plates for the book between December 1804 and February 1805, and a small edition was published in England in 1807. The National Gallery of Australia's copy is one of 13 books known to have been produced in the Sydney edition of 1813. Lewin's distinctive style of closely cropped and often asymmetrical compositions, combined with his naively unscientific yet poetic texts, has ensured the book's place in Australian visual history. It is not only one of the most important colonial publications, but also one of the most beautiful.

Browne specialised in making drawings of Indigenous people and of Australian fauna after he moved to Sydney in 1817. The lyrebird or 'mountain pheasant' was one of the stock delineations of which Browne made a number of copies. While at Newcastle, he had illustrated a manuscript on natural history compiled by Lieutenant Thomas Skottowe, the commandant there. Neither the illustrations to that text nor his Sydney drawings are distinguished for their scientific accuracy. Nonetheless, Browne often achieved the effect of graceful design such as in this drawing of a lyrebird perched on a rock.

Anne McDonald[6]

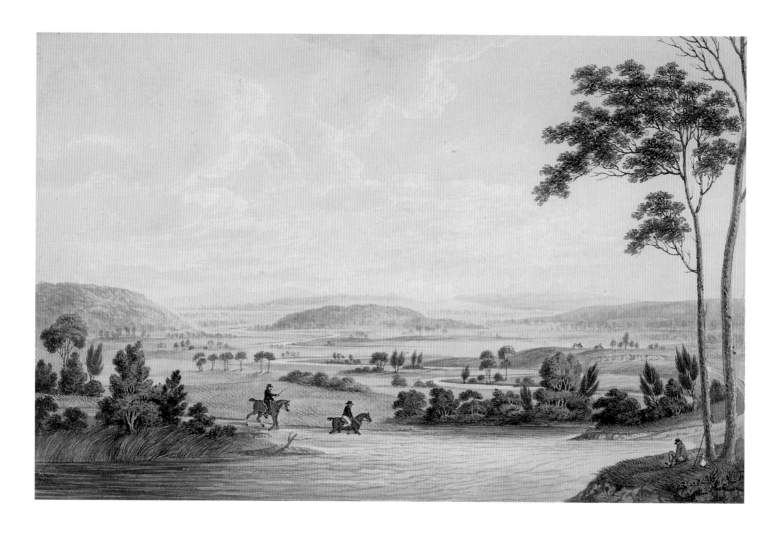

Joseph Lycett c.1774–1828

View on the Macquarie River near the ford, on the road to Launceston
c.1824
watercolour on paper 21.0 x 28.4 cm
purchased 1978 78.180

Colonial artists depicted views of their new land for a European public. They expressed pride at transforming the 'untamed' land into a rich European pasture and frequently changed the features of the landscape to comply with contemporary British interpretations of the picturesque.

Joseph Lycett was one of a large number of convict artists sent to Australia after limited training in Britain. He had worked as a painter of portraits and miniatures and was sentenced in 1811 to 14 years transportation for forgery. Shortly after his arrival in Sydney in 1814, he was appointed to the police office as a clerk. However, in 1815 he repeated his original offence and was sent to the secondary penal settlement at Newcastle, where he worked as an architect and artist for Captain James Wallis until he

received a pardon in 1819. He made sketching expeditions around Sydney, but there is no evidence that he ever visited Tasmania and he probably based this watercolour of the Macquarie River and Argyle Plains on sketches by other artists.

After he received an absolute pardon and left Sydney to return to Britain in 1822, Lycett made a series of aquatints based on watercolours such as this one, of the same size as the finished prints. Originally conceived in the relatively new technique of lithography, they were finally produced as hand-coloured aquatints in the book, *Views in Australia*. The views do not reflect the hardships of Lycett's past, or suggest Australia as a convict colony. Instead, they portray a fertile land which has been ordered by European civilisation to provide a comfortable life for those living on it. However, in 1825 when the book was published, the wool markets had fallen and, shortly afterwards, a serious drought threatened Lycett's rather optimistic view of Australia.

Anne Gray

Augustus Earle 1793–1838

Captain John Piper 1826
oil on canvas 44.4 x 30.8 cm
purchased 1980 80.1082

Mrs John Piper 1826
oil on cardboard on wood panel 45.8 x 31.0 cm
purchased 1980 80.1083

The Pipers were conspicuous figures in the early European settlement of Sydney, the city in which the itinerant Augustus Earle resided between 1825 and 1828. John Piper served in the New South Wales Corps from 1791 until 1811 and met Mary Ann Shears during this period. They married in 1816 and had numerous children. After visiting his native Scotland, Piper returned to Australia in 1814 where he took up the lucrative civilian post of Naval Officer. He was rewarded with a large block of land (now Point Piper), where he built a spectacular house, Henrietta Villa. But his ambitions ran ahead of his finances and he suffered a complete financial collapse in 1827.

Earle was responsible for the first large-scale portraits in Australia. These include two impressive full-length paintings of Captain John Piper and Mrs Piper (with children) now in the collection of the Mitchell Library, State Library of New South Wales. The two portraits in the National Gallery of Australia collection are much smaller and it is not clear exactly how they relate to each other, or to the larger paintings.

Despite these paintings being paired, there is an intriguing stylistic difference between them. Captain Piper is shown in three-quarter view, with a look of ease in his public position. It is possible to imagine this head atop a confident full-length portrait, one that reflects the man's office. Mrs Piper, on the other hand, is shown rather plainly. She is facing front-on and lacks the refined turn of the head of her husband's portrait. In short, Captain Piper has bearing, Mrs Piper simple presence.

Andrew Sayers

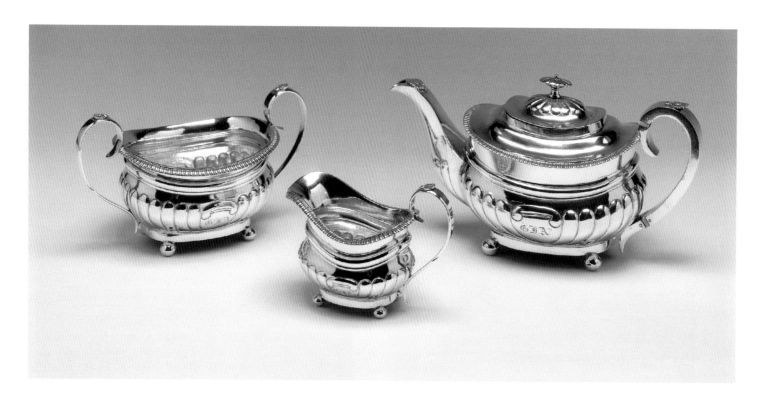

Maker unknown

Workbox with folding handle c.1825
whalebone, Huon pine, pine, velvet 9.1 x 23.5 x 18.0 cm
purchased 1980 80.1825.A-B

Alexander Dick 1800–43

Tea service c.1828
silver and bone teapot: 16.5 x 29.9 x 13.9 cm, jug: 11.2 x 15.4 x 9.3 cm,
sugar bowl: 13.0 x 23.4 x 13.1 cm
gift of David Wigram Allen and Dennis John Wigram Allen 1979
79.2305.1-3

European settlers in Australia showed considerable initiative in creating decorative and practical objects for their homes. This workbox, with lid and folding handle, was made in the 19th-century seafaring tradition of scrimshaw, the sailors' craft of making small, decorated objects from ivory, bone, whale teeth, shells and other natural materials. It was probably made by a British or Australian seaman on board a whaling ship in the waters off Tasmania. The ready availability of whalebone and ivory provided sailors with a strong and durable material for making small, practical tools and decorative objects. Such items were often made as souvenir gifts for loved ones and, like this example, exhibited a delicacy of form and decoration at odds with the harsh conditions endured by workers in this robust industry.

From the same period in Australia's colonial history is this tea service, an object of considerable refinement and elegance, made by the silversmith, watchmaker, jeweller and engraver, Alexander Dick, who established his business in Sydney after arriving from England as a free settler in 1824. This tea service demonstrates the English neoclassical style of the early 19th century and Dick's silversmithing skill in using the characteristic design motifs of gadrooning, or reverse fluting. It was commissioned from Dick by the Hon. George Allen (1800–77) who, after arriving in Sydney in 1816, became the first Australian-trained solicitor; Allen's descendants gave it to the National Gallery of Australia.

Robert Bell

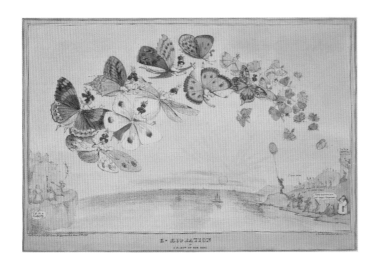

Alfred Ducôte active 1829–42

E-migration or a flight of fair game 1832
lithograph, printed in black ink from one stone; hand-coloured on
cream paper 23.6 x 38.2 cm
purchased 1975 75.229

Abraham Solomon 1824–62

Second Class – the parting: 'Thus part we rich in sorrow parting poor'
1854
oil on canvas 69.4 x 96.6 cm
purchased 1981 81.8

From the early 1800s, the British were encouraged to emigrate
to Australia and become wealthy by working the land or, from
the 1850s, by trying their luck on the goldfields. These two works
represent two facets of emigration to Australia and the changing
popular response to them.

Produced in London in 1832, the hand-coloured lithograph
E-migration or a flight of fair game came towards the end of a long
tradition of printed social and political satires. Nothing was
sacred to these satirical artists and their print publishers,
and the engravings, etchings and later lithographs they produced
provided popular amusement for all classes.

E-migration addressed itself to both an English and Australian
audience. The assisted immigration of single women was
designed to help overcome the extreme shortage of females
in the colony. The print shows the men of Van Diemen's Land
eagerly awaiting the arrival of the young women, while older
women left behind in the workhouses of England are left wishing
that they too were eligible.

Although Abraham Solomon painted *Second Class – the parting*
just two decades later, circumstances in England and Australia
had changed dramatically. Gold had been discovered in
Australia, transportation had virtually ceased and the political
print had lost its popularity in England. Solomon's painting
shows a young man leaving for the goldfields, his family
accompanying him on the train journey. The work is aimed at a
sentimental middle-class market – when will the mother see her
son again?

This painting forms part of a wider genre portraying free
settlers (and gold rush emigrants) to Australia and other British
empire colonies. After receiving accolades at the Royal Academy,
Second Class, together with its counterpart *First Class* 1854,
became popular through printed reproductions, being produced
as a lithographic print both in England and Germany.

Roger Butler

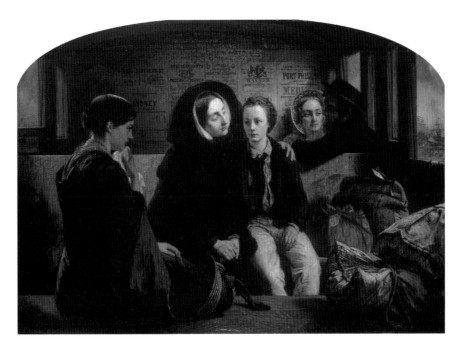

John Glover 1767–1849

Mount Wellington and Hobart Town from Kangaroo Point 1831–33
oil on canvas 76.2 x 152.4 cm
National Gallery of Australia and Tasmanian Museum and Art Gallery
purchased with funds from the Nerissa Johnson Bequest 2001 2001.207

Mount Wellington and Hobart Town from Kangaroo Point is an image of mysterious, powerful nature: the large mass of Mount Wellington, looming clouds, the broad expanse of the River Derwent and the nearby open grasslands. It portrays Tasmanian Aboriginal people singing and dancing, fishing and swimming, at ease in the natural environment; it also shows European civilisation – the buildings and streets, the ships, and the marching red-coated soldiers – hovering tentatively at the base of the mountain and on the edge of the water. It is an image of two worlds: the natural environment of Kangaroo Point and Mount Wellington contrasted with the bustling 'civilised' settlement of Hobart Town; the uninhibited energy and ease of the Tasmanian Aboriginal people as opposed to the regimented activities of
the soldiers.

The son of a Leicestershire farmer, John Glover achieved success as an artist in Britain from the 1790s to 1820s, painting picturesque watercolours and oils of the mountains and lakes of Europe. He worked in the classical tradition of the 17th-century French landscape painter, Claude Lorrain and his 18th-century English follower, Richard Wilson, to create images with poetic appeal and charm. He worked with deliberate care, with relentless attention to detail, portraying the landscape directly.

In 1830, he had auctioned the contents of his studio in London and, with his wife and elder son, followed his three younger sons to Van Diemen's Land, where they had already established themselves as farmers. Glover painted *Mount Wellington and Hobart Town from Kangaroo Point* during his first years in Van Diemen's Land, when he was at the height of his career.

In Australia, Glover painted two types of images (broadly speaking): those that portray Indigenous people living an idyllic life before the European invasion, and those that show the domestication of the landscape by the settlers. *Mount Wellington and Hobart Town* differs from these other works in that it shows Tasmanian Aboriginal people living happily in conjunction with European settlement (albeit – historically – for a very brief moment), and in that it presents the new, domesticated township incorporated into the larger natural world.

When Glover arrived in Van Diemen's Land, martial law had been in force against the Aboriginal people for over two years. He was living in Hobart during the summer of 1831–32 and was present when George Augustus Robinson, under the auspices of the colonial government, brought the last of the Tasmanian Aboriginal people of the Big River and Oyster Bay regions from their own land to Government House in Hobart. Glover, like many of his contemporaries, admired Robinson and supported the government's misguided policy of 'conciliation', believing it to be in the Aboriginal people's interest. However, ten days after their arrival in Hobart they were shipped to Flinders Island, in Bass Strait, where they eventually died. In *Mount Wellington and Hobart Town* Glover paid homage to these men and women.

Glover painted at least 13 images in which he incorporated Tasmanian Aboriginal figures, based on sketches made during his early years in the colony. His sketchbooks contain over two dozen drawings, taken from life, in Campbell Town goal in 1831, in Hobart Town in January 1832, and later at the artist's 'Patterdale' property during a visit by Robinson and his 'friendly mission' in January 1834. Glover's depiction of Aboriginal people in *Mount Wellington and Hobart Town* is markedly different from his approach in later paintings, such as *The bath of Diana, Van Diemen's Land*. There, he depicted the Aboriginal people living in an untroubled, idyllic paradise, before the European invasion. He later painted a nostalgic memento, *The last muster of the Aborigines at Risdon* 1836, in which he focused on this subject alone. *Mount Wellington and Hobart Town* differs from both these images in that it shows the Indigenous people living in harmony with the new European civilisation.

Glover's image also differs from other works portraying this tragic moment in Aboriginal history, because it was painted near to the time. Benjamin Duterrau did not paint his well-known images of the conciliation until 1840, when approximately half the Tasmanian Aboriginal people who had been removed to Flinders Island as a result of Robinson's efforts had died. Moreover, while Duterrau glorified Robinson as a heroic missionary and showed the Aboriginal people wearing loin cloths according to European convention, Glover eschewed the image of the 'noble savage' and simply depicted the 'gay, happy life' of the Tasmanian Aboriginal people juxtaposed with European settlement.[7] He left it to viewers to make their own conclusions. His figures were small, but his vision was huge.

Anne Gray

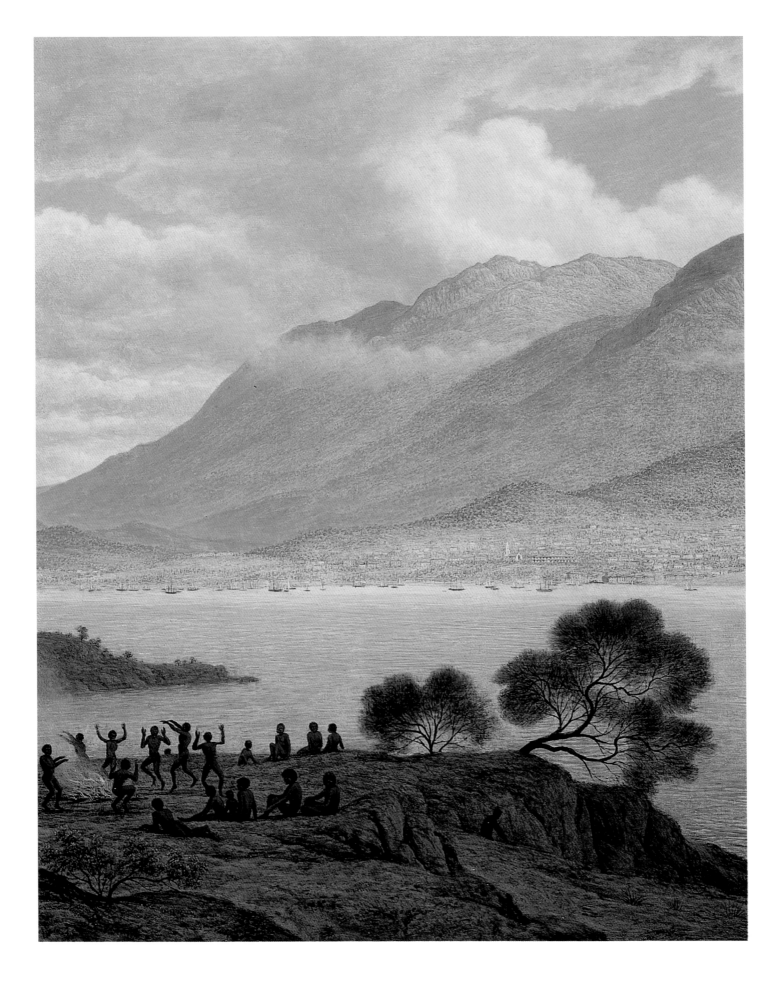

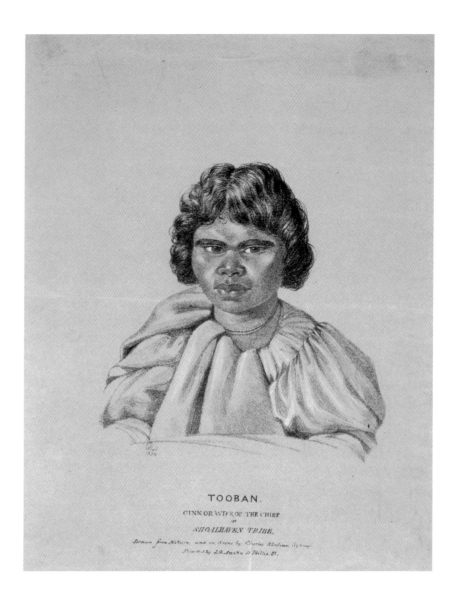

TOOBAN.

GINN OR WIFE OF THE CHIEF
OF
SHOALHAVEN TRIBE.

Drawn from Nature, and on Stone by Charles Rodius, Sydney.
Printed by J.G. Austin 13 Phillip St.

Charles Rodius 1802–60

Tooban, Ginn or wife of the chief of Shoalhaven tribe 1834
chalk lithograph, printed in black ink, from one stone; gouache
additions on brown paper 21.7 x 16.5 cm
purchased 1985 85.8

The artist Charles Rodius was one of the many convicts who
were transported from England to Australia between 1788 and
the middle of the 19th century. German-born, he trained in France
and arrived in Sydney in 1829 after his conviction in London.
His portrait *Tooban, Ginn or wife of the chief of Shoalhaven tribe* is
one of the most sensitive portraits of Indigenous Australians
produced in the period. Rodius was a skilled graphic artist,
equally at home with pencil, watercolour, charcoal or, as this
work reveals, with his favoured technique of lithography.

This chalk lithograph is one of a series depicting the
Indigenous peoples of Australia, all of which show his acute
observation, with facial features clearly rendered. As the caption
declares, the portraits were drawn 'from nature, and on the
[lithographic] stone' by the artist. Despite this, Rodius was still
greatly influenced by his early 19th-century training: the portrait
of Tooban is bust length and she wears a classical-style robe.

The sense of dignity that Rodius conveys in his portraits of
Indigenous Australians is in marked contrast to those of his many
contemporaries such as Thomas Balcombe or to the later work
of Augustus Earle.

Roger Butler

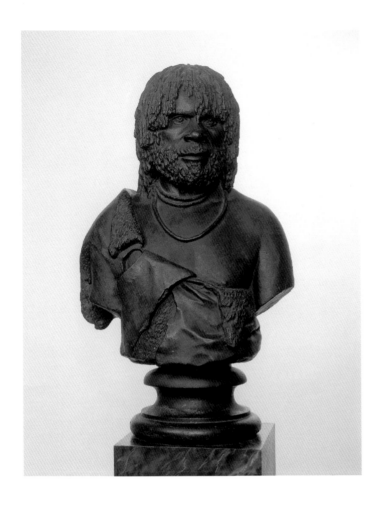

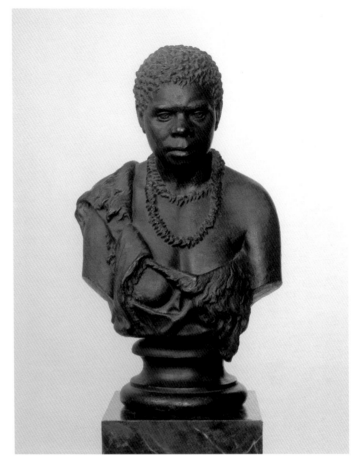

Benjamin Law 1807–90

Woureddy, an Aboriginal chief of Van Diemen's Land 1835
cast plaster, painted 75.0 x 48.3 x 27.0 cm
purchased 1981 81.3041

Trucaninny, wife of Woureddy 1836
cast plaster, painted 66.0 x 42.5 x 25.7 cm
purchased 1981 81.3042

Benjamin Law's busts of Woureddy and Trucaninny, two of the most celebrated Tamanian Aboriginal people of the 1830s, are the earliest major pieces of Australian sculpture. Woureddy sat for Law at the start of 1835 and, by April, his bust was ready. Trucaninny probably sat a few months later, though Law may only have completed her bust the following year.

Law's contemporaries recognised that these busts were accomplished works of art but valued them primarily as ethnographic records. When the conciliator of the Tasmanian

Aboriginal people, George Augustus Robinson, described the bust of Woureddy in 1835, he noted that it recorded the appearance of the Aborigines in their 'primitive state'.[8] A few years later, the Polish scientist John Lhotsky observed that the busts were 'of full size, perfect likenesses ... As the race of the natives of this island is nearly extinguished, these casts will retain a constant historical value'.[9]

The difference between the two sculptures is profound. Law's bust of Woureddy gives no hint of the decimation of the Tasmanians. As noted by Mary Mackay, it shows Woureddy 'as hunter, warrior and man-in-command, a Greek hero in kangaroo skin'.[10] Law's bust of Trucaninny, who saw her mother killed by a white settler and her first husband murdered by two sealers, is probably the most emotional colonial portrait of an Aboriginal person. According to one colonial account, she is 'sorrowing, mourning the slain members of her family and race'.[11]

Tim Bonyhady[12]

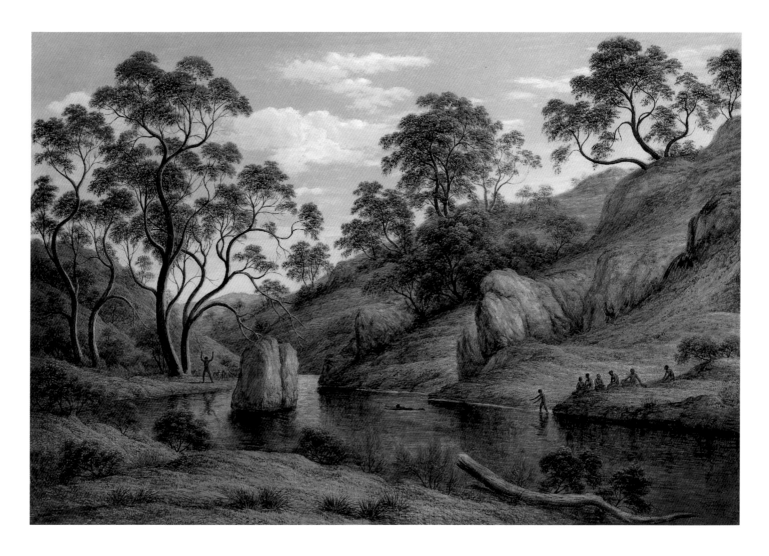

John Glover 1767–1849

The bath of Diana, Van Diemen's Land 1837

oil on canvas 76.4 x 114.4 cm

purchased 1993 93.1777

By the time John Glover arrived in Tasmania in 1831, it was too late (it is thought) to see Aboriginal people living freely in the bush as he depicts in *The bath of Diana, Van Diemen's Land*. However, from the moment of his settling in the colony, Glover was acutely interested in the Tasmanian Aboriginal people. Here, he presents an imagined scene of their idyllic and untroubled life before the European invasion – what Glover called 'the gay, happy life the natives led before the White people came here'.[13]

There is evidence in several of his other paintings that Glover saw the life of Aboriginal people in Tasmania before the arrival of Europeans as rather like the existence in Eden before the fall. In one small drawing he explicitly compares the Aboriginal people to Adam and Eve, with the serpent coiling around the tree, as yet unseen.

The bath of Diana, Van Diemen's Land is a further expression of this view. In the Greek myth, the hunter Actæon comes upon Diana and her attendants bathing. When she discovers his presence, the outraged Diana turns Actæon into a stag and he is set upon by his own hounds who tear him to pieces. As Tim Bonyhady has pointed out in his discussion of this painting, the moment in the story of Diana and Actæon which Glover depicts in the painting is 'the last moment of order and tranquillity before invasion is apprehended and violence and mayhem break out'.[14] In Glover's painting the Actæon figure is obscured from Diana's view behind a large rock.

Glover's explicit use of mythology to comment on contemporary events makes his painting unique in Australian colonial art.

Andrew Sayers

Augustus Earle 1793–1838

A bivouac of travellers in Australia in a cabbage tree forest, daybreak
c.1838
oil on canvas 118.0 x 81.9 cm
Rex Nan Kivell Collection. National Library of Australia
and National Gallery of Australia

Augustus Earle was the first freelance professional artist to tour the world, painting primarily watercolours of views and local customs. In New South Wales he continued this practice, especially on the two major sketching trips he made from Sydney – first to the Blue Mountains at the end of 1826 and then to the Illawarra district in May 1827. Following his return to England in 1828, Earle painted a small number of oil paintings of Australian subjects, including *A bivouac of travellers in Australia in a cabbage tree forest, daybreak*, the only Australian subject he exhibited at the Royal Academy in London. The painting was based on sketches made by Earle 11 years earlier.

A bivouac of travellers in Australia in a cabbage tree forest, daybreak shows jungle-like vegetation with dense forest, palms and towering trees. The term 'bivouacking' was widely used in the 19th century to describe setting up camp and sleeping out in the wilderness. It became common practice in Australia, as journeys between settlements often could not be completed in one day. The cabbage tree palm (*Livistona Australis*), so called because of the cabbage-like growth at the head of the trunk, can be seen in several places throughout the composition. The tree is native to Victoria, New South Wales and Queensland. In his painting, Earle has incorporated many romanticised aspects of colonial life that had wide popular appeal and mystique: weary travellers resting around an open fire, Indigenous guides, hunting and the experience of direct contact with an exotic, untamed landscape.

There has been some interest in an Indigenous figure which Earle painted out of the finished picture and covered by the billowing smoke of the campfire. This was probably a late decision to improve the composition and balance of the group around the fire.

Magda Keaney

Theresa Walker 1807–76

Kertamaroo, a Native of South Australia c.1840
cast wax 10.6 x 10.6 x 0.5 cm
purchased 1979 79.2244.A

Mocatta, commonly called Pretty Mary, a Native of South Australia c.1840
cast wax 10.3 x 10.3 x 0.8 cm
purchased 1979 79.2244.B

The small wax profile portraits of *Kertamaroo, a Native of South Australia* and *Mocatta, commonly called Pretty Mary, a Native of South Australia* are amongst the earliest examples of non-Indigenous Australian sculpture. Theresa Walker migrated from England and arrived in South Australia in 1837. Her work adheres to the conventions of neoclassical portrait medallions and cameos, which were popular in the late 18th and early 19th centuries, and which were commercially produced by manufacturers such as Wedgwood.

Walker first modelled the portraits in wax, then a mould was taken of this original so that a number of replicas could be cast for exhibition and sale. The portraits of Kertamaroo (known also as Mullawirraburka) and Mocatta are amongst her earliest surviving works. Undertaken in Adelaide about 1840, casts of both portraits were sent to the *Summer Exhibition* at the prestigious Royal Academy in London in 1841. Mocatta is cloaked in a manner reminiscent of classical drapery, whilst Kertamaroo, of the Kaurna people, the traditional owners of coastal plains around Adelaide, is dressed in European attire which presumably covers the scarification of the traditional *wilyaru* rite. In both the scale and sensitive manner of their depiction, Walker's portraits present a contrast to the near-contemporary mock bronze portrait busts of Woureddy and Trucaninny, produced by Benjamin Law in Van Diemen's Land.

Walker lived in South Australia from 1838 to 1846, then spent periods of time in New South Wales, Van Diemen's Land and Victoria. She is considered to be Australia's most important colonial woman sculptor, with an output that includes portraits of colonial governors, prominent citizens, members of the clergy, the ill-fated explorers Burke and Wills as well as more personal family and self-portraits.

Steven Tonkin

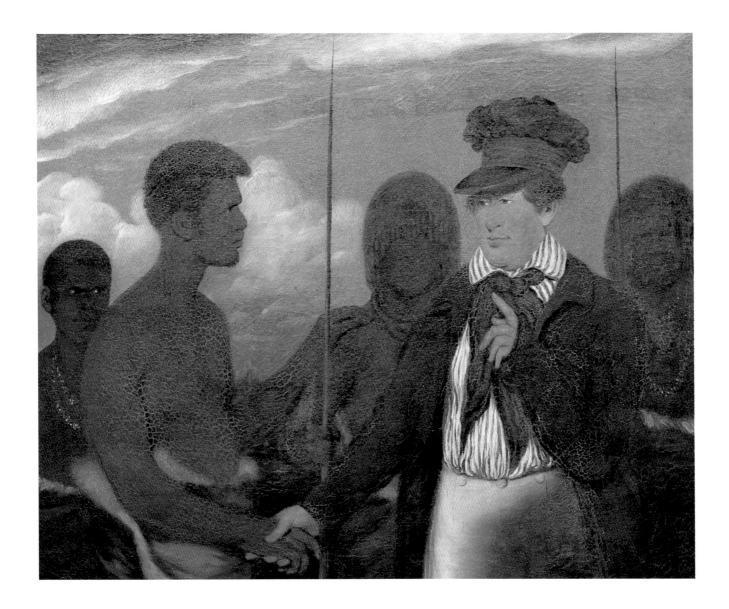

Benjamin Duterrau 1767–1851

Mr Robinson's first interview with Timmy 1840
oil on canvas 113.0 x 142.0 cm
purchased 1979 79.2859

Benjamin Duterrau emigrated to Tasmania in 1832 at the age
of 65. In England, he had been a minor painter and printmaker
who had exhibited only a small number of portraits and genre
pieces. In Hobart, he became one of Australia's most remarkable
colonial artists.

In addition to producing the first etchings executed in
Australia, Duterrau made some of the first colonial sculptures,
gave the first recorded lecture on art and, most significantly,
produced an extended series of oil paintings of Tasmania's
Aboriginal people. These paintings include portraits,
ethnographic pictures of the Tasmanians' 'occupations and
amusements' and the first Australian history paintings which
celebrate the 'conciliation' of the Aboriginal people by
George Augustus Robinson, who was employed by the
colonial government to bring in Tasmania's remaining 'wild'
people by peaceful means.

Mr Robinson's first interview with Timmy shows Robinson
pursuing this work – a solitary white man surrounded by
Aboriginal people. When Duterrau conceived this painting in
1834, he intended it as a tribute to Robinson's success in
peacefully persuading the Tasmanians to surrender after all the
violence of the frontier. By 1840 when Duterrau completed it,
approximately half the Tasmanian Aboriginal people who had
been removed to Flinders Island as a result of Robinson's work
had died. Yet Duterrau continued to think of Robinson as a 'real
hero' – a man of 'noble deeds'[15] who induced the Aboriginal
people 'to quit barbarous for civilised life'.[16]

Tim Bonyhady

Makers unknown
 Rajah quilt 1841
 cotton, silk thread 325.0 x 337.2 cm
 purchased 1989 89.2285

In 1816, Elizabeth Fry, concerned by the plight of women prisoners in gaol and during transportation, formed the Quaker group, the British Ladies Society for the Reformation of Female Prisoners. One of the many improvements that the Society implemented was to offer prisoners useful tasks such as needlecraft to keep them occupied during incarceration. The Society donated sewing supplies, which included 10 yards of fabric, 100 needles, threads, pins and scissors.

These provisions were carried by the 180 women prisoners on board the *Rajah* as it set sail from Woolwich, England on 5 April 1841 bound for Van Diemen's Land. When the *Rajah* arrived in Hobart on 19 July 1841, Governor Franklin's wife was presented with an inscribed patchwork, embroidered and appliquéd coverlet: the *Rajah quilt*.

A fine cross-stitch inscription on the lower border declares that the quilt was made by the prisoners for the British Ladies Society in gratitude for their kindness. This testimony was unusual as most items made were kept by the women or sold en route.

Several different women with varying sewing skills produced the *Rajah quilt*. The 2,815 fabric pieces are joined in the medallion or framed quilt style popular in the late 18th century in England and Ireland. The central field (and the area surrounding the inscription) is decorated with *broderie perse* or appliqué chintz. This is bordered by eight rows of patchwork in printed cottons, which showcase the fashion and changes in the textile printing industry at the time.

The *Rajah quilt* is a work not only of great historical significance but also of visual symmetry and elegance, an important example of Australian women's art of the 19th century.

Debbie Ward

Thomas Griffiths Wainewright 1794–1847

The Cutmear twins, Jane and Lucy c.1842

pencil, watercolour over pencil on paper 32.4 x 30.0 cm

purchased 1969 69.121

A number of convicts and ex-convicts made portrait drawings during the early years of the Australian colonies. In Sydney there was Charles Rodius and, in Hobart, Thomas Bock and Thomas Griffiths Wainewright. Wainewright, who was a recognised artist and renowned essayist in England, spent his last ten years in Hobart. His transportation for life to Van Diemen's Land in 1837 followed his conviction for forgery and for attempting to defraud the Bank of England. Although his means restricted him to watercolour, pencil and paper, he painted over 50 portraits during the final decade of his life – some in gratitude for kindnesses bestowed upon him, others by commission. He made this portrait as a token of gratitude to the girls' father James Cutmear who, as gatekeeper of the Prisoners' Barracks where Wainewright was imprisoned, supplied him with materials.

The young girls Jane and Lucy Cutmear transfix us with their gaze. Jane, her head slightly tilted, regards us from behind her sister with a slightly shy, yet quizzical look, as if momentarily distracted. Lucy's gaze is straight and sure – a wayward curl over her forehead makes us wonder if she is more concerned with holding our attention than with her appearance.

Likewise, Wainewright is confident in the application of his delicate pencil lines and sensitive brush strokes. In following the popular portrait style of the period, he carefully detailed the twins' young faces and carefully groomed hair, and gave only a cursory treatment to their clothing. To both girls he gave small, cupid's-bow lips – a very feminine and sensual characteristic which he imparted to almost all his subjects, and one which momentarily detracts from the twins' childhood innocence. However, Wainewright's portrait takes on a certain poignancy knowing as we do that Jane died in 1845, aged 12, and Lucy died in 1854, aged 21.

Anne McDonald

Maker unknown

Sofa c.1840

Australian red cedar, brass and ceramic casters, woven horsehair
upholstery 115.0 x 210.0 x 56.0 cm

purchased 1981 81.329

This sofa, by an unidentified Tasmanian designer and maker, is a
fine example of the late neoclassical style of furniture produced
in Australia in the mid-19th century. Such design was a
development from the earlier, plainer furniture that had been
made during Tasmania's early colonial period and reflected the
increasing confidence, visual complexity and design eclecticism
of Australian production.

The plentiful supply of Australian red cedar (*Toona australis*)
gave local cabinetmakers an easily-cured, light, strong and white
ant-resistant timber that was easy to work and carve. When
polished, it resembled fashionable mahogany, making it a
desirable and profitable export commodity throughout the
19th century. It was used for this sofa's lyre-shaped frame, its rich
colour and grain being enhanced by the extravagantly scrolled
and gadrooned decoration on the high back rail. The upholstery
is a modern replacement of the sofa's original woven horsehair
fabric, its natural glossy black colour and strength adding to the
visual drama of this object.

Robert Bell

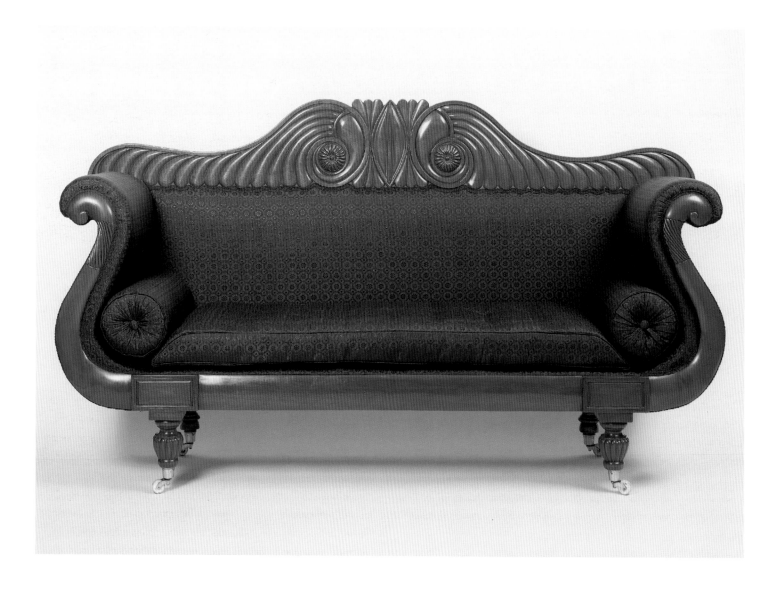

John Skinner Prout 1805–76

Fern Tree Valley, Mount Wellington 1844

from his *Tasmania Illustrated* Hobart Town: T. Bluett, 1844

lithograph, printed in colour, from two stones on paper 29.6 x 41.6 cm

purchased 1984 84.1292

The Tasmanian landscape, and particularly the falls, rivulets and fern gullies of Mount Wellington, inspired John Skinner Prout and provided him with a subject suited to his energetic style. In *Fern Tree Valley, Mount Wellington*, he depicted an artist at work in a pretty fern tree thicket near Hobart. He made many drawings, watercolours and paintings of this place, including one painting portraying a family picnicking there with baskets of food.

Prout travelled around Hobart and the nearby area collecting material for this and the other 17 lithographs that he published in *Tasmania Illustrated*. He described one of his sketching trips as follows:

> While my companions pursued their course I dismounted, tied my horse to a tree, and deviating a little from our track, reached a very pretty cascade, the position of which had been previously indicated to me, and which in a quarter of an hour was figuring among my sketches.[17]

He had just moved to Hobart, after living in Sydney for four years, where he had sketched that town and published a volume of 15 lithographs, *Sydney Illustrated* (1843–44). Prout made a successful career out of journeyman sketching, but he was much more than a topographer; he interpreted the scene freely, creating picturesque effects and capturing light and colour, air and space.

He was a popular teacher and lecturer in Hobart and members of the local community bought his lithographs. But Prout's stay in Australia was brief, as he always retained an interest in achieving success in Britain. He returned to London in 1848 and spent the next 20 years sketching the European countryside.

Anne Gray

W. B. Gould 1803–53

Fish on a blue and white plate 1845

oil on canvas 20.3 x 30.5 cm

purchased 1980 81.2168

Fishing enthusiasts will find the seven fish difficult to identify
in W. B. Gould's *Fish on a blue and white plate*, but they are
possibly Australian redbait or teraglin. If Gould did indeed
depict these fish from actual specimens, then it represents an
early instance of the meeting in colonial art of natural history
painting and the conventional still-life form. Although Gould
worked as a natural history artist for colonial officials, like other
colonial artists he rarely showed interest in Australian flora and
fauna as subjects for his still lifes. Most of his paintings followed
standard European models and presented European flowers, fruit
and game. However, he painted *Fish on a blue and white plate*
towards the end of his life, when perhaps he felt able to move
away from the European examples; in his attention to detail in

depicting the fish and the fly, he suggested a new interest in
natural history.

In England, Gould had first worked as a printer–lithographer
and then in the Staffordshire potteries. In 1827 at the age of 24,
he was transported for seven years to Van Dieman's Land for
stealing clothes. In Tasmania, he worked as a natural history
painter and, when serving time in the penal settlement at
Macquarie Harbour, drew marine life and animals for an amateur
scientist. After attaining his ticket-of-leave, he earned a meagre
living from his still-life paintings and often paid for his drink
by giving the hotelier one of his works.

Despite Gould's carefully composed, overlapping
composition, the fish in *Fish on a blue and white plate* seem to be
floating. This approach is characteristic of his work and may
be a result of his early experience of painting decorative images
on ceramics at the potteries in England.

Barbara Brinton

Thomas Bock 1790–1855

Mary Anne Vicary (Mrs John Roberts) c.1845

crayon, chalk, charcoal, watercolour wash on paper 35.8 x 30.4 cm

purchased 1980 80.3314

Mary Anne Vicary was born in c.1823 and arrived in Van Diemen's Land in 1828. She grew up on the property 'Rostrevor' on the east coast of Tasmania. She married John Roberts (1813–99), a Hobart Town solicitor and son of a Welsh clergyman, on 1 May 1841, at St David's Church. She died on 24 May 1903, aged 80.

The portrait is typical of Thomas Bock's work: a bust with the sitter turned three-quarters to us. His subject appears a calm, confident and pretty young woman in her early twenties. One might imagine John Roberts, proud of his new wife, commissioning the portrait from the artist who had previously drawn Jane, Lady Franklin, wife of the Lieutenant-Governor. Mary Roberts wears the pleated v-neck and flounced sleeve seen in several portraits of the period.

Bock invariably used chalk and charcoal on a dark paper, with highlights of white and, in this case, coloured crayon for the highlights of the gold chains. Another of Bock's hallmarks was his use of watercolour wash for the eyes. He was perhaps the finest portrait artist to work in Tasmania in the 19th century. A convict, he arrived in Hobart Town in 1824 and died there in 1855. He was one of the few convicts to live out his days in his place of exile and he died a respected artist in Hobart society. Bock was an engraver, lithographer, painter and photographer but most know him from portrait drawings such as this.

By the end of his life, Bock was experimenting with daguerreotypes and photography and, with this innovation, portraiture was to change forever. His chalk portraits might then be cherished for the very reason that they represent such a brief but appealing period of our early art history.

Philippa Kelly

William Strutt 1825–1915

Black Thursday – Melbourne, Victoria, 1851 c.1863
pencil, watercolour wash on paper 18.1 x 28.9 cm
purchased 1973 73.318

Montford an actor c.1886
oil, pencil on paper on plywood panel 26.5 x 22.8 cm
puchased 1973 73.714

William Strutt was trained in the European tradition and spent less than 12 years of his life in Australia. However, his experiences of colonial life resulted in two major paintings – *Black Thursday, February 6th, 1851* and *Bushrangers, Victoria, Australia, 1852*. A number of the drawings in the National Gallery of Australia's large collection of more than 60 Strutt drawings, oil studies, sketches and watercolours, relate to these important works.

The pencil and watercolour study for *Black Thursday* is part of the preparatory work for Strutt's largest and most impressive painting of an Australian subject. A devastating bushfire swept the state of Victoria in February 1851 shortly after Strutt's arrival. He made a tour of the burnt-out areas, listened to eyewitnesses' accounts and made many sketches. This compositional study must have been drawn at a stage when plans for the final

painting were approaching maturity, for it appears, with alterations, as the section on the extreme left of the painting which Strutt painted after his return to England in 1862.

It seems likely that an actor called Montford posed for the oil sketch and it was used for the head of one of the seated victims in *Bushrangers, Victoria, Australia, 1852*, painted in 1887.

James Gleeson[18]

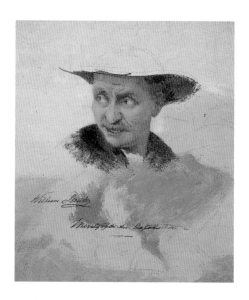

Knut Bull 1811–89

The wreck of the George III 1850

oil on canvas 84.5 x 123.0 cm

purchased with funds from the Nerissa Johnson Bequest 2001 2001.35

Both New South Wales and Van Diemen's Land were settled as penal colonies but, paradoxically – or perhaps out of shame – there are few representations of convict life in Australian art. Knut Bull's *The wreck of the George III* and his two versions of *The wreck of the Waterloo* 1846 are rare images of convict transport ships, and their unhappy ends.

The *George III* sailed from England in December 1834 and almost reached Hobart four months later but, on the evening of 12 April 1835, within a day's journey of its destination, it struck an uncharted rock (now known as King George Rock) to the north of Black Reef. The calm sea soon became rough, causing the ship to strike the rock violently and flinging people on the deck off their feet. In less than 20 minutes, the masts were broken and the ship was taking water.

The wreck remains one of the worst maritime disasters in Tasmanian history, with only 81 of the 208 prisoners on board being saved. That only two seamen were lost, and the whole of the guard and their families reached the shore, suggests that no real attempt was made to save the convicts and that perhaps the guards prevented them escaping from the holds below.

In 1845, the Norwegian-born Knut Bull was arrested in London for feloniously making part of a foreign note and sentenced to 14 years transportation. He arrived at Norfolk Island on board the *John Calvin* in 1846 and was transferred to the Saltwater River probation station in Van Diemen's Land in 1847. He painted *The wreck of the George III* in 1850, soon after he received a certificate of general good conduct which enabled him, with official consent, to accept payment for private work. Bull made a successful career in Hobart in the mid-1850s, painting several detailed landscapes of Hobart Town and the surrounding area.

Anne Gray

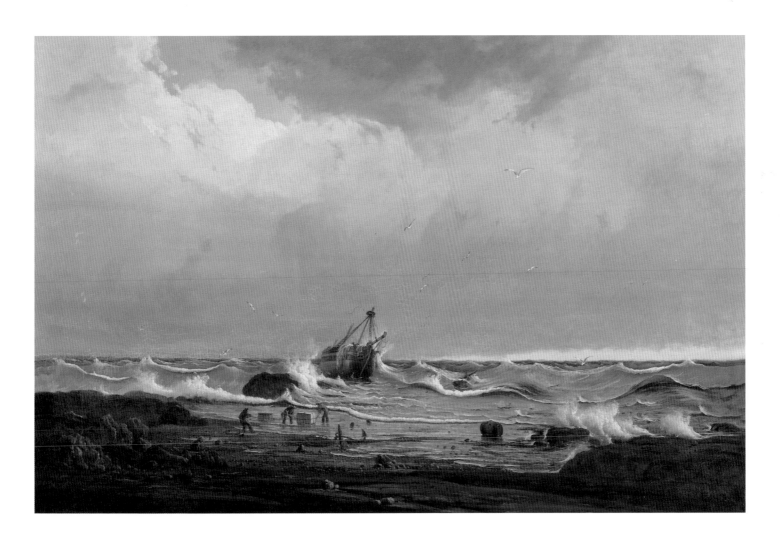

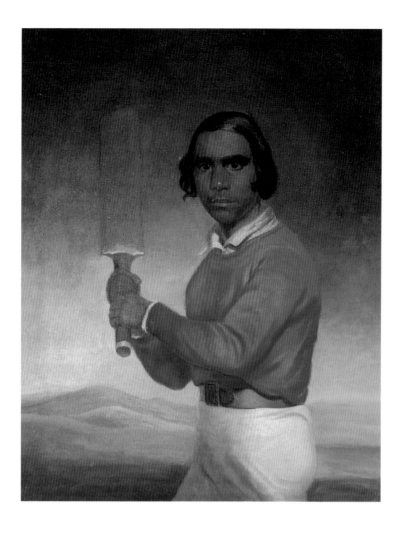

J.M. Crossland 1800–58

Portrait of Nannultera, a young Poonindie cricketer 1854
oil on canvas 99.0 x 78.8 cm
Rex Nan Kivell Collection. National Library of Australia
and National Gallery of Australia

Nannultera was born into a culture suffering inexorable pressure from land-hungry colonists. By 1838, Governor Gawler was voicing what many colonists believed was the only hope for survival left to the Indigenous people. 'We wish to make you happy', he proclaimed. 'But you cannot be happy unless you imitate good white men. Build huts, wear clothes, work and be useful. Above all … love God.'[19]

Archdeacon Mathew Hale sought to create the conditions for this 'happiness', establishing the Aboriginal Mission Institution of Poonindie near Port Lincoln in 1850. Cricket was introduced at the mission as a healthy recreation and useful part of the 'civilising' process. The Poonindie cricketers were considered the best in the district. On occasion they played in Adelaide and it is most likely on one of these visits in 1854 that Nannultera sat for his portrait.

Crossland accepted an uncharacteristically small fee for this work and its companion portrait of Samuel Conwillan, a lay preacher at Poonindie. He had exhibited at the Royal Academy and the Society of British Artists in London before migrating to South Australia in 1851, becoming society portraitist to eminent South Australians.

His Poonindie portraits are amongst the earliest depictions of Indigenous Australians appearing fully Europeanised and were commissioned by Hale in an attempt to show that colonisation had benefited the Indigenous population.

The portraits accompanied Hale back to England, where he died in 1895. That year government indifference and the greed of surrounding pastoralists saw the mission closed, its lands reallocated, and its inmates dispossessed once again.

Michelle Hetherington

Adelaide Ironside 1831–67

after George Hayter 1792–1871
The twin sisters 1850
pencil on paper 25.4 x 20.0 cm
purchased 1983 83.3303

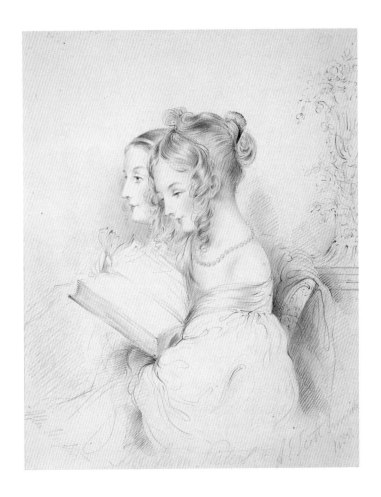

Recognised by powerful patrons for her artistic talent from
an early age, Adelaide Ironside left Sydney for Rome with
her mother at the age of 23, the first Australian artist to study
in Europe.

The early training from her devoted mother resulted in
accomplished pencil drawings of Australian wildflowers,
which were later exhibited in Paris. Many of the drawings
Ironside did before she left Sydney are copies after engravings,
a copyist's work considered a legitimate way of learning art at
the time. This copy that Ironside made of the British 19th-century
romantic artist George Hayter's painting, *The twin sisters,* is
typical of her work in this period. Her sensitive drawing,
highlighted with delicate colour, captures the appealing profile
view of twin sisters – one staring aimlessly into space and the
other engrossed in an open book. Flawless skin, comb and ribbon
in the pale hair, pearls and swathes of diaphanous material
contribute to the fragility of the image.

During Ironside's time in Europe, she was encouraged in her
professional career by the influential English critic John Ruskin
and granted permission by Pope Pius IX to study frescos in
Perugia and to copy works in the papal collection. In this period
her ambitions enlarged and she also completed several large oil
paintings of religious and allegorical subjects.

After her untimely death from tuberculosis, three of her
major history paintings were hung together in a memorial
exhibition in Sydney, and again at the opening of the Art Gallery
of New South Wales, Sydney, in 1880.

Susan Herbert

Ludwig Becker 1808–61

Blow-hole, Tasman's Peninsula, Van Diemen's Land 1851
watercolour, gum arabic on paper 17.2 x 24.7 cm
purchased 1989 89.515

Ludwig Becker, a German migrant, experienced life in Australia for only a decade, but his rare works rate highly with those of other artist–explorers, William Blandowski and Eugene von Guérard. He shared with them a unique approach to the Australian environment, inventive though precise in execution, complex in thought and feeling.

Becker's watercolour of the well-known Tasman Peninsula blow-hole focuses on the improbable shimmering light at the end of the dark rock tunnel. This was a rare use by Becker of artist's licence as the horizon line could not be seen from the elevated vantage point he adopted in this work.

By placing himself at the centre of the picture, intent on drawing, his cane and portfolio at a safe distance, the artist created an amusing contrast with the two figures rearing away from the splashes from the blow-hole. Eucalyptus tree roots protruding through the bank in the upper centre, and the burnt-out tree trunk in the top-right, show the artist's experience in perfectly reproducing his botanical subjects.

The pristine condition of the watercolour is unusual and probably due to its benign collection history. It remained privately owned until 1989 when it entered the National Collection.

Becker is better known for the arid inland desert subjects he painted long before these attracted 20th-century artists. The drawings he did in western New South Wales on the ill-fated Burke and Wills expedition in 1860–61 were exquisitely detailed. He died on the expedition on 29 April 1861 at Bulloo, north of the Queensland border.

Lyn Conybeare

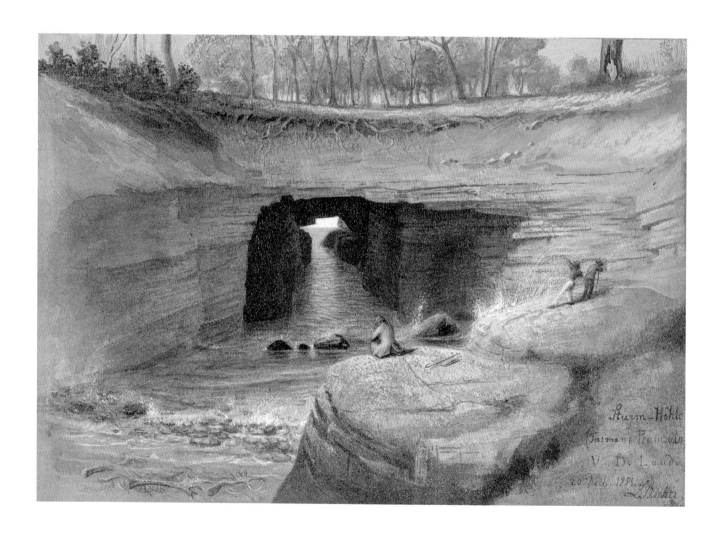

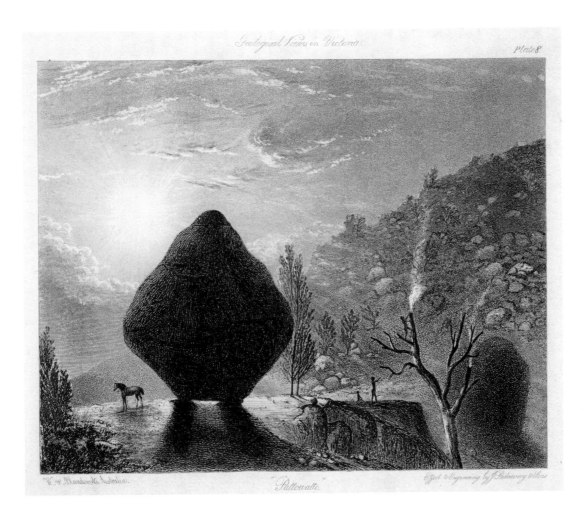

"Pattowatto."

William Blandowski 1822–c.1876
James Redaway and Sons engraver

Pattowatto. Granite boulders (Perrys Haystack) looking NW,
47 miles N by W of Melbourne from *Australia Terra Cognita*
portfolio 1855–59
etching, engraving, aquatint, roulette and lavis, printed in black ink,
from one copper plate on paper 21.2 x 27.8 cm
gift of Major-General T.F. Cape in loving memory of his wife
Elizabeth Rabett 1996 96.545

The granite boulder at Pattowatto sits timeless, its bulk
silhouetted against the glare of the late afternoon sky. Its ancient
grandeur is contrasted with the ephemeral, as wisps of high
cloud catch the last rays of the setting sun and the Indigenous
people continue their hunting, smoking a possum from a tree,
seeming oblivious to this wonder of nature. Even the horse
has turned its back.

In colonial art, scientific observation often merged with artistic
vision. This engraving was produced to illustrate a scientific text,
Australia Terra Cognita. Its author, the Prussian-born William
Blandowski, mining engineer, naturalist, photographer and
natural history artist, intended the book to be a compilation
of his scientific inquiries in Australia. Arriving in Adelaide in
1849, he explored widely, travelling overland to Victoria where
he made money from goldmining before being appointed
government zoologist. After conducting three expeditions, he fell
out with his colleagues and, in 1859, he returned to Germany.
His book was never completed, only 29 of the projected 200
illustrations having been engraved.

Blandowski was no more than a competent draughtsman and
was aware of his limitations as an artist. In Melbourne he
employed engravers, James Redaway and Sons, to translate his
work into prints and Redaway's role in turning a scientific sketch
into a luminous work of art cannot be underestimated. Blandowski
allowed the engraver extraordinary latitude in the interpretation
of his landscape subjects, particularly those depicting geological
formations. Redaway claimed the central role in the final look
of the finished work by the unusual engraved description:
'Effect & Engraving by …' The similarity of these works with
the engravings in J.M.W. Turner's *Liber Studiorum* (1807–19) is
obvious and it is not surprising to find that Redaway engraved
one print after Turner before migrating to Australia in 1852.

Roger Butler

Eugene von Guérard 1811–1901

Ferntree Gully in the Dandenong Ranges 1857
oil on canvas 92.0 x 138.0 cm
gift of Dr Joseph Brown, AO, OBE 1975 75.41

In its day, this was the most celebrated of all Australian paintings. In December 1857, the art critic of the Melbourne *Argus* greeted *Ferntree Gully in the Dandenong Ranges* as deserving 'a place in one of the royal or national galleries of Europe'[20] and launched a campaign to buy it for Queen Victoria. The Melbourne *Herald* instead hoped it 'will be kept amongst us [and] become the centre of our own "National Gallery"'.[21] The schemes failed and a pastoral company tycoon, about to retire to England, added it to his large collection of work by Eugene von Guérard, the colony's best artist.

When *Ferntree Gully* was lent to the Victorian Court at the *London International Exhibition* of 1862, the Melbourne press eagerly published a letter comparing it with works by the late great J.M.W. Turner, claiming that von Guérard's work was a truthful 'study from nature herself' compared with 'impossible' inventions 'in a cockney studio'. Yet von Guérard in Melbourne, like Turner in London, painted in a city studio from field sketches taken on spring and summer landscape tours. The reviewer said that *Ferntree Gully* offered 'grateful relief' after the 'feverish' Turners,[22] a reminder that mid-19th-century gallery-going was hot, crowded and smelly; the pleasure of looking at this work lay chiefly in its cool sunniness.

Forty kilometres out of town, the tree fern gullies of the Dandenong Ranges were in 1857 not often visited by tourists. This picture put them on the Melbourne excursionists' map.

Success engendered follow-up variants. A small canvas, lacking the lyrebirds, is framed with rounded corners to echo the graceful curves of the composition. Large drawings of the gully, in pen & ink and wash, occur in two commissioned series of Australian views, one of them for Sir Henry Barkly, Governor of Victoria, to take home to England. Best known is the version in *Eugene von Guérard's Australian Landscapes, A Series of 24 Tinted Lithographs*. Published ten years after the painting was executed, the lithograph no longer represented reality; the place had been degraded by timber-getters, fern-smugglers for the city market and by innocent excursionists. There was now 'a comfortable hotel in [the] immediate neighbourhood'.[23]

The text accompanying the lithograph reiterates appreciation characteristic of the age of international 'Fernmania' and, following the celebrity scientist Alexander Humboldt, of fascination with tropical ecosystems: 'the vivid verdure, the cool freshness, and the shadowy softness of an English woodland stream, [combined] with the luxuriant richness and graceful forms of tropical vegetation.' The unknown writer then introduces the idea of a religious sanctuary: 'nature builds up a vista of rounded columns sometimes attaining a height of thirty feet … constituting one of the loveliest cloisters it is possible to imagine … aromatic shrubs and creepers …[a] delicate and fragrant tapestry … giants of the forest, the lofty *eucalypti* and blackwood trees … attain an altitude of 200 or 250 feet … The wind may be "chanting a thunder-psalm" overhead, but below all is calm and silent; save for the musical ripple of the mountain brook, or the peculiar note of the lyre-bird … whose graceful plumage seems to have been designed to harmonize with the exquisite forms of the surrounding foliage'.[24] When the society artist Nicholas Chevalier designed a fancy dress costume 'emblematic of Australia, or of this colony'[25] for the Governor's wife in 1860, the conspicuous elements were a lyrebird-tail fan and, appliquéd to the edges of Lady Barkly's ball gown, tree fern fronds.

Close scrutiny of the colonists' new world, identification of the spirit of a particular cool and fragrant place, and a general mood of nature-worship contribute to the aesthetic force of this masterpiece. More significant is the underlying geometry, an intricate counterpoint of ecstatically writhing ferns, backed by the solemn verticals of dead white eucalypts, and all framed by a clockwise oval leading from the centrepiece lyrebirds through fallen trunks, then up an arching tree that eventually echoes the Dandenongs' skyline from above. This sinuous tree might be intended for the Austral mulberry, *Hedycarya angustifolia*, rarely so large but, as with the imaginary rocks that von Guérard introduced to the top left of his *North-east view from the northern top of Mount Kosciusko*, niceties of observation had to give way to the generation of visual flow. Partly a particular botany lesson, but more an image of the great cycle of nature, *Ferntree Gully in the Dandenong Ranges* is, above all, a field of energy. It holds the eye, continually inviting yet another brain-teasing circuit of the teeming earth, the water, the rising sap, the breathing leaves, the air, and back to the stillness of afterlife skeletons.

Daniel Thomas

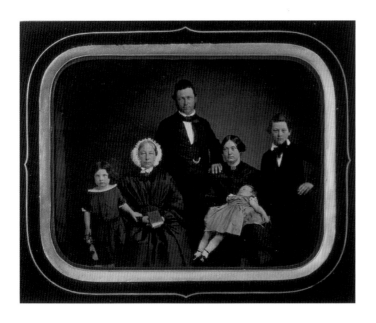

Thomas Glaister 1825–1904

Family group 1858
ambrotype, colour dyes 14.8 x 19.8 cm
purchased 1983 83.1161

Louisa Elizabeth How 1821–93

William Landsborough and his native guide Tiger 1858
salted paper photograph 15.5 x 11.5 cm
purchased 1994 94.993

After its introduction in Australia in 1842, portrait photography was quickly adopted as a valuable means of recording history in the colony. It was considered to be a true-to-life copy of a person, providing a record for future generations. It presented the prosperity and social standing of the sitters, as well as recording life in the new land.

In the 1850s, the American-trained photographer Thomas Glaister ran the most accomplished and ambitious portrait studio in Sydney. He was noted for the large size of some of his portraits, as in this elaborately framed group. Only a small number of citizens could afford expensive Glaister portraits such as the one seen here. It is a large coloured ambrotype, which is a negative on glass backed with black to make it a positive image. This unknown family is very much on show, recording their image and material success in society for posterity. It seems strange indeed then that their descendants have parted from their heirloom.

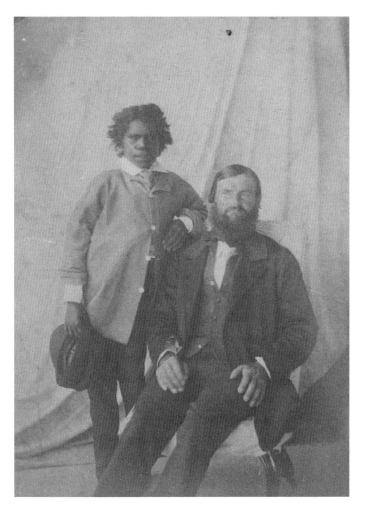

Amateur photographers could not easily make ambrotypes but they could make their own portraits on paper. Louisa How, the wife of Sydney merchant James How, is believed to have taken the photographs in an album of portraits of the couple's friends and family taken in 1858–59 at 'Woodlands', their home at Kirribilli Point. Despite the need to sit still for several minutes and have a support of some kind, How's sitters appear more at ease than those in the stiff studio portraits of the day. William Landsborough was an explorer and is shown with Tiger, a young Indigenous boy whom he had virtually adopted. The How album conveys the relaxed and assured life among the photographer's circle in colonial Sydney.

Gael Newton

Robert Dowling 1827–86

Mrs Adolphus Sceales with Black Jimmie on Merrang Station 1855–56

oil on canvas mounted on plywood 76.0 x 101.5 cm

purchased through the Founding Donor Fund 1984 84.260

The artist Robert Dowling took drawing lessons from a number of Tasmanian artists, including Thomas Bock, and became the first important colonial artist trained in Australia. In 1854, he moved to Geelong, Victoria, intent on making a reputation as a portrait painter.

When Dowling painted this extraordinary mourning tableau, Jane Sceales (née Paton) was a 34-year-old widow with young children. Her husband, Adolphus, had died some two years earlier; the groom-held chestnut mount had been his, the dogs as well. In 1848, Jane had come out from Scotland to marry and raise a family in Australia. In 1852, Adolphus purchased 'Merrang', a huge 44,910-acre run on the Hopkins River in the Western District of Victoria. The painting's imagery evokes a shared life, sadly cut short.

In 1856, in the Kilnoorat Church, Jane remarried. Her second husband, Robert Hood, was another emigrant Scot and a

widower with a family. He went on to purchase 'Merrang' from Sceales's trustees for £11,000 and so Jane, who lived until 1910, became the matriarch of a notable pastoral family. Their descendants still own the property.

'Merrang' meant brown snake to the Mopors, the displaced local Indigenous tribe. Jimmie, the young groom, was one of many Aboriginal people employed on 'Merrang' and neighbouring properties, as was Jane's long-serving housemaid Jeanie, who died there in 1899. The men worked as station hands and their horsemanship and skill with stock were particularly admired. The artist Eugene von Guérard celebrated this in *Cutting out the cattle, Kangatong*, painted for James Dawson, the anthropologist–pastoralist and Hood's friend, in 1855.

Jimmie looked after the stables and cared for 24 horses on 'Merrang'. I like to think he worked with them as well and perhaps, like his Mopor cousin Johnnie, head stock-keeper on Dawson's 'Kangatong', galloped freely across the lush green open woodland plains that no longer belonged to his people.

John Jones

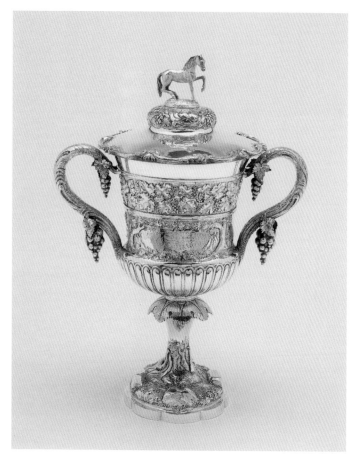

Stephen Smith and William Nicholson manufacturing
silversmiths London 1850–65

Table garniture (centrepiece and two épergnes) 1859
sterling silver and glass centrepiece: 79.0 x 46.5 x 46.5 cm
épergnes: 48.0 x 24.5 x 24.5 cm
purchased 1980 80.1588.1-3

William Edwards 1819–89

Presentation cup c.1859
silver with silver gilt interior 43.9 x 32.9 x 22.3 cm
purchased 1982 82.1953.A-B

The extravagance and eclecticism of mid-19th century English
and Australian presentation silver are visible in both of these
objects. The Smith and Nicholson table garniture is a tableau
of allegorical images of colonial success, depicting a shearer,
the classical figure of Ceres holding a cornucopia, an Indigenous
figure and a variety of native flora and fauna. Such naturalistic
objects were commissioned to commemorate the successes of
prominent colonial figures and were a specialty of British
silversmiths. Thomas Ware Smart (1810–81) purchased this
example in London with a £500 gift from the Australian Joint
Stock Bank.

Celebrating a different type of success is the presentation
cup by the Melbourne goldsmith, William Edwards. Made soon
after his arrival in Australia in 1857 and the establishment of his
business in Melbourne, this extravagant work combines
neoclassical forms with robust decoration, suggesting the
abundance and success achieved by many in mid-19th-century
Australian colonial life. There are kangaroos and emus on the
base, racing horses, vine leaves, fruit and grapes in a cast band
on the body of the cup and a figure of a horse on the lid. It is
engraved with the following inscription:

Melbourne Hunt Club Cup
Won by 'Bobby'
Ridden by his owner Jas Bevan Esq
Oct 8th 1859.

Robert Bell

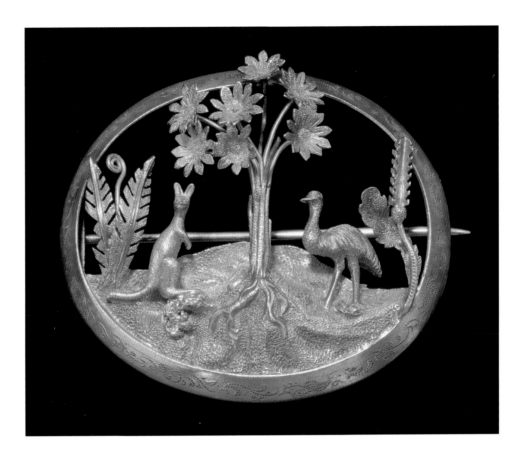

Thomas Wright 1828–1912

Brooch c.1860

gold 3.7 x 4.6 x 1.4 cm

gift from the collection of Florence May Gunson, grand-daughter of
Thomas Wright 1990 90.556

This gold brooch by Thomas Wright exemplifies the Australian
'goldfields' jewellery produced during the Victorian gold rush
of the 1860s.

Colonial jewellery and objects were often descriptive of the
'exotic' Australian environment, so utterly different from Europe.
Specific regional imagery developed as the colonists searched
for a personal and collective identity in their unfamiliar situation.
Successful miners fashioned locally prospected gold into brooches
in the form of miniature tools, as souvenirs or gifts for loved
ones. They used Australian flora and fauna as motifs and
sometimes carved emu eggs, combining them with elaborate
silver mounts to form inkwells or even teapots – objects that
epitomised the European way of life yet were also presentations
of native exotica. Tiny gold emus and kangaroos, such as are in
this brooch, had a similar iconic function, suggesting not only
that it was possible to control the overwhelmingly strange
environment, but also importantly demonstrating to those
in Europe the existence of such remarkable flora and fauna.

Colonial goldsmiths were almost all European trained
and the objects they produced derived from 'old world' models,
reinterpreted to incorporate the new environment. The great
European curiosity about Australia was an additional commercial
incentive, for the work sent back was highly desirable and proved
an effective way of adding value to the exported raw materials.

This gold brooch was made by Thomas Wright for his wife,
Emma (née Wollard), probably as a wedding present. It was
a treasured object, kept in the family until presented to the
Gallery by their grand-daughter, 130 years later.

Eugenie Keefer Bell

Eugene von Guérard 1811–1901

From the verandah of Purrumbete 1858
oil on canvas 51.4 x 86.3 cm
purchased 1978 78.173

Purrumbete from across the lake 1858
oil on canvas 51.0 x 85.5 cm
purchased with funds from the Nerissa Johnson Bequest 1998 98.148

When Eugene von Guérard began trying to make his living as an artist in Victoria in the mid-1850s, he found a big market for paintings of properties in the colony's Western District, Australia's wealthiest pastoral region. Usually, von Guérard painted one picture per property but a few squatters, starting with John and Peter Manifold of Purrumbete, ten kilometres east of Camperdown, were more ambitious. When von Guérard visited them in November 1857, the Manifolds commissioned a pair of these 'homestead portraits' to celebrate their success. While one looks east from the verandah of the house across Lake Purrumbete, the other looks west across the lake towards the homestead.

The main differences between these paintings are compositional. *Purrumbete from across the lake* is, like most homestead portraits, a straightforward view of a house. *From the verandah of Purrumbete* is exceptional for its pictorial inventiveness. By taking the verandah as his vantage point, von Guérard created a strikingly interesting painting in which the cool, shadowed areas of the house behind the spectator are set against the bright external world, and the rather featureless landscape is enlivened by the curves of the vines and the rectangular internal framing provided by the verandah posts, roof-beam and balustrade.

Tim Bonyhady

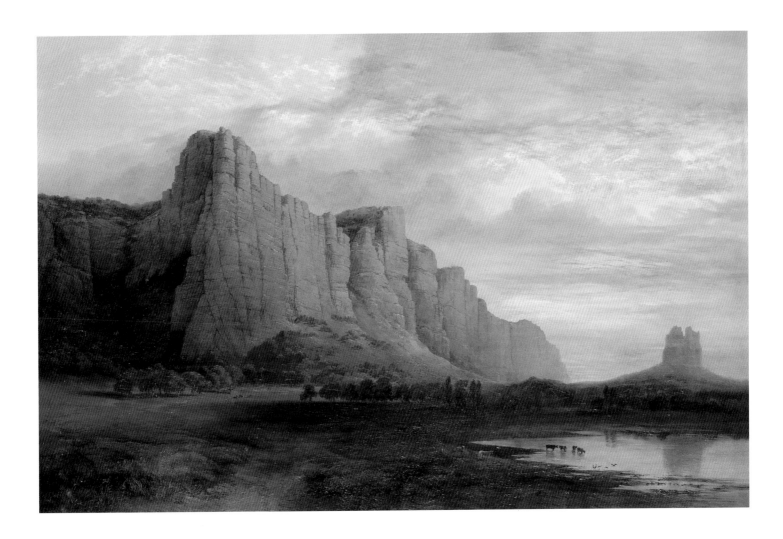

Nicholas Chevalier 1828–1902

Mount Arapiles and the Mitre Rock 1863
oil on canvas 77.5 x 120.6 cm
gift of Dr Joseph Brown, AO, OBE 1979 79.2344

Nicholas Chevalier first travelled to Mount Arapiles,
30 kilometres west of Horsham in the Wimmera district of north-
western Victoria, in May 1862. He accompanied Georg Neumayer
on a scientific expedition, a magnetic survey of the colony. Such
collaborations were common at the time, when art was frequently
seen as a handmaiden of science, rather than its opposite. The
commanding presence of Mount Arapiles was first documented
by a European in 1836, by the explorer Major Thomas Mitchell.
By the time Chevalier visited the area, it and the nearby monolith
the Mitre Rock were part of the station owned by Alexander
Wilson. He or his brother Charles commissioned the painting,
which was exhibited in Melbourne in 1864, to high praise.

In *Mount Arapiles and the Mitre Rock,* Chevalier portrayed the
might of nature compared with the efforts of humans. This was
an important theme of the sublime, the aesthetic doctrine

pondering the awe-inspiring, indifferent and immeasurable
vastness of creation, made manifest in the paintings of
J.M.W. Turner. The new animals, the cattle, are small in the
foreground while the surveying party's camp is all but obscured
under the trees. Neumayer wrote that on 5 May 1862 the party
'enjoyed a magnificent view of the setting sun',[26] which Chevalier
used to contrast the enduring granite of the rocks with the
evanescent light effects of the sky.

Chevalier came to Australia in 1854 during the gold rush, part
of the influx of cultivated immigrants from Europe. Born in
Russia, with a Swiss father, he studied art in Lausanne, Munich
and Italy and worked in London as a lithographer. This was
useful experience for his Australian career as a newspaper and
magazine illustrator. His ambitions as a painter remained,
however, and in the 1860s he produced some major paintings
of scenic landscapes in Victoria. He returned to England
permanently in 1869.

Christine Dixon

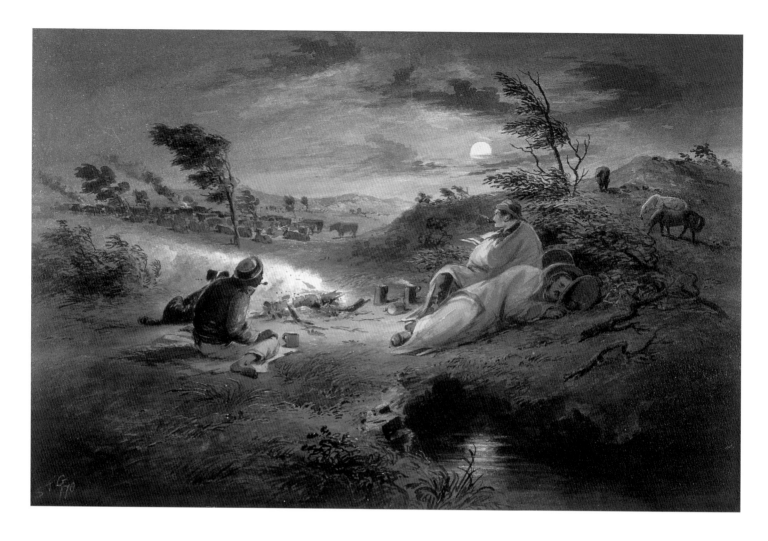

S.T. Gill 1818–80

Night 1870

watercolour, gum arabic over pencil on paper 29.0 x 44.8 cm

purchased 1969 69.24

In the relatively small watercolour, *Night*, S.T. Gill presents what could be termed a snapshot from a stockman's life. Sheltering in the hollow of a hill near a billabong in a windswept landscape, two stockmen wrapped in blankets huddle near the campfire and their boiling billy, while the native stockman sits to one side, barefoot on an exposed patch of ground. In the distance, the cattle graze in the moonlight under a stormy sky, while far away amongst the undulating hills there burns another campfire with its puff of smoke.

Gill arrived at Glenelg in South Australia in 1839 as a 21-year-old English trained artist. He brought with him a considerable amount of intellectual baggage, including ideas concerning landscape art in general as well as some views on the likely appearance of the Australian landscape. All these notions had formed during his childhood and youth in Plymouth and apprenticeship and training in London.

In the subsequent 40 years which he spent in Australia, until his death in 1880, many of these ideas were modified as he travelled extensively throughout South Australia, Victoria and New South Wales. Gill was predominantly a watercolourist and lithographer and produced literally thousands of images of the Australian landscape and, more particularly, of life in the fledgling towns, on the goldfields and in rural Australia. Although quick to exploit the satirical and topical aspects of the scenes which he encountered, Gill was also a very exacting and astute observer of life.

Sasha Grishin

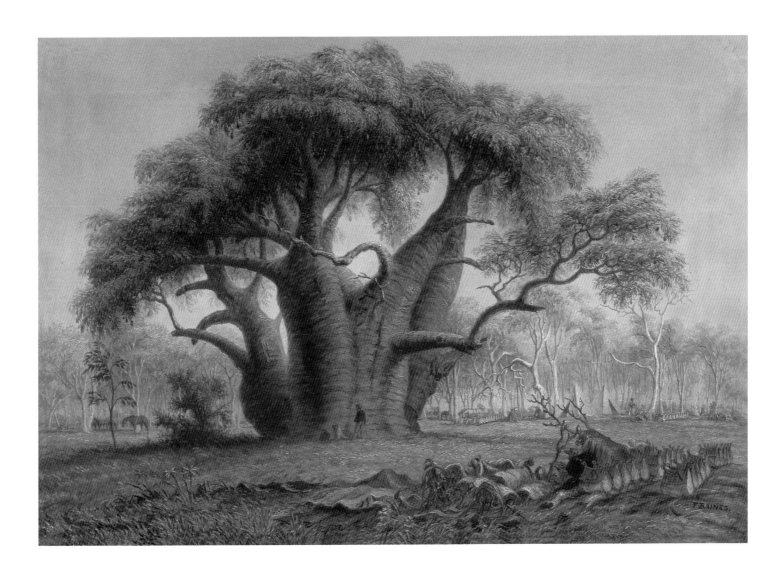

Thomas Baines 1820–75

Gouty stem tree, Adansonia gregorii, 58 feet circumference,
near a creek south east of Stokes Range, Victoria River 1868
oil on canvas 45.2 x 66.5 cm
purchased 1973 73.641.2

Thomas Baines, an English artist who had had considerable experience working in South Africa, was one of a number of European artists who came to Australia as members of exploring expeditions. Whereas most of these artists went to Australia on maritime voyages of discovery, Baines came as part of an expedition exploring the inland. Organised by the British Government at the instigation of the Royal Geographical Society, London, the North Australian Expedition set out to investigate the source of the Victoria River, to provide information about the country's north-west interior and to determine whether there was an inland sea or large river in the heart of the continent.

In the course of this expedition, which lasted from August 1855 to November 1856, Baines had only limited time to devote to art. Nevertheless, he still succeeded in making hundreds of pencil, watercolour and crayon sketches of the topography of the country, natural history subjects and significant events which occurred during the expedition. As soon as it was over, he turned some of these sketches into 40 oil paintings for the Royal Geographical Society.

Baines's *Gouty stem tree, Adansonia gregorii, circumference 58 feet*, which he painted in London a decade later, probably depicts the largest gouty stem tree seen by members of the expedition in Australia. Like many 19th-century artists, Baines would have been excited by the scale of such trees, but he also would have known that one of many discoveries by the party's botanist, Ferdinand von Mueller, involved this species. Von Mueller established that the gouty stem tree, like the baobab of tropical Africa, constituted a species of *Adansonia*.

Tim Bonyhady

Photographer unknown

'Noarlunga', Horse Shoe Bend, Onkaparinga Creek, South Australia
c.1865
albumen silver photograph 29.4 x 41.2 cm
purchased 1984 84.2907.104

This rather eerie view comes from an album of photographs assembled in the late 1860s by Englishman Robert Monkton (1831–1901) from his travels in Australia and New Zealand. It shows the St Philip and St James Anglican Church on the ridge above Horse Shoe Bend on Onkaparinga Creek, some 35 kilometres south of Adelaide. Despite the emptiness in the photograph, Onkaparinga was a busy town, being the inland loading point and a main stop on the way to the shipping port on the coast.

The photographer is unknown, but the size and quality of the print point to a skilled professional from Adelaide. In the 1850s and 1860s there were no 'snapshots'; photographers had to coat and prepare their glass negatives and then fix them on the spot. Exposures needed to be long; any moving figures or flowing water became blurred. The plates were also insensitive to blue skies, which registered as blank white. Clouds could be drawn in or another negative exposed just for the clouds. Nineteenth-century viewers were delighted by these scenic photographs, as witnesses to the progress of the colonies as much as any aesthetic appreciation of the Australian landscape. Over a century later, the minute details and character of this print give it its own aesthetic power.

Gael Newton

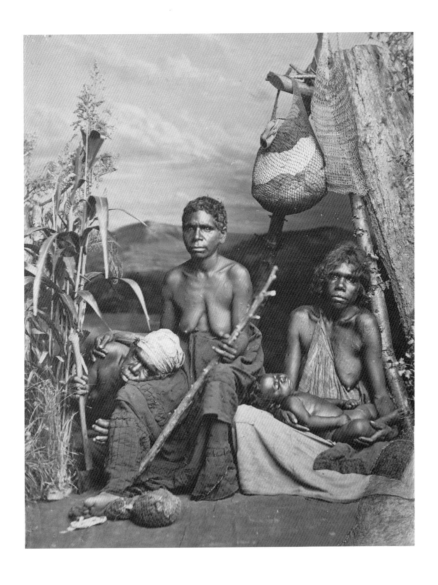

J.W. Lindt 1845–1926

Family group, Ulmarra tribe, Clarence River, N.S.W. 1872
printed 1890s gelatin silver photograph 30.8 x 24.0 cm
purchased 1993 93.448

In 1862 J.W. Lindt, the son of a customs agent in Frankfurt, worked his passage from Germany to Australia. He spent a year as an itinerant piano tuner and repairer before settling amongst the German community at Grafton in New South Wales, where he became a professional photographer. In 1869, Lindt took over a local studio; he was well educated and enterprising and the company flourished. While in Grafton, he published several series of Australian subjects destined for the national and overseas market, one of which was made between 1873–74 in the form of a portfolio of a dozen portraits of 'typical' Indigenous Australian people. That portfolio won a gold medal at the 1876 *Philadelphia Centennial Exhibition*, alongside panoramas of Australian scenery organised by his countryman B.O. Holtermann.

For his portraits, Lindt asked local Indigenous people to come to his studio and pose amongst props he had gathered from various sources. The portfolios, which had different combinations from a stock of about 50 images, became the most widely distributed images of Indigenous people in the 19th century.

Lindt relocated to Melbourne in 1876, running a very successful business as a photographer until his retirement. From the 1880s, he also became known as a collector of Australian and Pacific Island artefacts. In the late 1890s, Lindt produced a number of enlarged prints, with softened details, of his Grafton Indigenous subjects which appear to have been directed at the rising art photography market. Throughout his career, Lindt shared the view of his contemporaries that indigenous peoples worldwide were 'dying races'. In this attitude he was incorrect and eventually Indigenous Australian photographers in the 1980s would present their own counter-images of Indigenous people.

Gael Newton

Emma Minnie Boyd 1858–1936

A bush gully 1874
from her sketchbook, leaf 52
pen and ink on paper 12.8 x 18.5 cm
purchased 1970 70.65.52.AB

Filling sketchbooks with images of family and the local environs
was considered a fitting pastime for cultivated young ladies
of the colony. *A bush gully* is one such image in this artist's
sketchbook of precise and skilfully executed portraits, domestic
interiors, streetscapes and landscapes. This small
pen-and-ink sketch describes a non-specific place, yet is a
quintessential image of the Australian bush. It is full of spring
sunlight and airiness and the composition is carefully structured
to give a sense of deep space. The gums and native trees of an
enclosed and gentle landscape give a sense of nature
undisturbed, yet the felled log and figures nestled into the slope
indicate that European settlement has taken place, putting
it within the convention of colonial drawings.

Emma Minnie Boyd (Minnie) was brought up in a privileged
family and exhibited her paintings as an amateur – like many
women of her class she did not seek to sell her work. She
attended the National Gallery Art School, Melbourne, studied
privately with Louis Buvelot and exhibited alongside her male
counterparts Charles Conder, Tom Roberts and Arthur Streeton.

Between 1890 and 1893, Minnie and her husband Arthur
Merric Boyd travelled throughout Europe and exhibited at the
Royal Academy. Following a downturn in the fortune of her
parents, and consequently their allowance, they returned to
Melbourne where Minnie gave painting lessons to supplement
the family income.

While remembered as the matriarch of generations of talented
artists, including her sons Merric and Martin and grandson
Arthur, Minnie Boyd created accomplished portraits, domestic
scenes and landscapes of great sensitivity and delicacy.

Susan Herbert

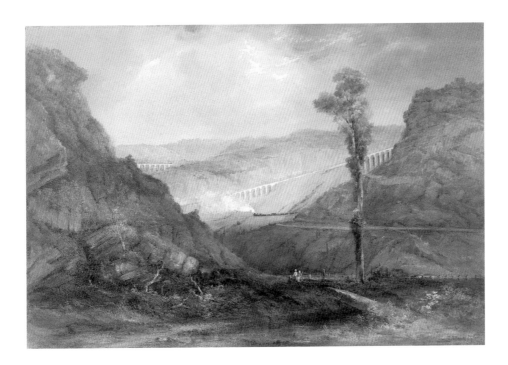

Conrad Martens 1801–78

Viaducts on the descent to the Lithgow Valley 1872
watercolour, gouache, varnish on card 46.4 x 67.2 cm
purchased 1968 68.11

View from Rose Bank 1840
oil on canvas 46.8 x 65.2 cm
from the collection of James Fairfax, AO; gift of Bridgestar Pty Ltd
1993 93.549

From 1835 until his death in 1878, British-born Conrad Martens lived and worked in Sydney, making occasional sketching expeditions along the coast and into the nearby ranges. Some years later, he travelled by ship to the newly-established settlement at Brisbane and returned by the Darling Downs and the New England tableland.

Although Martens had a facility in oils to match his skill in watercolours, it was the latter medium that aroused his greatest enthusiasm. As an artist, he allowed himself the right to adjust the details of his subjects so that they would relate in ways that conformed to the requirements of picture making as he understood them. He was willing to falsify the fact, but only if the falsifications brought the facts of nature into a closer harmony with the demands of art.

By the 1870s, the colony had broken through the barrier of the coastal ranges and was opening out towards the west. The discovery of gold was an incentive, townships grew and railways were built to link them with the city on the coast. The steep western escarpment of the Great Dividing Range necessitated a zig-zag track on a series of massive viaducts, and it was this engineering feat in its wild natural setting that caught Martens's imagination.

The *View from Rose Bank* is one of the most Italianate of Martens's landscapes, and one of the most pleasing. He has made little attempt to render the scene in factual terms but converted it into a dreamy, light-drenched vision of patrician villas, gracious parklands and sky-reflecting water such as one might find in the Alban Hills near Rome, or around the lakes of Northern Italy. Even the colour has changed, from a palette which normally favoured the warmer tints and deeper tones to one pitched higher and on the cooler side.

James Gleeson[27]

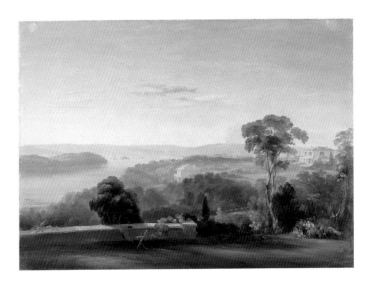

Macedon 1872

Louis Buvelot 1814–88

Macedon 1872
pencil on paper 26.8 x 32.6 cm
purchased 1950 59.5

Although he usually annotated his sketches with the location of the subject, Louis Buvelot had little interest in precise or particular topographies. He often drew in pencil but unlike his contemporary, Eugene von Guérard, he rarely employed its capacity to produce sharp details or outlines. Rather, as this typical 1872 drawing of Macedon shows, he used the pencil to create patches of rough tone with which he built up a dense variegated sketch of the bush. This drawing is concerned with light and shade; it possesses a complete tonal range, from the blank glare of paper to the deep shade under the densest copse of trees. Buvelot's other preferred drawing media – charcoal, and brush and ink wash – were those capable of achieving tonal effects quickly and effectively.

Buvelot undertook a number of sketching journeys, some of which took him a considerable distance through Victoria. But his favourite sketching grounds, where rustic landscapes mingled with picturesque bushland, were found close to Melbourne.

Buvelot appears to have exhibited sketches only in the last few years of his life and to have used sketching for the orthodox purpose of working towards producing pictures in the studio. After his death in 1888, one of his acquaintances described camping with the artist and collecting material for pictures. He recalled that, when Buvelot had 'looked long in the bush and made his many sketches, and taken all the impressions he thought it possible to remember and reproduce, he would go home to his workroom'.[28]

Andrew Sayers

Louis Buvelot 1814–88

Near Lilydale 1874
oil on canvas 46.0 x 69.0 cm
purchased 1977 77.666

The Swiss landscape painter, Louis Buvelot, arrived in Victoria in 1865. A year later, he began exhibiting in Melbourne. By the end of the decade, he was regarded as the colony's leading landscape painter, eclipsing Eugene von Guérard.

Buvelot achieved this status partly because von Guérard's painting was generally much more mundane from the mid-1860s than it was in his first ten years as an artist in Melbourne. Yet Buvelot also triumphed because of the breadth of his technique (which offered a stark contrast to the great precision with which von Guérard painted) and because of his focus on apparently nondescript aspects of the settled countryside, generally close to Melbourne (which were very different to the spectacular mountain ranges, crater lakes and waterfalls that von Guérard preferred).

Near Lilydale exemplifies these aspects of Buvelot's work. Its paintwork is relatively broad. The main features of the landscape – sunlit gum trees, background hills and rough pastures with cattle at water in a shadowed foreground – are commonplace. It is the kind of 'comfortable' subject which a new breed of urban, middle-class art patron came to prefer to the sublime and spectacular.

Tim Bonyhady

B.O. Holtermann 1838–85
Charles Bayliss 1850–97

from *Panorama of Sydney Harbour and suburbs from the North Shore*
1875
23 albumen silver photographs 52.2 x 978.6 cm (overall)
purchased 1982 82. 1159

B.O. Holtermann migrated to Australia in 1858 and, by 1872, he had made a fortune through mining and other business ventures. He dedicated the rest of his life to promoting his wonderful new homeland. In early 1876, Holtermann first displayed his *World Exposition* to the Photographic Society of the Pacific Coast in San Francisco. This exhibition comprised views of Australian cities, suburbs and towns. For his audience, he unrolled a 33-foot (nearly 10-metre) panorama of Sydney Harbour taken from the tower of his own home atop a ridge of Sydney's North Shore. Holtermann had engaged Charles Bayliss,

a professional photographer, to produce a number of panoramas for this *World Exposition,* which was designed to promote Australia overseas.

The National Gallery of Australia owns the finest surviving copy of the 33-foot panorama. The San Francisco viewers may also have seen Holtermann's masterstroke, a panorama made up of three sections with two negatives 3 by 5 feet and one of 3 by 4 feet. These glass plates were the largest wet-plate negatives ever made. A few plates remain in the State Library of New South Wales, but no copy of the giant panorama is known to survive.

The vision and patriotism of Holtermann, combined with the skill and efficiency of Charles Bayliss, resulted in an extraordinary record of Australia, flushed with new affluence and confidence from the gold rush era, and seeking to define itself in the years leading up to the Australian Centennial in 1888.

Gael Newton

W.C. Piguenit 1836–1914

On the Nepean, New South Wales 1881
oil on canvas 106.5 x 92.0 cm
purchased 1976 76.2

On the Nepean, New South Wales displays several features common in W.C. Piguenit's art: a low perspectival point, little foreground interest, and a contrast between human activity and the unspoiled natural world. The viewer is led with the rowers in their boat through the river valley, between its towering cliffs into a sunlit settled clearing surrounded by mountains. Humans take part in the scene, but they appreciate rather than dominate nature.

In his native Tasmania, Piguenit worked first as a draughtsman, resigning to pursue his artistic career. He explored the wild mountains and rivers of Tasmania, creating sketches, watercolours, lithographs and photographs as well as oil paintings of little-known places. His works became popular in the 1870s and 1880s, showing as they did the dramatic beauty of newly-encountered landscapes. Piguenit first ventured into the inaccessible valleys of the Blue Mountains in 1875, where he spent a month at a series of artists' and photographers' camps before moving permanently from Tasmania to Sydney in 1880.

Piguenit exhibited several Nepean paintings at the Art Society of New South Wales in the 1880s. He was attracted always to powerful and extreme vistas; he found new romantic and picturesque qualities in the Australian landscape.

Christine Dixon

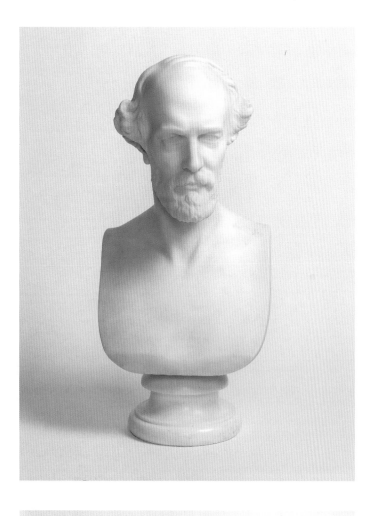

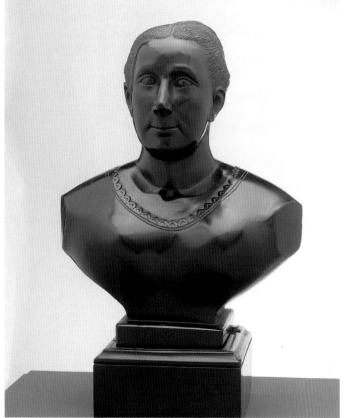

Charles Summers 1825–78

William Wilkinson Wardell 1878
carved and polished marble 66.5 x 31.5 x 28.0 cm
purchased 1984 84.3

John Baird 1834–94

Jane Baird 1876
carved, polished and waxed kerosene shale 58.1 x 39.0 x 23.5 cm
purchased 1980 80.1091

Charles Summers's portrait bust of *William Wilkinson Wardell* and John Baird's near-contemporary depiction of *Jane Baird* illustrate the professional/amateur divide in 19th-century Australian sculpture. Summers, the son of a stonemason, arrived in Melbourne in 1853, after distinguishing himself as a student at the Royal Academy Schools in London. He became a pivotal figure in local artistic circles and was highly sought after for portraits and commissions. His finest public monument is the bronze statue to the ill-fated explorers, Burke and Wills, made in 1864–65.

In 1867, Summers left Melbourne and set up a large studio workshop in Rome, where he employed a number of trained assistants. His established reputation ensured that he continued to obtain Australian commissions, a superb example being the Italian marble bust of the architect and engineer *William Wilkinson Wardell*. Wardell was Inspector General of Public Works in colonial Victoria from 1861 to 1878. During a tour of Europe in 1870, Wardell sat for his portrait in Summers's studio in Rome; the work was completed in 1878 and later shipped to Australia. This portrait bust encapsulates the professional status of both the sculptor and the subject.

In striking contrast to Summers's polished professional output is Baird's portrait of his wife, *Jane Baird*. Little is known of this amateur sculptor's life except that he worked as a postman in Sydney. In private, he carved a small number of objects in an unusual material for sculpture, kerosene shale, which was mined locally on the North Shore and at Hartley, near Lithgow. Baird did not exhibit his work, so a short article in the *Illustrated Sydney News* in 1886 entitled 'Carvings in shale – A Sydney postman's discovery' appears to be the only recognition he received during his lifetime. The directness with which Baird has carved this portrait and the stoic gaze of his subject communicate much about his wife's character.

Steven Tonkin

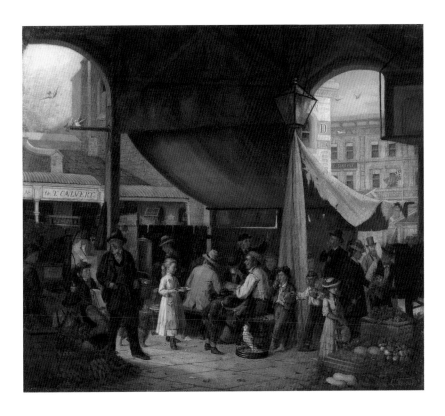

Louis Tannert c.1833–after 1893

The Eastern Market 1878
oil on canvas 73.0 x 83.0 cm
purchased 1982 82.597

Although the landscape and a rural existence were the most popular subjects for Australian artists and writers for many years, most of the population has always lived in urban surroundings. Few early Australian artists took the city and its business as the subject for their art. Louis Tannert's *The Eastern Market* is an interesting exception. It shows the variety of life in the market – on the corner of Bourke and Exhibition Streets in Melbourne – that was demolished in the early 1960s. In the shadowed gas-lit and awning-draped market, a great cross-section of city dwellers is shown, from the barefooted urchin to the top-hatted gentlemen. In the hustle and bustle of this busy scene, a young girl waits on a group of diners, while another accompanies her mother shopping for vegetables; a young boy sells newspapers, while another taunts a caged cockatoo. Beyond the market arcades can be seen the sunlit and fashionable Italianate facades of a prosperous city, soon to be known as 'Marvellous Melbourne'.

Tom Roberts was another artist who depicted city life at the turn of the century, in works such as *Allegro con brio, Bourke Street west*. The etching *Chinese cook shop* is Roberts's most sophisticated and ambitious print. In its composition and the domestic realism of its subject matter, Roberts was influenced by James McNeill Whistler's prints of the late 1850s, but this work is firmly placed in an Australian historical context – emphasised by the later alternative title *The opium den*. Popular prejudices at the time were anti-Chinese in the wake of the influx of prospectors from China arriving to seek their fortune, and their opium smoking habits were vilified. Early Australian etchers, such as Roberts and John Mather, took the European, especially the French, etching tradition and applied it to Australian subject matter.

John McPhee[29] and Roger Butler

Tom Roberts 1856–1931 *The Chinese cook shop* 1887
etching 20.4 x 15.2 cm purchased 1976 76.722.21

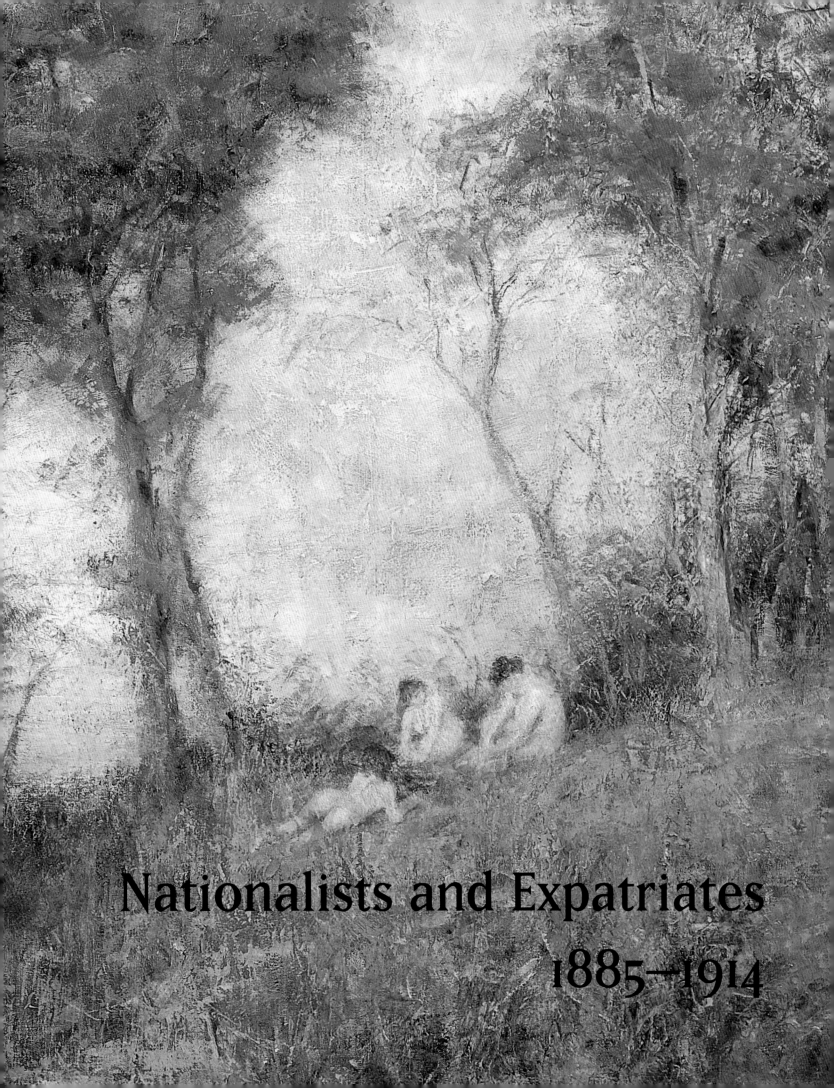

Nationalists and Expatriates

1885–1914

William Barak c.1824–1903

Wurundyeri/Woiworong people

Corroboree (Figures in possum skin cloaks) 1885
natural pigments, pencil on paperboard 56.4 x 76.0 cm
purchased 1985 85.1692

William Barak's style and subject matter are unique in Australian 19th-century art. The work in the National Gallery of Australia's collection is characteristic of his many compositions depicting groups of people wearing possum skin cloaks, the traditional dress of Indigenous people across the colder parts of the mainland. Possum skin cloaks were generally worn skin-side out and the skins were elaborately decorated with incised geometric patterns coloured with ochres. This variegated patterning is typical of Barak's style.

During his lifetime, Barak experienced enormous cultural change. He was a child when Europeans began to make pastoral incursions into the Port Phillip district of Victoria in the mid-1830s, went to a mission school and was a member of the Native Police (disbanded in 1853). In 1863, he was one of a large group of Indigenous people from across Victoria who were the first members of the Aboriginal settlement at Coranderrk, outside Melbourne. Barak had hereditary status as clan elder of his people (the Wurundyeri) and was one of the leaders of the Coranderrk community. When the settlement was threatened by competing pastoral interests, Barak led a determined opposition to any move: 'Yarra', he said, 'my father's country'.[30] He lived at Coranderrk until his death in 1903, by which time he was one of the few people in Victoria with a first-hand knowledge of the traditional language, songs and religious law of the original inhabitants of the Yarra valley. Europeans often referred to him as 'the last chief of the Yarra Yarra Tribe'.

Barak appears to have made most of his drawings in the last decades of his life and there are many stories of such drawings being commissioned for the stream of important visitors who travelled from Melbourne out to Coranderrk. A photograph of Barak at work on a drawing, taken in the last years of his life, clearly shows his unique blend of materials: pencil (for underdrawing), watercolour, ochres and charcoal.

Andrew Sayers

John Longstaff 1862–1941

Motherless 1886
oil on canvas 91.0 x 124.6 cm
purchased 1971 71.110

Senior students at the National Gallery School in Melbourne produced 'story' paintings for their annual exhibition and awards. These paintings presented a critical moment in a narrative in such a way as to infer the rest of the story. These genre pictures were popular because they appealed to the Victorian taste for melodrama and high sentimentality. Other typical subjects included lost children, parting and separation, lost love and the fallen woman. John Longstaff inscribed the original frame for *Motherless* with a sentimental line from Tennyson: 'O for the touch of a vanish'd hand/And the sound of a voice that is still'. An obsession with mortality was often evident in such works, coupled with the theme of excessive piety.

These three sisters are deep in mourning for their mother. They appear to be close in age, the youngest kneeling, with her face buried in her hands. The second sister is slumped in despair against the wall, while the seated figure, possibly the eldest, appears numb with grief and with the responsibility that has now fallen upon her. Death was a favoured subject for many artists in a time of short life-spans and epidemics.

Longstaff studied at the Gallery School under the artist G.F. Folingsby, who succeeded Eugene von Guérard as head of the Gallery School. Folingsby had a reputation as a figure painter and encouraged his students to use painting techniques that he had learned at the Munich Academy. He taught his students to paint a naturalistic kind of history painting, to select a dramatic subject viewed under carefully controlled lighting and to use a grey-brown palette enlivened with red. Folingsby's influence on Longstaff shows in the sombre brown tonality of the interior of this painting (befitting the sadness of the image) and the capable drawing of the figures and costumes.

Barbara Brinton

Frederick McCubbin 1855–1917

Girl with bird at the King Street bakery 1886

oil on canvas 40.7 x 46.0 cm

purchased 1969 69.77

In the 1880s Frederick McCubbin painted a number of interior and exterior scenes of his home, the old bakery in inner Melbourne where he was born and lived until he was in his thirties. Here, a girl sits quietly at the side of the bakery kitchen behind her house, while a bird (perhaps a magpie) pecks for insects in the rotting wooden fence.

The Munich-trained head of the National Gallery School, G.F. Folingsby, had a marked effect on McCubbin's development, as can be seen in *Girl with bird at the King Street bakery*. Observations of everyday life were considered worthy of serious art, realised with smooth brushwork and reduced colour. As Ann Galbally has noted, he 'has paid particular attention to the textures of the buildings, contrasting their tonal blend of warm browns and greys with the white areas of the girl's pinafore'.[31]

The late 1880s were crucial years for McCubbin; he had finally graduated from student to teacher after more than eight years at the Gallery School, allowing him to become a professional painter and give up the family baking business he had shouldered after the deaths of his father and elder brother. *Girl with bird at the King Street bakery* was perhaps the last work he produced before he came under the influence of Tom Roberts and turned from painting urban settings to bushland scenes.

Christine Dixon

Julian Ashton 1851–1942

Hordern Stairs c.1885

watercolour, gouache, pen and ink on paper 67.0 x 46.4 cm

purchased 1971 71.95

A well-dressed lady takes a late morning stroll on a bright day, walking down the Hordern Stairs in Woolloomooloo. The stairs were named after Edward Hordern, a local resident, to commemorate his term of office with the Sydney Council.

By contrasting the bleached yellow ochre of the sandstone with distant foliage and darkened shadows, Julian Ashton accentuated the brightness of the sunlight and the clearness of the sky. His heavy use of gouache also highlighted areas of the sandstone and stairs. The detail of the plants in the foreground almost frames part of the work in a decorative style similar to many of the illustrations found in the *Picturesque Atlas of*

Australasia, a publication for which Ashton worked as an artist from 1883–85. The use of the colour red in the parasol to highlight the figure in the landscape was a compositional device often found in paintings of the time.

Ashton, who was trained as a painter and illustrator in London, arrived in Melbourne in 1878 to work as an artist for the *Illustrated Australian News*. He moved to Sydney in 1883 and was soon charmed by its winding streets and picturesque buildings. He later founded an art school there, where he encouraged students to sketch outdoors and to focus on drawing as a basis for art. Ashton soon became influential in the Sydney art scene, as a teacher and as a trustee of the Art Gallery of New South Wales (1889–99). His emphasis on placing drawing above painterly values had an impact on art in Sydney for many years.

Ron Ramsey

Tom Roberts 1856–1931

Allegro con brio, Bourke Street west c.1885–86 additions 1890
oil on canvas mounted on composition board 51.2 x 76.7 cm
purchased 1918 National Library of Australia
and National Gallery of Australia

Allegro con brio is the musical term for 'lively with fire', appropriate to this searing streetscape. *Allegro con brio* was also Beethoven's marking for the first movement of his *Eroica* symphony, a work which Tom Roberts and his confrères interpreted as asserting the value of art over commerce and politics. However, those latter forces inhabit Roberts's painting.

Allegro con brio, Bourke Street west expressed the globalising of the Imperial bourgeoisie, albeit portrayed from the perspective of a self-employed painter enjoying the elevation of a first-floor window. At the western end of Bourke Street was the General Post Office, almost out of sight in his painting, its extensions appearing in the girder to the far right. The building was important for Melburnians because a succession of flags above the clock tower signalled the progress of the overseas mails, indicating when the steamer had been sighted off Albany (WA) through to the completion of the sorting. The Post Office corner was a hub of commerce, not only for business correspondence but also for its savings bank and money orders. A third of the canvas contains images of buildings, with verandahs as prominent as the advertising on the walls. Although 'Marvellous Melbourne' had become one of the world's great metropolises, Roberts later disparaged its architecture as 'expensive vulgarity',[32] wrapped in styles as borrowed as the money that built them.

The small scale of this work for so large a subject suggests that it was a draft for a larger and more sharply delineated work, one which Roberts had hoped to send to the 1886 *Colonial and Indian Exhibition* in London. Had he done so, he would have had to work the painting up in greater detail before varnishing it, as demanded by the academic standards to which he subscribed. However, he set the painting aside and later altered it into a high-keyed, bright 'impression'.

The word 'impression' was then synonymous with sketch and, in the Melbourne of the 1880s, was associated more with the 'nocturnes' of James McNeill Whistler than with the Impressionism of Monet. A possible source was the work of the Austrian painter, Franz Richard Unterberger, one of whose Italian scenes had been acquired by the National Gallery of Victoria in Melbourne in 1875, the year Roberts commenced his studies there. Three more Unterbergers went on sale just before Roberts commenced his canvas, which a contemporary critic would compare with the Austrian's streetscapes.

The line of cabs down the middle of Bourke Street and the stables to the left add to the bustle. The cabs gave way to the laying of track for the cable trams that ran from August 1887. Staid as those vehicles now appear, late in 1885 their drivers were a point of social disturbance, striking for unionised wage-rates and shorter hours. Three-quarters of the 150 figures are dabs or single strokes, as if shadows blurred by the long exposures needed for photography. Nonetheless, Roberts detailed street life in the shoeshine man on the south-east corner.

Urban subjects were less popular than bush scenes because cities were seen as sites for crime, revolt and sickness. Moreover, late Victorian art-lovers preferred paintings that told a story with a moral; painterliness was a secondary concern. Roberts wanted to convey an impression of the glare of the sun and the scorching northerly wind, 'the brickfielder', against which women carry parasols; the word 'ICE' on the cart in the dead centre emphasises this aspect of the subject while promising relief. Thus, *Allegro con brio*, without a straightforward narrative, would have perplexed those Victorian viewers accustomed to looking at story paintings. At best, this streetscape offered a *tableau vivant* for which they could supply their own tale of letters and packets.

Five days before Roberts first exhibited *Allegro con brio*, on 3 December 1890, he posed three women so he could paint their bright frocks over the top of a black cab which was then in the lower left corner. His use of models underlined the fact that he could not rely on recollected experience, let alone on his imagination. This brightening of the bottom left corner altered the chromatic balance of the whole, leaving open the possibility that he added the white bars to the cab roofs and inserted the French flag as a visual accent.

In 1903, unable to find a buyer, Roberts handed the canvas to his friend and colleague Frederick McCubbin, whose widow sold it in 1918 to the Commonwealth Parliamentary Library for 20 guineas, which she forwarded to Roberts in London.

Humphrey McQueen

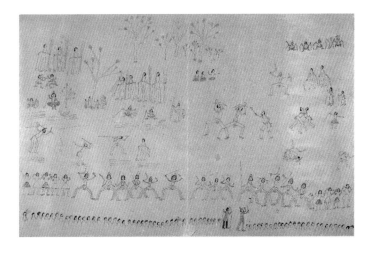

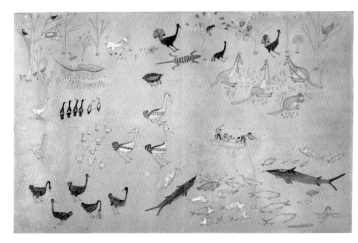

Mickey of Ulladulla d.1891

Dhurga/Yuin people

Corroborree c.1888

pencil, coloured pencil, ink 43.8 x 68.5 cm

purchased 1991 91.870

Fishing: Native flora and fauna c.1888

pencil, gouache, watercolour 44.0 x 68.5 cm

purchased 1991 91.871

Like his 19th-century Indigenous contemporaries, little is known of artist Mickey of Ulladulla. Few of his drawings survive and the artist remains elusively out of reach for the present-day viewer, apart from a brief self-reference, as Andrew Sayers has stated: 'From such inscriptions [by the artist on his drawings] we learn little except for one important thing: that the man supporting himself with two sticks who appears in many of the drawings is the artist himself'.[33]

However, Mickey's vignettes of rural Indigenous life on the south coast of New South Wales reveal the shared experience of hundreds of traditional south-eastern Indigenous communities on the cusp of irretrievable change. Non-Indigenous influences are apparent in the apparel of the artist and in other scenes not pictured here: sailing ships, sawmills and government rations, which replaced the bountiful native flora and fauna as portrayed in his drawings.

The ephemeral nature of these drawings reflects their rarity, with so few represented in public collections today. Yet, almost two decades after the artist's death, these works of art were considered extraordinary enough for a selection of them – drawn from government and judicial collections, including ironically, the New South Wales Aborigines Protection Board – to be exhibited at the 1893 World's Fair in Chicago in the United States. Following this, they remained for a century relatively unknown to an audience that became increasingly engaged with Indigenous visual art until, in 1994, Mickey of Ulladulla's work was addressed in Sayers's publication and accompanying exhibition.

The contemporary viewer can only imagine whether the artist's depiction of the abundant native fauna portrayed in the Ulladulla region was a true representation of available bush tucker at the time, or whether it depicted a scene already past. Whilst seemingly idyllic on the surface, this and similar scenes must be considered in a more poignant light when the present-day viewer is aware that they portray a way of life denied to Indigenous people of this region through the impact of over two centuries of colonisation.

The luminosity of the watercolours – the azure blues and brilliant whites – gives the drawings a fresh tactility that still shines from the surface over a century after their execution: bittersweet cameos onto a not-so-distant, yet long-vanished past.

Brenda L. Croft

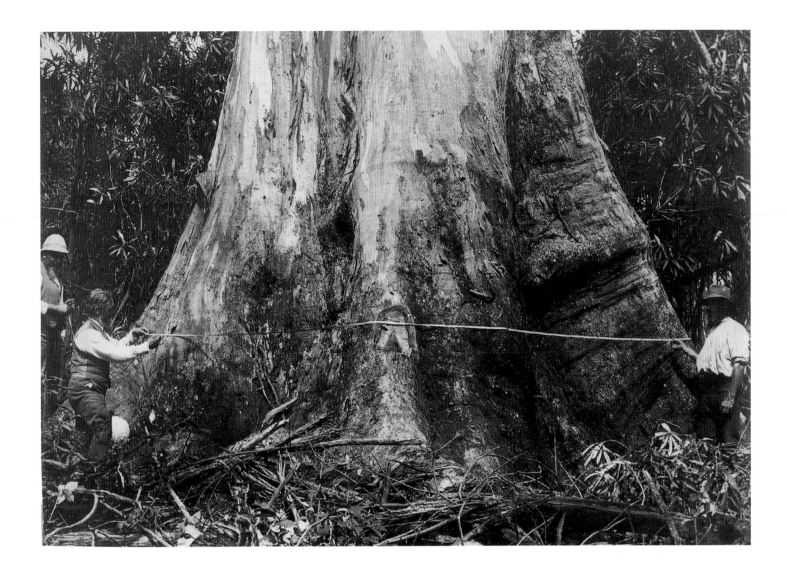

Nicholas Caire 1837–1918

Giant tree at Neerim, forty feet girth c.1889 printed later
gelatin silver photograph 15.0 x 20.2 cm
purchased 1983 83.3083

The men shown here measuring the diameter of a giant eucalypt were not loggers or tree-lovers. They were attempting to determine whether Australian trees were bigger than the famed 400-foot-high giant redwoods of California. It was mostly national pride surrounding the Australian Centennial of European settlement which motivated scientists and photographers in the 1880s to seek out the remaining giant trees in the more remote areas of Victoria. The Americans claimed that their redwoods were the greatest because of their combined height and girth. In the dense Australian bush, it was easier to measure the girth than the height and presented a much more dramatic image for a photograph.

The general public followed the giant tree debate in the papers and also purchased photographs of them and other idyllic bush scenes. By the late 19th century, the Australian population mostly lived and worked in the cities. They became day-trippers and used the new railway networks to take their recreation in the bush. Nicholas Caire, one of the most active photographers to seek out and record the giant trees, travelled over a number of years on the new rail line to Neerim town reserve.

Australia's giant trees were widely depicted in late colonial art as mighty symbols of the pre-settlement and pioneer era. Caire, whilst accepting the necessity of logging and urban development, was also one of those who argued for the preservation of examples for future generations. Most of the awesome giant trees were felled or burnt in his lifetime. Now they are preserved only in photographs.

Anne O'Hehir

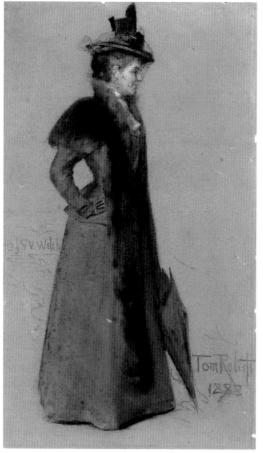

Tom Roberts 1856–1931

An Australian native 1888
oil on canvas 127.2 x 76.2 cm
purchased through the Joseph Brown Fund 1979 79.2543

Mrs John St Vincent Welch (née Emily Thackeray) 1898
pastel on buff paper 87.6 x 52.0 cm
purchased 1976 76.259

Portraiture earned Tom Roberts his living, 40 per cent of his oeuvre being in this genre which he held in low regard. Yet when he was truly engaged with his subject – especially if it was a beautiful lady – his portraits resulted in some of his most striking achievements, as is evident in this contrasting pair. In *An Australian native*, his 'wondrous soft way with women'[34] is apparent in the lady's wistful gaze and in her delicate and translucent finery.

The adopted title *An Australian native* invokes the Australian-born of Anglo-Celtic descent who were asserting themselves during the Centennial celebrations of 1888 and in the run-up to Federation. The Federation Movement had to build a bridge between attachment to the colony and loyalty to the British Empire. In portraiture, this dualism manifested itself through the creation of a physical type: healthy and vigorous young Australian-born men and women, capable of producing strong children. Here is one of many such portraits made in the colony.

Mrs John St Vincent Welch (née Emily Thackeray) is in pastel, a medium Roberts favoured for women because of its tonal warmth. A preparatory pencil sketch has her facing the opposite way, her face unveiled and no space between her arm and torso or between her umbrella and hem. The changes indicate the thought Roberts gave even to informal depictions.

Mrs John St Vincent Welch was in accord with a run of small-scale, yet generally full-length, portraits which Roberts completed during the second half of the 1890s. This survey of famous or familial figures celebrated the native-born as much as did his landscapes and subject paintings.

Humphrey McQueen

Charles Conder 1868–1909

Impressionists' camp 1889
oil on paper mounted on cardboard 13.9 x 24.0 cm
gift of Mr and Mrs Fred Williams and family 1979 79.1270

The Yarra, Heidelberg 1890
oil on canvas 50.6 x 91.0 cm
gift of James Fairfax, AO 1992 92.1421

During the 1880s and 1890s, Australian artists established outdoor painting camps in rural areas on the outskirts of Sydney and Melbourne. Among these, perhaps the best known is that at Eaglemont near the suburb of Heidelberg, because it gave the group of artists who painted here their name, the Heidelberg School.

In the summer of 1888, Arthur Streeton was given the use of the eight-bedroom semi-derelict weatherboard farmhouse on the summit of the hill at Eaglemont. It had expansive views eastward across the Yarra valley towards the Dandenong Ranges. Charles Conder and Tom Roberts joined him, and the three artists painted there for two summers, visited from time to time by Frederick McCubbin, Walter Withers and other artists and friends. Conder recorded this sparsely furnished hut in his *Impressionists' camp*, portraying Roberts seated reading and Streeton standing, with Streeton's painting *Impression for 'Golden summer'* 1888 on the wall above the camp bed. It was perhaps Conder's happiest time, which he recalled nostalgically from his studio in Paris: 'Give me one summer again, with yourself and Streeton', he wrote to Roberts, 'the same long evenings, songs, dirty plates, and last pink skies. But these things don't happen, do they? And what's gone is over'.[35]

The artists organised picnics and painting excursions to the nearby hill and valley. In *The Yarra, Heidelberg*, Conder portrayed two young women bathing in the shallow river, having left their clothes on the nearby shore. Willy-wagtails pick the earth in the foreground and cows graze on the cleared land on the far hill, under the warm glow of late afternoon. Conder rarely worked on such a large scale, and was probably encouraged by the success of Streeton's bathing pictures, especially *Spring* 1890, painted nearby only a few months earlier. Streeton's image, however, is painted in a golden palette celebrating the new energies of spring, while Conder's painting, with its deep browns and greens, can be seen as his lyrical farewell to long evenings, songs and dear friends; he left soon after for Europe, where he remained until his death in 1909. In Europe, in a response to Aestheticism and the fin de siècle, he established a reputation as a decorative artist, a painter of imaginative images of sexual intrigue and of people dressed in exquisite costumes in elegant settings.

Anne Gray

Charles Conder 1868–1909

Herrick's blossoms c.1888

oil on cardboard 13.1 x 24.0 cm

purchased 1969 69.48

Arthur Streeton 1867–1943

Hoddle St., 10 p.m. 1889

oil on cardboard 7.9 x 23.3 cm

purchased 1974 74.138

Tom Roberts 1856–1931

Going home c.1889 (opposite)

oil on wood panel 23.4 x 13.6 cm

purchased 1976 76.567

On Saturday morning 17 August 1889, a group of artists opened the doors to the *9 by 5 Impression Exhibition* at Buxton's Art Gallery in Melbourne. Among them were Charles Conder, Frederick McCubbin, C. Douglas Richardson, Tom Roberts and Arthur Streeton. The rooms were decorated in an aesthetic style, with draperies of soft Liberty silk, Japanese umbrellas and blue and green vases filled with japonica and roses, violets, jonquils and daphne, which perfumed the room. Afternoon tea was served in dainty cups and Miss Fanny Bristow sang. The title of the exhibition referred to the size of the 182 works on display, many of which had been painted on cedar cigar box lids measuring nine by five inches. The artists wanted to convey momentary impressions of colour and light, fleeting atmospheric effects, transient moods of nature, writing in the catalogue:

'An effect is only momentary … two half-hours are never alike … it has been the object of the artists to render faithfully, and thus obtain the first record of effects widely differing, and often of very fleeting character'.[36] They somewhat controversially asserted that these 'impressions' were finished, independent pictures.

Probably the most famous display in Australian art, the *9 by 5 Impression Exhibition* was well appreciated by members of Melbourne's intellectual and social circles, who visited in large numbers. The show received controversial press coverage, with some reviewers suggesting that the impressions were not appropriate for display as they were nothing more than slight preparatory studies, executed in a 'slap-dash' manner. Others described it as an attractive display of clever sketches for an educated taste, and declared that the exhibition was not to be missed. The pictures were affordable and sold well, and the exhibition established the artists' reputations as innovators, and created their identity as a group of Australian Impressionists (or Impressions-ists).

Conder's *Herrick's blossoms*, Streeton's *Hoddle St., 10 p.m.* and Robert's *Going home* were all included in the exhibition. Conder painted his work in response to Robert Herrick's poem, 'To Blossoms'. He painted it quickly with sparse brushwork to evoke the look of a landscape at the beginning of spring, when the blossom begins to flower and provides a note of colour among wintry greys and greens. In the spirit of springtime and to give the view a touch of humanity and romance, Conder sketched in two small figures: a man kneeling at the feet of a woman. Most of Streeton's contributions to the exhibition conveyed the atmospheric effects of twilight and half-light. In *Hoddle St., 10 p.m.* he depicted night-time in a Melbourne suburb during winter, with pedestrians walking the pavements and a solitary horse-drawn cab driving down the road, with a few lights glowing in the houses of those who had not yet gone to bed. In *Going home*, Roberts likewise portrayed evening effects: the dark, silhouetted forms of a man and a woman with their arms linked, walking along a wet pavement at sunset. He painted the image swiftly, in a limited range of colours and tones to convey an impression of the last red-gold light of the evening.

The artists captured the scene, the atmosphere of place, with few brushstrokes. They created paintings that are remarkable for their freshness. The colour harmonies, the subtle nuances of pink, mauve, purple and grey, are as seductive today as they were when painted. Likewise the lively gestures, the mark-making on the surface of the boards, are as expressive now as when they were first applied.

Conder, Streeton and Roberts shared an interest in using fresh colours and energetic brushstrokes with the Impressionists Monet and Pissarro. They wanted to paint freely from nature in the open

air and to observe the effects of light, but their small panels were in no way comparable to the larger canvases of the French artists. In their adoption of poetic and musical titles, their concern to capture the underlying moods of nature, and their use of small panels, they followed the British artist James McNeill Whistler and his subtle, evocative sketches, which he displayed in his well-publicised exhibition, *Notes – Harmonies – Nocturnes*. The main instigator and stage-manager of the *9 by 5 Impression Exhibition*, Tom Roberts, had seen Whistler's exhibition in London in May 1884. He returned home to Australia enthused with the idea of painting rapid outdoor impressions, which resulted in this innovative exhibition.

Anne Gray

Arthur Streeton 1867–1943

Golden summer, Eaglemont 1889
oil on canvas 81.3 x 152.6 cm
purchased 1995 95.604

While to some viewers *Golden summer, Eaglemont* is a superior chocolate-box image, sentimental and nostalgic, the picture rewards detailed contemplation. It is indeed pretty but also profound. Streeton loved the 'coppery light' of long, lazy afternoons and perhaps the key to the painting is the bird in the right foreground. It signifies Australians at one with nature, a sense of well-being, comfortable occupation of a new country. The bird is still, at ease.

Golden summer, Eaglemont is one of the best-known paintings of the Heidelberg School and has long been recognised as an Australian masterpiece. Painted in early 1889 during a summer of drought, it was consciously an epic work, large-scale and in keeping with a contemporary spirit exemplified in a lecture presented to Melbourne artists in June 1889 by Professor Laurie, who called for a poetic approach to native scenery. Australian artists should 'paint it as it appeared to them in all the beauty of atmospheric effect'.[37] They should present the Australian landscape so that those unfamiliar with it would appreciate its loveliness.

Streeton's famous idyll has become a quintessential Australian painting of the years leading up to Federation in 1901. It emphasised the growing nationalism of the period, not yet a country but, in David Malouf's words, 'a place that was still being made habitable … another example of the inextinguishable will of men ... to claim some patch of the earth, however small, where they could stand up, feel the ground under their feet and say, this is mine, I have made it, I have made it mine'.[38]

In 1889, a critic described *Golden summer, Eaglemont* as 'a large summer landscape … a long undulating plain, which, lying in all the glory of a warm sunny afternoon, appears as a stretch of golden meadow land, while in the distance the purple shadows are fast creeping over the hills, and lurking in little patches among the hollows of the ground'.[39] Streeton first occupied the weatherboard farmhouse on the Eaglemont estate at Heidelberg near Melbourne in 1888, the year before he painted *Golden summer, Eaglemont*. He was deeply fond of Mount Eagle and called it 'our hill of gold'.[40] He made an initial oil sketch (now in the Ledger Collection, Benalla Art Gallery) which was an impromptu 9 by 5 'impression' rather than a lyrical large-scale painting. The extraordinary visual poetry of the large painting won it praise when exhibited at the Royal Academy, London, in 1891 and it received an award when shown at the Paris Salon in the following year.

In the early 1920s, Streeton altered the painting by making the shadow of the river-plain stronger to the left, and by emphasising the foliage of the trees. His inability to resist reworking the painting was modified by his decision to paint on the original varnish. This meant that the alterations could be removed more easily, revealing the work as originally painted, exhibited and sold in 1892 to an English industrialist. Streeton bought the painting back in 1919, and made the alterations before selling it again in 1924. The question of whether the alterations by the artist should have been removed is a debatable one, but the quality of the paintwork and the beauty of the picture, now in its original state, provide the answer eloquently.

When sold in 1924, 1985 and 1995, *Golden summer, Eaglemont* established each time a record price for an Australian painting. The acquisition by the National Gallery of Australia was the fulfilment of a long-held goal by the then Director, Betty Churcher.[41]

Brian Kennedy

Charles Conder 1868–1909

Under a southern sun (Timber splitter's camp) 1890
oil on canvas 71.5 x 35.5 cm
bequest of Mary Meyer, in memory of her late husband
Dr Felix Meyer 1975 75.667.11

Conder's *Under a southern sun (Timber splitter's camp)* and
Streeton's *The selector's hut (Whelan on the log)* form one of several
pairs of images that the two artists painted when they worked
together for two months during the summer of 1890. Both works
are painted in a palette of yellow, blue and pink, portraying a tall
slender eucalypt, a settler and a log, and both convey a bright
blue sky and the effect of strong sunlight. Conder decoratively
arranged the scene, placing the bushman and log towards the
back of the composition, while Streeton built up drama through
a strong sense of midday heat and glaring light. Conder used a
soft 'reflected shadow' in the foreground to create a gentler light
and to push back the scene, while Streeton limited his shadows
to 'attached shadows' to enhance the sense of bright light.
Conder gave his image a characteristic touch of humour by
portraying the washing on the line. By including the child,
Conder made the scene a more domestic homely one than
Streeton's heroic image.

Conder and Streeton were both motivated by aesthetic
principles and were also interested in combining painting,
music and poetry to create a total artistic experience. In April
1890, Conder wrote enthusiastically to his cousin about Walt
Whitman's poem, 'Song of the Broad-axe'. His discovery of this
poem may have inspired him, and Streeton, in their paintings.
Under a southern sun, however, with the dusty heat haze rising
from the horizon, is the more lyrical image of the two. This
typical Australian scene of a bush camp is far removed from
the decadent interiors which Conder began to paint and draw
after he moved to Europe in 1890. It reflects a time of innocence
in his life and art.

Anne Gray

Arthur Streeton 1867–1943

The selector's hut (Whelan on the log) 1890

oil on canvas 76.7 x 51.2 cm

purchased 1961 61.15

In 1888, the Australian Centennial of European settlement created an increased public interest in Australian history and fostered a desire to develop a particularly Australian culture. It was generally a nationalist view of the bush created by city dwellers. Streeton did not portray heroic subjects of life on the land with the figure playing a dominant role, as did Frederick McCubbin or Tom Roberts, but he did paint images of men at work, such as the men blasting the tunnel in *Fire's on* 1891 and the surveyor in *A surveyor's camp* 1896. *The selector's hut (Whelan on the log)* is another such picture. As Mary Eagle has pointed out, this painting can be read as telling the story of a man on 'the road to wealth', a hardy pioneer who has selected a lonely patch and has been busy clearing the land and making his home in the makeshift hut behind him.[42] The summer wind blows up the dust on the ground and stirs the leaves, while magpies whirl in the translucent blue sky.

That is the story that Streeton tells us in this picture; but the facts behind the making of the image are different. The man who posed for the picture was Jack Whelan, the tenant farmer of the Eaglemont estate, and the environs were not the native bush but the outer suburbs of Melbourne, where the artists had their camp. Moreover, when Streeton painted this picture the speculators, who owned the land and proposed to redevelop it as housing blocks, were far from the road to wealth: they were having difficulties selling their land because of the financial crash of 1889–90.

Many of Streeton's viewers, however, would have accepted the fictional message of this image, as suggested by his title, and would have viewed Whelan as representing one of the many selectors who pegged out their own farms in order to 'civilise' the bush.

Anne Gray

E. Phillips Fox 1865–1915

Sunlight effect c.1889

oil on canvas 41.0 x 32.2 cm

gift of the artist's nephew, Len Fox, in memory of his mother,
Irene Fox 1984 84.1542

E. Phillips Fox, together with Rupert Bunny, Bertram Mackennal
and John Peter Russell, worked in Europe intermittently during
the late 1880s and 1890s. Instead of portraying Australian life,
they sought a wider experience, an encounter with the diversity
of styles being adopted by artists in London and Paris.

Sunlight effect was painted when Fox was a student of two
years standing at the Académie Julian in Paris. He had encountered
the French modern style of painting and taken lessons in
prismatic colour practice. In Paris he discovered his major theme
– light. The subject of a Breton novice coifed in white was popular
with the French artist Jules Bastien-Lepage, who had gained a

following with his paintings of peasant life. Fox's composition is
not even original. Instead, *Sunlight effect* is remarkable for other
qualities: the patterning of the landscape as a medley of confetti-
sized touches of colour, and the glowing illumination of the head
enclosed in a white coif. Undiverted by the conventional
elaboration of narrative detail, the content is expressed through
colour and light.

Even for a painter in Paris the colour was avant-garde. These
were neither the sappy greens, crisp blues and poppy reds of the
French Impressionists nor the primary colours in saturated
strength, but the rainbow hues mixed with white to an even,
pastel brightness that was currently fashionable. More
significantly, it was the approximation of prismatic light, the goal
of so much painting in the later 19th century, witnessed by Fox
in Paris in the new palette of Impressionists Monet, Pissarro
and Seurat, and Fox's American teacher, Alexander Harrison.

Mary Eagle[43]

John Peter Russell 1858–1930

In the morning, Alpes Maritimes from Antibes 1890–91
oil on canvas 60.3 x 73.2 cm
purchased 1965 65.25

Landscape, Antibes (The Bay of Nice) 1891
oil on canvas 81.0 x 100.0 cm
purchased 1976 76.541

John Peter Russell was of the same generation of Australian artists as Tom Roberts and Arthur Streeton, but he lived and worked in Europe for 40 years during the period 1876 to 1921, having direct contact with some of the significant artists of his time. He became friends with van Gogh and was influenced by his theories of colour, in particular his view that artists should not render local colour, but use complementary colours in combination, such as blue and orange, yellow and violet. In 1886 Russell visited Belle Ile, a small island in the Bay of Biscay off the coast of Brittany, where he encountered Monet; the two artists painted together during that summer. Under Monet's influence, Russell began to paint more freely with a visual rhythm and using a heightened palette.

Both *In the morning, Alpes Maritimes from Antibes* and *Landscape, Antibes (The Bay of Nice)* are of the same scene in the south of France.

In both, Russell captured the rippling, sparkling surface of the intense blue-green sea, the sun on the dappled golden-green grass and the mellow pulse of the distant mauve-blue mountains. He immersed himself in nature. In *Landscape, Antibes*, he moved towards the edge of the cliff in order to portray more of the water and the boats sailing on it and less of the foreground foliage.

Anne Gray

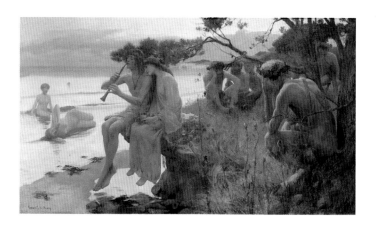

Rupert Bunny 1864–1947

Pastoral c.1893
oil on canvas 142.0 x 251.0 cm
purchased 1969 69.76

A triton's family c.1898
monotype 25.0 x 34.8 cm
purchased 1984 84.1389

Rupert Bunny was conventionally of his time, assimilating aspects of Symbolism and Aestheticism and adopting similar allegorical subjects as a number of his European contemporaries. Water was recurrent in his imagery; it had a special role. The artist's strong feelings about water can be traced back to childhood, when he saw a group of people strangely dressed in long white gowns walking into the sea near his home at St Kilda, Melbourne. From where Bunny watched, he did not realise that the solemn ceremony was a Christian ritual of baptism. Bunny's first lonely adult grief also involved water. Aged 19, he escorted his dying father on a journey across the world to try the cure of the Karlsbad waters. Bunny in adult life coped with personal stress – and the rashes resulting from it – by bathing in warm water. Baths were, he said, the only cure.

In a series of paintings produced in the 1880s and 1890s, water was present as the 'natural' element of strange sea people. Bunny first sketched sea nymphs and tritons in 1887, in the French province of Brittany. In his sketchbook, among drawings of ancient menhirs, steep cliffs and sea, one image shows a nude female whose legs end in fishtails, lying back over a rock in the sea. Brittany, known as a region of myth and legend, and a resort since the 1860s for painters inspired by its exoticism and the mystery of its silver light, therefore appears to have been one source of inspiration for Bunny's images of tritons. Another source was the Swiss romantic artist Arnold Böcklin, whose paintings abound in centaurs, tritons, nymphs and extravagant creations of fancy.

The 1893 painting was Bunny's second 'pastoral' – 'oddly enough named', said the *Magazine of Art*, 'seeing that it is, above all, a seashore picture of ideal nymphs'.[44] The 1890 *Pastoral* had also been a seashore picture. Judging from these paintings, Bunny's conception of a pastoral was an allegory of the sort popularised by the French painter Puvis de Chavannes. Van Gogh wrote about Puvis de Chavannes's seashore picture *Pleasant land* c.1882, in terms that encompass Bunny's pastoral idea: 'you feel you are witnessing ... a strange and happy encounter between very remote antiquity and naked modernity'.[45] The encounter between antiquity and modernity is crucial to the way Bunny's pastorals were conceived and the feelings they evoke. The mood is not so much nostalgia as an awareness of contrast: Bunny's pleasant land exists side by side with modernity, in critical relation to it.

There are contrasting realms within each of Bunny's pastorals. Though the images are quite different, both are divided into realms of land and sea, each with its pagan inhabitants: mermaids and mermen in the sea; monkey-like fauns on the land; and between them, literally filling the space between, the 'ideal nymph' mentioned by the *Magazine of Art* and a handsome youth. Bunny's nymph and young man are of the pure modern type extolled in aesthetic novels and the pictures of the Pre-Raphaelite artist Edward Burne-Jones. Slender, pale, discreetly clothed and virginal, they possess a gentility conspicuously lacking in the naked creatures on either side. The youth in both paintings is seated on the bank with legs dangling and plays upon a pipe; music, for Bunny, is the element that binds these disparate realms together. The sea nymphs look towards the music, the fauns cup their hands behind their ears to hear better and the nymph listens with her head on the youth's shoulder. Red poppies, symbolising sweet dreams, flower in the grass. White cliffs and a grotto in the distance suggest that Bunny may have had in mind the chalk cliffs of Brittany and Normandy. However, he was not interested in describing either a particular site or even a specific effect of light. His concern was to evoke a world of reverie.

Mary Eagle[46]

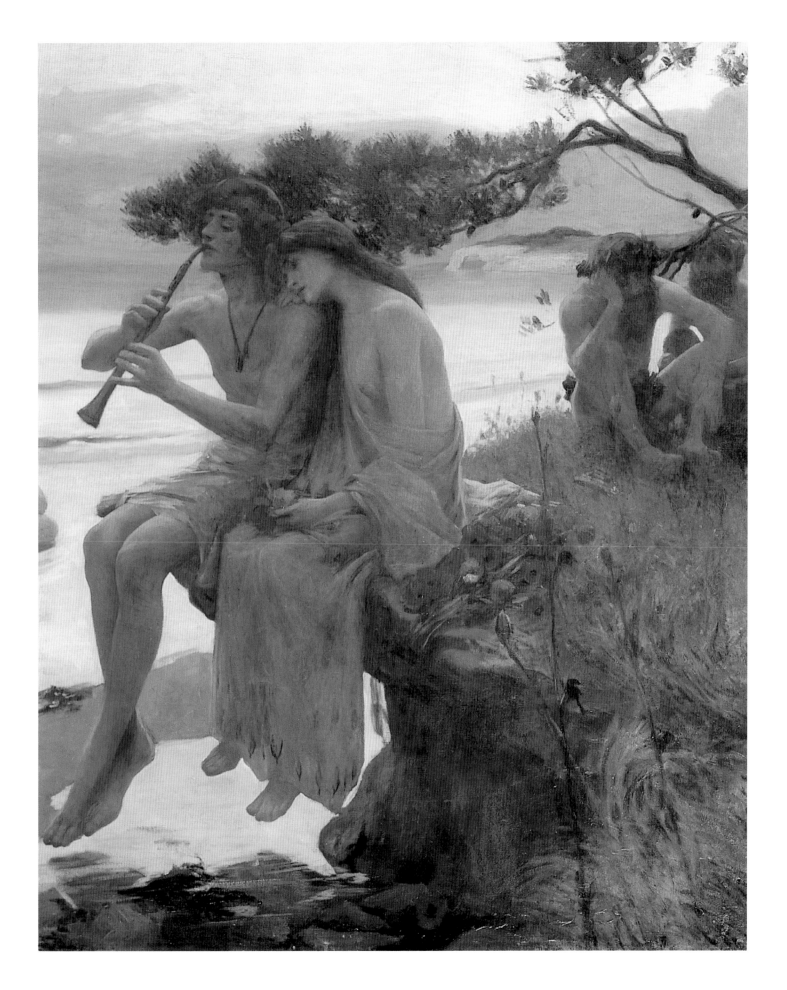

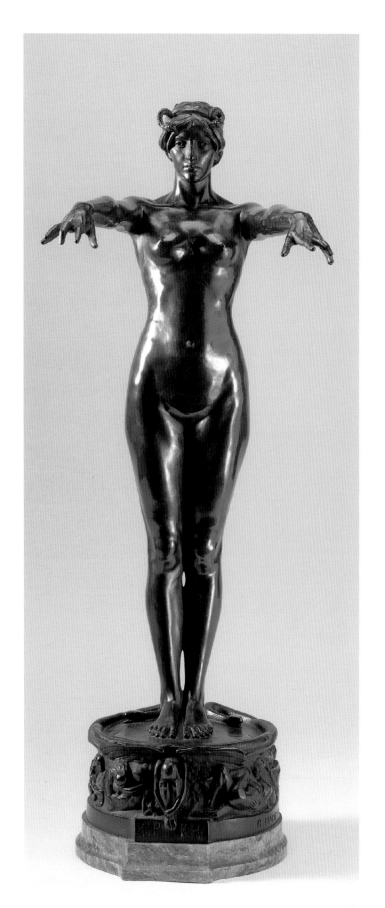

Bertram Mackennal 1863–1931

Circe c.1893, cast later

cast bronze, patinated 58.0 x 22.0 x 26.0 cm

bequest of Dr Don R. Sheumack 1990 90.536

The sorceress Circe is a central figure in Homer's ancient epic, the *Odyssey*. When the Greek hero Odysseus, on his return from the destruction of Troy, arrived on the enchanted island of Aeaea, Circe beguiled his unsuspecting crew and transformed them into swine. Bertram Mackennal's slender and eroticised *Circe* holds her arms outstretched, as if casting a hypnotic spell and playing with her hapless victims like puppets. This incident in Greek mythology provided the sculptor with a pretext by which to indulge in a symbolist preoccupation with the *femme fatale* as well as to affront conservative values.

This is a statuette, or small-scale version, of Mackennal's most renowned sculpture. He first exhibited a life-size, plaster statue of *Circe* in Paris in 1893. The following year, the same work was shown at the Royal Academy in London. Around the base of *Circe*, there is a relief of writhing figures showing Odysseus's companions succumbing morally to temptation and physically to sexual desire. These 'scandalous' images were covered by the Royal Academy's prudish selection committee in order to uphold standards of public decency. This act of concealment fostered intrigue among visitors, only adding to the notoriety of the work. The controversy surrounding *Circe* launched Mackennal's career in London, where he became Australia's most successful expatriate sculptor.

The New Sculpture movement in Britain at the turn of the century elevated the sculptor from artisan to artist, and revitalised almost all aspects of sculptural activity. The statuette was a phenomenon of the New Sculpture movement, whereby small-scale sculptures or 'art bronzes', often of mythological or allegorical subjects, were promoted as collectable domestic ornaments to the Victorian middle class. Several editions of the statuette version of *Circe* were cast.

Steven Tonkin

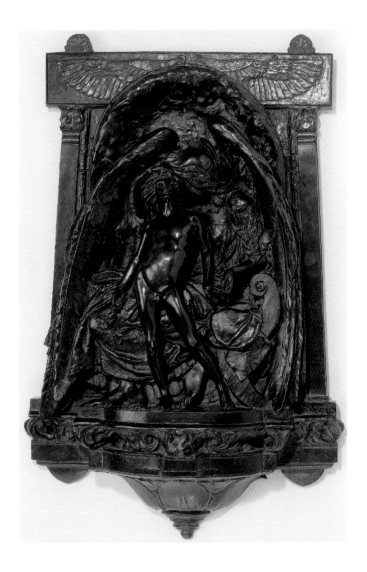

Paul Montford 1868–1938

Memorial to youth 1895
cast bronze, patinated 85.0 x 56.4 x 14.5 cm
purchased 1979 79.1346

In *Memorial to youth*, a beautiful young male loosens his grip on life and slides into the protective embrace of an angel and its impending kiss of death. There is an eclectic fusion of influences: a mélange of mythological and historical references, Christian and pagan symbolism, with a touch of Art Nouveau. The central composition is framed by architectural features which suggests that its placement was to be in a recess or niche in the wall of a chapel or civic building.

Paul Montford concentrated on architectural decoration; sculptural reliefs and figure groups commissioned for the facade of public buildings. *Memorial to youth* is indebted to this professional specialisation. It is elaborately conceived, perhaps over-embellished with imagery, as the young and ambitious sculptor paraded the full repertoire of his talents.

Memorial to youth presents a symbolic and universal commemoration of fallen youth and appears a shrewd manoeuvre by the sculptor to advertise his skills and suitability to prospective clients for more specific commissions.

Both the Australian sculptor Bertram Mackennal and the British-born Montford established their professional reputations in London in the 1890s. Mackennal remained there for the rest of his career whereas Montford migrated to Australia and became one of the most significant sculptors working in Melbourne between the wars. Montford trained in London with his father, the sculptor Horace Montford, and distinguished himself as a student at the Royal Academy Schools between 1887 and 1891. *Memorial to youth* dates from before the sculptor's arrival in Australia and is a valuable contextual example of the near-contemporary statuettes produced in London by Australian expatriates, such as Mackennal's *Circe* and Harold Parker's *Orpheus*.

Steven Tonkin

David Davies 1864–1939

Templestowe c.1893

oil on canvas on composition board 36.5 x 46.4 cm

purchased 1965 65.148

When the artists' camp at Eaglemont dispersed in 1890, artists continued to paint in the Heidelberg area, at Charterisville and Templestowe. Among those who worked in the area was David Davies.

In *Templestowe*, Davies depicted the end of the day, a moment of tranquillity and rest. He created a composition that is daring in its abstract simplicity, and painted it energetically, placing patches of colour knowingly side by side. Three quarters of the picture is no more than a field: a study of the scraggy grasses and bushes, the gentle undulating hills and slopes around Templestowe. But unlike many of his contemporaries, who were concerned with creating national images and the glare of the Australian midday sun, Davies conveyed the quiet face of nature and a mood of reverie.

Davies had studied at the National Gallery School in Melbourne and was one of a generation of students who were attracted to painting outdoors. By the time he returned to Australia in 1893, after studying in Europe and painting in France and St Ives, he had developed a subtle and refined technique. He had viewed the 'nocturnes' of James McNeill Whistler, and these confirmed his interest in depicting the soft glow of evening light and scenes with long foregrounds and high horizons.

Deciding that he could not earn enough from his art in Melbourne, Davies returned to Europe in 1897, where he worked in picturesque areas of England and France. There he made a reputation for his watercolours of village street scenes and rural life, until his death over 40 years later.

Anne Gray

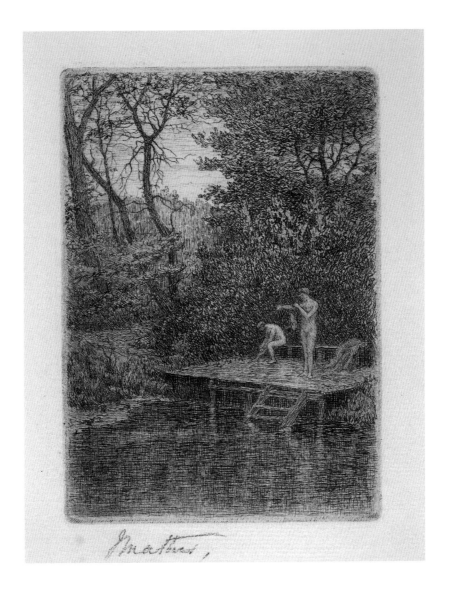

John Mather 1848–1916

The bath, Healesville 1896

etching, printed in black ink on cream paper 13.3 x 9.6 cm

gift of D.M. Desouker 1961 61.36

Although etchings were occasionally produced by Australian artists, they were not regularly exhibited until the 1880s. In England the etching revival, or painter–etchers movement, was well known through art magazines, but it was the French tradition relayed by American artists that was most influential. The tradition of the Barbizon school, where people were depicted as having a relaxed understanding of their relationship with the countryside, was apt for Australia in the 1890s.

The inhospitable Australian bush had become a friendly place, a park-like setting where weekend visitors might spend the afternoon walking bush tracks, painting and perhaps bathing naked in the rejuvenating waters of a clear running stream.

The bucolic etching *The bath, Healesville* is of a popular 'Bathing place on the Watts River'.

Mather was one of the many artists who set up camp on the fringe of urban settlement. He frequently visited Coranderrk, near Healsville, north east of Melbourne, an area known for hop growing, the hop kilns being picturesque additions to the semi-rural landscape. It was also an Aboriginal reserve, the mission houses and cultivated gardens were seen at the time as being further symbols of the 'taming of nature'. As well as images such as *The bath, Healesville*, Mather also etched portraits of the Indigenous people in the settlement.

John Mather, who learned etching in Scotland, captured the carefree mood of one of the many artists' camps in *The bath, Healesville* where the life of the Bohemian artist is equated with an Arcadia, with natural pleasure and the untamed Australian bush.

Roger Butler

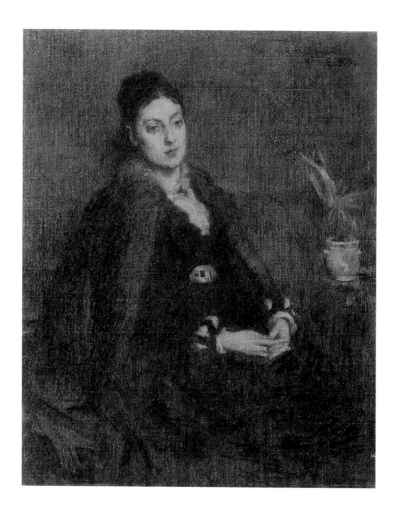

E. Phillips Fox 1865–1915

Portrait of Mary Meyer late 1890s
charcoal on cream paper 43.0 x 34.5 cm
bequest of Mary Meyer in memory of her husband
Dr Felix Meyer 1975 75.7667.46

E. Phillips Fox's delicate charcoal study of Mary Meyer was drawn in the late 1890s, just a few years after his return to Melbourne from France. In Paris, Fox had been disciplined in the academic tradition under Gérôme and Bouguereau at the Académie Julian and the Ecole des Beaux-Arts. He had gained first-hand knowledge of the works of the Romanticists Millet, Corot and Courbet, and had become steeped in the art of the Impressionists, with its remarkable qualities of colour and light.

In 1893, the year after his return from France, Fox established the Melbourne Art School with Tudor St George Tucker. Mary Meyer was a student at the school and an accomplished artist in her own right. She was the wife of Dr Felix Meyer, an early patron of the Heidelberg School. The couple were great collectors and respected and liberal supporters of the arts.

In the quiet half-light of the closing day, Mary sits calmly in the comfort of her solitude, as if in a dreamlike trance. This typically intimate study embodies Fox's expertise as a draughtsman and portrait artist and illustrates his appreciation of the tonal qualities of the charcoal medium in which he was so skilled. The portrait also provides an insight into Fox's understanding of composition. Mary sits slightly to the left of centre. The eye follows her subtly modelled form diagonally down the picture plane; from her gentle face to the ruffle of her shirt, to her opulent belt buckle and the elegant flounces of her cuffs, and then to her hands lightly clasped in her lap. All are luminous in the subdued afternoon light.

Anne McDonald

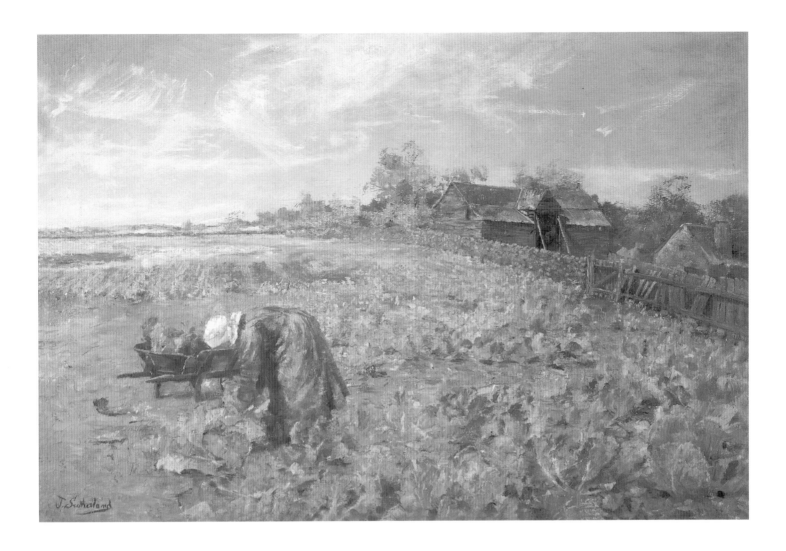

Jane Sutherland 1853–1928

A cabbage garden 1896
oil on canvas 51.1 x 76.4 cm
purchased 1978 78.1298

Jane Sutherland, one of the first professionally trained women artists in Australia, attended the National Gallery School in Melbourne between 1871 and 1885. She shared a studio with Tom Roberts, but she deliberately avoided the masculine imagery of bushrangers, heroic male workers such as shearers, and images of pioneers. She painted women and children within a domesticated rural landscape, using the stylistic methods of her fellow male artists but without the bravura and machismo associated with some of the best known works of Roberts and Frederick McCubbin.

Jane Sutherland painted *A cabbage garden* in 1896 when she was 43. The colours are subtle but the light is clear and bright. The blue-green cabbages contrast with the sandy beige colour of the soil, the fence and buildings. The wheelbarrow and the stooping figure are placed to lead the eye into the painting, while the sweeping arc of the fence line directs the viewer to the far distant horizon. The figure neither dominates, nor is dominated by, the landscape.

During the 1880s, a number of Melbourne artists sought to attain professional credibility for their work and to prohibit amateurs from joining the Victorian Artists Society. Jane Sutherland was the first woman elected to the governing body of this society. Despite this, she was never accepted as a serious professional artist and she priced her paintings at a tenth of the value of those of her male peers.

Jenny Manning

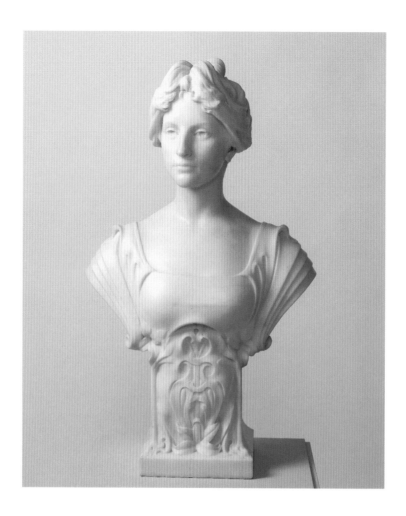

Bertram Mackennal 1863–1931

Miss Grace Dunham 1896

carved and polished marble 80.0 x 49.0 x 27.0 cm

purchased 1976 76.301

In the 19th century, wealthy families and public figures commissioned portraits as an affirmation of their social status. These commissions provided an important source of income for both painters and sculptors. They were also a means by which more conventional artists could enhance their reputation among patrons, by exhibiting these works at a prestigious, though conservative, public venue such as the Royal Academy in London.

Bertram Mackennal's reputation soared following the scandal that *Circe* created when it was shown at the Royal Academy in 1894. He exhibited there regularly for the rest of his career and, as a crowning honour, was admitted as a Royal Academician in 1922, the only Australian sculptor to receive such an accolade. Mackennal's exquisite marble bust of the young American *Miss Grace Dunham* is indicative of the sophisticated clientele that the sculptor secured from the 1890s.

Grace Dunham was born in New York and, like many of the cosmopolitan social set, made the transatlantic sea voyage to make her debut in London society in the 1890s. Mackennal skilfully captured the elegance and refined beauty of his subject. Her head is turned slightly, as if averting direct eye contact with the viewer, a detached poise befitting her social and unmarried status. She is 'clothed' in a stylised bodice decorated with a distinctly fashionable art nouveau motif. The sides and rear of the sculpture, however, remain largely unadorned, as this portrait bust would most likely have been placed in an alcove or recess in a fashionable New York or London residence.

Grace Dunham would have posed for Mackennal while he modelled her features in clay. As was accepted practice, a trained assistant would then have undertaken the laborious task of transferring the original clay model into the finished marble bust. *Miss Grace Dunham* was exhibited publicly at the Royal Academy in 1897, after which it remained in the possession of the sitter and her descendants for over half a century, before it was purchased by the National Gallery of Australia. It is a work that encapsulates the essence of youth, preserved in marble for a lifetime and beyond.

Steven Tonkin

C. Douglas Richardson 1853–1932

The cloud 1900 cast c.1908

cast bronze, patinated 46.2 x 15.7 x 14.1 cm

purchased through the Joseph Brown Fund 1979 79.2556

Many sculptors at the turn of the century used mythological or
symbolic imagery as a justification for portraying the naked form.
In *The cloud*, C. Douglas Richardson portrayed a woman bending
over and holding a pitcher upside down, directing water to the
'thirsting' flowers. She is the personification of a cloud, or the
rising mist, with wet drapery sensually clinging to her body.
She is an allegorical interpretation of the poem, 'The Cloud',
by British poet Percy Bysshe Shelley, first published in 1820,
which began:

> I bring fresh showers for the thirsting flowers
> From the seas and the streams;
> I bear light shade for the leaves when laid
> In their noonday dreams.

Below the woman, at the base of the sculpture, Richardson created
a decorative array of blossoms, as suggested by the poem's
opening lines.

Born in England, Richardson was trained in Melbourne
and at the Royal Academy Schools in London. In Britain, he was
impressed by Art Nouveau and Symbolism and introduced the
swirling curves and pure lines of the former into sculptures such
as *The cloud*.

Returning to Australia in 1889, he influenced local sculptors
through his teaching. He received a number of sculpture
commissions, including the impressive art nouveau *Discovery
of gold* memorial created for Bendigo in 1906. He completed his
large version of *The cloud* in 1900, and made several smaller
plaster and bronze versions over the next decade.

In his poem, 'The Sculptor Sees The Cloud', Ernest Fysh
provided a poetic description of this work:

> Rapt in trance, behold the Sculptor stand,
> Moulding the plastic clay with eager hand;
> Above him rose the Cloud, all glorified
> Fresh from the cool heart of the mountainside;
> No swirling veil of mist, bust soft and warm,
> The unchanging presence of a woman's form.[47]

Anne Gray

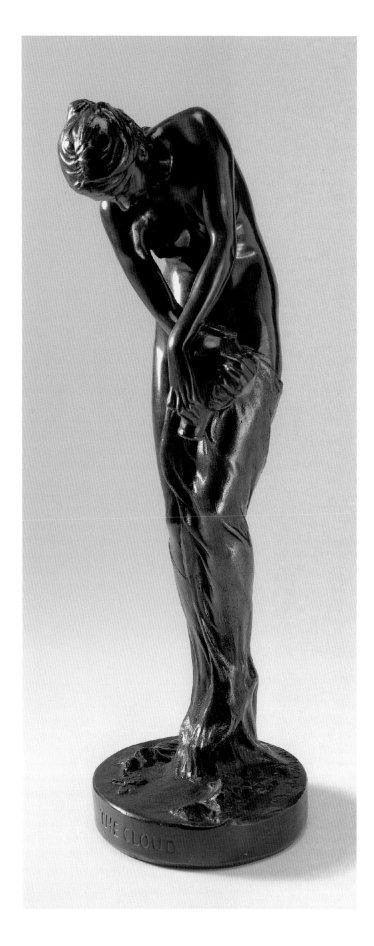

Charles Conder 1868–1909

Esther 1899
from 'The Balzac Set' London: Carfax and Co Ltd
transfer lithograph, printed in brownish-red ink from one
stone on paper 24.4 x 31.8 cm
purchased 1983 83.3060.4

Esther is from a series of six lithographs, known as 'The Balzac Set', which Conder produced in 1899. It shows the dramatic scene from Honoré de Balzac's novel *Splendeurs et misères des courtisanes* (*Scenes from a Courtesan's Life*), first published in 1839–47, in which the heroine, Esther, is found dead in her bedroom by her lover, the elderly and avaricious banker, Baron Nucingen, and her two maids, Europe and Asia. Whereas Balzac created a broad panorama of early 19th-century French society in over 90 novels and stories, Conder focused on those aspects of the writer's work which portrayed the Paris demimonde.

In Paris, Conder plunged wholeheartedly into the bohemian life of Montmartre, where he found studio lodgings on his arrival from Australia in 1890. As the English artist William Rothenstein, whom Conder first befriended in Paris, later recalled: 'there is …

a charm to be living in circumstances which wear a character of romance, to be reading Balzac and Stendhal … and to find oneself at supper parties among poets and painters and their women friends, the Esthers and Coralies of the day'.[48]

In 1899, Rothenstein, in his Kensington studio in London, showed Conder the process of drawing on specially prepared paper for transfer to the lithographic stone. 'I find lithography very hard but most interesting', Conder confided to his friend in a letter of 8 November 1899, and sent for approval three new lithographs for 'The Balzac Set', including *Esther*, which 'I like the best'.[49]

The lithographs were published as a portfolio entitled *Six Lithographed Drawings from Balzac* by the London gallery, Carfax. Printed in brownish-red ink in an edition of 25 sets, they recalled the earlier red chalk drawings of the 18th-century French artists Jean-Honoré Fragonard and Antoine Watteau, whose rococo fantasies and idylls Conder greatly admired. During his brief printmaking career, Conder made 33 lithographs between 1899 and 1905. Interestingly, the National Gallery of Australia's 'Balzac Set' was once owned by Rothenstein.

Stephen Coppel

Hugh Ramsay 1877–1906

A mountain shepherd 1901

oil on canvas 167.5 x 110.8 cm

gift of Nell Fullerton, niece of the artist, in memory of her parents,
Sir John and Lady Ramsay 1980 80.876

George Lambert 1873–1930

Hugh Ramsay in London 1900

brush and ink, grey wash, opaque white highlights 25.9 x 32.6 cm

purchased 1959 59.226

Many expatriate artists working in Paris and London at the
turn of the century were influenced by the fashions of the time,
the soft palette and Aestheticism of James McNeill Whistler,
and Velázquez's use of light and dark to define space and form.
In *A mountain shepherd*, Hugh Ramsay paid homage to Velázquez,
in his choice of subject and in his use of an uncompromising
realism.

Ramsay depicted this bearded man staring out at the viewer
with a simple dignity. He wrote:

> I am painting a brigand or something. Supposed to be an
> Italian Mountain Shepherd, but looks more like a gnome or
> hobgoblin. He's a little nuggety dwarflike fierce little cuss,
> so I keep me 'verolver' in my hip pocket ready. It's awfully
> interesting both the man and the costume.[50]

He portrayed the man as being sure of himself and his place
in the world.

Before moving to Paris, Ramsay spent some time in Scotland
visiting relatives. He had met fellow Australian artist, George
Lambert, in 1900 while on board a ship travelling to Britain.
Later that year, exhausted from his Scottish social round, he
arrived one evening at the Lamberts' home in London and
collapsed into a chair in his morning coat and silk hat. Lambert
rapidly sketched this unusual and striking portrait (while his
wife, Amy, revived Ramsay with tea and sympathy), creating
a memorable image of an artistic friendship.

Anne Gray

Hugh Ramsay 1877–1906

Madge 1902
oil on canvas 81.0 x 65.0 cm
gift of Janet and John Wicking in memory of Madge,
Janet's mother and Hugh Ramsay's sister 1996 96.1035

Hugh Ramsay received early acclaim when, in 1902 at the age
of 24, he had four works shown at the New Salon exhibition in
Paris. Later the same year, in London, he began a portrait of
Nellie Melba, but became seriously ill with consumption and was
urged to return home.

In portraits, artists frequently depict their families and men
and women with whom they feel empathy – who attract them
as human beings. Painted on Ramsay's return to Melbourne, this
full-length portrait of his sister Madge is a carefully constructed
work, a delicate balancing act between artifice, naturalism and
psychological insight. On numerous occasions Ramsay painted
portraits of members of his family that are imbued with an
intimacy of subtle communication and mutual recognition.

Madge, who dons a big picture hat, is portrayed with
decorative studio props such as a tall vase of Chinese lilies
and a Japanese screen. The emphasis on tonalism and sensuous,
painterly brushwork is characteristic of Ramsay's art, reflecting
his interest in John Singer Sargent and Velázquez, whose
paintings he had recently seen in London. Apart from the
brushwork and hint of movement in the way Madge slightly
raises her skirt with her right hand, the overall impression
is one of stillness and reflection. Here is the loving sister caught
in a double bind: agreeing to pose for her brother, who is driven
by a relentless passion for his art, but with the knowledge that
he should really be resting because of his illness. Madge looks
directly at him with an expression of quiet concern and
compassion.

Four years after this elegant portrait was painted, Hugh
Ramsay's death from consumption represented a great loss
for Australian art.

Deborah Hart

Ambrose Patterson 1877–1967

Self-portrait c.1902
oil on canvas 130.5 x 81.5 cm
purchased 1976 76.1057

Artists have often painted their own portraits because of the
ready availability of the model – themselves – and also as a
means of self-enquiry. In this self-portrait, the thin young man in
the skimpy singlet faces us, but his head is in shadow and so we
cannot see his features; we see these more clearly through the
reflection in the mirror in the centre of the picture. The artist,
Ambrose Patterson, was feeling insecure and experiencing a loss
of self-esteem because, in 1902, his work had been rejected from
a New Salon exhibition in Paris. Furthermore, his sister-in-law
Nellie Melba had withdrawn her patronage (because he had
married without telling her) in favour of his friend, Hugh
Ramsay, whose talent, dedication and recent success appealed
to her. In this portrait Patterson showed his inner darkness by
placing his head in shadow, but revealed his hopes for a more
positive future by creating another lighter and brighter image
of himself in the mirror.

This remarkable self-portrait was the culmination of a series
of paintings of rooms with open windows that Patterson made
in Paris. He created a striking composition, a criss-crossing
pattern of verticals and horizontals and of silhouetted forms.
He may have used large areas of light and shade under the
influence of Ramsay, in the hope of gaining some of the success
of his fellow Australian expatriate.

Patterson had also observed the work of other artists, including
Velázquez's group portrait, *Las Meninas* 1656. The mirror image
in the centre of the composition, the light coming in from outside,
the artist's pose and the painting on the easel are all devices taken
and adapted from the master's painting.

Anne Gray

Tudor St George Tucker 1862–1906

Nasturtiums c.1903
oil on canvas 101.0 x 71.6 cm
purchased 1976 76.362

Painted in 1903, soon after Tudor St George Tucker returned to Europe in 1899, this painting is decidedly non-Australian in its colour: Tucker used white paint freely, while employing a brushy gestural technique to define the textures of different forms. He captured the effects of light and shade on a homely, domestic scene.

The enclosed courtyard garden's towering cream walls cut out the sky and contrast with the round clumps of vivid green nasturtiums and climbing plants. Sunlight dapples through the unseen foliage of the tree, adding movement and immediacy to the composition. The brightly lit diagonal path leads the eye to the two figures, placed in the middle distance, each defined by its own space. Posed in the tradition of 19th-century academic painting, the woman leans against the doorway and a brown clad older man smokes while seated. Dominated by the luminous shadow, sunlight and the mass of nasturtiums, their apparent lack of communication conveys a sense of separation and sadness.

Born in England, Tucker came to Australia for health reasons when he was nearly 20. He studied at the National Gallery School in Melbourne, then departed for Europe where he met E. Phillips Fox. When he returned to Australia in 1892, he joined Fox in running the Melbourne School of Art. With an emphasis on drawing from a live model, painting outdoors and the use of bright colour broadly and rapidly applied, these artists offered a popular alternative to the conventional teaching provided by the Gallery School.

Jenny Manning

Rupert Bunny 1864–1947

Who comes? c.1908
oil on canvas 81.0 x 54.2 cm
bequeathed by John B. Pye 1963 63.7

Who comes? is one of a series of works called 'Days and Nights in August', painted by Rupert Bunny between 1907 and 1911, which evoke a mood of intimacy and luxurious leisure; of perfume, poetry and distant music. The colours in *Who comes?* are few – white, black, brown, red, yellow – and they have been orchestrated so that small colour accents are played off against a basic theme. Warm sunlight, filtering through a boldly striped blind, colours the upper part of the picture, whereas in the half-light below the blind the flounced skirts shimmer translucently.

Bunny's chief model, posing for both figures in this painting, was his wife Jeanne. She was 'a beautiful French woman and her husband delighted to paint her in the long, flounced and flowing dresses of the period. Once he said, with faint distaste: "When short skirts came in I no longer wanted to paint women"'.[51]

The drapery has been painted in a way that has little relation to the bodies beneath. One reviewer in 1911 explained Bunny's preference for loose drapery as a way of capturing or complementing the indefiniteness of nature, 'leaving forms and outlines in a state of indecision and flux'.[52] In contrast to the geometry of the striped blind, Bunny's rendering of filmy cloth breaks the shapes so that the attention goes not to outlines and large areas but to surfaces and small accents. The effect is sensuous. Bunny was portraying a luxurious domesticity which, in the fashion terms of the day, was well represented by the tea-gown: 'It gives a man a sort of luxurious feel of being an Oriental Pasha, as he lies in his chair, smoking the ever-present cigarette, to see himself surrounded by graceful houris clad in gauze and gorgeous draperies shimmering'.[53] Marcel Proust wrote at length on the same theme in *A la recherche du temps perdu* (1913–27) and, like Bunny, he lamented the passing of this excessively feminine style with the coming of the First World War.

Mary Eagle[54]

Bernard Hall 1855–1935

The quest c.1905
oil and canvas 154.0 x 94.5 cm
purchased 1977 77.87

Bernard Hall first exhibited *The quest* with a verse from the *Rubaiyat of Omar Khayyam*: 'I sent my soul through the Invisible/ Some letter of that After-life to spell'. The 12th-century Persian poem *The Rubaiyat* was translated into English in 1859 and, with its mystic, exotic philosophy and sensual imagery, became a popular source of inspiration. The work of symbolist poets such as Mallarmé and Verlaine had also been influential in Australia since the late 1890s.

The quest was an important symbolist painting because it introduced to the Australian public the types of symbolist works popularised in Europe by artists such as G.F. Watts and Gustave Moreau. Hall used a composition derived from Watts and previous artists – that of a woman seated on a globe symbolic of the spheres. Yet his is the most pared-down allegory, his female figure holding no identifying objects to give clues as to her purpose. Suggestive rather than didactic, Hall gives the viewers' imagination full rein to impose their own interpretation of the nature of the subject's quest. The figure floats mysteriously, her face in shadow – anonymous – and her hair becoming a long flimsy swathe that curves round the globe, suggesting an ethereal soul drifting into space. The contemplative mood suggests that this is an inner quest, not a physical journey such as that pursued in Arthurian legend. Hall's first wife had died in 1901 and perhaps his thoughts were turning towards the passage of the soul to an afterlife.

The muted colour of the globe, the dark veil encircling it and the dulled background suggest the enveloping blankness of eternity. While the subject's face is obscured, the soft illumination from above highlights the body, whose smooth skin and sensuous curves still hint at the eroticism of wordly flesh. The eye is drawn to a bright halo-like aura around the head, perhaps the pure light of the living soul.

Bernard Hall was born in England in 1859 and had completed his studies at the Royal College of Art, London, and at the Antwerp and Munich Academies before coming to Melbourne in 1892 to become Director of the National Gallery of Victoria and head of the National Gallery School.

Susan Hall

Lionel Lindsay 1874–1961

Edge of the world 1907

etching, aquatint, burnishing, printed in black ink, from one plate

14.2 x 11.7 cm

purchased 1983 83.771

reproduced courtesy of the National Library of Australia

On his return from an extended journey through Europe in 1903, Lionel Lindsay was struck by the need for a distinctly Australian visual vocabulary. *Edge of the world* presents an Arcadia of scrubby, sunbleached eucalypts and was influenced and inspired by a variety of sources: prints by followers of William Blake, the classical revival within Australia, the idealised landscapes of the Heidelberg School artists and the impact of Symbolism. The inclusion of the naked female figure tempers the specificity of the Australian setting and the detailed rendering of the rocks, trees and sweeping sky. While she is depicted as being at one with her environment, she looks into the distance to the possibility of a world beyond the one she knows.

Lindsay's *Edge of the world* was an experiment in using the characteristics of aquatint to enhance his line etchings. The work marked a turning point for Lindsay and he received much acclaim following its display in the Society of Artists exhibitions in Sydney and Melbourne in 1907. While never equalling the attention lavished upon his brother Norman, with this print Lionel received acknowledgement for both his virtuosity in the medium and for the evocative subject matter.

Lee Kinsella

Eirene Mort 1879–1977

Mirror c.1906

copper over cedar frame and glass mirror 85.0 x 85.0 x 3.0 cm
purchased 1984 84.681.19

Robert Prenzel 1866–1941

Fireplace surround and mantel 1910
Queensland black bean
170.0 x 188.3 x 34.4 cm
purchased 1980 80.3675

By 1900, Australian decorative arts and design reflected British and European design styles of the late 19th century, such as the Arts and Crafts movement, the Aesthetic movement and Art Nouveau. The emphasis on nature as subject matter, the expression of nationalism and regionalism and the return to handcraft values in these styles found favour with designers and craft practitioners seeking to celebrate Australia's unique flora and fauna with the advent of Federation.

Eirene Mort's work resulted from a thorough training in art, design and craft in England from 1899 to 1906. Her subsequent work as an etcher influenced her craft output in metalwork, ceramics and woodcarving, giving her work a strong and consistent design character. While influenced by the Arts and Crafts movement and Art Nouveau, Mort concentrated on Australian subject matter, using native flora and fauna as design motifs in book illustrations, bookplates, postcards and illustrated manuscripts. This wall mirror, with its repoussé copper design of eucalypts, is a fine example of the integration of her design and craft skills. Mort made her designs available to other craft workers, broadening her influence in the burgeoning nationalism of Australia's post-Federation period.

Australia's most celebrated carver of the Federation period, Prussian-born Robert Prenzel, undertook a cabinet-making apprenticeship and study of woodcarving in Europe before travelling in 1888 to Melbourne, where he set up business as a designer and carver of furniture and architectural fittings. Following his naturalisation in 1897, he began to incorporate Australian motifs into furniture and carved panels in a rich regional variation of European Art Nouveau, with an emphasis on sinuous natural forms and exotic materials. His repertoire of traditional woodcarving skills formed the basis for work in Australia that celebrated native woods, flora and fauna and can be seen in this fireplace surround, part of a larger, commissioned suite of related furniture.

Robert Bell

Alice Mills 1870–1929

Winter c.1907

gelatin silver photograph, watercolour 37.0 x 29.0 cm

gift of Dr Mary True 1982 82.1936

In the first decades of the 20th century, many women found in photography a means to independence and creativity. Previously, women had been chiefly employed in the backroom production and retouching facilities of many studios. In the 19th century, few women were listed as proprietors of studios, except in association with their husbands. Alice Mills from Bendigo started work as a retoucher in the studio of one such partnership: the well-known (Henry) Johnstone and (Emily) O'Shaughnessy studio in Melbourne. In 1900, she set up a studio in Melbourne with her husband, the painter Tom Humphrey, and from 1913 she had her own studio in the Centreway, Collins Street.

In Victorian and Edwardian times, themes in the visual arts contrasting youth and age or the progress between birth and death held a particular fascination. For a display of her work at the *First Australian Exhibition of Women's Work* in Melbourne in 1907, Mills chose to illustrate the four seasons. She used her mother as the sitter for the representation of 'Winter', posing her dressed in a plain shawl and lighting her from below to suggest a winter fireside. The old lady of the picture pauses in her knitting and stares off into the distance as if remembering the past. It was a clichéd subject handled with restraint and effectiveness. Perhaps Mills's mother, Margaret Journeaux, was remembering Cork, where she had been born, but in real life Mrs Journeaux also did another kind of 'women's work', as a writer. The whereabouts of the remaining seasons is unknown.

Gael Newton

Norman Lindsay · 1879–1969

The bacchanal c.1909

lithograph, printed in brown ink, from one stone on paper

25.6 x 27.4 cm

purchased 1981 81.112 © H.A. & C. Glad

The motivation behind Norman Lindsay's use of elements from the classical tradition was far removed from that of his brother Lionel's, and represented a retreat from reality to an imaginary world. In 1901, he moved from Melbourne to Sydney to work as an illustrator for the *Bulletin* magazine. In Sydney, he joined a circle of poets, writers, musicians and artists committed to a classical revival within Australia; this provided him with the impetus to continue to pursue mythological representations in his art. Lindsay and Hugh McCrae published *Satyrs and Sunlight* together in 1909 – poems by McCrae accompanied by Lindsay's illustrations of nymphs, satyrs and fauns.

The bacchanal typifies Lindsay's representation of mythological and mortal figures enjoying uninhibited revelry and merriment. Set in a land far removed from the reality of urban Australian life in the 1900s, the bulky figures blissfully celebrate the abundance of nature. The half-goat/half-human form of the satyr is the point of commonality between human and beast, and all partake in 'animal' passions and pleasures.

The bacchanal demonstrates Lindsay's superb drafting ability and confidence utilising the medium of lithography. Detailed areas, such as the panther's markings and the texture of the animal skins, contrast with the lighter skin tones and unembellished areas of the central female figures. However, while the tumbling figures direct the action from left to right, the scene seems strangely still. The composition is contrived as if to heighten the drama and spectacle of the subject matter. Lindsay consciously created a sense of theatre in the image by presenting several of the figures looking out to challenge the viewer. In this, he jubilantly touted for comment and hoped to provoke a response from his audience. His ongoing celebration of paganism and his use of buxom female nudes inspired controversy throughout his life.

Lee Kinsella

Frederick A. Joyner 1863–1945

Harvest-time c.1910 printed later
gelatin silver photograph 15.9 x 21.4 cm
gift of Mrs Max Joyner 1982 82.1848

With improvements in the ease and cost of making photographs throughout the 1890s, photographic societies flourished and a distinct movement of art photographers arose among the legions of amateurs. In the late 1890s, John Kauffmann returned to Adelaide from Europe and showed some of the first examples in Australia of the new soft-focus art photography. Other local photographers were already interested in developing photography as an art. One of the new wave was Frederick Joyner, a lawyer by profession and also a skilled plant breeder who experimented with new varieties on his property at Bridgewater in the Adelaide Hills. He began exhibiting his

photographs in 1894 and was one of the most active members of the South Australian photographic scene, from the turn of the century through to the First World War and, after a break, again in the late 1920s. He was a pioneer colour photographer and a supporter and adviser to the young painter Hans Heysen. Joyner made a series of photographs of harvest time, some showing the old handyman on his property at Bridgewater. The old man is shown with a scythe and probably used this tool, but he is also the traditional allegorical representation of Time. Modern machine harvesting is not shown and the scenes evoke the passing of the old ways. Joyner's prints were made on toned matt-finish papers, designed to soften down the detail and contrast of the negative, so that the prints also seemed to come from another time and encourage reverie.

Gael Newton

Ethel Carrick 1872–1952

Sydney Harbour 1908

oil on wood panel 26.4 x 34.9 cm

purchased 1975 75.111

Ethel Carrick first visited Australia in 1908, three years after her marriage to fellow painter E. Phillips Fox. English-born and trained, Carrick delighted in the light and colour of open air subjects – whether in Cornwall, France, North Africa or Australia. She painted many oil sketches that capture the casual attitudes of passers-by in public spaces. She used short brushstrokes to animate the scene, creating a sense of transient natural effects and human movement.

In *Sydney Harbour*, Carrick placed four horizontal bands across the picture: jetty, water, city, sky. In the foreground are two groups of women and children waiting for the ferry, probably from McMahon's Point or Milson's Point. She used dark and white dresses (and just one boldly striped gown) to balance the left and the right. In the centre of the composition she placed a band of sea, populated with ferries, yachts and ships and, above that, a view of the city beneath a smudged swathe of sky.

Carrick used a high-key palette, that is, colours mixed with white rather than darker hues. As the Impressionists had demonstrated, tonal contrast and detail diminish with distance. The artist accentuated her free brushwork, especially on the white dresses, hats, shirt and parasol, by the use of impasto, thick layers of paint in which brush marks are visible.

Christine Dixon

Bernard Hall 1859–1935

Under the studio window: Grace Thomson c.1910

oil on canvas 68.6 x 50.6 cm

purchased 1978 78.98

Bernard Hall was known for his figure paintings and his interiors. He often favoured the highly tonal style popular at the time, in which a picture's composition was defined with contrasting tones of light and dark and in which colour was of secondary importance. Tonal works were often low key and sombre, with a highlighted subject emerging from a muted background.

Depicted seated under a window, this woman appears to be reading a magazine although one can also sense her consciousness of the painter's scrutiny. The subject is Grace Thomson, who became Bernard Hall's second wife in 1912. Bathed in the window light which reflects starkly off her long dress, her figure stands out dramatically from the dim surroundings. Sunlight also reflects off the magazine pages towards her shadowed face, etching highlights on chin, nose and eyebrows. Above and behind the subject is a mantelpiece with ornaments and she sits among them, perhaps feeling as if she is on show, like an ornament herself being appraised as a potential wife.

Bernard Hall moved from England in 1892 to take up the directorship of the National Gallery of Victoria, Melbourne. His contract required him to run the Gallery and the Art School in the afternoons and included a free studio in which to undertake his own work in the mornings. Among the students he taught and influenced were Hugh Ramsay, George Coates and Max Meldrum.

Bernard Hall died in 1935 while in London on a purchasing trip. The riches of the Felton Bequest had fuelled a time of rapid expansion for the National Gallery of Victoria and, during his 40 years as director, he was responsible for many important acquisitions. After his death, his widow, Grace, was left with no pension and the burden of supporting school-age children. She found herself then in difficult circumstances, perhaps a contrast to the carefree magazine-reading days when she posed for this portrait.

Susan Hall

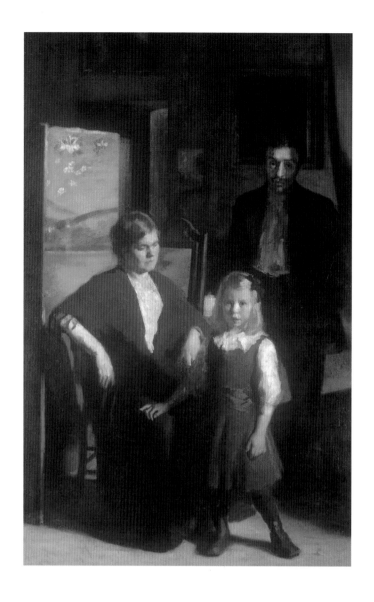

Max Meldrum 1875–1955

The yellow screen (Family group) 1910–11

oil on canvas mounted on composition board 140.0 x 217.5 cm

purchased 1969 69.52

Max Meldrum left Australia on a Travelling Scholarship in 1899 after studying with Bernard Hall at the National Gallery School, Melbourne. He found the academic theories being taught in the Paris art schools uncongenial and soon moved to Pacé, a village in Brittany, to study in 'the school of nature'. It was here that he painted this family group. The figures represented are Max Meldrum (at the age of 35), his wife Jeanne and his eldest daughter Ida. Another three years were to pass before his 'French' period was ended by his return to Australia in 1913. This work is a major portrait from this period and is in fact his only painting to contain three life-sized figures.

Hall's training had directed Meldrum towards the work of the Spanish artist Velázquez and his methods of arriving at visual truth through a searching study of tone, contrasting light and dark. Accepting this approach without question, Meldrum felt bound to record only what the eye saw at any particular moment. Forms existed only if they were defined by light; as they lost their substance in shadows, Meldrum refused to substitute conceptual forms to compensate for the visual loss. The result is a kind of tonal impressionism akin to that of Velázquez in his painting *Las Meninas* 1656. In Meldrum's work, the fair-haired daughter, Ida, stands looking out of the painting, with her right hand extended as a distinct echo of the flaxon-haired Infanta in Velázquez's masterpiece, and the artist has depicted himself dramatically lit, directly related to Velázquez's own self-portrait in that painting.

For all its visual objectivity and size, it is probably Meldrum's most intimate and personal work in this genre. Feeling has not yet been submerged by the clinical analysis and insistence on scientific method so characteristic of his later work.

James Gleeson

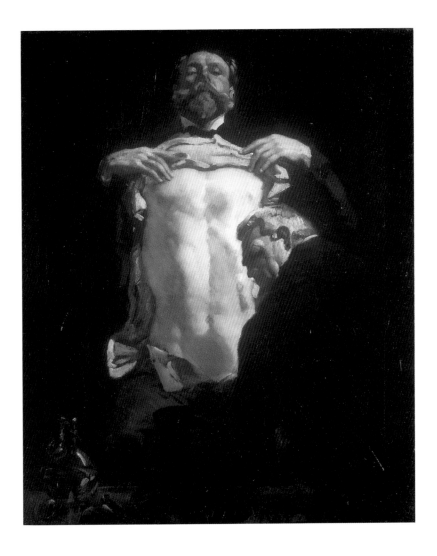

George Lambert 1873–1930

Chesham Street 1910
oil on canvas 62.0 x 51.5 cm
purchased 1993 93.1191

Chesham Street is one of a group of works that George Lambert painted between 1910 and 1914 which are puzzle pictures – paintings that appear to have a meaning and yet are not strictly narrative – that invite the viewer to provide their own interpretation. It is a bravura work that demonstrates Lambert's considerable technical prowess but, more than this, it is a challenging and demanding image, which asks 'who is this man and what is going on?' The man sits boldly in front of the viewer, holding up his shirt and revealing his entire torso. His head is held high, his lips are closed and he looks down at the viewer, seeming somewhat superior. His pale flesh, with the play of light on it, gleams against the dark surroundings. The model is believed to be Lambert himself.

Contemporary critics acknowledged the 'truly masterly painting of a male form'[55] and, when exhibited in Australia,

Lambert's artist friends recognised that the subject provided a splendid opportunity for the representation of nudity. But this is not strictly speaking a male nude, as Harold Parker's *Orpheus* is. The figure is not naked, he is half clothed and is intentionally shown in this way to give the image greater impact – to make it more sexually charged.

Although contemporary critics read the image narratively, seeing it as a scene in a consulting room with a doctor examining the heart or lungs of his patient, and although Lambert did depict such a scene, this is not the subject of the painting but the excuse for the subject. Dramatically, the painting is not about a physical medical examination at a specialist's room in Chesham Street, London, but rather the psychological intrusiveness of that process. In 1901, Freud published his *Psychopathology of Everyday Life* and, during the decade, his ideas about exploring the psyche gained wider understanding. This painting is a metaphor: this man seems to have nothing to hide, to be literally and metaphorically baring his breast, exposing his heart and soul to the world.

Anne Gray

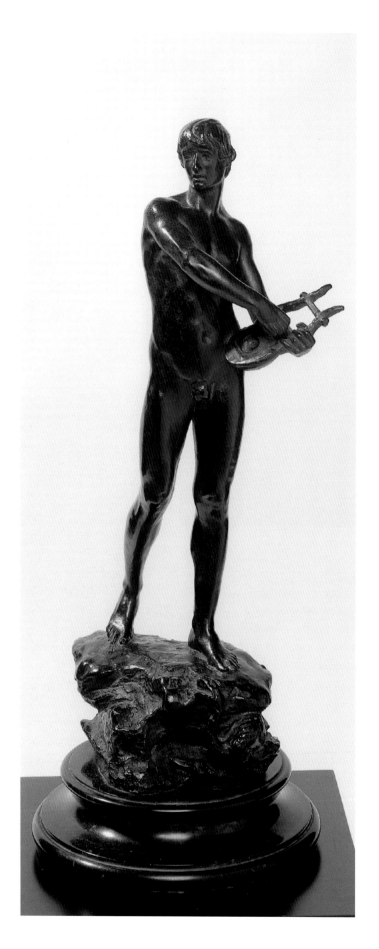

Harold Parker 1873–1962

Orpheus 1904
cast bronze, patinated 43.6 x 15.0 x 17.5 cm
gift of William Richard Cumming 1984 85.421

In the 1880s, the New Sculpture movement revitalised British sculpture with the introduction of 'art bronzes', or small-scale sculptures, which became a well-established genre by the 1890s.

In Greek mythology, Orpheus is the legendary musician who descended to the Underworld in an attempt to retrieve his love, Eurydice, after her untimely death. Mesmerised by Orpheus's music, Hades, ruler of the Underworld, gave him a chance to lead Eurydice back to the living on condition that he did not look back at her during their journey. Despite this warning, in a fateful moment of self-doubt, he stole a glance and lost her forever. Harold Parker's *Orpheus* plucks his lyre, a symbol of his divine talent, yet his melancholic gaze foreshadows his human vulnerability and the ultimately tragic end to his heart's quest.

Parker arrived in London in 1896 at the age of 22, where he studied sculpture under the influential teacher W.S. Frith, then worked as an assistant to a number of eminent Victorian sculptors. *Orpheus*, first modelled in clay in 1904, is Parker's earliest known statuette, although it was not exhibited as an 'art bronze' at the Royal Academy until 1909, two years after the companion statuette of *Eurydice*.

Steven Tonkin

Violet Teague 1872–1951

The boy with the palette 1911
oil on canvas 175.5 x 108.5 cm
gift of U.S. Teague 1976 76.103

Violet Teague's life was a compromise between the conservative world of a dutiful daughter and the somewhat daring existence of a serious female artist. Likewise, her art was a blend of the traditional and the modern. She began her art studies in Brussels and England and continued them in Melbourne during the 1890s. Like many others, she was inspired by the broad, bravura brush work of John Singer Sargent. In this work, however, her inspiration was Manet and his painting, *The piper* 1866. She took from Manet the sweeping brushstrokes and dramatic composition, with the crisply contoured, sinuous figure of the boy placed against a large area of thinly painted gold. She depicted the figure realistically, but used modernist flat colours and an underlying asymmetrical abstract design (which could have derived from the Japanese colour prints that were much admired at this time) to make the figure stand out.

The boy with the palette is an aesthetic object first and a character study second. Her model was Theo Scharf, the 12-year-old son of a prominent Melbourne family, who was considered to be a child prodigy and who often painted with Teague. In 1914, he travelled to Munich to further his training and, after the war, obtained a teaching position at the Munich Academy. In this portrait Teague portrayed the artist as a young man, conscious of his talent and confident of his future. She did so through the bold composition and energetic paint surface as well as through his assertive gaze and studied stance. But this work is not so much about Scharf and his prodigious talent, or even about an artistic friendship, as it is a painting of forms and colours, a melody in black-brown and gold.

Anne Gray

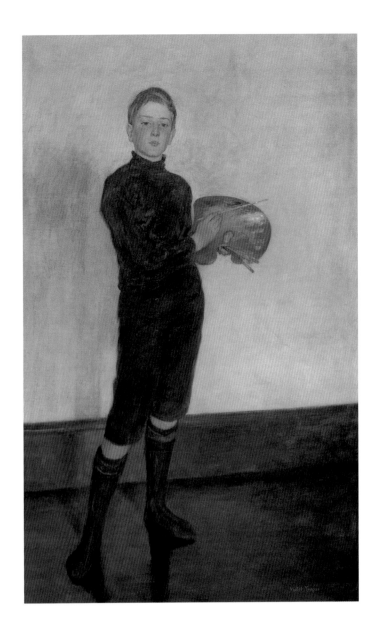

Blamire Young 1862–1935

The rehearsal c.1911

watercolour, gum arabic on paper 21.0 x 27.2 cm

bequest of Henriette von Dallwitz and of Richard Paul,
in honour of his father, Dr Oscar Paul 1965 65.100

The rehearsal is typical of Blamire Young's later watercolours.
It presents an imaginary scene on stage, with a cast of characters
in Victorian dress, sitting waiting under the shadow of a huge
stage curtain. While painted in Young's idiosyncratic watercolour
style, it expresses an Edwardian fascination with the romantic
and the dramatic, and a period interest in technical virtuosity.
The artist commented about this work to a prospective buyer:

> The price on *The Rehearsal* was protective, because this picture
> I have always had a special regard for. I think I shall have to
> keep it a bit longer. There is a quality in the background that
> I never was able to get again – though I have tried several
> times – which distinguishes it from other drawings.[56]

English-born Blamire Young emigrated to Australia in 1885
to teach mathematics, but was persuaded to pursue a career
as an artist by his friend, the cartoonist, Phil May. While living
in Britain from 1893–95, he became familiar with the work
of the Beggarstaff Brothers, William Nicholson and James Pryde,
who had revolutionised poster design in England through their
decorative approach. On his return to Australia, Young used
similar bold designs and areas of flat colour in his work.
Young exploited the possibilities of watercolour and the texture
of the paper to create poetic effects. He mixed bright colours with
quiet tones to create dramatic contrasts. He quickly covered a
sheet of paper with a general tint and then, before this was dry,
he tilted the paper to let the wash settle into forms that he used
as a basis for his images – both Australian landscapes and
imaginative scenes. Fellow artist, Julian Ashton, maintained:

> His long experiments had given him a dexterity in the use
> of all sorts of inventions in the practice of watercolour
> which has certainly never been equalled by any Australian
> watercolourist.[57]

Anne Gray

A. Henry Fullwood 1863–1930

The Medway Valley, Kent 1907

lithograph, printed in black ink, from one stone on paper 20.0 x 31.5 cm
purchased in 1987 87.605

Harvest in Suffolk 1914

monotype, printed in colour, from one plate on cream paper 20.3 x 20.3 cm
purchased in 1988 88.738

When A. Henry Fullwood came to Australia in 1883, he found work as an illustrator and lithographic draughtsman in Sydney. He painted spontaneous, lyrical landscapes around Sydney Harbour and along the Hawkesbury River and was one of the first to make etchings as a fine art. In 1900 he left Australia for Europe, like many other artists, not returning until 1920.

In London in the early 1900s, he continued to make etchings of historic places and scenic sights, but also worked with two other printmaking processes – lithography and monotype. In his lithograph, *The Medway Valley, Kent*, Fullwood selected a bold subject with a dramatic vantage point, viewing the valley from on high, past the sweeping curve of the arched bridge towards the ships in the harbour. He presented the scene with a radiant light on one side, throwing highlights onto the landscape below, and with contrasting dark storm clouds and rain casting other areas into shadow. To create these dramatic effects, he took full advantage of the soft, rich, deep blacks and the varying shades of grey that are possible with lithography.

Fullwood was so fascinated by the process of making monotypes that he wrote an article about it for *Studio* magazine in the summer of 1904, suggesting that the paper and printing techniques that an artist used were crucial to the effects they could achieve. In *Harvest in Suffolk* he used the delicacy of this medium to create a soft, low-key view of a quiet rural landscape. His experience with the medium meant that he could create as complex an image as if he were painting directly onto paper, while at the same time taking advantage of the subtle textural effects that can be obtained through monotype.

Anne Gray

Hans Heysen 1877–1968

Landscape with gums and oxen 1910

watercolour over pencil on cardboard 41.0 x 34.0 cm

purchased 1985 85.1647

During the years following Federation and before the beginning of the First World War, artists working in Australia became increasingly nationalistic in their subject matter and in their unwillingness to accept new modernist European approaches. Traditionally based and highly conservative in outlook, Heysen's art embodies this nationalistic spirit in his depiction of landscape.

Landscape with gums and oxen is redolent of the blue-gold colours of summer at dusk. The luminescent light bathes the ubiquitous eucalypts that dominate the central space, while the sturdy beasts of burden are guided home. Hans Heysen greatly admired the 19th-century French artist Millet and emulated that artist's belief in the heroism of simple rural toil. In this work, Heysen created a powerful embodiment of the beauty of nature and an idyllic rural state.

Heysen's early preoccupation with depicting sunlight and the unique sensations of the rural bush environment is evident in this watercolour. Living at Hahndorf in the Adelaide Hills isolated Heysen from the wider art world, although his correspondence with Lionel Lindsay over many years provided a critical link to Sydney and Melbourne and produced valuable responses to his own work.

In a letter to Lindsay of 3 February 1910, Heysen wrote of *Landscape with gums and oxen*: 'what I tried to give [is a] sense of space and atmosphere with movement in nature' and, in the same letter, 'I am just on a small watercolour for Mr Gill of Melbourne of a Gum tree seen against a setting sun with two oxen trudging in the dusk'.[58]

While setting the precedent for the cult of the eucalypt, Heysen's art remains an honest response to his environment, and his rural subjects have captured the national imagination.

Betty Snowden

Frederick McCubbin 1855–1917

Afterglow 1912
oil on canvas 91.5 x 117.0 cm
purchased 1970 70.95

Afterglow is one of a number of landscapes that Frederick McCubbin painted with plump females basking on grassy slopes. Charles Conder, Tom Roberts and Arthur Streeton had all painted images of nude bathing in a bush setting in the late 1880s. Streeton and Conder both painted views of boys bathing in the Yarra river in 1890 (*The Yarra, Heidelberg* and *Spring* 1890).

McCubbin's bathers inhabit a soft dreamy landscape. There is a certain traditional influence felt in the work which is reminiscent of old master depictions of the story of the bath of Diana. This painting is clearly influenced by Corot's version, in which a single bather stands in the water while her companions remain on the bank, a reproduction of which was pasted into McCubbin's sketchbook.

This work, which was exhibited in 1921 as *Afterglow, Macedon*, seems to be inspired by a swampy area at Macedon on the road near Fontainebleau. It was completed in McCubbin's studio with the addition of the female figures. These would have been painted from sketches he had made earlier.

Despite the influence of Corot's painting and others depicting the story of Diana, McCubbin did not title his painting 'Bath of Diana', as John Glover did a century before – he was not using mythology to make a comment about contemporary life. Instead, his title highlights his concern with painting light effects; *Afterglow* shows the glow of evening light which remains lingering in the sky after sunset. McCubbin wanted to portray the subtle effects of light on foliage and flesh.

Bridget Whitelaw[59]

Frank Hurley 1885–1962

Penguins on the beach at the Nuggets and the remains of the Gratitude
1911

carbon photograph 58.0 x 78.5 cm

purchased through the Kodak (Australasia) Pty Ltd Fund 1992 92.1382

Photographs were made on Antarctic voyages from the 1870s, but it was not until the age of the picture magazine and film that they became an indispensible part of Antarctic expeditions and their associated marketing and publicity campaigns.

In 1911, Frank Hurley, the Sydney professional photographer known as one of the more stylish postcard producers, was appointed by scientist Douglas Mawson to be the official photographer and cinematographer on the Australasian Antarctic Expedition 1911–14. One of the first ports of call for the expedition in early December 1911 was to the sub-antarctic Macquarie Island. Mid-way to the Antarctic and home to large penguin rookeries, this island was also a long-established base for whaling and sealing operations and New Zealander Joseph Hatch's refinery. Hurley made several images of the penguins on the shingly beach of the east coast against the remains of Hatch's ketch the *Gratitude,* which was wrecked in 1898. The image suggests the majesty of the natural world. Hurley later successfully campaigned with Mawson to curb the destruction of the fauna on Macquarie Island.

Hurley had learned how to make dramatic postcard images using forms silhouetted against the sky and capturing trains or waves in motion, but he had little experience with wildlife photography. As one of the earliest images made on the Antarctic Expedition, the photograph of the penguins on Nuggets beach became a classic. Hurley chose it as one of the images printed as enlargements in carbon to publicise the expedition. Hurley's photographs and films helped recoup the cost of the expedition for the sponsors and led to his appointment, in 1914, as the photographer and cinematographer for Ernest Shackleton's ill-fated Imperial Trans-Antarctic Expedition on the *Endurance* in 1914–17.

Gael Newton

Sydney Long 1871–1955

The Spirit of the Plains 1914

oil on canvas 76.8 x 153.7 cm

purchased 1971 71.147

reproduced with kind permission of the Opthalmic Research Institute
of Australia

Pan 1916

etching, printed in black ink, from one plate on paper 27.8 x 41.5 cm

bequest of Henriette von Dallwitz and of Richard Paul, in honour
of his father Dr Oscar Paul 1965 65.136

reproduced with kind permission of the Opthalmic Research Institute
of Australia

Playing a flute-like instrument, a naked figure leads a flock of birds
in a synchronised, rhythmic formation towards a group of sinuous
gum trees. The moon has just risen and the face of the spirit is
thrown into silhouette. An aura of mystery surrounds the scene.

Painted whilst Long was in London, this work is a variation
of his *The Spirit of the Plains* painted 17 years earlier in 1897
(now in the Queensland Art Gallery, Brisbane). This later work
has been simplified, with fewer trees in the background, one less
brolga and not as much detail in the foreground foliage.

Whilst in London, Long studied etching at London Central
School, producing prints of Australian flora, fauna and landscapes,
as well as interpretations of some of his earlier paintings such as
The Spirit of the Plains and *Pan*. With these wistful, lyrical images,
he made his modest British reputation as a printmaker.

Born in Goulburn, Long was taught by Julian Ashton and, while
still a student, achieved early success when the Art Gallery of New
South Wales purchased his *Tranquil waters* 1894. The first in a series
of idylls featuring naked youth in the Australian landscape, *Tranquil
waters*, caused a sensation in the 1890s because its morality was
questioned by the press and parliament. However, the nudity as
depicted in *The Spirit of the Plains* and *Pan* was considered
acceptable and the painting was appreciated for the way it
contributed to the development of a specifically Australian
mythology.

Ron Ramsey

Florence Rodway 1881–1971

Portrait of a lady c.1914

pastel on buff paper on stretcher 73.0 x 50.0 cm

gift of Dr Joseph Brown, AO, OBE 1970 70.7

The *First Australian Exhibition of Women's Work*, mounted in Melbourne in 1907, was an expression of an increased political and cultural profile of women in Australia that had been developing since at least the 1890s. The exhibition included two impressively large charcoal drawings of draped figures by the young Hobart-born artist, Florence Rodway.

In the latter half of the first decade of the 20th century, Florence Rodway developed a distinctive style of pastel drawing (or pastel painting as the medium was often described). The approach used by Rodway between 1910 and 1914 was freer than most painting of the period. The works were vigorous and linear; form was developed through layers of strokes, rather than through blending. Critics writing of her work in these years were uncertain whether to accept her lively use of the medium or to denegrate a quality perceived as excessive mannerism. They all agreed, however, that her pastels fulfilled the first function of portraits – to present living likenesses. One feature of Rodway's portraits was a focus on the face and the merging of the sitter's clothes with the background. 'The artist has evidently gone on the principle of the central feature of vision being most distinct, and the balance being framed more by suggestion', wrote one commentator.[60]

Rodway was one of Australia's most original pastellists, yet she shares one characteristic with Tom Roberts and the more prolific Janet Cumbrae Stewart: most of her sitters for pastel portraits were women and children. However, she drew portraits of a number of well-known sitters including Henry Lawson and Nellie Melba. By the 1920s her style had changed – the vigour of her earlier pieces was replaced by a more tonal approach, closer to painting than drawing.

Andrew Sayers

Hilda Rix Nicholas 1884–1961

In the fields by the sea (Brittany) 1914
oil on canvas 81.2 x 65.2 cm
purchased 1967 67.44

Hilda Rix Nicholas painted *In the fields by the sea (Brittany)* while working in her studio in the artists' colony of Etaples in Picardy during the summers of 1910–14, before the beginning of the First World War. It is one of several images of French country people wearing traditional costume that she painted at this time. Like a number of other contemporary artists, she provided an alternative image of women to the elegant portraits of ladies used as emblems of their husbands' wealth and power; she showed them as resolute, independent women with a presence.

Like her subjects, Rix Nicholas was a capable woman; she sought equal standing in the artistic hierarchy. She travelled with her family in Europe in 1907–18, where she continued her studies in art and established herself as an accomplished artist. In much of her work she captured the nostalgic reverence for the 'purity' of rural life. She drew on a specific type to comment about the value of country life, as she was later to do in her images of confident women on horseback in rural Australia.

In 1919, Rix Nicholas showed *In the fields by the sea* in her controversial Sydney exhibition. Grace Cossington Smith viewed the exhibition and commented:

I went to see it three or four times … the most astonishing thing was the [feeling of] life in them … A French critic says 'the artist has the peculiar gift of expressing the spiritual character of the subject' – that was just it – Portraits & studies of people are usually just dull sort of wooden things, but these had a funny way of 'getting hold of you'.[61]

Anne Gray

Modernism and Feminism

1915—1939

Merric Boyd 1888–1959

Vase 1916
glazed earthenware 19.8 x 17.8 x 17.8 cm
purchased 1977 77.102

Jessie Simpson 1883–1965

Magpie vase 1917
porcelain (commercial blank) with painted overglaze enamel
26.3 x 14.0 x 14.0 cm
purchased 1981 81.315

The pioneer studio potter, Merric Boyd, set a new direction for Australian ceramics in the early decades of the 20th century after establishing his pottery at Murrumbeena, on the outskirts of Melbourne, in 1911. This vase, with its vigorous modelling and glaze colouration, reflects Boyd's interest in using the qualities of clay to achieve sculptural form and a sense of connectedness with Australia's natural environment. Following his service in the First World War, he worked and studied in the English Staffordshire potteries from 1917 to 1919. On his return to Australia, his robust evocations of the Australian landscape offered an alternative to the refined imported porcelains, with their floral imagery and fashionable design, available at the time.

As Australian decorative arts and design began to reflect and celebrate the post-Federation period's burgeoning interest in native flora and fauna, crafts such as china-painting, woodcarving and metalwork entered the repertoire of leisure skills of many women. Their work celebrated Australian nature, popularising the idea of the bush in the comfort of the growing suburbs. Jessie Simpson painted this vase in 1917, placing the image of that quintessential suburban companion, the magpie, within a decorative frieze below an unusual black-painted band. Its bold design reflects the transition from the Federation period's earnest expressions of Australia's indigenous natural environment to the more decorative geometric style of domestic objects and decoration (now known as Art Deco) that became popular during the 1920s.

Robert Bell

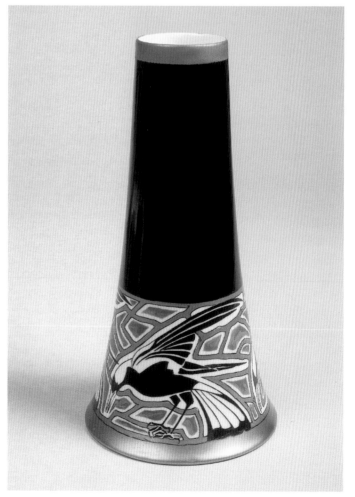

Roland Wakelin 1887–1971

The fruit seller of Farm Cove 1915
oil on canvas mounted on composition board 91.5 x 116.5 cm
purchased 1960 60.22

Roland Wakelin painted *The fruit seller of Farm Cove* at weekends in the dim light of a boarding house bedroom in Sydney. The year was 1915, the war was in progress, Australian casualties were high and public feeling about the war was at hysterical pitch. That year Wakelin worked as a clerk five and a half days a week, living with his family in no more than a bedroom and painting on Sundays. The uneven light in the room meant that he had periodically to carry the cumbersome, wet canvas into the open air to check the tonality.

Painting the picture was a paradoxical exercise for, as Wakelin said later, he intended to paint light: light expressed through colour, pure Impressionism. Yet he did not enjoy the luxury of working rapidly before his subject in the open air. Instead he worked from his head and slowly. Did he realise that under these circumstances he could not paint a pure impression? He was aided only by a small sketch made on the spot at

Farm Cove of 'the old fruit stall that used to be there in those days'.[62] He played freely with the placement of buildings.

To compensate, he had rules. He used a palette limited to black and white and three primaries – alizarin crimson, French blue and cadmium yellow – applying colours pre-mixed in a juxtaposition of small dabs, in emulation, he said, 'of the Impressionist method of simulating the vibration of light'.[63] For the viewer, the main effects of *The fruit seller of Farm Cove* – after its morning light and misty, wintry atmosphere – are the opaque, finely striped and dotted applications of paint and the careful, even rigid composition. Wakelin emphasised only those volumes that are emphatically cubic and his composition concentrated on a few long, straight lines. Its intellectualisation and artistic problem-solving qualify *The fruit seller of Farm Cove* as one of the first full-scale modernist paintings in Australia.

Living and painting in and around Sydney until his death in 1971, Wakelin remained faithful to theories of spectrum colour and simplified form, conscientiously working with the full range of rainbow tints and eschewing brilliant effects.

Mary Eagle[64]

Marguerite Mahood 1901–1989

Actress in medieval costume 1919
pen and brush and ink, watercolour over pencil on card
46.3 x 22.8 cm
purchased 1979 79.2166

Never much interested in portraying the prosaic side of life, Marguerite Mahood preferred instead subjects from history or from a whimsical world of Gothic fantasy. She was also much influenced by the sensibilities and aesthetics of the Art Nouveau and Arts and Crafts movements.

Mahood, like artists Thea Proctor and Violet Teague, was fascinated by costume and artifice. Her actress stands on a stage, a closed curtain behind her. She is an eloquent image of the theatrical world and quietly invites us into her domain. The mask she holds delicately in her hands draws us to her; its sorrowful downcast expression is in contrast with her gentle smile and symbolises the pretence and emotional breadth required of an actor.

The bold black and red decorative patterning of her costume, with its elegant line and supple folds, is reminiscent of medieval dress and contrasts with the soft glow of her porcelain-like skin. The form and design of the costume also resembles women's kimonos in 19th-century Japanese prints, and reflects a late manifestation of the turn of the century fascination with *Japonisme*.

Mahood painted *Actress in medieval costume* when she was just 18 and studying drawing under Frederick McCubbin at the National Gallery School in Melbourne. The strict academic training she received there honed her precocious skill as a draughtsperson. She signed this study in her maiden name of Callaway. By the 1920s, Mahood was working as a professional artist and often showed her drawings and watercolours, linocuts and oil paintings with the Victorian Artists Society. While she became more widely known for her ceramics from the 1930s, her fascination with history and fantasy remained.

Anne McDonald

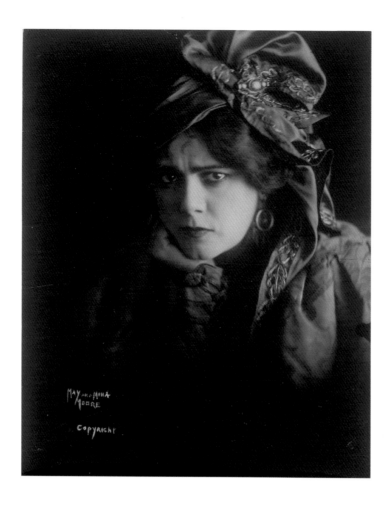

May Moore 1881–1931
Mina Moore 1882–1957

Portrait of an actress c.1916

gelatin silver photograph 19.9 x 15.2 cm

purchased 1989 89.1603

Sisters Annie May (May) and Minnie Louise (Mina) Moore ran photographic studios, first in Wellington and then in Sydney and Melbourne. Their work was most often jointly stamped 'May and Mina Moore' and was remarkably consistent. They portrayed their subjects in head and shoulder shots, focusing attention exclusively on the face through the use of dramatic lighting and dark backgrounds.

From the 1880s until well after the turn of the century, women in photography were more commonly employed as retouchers and hand-colourists. The number of women running photographic studios, however, increased noticeably around 1910. This was an era in which the graceful and distant Edwardian 'ladies' shown in so many paintings of the late 19th and early 20th century were being replaced by the jazz age flappers and mass media celebrities. The Moore sisters were themselves typical 'modern women' of the 1910s–1930s in seeking their independence and social mobility through new types of careers in photography. They both mixed in artistic circles and May, in particular, was interested in the theatre. In 1931, the *Australian Worker* stated about May: 'practically every artist, musician, critic, journalist, story-writer and poet of local celebrity was at some time or other a subject for her camera'.[65]

It is not clear which sister made this striking close-up of a stylish young woman (who may have been an actress or entertainer as the image was registered for copyright). She is shown in the recognisable Moore style but with particular verve as she stares straight into the camera, head slightly lowered in the *femme fatale* guise made popular in celebrity portraits and stills for the silent movies. Through the mass circulation of celebrity images, everyone could have their favourite star for their wall.

Anne O'Hehir

Jessie Traill 1881–1967

Good night in the gully where the white gums grow 1922
etching and aquatint, printed in brown ink, from one plate on paper
49.7 x 46.5 cm
purchased 1977 77.234

Jessie Traill was arguably the finest etcher working in Australia during the first half of the 20th century. A student of the Scottish artist John Mather, who had settled in Melbourne in 1878, she later travelled to England where she worked with the painter–etcher Frank Brangwyn, from whom she learned to work boldly and on a large scale.

In the 1920s and 1930s, at a time when women producing prints in Australia were expected to practise such 'friendly little crafts' as the woodcut and linocut,[66] Traill created large and technically demanding etchings, often with added aquatint to give tonal richness.

Good night in the gully where the white gums grow, produced in Melbourne in 1922, is one of her most beautiful prints. Large in scale and subtle in texture, the print, with its depiction of thin sinuous tree trunks and silhouettes against a distant sky, is turn of the century Art Nouveau in style. However, the composition, with the young gum trees beginning and ending outside the picture frame, is a daring innovation and foreshadows Fred Williams's classic vision of the Australian bush.

Traill was a friend of Tom Roberts and later took over his Melbourne studio, but was also a friend of a younger generation: it was Traill who taught Arthur Boyd the rudiments of etching.

Roger Butler

John Peter Russell 1858–1930

Flame tree, Sydney Harbour in the background 1921
watercolour over pencil on paper 25.0 x 31.0 cm
purchased 1976 76.471

In 1921, John Peter Russell returned to Sydney after 40 years in Europe and produced many vibrant watercolours, such as *Flame tree, Sydney Harbour in the background*. He painted in bold fauvist colours of contrasting orange-reds and lime greens, the bright intense colours that were made possible by using pure pigments. He painted with rapid gestures that derive from Impressionism, but with an energetic, 'unruly', vigorous approach that veers towards Expressionism. In these works he found his own voice.

In Europe, Russell had known and worked with artists such as Matisse, Monet and van Gogh. He had shared van Gogh's enthusiasm for the primacy of colour, and encouraged Matisse's delight in bold hues. However, when Russell returned to Australia, the country was hostile to European art and to returning expatriates. Reactionary critics and artists wanted to restrain Modernism in Australia, and referred to it as 'ugly forms ... presented in an ugly way'.[67] Within this environment, Russell's brightly coloured images stood out as innovative. Although there were numerous artists who worked in a modernist fashion in Sydney at this time, such as Roy de Maistre, Margaret Preston, Thea Proctor and Roland Wakelin, they were more interested in a formalist modernism than the impressionist–expressionist approach Russell adopted. Proctor, who was Russell's cousin, made efforts to promote his art but could not get others to appreciate its remarkable vitality and freedom as it was too radical for Australia at this time. He had to wait until the 1970s for his achievements to be reviewed and appreciated; when research and publishing on Australian artists was revitalised, when there was a renewed interest in art on paper, and when contemporary artists were painting in strong colour and using bold gestures.

Anne Gray

George Lambert 1873–1930

The squatter's daughter 1923–24
oil on canvas 61.4 x 90.2 cm
purchased with generous assistance of James Fairfax, AO, and Philip Bacon, AM 1991 91.537

When the 'Squatter's Daughter' was first shown, to the best of my knowledge, only three Australian artists proclaimed its originality and truth. Such a break with suave sentiment and surface drawing met with a protective opposition – here was almost an attack upon established income. It was pronounced hard, untrue, unsympathetic. To-day we know this landscape to possess the largest local truth, supreme draughtsmanship and design, and to exhale the very spirit of Australia.
Lionel Lindsay[68]

The squatter's daughter created a stir in Australia when it was first exhibited in 1924, because Lambert created a new way of looking at the Australian landscape. He assimilated the blue and gold palette that Streeton had used to convey the heat and glare of the Australian scene, but he moved from an intuitive response to the landscape to a more formalist approach. He simplified the triangular mass of the hill and sharpened its outline and counterbalanced this with the strong verticals of the trees and the horizontal streak of green grass in the lower centre. Lambert painted with tight controlled brush strokes, so that the image seems still, but lifelike, with the trees and grass delineated by a sharp, scintillating light.

Our interest in stories encourages us to look at the painting as if it were an image of a particular person in a specific place at a certain time. We note that the girl, Gwendolyn (Dee) Ryrie in white shirt and jodhpurs, is leading her horse (which Lambert had given her) across the family property at Michelago,

sometime during Christmas and New Year 1923–24. Lambert had met Dee's father, Major General Sir Granville Ryrie, in 1918 while serving as an official war artist in Palestine during the First World War. Following his return to Australia in 1921, he became a regular visitor to the Ryrie property on the outskirts of Canberra.

Lambert had gloried in painting the Palestine landscape as part of his war work, and he returned to Australia with the aim of painting images that would be 'for all times a record of bush life by one who really knows'.[69] In *The squatter's daughter* he created a 20th-century image of squattocracy, of success, of a woman in command of her terrain (as opposed to the masculine labour portrayed by Frederick McCubbin and Tom Roberts at the end of the 19th century). This woman does not need to work the land, but visits it for her health and recreation. In the 1920s, the politics and economy of Australia were strongly based on life outside the cities; political power was in the hands of the Nationalist Party and the newly formed, basically conservative, Country Party, and half the national income was derived from pastoral and agricultural production. The pastoralists were successful, their yields profitable and their relationship with the land more detached than that of earlier pioneers.

In viewing the painting in this way, as illustrating an episode in the artist's life or as social history painting, however, we ignore what was new about it and why it created a revolution in Australian landscape painting. There is another way of looking at this work: as a formalist composition of triangle, verticals and horizontal. Lambert wanted to paint the structure of the landscape in its essential shapes and advised young landscape painters that there was always perfect design in nature and that they should reduce it to definite forms. He attacked the intuitive approach to landscape. In response, critics such as Howard Ashton maintained that Lambert's work was decorative and lacked emotion; but this was his aim – he intentionally created a stylised, formalist view.

A contemporary critic commented: 'The Lambert landscape, "The Squatter's Daughter", will be of unique interest … as representing a direct break with the Streeton convention … It has the clarity of outline and the vivid color contrasts of his portraits and the girl in the foreground is true to the Lambert type'.[70] As a result of his formalist approach in *The squatter's daughter* and his denunciation of the sentimental Australian landscape, Lambert inspired other artists to make changes in their work. Hans Heysen and others came to believe that they should now explore organic form, seek greater simplicity and use sharper contours; *The squatter's daughter* became a model to follow.

Anne Gray

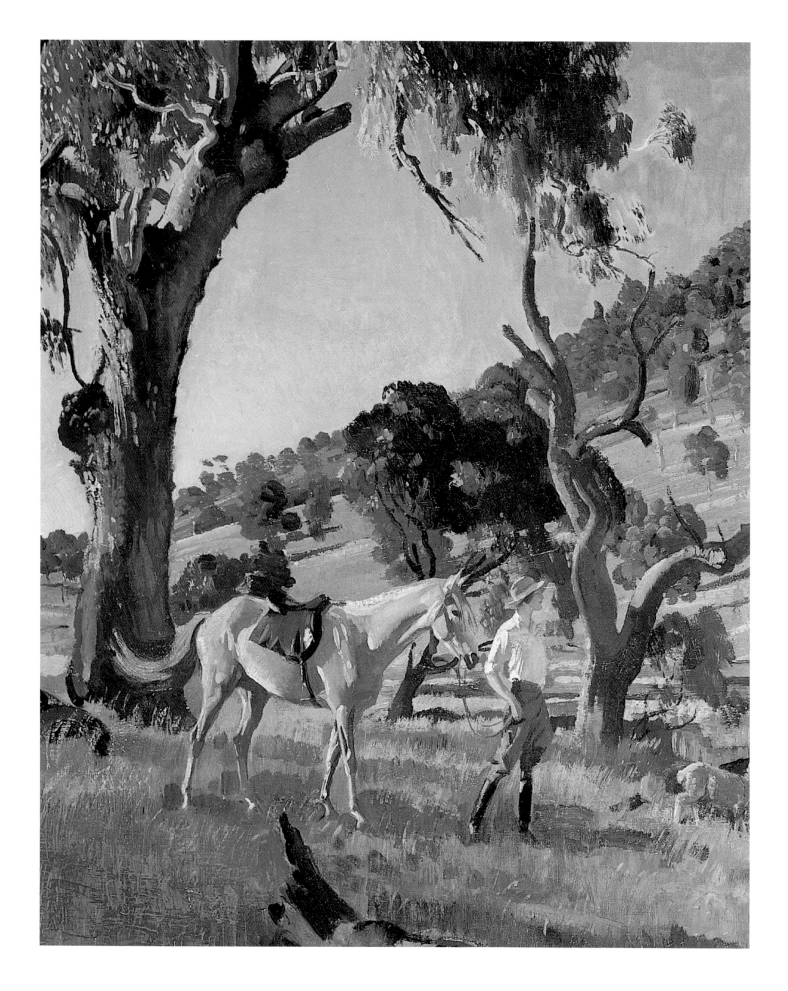

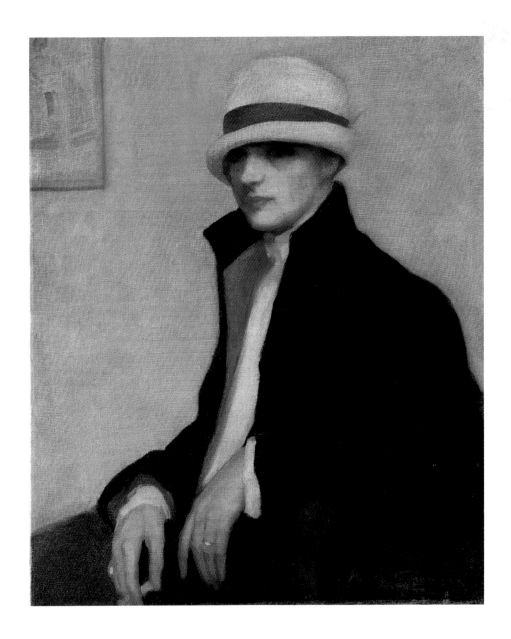

Agnes Goodsir 1864–1939

The Parisienne c.1924
oil on canvas 61.0 x 50.1 cm
purchased 1993 93.5

The Parisienne is one of several major portraits of the 'modern woman' that Agnes Goodsir painted in Paris during the mid-1920s. Dressed in masculine attire with a cigarette in hand, the sitter personifies the type of woman found in the cafés of the Montparnasse district, where Goodsir had her studio. The androgynous appearance of the sitter is accentuated by her short modern hairstyle, loose but elegant clothing and elongated fingers.

Like the woman portrayed in this portrait, Goodsir lived her own life outside the confines of traditional roles assigned to bourgeois women. She left Australia in 1900 and established herself as a professional artist in London and Paris, exhibiting throughout Europe in the 1920s. Goodsir led an unconventional personal life through her close long-term relationship with her studio model and companion, 'Cherry' (Mrs Rachel Dunn).

As in Goodsir's other portraits of Cherry, this is an intimate character study which challenges perceptions and gender stereotypes. The flat and uncompromising background, stark tonal contrasts and boldness of the composition emphasise the modernity of the subject. Yet, by casting the face in shadow as if to conceal the sitter's identity, the artist also created a sense of ambiguity. Capturing the spirit of the times, this portrait is a poignant example of the way in which modern women artists called into question, and indeed provided alternatives to, conventional female identities.

Jacqui Strecker

Bessie Davidson 1879–1965

Madame Le Roy assise de dos dans un intérieur (*Madame Le Roy seated in an interior*) c.1920
oil over charcoal on cardboard 72.8 x 60.0 cm
purchased 2000 2000.230

Bessie Davidson, born in Adelaide in 1879, was active in Parisian artistic circles, and exhibited frequently and to considerable acclaim throughout the 1920s and 1930s. *Madame Le Roy assise de dos dans un intérieur* (*Madame Le Roy seated in an interior*) was painted in Paris, probably around 1920. It is a closely and affectionately observed domestic scene, which portrays Davidson's friend Marguerite Le Roy, reading in Davidson's Montparnasse apartment. Evoking a mood of feminine domesticity and quiet solitude, it belongs to the distinctively French genre of *portraits intérieurs*, most famously expressed in the work of

Bonnard, and also popular with other Australian expatriates in Paris such as Rupert Bunny. Painted loosely using a characteristic post-impressionist palette of tertiary colours, the work is filled with a soft light which enters through the window. Davidson has allowed the warm tones of the unprimed cardboard on which it is painted to remain visible, also the charcoal underdrawing.

In 1904, in the company of her friend and former teacher Margaret Preston, Davidson left Australia for the first time. After a brief period of study in Munich, the two women moved to Paris where Davidson enrolled at the Académie de la Grande Chaumière. In 1907, Davidson and Preston returned to Adelaide where they again shared a studio and exhibited together. In 1910, Davidson returned to Paris alone and, apart from two short visits to Australia, was to live in France for the remainder of her life.

Elena Taylor

139

Margaret Preston 1875–1963

Flapper 1925
oil on canvas 77.3 x 58.5 cm
purchased with the assistance of the Cooma–Monaro Snowy River
Fund 1988 88.326

Although the predominant subject in Margaret Preston's oeuvre
was still life, in paintings such as *Flapper* she proved herself to be
a competent portrait painter. The sitter for this work was her
maid, Myra Warrell.

The 'flapper' was a mass media creation of the 1920s – a
bohemian woman with cropped hair, who wore short skirts,
smoked cigarettes, drank cocktails and frequented late-night
parties. The image of a flapper was identifiably part of the
modern world, a colourful figure in art and film of the period.
Roger Butler has noted, however, that Preston's young sitter is
'only partly successful in meeting her role as flapper':

The wool of her dress is too thick and the detachable collar
and cuff and knitted stockings are too practical to be stylish.
The *Flapper* shows the artist's sophistication set against the
young girl's attempt at sophistication – and this is what makes
the artist's title so appropriate.[71]

Indeed, what makes the *Flapper* so striking is Preston's insight
into the desire of the demure young girl to adopt a more
daring persona, and her own daring approach to painting in the
paring away of extraneous detail through the application of bold,
flat areas of colour. In the mid-1920s, Preston was also working
on woodcuts which similarly employed simplified compositions
bounded by broad areas of untextured colour – an approach
inspired in part by Japanese prints, which had been a springboard
for many innovative artists since the late 19th century. Preston's
work conveys an openness to new possibilities, to a spirit of
invention, as the key to the future.

Deborah Hart

Thea Proctor 1879-1966

The swing 1926

watercolour on silk 32.8 x 30.8 cm

purchased 1973 73.317 © Thea Waddell

Stunting (The aeroplane) c.1918

lithograph, printed in black ink, from one stone on tan paper

40.4 x 35.8 cm

purchased through the Rudy Komon Fund 1982 82.1

© Thea Waddell

Like the women in her images, Thea Proctor followed two somewhat contradictory paths: that of advancing the cause of the modern woman and that of escape into an imaginary life. She was tall, stately, dignified and exquisitely groomed – a model of style and stylishness who lived her life as artistically as her art. She knew about the latest fashions, but preferred to design her own idiosyncratic clothes that expressed her individual style. Nonetheless, she promoted contemporary art and championed modern interior design, clothes and motor cars. She made a concerted effort to expand the aesthetic awareness of the Australian public, by promoting art as having an integral place in, and positive influence on, modern life.

In *The swing*, Proctor looked back to the past, depicting women and children wearing 19th-century clothes in a land where the sun shines, the grass is always green and it is possible to play all day – a universe free from the financial pressures or social inequalities of the real world. Proctor painted this decorative watercolour on silk, a medium she took up in response to Charles Conder's exquisite drawings on silk. She also produced this image as a brightly coloured woodcut, one of a number that she made in Australia during the 1920s depicting people from past times engaged in leisure activities. They were escapist images, made for a society moving towards the Depression.

By contrast, in the earlier print, *Stunting (The aeroplane)*, one of several lithographs Proctor produced in London in 1910–20, she portrayed women with slim boyish figures dressed in fashionable pyjama-suits and modish dresses, paying homage to modern machines, the aeroplane and the searchlight. They are women of the world, aware of the latest advances.

Anne Gray

Adrian Feint 1894–1971

The collector 1926

etching, printed in black ink, from one plate on cream paper

25.0 x 26.6 cm

purchased 1980 80.904

reproduced courtesy of the estate of the late Adrian Feint

Will Dyson 1880–1938

Our ultra moderns: "Sometimes I feel like chucking it all in and going in for art!" c.1929

etching, printed in black ink, from one plate on paper 30.0 x 25.1 cm

purchased 1977 77.456

These two prints convey two different views of art and the art market and the attitude of artists towards them: one is a celebration of works of art and the other is a satirical look at the latest artistic fashion.

Adrian Feint, a painter, printmaker, commercial artist and, for a time, gallery director, was a popular tastemaker. His work was always stylish, whether he was depicting fashionable goods in bright art deco rhythms for illustrations in *The Home* magazine, or the *ex libris* plates he produced for royalty and wealthy collectors. His etching *The collector*, possibly a self-portrait, shows a connoisseur surrounded by his prize possessions. In frock coat and top hat, with cane in hand, he examines a priceless treasure while in the foreground a table is massed with what he has selected as representing the good things in life. The fine working of the plate with exuberant decorative details intensifies the overall feeling of luxury and opulence.

Will Dyson, brother-in-law of Norman and Lionel Lindsay, spent much of his life in England where his cartoons for the *Daily Herald* were acclaimed for their biting sarcasm. In the lithographs which were commissioned by the Australian government during the First World War, Dyson did not glorify battle but revealed the human tragedy resulting from conflict. Dyson returned to Australia in 1925 and, in the next five years before his return to England, produced a series of prints criticising social injustices and prejudices. In his drypoint *Our ultra moderns: "Sometimes I feel like chucking it all in and going in for art!"*, he attacked artists who felt they had to respond to the current artistic fashion, in this case distorted figurative painting.

Roger Butler

Mashman Brothers established 1885
George Day 1884–1966

Jardinière 1923
salt glazed stoneware 118.0 x 43.5 x 39.5 cm
purchased 1981 81.2466
© George Day estate, Kenneth Day

Signed by George Day, the head potter at Mashman Brothers in the 1920s, this impressive jardinière, in five sections, is reputedly one of a pair thought to have flanked the steps to the verandah of the potter's Federation-style villa in a Sydney suburb.

The blue and brown colouring of the jardinière emulates the stoneware produced in the late 19th century by the English firm Doulton and Co., where the Mashman brothers (Henry, William and John) had trained. The decoration on the neck of the vase, the imprint of real leaves, is also in imitation of 'Natural Foliage Ware' pottery produced by Doulton and Co. This ware derived its name from the technique of decoration which involved pressing real leaves into wet clay to obtain an imprint of their shape, which was later coloured and glazed to suggest natural autumnal tonings. In the 1890s, the Mashman Brothers pottery produced a range of wares imitating 'Natural Foliage Ware'.

On George Day's jardinière, the sprays of imprinted gum leaves are joined by sprays of modelled gum leaves around the bowl of the vase. His enthusiasm for Australian motifs is further demonstrated by the addition of exaggerated lugs formed by fully three-dimensional models of a possum and a koala. This whimsical expression of an Australian style rests on a neoclassical base, the style of which is more reminiscent of an object made in cast-iron than clay.

William and Henry Mashman arrived in Sydney in 1883 and were joined by their brother John in 1886; by the 1890s Mashman Brothers was producing a range of domestic wares, including vases and jardinières. In 1886, George Day arrived in Australia and studied art and ceramic modelling under Alexander Murray at the Sydney Technical College. George Day's working life was spent with Mashman Brothers where he specialised in modelling and mould making.

John McPhee[72]

Grace Cossington Smith 1892–1984

Eastern Road Turramurra c.1926

watercolour over pencil on paperboard 40.6 x 33.0 cm

bequest of Mervyn Horton 1984 84.263

Grace Cossington Smith was above all a painter of landscapes and later, of interiors. In the 1920s, when she painted her pellucid watercolour of the Eastern Road, she sought to invest her landscape painting with clarity of light and compositional vitality. This watercolour was developed from a detailed pencil sketch (to be found in one of the sketchbooks in the National Gallery of Australia's collection) in which she worked out the composition in great detail. She wrote notes to herself in the margins of the drawing; '1. direction/2. contour … simple masses conforming to whole' – reminders of the formal ideas she wanted to underpin the final composition.[73] In the upper part of the drawing she sketched clouds; by the time she came to the watercolour she enlivened the sky with radiating arcs of pure colour.

Compared with her output of oil paintings, Grace Cossington Smith's watercolours constitute a small part of her total number of works. Yet she brought to the medium the same qualities she sought in her oils. She wanted a fresh, unworried approach. This approach was even more essential in transparent watercolour than in oils. The preliminary drawing in pencil allowed her to achieve a direct attack.

The subject of this work, the Eastern Road, was very near Cossington Smith's family home in Kuring-gai Avenue in the Sydney suburb of Turramurra. The semi-rural landscape (now a leafy suburban one) was the source of most of the artist's landscape subjects in the 1920s. Although she was also interested in the urban landscape at this time (made dynamic by the construction of the Sydney Harbour Bridge), her own local landscape was full of engaging drama. Many years after she completed her watercolour, she told Daniel Thomas she had been pleased that, as she sat making her drawing of the Eastern Road, a figure came onto the road, animating the composition. Also, a traction engine came rumbling up the hill, the driver bringing it as close to the artist as he could: 'I looked up' she remembered, 'he was *grinning* … I suppose I might have been run over'.[74]

Andrew Sayers

James W.R. Linton 1869–1947

Falls Road, late evening 1926
watercolour over pencil on paper 54.4 x 75.4 cm
purchased 1980 80.3788

Casket c.1935
brass with cloisonné enamel panels 10.0 x 14.6 x 9.9 cm
purchased 1981 81.365

James W.R. Linton studied painting and architecture in London before coming to Western Australia in 1896, where he taught at the Perth Technical School and his own art school. As a watercolourist, Linton was principally interested in depicting nature defined by light. From the 1920s, he painted many landscapes of his property at Parkerville, such as *Falls Road, late evening*, in which he often dramatically divided the composition into light and shade, and used colour contrasts of rust against green. He applied the colour in small dabs over a densely worked surface, creating a scene radiant with light.

Linton returned to London in 1907 to study the techniques of metalwork, jewellery and enamelling, returning to Perth in 1908 highly skilled in these crafts. He became the city's most prominent practitioner and teacher of the decorative arts, establishing a style that would be carried on by his son, Jamie Linton, and other collaborators and family members through the 20th century. Linton's training and work was in the style of the British Arts and Crafts movement, popular from the 1870s to the 1910s. Its tenets of simplicity, practicality and the clear expression of materials and process gave him a way to express his adopted Western Australian environment. He used its native woods, such as jarrah, for carved furniture, and silver for objects, jewellery and cutlery with designs based on the forms of Western Australian wildflowers. This casket from the 1930s, featuring a stylised cloisonné enamel ibis, shows how Linton's arts and crafts aesthetic began to incorporate elements of that period's modern, geometric art deco style.

Robert Bell and Anne Gray

Adelaide Perry 1891–1973

The Bridge, October 1929 1930

linocut, printed in black ink, from one block on thin cream paper

32.8 x 44.5 cm

gift of John Brackenreg 1978 78.1097

Linocut printing became popular among Sydney women artists between the wars through the example and teaching of Adelaide Perry, Margaret Preston and Thea Proctor. Prices were low and they promoted these frequently bright and cheerful prints as the perfect form of decoration for a modern home.

Adelaide Perry is known particularly for her contribution to Australian printmaking from the late 1920s. Like many Australian artists in the 1920s, she made the pilgrimage to Europe to learn more about Modernism. She studied at the Royal Academy School in London from 1922–25 and returned to Sydney a few years before the building of the Sydney Harbour Bridge began. It captured the imagination of Sydney-siders and, both throughout its construction and in its final form, was the inspiration for artists like Grace Cossington Smith, Dorrit Black, Roland Wakelin and Robert Emerson-Curtis.

In *The Bridge, October 1929*, Perry has viewed the construction site from across the bay. The formation of the arch in its early stages, with crane aloft, is almost incidental to the intense foliage in the foreground. Stylised trees, that clearly show Perry's allegiance to English printmakers and painters, inhabit more than half the picture. Beyond, we glimpse the daily life of the harbour, the distant suburbs and the ferries and other boats traversing the bay. Small peaks in the water and the tilting of the trees suggest perhaps a gentle breeze. The arcs that define the tree tops on the right-hand side mirror the absent arch of the Bridge, which was slowly built over the next two years.

Helen Maxwell

Dorrit Black 1891–1951

Music 1927–28

linocut, printed in colour, from five blocks on thin cream oriental laid
paper 24.0 x 21.4 cm

purchased 1976 76.1220

Eveline Syme 1888–1961

Skating 1929

linocut, printed in colour, from two blocks on paper 12.2 x 15.3 cm

purchased 1979 79.904

Both Dorrit Black and Eveline Syme studied in London at the
Grosvenor School of Modern Art under the tuition of Claude
Flight, and there began to produce the linocuts for which they
are best known. They learned from Flight to depict their subjects
within geometrical patterns of opposing rhythms, using
harmonious colour schemes.

Linocuts allowed Black to explore abstraction and to see form
in a new way. By eliminating detail and emphasising the
important parts of the subject, she was able more effectively to
communicate a sensation. The formal elements in *Music* have
been pared down. Four figures dance wildly to the music of the
piano player seated in the upper left-hand corner. All the figures
are printed in ochre and details of clothing and facial features are
absent. The movement is emphasised by the limited palette of
four clear colours within dark outlines and the curved lines
crisscrossing the background plane from either side. Black
wanted us to experience the exhilaration of her dancers as they
abandoned themselves to the music. Her inspiration for the
linocut came from a concert which she attended at the Dominion
Arts Club in London. It reflects the influence of Flight and also
makes reference to Matisse's *Dance* of 1910. *Music* may also be
read as an expression of the artist's intense joy at the beginning
of her journey into a world of new and exhilarating ideas that
were to shape her development as a modern artist.

As Stephen Coppel has observed, in Syme's *Skating*, made
soon after she had enrolled in Flight's linocut class, 'the
geometrical construction of the composition is conceived as a
system of rhythmic lines and intersecting arcs'.[75]

Helen Maxwell

Stella Bowen 1893–1947

La terrasse (The terrace) c.1931
oil on canvas 74.5 x 54.5 cm
gift of Oliver Postgate 2001 2001.134

La terrasse (The terrace) was painted at Villa Paul, Cap Brun in the south of France. It is a painting of Stella Bowen's personal world at the time. Bowen and her daughter Julia sought refuge in this villa, picturesque but without amenities, to escape the financial difficulties they were experiencing in Paris. Bowen's original intention was to take Julia to her old attic studio at Toulon but the English writer Ford Madox Ford, who had been Bowen's partner for nine years until 1928, suggested that Bowen take their daughter to the villa he was vacating for the winter. Julia continued to remain the link between them despite the end of their relationship.

In *La terrasse* Bowen used a sombre palette, one she reverted to after her break-up with Ford. The paint surface is broad and loose, probably painted very quickly. One of her favourite motifs was a glimpse of interiors, with windows looking out into the garden. The interior here is drab, reflecting the condition of the premises. In her autobiography *Drawn from Life*, Bowen described the villa: 'when we arrived in October the weather broke, and we had to live indoors. Here cobwebs hung in black festoons, and broken windows admitted rushing draughts, and the three of the five electric lights were out of action'.[76] It also matched her mood, which was compounded by her continuing struggle to survive in Paris, as both single parent and artist, while the economic situation for foreigners worsened. It became increasingly difficult for Bowen to obtain portrait commissions, her main source of income at the time.

In the painting, the foot of the sleigh bed indicates that this could be a bedroom, possibly Bowen's. The view through the window is wintry. The gnarled tree with its broken branches seems to be a symbol for the end of their relationship. Yet despite the desolation she felt, Bowen loved the south of France, particularly the relaxed lifestyle, friendships, food and conversation; it imbued her with a new lease of life when all else was gloom.

Lola Wilkins

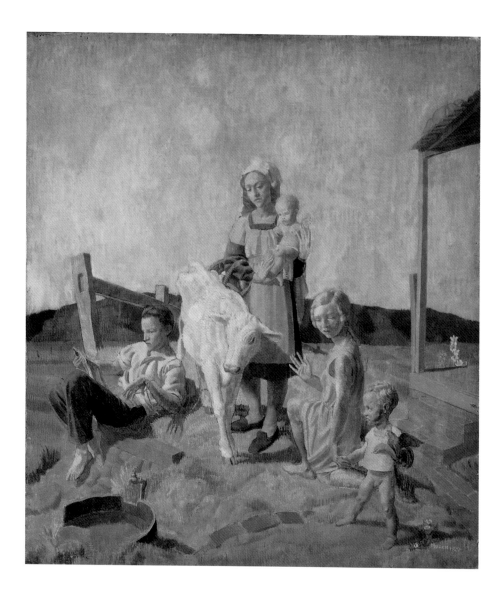

Arthur Murch 1902–89

The calf 1929

egg tempera on canvas on board 51.0 x 45.4 cm

purchased 1986 86.1387

© Arthur Murch, 1929. Licensed by VISCOPY, 2002

During the 1920s and 1930s, a number of Australian artists such as Arthur Murch, Rayner Hoff, Dorothy Thornhill and Napier Waller wanted to link their art with European tradition, and to celebrate the healthy body and idyllic Australian way of life.

Murch's style was built upon his early academic training and the influence of the old master and modern artists, whose work he had seen when touring through Europe from 1925–27 as a beneficiary of the Society of Artists Travelling Scholarship. On returning to Australia, he assisted George Lambert with sculptural commissions and worked to resolve and refine his own painting style. *The calf* was painted during this period and in it Murch clearly exploited some of the compositional devices utilised by artists of the Renaissance. He used the fence and verandah to distort perspective, both flattening and tilting the picture plane. This positions the figures as separate studies within a triangular composition, with the 'Madonna and child' at the apex. The frozen gestures and mannered poses of the figures in *The calf* are visual references to the religious works of masters of 13th-century Italy. Far from being a divine figure, however, this modern Australian Madonna is bound to the earth by her sturdy legs and the basket of produce on her arm. The children and the calf, hen and flowers are included not as religious but as secular symbols in a modern allegory of a youthful, plentiful nation.

Lee Kinsella

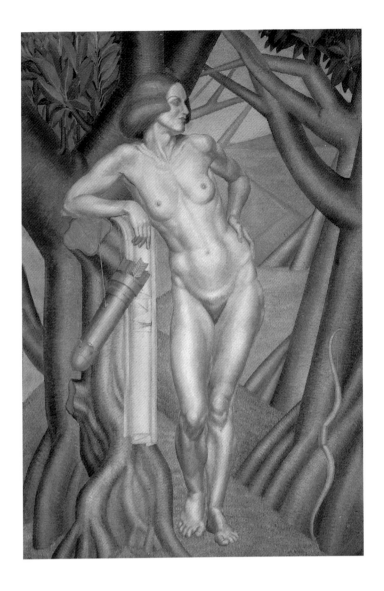

Dorothy Thornhill 1910–87

Resting Diana 1931
oil on canvas 76.5 x 51.5 cm
purchased 1977 77.640

Painted by Dorothy Thornhill when she was 21 and still a student, *Resting Diana* is one of the most extraordinary female nudes of the inter-war period. Stylistically, the work owes much to Art Deco in its volumetric modelling of form with smooth surfaces and sharp outlines, as well as in its classical subject.

However, what is truly startling about this work is Thornhill's depiction of Diana (in Roman mythology the virgin goddess of the hunt), for her lean, muscular and powerful physique has no precursor in the tradition of the female nude in Australia. Her stance and studied air of nonchalance are not poses derived from classical references, but instead seem to come from the glamour photography of the period. Similarly, Diana's fashionably bobbed hair and finely drawn eyebrows indicate that this is an image of

the type of 'modern woman' of the inter-war period, who was increasingly asserting her independence and rights. In contrast with the physical strength and self-assuredness of Diana, the clearly phallic and downward-pointing quiver of arrows hanging from a severed branch suggests the triumph of the female in this particular encounter between the sexes.

Thornhill was born in England in 1910, and emigrated with her family to New Zealand where she studied at the Elam School of Art in Auckland. In 1929, she moved to Sydney to study at the East Sydney Technical College. At that time Rayner Hoff was an influential teacher at the school and a leading proponent of the art deco style in his sculptural work. In 1934, Thornhill was appointed drawing teacher at East Sydney Technical College, a position she held for nearly 40 years, and where she was considered an inspirational teacher of life drawing.

Elena Taylor

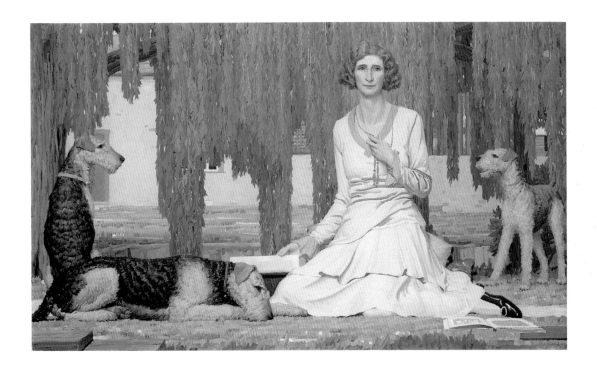

Napier Waller 1893–1972

Christian Waller with Baldur, Undine and Siren at Fairy Hills 1932
oil and tempera on canvas mounted on composition board
121.5 x 205.5 cm
purchased 1984 84.845

The man in black 1925
linocut, printed in colour, from multiple blocks on cream parchment
paper 30.7 x 17.6 cm
purchased 1975 75.98

Napier Waller painted this portrait of his artist wife, Christian,
with her Airedale dogs in 1932. She sits on the grass in front of
their recently completed arts and crafts style home, situated on the
banks of the Merri Creek at Fairy Hills, a picturesque enclave in
suburban Melbourne. The painting, almost of mural proportions,
was the centrepiece of their dining room, hanging over the
massive fireplace – it was also visible from the minstrels' gallery.

The early 1920s and 1930s were years of professional acclaim
for both husband and wife. Napier had become a successful
mural and mosaic artist and printmaker. In his linocut self-
portrait *The man in black*, he posed himself in front of his
commissioned mural for the State Library of Victoria. Christian
published her book *The Great Breath: A book of seven designs* in
1932, containing a series of linocuts that received an enthusiastic
response, and in 1929–30 they travelled together to England and
Europe to study stained-glass design and production.

The portrait of Christian should have been a joyous
celebration of the Wallers's working partnership but instead
defined the moment of their emotional estrangement. The frieze-
like formality of the painting and its cool crisp colours
underscore the demise of their marriage. While Napier became a
man of the world, Christian retreated into an esoteric religion.

Appropriately, for an artist steeped in symbolism, Waller used
the decorative form of branches of elongated leaves of the willow
tree (long associated with sadness and isolation) to frame the
elements of his composition.

Roger Butler

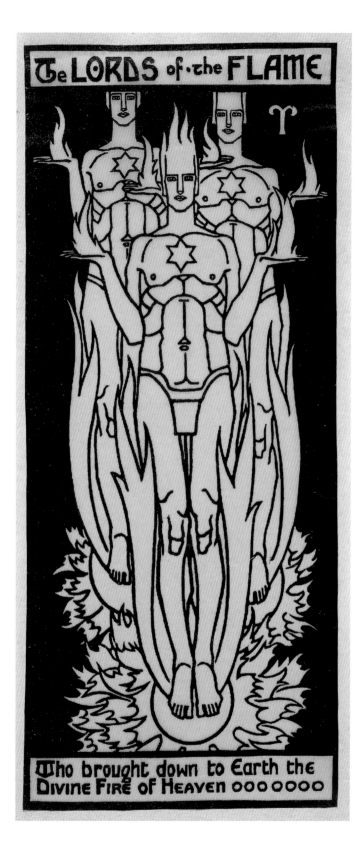

The Lords of the Flame

Who brought down to Earth the Divine Fire of Heaven oooooooo

Christian Waller 1894–1954

The Lords of the flame 1932
from her *The Great Breath: A book of seven designs*
Melbourne: The Golden Arrow Press, 1932
linocut, printed in black ink, from one block on white wove
translucent paper, tipped onto thick cream wove paper 31.8 x 13.5 cm
purchased 1976 76.722.23.6

Christian Waller's intensely creative energy and superb mastery of the printed medium suffuses *The Lords of the flame*. It is the third in a sequence of seven images from the illustrated book, *The Great Breath*, widely acknowledged as Waller's finest work and the most stunning example of art deco books produced in Australia. Waller's interest in theosophy and the divine inspired her conception and depiction of the seven steps of spiritual evolution and development.

Waller also drew upon the experience of her travels in Europe in 1929–30 where her inspiration came from ancient Greek and Egyptian imagery, the new art deco style and her study of stained glass, on which she solely focused her later career. *The Lords of the flame* is imbued with Waller's own system of esoteric code, astrological references and numerological interpretation. It displays identifiable symbols, such as the astrological sign for Aries in the top right corner and the six-pointed stars of the theosophists, yet also conceals many complex symbols only accessible to the initiated. Its mystic quality is further enhanced by the luminosity of black ink on translucent paper.

The sleek, vertical black-and-white composition of Waller's work characterises the art deco style. Elongated sinuous flames emphasise the descent of the Lords through a dark void, as they levitate on flaming discs like a divine vision. These formidable figures are both compelling and inspirational. They have a god-like presence, proudly delivering divine flames to earth and, with it, their message of spiritual evolution.

Emma Fowler-Thomason

Rayner Hoff 1894–1937

Theseus c.1932

carved sandstone, cast bronze, patinated 84.5 x 20.0 x 24.7 cm

purchased 1985 85.1886.A-B

One of Australia's most important sculptors of the inter-war period, Rayner Hoff was also one of the most influential teachers of his time. During the 14 years that he worked in Australia until his sudden early death in 1937, Hoff's ideas injected a new vitality into the languishing Sydney sculpture scene. At the same time, the artist developed a distinctive style of his own. Abundant in pagan imagery and in references to classical Greek ideas, this style was equally relevant to the Australian inter-war context, appealing to nationalist sentiment and concentrating on the vitality and potential of the human body.

A neoclassical expression of the heroic warrior, *Theseus* represents the Greek hero whose best-known achievement was the slaying of the Minotaur. Hoff made the figure of Theseus from a block of sandstone. The carving is minimal and stylised. Very little of the stone was removed, and the result is an image of strength and control, whose severity is exaggerated by the bronze helmet. In its austere simplicity, *Theseus* conveys a sense of virility, restrained passion, determination and courage – the archetypal virtues of the classical warrior.

Hoff produced many individual works during the 1920s and 1930s and also designed sculptures for a number of public monuments. He worked closely with architects on these public commissions, the most important of which was the *Anzac Memorial* in Hyde Park, Sydney 1931–34.

Helen Maxwell[77]

John Kauffmann 1864–1942

Jungle c.1933
gelatin silver photograph 30.5 x 22.8 cm
purchased 1980 80.3868

In the early 1930s, the elderly Melbourne art photographer John
Kauffmann produced a large number of luminous flower studies.
These showed not only the influence of 1920s and 1930s
Modernism in their abstract formal beauty but also that of the
older soft-focus style of pictorialist art photography. *Jungle* was
the title Kauffmann gave to this close-up study of light striking
the woody stems of a rosebush. He was making a little joke,
but also a serious point about the power of the camera to
transform reality.

Born in Adelaide in 1864, Kauffmann became an enthusiastic
practitioner of the impressionistic style of art photography,
known later as Pictorialism, after he travelled to Europe in the
1880s. His artistic career in Australia began on his return to
Adelaide in 1897. Over the next three decades, Kauffmann
actively exhibited his work and undertook various professional
assignments for magazines. He specialised in architectural,
landscape and still-life work.

In 1933, critic Ambrose Pratt wrote in the November issue
of the journal *Manuscripts* that Kauffmann would be most
remembered for his flower studies. By the time he died in 1942,
Kauffmann's work was seen as old fashioned and he felt
forgotten and unappreciated. The critic, however, was correct
and Kauffmann's floral studies are considered by some to be
his lasting legacy.

Gael Newton

Clarice Beckett 1887–1935

Sandringham beach c.1933
oil on canvas 55.6 x 50.8 cm
purchased 1971 71.192

Frederick McCubbin tutored Clarice Beckett at the National
Gallery School in Melbourne in 1914. Like many students seeking
a more contemporary path, she later chose to study with
Max Meldrum; from him she absorbed and adapted components
of his theory of art as optical illusion based on tonal harmony.
Seldom signing or dating her works, Beckett sold few paintings
during her lifetime and, as with many female artists, her work
was treated with critical disdain by her male counterparts.

Brought up in a family that enjoyed a cultured and comfortable
lifestyle, Beckett, as the dutiful unmarried daughter, was unable
to concentrate solely on her painting but was obliged to care
for her aging parents. She had no dedicated studio and, in the
early mornings or late evenings, wheeled her easel, brushes and
canvases in a small cart around the shoreline or cliffs near her
home in Beaumaris. It was this passion for realism – painting
outdoors – that, in 1935, contributed to her death from
pneumonia after being soaked in a rainstorm while painting near
her home.

Her evocative subject matter includes foggy suburban
streetscapes that are either punctuated by the verticals of electric
light poles or pierced by acid yellow headlights, and smoky
sunsets that glow with reflections into the bay.

Sandringham beach is one of the artist's later works where she
used a stronger palette to define the structural elements of
bathing boxes, bathers, horses and riders, shadows, ocean and
vegetation shimmering and dissolving in the sunlight. In this
painting, she seemed to move away from the impressionistic
realism of the earlier works to experiment with elements of
Modernism, by reducing the scene to its basic forms.

Susan Herbert

Sam Atyeo 1910–90

Organised line to yellow c.1933

oil on canvas 68.0 x 54.2 cm

purchased 1970 70.99

Imitating nature on a canvas is to put painting on a very low level. Interpreting nature is only slightly higher. It is extraordinary that up till now there have never been anything but paintings of the image of nature (with some possible rare exceptions). There must be a profound reason, but it escapes me, why man finds it necessary to embellish everything with his own image, or all that which surrounds him visually. It is all the more curious that his music is very rarely anything but abstract and, when it isn't, it is rightly judged bad. How deeply this sentiment runs can be seen by the following story: recently an old lady asked me to paint a picture of the mountains outside her home. I suggested she cut a window in the wall so as she could see these mountains and of course it would be much cheaper. She said I was being flippant ...

If one is to reject nature painting, what then is to take its place? I will try and explain what painting should first become, if it is to become a creative art. All pictures must have a start somewhere, so we'll start with a square or rectangular canvas. Now within the outside dimensions of the canvas we design and paint coloured shapes, surrounded by other coloured shapes. The various combinations are limitless. These shapes could be loose freehand ones or tight geometric ones (geometry is human). All shapes should have some relationship with the outside edge of the canvas.

Finally, I should like to restate what I think is the single biggest obstacle in the way of painting becoming an art today and that is the conviction of everybody that painting is an imitation of nature and a handmaiden of literature, with warts or without warts, according to the school one follows.

Sam Atyeo, 1983[78]

Gert Sellheim 1901–70

Australia surf club c.1936

lithograph, printed in colour, from multiple plates on paper

98.6 x 60.9 cm

purchased 1989 89.1626

© Nik Sellheim, courtesy of Josef Lebovic Gallery

Gert Sellheim was born of German parents in Estonia. Initially trained as an architect, he was in the first exodus of émigrés from Europe in the 1920s who anticipated German repression.

In 1930, Sellheim moved to Melbourne where he set up his own architectural practice and also began designing and exhibiting posters. It was not until the 1930s that commercial art became recognised in Australia as a profession. Sellheim produced many commercial designs, most memorably the QANTAS flying kangaroo. Increasingly, Sellheim's work became more closely associated with the Australian tourist industry, with his most distinctive posters, which were widely distributed overseas, being produced for the Australian National Travel Association. Tailored for an international market, Sellheim's images display the archetypes of Australian beach culture with catch phrases like 'Sunshine and Surf' and 'Surf Club'.

From 1902, beach swimming and surfing had become a popular recreational and sporting pastime – part of the Australian way of life. As surf bathing grew rapidly in popularity, its dangers also became apparent, and this in turn spawned the surf lifesaving movement that this poster promotes.

Sellheim was considered to be one of the most innovative poster designers and *Australia surf club* is typical of his cutting-edge design; he employed a strongly diagonal composition with dynamic repeated elements of lifesavers participating in a routine reel-and-line rescue exercise. Surf, sun and sand are strikingly captured by Sellheim with his use of flat areas of colour – the sea blue of the stylised foaming waves, the deep sandy yellow and ochre of bronzed suntans, with minimal black accents and the white of the paper.

Jude Savage

Lloyd Rees 1895–1988

Rock formation, Waverton 1934
pencil on paper 21.6 x 27.6 cm
purchased 1977 77.713.15
© Lloyd Rees, 1934. Licensed by VISCOPY, 2002

In the early 1930s, Lloyd Rees all but abandoned painting for drawing and created a place for himself as one of Australia's finest draughtsmen. A newfound understanding of the importance of paper type and surface, pencil grade and technique was crucial in liberating his approach and it enlightened his appreciation of the power of the line.

Rees became fascinated with light and with analysing the complexities of form in the landscape. He believed that line could 'suggest the essential character of objects, more so than most renderings of light and shade'. He recalled this period:

The full measure of my highly detailed drawings of Sydney Harbour were done at McMahon's Point. It was drawing purely for the sake of drawing … [it] was simply an obsession and I was completely absorbed in the discovery of form and composition. The drawings were by no means naturalistic in the sense of simply selecting a subject and drawing it, for there were things brought in and things left out. They were highly worked and I had an intense interest in the manipulation of them. I drew in the morning and then took the work home and looked at in the afternoon and if I saw anything superfluous, I rubbed it out.[79]

Rees felt that by working closely with nature, he and the landscape would eventually become one. At times this obsession with analysing and detailing every form and facet of nature created an underlying psychological impact. While Rees paid homage to the landscape in this drawing, the shadows became dark and foreboding in this precisely composed environment.

Anne McDonald

Elioth Gruner 1882–1939

Murrumbidgee Ranges, Canberra 1934
oil on canvas 51.6 x 89.0 cm
bequest of Stuart A. Johnston 1964 64.75

Art dealer and artist John Brackenreg, who lived with Elioth Gruner in the 1930s, said *Murrumbidgee Ranges, Canberra* was painted on the road leading down to the Cotter River and depicted a scene of bucolic grandeur:

> This [painting] was painted entirely plein air ... [Gruner] always painted with sun full on his canvas ... If he couldn't finish in one go he'd paint in adjoining details in light tone so that when he went back it was all in tone. He found one of [the] most useful designs in landscapes was smoke.[80]

There is little evidence of man included in the painting save for glimpses of the road and sheep grazing. Two thin columns of smoke in the background hint at bushfires, but any sense of drama or narrative remains sublimated by the expanse of countryside surrounding it. Gruner was meticulous in the application of his characteristically dryish paint with which he endeavoured to achieve an evenness of surface, using typical cool pastel tones of blues and greens and simplifying the natural forms to their essential shapes.

Born in New Zealand to Norwegian and Irish parents, Gruner came to Australia in 1883. He showed precocious artistic talent, becoming Julian Ashton's pupil at the age of 12. Awarded the 1934 Wynne Prize by the Art Gallery of New South Wales in Sydney, *Murrumbidgee Ranges, Canberra* was painted during the last decade of Gruner's life, when he suffered from depression. He found respite by escaping Sydney in his beloved car to roam the countryside, painting landscapes and staying with friends on their properties – he particularly responded to the quality of light found in the Murrumbidgee district.

Belinda Cotton

Kenneth Macqueen 1897–1960

Cloud shadows c.1935

watercolour on paper 39.5 x 49.3 cm

purchased 1976 76.1140 © The Macqueen family

Kenneth Macqueen shared his time between watercolour painting and farming. From 1922, he farmed a property near Millmerran on Queensland's Darling Downs and it was this landscape which provided the subjects for the majority of his watercolours. The rural landscape of undulating hills, wooded with occasional copses of trees, inspired the artist to make works in which shape and structure played a dominant role. 'Design in landscape interests me tremendously', he wrote, and described his creative process as originating in his response to the 'shape of a tree, hill or cloud'.[81]

Macqueen painted his watercolours in the studio, finding that to have the subject before him caused his 'original conception to be lost in a maze of unnecessary detail'.[82] He carefully drew the composition in pencil before filling the shapes with transparent washes of colour. The flat areas of colour and sweeping rhythms of his work immediately impressed his contemporaries as embodying the 'new vision' which looked for 'simplification and reduction to essentials' in landscape.[83]

Andrew Sayers

James Cant 1911–82

Objects in a landscape 1936
oil on canvas 121.8 x 96.5 cm
purchased 1995 95.1011

After briefly attending several art schools in Sydney, James Cant went to London in 1934, where he stayed until the onset of war six years later. In 1935, the expatriate Australian painter Roy de Maistre introduced him to art dealer Fred Mayor, whose gallery showed works by such avant-garde artists as Ernst, Miró and Picasso. Cant was powerfully influenced by Surrealism, which came to prominence in British art circles with the great *International Surrealist Exhibition* in London in 1936, the year Cant joined the British Surrealist Group. The artists tried to delve into their subconscious minds, using odd juxtapositions and 'automatic' creative processes.

The kinetic elements, setting and style of *Objects in a landscape* demonstrate Cant's debt to the radical art of the day, and that of Miró in particular. The tethered balloon is a reference to Miró, as are the use of flat areas of colour and defined forms scattered over a schematised landscape. Cant's choice of colours reinforces the strangeness of the subject: acid pinks are contained within dark grey and black confines, against a background of lavender greys. The objects and shadows are anchored by a rich dark brown earth, which adds to the atmosphere of brooding desolation.

The forms derived from dry bone and driftwood, the spliced string anchoring a lifebuoy shape and the concept of the image as a series of objects conforming to the laws of gravity and balance, indicate the influence of pure British Surrealism.[84]

Objects in a landscape is a theatrical work, a stage where human and natural detritus play out their own drama of connection and disconnection.

Christine Dixon

Harold Cazneaux 1878–1953

Untitled (B.H.P plant, Newcastle) c.1935
gelatin silver photograph 18.3 x 30.3 cm
purchased 1982 82.1209

As a photographer, Harold Cazneaux was highly versatile, an essential attribute if one were to make a living as a professional in the early 20th century. A consummate portraitist and a fine landscape photographer, he also made artful studies of modern industrial scenes such as construction sites and factories. However, such subjects were rare in his oeuvre, confined to the mid-1930s when the Australian company, Broken Hill Proprietary (BHP), commissioned him to photograph their steel works at Newcastle in New South Wales. This photograph was probably taken at that time.

A commanding image, it is testament to Cazneaux's exceptional compositional abilities. Never predisposed to spontaneity, he chose a vantage point that enabled him to exercise full control over what he saw. He was especially attentive to the relationship between diverse formal elements, for example, focusing on the different shapes and forms of the buildings, pylons and power lines, rather than their industrial function.

Cazneaux's photograph is highly reminiscent of a drawing or a print, in its use of line as a formal accent and in the rich array of tones. Such associations are significant: he was very familiar with the traditions of western art and, as a Pictorialist, was committed to emulating them in his photographs.

What is most curious about the image is that, despite its contemporary subject matter and the fact that it was taken during a period of rapid modernisation, it looks remarkably old fashioned. Dominated by the monolithic industrial structures, the photograph is more evocative of the 'dark satanic mills'[85] of the 19th century than modern industry. Were it not for the smudge of smoke at the rear of the composition, one could believe momentarily that this is an abandoned site, a ruin rather than an exemplar of modern industry.

Helen Ennis

Ethel Spowers 1890–1947

The works, Yallourn 1933

linocut, printed in colour, from seven blocks on buff oriental
laid tissue paper 15.7 x 34.8 cm
purchased 1976 76.136

Frank Hinder 1906–92

Excavation for Wynyard 1935

conté crayon on paper on cardboard 51.6 x 38.2 cm
purchased 1981 81.1370

Travel overseas and two quite distinct experiences of cubist and
futurist art impacted enormously on the modernist style of Frank
Hinder and Ethel Spowers. For Spowers, it was the teachings of
Claude Flight at London's Grosvenor School that most influenced
her development. Working mostly as a printmaker, Spowers
found her own sources of inspiration in Australia and saw the
Yallourn coal mines in Victoria as a potent symbol of the new
machine age. In this boldly modernist linocut, with its patterns of
flat colour, Spowers created a composition with a slow and
powerful rhythm. This she enhanced with a repetition of
sweeping curves – grey clouds streak through the sky and endless
processions of rail trucks haul coal from the mine. Power poles in
a row stand as sentinels of the new modern age. They are
balanced by the struts and curve of the bridge and, behind them,
the bold diagonal forms of towering buildings. In shadow in the
foreground are the remnants of a bygone era – two men collecting
coal by hand with a horse and cart.

Hinder lived in America during the vibrant modernist period
of the late 1920s when construction and design were dominant.
Attracted by the dynamism and geometric linear patterning of
futurist art, he found particular inspiration in Joseph Stella's
iconic Brooklyn Bridge paintings. On his return to Australia,
Hinder created precisely structured semi-abstract compositions of
the modern city of Sydney. This construction site in *Excavation for
Wynyard* bustles with energy and vigorous movement. Cranes
reach upwards, rows of trucks and tall buildings intersect to
create complex patterns which overshadow the central rhythmic
curve of the Sydney Harbour Bridge.

Anne McDonald

Sargison's manufacturer established 1928
Harold Sargison designer 1886–1983

Silver necklace c.1935

silver, coral 42.5 cm length

purchased 1988 88.1411

Harold Sargison began his career as a jeweller and silversmith in 1902 and worked in Hobart until retiring in 1981. The firm of Sargison's, like its counterparts such as Linton's in Perth, was noted for its consistency of design and high quality of craftsmanship.

Sargison's made this modest silver and coral necklace from nine pieces of sterling silver wire, hammered flat at the ends and bent into mask-like shapes soldered together. Each element had a cabochon (dome) of coral set at the juncture of the hammered ends. Finally, small silver rings linked the units together, creating a light and flexible chain.

The design for the necklace had two main influences: the Arts and Crafts movement and Art Nouveau. The Arts and Crafts movement began in Britain in the latter part of the 19th century and similar ideas flourished in Australia at the turn of the century, when Sargison was beginning his apprenticeship. Here the arts and crafts tenets of 'truth to materials' and retaining evidence of handcrafted manufacture are evident.

The design also refers to Art Nouveau, a late 19th and early 20th-century movement characterised in France by sinuous, fluid line and luxurious materials. In Britain, Art Nouveau linearity was more restrained, an attitude reflected in this necklace. But it was also a contemporary 1930s piece, and one can easily imagine it worn with a smart dress of that time.

Eugenie Keefer Bell

Douglas Annand 1903–76

Lady with feather in hat 1935

cover design for *The Home*, vol.16, no.4, April 1935

collage of steel, feathers and black paper on fabric mounted on card

34.3 x 32.4 cm

purchased 1989 89.11.256

In 1935, Sydney Ure Smith commissioned Douglas Annand to design a cover for the April issue of his magazine *The Home*. It was the premier women's magazine published in Australia between the wars, when the growing consumer market focused on women in an increasingly fashion-conscious society. Annand played a significant role at this time, joining Adrian Feint, Thea Proctor and Hera Roberts in producing cover designs in a period when commercial art replaced illustration as a mode of employment for artists. These artists transformed the image of Australian women, from maternal figures to sophisticated symbols of modern Australian society.

This cover portrays in profile the head of an elegant, fashion-conscious young woman, perhaps an allusion to the line drawings of Picasso and Toulouse-Lautrec. Her image is represented in outline only, in wire on a background of red velvet. An elegant hat, adorned with a large feather, partly hides her hair and face. Annand portrayed her hair as thins curls of wire and, ever the purist, signed his name in the same medium. He used unexpected textural contrasts to advantage, with the flowing linear outline in wire – used completely out of context – indicating the strength of this thoroughly modern woman. The plush red velvet, with its implication of refinement, suggests dignity and grace.

The female form Annand chose for his first cover of *The Home* was simple and sophisticated and typified the restraint of 1930s fashion. For this, and the majority of his cover designs, Annand continued his experiments with collage. He created images which rendered perfectly the shapes and textures of his carefully chosen materials.

Anne McDonald

Anne Dangar 1885–1951

Jug c.1937
glazed earthenware 23.5 x 13.7 x 14.5 cm
gift of Grace Crowley 1979 79.1307

Travel overseas and study with cubist painter, Albert Gleizes in his artists' colony Moly-Sabata in France, was the creative and spiritual inspiration for Anne Dangar. She was attracted by Gleizes's theories on employing shifting planes and circular rhythm in art to explore the spiritual and symbolic values of life. Upon his invitation, Dangar left Australia in 1930 and settled in central France permanently.

Life on Gleizes's artists' commune was not easy, however, and she had to toil in the garden to eke out a meagre existence. To help improve her income, Dangar learned traditional folk pottery at nearby villages. She became immersed in the fundamental styles and shapes that had for centuries characterised the region's potteries.

This domestic *Jug*, in local terracotta, follows a traditional tapered cylinder form. Dangar believed the potter's craft had an elemental spiritual quality. This belief partly sprang from the fact that throwing on the wheel created its own rhythmic motion. It seemed a natural progression that the rhythmic designs she had embraced from Gleizes should then be translated onto pottery. In this example, non-objective decoration in warm brown and creamy yellow was applied over the jug's black slip ground.

This work was given to the National Gallery of Australia by Grace Crowley, who first introduced Dangar to Gleizes, and who remained her lifelong friend and correspondent.

Robert Reason

Roy de Maistre 1894–1968

Arrested phrase from Haydn Trio in orange-red minor
conceived 1919 painted 1935
oil on paperboard 72.2 x 98.5 cm
purchased 1972 72.354

Colour is … the very song of life … the spiritual speech of every living thing. *Roy de Maistre*[86]

Roy de Maistre conveyed the sounds he heard – the counterpoint and melody – in this rhythmic abstract arrangement of shapes, forms and colours. In the reds, greens, purples, yellows, blues and greys, he expressed his innermost response to a dynamic Haydn trio. He did not want to paint a picture of things, but sought instead to portray a pure realm, a spiritual plane beyond words and everyday imagery.

Throughout his life, de Maistre arranged colour as an expression of emotion. In 1913, aged 19, he studied the violin and viola at the New South Wales Conservatorium and painting with Dattilo Rubbo. In 1917, following a brief period in the AIF, serving on the home front, he became interested in the relation of colour to mental health and its use in the treatment of shell-shocked soldiers by decorating their rooms in soothing colours. In 1919, influenced by recent American books, de Maistre and fellow artist, Roland Wakelin, exhibited their first 'colour music' paintings. In these images, the artists translated the local landscape into patterns of strong forms and vivid colour. They believed that the seven colours of the spectrum corresponded to the seven notes of the octave and that compositions could be developed visually as well as through sound.

After 1919, de Maistre and Wakelin abandoned 'colour music' and abstraction and turned to painting representational images. In the 1930s, however, while living in Britain, de Maistre briefly renewed his interest in 'colour music', and painted a number of abstracts, including *Arrested phrase from Haydn Trio in orange-red minor*.

De Maistre's interests were a reflection of his time: his belief in the spiritual qualities of colour had parallels with the ideas of theosophist artists Kandinsky and Mondrian, and his interest in creating visual equivalents of music was shared by European artists like Robert Delaunay and Frantisek Kupka and the Australians Sam Atyeo and Ludwig Hirschfeld Mack.

Anne Gray

John Castle-Harris 1893–1967

working as Castle Harris

Fish c.1935

glazed earthenware 23.6 x 21.9 x 25.8 cm

purchased 1981 81.1443

The tradition of ceramics decorated with reptiles, particularly frogs, lizards and snakes, is an ancient one. The greatest exponent of pottery decorated in this manner was Bernard Palissy who, in 16th-century France, decorated his work with fish, frogs, snakes, lizards, shells and foliage cast from life and coloured as naturalistically as possible, with lead glazes in ochres, browns, blues and greens. The ware met with such success that Palissy was copied by his successors and numerous imitators. In Great Britain in the 1880s and 1890s, there was a revival of Palissy-style ceramics and majolica glazes, partly as a response to the influence of Liberty's, the fashionable store, and the popularity of Asian art.

In Australia, the fashion for the romantic imagery of the Arts and Crafts movement continued into the 1930s. Plaques, masks, pot-pourri containers, candle-jars and ornaments, as well as more useful objects such as plates and vases, were often decorated with mythical creatures, mermaids and dragons being the most popular. Potters such as John Castle-Harris, Allan Lowe, Marguerite Mahood and Klytie Pate all made pots employing these motifs.

Castle-Harris is best known for his bowls and vases elaborately decorated with dragons and lizards. *Fish*, a table ornament meant to be viewed in the round, is an outstanding example of Castle-Harris's skill as a potter. Vigorously modelled and brilliantly coloured, it possesses a vitality rare in Australian ceramics. The colours are those of Italian majolica, and its leaping, gasping fish has a realism that reminds one both of Palissy and the carp of Asian culture where they are symbolic of good fortune and prosperity.

Castle-Harris studied pottery in Melbourne with Una Deerbon in the 1930s and established his studio at Lawson in the Blue Mountains, New South Wales, where he worked until his death.

John McPhee[87]

Mary Cockburn Mercer 1882–1963

Tahitian lily 1938
watercolour on card 28.0 x 38.0 cm
purchased 2000 2000.115

Tahitian lily was painted while Mary Cockburn Mercer was living in Tahiti in 1938 and captures the essence of her bohemian, nomadic life. A seemingly fragile lily, with delicate white petals and overt spiky stamens, emerges from a strong and sturdy stem. This lush tropical flower, shimmering in the sparkling light from the open window, bends to the world outside where the ocean stretches endlessly to the horizon. On the wall is a map of Moorea, an island to the west of Tahiti.

Mercer was born into a wealthy Victorian family, giving her the freedom to live the life she desired. At the age of 17, she ran away from school in London to Paris, to live in the artists' community of Montparnasse, mixing with artists such as Chagall and Picasso and later working as a studio assistant to André Lhôte. In the 1920s, she lived in Cassis with American artist Alexander Robinson and later moved to Capri to mingle with the fashionable lesbian set. Here she fell in love with a German photographer and travelled with him to Spain, but was forced to escape by ship during the rising unrest of the Spanish Civil War and ended up halfway across the world in Tahiti.

By 1938, Mercer had made her way back to Australia. She studied with George Bell, exhibited with the Contemporary Art Society and gave classes to artists (including Lina Bryans and Colin McCahon) in her studio apartment in Bourke Street, Melbourne. Mercer returned to France in 1952, where she remained until the end of her life.

Anne McDonald

Nora Heysen b.1911

London breakfast 1935
oil on canvas 47.0 x 53.5 cm
purchased 1996 96.1046

Nora Heysen depicted her friend, Everton (Evie) Stokes in this breakfast scene, resplendent in Heysen's blue dressing gown, her foot casually balancing the slipper. The scene is peaceful, contemplative and domestic. Evie is absorbed in reading, her fingers poised on the handle of the cup. Heysen has carefully arranged the breakfast items on the tray and table. Above the bookcase, a portion of a framed painting is revealed. The light source from the left indicates a window. The simplicity of the decor enhances the formality of the composition.

This is one of a number of paintings by Adelaide-born Heysen portraying her small flat in Dukes Lane, Kensington and, like the others, it is a homage to Vermeer. What is illuminated in this painting is Heysen's arrangement of the world around her, which she did in order to create stability and a sense of control. The work was painted when Heysen's family returned to Australia and Heysen found herself alone with only her art classes providing daily human contact, until the arrival of Evie. Heysen celebrates her visit in this painting. Evie is the focus of the work but it is not a portrait, rather Heysen is exploring the arrangement of the figure with the other objects in the room and the interplay of light on all the surfaces. Here, her palette reflects sombre elements, seen in the furniture and shadows, in contrast to the lighter palette she started to adopt after her meeting with the Pissarro family. Heysen painted *London breakfast* in precise detail, although she used broad brushstrokes in some areas of the painting to enliven the surface. Heysen's interest in Vermeer extended to emulating his selection of dark wood for the frame (and like the one on the picture depicted above the bookcase).

Lola Wilkins

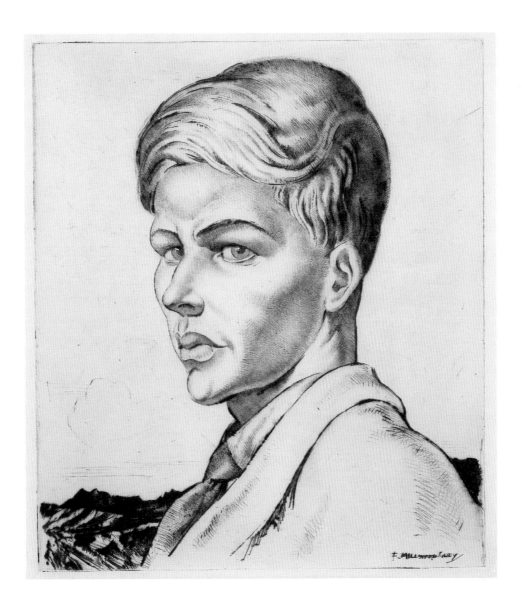

F. Millward Grey 1899–1957

Jim, an Australian boy c.1935
drypoint, printed in brown ink, from one plate on paper 21.4 x 18.8 cm
purchased 1980 80.918

Jim, an Australian boy was produced in the inter-war years by
F. Millward Grey, who had recently travelled to Adelaide from
England to take up his appointment as teacher of painting,
drawing and commercial art at the School of Fine Arts. In his
realist approach, he has much in common with that of fellow
British contemporaries such as etcher Gerald Brockhurst. His
works are dispassionate and psychologically probing studies.

The portrait of the unknown young boy is sharp and cutting,
and the technique of drypoint used by the artist is in perfect
accord with the image. It is an uneasy portrait; the boy, still
perhaps a school student, turns to face Millward Grey. His clearly
modelled facial features reveal a sensitive nature, but one that is
perhaps already sceptical of the future.

It could be that Millward Grey was reflecting his own unease
with the political situation in Europe in the 1930s. As a young
student, his life had been thrown into disarray by the First World
War, and his later prints of pilots and naval officers in uniform
have a sense of futility and heroic sadness. His move to Australia
may have been a physical escape from Europe, but its war-torn
legacy is seen in his haunting images.

Roger Butler

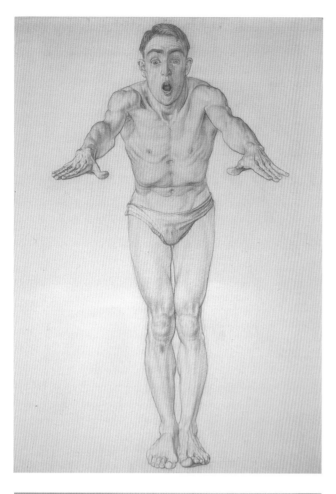

Eric Wilson 1911–46

Life drawing – self-portrait as a diver 1937
pencil on paper 76.2 x 56.0 cm
purchased 1977 77.350.2

Portrait of the artist's mother 1937
oil on canvas 95.0 x 71.6 cm
purchased 1975 75.57

Eric Wilson was a deeply religious man and a disciplined artist. His training in the realist tradition, at Julian Ashton's Sydney Art School during the 1930s, reinforced his conviction that in art truth can only be achieved by copying precisely from life.

A consummate draughtsman, Wilson never wavered in his dedication to his chosen field and lived a frugal lifestyle in order to paint and eventually fulfil a dream of studying overseas. He entered the New South Wales Travelling Scholarship three times before he eventually won, in 1937, with six precisely composed and constructed works including this drawing and painting. One is a curious self-portrait as a diver, the other a portrait of Wilson's mother. His familiarity with his subject matter allowed him to study his subjects intimately and then reproduce them in meticulous detail. Both gaze calmly and unflinchingly at the viewer, for truth is of the essence. Wilson did not clutter his portraits with background detail; all attention is focused on the subjects as they are of prime importance.

Paradoxically, it was the Travelling Scholarship, awarded for these incredibly detailed realist works, that made possible Wilson's experimentation with abstraction. In London, he studied at the Westminster School and at the London Academy under Amedée Ozenfant, who introduced him to Purism, an academised form of Cubism. With the outbreak of the Second World War, Wilson was forced to return to Australia and, over the next few years, he took up teaching positions at East Sydney Technical College, Cranbrook School and the Sydney Art School. He continued to experiment with abstraction but always maintained his dedication to realism through his sketchbooks, portraiture and landscapes. Tragically, Wilson's career was cut short by his sudden death in 1946.

Anne McDonald

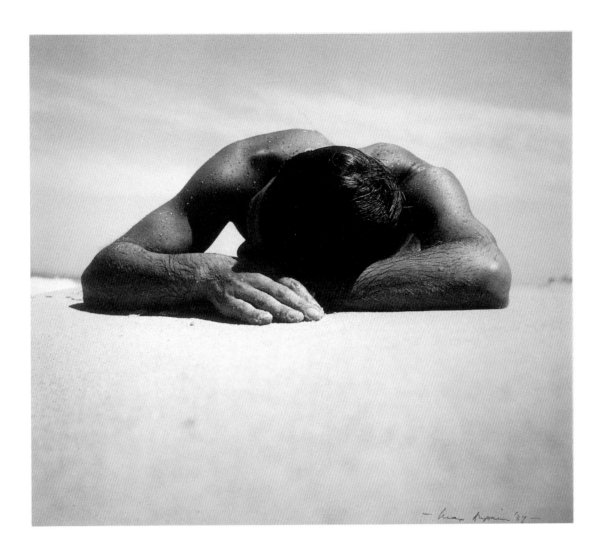

Max Dupain 1911–92

Sunbaker 1937 printed c.1980
gelatin silver photograph 37.7 x 43.2 cm
gift of the Philip Morris Arts Grant 1982 83.2209

During a camping trip with friends in bushland on the coast south of Sydney in 1937, Max Dupain made two negatives of his friend Hal Salvage after a swim: an image which he later called *Sunbaker*. The power of the image comes from being so close to the man's body, though he remains unrecognisable and unknowable. The figure could be a stand-in for Dupain himself, then a fit 26-year-old whose father ran a modern physical education gym in Sydney. Although Dupain later described the image as a virtual holiday snap, the low-angle close-up and simple geometry of the composition is classic modernist styling. It is unlike the other images of jollity around the camp and playing up for the camera which Dupain made on several trips with his friends in the late 1930s. By this time Dupain had, within a few short years of setting up his studio in Sydney, achieved a considerable profile as a modernist photographer in Australia, both for his personal exhibition work and in promotion of his commercial practice.

Dupain regarded the *Sunbaker* image as special; he published it in 1948 in a monograph described as 'my best work since 1935'.[88] On that occasion, Dupain chose the alternate *Sunbaker* negative showing Salvage with his fingers closed (it seems that negative was lost by 1948 as the book reproduction was made from a print dated 1940). Dupain is not known to have printed the surviving *Sunbaker* negative again until 1975, for a retrospective at the Australian Centre for Photography. It was not until the Australian Bicentennial celebrations in 1988 that *Sunbaker* started to acquire iconic status as an image encapsulating a way of life and values in Australia, perhaps nostalgically evoking a bygone, less complicated, era.

Gael Newton

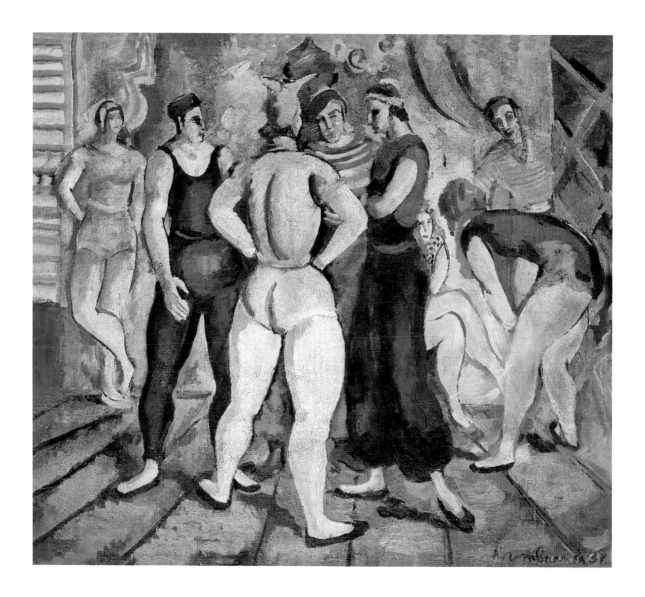

Francis Lymburner 1916–72

The dancers 1937
oil on canvas 76.6 x 86.7 cm
purchased 1976 76.739

Francis Lymburner painted *The dancers* in 1937, the year after he left Brisbane Technical College and two years before he moved to Sydney. The theatre, and in particular the ballet, held a great fascination for this artist. During the 1940s, he was considered by many to be at the forefront of developments in contemporary art in Sydney, alongside William Dobell, Russell Drysdale and Donald Friend.

The dancers shows Lymburner's interest in works from Picasso's 'rose period', using similar subject matter. Like Picasso, Lymburner was interested in performers – dancers, actors, musicians, clowns – a world away from everyday reality. As Barry Pearce said: 'He painted the world the way he wanted it to be, a romantic, fantastic counterpart to the dreary realities of existence'.[89] Lymburner depicted the dancers with warm pink and flesh tones, exaggerating their solid muscular legs with long elegant curves. He placed them in a balanced composition of wedges. The grooves of the floorboards draw the eye towards the centre of the canvas, while the arrangement of feet forms an apex pointing towards the bottom. Rather than performing, Lymburner's dancers are clustered, perhaps on a break during a rehearsal. Chatting or resting, the dancers appear to be waiting, maybe for a curtain call.

David Sequeira

Russell Drysdale 1912–81

The rabbiter and his family 1938
oil on canvas 61.5 x 76.7 cm
purchased 1980 80.1084

Russell Drysdale was a painter of people, and of their lives in small country towns and outback places. In *The rabbiter and his family* he created a tableau of modern life: a happy worker with his family grouped together in a brightly coloured field of flowers, looking directly at the viewer as in an olden-days family photograph. The man stands assertively with one finger in his belt, with his son posed in similar fashion, suggesting that he will follow in his father's footsteps. Likewise, the two small girls have hair and dresses styled after their mother's, but in recognition of their youthful freedom they, like their brother, have bare feet. In contrast to heroic 19th-century scenes of the Australian pioneer forging a new relationship with the land, this is an image of the unheroic worker, comfortable in his environment.

The rabbiter and his family is one of Drysdale's early works, painted soon after he completed his studies with George Bell. During this time, Drysdale assimilated elements of the work of other contemporary artists. He adopted aspects of the naïve-looking approach of the British artist Christopher Wood and Picasso's restrained haunting images of circus families. Drysdale also looked closely at Modigliani – simplifying the faces and elongating the figures – although Drysdale's faces have a more whimsical expression than Modigliani's melancholic ones.

With a characteristically Australian laconic manner, Drysdale recorded some of the humorous aspects of everyday life – the pompoms on the woman's slippers, and the dog scratching itself. He created an image that presents typically Australian characters and poses. They look at us with a sense of comfort and familiarity and we feel as if we know them, or people like them.

Anne Gray

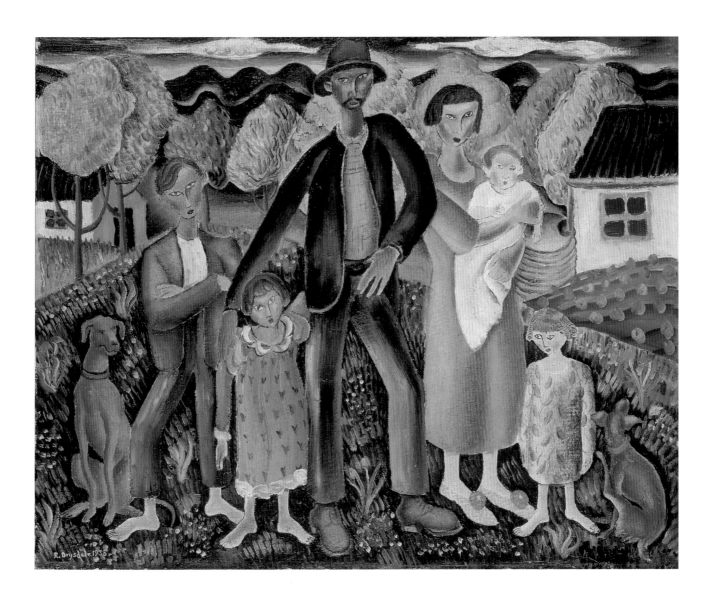

William Dobell 1899–1970

The red lady 1938
oil on canvas 77.0 x 66.2 cm
purchased 1977 77.518
© William Dobell, 1938. Licensed by VISCOPY, 2002

He sees the ordinary and paints it as though it was
extraordinary; he sees the commonplace and paints it as
though it was unique; he sees the ugly and paints it as though
it was beautiful. *James Gleeson*[90]

The red lady was painted during Dobell's last year in London
before he returned to Australia. Brian Adams records that Dobell
and Donald Friend visited the Caledonian Market, where they
bought art materials cheaply. There, they could also observe the
cockney characters including an 'enormously fat woman with a
red face who sold carpets and brass jardinières and later inspired
one of his archetypal pictures of cockneydom'.[91]

Dobell arrived in England in 1929, having been awarded the
New South Wales Society of Artists Scholarship, and spent the
next nine years living there in poverty and pursuing his passion
for painting. During this time, he explored the physicality of

painting by observing the styles and techniques of artists like
Daumier, El Greco, Goya, Hals, Rembrandt, Renoir and
Tintoretto. He was a keen observer of humanity, storing up visual
impressions which later appeared as types rather than
individuals – and often portrayed with a satirical slant.

The heavily swelling figure of *The red lady* is poured across
the canvas in swathes of flesh and fabric, creating a monumental
form. She sits complacently peering at the viewer through
wrinkled eyes. She is disquieting, both voluptuous and repulsive.
Dobell's fluid handling of paint creates texture and pattern,
whilst his colours owe much to Renoir of his later red period.
The hair is festooned over the moon-like features and tawdry
jewellery glistens on the fleshy arms and breasts.

At this time, Dobell was enjoying the financial benefits of
having worked as one of a team of artists on decorations for the
Wool Pavilion at the Glasgow Trade Fair. However, the grim
years of the Depression were leading to war and, against this
background, the devouring form of *The red lady* seems to
exemplify greed and overindulgence.

Lola Wilkins

James Gleeson b.1915

Study for 'We inhabit the corrosive littoral of habit' c.1940
pen and ink, brush and ink, with scraping out on paper 36.6 x 26.6 cm
purchased 1976 76.112.134

Those who have crossed
With direct eyes, to death's other Kingdom
Remember us – if at all – not as lost
Violent souls, but only
As the hollow men
The stuffed men.

T.S. Eliot, *The Hollow Men*, 1925

Surrealism has always been suspicious of the weight put upon
us by habits of thinking. Established patterns can restrict our
reactions to reality by predetermining our response to an event
or condition. Tradition, and habit, often stand in the way of an
instinctive and personal response. It is a corrosive factor that can
eat away and hollow out the truth of the matter.

It was in this mode of thinking – sometime late in 1939 – that I
imagined a seashore with a male head on the left and a female
torso on the right, both hollowed out and corroded by a strong
salt wind. The title *We inhabit the corrosive littoral of habit* occurred
to me almost at the same time as the image. In the final painting it
is inscribed on the lower section of the man's head.

The influence of Salvador Dali is obvious in the finished
painting. It was in 1939 that a painting by the Spanish Surrealist
first reached Australia, though another source of the initial image
could probably have come from a reading of T.S. Eliot's
The Hollow Men of 1925.

James Gleeson, 2002

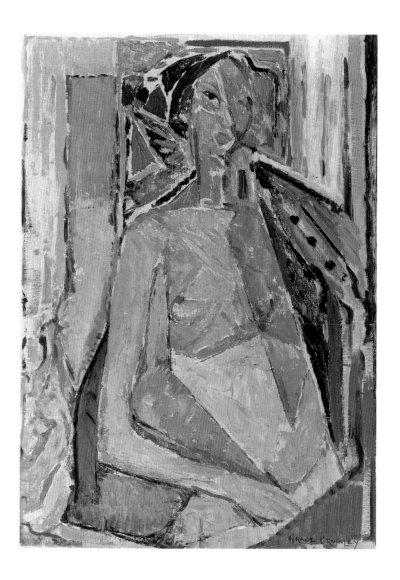

Grace Crowley 1890–1979

Woman (Annunciation) c.1939

oil on canvas mounted on composition board 73.5 x 53.0 cm

purchased 1972 72.482

Grace Crowley belongs to the generation of women artists who emerged so brilliantly in the inter-war period, having spent their formative years living overseas and returning to Australia with knowledge of recent developments in art.

Between 1926 and 1930, Grace Crowley studied in Paris with André Lhôte, an early Cubist and a well-known teacher of the time. Crowley became one of Lhôte's star pupils and absorbed his manner of reducing forms to a basic geometric vocabulary, resulting in a kind of 'academic cubism'. Returning to Sydney in 1930, Crowley opened an art school with Rah Fizelle where she taught Lhôte's methods, and also became one of the leading proponents of Modernism.

Throughout the 1930s Crowley moved further and further towards complete abstraction. In this she was strongly influenced by the theories of the French artist Albert Gleizes, transmitted to her via the letters of her close friend Anne Dangar who was living in France.

Woman (Annunciation) is one of Crowley's last figurative paintings. Clearly, her primary interest is not in the subject, but in the organisation of coloured planes into a two-dimensional composition. This aim was clearly articulated in Eleonore Lange's foreword to *Exhibition 1* where *Woman (Annunciation)* was first exhibited: 'the painter today uses a scene or a posing model only to elaborate its inherent colour-sensations into an artistic theme of colour relations; the endeavour to arrange these special values into an ordered whole is the subject of a modern picture'.[92]

Exhibition 1, a group show, was intended as the first of a series of exhibitions showcasing the geometric semi-abstraction practised by this group of artists. In fact, no further exhibitions followed and Crowley, together with Ralph Balson, soon abandoned the subject entirely and moved into complete abstraction.

Elena Taylor

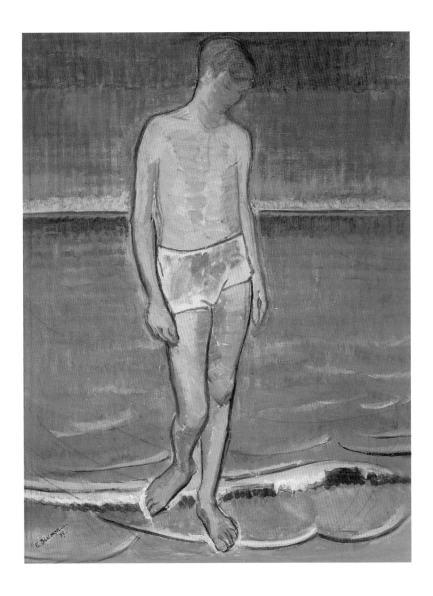

Elise Blumann 1897–1990

Charles, morning on the Swan 1939
oil and crayon on canvas 101.8 x 76.8 cm
purchased 1978 78.630

Charles, morning on the Swan is a sensual, seductive image of a young boy standing calmly at the edge of a river. Elise Blumann painted it with broad rhythmic brush strokes, using a limited palette in a restricted key. The youth is her son, Charles, and the location the foreshore near her home in Crawley, a suburb of Perth. She painted it soon after she arrived in Western Australia as a refugee from Nazi Germany with her husband, Dr Arnold Blumann, and their two sons. She was a mature woman who had studied in Germany, where she had been exposed to a range of European modernist painting.

Blumann was one of a number of artists who came to Australia in the 1930s to escape from the turmoil in Europe and Hitler's ethnic cleansing. Some, like Yosl Bergner and Sali Herman,
depicted scenes of life in the city streets that reminded them of Europe; Blumann, on the other hand, made images of her new landscape, imbuing it with emotional and spiritual significance.

In this painting, as in many others, Blumann expressed the dynamism of nature, melding the boy to his surroundings through her unifying expressive and rhythmic brushstrokes, contrasting the bold outlines of the boy's figure and of the waves breaking on the shore with the overall patterned surface of paint. She gave the figure a kinaesthetic force, making the weight and tensions of the body visible, and counterbalanced this with the repeated curves that suggest the rippling motion of the water. She wrote in her notes: 'The sensuous awareness of beauty and harmony which enters into the constitution of all living plants and bodies … is the formal foundation of all works of art'.[93]

Anne Gray

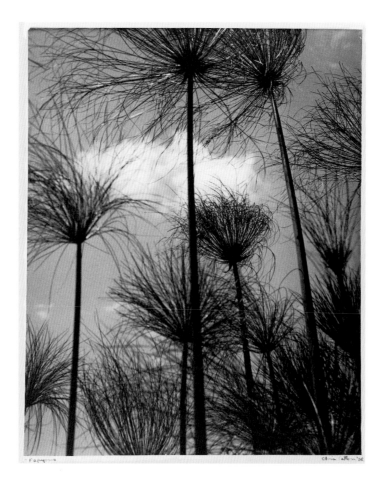

Olive Cotton b.1911

Papyrus 1938
gelatin silver photograph 36.8 x 30.0 cm
purchased 1987 87.1440

For Olive Cotton, the natural world was a lifelong source of inspiration. In the 1920s and 1930s, and again in the 1970s and 1980s, she frequently photographed natural subjects – landscapes, trees, plants and flowers. Her approach to nature, and her desire to unify her dual interests in art and science through her photographs, owed much to her family background: her father was a geologist and her mother was interested in the visual arts and music.

Cotton was captivated, not only by the beauty she found in the natural world, but also by the principles that determined its structure and organisation. Her photographic work grew out of careful and often lengthy observation. Photographing this clump of papyrus growing by a pool at the Sydney Botanic Gardens involved watching and waiting until, in her own words, 'the wind blew a white cloud into place' behind the fronds.[94]

Cotton took *Papyrus* at a time when she was revelling in her creative powers and her technical mastery of the photographic medium. This confidence shows in the selection of relatively prosaic subject matter and the audacious choice of an unusually low viewpoint. This style of modern photography was associated with the Max Dupain circle, of which she was a key member.

Cotton introduces dynamism into her composition through the use of asymmetry and an interplay between still and moving elements. Some fronds are in sharp focus, others are blurred by the wind, on what she later recalled was 'a breezy summer afternoon'.[95] This abstracted quality of the image, reinforced by the play of tones, is entirely consistent with her view of photography as 'drawing with light'.[96]

Another hallmark of Cotton's practice evident in *Papyrus* is her democratic approach to subject matter. Instead of isolating a single frond for dramatic effect, she focused on the group of fronds. This is a group with qualities particularly relevant to Cotton, one in which highly individualised elements form an irregular and vibrant whole.

In Sydney's Botanic Gardens, where other visitors may have seen only an ordinary papyrus plant, Olive Cotton saw the potential for a photograph. The result is a coherent, energetic and immensely satisfying image.

Helen Ennis

Kathleen O'Connor 1876–1968

In my studio, Paris c.1937
oil on canvas mounted on composition board 101.3 x 98.5 cm
purchased 1973 73.23

Kathleen O'Connor arrived in Paris from Australia in 1906 and soon immersed herself in the artistic and cultural life of the city. Frequenting the galleries, cafés and restaurants of Paris's Left Bank, O'Connor painted by day and took sketching classes at night. She showed her work at prominent exhibitions, but found it difficult to sell and depended upon regular payments from her family in Western Australia to sustain her.

In my studio, Paris, painted when she had been in France for almost 30 years, shows an arrangement of flowers and tea set dissolving into a jubilant shower of light and colour. Form gives way to a celebration of the tactile qualities of paint. O'Connor varied her brushstrokes and application of paint, from areas of bare, primed canvas to the layers of built-up paint of the glass

goblet. She often imbued her paintings with a personal narrative and included her favourite objects in various compositions.

O'Connor was inspired by the work of the Impressionists and Post-Impressionists but developed her own unique style, rather than trying to mimic the work of French artists. *In my studio, Paris*, consistent with O'Connor's later work, is characterised by a freer use of paint and a lighter palette than the style of flat pattern and tight composition typical of her 1920s still lifes.

While probably best known for her still-life painting and a small number of portraits, she also made many outdoor sketches of scenes from the Paris Luxembourg Gardens. She made a significant contribution to the introduction of Modernism into Western Australia through regular visits, and commentaries on art and fashion sent from France. She returned to Perth permanently in 1955, at the age of 79, where she continued her studio practice.

Lee Kinsella

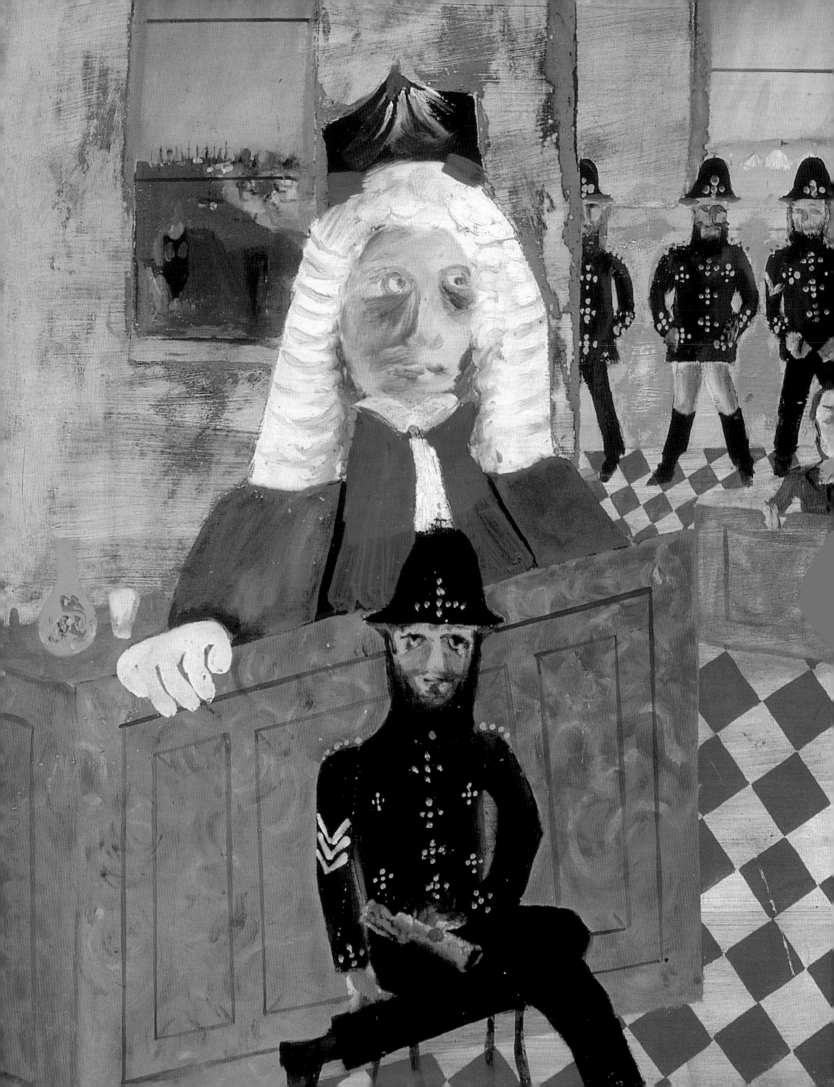

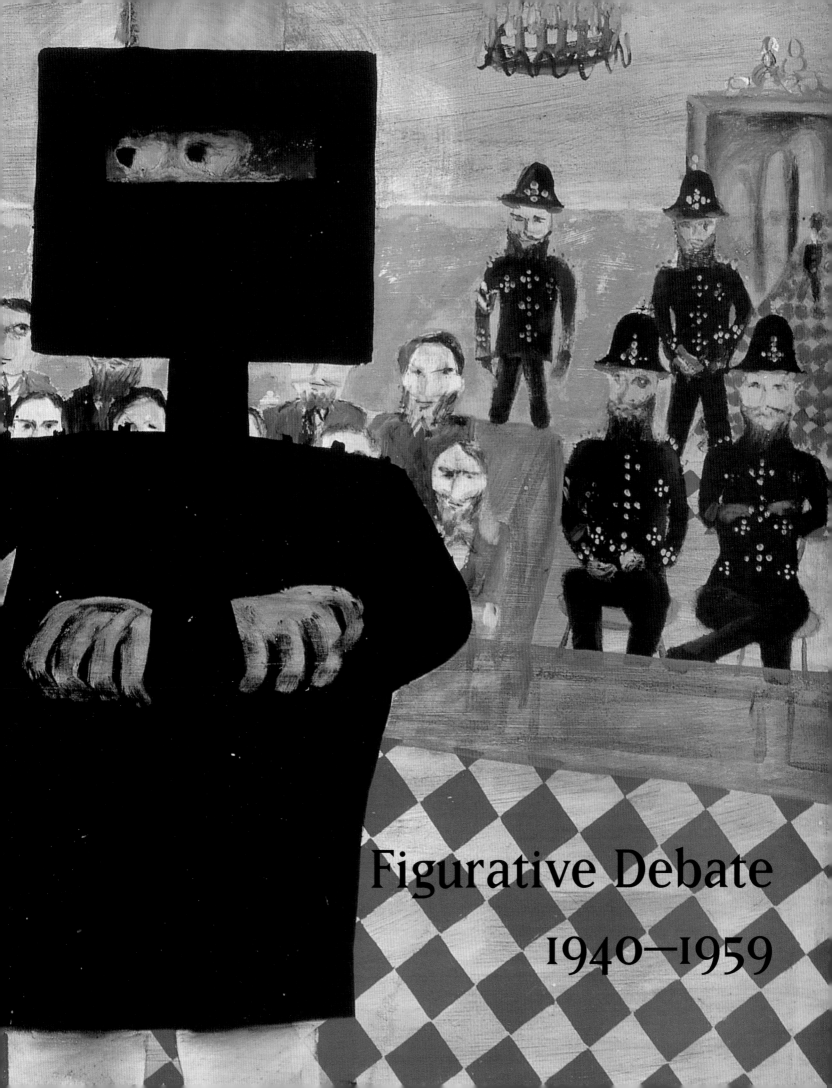

Figurative Debate

1940–1959

William Frater 1890–1974

A narrow street c.1940

oil on primed plywood 61.2 x 50.5 cm

purchased 1977 77.83

In *A narrow street*, William Frater depicted the kind of laneway that can be found in the inner suburbs of most Australian towns and cities: a back street with rickety fences, rampant creepers, ramshackle sheds and a few children playing. It has a matter-of-factness, without the kind of stories or myths found in the art of other Australian artists at this time. Unlike the social realist Yosl Bergner, Frater was not interested in showing the unhappy life of inner city dwellers and, unlike Arthur Boyd and Albert Tucker, he did not portray images of city evil. Rather, he presented a different vision of the Australian streets, and a world aloof from the war in Europe. He captured a sense of suspense in the quiet stillness of place and an atmosphere of brooding heat, with a strong glare infusing the scene.

Frater, together with Arnold Shore and George Bell, played an important role in increasing the understanding of Modernism in Melbourne between the wars. He was a prolific artist, painting exuberant images with strong underlying structures. From Cézanne and his contemporaries he inherited a concern for the picture plane: for the energetic marks of the brush on the surface of the board, for the tactile qualities of paint, for the building up of volume by planes and for the representation of space through colour.

In addition to country lanes and rural scenes, Frater painted some memorable portraits and depicted Central Australia and Indigenous people. Around 1955 he painted a 'Corroboree' series, orchestrating the figures in the landscape in the fashion of Cézanne's well-known images of bathers. His best work is emotional, based on a deep response to the world around him, mixed with an element of analysis and a feeling for paint, form, tone and colour.

Anne Gray

Arnold Shore 1897–1963

Valley (Green landscape) c.1940

oil on canvas 61.8 x 44.6 cm

purchased 1949 59.57

reproduced with permission

In *Valley (Green landscape)*, Arnold Shore juxtaposed greens against yellows, browns and greys; he painted an image that vibrates with pure colour. It is a modest subject – a mass of trees, crossing the canvas like a barrier – but Shore treated it imaginatively and created a richly textured and expressive paint surface.

Shore studied at the National Gallery School in Melbourne under Frederick McCubbin, while working as an apprentice stained-glass craftsman. He was also, for a short time, a pupil of Max Meldrum, but soon lost interest in that artist's objective approach as it went against his impulsive nature. In 1932, Shore founded a school with George Bell, where the emphasis was on a more modern approach to art. Through his teaching, as well as through his work as a guide lecturer at the National Gallery of Victoria, Melbourne, and as art critic for the *Argus* 1951–56 and the *Age* 1957–63, Shore played an important role in establishing more enlightened attitudes to contemporary art.

Shore emphasised the vitality of the things he portrayed: flowers, gardens and the bush. He depicted scenes close to his home, including many images of bush glades that share a painterly energy with those of his teacher McCubbin (in works such as *Winter sunlight* 1908) and with the 1960s landscapes of the younger Melbourne artist John Perceval. McCubbin, however, included narrative in his bush landscapes, while Perceval veered more towards the abstract, focusing on gesture and impasto. Shore, on the other hand, was motivated by the life force of the bush – the abundance and fertility of nature.

Anne Gray

Ludwig Hirschfeld Mack 1893–1965

Desolation: Internment camp, Hay, N.S.W. 1940–41
woodcut, printed in black ink, from one block on thick yellow paper
21.8 x 13.1 cm
gift of Olive Hirschfeld 1979 79.812

One of the most poignant images of Second World War Australia
is not of Australians fighting for God and Country on foreign
shores; it is rather this image of a solitary unidentified figure in
an Australian internment camp. It graphically portrays the utter
desolation and loneliness of an individual separated from loved
ones and in a vast and unfamiliar environment.

In 1936, Ludwig Hirschfeld Mack fled from Germany to
England, to escape fascism and Nazi persecution because of his
association with the teachings of modern art at the Wiemar
Bauhaus. Ironically, by 1940 British wartime security regarded
him as a threat and interned him as an 'enemy alien' before
sending him halfway round the world to Australia. From Sydney,
he travelled hundreds of kilometres by rail to an internment
camp as far removed from Europe as he could ever have
imagined. Over a two-year period he lived in camps in Hay,
Orange and Tatura.

For an Australian, to see the Southern Cross in the night sky
is to know he is home. While soldiers serving overseas may have
despairingly searched foreign skies for the comfort of this iconic
constellation, its brilliant glow in the crisp, clear sky of outback
Australia taunted Hirschfeld Mack. It would eventually, however,
become a symbol for his transition to a new world, a world that
was so vast, yet was then denied him by the confines of barbed
wire and misunderstanding. In 1942, Hirschfeld Mack was
offered an unconditional release. He lived in Melbourne until
his death in 1965.

Anne McDonald

William Dargie b.1912

Brisbane 1942
etching, printed in black ink, from one plate on paper 22.4 x 22.5 cm
purchased 1995 95.923

Yosl Bergner b.1920

Pumpkins c.1942
oil on composition board 79.0 x 96.4 cm
purchased 1970 70.100

The experience of wartime impinged on everyday life, not just on the battleground. The first American soldiers arrived in Brisbane in 1942. They were paid significantly more than their Australian counterparts, they could purchase cigarettes excise free, their uniforms were smart, and they got the attention of the taxi drivers, barmaids and the girls in general. The smouldering resentment of the Australian troops gave way to some huge street fights, most notably the so-called 'Battle of Brisbane'. These clashes between Australian and American soldiers were censored, and were certainly not suitable subjects for an Australian official war artist such as William Dargie, who was stationed in Brisbane at the time. Yet Dargie's etching, *Brisbane*, provides a graphic insight into the situation. A young, flimsily-clad girl is walking with two American soldiers. One, a stylishly dressed negro, strides ahead, while another cigarette-smoking American is at her side. Behind them, a downcast Australian soldier in his army fatigues plods along, fully aware that he is not going to feature in the action.

Yosl Bergner served in the Army Labour Corps from 1941 to 1946 and was stationed at Tocumwal, New South Wales, the Australian–American base that was to be the final command post if Australia was invaded and overrun. Yet, it was not the war in Australia or the Pacific that was the subject of his paintings during those years. Bergner's mind was filled with stories and images of the plight of Jews in Europe.

In 1934, his father travelled to Australia, searching for a new country for the Jews, free of anti-semitism and fascism; Yosl followed in 1937. In Melbourne, he became close friends with artists James Wigley, Noel Counihan, Albert Tucker, Vic O'Connor and Arthur Boyd, with whom he exhibited. *Pumpkins* is one of the many paintings Bergner produced during these years depicting life in the Jewish ghettos of Europe. Against a backdrop of tenement houses, an impoverished family drags a primitive cart filled with pumpkins to sell at a local market. It appears that the pumpkins are all that lie between them and starvation.

Bergner's quest for a home for the Jewish people was paralleled by his interest in the plight of Indigenous Australians. In 1948, Bergner left Australia and settled in Israel.

Roger Butler

Margaret Preston 1875–1963

Flying over the Shoalhaven River 1942
oil on canvas 50.6 x 50.6 cm
purchased 1973 73.21

Shoalhaven Gorge, N.S.W. 1953
stencil print, printed in colour, from one stencil on thin black card
55.4 x 46.8 cm
purchased 1983 83.1320

Margaret Preston was the leading protagonist for Modernism in Sydney between the wars. She created many still lifes that emphasised strong design and simplified forms.

In her 1942 article 'The Orientation of Art in the Post-War Pacific', Preston argued that Australian artists should draw on the art of the country's Indigenous peoples and that 'it is necessary that they should seek from other sources knowledge and inspiration for their craft, thereby combining to produce a National Australian culture'.[97] She foresaw that, at the end of the Second World War, 'Australia will find herself at a corner of a triangle; the East as represented by China, India and Japan, will be at one point, and the other will have the United States of America representing the West'.[98] It was obvious to Preston which direction Australian artists should take after the war. If an artist went to the West to study, that would be 'Post-War Art done in the easy way. The great danger is that of the artist becoming a copyist'.[99] In the post-war era, Preston hoped that Australia would be guided, not controlled, by outside influences, and believed that the East offered artists opportunities to develop mature perceptions of their own country.

In her painting of 1942, *Flying over the Shoalhaven River*, the river lazily meanders between soft hills. As with the Chinese and Indigenous Australian art that Preston admired, it was a timeless depiction of space. Ephemeral, ever-changing clouds pass between the viewer and the eternal landscape. This aerial view may have been the result of plane travel, but it is just as likely to have been inspired by her understanding of Chinese and Indigenous Australian modes of representing the landscape.

In preparing a lecture on the nature of the Australian landscape, Preston noted 'the gay setting sun or the sweet morning mists are all accidents of time … droughts are a misfortune but like the sunrise, only temporary. It is the land itself'.[100] A 17th-century Chinese painting manual describes hills and streams as embodying 'the inner law of the universe … [but warns] One cannot attend to the appearance without regard to the inner law, or attend to the substance alone without regard to the method'.[101]

Preston's stencil print, *Shoalhaven Gorge, N.S.W.* produced 11 years later in 1953 when the artist was 78 years old, is one of her most complete syntheses of Chinese and Indigenous Australian concepts, brought together to achieve what she termed a uniquely Australian national art. Preston chose the stencil process for this print, a technique which had been introduced to the West from China. It was also an ancient art practised by Indigenous Australians who used it to produce hand prints on cave walls. Similarly, the use of thick opaque browns, whites and ochres and the dotted application of the paint is inspired by Indigenous bark painting.

Human habitation has no place in this timeless depiction of the Australian landscape. The physical features of the landscape are ambiguously rendered as massed shapes which can be read as a flat plane, or a waterfall over a gigantic cliff, or a river valley. The never-ending geological forces which form the landscape – earthquakes, upheavals and slow erosion – are all acknowledged. The flat black of the cardboard, onto which the stencil has been worked, sometimes appears to define the structure of the landscape while at others it evokes the blackness of infinity, the Dreamtime, the void into which all eventually return, before being reborn.

Roger Butler

John Perceval 1923–2000

Boy with cat 2 1943
oil on composition board 59.0 x 43.8 cm
purchased 1970 70.55
reproduced courtesy of the artist's estate

John Perceval, Arthur Boyd, Joy Hester, Sidney Nolan and Albert Tucker, each in their own way created highly imaginative and expressive images in Melbourne in the 1940s. Their collaborative achievement was immense. They were supported by friends and patrons, John and Sunday Reed.

John Perceval painted Boy with cat 2 in 1943, when he was 20. It is a cry from the depths of the soul. Painting expressively and with psychological insight, the artist reflected the intense frustrations of childhood, recalling his own difficult early years. The work is also connected with the collective psyche of a generation that had grown up in the shadow of the Depression, crossing the bridge into adulthood in wartime Melbourne when discussions raged about human beings' capacity not only to destroy others but also to self-destruct in the process.

In the painting, a young blond boy is being viciously clawed by a wild cat, his own clenched hands suggesting that this creature might also be a mirror or metaphor for the torments of the inner self. The tension is emphasised by the way that the pair, locked in their terrifying embrace, is trapped in a shallow, stage-like setting – a fitting backdrop to the idea of inescapable fate. It is a potent image of deep-seated isolation, fear and repressed anger. A more specific reference may also have provided the initial springboard for the work: 'Remembering a father who is reputed to have docked cats' tails, the cat retains for the artist an awful fear that every one of the species might recall and repay'.[102]

In the context of the 1940s, there are affinities between Boy with cat 2 and the alienated, fearful figures in deserted plazas in paintings by Perceval's friend Arthur Boyd. There are further correlations with the works of the German Expressionists and films of the day. In its focus on the young boy's psyche, the painting is also a precursor for the preoccupation with childhood informing the work of many of Perceval's artist-friends in the following decade. There are, however, few images of children in the history of art that match the intensity and psychological complexity of Perceval's Boy with cat 2 and it is not surprising that this work has become widely considered an icon of 1940s Melbourne painting.

Deborah Hart

Albert Tucker 1914–1999

Victory girls 1943

oil on cardboard 64.6 x 58.7 cm

purchased 1971 71.42

© Barbara Tucker, courtesy Lauraine Diggins Fine Art

The power and the anger of Tucker's imagination in the war years is seen in *Victory girls*, painted in 1943 in Melbourne. After being conscripted into the army in April 1942, he was employed as an artist at the Heidelberg Military Hospital to illustrate the injuries of soldiers awaiting plastic surgery. Tucker left the army in October 1942, still concerned about social issues such as poverty and injustice but even less convinced that the Social Realist style adopted by Communist artists was aesthetically and intellectually satisfying. Like his avant-garde peers, Tucker was familiar with modernist European art. He was particularly struck by the savage commentary of the German artists George Grosz, Otto Dix and Max Beckmann.

In *Victory girls*, the heads of the two teenage prostitutes are reduced to schematised features: blonde hair, mascaraed eyelashes, piggy nostrils and gashes of red-lipsticked mouths. Similarly their bodies consist only of breasts and ribs, painted Picasso-style, above flaring striped skirts. The irony of the patriotic colours and American motif is glaring in this morality tale of sexual corruption and social decay.

The two soldiers are Australians rather than GI's, as their slouch hats make plain. They have become bestial rather than human; they are the embodiment of grasping lust, complicit with the sexually predatory girls. Tucker said: 'All these schoolgirls from 14 to 15 would rush home after school and ... go tarting along St Kilda Road with the GIs ... the crescent seemed to embody the virulent and primal sexuality which had been released in the blackout.'[103] Tucker's manner of painting emphasises the immediacy and passion of his response to the situation. He uses bold, broad strokes for the essential forms – the reaching arms and hands of the diggers, the simple stripes of the skirt and teeth, the violence of the red mouths.

Christine Dixon

Donald Friend 1915–89

Self-portrait 1944
pen and ink, brush and ink wash on paper 36.7 x 27.2 cm
purchased 1976 76.1131

Greek Club, Brisbane 1944
pen and ink, brush and coloured ink, wash, gouache on paper
45.0 x 61.0 cm
purchased 2001 2001.139
reproduced courtesy of the estate of Donald Friend

He looks at you out of the corner of his eyes, he smiles at you with his pursed lips, he stands there self-aware, wanting you to look at him, to like him, to admire him. He is the artist Donald Friend, and this is one of his many self-portraits, drawn during the Second World War, while he was a serving soldier. Here, Friend presents his assertive self in the foreground, with another, slightly menacing, darker figure, his alter-ego (or his lover) behind him, in the background.

The portrait is drawn with considerable freedom, with energy and assuredness, with a sense of knowing where to put the line. So, too, is his dramatic image of the *Greek Club, Brisbane*, drawn in the same year. It is one of a series of watercolour drawings Friend made while serving in Brisbane during the war. It is a bold composition, presenting three figures sprawled in front of Hellenic House with its arched veranda in the centre and part of the Greek Church on the right. It is an allegorical expression of the interminable waiting that was so much a part of every soldier's wartime experience.

In the 1940s, Donald Friend was recognised as one of the promising young Sydney artists, mentioned in reviews alongside William Dobell and Russell Drysdale. He had considerable facility with pen and ink – as a draughtsman and as a writer. In 1943 the first volume of his war diaries, *Gunner's Diary*, was published, followed by *Painter's Journal* in 1946. He lived a colourful life, spending much of it in romantic places such as Malaytown, Nigeria, Sri Lanka and Bali – as well as in the almost deserted gold-mining town, Hill End, in western New South Wales. He became known for his images of beautiful young men and for his audacious wit, but behind this more public face was a keen mind, an acute eye and a remarkable ability to draw.

Anne Gray

Noel Counihan 1913–86

The new order 1942

oil on composition board 61.7 x 80.1 cm

purchased 1971 71.200

Noel Counihan believed that art had a social mission and that it could be used as a tool to expose political corruption, the hypocrisy of the church and the inequalities in society.

When Nazi Germany invaded the Soviet Union, Counihan, together with a number of other Australian artists aligned with the communist left, created powerful images directed against these new totalitarian oppressors. *The new order* is an early oil painting – prior to that Counihan had mainly worked as a printmaker and cartoonist – which comments on the current political circumstances as well as on an artistic tradition.

The Nazi soldiers are shown from behind – faceless, as anonymous symbols of oppression. Counihan has included neither the swastika nor any other signifier of a particular regime; instead they become symbols for all military oppressors, while the victims, an elderly bearded peasant who has been shot and a decapitated woman, are symbolic of the civilian human sacrifice throughout the ages. The setting is also unspecific, perhaps a desolate hillside or the wall of some abandoned building. Counihan is drawing on a particular historical circumstance to make a comment which has a timeless and universal significance.

A formal source of inspiration for Counihan was the Spanish painter Goya's great anti-war icon *The third of May, 1808*, painted in 1814–15. Here, Goya commemorated the martyrdom of the citizens of Madrid who were executed by the Napoleonic troops occupying Spain. Counihan revisited Goya's study of that explosion of light, blood and heroism to give it a distinctly 20th-century interpretation.

Sasha Grishin

Attributed to **Pankalyirri** died c.1970

Kurajarra/Mardu people

Jijigarrgaly, spirit being of Lake Disappointment c.1943

carved and engraved mulga wood 95.5 x 23.6 x 4.0 cm

purchased 1998 98.169

Wooden sculptures depicting humans are rare in Australian desert societies. Indigenous people attach much significance to metaphysical experiences, which in many areas inspired the creation of rituals, and it was one such experience that gave rise to this work. The Mardu people of Western Australia call this kind of popular contemporary ritual *partunjarijanu* 'from the dream-spirit'.[104] Through discussing their dreams with one another, groups of Mardu would periodically compose songs, tunes and dances around a given theme, and create associated body decorations, ornaments and sacred objects, from what had been revealed to them during trips undertaken in 'dream-spirit' form.

This sculpture depicts a spirit being messenger, *Jijigarrgaly*, recognisable by the beautiful body-decorations. The engraved designs on the figure are related to rain-making, water and lightning, as well as the shimmer of light off the surfaces of bodies of water. *Jijigarrgaly* are most often encountered during dreams, in which they convey new knowledge to human society from the spiritual realm, home of the ancestral beings of 'the Dreaming'. Pankalyirri, the Mardu elder who carved this figure, came from Punkulyi (McKay Ranges), and had as his ancestral totem the Ngayunangalku beings, who in the Dreaming created their own world under the surface of Lake Disappointment, and later became cannibals. They are said to live there still, so even today Mardu avoid the salt-lake.

According to Pankalyirri, around 1940 he saw this spirit being in a dream, then made the first of a small number of wooden figures depicting the *Jijigarrgaly*, to be exhibited during performances of a dream-spirit ritual whose main theme is the Ngayunangalku and their exploits. Because he was spiritally 'descended' from these ancestral beings, Pankalyirri felt a close affinity with them and was an active composer of songs for dream-spirit rituals. Those descended from the Ngayunangalku could safely interact with the associated spirit being messengers and could enlist the help of these ancestors, for example, in healing sick people. Wally Caruana notes: 'The beak-like nose of the figure implies the profile of the butcher bird which is also associated with the attributes of health and well-being … The shape of this figure, with its flattish, slightly curved profile with accentuated nose, seems to derive from the shapes of carrying shields or even spear-throwers made in the area'.[105]

Robert Tonkinson

Ola Cohn 1892–1964

The people c.1945
carved wood, oiled and waxed 41.9 x 17.6 x 19.8 cm
purchased 1976 76.1087

I thought of sculpture as something copied from nature as well as possible in any material; but now I realise that sculpture is a very different thing from nature and should be treated as such. If one carves a figure in stone or wood, or models in clay, it should look like stone, wood or clay. It is a *symbol* of a figure, not flesh and blood and never could be.
Ola Cohn[106]

Ola Cohn's *The people* is a contemplative sculpture, a vision of peace and human strength. Like much of Cohn's work, *The people* has a tranquil and spiritual sensibility, intended by the artist to convey an 'essence of being' through sculptural form. Created around 1945, the sense of reflection and solitude that this work evokes relates also to the human loss and suffering caused by the Second World War and the impact of these events 'back home'.

Cohn's affinity with wood as a material and her capacity to use its inherent qualities to enhance her sculpture is demonstrated in *The people*. The grain of the wood provides a graphic element to the work, lines running down the face of the figure and across the neck, forming the shape of the hand. Like a softly-drawn portrait, the facial features are delicately carved, the subtle cheek bones and hairline contrasting with the sharper edges of the brow and nose. The smooth, shiny surface and scale of this work evoke a very physical response, triggering the human sense of touch.

Born in Bendigo in 1892, Ola Cohn was a dedicated artist, author and arts administrator. In 1926, Cohn moved to London to study sculpture at the Royal College of Art and was tutored by Henry Moore, an artist whose ideas greatly influenced her development. While in London, she also studied wood carving and bronze casting at the London School of Arts and Crafts. Following her return to Australia in 1930, Cohn became a teacher and, in 1948, became president of the Melbourne Society of Women Painters and Sculptors, a position she held until her death in 1964.

Beatrice Gralton

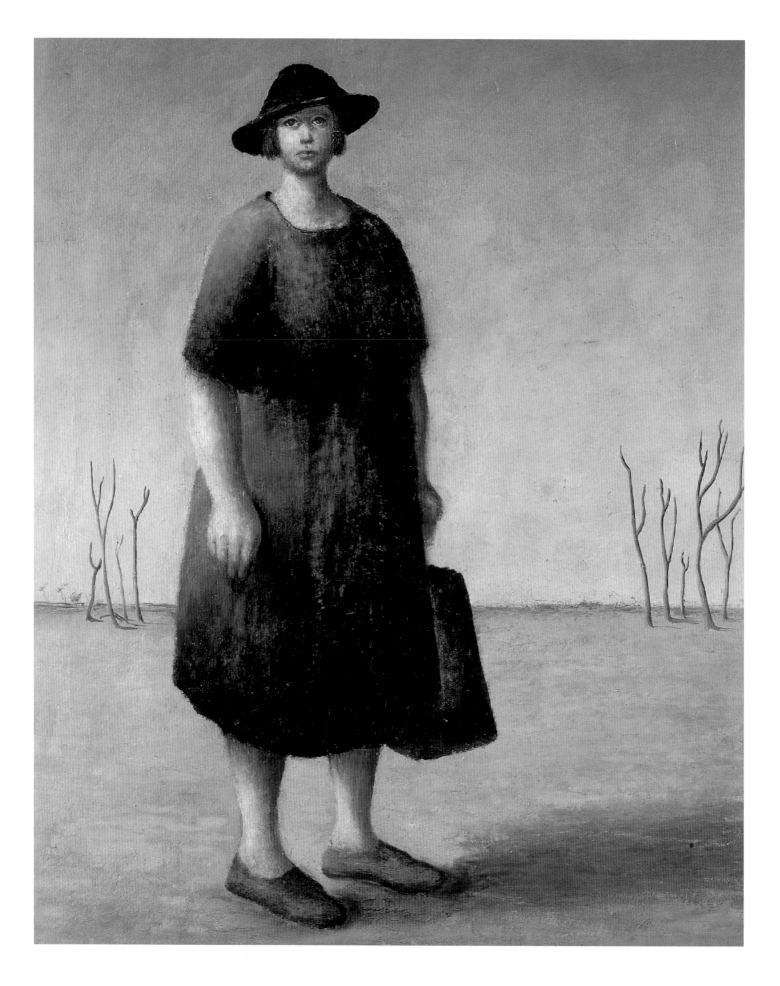

196

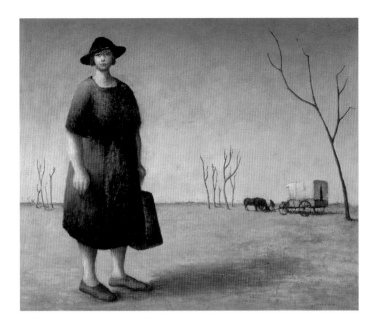

Russell Drysdale 1912–81

The drover's wife c.1945
oil on canvas 51.5 x 61.5 cm
a gift to the people of Australia by Mr and Mrs Benno Schmidt
of New York and Esperance, Western Australia, through the American
Friends of the Australian National Gallery 1987 87.1612

Russell Drysdale created a new vision of Australia. He painted
compassionate images of unheroic women and men in the
outback, loving their individuality and their peculiarities. He
portrayed a drought-ridden and eroded landscape that appeared
to have existed before time, as well as seemingly haunted towns
with quaint buildings framing gaping streets.

In 1944, Drysdale was commissioned by the *Sydney Morning
Herald* to record the drought devastation and associated soil
erosion in north-western New South Wales. These drawings,
and the paintings Drysdale subsequently produced on this
theme, present a reality he had seen. Nonetheless, they resulted
in controversy, with some writers believing that the images might
upset people who worked on the land and devalue land prices,
and others maintaining that they would increase sympathy for
country people and encourage the government to spend more on
solving the cause of soil erosion.

Drysdale made a drawing during his drought journey, *A drovers'
camp near Deniliquin* 1944, that shows a sparse landscape with
the drover, his wife and their wagon. Soon after, he painted
The drover's wife, depicting the vast, flat and barren landscape
with dead trees and a cloudless sky and bringing forward and
enlarging the woman, making her monumental. She may have
lank hair, wear a drab, unfashionable dress, a nondescript hat
and flat lace-up shoes, but she stands assuredly, looking out
towards the viewer with her feet planted firmly on the ground.
There is a gentleness in her face and eyes. The drover is still
present, but set back in the background, with his horses and
covered wagon.

A contemporary of Drysdale, the art critic and artist, Paul
Haefliger, said that Drysdale 'conveys a difficult and lonely
existence, where man constantly battles against the elements'.[107]
But is this true? Although his people are often alone, as is the
drover's wife, they rarely seem to be lonely; rather, they appear
to be in harmony with themselves and their place. The drover's
wife is not battling against the elements, or anything else. In her
own way she is heroic.

Like Tom Roberts, Drysdale carefully structured his pictures,
arranging space and volume and using a luminous, old-masterly,
approach to his paint. However, unlike the people depicted by
earlier artists, Drysdale's subjects are not pioneers struggling to
tame the bush or shearers working up a hard sweat, they are
strong men and women who are laconically at home in their
environment. And, unlike some other artists of the 1940s, such as
John Perceval and Albert Tucker, whose paintings are expressions
of anger and frustration, Drysdale showed people who are calm.
They are working people located in what might seem to be an
inhospitable environment, but who appear perfectly at ease there,
as resilient as the environment demands. He created a new sense
of what it feels like to live in Australia. Drysdale observed:

> To live for any length of time in the far regions of The Centre,
> camped in a swag and removed from the compass of society,
> needs a new adjustment … It is a life that demands a different
> set of values, a heightened perception which in turn develops
> a new awareness. What appear at first oddities become almost
> commonplace through a new interpretation.[108]

Drysdale was inspired by his own experiences in the Australian
outback in the 1940s, but he took his title from Henry Lawson's
well-known 19th-century story about a strong woman left in an
isolated hut while her husband went droving. The similarities
between the titles has meant that the drab existence of Lawson's
pioneer has sometimes been imposed upon Drysdale's image of
another women at a different time. Lawson's tale and Drysdale's
image have also inspired contemporary stories of 'The Drover's
Wife' by Murry Bail, Barbara Jefferis and Frank Moorhouse.

Drysdale's paintings have had a pervasive impact on the
Australian psyche. *The drover's wife* has a specific setting –
Deniliquin, in south-west New South Wales – and is connected to
a particular event: the drought and soil erosion of 1944. But it is
much more than this, it is an allegory of the non-Indigenous
Australians' relationship with this ancient land.

Anne Gray

Frances Burke Fabrics 1937–94
Frances Burke 1907–94

Phoenix 1945
screenprint on cotton 223.0 x 119.6 cm
gift of Frances Burke 1986 86.1024

From her earliest days as a young designer, Frances Burke was noted for her fearless use of simplified shapes and bright clear colour. These quickly became her signature and ensured her success. Designs with specifically Australian themes and colours proved popular with an increasingly confident and prosperous post-war society. Designers, such as Marion Hall Best in Sydney, advocated Frances Burke's fabrics as epitomising the very best of contemporary design.

Phoenix, an unusual textile among the great variety of Frances Burke's work, features a textured cloth. The design takes advantage of the texture to produce a mottled background for the brilliant and flat colour of the phoenix and flower motif. Unlike most of her other textiles, in *Phoenix* Frances Burke makes use of more than one colour. The overall effect is of a complexity and richness not usually associated with her work.

The rising phoenix motif seemed especially appropriate at the end of the Second World War. The mythical Arabian bird burnt itself on a funeral pyre and rose from the ashes with renewed youth. In this textile, the purple phoenix flies above a shocking pink floral motif, perhaps suggesting the flower bract of the Mussaenda or tropical rose. It may be seen as a symbol of hope and aspiration used by the young designer whose career was developing so quickly.

Undoubtedly *Phoenix* was especially commissioned, probably for a private interior. On the part of the owner it would have represented a considerable commitment to the most strikingly modern design possible in post-war Australia.

John McPhee

Mary Cecil Allen 1893–1962

Screen; five panels, a design of seven kangaroos c.1941

oil on paper on cardboard mounted on a wooden frame

183.0 x 60.0 x 2.5 cm

gift of Lady Casey 1979 79.2264

This screen, decorated with a design of seven kangaroos, was commissioned by Mary Cecil Allen's friend and admirer, Maie Casey, the wife of Australia's first representative to the United States 1940–42 (Richard, later Lord Casey). The screen, which was for the dining room of the Caseys' Washington residence, formed part of a distinctly Australian decor which included Russell Drysdale's *The rabbiter and his family*.

Seven finely drafted kangaroos fill the five panels in a decorative pattern, with overlapping lines and colour highlighting some of the kangaroos' forms. The animals are in a range of postures, with the central panel carefully chosen for the brightest colour and the engaging stare of one of the kangaroos.

The free-standing concertina nature of the screen also adds to an illusion of depth and movement.

The daughter of a professor at the University of Melbourne, Cecil Allen qualified for entrance to the University in 1910 but opted instead for the National Gallery School in Melbourne. Two years later she accompanied her family to London and attended the Slade School of Fine Art, later returning to her National Gallery School studies in Melbourne with new ideas.

Whilst enjoying some early success as a painter, Cecil Allen also excelled as a lecturer. After a study tour of Europe in 1926, she was invited to lecture in New York and soon decided to make her home in the United States, where she lived until her death in 1962. She made several visits home, however, and created a stir with her lectures on modern art which influenced a number of the more advanced Melbourne artists.

Ron Ramsey

Eric Thake 1904–82

Kamiri searchlight 1945

watercolour and gouache over pencil on paper on cardboard

39.3 x 51.5 cm

purchased 1973 73.19

Eric Thake was an outstanding draughtsman. His interest in drawing developed as a boy and was refined throughout his training and career as a commercial artist. Although Thake studied with George Bell in Melbourne during the 1930s, his interest in the so-called 'fine art field' was mostly allocated to his spare time.

Thake never really saw himself as a Surrealist, yet much of his work, including *Kamiri searchlight,* has a surreal quality. He was particularly fascinated by the work of the English artist Edward Wadsworth, who delighted in placing unusual subjects in strange surroundings. Like Wadsworth, Thake too enjoyed the possibilities that this allowed him to instil humour and wit in his art.

Design was also a critical element in Thake's work and he would spend much time sifting out, refining and rearranging his subject and composition until he came to a simplified form that would at first sight appear to be spontaneous.

Kamiri searchlight was painted on Numfoor Island, off Western New Guinea (Irian Jaya) towards the end of the Second World War, while Thake was on service as a war artist. Often he would seek out the detritus of war – wrecked buildings and aircraft and the everyday tools of war, such as this searchlight belonging to the American 16th Anti-aircraft Battery at the Kamiri Airstrip. The inverted reflection of the searchlight's support structure and of Thake drawing on the airstrip create an unfamiliar and curious view of the world.

Anne McDonald

Robert Klippel 1920–2001

Number 24, Harry Boyd 1946

carved Hawkesbury sandstone 69.3 x 107.0 x 78.3 cm

purchased with the assistance of the Crebbin family 1993 93.9

Robert Klippel's monumental sculpture *Number 24, Harry Boyd* was initially inspired by a friend who posed for him early in 1946. What is so striking about this work, however, is not that this is a portrait of a particular individual but rather the ways in which it relates to universal, ancient interpretations of the figure, encapsulating in its bulk a sense of compressed masculine power and energy. Klippel wrote in a letter to a friend, Jack Giles, in January 1947: 'I wanted a feeling of bigness – not physically but some intangible essense of immensity'.[109] It was a remarkable achievement for a 26-year-old in his first year at East Sydney Technical College.

The strength of the work, with its curved and angular carved planes, emanates from the young sculptor's interest in African sculpture and European Modernism, from his efforts to resolve problems of form and from his own emotional response.

Klippel did schematic drawings as well as clay studies before embarking on the more arduous task of carving the figure from one ton of Hawkesbury sandstone. James Gleeson wrote of a diagram for the work:

> it is fascinating to see the strict geometry that lies behind the conception. This is fully worked out … with a tremendous concern for formal values. The most passionate and the most elemental of all his works has been built upon a framework of exact and refined calculations.[110]

As we contemplate these ideas, we come to realise that, although this early masterpiece is the antithesis of Klippel's best-known and more intricately complex works, there is already a precision and an underlying spirit of inquiry that would characterise the extraordinary inventiveness of his later development.

Deborah Hart

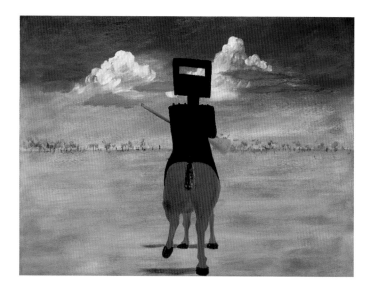

Sidney Nolan 1917–92

Death of Constable Scanlon 1946
enamel on composition board 90.4 x 121.2 cm
gift of Sunday Reed 1977 76.284

The chase 1946
enamel on composition board 90.5 x 121.3 cm
gift of Sunday Reed 1977 76.288

Ned Kelly 1946
enamel on composition board 90.8 x 121.5 cm
gift of Sunday Reed 1977 76.277

The trial 1947 (opposite)
enamel on composition board 90.7 x 121.2 cm
gift of Sunday Reed 1977 76.300

In 1961, Sidney Nolan told the writer Colin MacInnes that the main ingredients of the 'Kelly' series were 'Kelly's own words, and Rousseau, and sunlight'.[111] This characteristically pithy one-liner sums up the engagement with Australian history, Australian landscape and European modern art that led Nolan to create these iconic paintings.

Kelly's own words: At the first exhibition of the 27 Kelly paintings (at the obscure Velasquez Gallery in Melbourne in 1948), the catalogue included quotations taken from a variety of historical sources. Kelly's own words, the most celebrated record of which is the quasi-political, quasi-personal recital of grievance known as the 'Jerilderie Letter', fascinated Nolan with their blend of poetry and political engagement. Throughout his life Nolan was interested in literature and the visual arts and in many of his works sought to bring verbal images and pictures together.

Despite the fact that this historical grounding accompanied the paintings when they were first exhibited, the series was not intended as a literal illustration of the story. It appears rather as a meditation on the circumstances of Nolan's own life at the time and on the way in which the actions of one person could 'change the world'. Coming as they did from an immediately post-war milieu, Nolan's paintings had a particular and personal urgency. Originally, too, some of the paintings were reflections of a world of violence (although Nolan remarked that after a number of decades the paintings did not look particularly violent any more).

The series weaves biography and autobiography together, but we can only guess at the details of the autobiographical dimension. The narrative is strongly present, beginning with a scene-setting painting which shows an empty landscape lit by an eerie light from the horizon. The paintings take us through the main events of the story of Ned Kelly and his gang – the shooting

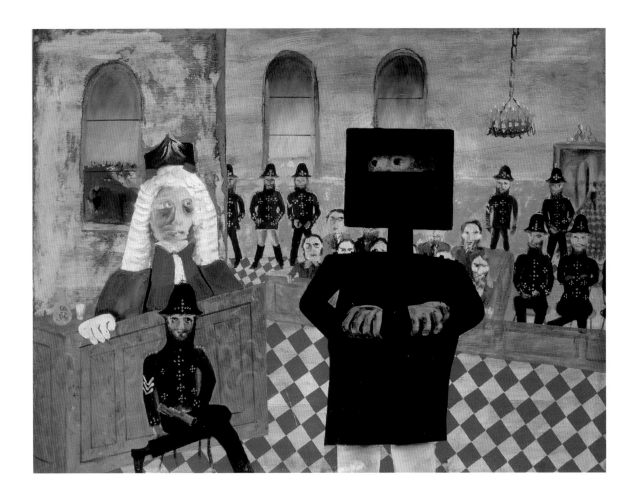

of police constables at Stringybark Creek, the ensuing police chase, the activities of the police spy Aaron Sherrit, the siege of the hotel at Glenrowan and the trial which ended in a sentence of hanging for Ned Kelly.

Rousseau: The overwhelming impression of the style of the Kelly paintings is of an uncomplicated, wilfully naïve execution, a quality Nolan admired in the art of the 19th-century painter and hero of the 20th century's avant-garde, Henri Rousseau. Nolan's admiration of Rousseau shows how determined he was to be a modern painter and how he admired French culture. As a young artist, Nolan was passionate about everything French, from the poetry of Verlaine and Rimbaud to the paintings of Cézanne and Picasso. He was fortunate enough to have access to the works of these artists in the magazines and catalogues in the up-to-the-minute library of his friends John and Sunday Reed in their home at Heide.

Yet Nolan was no slavish imitator. He developed his own style based on a principle of direct vision and intuitive execution. There were several ingredients in this approach. Nolan employed the simple bright colours and runniness of commercial house-painters' enamel. He produced his paintings quickly, often in a single session. Furthermore, he kept the forms big and bold,

particularly the black form of Kelly that constantly asserts itself across the planes of the paintings' pictorial spaces.

Sunlight: Nolan insisted that the Kelly paintings were more than simply a series illustrating the events of Australia's most famous bushranging story. In 1948, he wrote that the Kelly saga was 'a story arising out of the bush and ending in the bush'. An understanding of landscape was a motivation: 'I find the desire to paint the landscape involves a wish to hear more of the stories that take place in the landscape … which persist in the memory, to find expression in such household sayings as "game as Ned Kelly"'.[112] The landscape is therefore a crucial part of the Kelly paintings; the story gives meaning to the place.

The Ned Kelly paintings entered the collection in 1977. Their exhibition at the Metropolitan Museum of Art in New York, shortly after Nolan's death, cemented their position as one of the greatest sequences of Australian painting of the 20th century. As a result of their familiarity, Nolan's invention of an original and starkly simplified image for Ned Kelly – as a slotted black square atop a horse – has become a part of the shared iconography of Australia.

Andrew Sayers

Margaret Michaelis-Sachs 1902–85

Cynthia Reed 1948

gelatin silver photograph 29.7 x 24.1 cm

gift of the estate of Margaret Michaelis-Sachs 1986 86.1384.249

During the war years Margaret Michaelis, an Austrian-born photographer who settled in Sydney in 1939, was categorised as an 'enemy alien' and officials closely monitored her activities. By the time this portrait was taken, the Australian government's surveillance had all but ceased. However, with the visit to her studio by Violet Cynthia Nolan Hansen Reed (as she was named in the Security Report), Michaelis attracted official attention once again. Surprising as it may seem, this fact helps to explain why this is such an impressive portrait.

As a portraitist, Michaelis frequently photographed women but it was a certain kind of woman that elicited her strongest response. Cynthia Reed had the appropriate qualities in full measure. She was an independent, professional woman, well known for her strength of character and radical political views. Such characteristics could be applied equally to Michaelis, who had resolutely pursued her career against the backdrop of fascism in Europe and had mixed in anarchist circles in Berlin and Barcelona in the 1930s.

Michaelis's portrait gains its power from the rapport established between photographer and subject. With Reed's active collaboration, she could create what she regarded as a truly modern portrait, one that went beyond the description of her subject's physical features to reveal her 'essence', her inner truth. Working in the studio, Michaelis exerted full control over compositional and lighting elements, choosing an approach that was characteristically austere, pared down to essentials.

Reed presented herself to the camera with candour, her open pose and facial expression signifying an enticing form of complicity in the photographic exchange. Yet her manner was at once intimate and media savvy. The portrait is beguiling in its ambiguity for it could as easily be a private portrait as a public commission.

As the Security Report confirmed, Cynthia Reed had recently entered a new phase of her life, as the wife of Australian artist Sidney Nolan. Following her marriage, Cynthia's face was to become public territory. Australian writer and friend, Patrick White, famously referred to her 'patrician, increasingly ravaged face' in his autobiography, *Flaws in the Glass*. Cynthia herself came to wish that her face 'was a secret instead of a confession'.[113] What Margaret Michaelis achieves in her portrait of Cynthia Reed is a tantalising amalgam of these two modes of being.

Helen Ennis

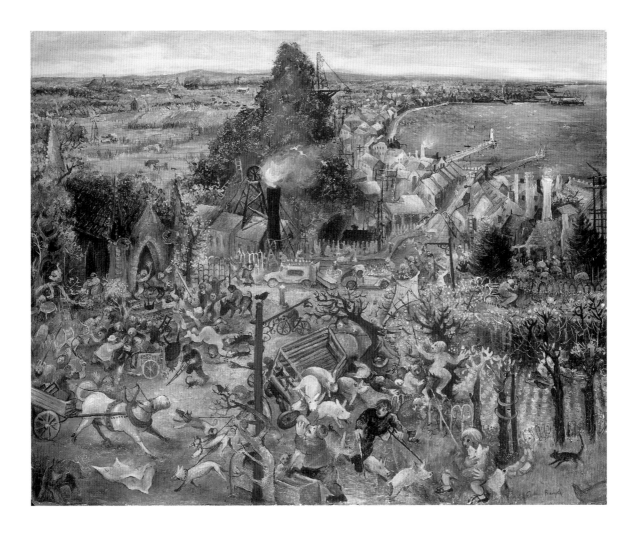

Arthur Boyd 1920–99

The mining town (Casting the money lenders from the temple)
c.1946
oil and tempera on composition board 87.4 x 109.2 cm
purchased 1974 74.326
Arthur Boyd's work reproduced with permission of Bundanon Trust

A man throws some people down the steps of a church and sets up a chain reaction of events. A truck spills its load as it smashes into a tree, the pigs on it scatter onto the street, a cripple hobbles away, a kite-flier grabs a pig, muzzled dogs on leashes frighten a horse pulling a cartload of people and a funeral procession stops in the street. Only two lovers, embracing in a garden, seem to be unaffected by the turmoil. Behind this hive of activity, the factory chimney belches smoke. In the distance, cows graze in tranquil fields and birds fly over a calm sea. The man who has caused this chaos and drama is Christ, returned from the dead, to cast the money lenders out of this suburban church.

The mining town (Casting the money lenders from the temple) is one of a group of multi-figured scenes with explicitly religious themes that Arthur Boyd painted towards the end of the Second World War. Son of the potter, sculptor and painter Merric Boyd, he was brought up in a family with strong religious beliefs, with his grandmother reading him stories from a large, illustrated family Bible when he was a child and his grandfather conducting prayer gatherings. In the late 1940s, he turned to the Bible for inspiration as a means of conveying universal stories. *The mining town* is an allegory of the impact of greed and corruption on ordinary people and their everyday lives; Boyd emphasised the reality of this by placing it in a recognisable Australian suburb: the long Station Pier identifies the suburb as South Melbourne and the bay as Port Phillip Bay.

The mining town expresses Boyd's anger at war profiteers and at the futility of war. However, its artistic heritage is the *Tower of Babel* 1563, a biblical painting by 16th-century Flemish painter, Pieter Bruegel, which Boyd had seen in reproduction at the Melbourne Public Library. Like Bruegel, Boyd produced an expressive image of his local landscape and imagined activities around him.

Anne Gray

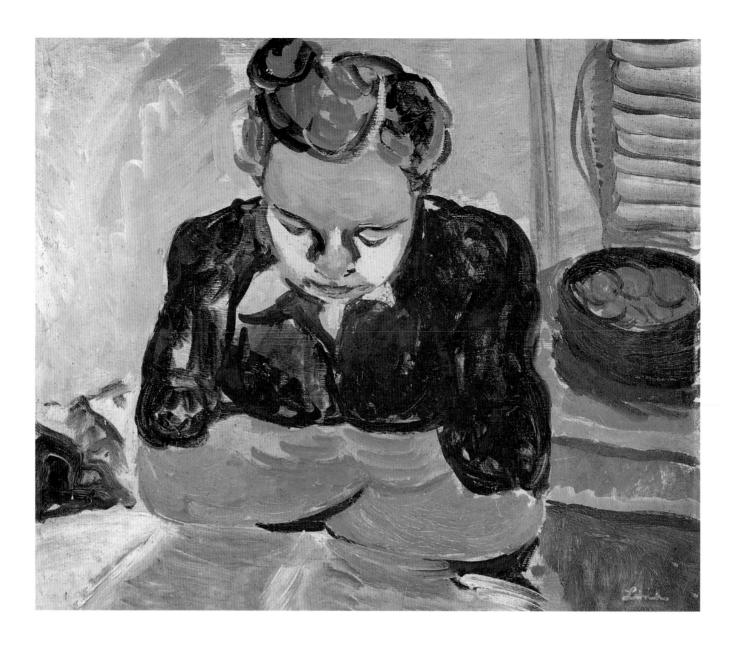

Lina Bryans 1909–2000

The student (Nina Christesen) c.1947

oil on paper on cardboard 48.5 x 58.9 cm

purchased 1996 96.1045

The student is one of three portraits of Nina Christesen painted by
Lina Bryans. Christesen was an important scholar of Russian
languages and culture, the founder and head for 30 years of the
Department of Russian Language and Literature at the University
of Melbourne and the wife of Clem Christesen, founding editor of
the journal, *Meanjin*. The Christesens moved to Melbourne from
Brisbane in 1945, relocating *Meanjin* to the University of
Melbourne Press. They soon found themselves an important part
of literary and artistic circles associated with the journal. Bryans
and the painter William Frater often visited 'Stanhope', the
Christesens' house in Eltham, and Nina and Clem also frequented

Bryans's Darebin Bridge House where this portrait was painted.

At the time she painted the portrait, Bryans was a keen
student of the works of Cézanne and Matisse. Her preoccupation
with the work of the latter is seen in her use of vibrant colour,
simplified forms and the domestic interior setting. In formal
terms, this painting is probably her most direct and successful
gesture toward early 20th-century European Modernism. In this
sense, the title of the work relates equally to the experimental
efforts of Bryans as to the pose of Nina reading or studying in the
kitchen at Darebin Bridge House. Bryans painted another portrait
of Nina in 1947, a larger and more traditional work than
The student. In the second portrait, Bryans revealed more of the
strength and sensitivity of the sitter than in *The student*, a painting
in which formal concerns were uppermost.

Magda Keaney

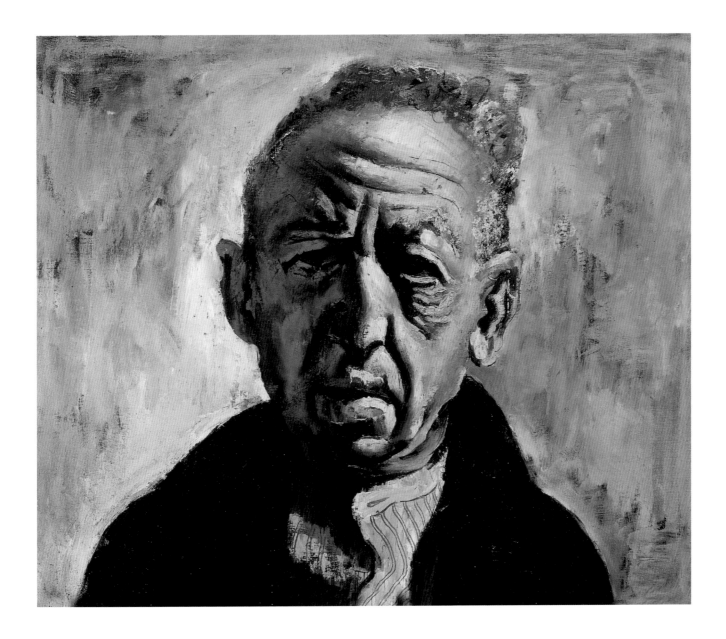

Albert Tucker 1914–99

Man's head 1946
oil on cotton gauze on cardboard 63.4 x 76.0 cm
purchased 1981 82.384
© Barbara Tucker, courtesy Lauraine Diggins Fine Art

This was painted from a newspaper photograph of a man who had been charged in court with kicking a small dog to death. And I remember I was fascinated with the utterly dissolute face of this man … he had that look about him, a collapsed kind of face, a kind of moral disintegration. And I realised it wasn't so much the person that was fascinating me – rather, he stood as a symbol for all sorts of things that work in the human condition. I remember once I located the photograph again and it's really nothing like it … I found that I'd extracted the corrupt disintegrating element in it. The face fascinated me because it was a key into a social-psychological landscape. A kind of refracting prism for the human condition. I saw it more as a psycho – in fact, I think I called them Psycho Landscapes at one stage.

Albert Tucker, 1982[114]

Sali Herman 1898–1993

Saturday morning 1948
oil on canvas mounted on plywood 38.8 x 51.4 cm
purchased 1972 72.472

Saturday morning shows a family sitting on the front porch of an inner Sydney terrace, chatting to a neighbour. It is a quiet suburban scene of a family relaxing in the immediate post-war era, but it could be anywhere at any time. Such scenes were relatively new subjects for Australian art when Sali Herman began to paint them in 1939 – a comment on how people lived in lower-class suburbs, reflecting an interest in the daily life of ordinary people.

Herman was genuinely captivated by the buildings and life in the high-density suburbs of inner Sydney. He commented: 'An old man or an old woman may not be attractive but may have beauty in their characters. So it is with houses. When I paint them I look for the character, regardless of prettiness or dirty walls'.[115] Later he noted, 'I had no "philosophy of slums". I painted houses, because houses are parts of people and people parts of houses'.[116] Herman's paintings convey the joy and magic he found in his immediate surroundings. He said:

> It is … not by any intention that I painted streets, it was simply because I loved them … I would never paint anything unless it does something to me, and it is this, what it does to me, I tried to convey in my paintings.[117]

Other artists were also interested in such subjects, with the Melbourne social realist Yosl Bergner portraying life in that city. Bergner and Herman both arrived in Melbourne in 1937 and began to create works which fused their European backgrounds with their Australian experience. They were accustomed to an urban-focused life and economy and inevitably sought subjects that reminded them of home. But whereas Bergner showed his people as victims, losers in a class struggle, Herman portrayed them as being comfortable and at ease. He valued these people and the sense of community they created, gathered together in the narrow streets.

Anne Gray

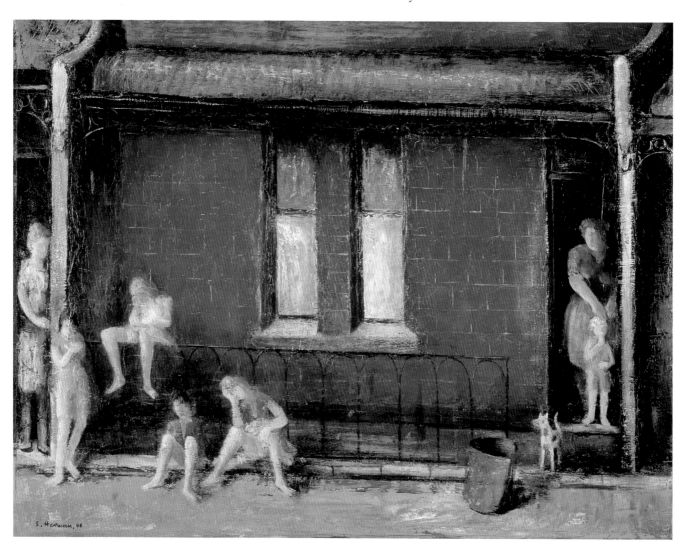

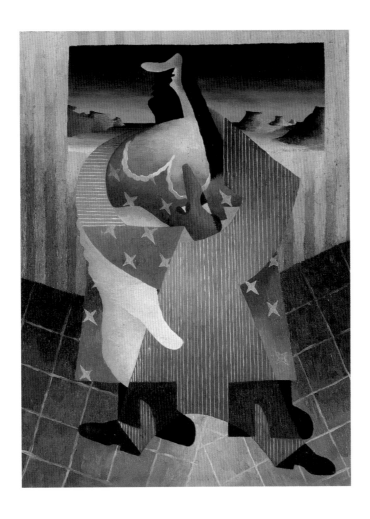

Peter Purves Smith 1912–49

The pleading butcher 1948
oil on canvas 61.4 x 46.2 cm
purchased 1971 71.79

The pleading butcher, one of Peter Purves Smith's last works, portrays a large woman in a green dress embracing a butcher in a blue-striped apron. The figures are entwined, merged together as one form. The artist's widow, Maisie, suggested that these figures were herself and her husband, and that it was a joke about the rules of painting. 'He was experimenting with surfaces and patterns … [his teacher] Old George [Bell] forbade what he called breaking the picture plane so Pete naturally fiddled with it'.[118] But as Mary Eagle has commented, 'the humour is heady and … as deadly as a surrealist nightmare'.[119] In playing with the rules, Purves Smith turned the solid forms of the figures into flat planes, the room into a giddy puzzle space with the floor slanting in two opposite directions, and the flat plane of the magical moon landscape on the back wall into an almost three dimensional perspective – like a view through a window. What is more, he created a sense of foreboding through the third, black silhouetted figure behind the woman.

Purves Smith painted *The pleading butcher* in 1948, after he returned from war service and married Maisie. In the 1940s he had been considered one of Australia's most promising young artists, along with William Dobell and Russell Drysdale, with one of his paintings acquired by the Museum of Modern Art (New York). In a career that spanned only two decades, owing to his untimely death from tuberculosis in 1949, he made a significant contribution to Australian art, producing a number of powerful and evocative works that convey his wicked sense of humour and warm humanity.

We can view *The pleading butcher* as a modernist exercise but, in the light of the artist's biography, it is hard not to see it also in terms of his life – as conveying the new-found happiness of his marriage, haunted by the shifting ground of his illness, and the shadow of death. The small figure of the butcher seems to be clinging on to the large woman for dear life, while she supports him with her big body and strong arms (her generous spirit and large heart).

Anne Gray

William Dobell 1899–1970

Study for 'Portrait of Margaret Olley' 1948
pencil on paper 25.3 x 20.2 cm
gift of the Sir William Dobell Foundation 1976 76.105
© William Dobell, 1948. Licensed by VISCOPY, 2002

Study for 'Portrait of Margaret Olley' c.1948
pen and ink, wash on paper 23.0 x 35.2 cm
gift of the Sir William Dobell Art Foundation 1976 76.185.6.27
© William Dobell, c.1948. Licensed by VISCOPY, 2002

Margaret Olley recalls that when Dobell saw her at a party in her extravagant 'duchess' gown of parachute silk, he asked to paint her portrait:

> I went to his flat the next week. I took a hat with some everlasting daisies on it, thinking, as one artist to another, the shape might appeal to his eye. Dobell did a lot of detailed sketches of me, and when I saw them later, he'd laid me down sideways, even drawn me in the nude with the hat on, though I certainly never posed like that. I didn't sit in the duchess dress, I wore a plain beige cotton dress, but he obviously remembered the grand dress, because in the finished work, there I am in it.[120]

In this study, we meet a young woman who is comfortable in the presence of a fellow artist and friend. Although in her early twenties, Olley is portrayed as a matronly Renoiresque figure.

She appears slightly crumpled in her button-through dress and seems out of place perched attentively on an elegant lounge chair. She has a child-like innocence and charm. The only hint of flamboyance is her showy hat. This is quite a different woman to the one in the finished portrait, which won the 1948 Archibald Prize. Olley sits transformed, shoulders straight, breasts high and thrust out confidently in her frothy white dress and showy hat – proud of her growing reputation as an artist and as a feisty individual.

The ink drawing from Dobell's Sydney sketchbook represents a stage between pencil study and finished painting, where he corrected what he regarded as compositional errors. As James Gleeson says:

> The changes introduced in the ink drawing are nevertheless significant modifications which when adopted in the painting endow it with rhythms that are at once more sweeping and more enclosing. By lowering the sitter's left arm, raising her right arm, emphasising the curves of her skirt and closing the composition just below her knees, Dobell changed the open, almost diffused character of the pencil study into a design that has an organic inevitability not unlike that of a sea shell.[121]

Dobell's characteristic drawing skills are highly acclaimed. He sketched often, but never to produce finished drawings for exhibition. Through these studies we share in the pleasure of seeing Olley through his perceptive eyes.

Anne McDonald

Horace Trenerry 1899–1958

The ploughed field c.1947

oil on canvas on cardboard mounted on composition board

48.0 x 65.5 cm

bequest of Dr Mildred Mocatta 1984 84.1267

Horace Trenerry, an eccentric and bohemian character who lived most of his life in relative artistic isolation, possessed an acute eye for the landscape without being confined to the 'blue and gold' tradition embodied by Arthur Streeton and a host of other artists of an earlier period. Struggling to realise a style of his own in the countryside surrounding Adelaide, Trenerry emerged from the influence of Elioth Gruner and Hans Heysen and matured into one of the most interesting and original painters of his time.

Works executed during the artist's last and most accomplished period, between 1945 and 1951, show a mature painter with a confident freedom of expression and a strong sense of originality.

The chalky oil paint – mixed in low, luminous tones of blue, grey and purple that are somehow appropriate to the all-pervasive, vertical light of the South Australian landscape – achieves a rare balance of spirituality and physical presence.

The ploughed field, painted with a sombre palette and thin expressive surface, flattens and compresses a landscape flooded with a directionless, fragmented light – which shows Trenerry's commitment to the artist's vision rather than to a realistic representation of the subject.

The ordinary has been transformed into the imaginative. The landscape of Wilunga has been removed from a specific time and place to be released, both by the unnatural colour combinations and by Trenerry's dry, scumbled surface, into the realm of contemplation and metaphor.

Tim Fisher[122]

Guy Grey-Smith 1916–81

West Australian landscape 1950

oil on canvas 40.5 x 50.5 cm

gift of the artist's son Mark Grey-Smith 1992 92.264

Guy Grey-Smith loved nature; to paint nature, to be in nature. In *West Australian landscape* he created a dynamic composition through the rhythmic arrangement of curves, circles and diagonals, and used strong yellows, greens, reds and blues to add to the energy of the design. It is an image of the trees, hills and rocks around his Darlington home – perceived through his understanding of British and French Modernism.

In the school holidays, he and his wife would pack their children into the family station wagon and go bush – south in May and north in August. Grey-Smith was not a city man and was not interested in portraying the city. He grew up in the south west and when he returned to Perth, after serving in the Second World War and afterwards training to become an artist in Britain, he built a house on the Darling Scarp. Then, in 1975, he and his

wife moved to live in a small cottage in Pemberton among the karri forests.

In 1957, together with Tom Gibbons, Robert Juniper and Brian McKay, he founded the Perth Group (1958–61), which was influential in increasing an understanding of Modernism in Perth. He explored a range of subjects including still lifes, figure studies and portraits, but he always returned to the landscape. He painted the dense karri forests of the south west, the wide expanses of the north west, and the waves crashing against the coastal cliffs; but whatever he painted he was essentially concerned with the forms, patterns and intense colours found in nature. He invested the places around him with emotional significance, maintaining: 'all my paintings are derived directly, really directly from nature, they are realistic in so far as they have a truth to me ... a truth of feeling, not visual truth, but a truth of feeling'.[123]

Anne Gray

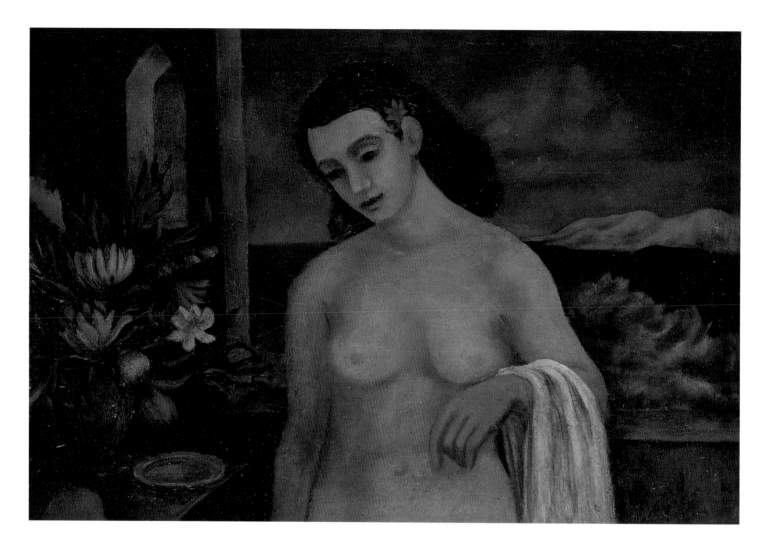

David Strachan 1919–70

Young girl on a balcony c.1947
oil on canvas mounted on plywood 42.5 x 61.8 cm
purchased 1972 72.137

Basically, the thing that I'm really striving for is to express the feeling I have about that subject. Sometimes I can put it down very quickly, and sometimes it takes me months and months of reorganization of the shapes and colours and tones to get that feeling. When I've got that, that is as much as I can do.
David Strachan[124]

In the tradition of the European Symbolists, David Strachan developed his own poetic imagery from an arrangement of figures, flowers and birds. In his late thirties he studied at the Jung Institute in Zurich, Switzerland, where he assimilated Carl Jung's ideas that dreams and subconscious experiences could be used for creativity. In his art, he sought to lend expression to personal feelings and imaginings and give them a general relevance.

In *Young girl on a balcony*, he depicted a pubescent girl standing naked with her head lowered in private thought, perhaps dreaming of a lover. The vase of flowers beside her and the water in the bay have sexual connotations; together they imply the awakening of love and passion. Strachan painted this tranquil, suggestive image while he was living on the top floor of Paul Haefliger's and Jean Bellette's house at Double Bay – probably using a model that Haefliger and Bellette also employed. Like Bellette, Strachan created timeless, classic images that contain some of the spirit and solidity of the old masters but, whereas Bellette turned to the realm of mythology, Strachan developed his images out of everyday scenes. Strachan gave his commonplace subjects a sense of mystery and enchantment: we do not see this girl as living in a pragmatic world, with a towel draped over her arm passing to or from a verandah bathroom, but rather as stilled in a dream world for all time.

Anne Gray

Jean Bellette 1908–91

Chorus without Iphigenia c.1950
oil on composition board 91.5 x 136.7 cm
purchased 1976 76.155

I have tried to paint groups of figures in landscape, using mythology as a pretext; my main pre-occupation was to try to order space and colours in a certain way, so that they would suggest to me some atmosphere I recognised, possibly a place I had seen. *Jean Bellette*[125]

These five figures, posed like statues in a *tableau vivant*, possess a kind of erotic energy. Their solidity suggests parallels to archaic sculpture and to the work of Aristide Maillol, and to the figures in the paintings of the Italian masters Masaccio and Piero della Francesca. This is hardly surprising given that the artist, Jean Bellette, wrote articles on these masters. She was also inspired by the monumental figures in Picasso's neoclassical paintings of the 1920s and the work of her teacher, Mark Gertler.

Although nothing is happening in this image, we associate the figures with tragedy, with death and mourning – with the classical reference in the painting's title. Iphigenia, Agamemnon's daughter, gave her life for her country when the goddess Artemis asked for it in exchange for favourable winds to enable the Greek ships to sail to Troy. Bellette's melancholic painting might be supposed to portray Iphigenia's friends mourning her death.

Bellette was one of a group of artists working in a kind of artists' community in Sydney and at Hill End during the 1940s and 1950s, which included Donald Friend, David Strachan and her husband Paul Haefliger. Like Piero della Francesca, she wanted 'to reduce the desperate adventure of a lifetime to something equable, calm and capable of enduring';[126] and to do so, she fused aspects of the classical tradition with the modern. Like several Sydney artists at this time, she used stylised figures and formal arrangements to create a timeless sense of mystery.

Anne Gray

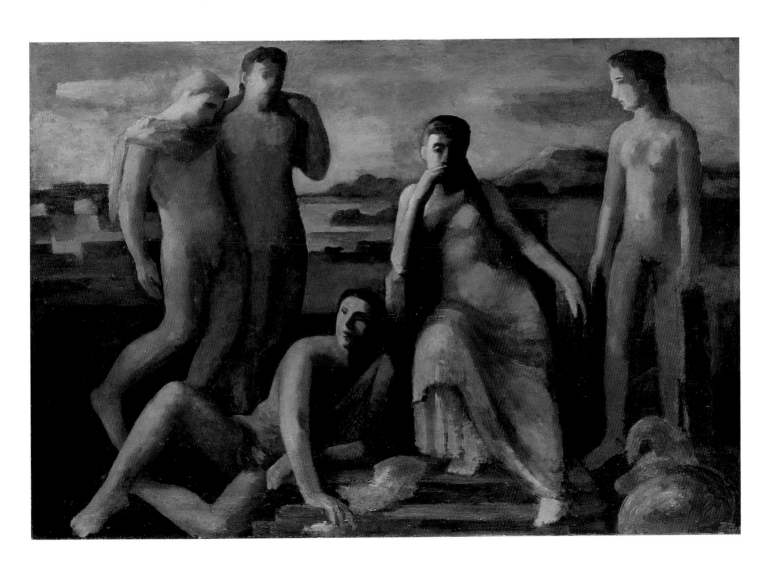

Lloyd Rees 1895–1988

A south coast road 1951

oil on canvas 65.7 x 101.5 cm

purchased 1977 77.327

© Lloyd Rees, 1951. Licensed by VISCOPY, 2002

Throughout his long life, it was always nature, the essence of nature and its relationship to light that was the main subject of Lloyd Rees's paintings and drawings. He altered his palette from warm reds and greens to light blues, pinks and yellows; he changed from painting the strong forms and sensuous curves of a scene to daring images evoking an ethereal aura of the universe. Whatever the approach, he was always concerned with the beauty of light and the way it radiates over and illumines a landscape. He pursued this unconcerned about current fashions.

Rees painted *A south coast road* during the summer of 1950–51, during a holiday visit to Werri Beach with his family. He first went to the area in 1940, and returned again and again over the years, eventually building a cottage, 'Caloola', at the northern end of the beach. In commencing a painting Rees would find a site that attracted him ('it finds you, not you it'), and his family would take him there and leave him to paint, while they spent the day swimming and relaxing. He frequently worked on two pictures at once – one in the morning and another in the afternoon.

The view Rees depicted in *A south coast road* is still there today, visible from a small lay-by on the Princes Highway on the road to Gerringong, sign-posted 'Bushbank Walking Track'. Looking down towards the bay you can see a large triangular shape that is framed by the road and the hedges that form the central focus of Rees's composition. He changed and modified the view, making

the road and the landforms more curvaceous. He invented a foreground, enhancing the sweeping, interweaving rhythms of the landscape that lead you into the distance. The actual countryside around Werri is a lush English green but Rees used reds and browns, deep blues and dark greens to give it warmth, to present it as bathed in a golden light. He looked at reality and modified it – he went beyond what the eyes see to convey a deeper, more intense feeling – the force and mystery of nature. He noted:

> that's what I felt about that south coast country. Realistically, if you looked at it in a colour sense it was often too green for me. So sometimes I'd absolutely bring the warmth into it.[127]

On Rees's first visit to a site he made a quick, rapid emotional sketch, a response to the place, through which he came to understand its structure. Later, he returned and painted outdoors directly onto the canvas, mapping out the main areas in paint and working this up into the final composition, in which he gave the painting an inner life of its own, independent of the subject matter. He commented:

> I might be out the whole morning and realise that I hadn't looked at the subject once. I'd been looking at the picture all the time, the canvas. But the sense of environment, you know, to be working on a headland and to get the ozone off the ocean, the waves pounding, that was to me what made it so important working out of doors.[128]

He assimilated the atmosphere of a place and infused this into his image. He worked slowly and returned to the site day after day, often finishing his paintings in his studio and using the initial drawing as a reminder of his strong sensation in front of nature. He noted:

> the drawings I did were merely enough to indicate the rhythm [of the landscape]. And a lot of them haven't even survived … I always, practically invariably, however short the session, cover the whole canvas … I never start with a section and then move from it. I must cover the whole thing.[129]

Over successive summers he painted many well-known scenes around Kiama, paintings such as *The road to Berry* 1947 and *The road to the mountain* 1954, some of his most lyrical landscapes. *A south coast road*, with its flowing rhythms and gentle caressing light, is typical of this time.

Anne Gray

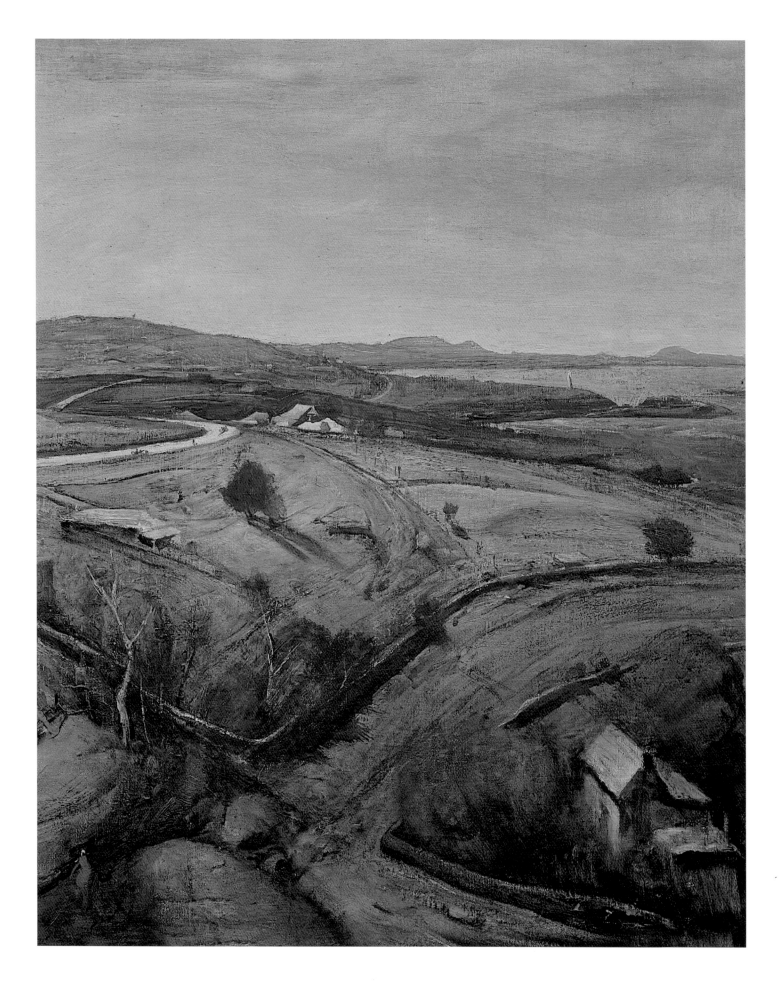

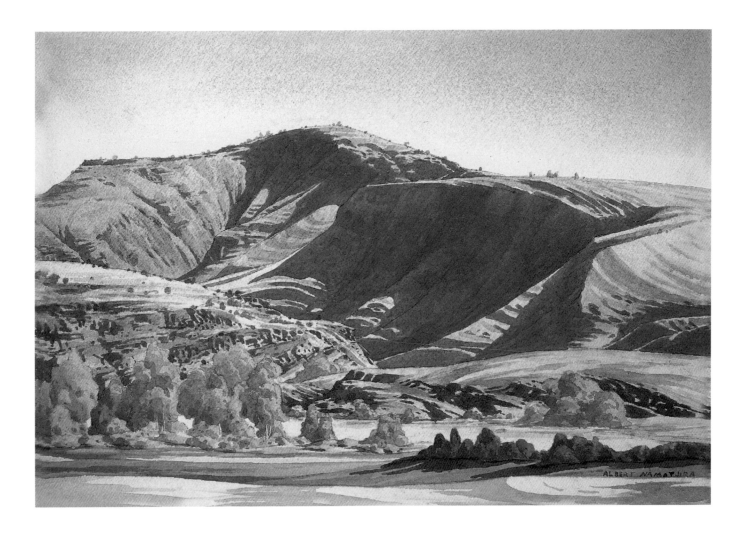

Albert Namatjira 1902–59

Western Aranda / Arrernte people

Mount Hermannsburg, Finke River 1946–51

watercolour over pencil on paper 36.7 x 54.0 cm

purchased 1977 77.46

© Albert Namatjira, 1946–51. Licensed by VISCOPY, 2002

Mount Hermannsburg, Finke River was painted in the final years of Albert Namatjira's life and is a majestic portrayal of the artist's traditional homeland, the country of the Western Arrernte in Central Australia. With its sweeping mountain range, rendered in purple hues and rising out of the deep red of the desert earth, *Mount Hermannsburg* can appear as a fitting metaphor for Namatjira: his imposing physical presence and larger-than-life personality. This often-dismissed artist was arguably the first Indigenous person to be considered an artist by non-Indigenous Australians.

It is well documented that Namatjira learned to paint in 1936 while working as a 'camel boy' for non-Indigenous watercolourist Rex Battarbee on one of his painting expeditions to Palm Valley in Central Australia. Namatjira painted his first work in 1935, but had no tutoring until he went on the eight-week trip with Battarbee. These were the only lessons Namatjira ever had, though he did go on further painting trips.

Namatjira's work was exhibited publicly from 1937, and his first solo show took place in 1938. A Namatjira watercolour, *Illum-baura (Haasts Bluff), Central Australia* 1939, the first Indigenous work of art to be acquired by an Australian art gallery as opposed to an ethnographic museum, was bought by the Art Gallery of South Australia, Adelaide, in the same year.

Without doubt the most famous Indigenous person in his lifetime, Namatjira was a prolific artist. Through his paintings he brought Central Australia, and particularly the country of the Western Arrernte, to a largely eastern seaboard-based Australian population that had had little contact or knowledge of Indigenous art practice outside ethnographic representation in natural history museums. The extent of Namatjira's watercolours – whether resplendent or evanescent – challenged non-Indigenous peoples' misconceptions of a lifeless inland desert by depicting the flora and ancient geography in an ever-changing palette of tone and light.

Brenda L. Croft

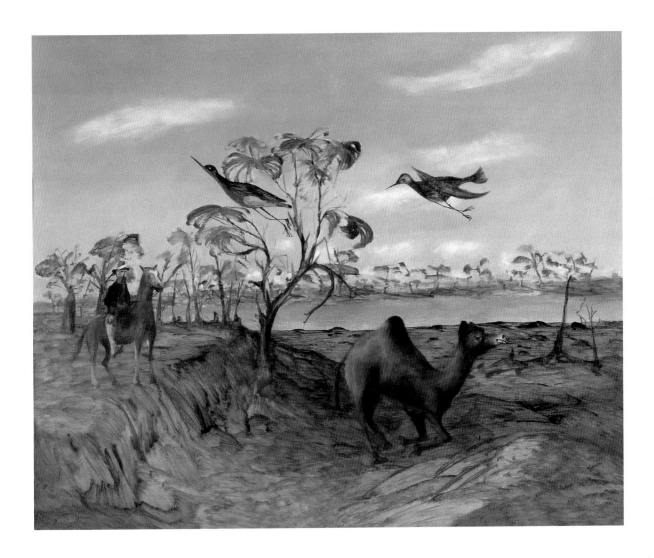

Sidney Nolan 1917–92

Burke at Cooper's Creek 1950

synthetic polymer paint on composition board 121.5 x 152.0 cm

a gift to the people of Australia by Mr and Mrs Benno Schmidt

of New York City and Esperance, Western Australia, through the

American Friends of the Australian National Gallery 1987 87.1610

reproduced courtesy of The Bridgeman Art Library

Sidney Nolan thought about the Burke and Wills expedition as
early as 1945, when he began to explore themes of European
history in the Australian landscape – and famously hit upon the
saga of Ned Kelly for his first sustained narrative series. By 1950
he had made several outback journeys, later writing, 'I doubt that
I will ever forget my emotions when first flying over Central
Australia and realising how much we painters and poets owe to
our predecessors the explorers, with their frail bodies and superb
willpower'.[130] *Burke at Cooper's Creek* is one of Nolan's Burke and
Wills paintings from that time – not simple illustrations of the
tragic events of 1860–61, but poetic, richly layered imaginings
with all the qualities of an Australian legend.

Here the ill-fated expedition leader, Robert O'Hara Burke,
astride his horse, surveys an ironically peaceful and plentiful
scene. He is alone, though in reality the Victorian Exploring
Expedition to cross the continent from south to north was large
(initially 19 men) and handsomely equipped. The creek is full and
lined with shady trees; soft white clouds billow in the burnished
blue enamel sky and birds fly overhead like specimens from a
contemporary ornithological textbook. One of the 26 specially
imported camels takes a rest in the foreground, thinly brushed in
with red-brown ochre oil paint suggestive of both real earth and
dream-like mirage.

Cooper's Creek, in south-west Queensland, was the
expedition's last depot and safe haven before the final, fatal race
north to the Gulf of Carpentaria and back. Nolan has captured
both the beauty of the landscape and the poignant sense of
displacement of his protagonists – European visitors who
completely misunderstood its power.

Jane Clark

Ralph Balson 1890–1964

Constructive painting 1951
oil on composition board 60.5 x 90.5 cm
purchased 1977 77.517
© Ralph Balson

Constructive painting shows Balson's exquisite use of colour and mastery of subtle tonal values to create luminous and transparent forms floating gently in a shallow space. Balson's sparing use of vivid orange and blue serves as a visual punctuation mark, bringing the viewer's attention back to the picture plane and stabilising the composition. *Constructive painting* expresses an aesthetic of calm and order, reflecting Balson's belief in art's purpose to reveal absolute and timeless truths.

In his 'Constructive Paintings' series, painted between 1940 and 1956, Balson pursued an idealised art based on a universal language of geometry, which rejected particulars of time and place and the artist's own subjective vision. Balson considered that the purposes of science and art were essentially similar, both seeking to discover inherent and fundamental laws of nature. In 1949, he was reported as stating that 'the source of true design is to be found in cosmic laws and that this truth offers a better basis for progress than any other'.[131]

In 1956, with the beginning of his 'Non-Objective Paintings' series, the serene geometry and stable order he expressed in the 'Constructive Paintings' would give way to a more fractured abstraction, images of universal flux, reflecting Balson's new understanding of the physical world according to Einstein's concept of relativity.

Painted in Sydney in 1951, *Constructive painting* contrasts with other Australian art of the time which tended towards romantic realism, heroic landscapes and nationalistic myth-making. One of the few artists who responded to Balson's work was the young sculptor Robert Klippel, who had recently returned from study in London and Paris. In 1952, Balson invited Klippel to share an exhibition with him. It is likely that *Constructive painting* was included in this show as it belonged to Klippel until acquired by the National Gallery of Australia in 1977.

Elena Taylor

Charles Blackman b.1928

The cigarette shop (Running home) 1954

enamel on composition board 91.0 x 121.0 cm

purchased from the Founding Donor Fund 1985 85.631

The theme of Blackman's art is the feminine psyche, which he explored through childhood memories (of his mother and sisters) and through his reading of the literature of adolescent fantasy. His reading stimulated his imagination by revealing the whole language of the emotions.

In *The cigarette shop*, which is almost a snapshot of the 1950s, the thrill comes from the conjunction of reality and dream. The blatant advertisements, featuring figures from fashionable society, contrast with the mystery of the fleeing child in the lower right. She runs one way and the architecture runs the other, receding diagonally towards the glimpse of twilight sky in the background. Her greenish dress calls to the timeless tones of the sky, while her emphatic shadow underlines the flatness of the hoardings and the competing perspectives of the quirky architecture.

Influence on Blackman's hoarding paintings came from the pre-Pop reality of his immediate suburban environment, such as the hand-painted shop signs which he recited (with comic overtones) to his low-visioned wife on morning walks. This reality reappears in Blackman's use of Dulux enamel paint which he bought (for practical reasons) at the local hardware shop. Similarly, the advertisements hark back to his newspaper training in lettering.

During his formative years, Blackman learned from the studios he visited in Melbourne, Sydney and Brisbane. Isolated from the great modern galleries of Europe and America, his generation of artists turned to one another to see original paintings and to discover new techniques.

Felicity St John Moore

Danila Vassilieff 1897–1958

Stenka Razin 1953
carved and waxed Lilydale limestone 57.0 x 40.0 x 13.5 cm
purchased 1973 73.557

The lively expression of this double-sided marble sculpture exemplifies the daring and original technique of Danila Vassilieff, a refugee from the Soviet Union. Stenka Razin was the peasant rebel and ataman (leader) of the Don Cossacks, celebrated in song and legend, with whom Vassilieff sometimes identified.

Vassilieff tackled the local limestone directly, responding to its metamorphic character with a variety of individual and asymmetrical features. Razin's bulbous winking eye corresponds with a grey coral discovered during the creative process, his open mouth is formed by a second happy 'accident', his warlike broken nose doubles as the intersection of two planes while a double row of tooled serrations shapes his barbed beard. By carving out spaces inside the form, in particular by undercutting the clasped arms, Vassilieff defies gravity in a kind of cut and thrust with the hard marble.

Vassilieff's approach to carving stone grew out of his experience of building his own extraordinary house at Warrandyte. However, whereas in his building he left the stone rough, in *Stenka Razin* (and about 30 other major carvings from 1947–54) he polished the surfaces smooth to reveal the life within the stone. Through this process, including the transparency and reflection he thus achieved, he invites our sense of touch. The individual expression of Vassilieff's art, especially of his paintings, encouraged the original visions of his younger contemporaries – Arthur Boyd, Charles Blackman, Joy Hester, Sidney Nolan, John Perceval and Albert Tucker.

Felicity St John Moore

Robert Dickerson b.1924

K.O.'d by Griffo 1953

oil and synthetic polymer paint on composition board

122.8 x 139.5 cm

purchased 1976 76.550

Robert Dickerson grew up during the Depression in the inner west working-class suburbs of Sydney. He left school at an early age, taking factory jobs and fighting as a professional boxer. A self-taught painter, Dickerson remained outside the Sydney 'art scene' of the late 1940s and 1950s. Melbourne provided a more receptive environment for his work and in 1953 he made his first visit to Heide, the home of the important patron of modern art, John Reed.

K.O.'d by Griffo was illustrated in the first article on the painter written by John Reed and published in an issue of *Ern Malley's Journal* in 1955. Supporters claimed that Dickerson's working-class background and '30 or so professional bouts' on the boxing circuit gave the artist his 'immensely powerful creative vision'. These were Dickerson's 'life-classes', with *K.O.'d by Griffo* a particularly poignant reference to his tough teenage years.[132]

All superfluous details have been stripped away so the viewer is confronted by the two central fig lights and no cheering crowd. The two wide-eyed young boys trappe participant K.O.'d, or knocked out, the other – cause and effect capture

The closed setting of a boxing m metaphor for the theatrically stage abstraction and figurative painting a crescendo in 1959 when a number together and exhibited as the *Antip Arthur and David Boyd, Charles Blackman, John Brack, Robert Dickerson, John Perceval and Clifton Pugh, while the eminent art historian Bernard Smith orchestrated a written declaration of principles called *The Antipodean Manifesto*. The only Sydney artist of the group, Dickerson's membership of the *Antipodeans* affirmed the personal friendships forged during the 1950s.

Steven Tonkin

Axel Poignant 1906–86

Swagman on the road to Wilcannia (Australian swagman) 1954
gelatin silver photograph 50.4 x 40.1 cm
purchased in 1984 84.149

Time as it were, fuses together with space and flows into it,
forming the road. *M.M. Bakhtin*[133]

In the years since I stood on the road to Wilcannia in 1954, next
to Axel as he clicked the shutter and imprinted onto film his own
vision of the swagman, this back-view of the old battler's
Chaplinesque figure has lodged itself firmly in the national
consciousness. What accounts for the persistence of this
essentially male vision of Australian identity? Where does the
road to Wilcannia lead today? Has the way via the harsh land
led only to the soft centre inhabited by Crocodile Dundee?

Does the *Swagman on the road to Wilcannia* represent an after-
image of a fading national fiction, or is it more durable?

My inclination is to reclaim the photograph from the myth
and to restore something of its historical specificity. For Axel, the
encounter marked a moment both of recognition and of
intersection between the past and future. It was the place where
his own memories of wandering the back roads of New South
Wales in the 1930s in search of work collided with the vision of
'the sunlit plains extended'[134] in the bright patch at the end of the
road. Taken shortly after our marriage, it looked forward to a
new, shared life. Thus the dynamic power of the image lies in the
tension between the lonely figure and the promise of the distant
view, accommodating readings of both hope and despair, and a
shift of focus between biographical and universal interpretations.

Roslyn Poignant

John Brack 1920–99

Third daughter 1954
drypoint, printed with plate tone, from one plate on paper
17.5 x 12.3 cm
purchased 1977 77.728

The bathroom 1957
oil on canvas 129.4 x 81.2 cm
purchased 1998 98.168

John Brack was a Melbourne artist who in his work engaged with an urban reality, one which the great majority of Australians experience in their daily life.

In 1954, he began to explore the techniques of printmaking and created a series of four small, intimate images in drypoint, one of each of his daughters. *Third daughter* is a little gem in characterisation, where the stark frontality, the clenched fists and the scowling expression denote defiance. This is accentuated by the rigid geometry of the setting, contrasted with the chaotic crosshatching around the feet of the child. The lines have a lightly scratched crisp quality which is set against the soft velvety surface textures.

In 1957, Brack embarked on a series of remarkable paintings of the nude. Although each painting in the series relates to a particular artistic tradition and to a specific master – Boucher, Gauguin, Manet and so on – in each instance he subverts the tradition. *The bathroom* painting relates to the series of sensuous nudes by the French artist Bonnard, where the nude would frequently be located within a bathroom, illuminated from behind by a rich glowing light. In Brack's painting we encounter an un-erotic, non-sensuous naked woman, clutching her towel, appearing slightly absurd and out of place in a suburban green-tiled bathroom. The blinding acid pinks and yellows are painful on the eye and serve to stress the conflict between an everyday reality and the imaginary world presented in art.

Sasha Grishin

George Bell 1878–1966

The mirror 1956
oil on plywood 34.5 x 26.6 cm
purchased 1965 65.153

In this teasing interior, the sight of an overblown nude in her tasteful boudoir brings a bonny blush to the window ledge in the upper right. Like an eternal flame, an analogy that George Bell would have enjoyed, the curvaceous form of the backview figure surges upward to erupt in a froth of towel. Seen from a low viewpoint, this monumental and headless form is engaged in the timeless ritual of drying her hair.

As a convert to modern art after years of traditional training and practice, it is the *idea* of emotional pleasure that Bell sought to capture. Rather than imitate the form, therefore, he expressed his understanding of the nude through an exaggerated rhythm of serpentine lines, quivering masses and fiddle shaped forms (he played the viola).

Bell's reputation rests chiefly on his determined defence and advocacy of modern art in the 1930s, when art was going through a conservative phase. At the George Bell School (which he and Arnold Shore started in 1932), his influential teaching method emphasised life drawing from the model as a basis for memory painting. Bell also gave his students a sense of history and a thorough grounding in craftsmanship and techniques. *The mirror*, painted at the age of 78 for Bell's own pleasure, combines innovation and tradition in a way that suggests that they are complementary and not opposed.

Felicity St John Moore

Klytie Pate b.1912

High diving c.1950
glazed earthenware 41.6 x 25.3 x 23.3 cm
purchased 1981 81.317

Klytie Pate, along with Allan Lowe, was part of a small group of potters who, based in Melbourne between the two world wars, are now recognised as the pioneers in establishing the foundation for the current evolution of ceramic art in Australia. The lack of an established local tradition and limited access to current trends from overseas prompted a highly experimental phase during the 1930s and 1940s. These artists developed a style of ceramics distinguished by decorating surfaces with carving or incising, applying modelled ornament as handles or finials and experimenting with bold, bright glazes.

A wide range of sources has informed Pate's work. Throughout her long career, ancient Egyptian and Chinese art have remained the artist's strongest visual influences and this is evident in the carved decorations, subject matter and glazes of her pots. Better known for her elegantly carved lidded jars, *High diving* remains unique in Pate's oeuvre for its refined simplicity. Although

produced after the war, this vase represents an aesthetic popular in the 1930s with its theatrical, graphic and linear presentation of the figure and strong use of the silhouette to form ornamental handles. Pate's experiments with the exotic glazes of oriental pottery are used to evocative effect on this work, with the softly golden figures poised on the body of this elegant vase as if to plunge into the lustrous green below. The colour of this vase and fluid posture of the diving figures evoke the essence of swimming and frolicking at the pool which is so much a part of the Australian way of life.

From an early age Klytie Pate came under the guiding influence of her charismatic aunt, the artist Christian Waller. Pate was educated in Melbourne and studied drawing at the National Gallery School there and later sculpture and modelling at the Melbourne Technical College. Pate is a vigorous artist who has remained singular in her vision, exhibiting her elegantly carved and strongly decorated vases and lidded jars until failing eyesight only recently curtailed her pottery production.

Jude Savage

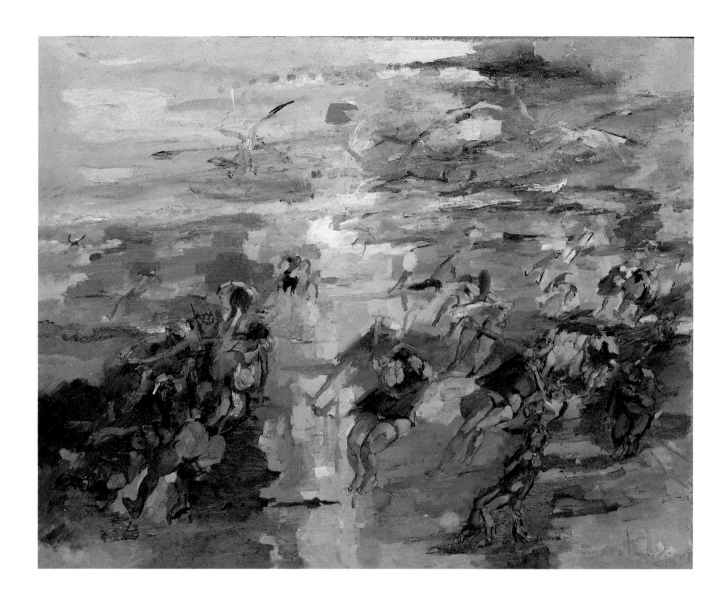

John Passmore 1904–84

South wind on the beach c.1955

oil on composition board 71.2 x 91.4 cm

gift of James Fairfax, AO 1982 82.595

They are moving against a wind; they must keep moving, as the wind buffets them about, exposed. The waves break on the shore. Birds spread their wings and float in the air, supported by the wind. In *South wind on the beach*, John Passmore evoked the experience of a windy day on the beach. He did not just depict how things look, or their underlying structure; he conveyed the impressions of his mind, through a mixture of visual fact and the relationships between colours energetically slashed onto the canvas. He derived even his most abstract works from nature, but he never created purely descriptive or literal images, capturing instead a psychic reality.

From an early age, Passmore watched sailing ships straining against the wind on Sydney Harbour, and he continued to be inspired by the harbour and the beach throughout his life. He probably painted *South wind on the beach* towards the end of his stay in Newcastle in 1954–55, at the height of his success.

In the 1950s, young Sydney artists admired Passmore's art for its painterly qualities and found him an inspired teacher, both at the Julian Ashton School and the National Art School. He advocated an approach to painting based on that of Cézanne and taught that what mattered most was to be a thinking artist. John Olsen, one of his most successful students, recalled that Passmore sought 'to make us understand that art comes out of something more than the personal ego – you are not just expressing yourself, you are expressing something implied by the whole tradition. Passmore was concerned in his teaching and in his own work to emphasize the process of the picture one has in hand, rather than the end product'.[135]

Anne Gray

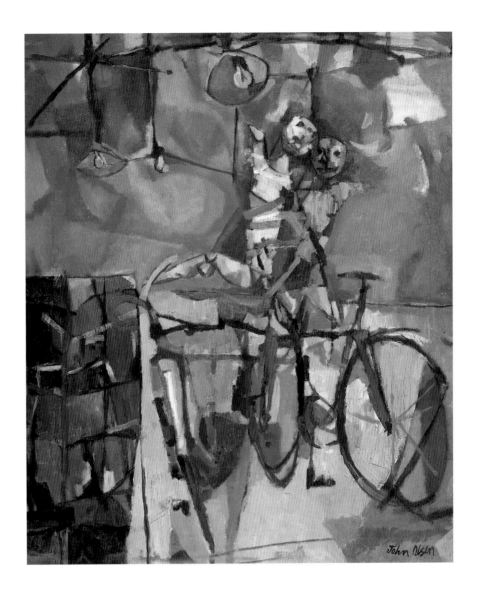

John Olsen b.1928

The bicycle boys 1955
oil on canvas 92.5 x 77.2 cm
purchased 1969 69.2
© John Olsen, 1955. Licensed by VISCOPY, 2002

The bicycle boys appears alive with promise – full of youthful energy and the transition of becoming. Later on, John Olsen would take up Paul Klee's idea of 'taking line for a walk' with gusto. At this point, in 1955, his line is still more tentative: defining particular shapes, circling the front bicycle wheel and dividing up planes of colour. There is a sense of the artist himself edging towards a new way of painting, yet still carrying with him aspects of John Passmore's teaching in relation to the figure, and thinking of Vittorio De Sica's film *The bicycle thief* (1948). This explorative melding of abstraction and figuration would become more confidently expressed in Olsen's works of the 1960s, such as *Sydney sun*. Imbued with luminous colour and an underlying poetic sensibility, this work nevertheless represents an important stage on the artist's journey.

This painting is one of a small group of works that Olsen undertook around the mid-1950s. The idea for using the subject of 'bicycle boys' in his drawings and paintings was in part based on his impressions of cyclists he saw on visits to Centennial Park in Sydney. As he said in an interview with James Gleeson in 1979:

> I used to go down to Centennial Park ... they had a lot of bicycle riding. And I was rather fascinated by the difference of the human body weight to the lightness of the bicycle. It had a kind of airiness about it. And they used to ride up and down hills; and the final moments of a race ... the winner would arrive and be absolutely totally exhausted. ... and they used to embrace each other and still there was that strange kind of balance thing ... I guess it stands as a disparity of the airiness of human rejoicing, with the perilousness of the bicycle shapes themselves.[136]

Deborah Hart

Schulim Krimper 1893–1971

Writing desk design 1955 construction 1960
New Guinea walnut and glass plate 74.5 x 172.0 x 78.0 cm
purchased 1982 82.2143.A-C

This classic of modern Australian furniture is a version of the desk Schulim Krimper designed for the Melbourne painter, Lina Bryans. Bryans wanted a desk that would float in the space under the suspended stairs at her East Melbourne home. Krimper responded with a plate-glass top supported by a hardwood trestle, pivoting on a cabinet of four drawers that could be swiveled to suit the writer. The contrast between the solid box and the spare drawing in timber and glass makes for the allure of this design.

The National Gallery's version of the desk (the third) was made for Robert Haines, director of the Queensland Art Gallery in Brisbane from 1951 to 1960 and a friend of Lina Bryans.

Krimper, a master cabinet-maker, had arrived in Melbourne in 1939 as a Jewish refugee fleeing Hitler's Germany. After Krimper established a workshop in Melbourne, Haines helped organise the exhibitions of the 1950s that found him a private clientele, and led to his enjoying a 'respect which had previously been accorded only to painters and sculptors'.[137]

The Haines desk is in New Guinea walnut, a timber whose density and colour delighted Krimper. If he repeated a design (which was rare), Krimper improved it: here, the cross-members that went towards the drawers in the Bryans desk cantilever in the opposite direction. This opens up space for the writer's legs and makes a feature of the flared, yet functional geometry. A solid plinth, not a swivel, attaches the desktop to the cabinet. The beauty of the desk's sculpted members and concealed jointing exemplify Krimper's passion for exact execution.

Roger Benjamin

Vincas Jomantas 1922–2001

Tower of grief c.1957

carved wood, stained and oiled, hessian, enamel 123.2 x 28.5 x 24.9 cm

purchased 1973 73.560

Tower of grief was carved from a single block of wood by Lithuanian-born artist Vincas Jomantas in about 1957. Although only a little over a metre high, the work has a totemic quality which gives it a commanding presence.

Jomantas's sculptures, usually carved in wood or cast in metal, have a strong emphasis on textures and technical skill. But his forms are symbolic rather than abstract, the projection of complex human emotions into bold, simple forms. Like many Baltic artists who emigrated to Australia, Jomantas found his forms in traditional motifs, in his case those of Lithuania. Vertical images that strive towards an image of the sun predominate, symbolising rebirth and fecundity after the darkness of winter.

Born in 1922, Jomantas trained with his father, a leading Lithuanian sculptor, before going on to study at the Lithuanian School of Fine Arts in Vilnius from 1942 to 1944 and the Academy of Fine Art and School of Applied Art in Munich, West Germany from 1946 to 1948. Jomantas arrived in Australia in 1949 as part of the displaced persons scheme and spent the following 11 years working in a variety of jobs. In 1960, he became a lecturer in the Fine Arts Department of the Royal Melbourne Institute of Technology where his virtuosi carving, which displayed the intrinsic qualities of materials, was appreciated. In that year he also became a founding member of the *Centre Five* group of sculptors, along with Clifford Last, Lenton Parr, and fellow émigré artists, Julius Kane, Teisutis Zikaras and lnge King. This group's commitment to creating art works for public places revolutionised the role of sculpture in Australia.

In 1961, Jomantas supplied a photograph of *Tower of grief* for Lenton Parr's small book, *The Arts in Australia: Sculpture*. In this photograph, he buried the base of the sculpture in sand next to an old sea wall, where it rose up like some strange new plant against the backdrop of a moody sky – a metaphor perhaps for his own exile from Europe and the ever-present grief caused by this separation.

Roger Butler

Joy Hester 1920–60

Lovers [II] 1956

brush and ink, watercolour on paper 75.3 x 55.5 cm

purchased 1973 73.33

© Joy Hester, 1956. Licensed by VISCOPY, 2002

The theme of love is a persistent one in the work of Joy Hester, particularly from 1947 until her untimely death in 1960. Her focused concentration on the human head and face as the source of feeling and psychological insight is the most distinctive aspect of her output. Compared with the work of a number of her peers in the 1940s such as Arthur Boyd, Sidney Nolan and her first husband Albert Tucker, Hester's work is elemental. It is neither narrative nor mythological, but instead pares away extraneous details to reach the essence of states of mind and emotional resonance. In her capacity to focus her vision – to encompass psychological complexity with a minimum of means – Hester recognised intuitively that the smallest details have the capacity to alter the mood of a work. She was able to compress a depth and intensity of emotion into specific features such as the eye, with a few precise strokes of brush or pen and ink.

In the 1940s, Hester was closely associated with the group of artists who have become known as the Angry Penguins, a phrase, coined by the poet Max Harris, which was the title of a well-known journal edited by Harris and John Reed. Hester received considerable support during these years from John and Sunday Reed, who drew a circle of artists and writers around them at their home at Heide on the outskirts of Melbourne. Hester's intense drawings during the war years were admired by many of her peers, although during her lifetime she did not receive the same public or critical recognition as her male counterparts. While Hester has often been most closely identified with the period of the 1940s, she went on to mature as an artist and to create many memorable images during the ensuing decade, as the collection of her works in the National Gallery of Australia reveals.

Lovers [II] is clearly one of Hester's most accomplished works. As in many of her other images of the human face, the artist eliminated features such as the nose in order to focus on the eyes and expressive qualities of the whole. Her mastery of drawing with a brush is evident in the way she delineates the heads and torsos of the joined female and male figures, combining dramatic contrast with immensely subtle washes of grey. Aware of the potency of spatial qualities, she also deftly utilises the white space of the paper to considerable effect.

The dramatic arc of the woman's neck is erotic, the long, vulnerable curve suggesting her sexuality and sensuality. The neck is framed between the woman's long, flowing black hair and the dark male torso. The luxuriant broad sweep of hair recalls Edvard Munch's *Madonna* 1895/1902, in which long black hair cascades around the woman's body. Munch's *Madonna* is, however, very definitely naked and goddess-like, whereas Hester suggests more earthly, modest touches in the lacy edges of the garment around the neck and shoulders. A transcendent dimension is conveyed in the swift, delicate notations of the woman's eyes which appear to be gazing into infinite space. While the figures are inextricably connected, the male is an ambiguous presence behind the female – a shadow between dark and light.

By the time she painted this evocative work, Hester was living with her partner, Gray Smith, whom she met in 1947. Around the time of their meeting, she had been diagnosed with terminal Hodgkins disease and, although she later went into remission for some years, by the mid-1950s symptoms of her illness began to recur. Smith and Hester experienced a passionate union of highs and lows. Smith, who suffered from epilepsy, was also an artist and shared Hester's love of poetry, storytelling and sense of the dramatic. In a letter to Sunday Reed in 1947, Hester wrote that she felt an intense identification with Smith: 'He is the "man" of me and I am the "woman" of him ... It's like a puzzle, piecing oneself together'.[138] In her works on the theme of love and lovers, including this masterful poetic image, Hester goes beyond literal representation to enter into the manifold ambiguities of relationships and states of being from a deeply personal viewpoint.

Deborah Hart

John Perceval 1923–2000

Figure of an angel playing a cello 1957

earthenware 30.0 x 24.0 x 27.5 cm

purchased 1972 72.529

reproduced courtesy of the artist's estate

There are some works of art that, given half the chance, would surely cast off the weight of words, the histories that preceded them. They would assert a presence that speaks for itself and, if we mere mortals demanded more, they might turn to music to make their point more clearly.

John Perceval's angels with musical instruments feel like such works. They confront us with their innocence and a knowing that is beyond easy description. They mingle beauty with raw energy, the earthly with the unearthly. The glazes that embellish their lively forms add to a feeling that these beings are recently born, carrying the accretions that newborns do, while their hollow eyes staring out at us seem to transcend mortality – as is the way with angels.

If we were to stick to the facts, it might help to know that Perceval, with Arthur Boyd and Peter Herbst, experimented with the ceramic medium at Merric Boyd's pottery at Murrumbeena in Victoria in the 1940s, extending traditions into new terrains of imaginative possibility. We might look for art historical angelic precedents and also find links with some of the figures in Perceval's paintings and drawings inspired by Brueghel and Hogarth.

But then again, if we did not know or find these things, the presence of these angels would still be there. Ingeniously crafted, they appear as robust free spirits. In the 1950s, Perceval and his good friend Mirka Mora, who also created many angels in her art, often engaged in free-spirited, outrageous behaviour – expressions of their longing to recapture a sense of play, interlaced with an awareness of the pitfalls of human nature, which Mirka described as the angels and devils in us all.

If we suspend purely rational thought in relation to Perceval's bold angels, we may be open to feeling their radiating energy, their unsettling, haunting presences – to imagine their timeless, vibrant music of sorrow and of joy.

Deborah Hart

Clifton Pugh 1924–90

A cat in a rabbit-trap 1957
oil on composition board 90.0 x 136.0 cm
purchased 1985 85.1752

In 1951, Clifton Pugh purchased a block of rugged bushland at Cottles Bridge, north-east of Melbourne, where he built a timber and mud-brick house and studio. He became a key figure among the post-war generation of painters concerned with the landscape, painting close-up snapshots of the bush and its unique wildlife. In his work, Pugh expressed his respect for the environment and his criticism of the intrusive and often disastrous actions of man, highlighted in his paintings of the feral cat.

The abandoned domestic cat is a particularly unwelcome intruder in the bush, a proficient and prolific hunter that wreaks devastation on small native fauna. In *A cat in a rabbit-trap*, the predator is now the victim. As if captured on film, the fragmented 'frame by frame' imagery suggests the violent struggle of the animal in a futile attempt to break free from the vice-like grip of the trap. The jawbone, in the upper-left corner of the painting, mirrors the clasping steel and alludes to the inevitable end of this struggle.

The rabbit-trap also indirectly refers to the damage caused by another introduced species, the rabbit, which at times has reached plague proportions across rural Australia. Both the feral cat and the rabbit are symptomatic of the destructive cycle of human impact on the native bush.

Steven Tonkin

Jon Molvig 1923–70

Primordia 1956–57

oil and wax on composition board 244.0 x 183.0 cm

purchased 1969 69.71

In 1955, Jon Molvig moved to Brisbane from Sydney where as a returned serviceman he had studied at the National School of Art. He arrived in Brisbane just ten years after the end of the war in the Pacific and the withdrawal of General Douglas McArthur's American troops from the city. When the troops returned home, they left behind a plethora of brothels, sleazy dance halls, hotel bars and nightclubs that had sprung up overnight to service them. Now these places of entertainment were left high and dry and gasping for life, like sea anemones in a rock pool after the tide has gone out.

Molvig loved the seedy underground tide that washed through the bars and brothels of Brisbane – those that had survived – it provided him with subject matter for many of his best pictures painted during those early years in that city. He painted *Primordia* towards the end of 1956: it was a demanding picture because of its large scale and scope. He wanted to incorporate all the painterly concerns that had been occupying his mind since arriving in Brisbane and he wanted it to be his masterpiece, like Picasso's *Demoiselles d'Avignon*. It was not, but it was an important milestone in his career.

The magnitude of this undertaking undoubtedly provided an incentive for Molvig because he loved nothing better than a challenge, and was always testing himself – and others!

The sustaining motivation was to manipulate paint and image in such a way that they would clearly communicate the deep-seated emotions that he attempted to bring to the surface each time he painted.

In *Primordia*, we see a giant demiurge (a supernatural creation-figure), legs splayed out and arms flailing against a sun which throws tongues of yellow flame into the top left-hand corner of the picture. The long looping brushstrokes that cross and re-cross the composition activate the whole picture surface, making it somewhat claustrophobic and airless. A white line loops around the figure, helping us to disentangle it from the background, twining around the legs, up the torso and coiling in the abdomen, as tense as an over-wound spring.

Molvig was fascinated by primal instincts, hence the title *Primordia*, the personification of that which is primitive in all of us. He was attracted to 'primitive' carvings, and I believe it is not accidental that the white line looks a little like engraved lines on wood carvings from New Guinea or Oceania. The tiny stick-like figures that surge forward from the left-hand framing edge towards the left knee, as if in worship, are a curious feature of this painting.

The picture relies on the energy of Molvig's muscular brushstrokes, which fuse the figure with its background. Yet it was not long after painting this picture that he made his first move towards isolating the figure from the background – a compositional change that became more pronounced in the 1960s.

Betty Churcher

John Coburn b.1925

Tiger, tiger, burning bright 1957
oil on composition board 60.2 x 89.1 cm
gift of John Coburn 1992 92.1422

I painted *Tiger, tiger, burning bright* in 1957 (I had discovered William Blake). It was one of the paintings of that year in which I arrived at my characteristic abstract style, one which I have used in many different ways during my career as a painter.

In 1953, having recently completed four years at the National Art School in Sydney, I had developed certain skills in painting and drawing and a rough knowledge of art history, but I didn't know what to do with them. Everything seemed to have been done better than I could do it. Then a big exhibition of French Modern Art came to Sydney at the Art Gallery of New South Wales, and this was my first view of paintings by Chagall, Matisse, Miró, Picasso, as well as many others by young French artists of the time. It was a revelation to me. After seeing it several times, I knew in which direction I wanted to go.

Over the next few years, my work became increasingly abstract. I was inspired by the new French and American painting which I saw later. I had seen, and copied as a student, examples of Australian Indigenous art at the Australian museum. I saw it all as a coming together of the new international abstraction and Indigenous art, with its spiritual reference to the Australian landscape.

In painting *Tiger, tiger* I tried to express the power and beauty of the tiger and also to capture something of Blake's poetry. I have always been interested in shapes and, as well as the overall shape of the tiger, I was interested in the negative shapes in the background.

John Coburn, 2002

Margel Hinder 1906–95

Revolving construction c.1957

monel metal and fuse wire, electric motor 61.5 x 81.7 x 83.0 cm

purchased 1980 80.3677

Composed in equal parts of 'geometry and poetry',[139] Margel Hinder's 'Revolves' are lyrical studies of the sculptural dimensions of space and movement.

Revolving construction, constructed of monel metal and fuse wire, is a delicate silver web of straight and curved lines. Suspended from the ceiling and powered by a small electric motor, the work slowly turns on its axis, presenting a complex choreography of opening and closing forms and of converging and dispersing lines. In *Revolving construction*, we see Hinder's highly sophisticated feeling for form within form, and for dynamic and asymmetrical composition.

American-born Hinder came to Australia in 1934 with her husband, artist Frank Hinder. Settling in Sydney, they soon became part of a small group of artists, including Ralph Balson and Grace Crowley, who were committed to exploring post-cubist abstraction in their work. Hinder's sculptures from this time were predominantly woodcarvings of abstracted organic forms. However, in the late 1940s and influenced by the European constructivist sculptors Naum Gabo and Lazlo Moholy-Nagy, Hinder began to experiment with 'modern' materials, such as wire and plastics, to construct open and transparent forms and to investigate the possibility of incorporating movement in her work. These experiments would eventually lead to the first of her 'Revolves', constructed in 1953. In her later career, Hinder executed many large-scale public commissions and was recognised as one of the pioneers of abstraction in sculpture in Australia.

Elena Taylor

Arthur Boyd 1920–99

Reflected bride 1 (Bride reflected in a creek) 1958
oil and tempera on composition board 122.0 x 91.4 cm
purchased with funds from the Nerissa Johnson Bequest 1999 99.42
Arthur Boyd's work reproduced with permission of Bundanon Trust

In 1951, Boyd visited Central Australia and witnessed the sad circumstances of the Indigenous people there. He travelled by the old Ghan train to Alice Springs and then by jeep to the former mining community of Arltunga. Before this time, as Grazia Gunn has recorded, he had only seen 'one Aboriginal, a chap around Melbourne who played a gumleaf'.[140]

Boyd was shocked and depressed to see the plight of Indigenous people. Their situation was not well known and he determined to show Australia that it had a moral responsibility to address such tragic neglect. Boyd was always the conscientious objector, the passionate protestor against inhumane treatment and acts of cruelty. He made many drawings of Indigenous people in his sketchbooks, but it was not until several years later that he began to make paintings based on them.

On the road to Alice Springs, Boyd had witnessed a truck carrying a group of Indigenous brides, whose white wedding finery contrasted sharply with the rudimentary vehicle normally used for transporting cattle. This memory was the origin of the 'Love, marriage and death of a halfcaste' series, better known as the 'Bride' series, an elaborate morality tale of an Indigenous trooper, a half-caste, and his half-caste bride. They are haunted by the dreamlike image of a white bride. For Boyd, the half-caste was the neglected outsider, neither black nor white, a nobody. His half-castes suffer the fate of the marginalised, isolated in a world of greed and selfishness.

In all there are, from 1955 to 1958, 31 'Bride' paintings, of which ten tell the main story of courtship, marriage and funeral. First exhibited in Melbourne in April 1958, the series met a mixed reaction, as it did later that year in Adelaide and Sydney. *Reflected bride 1*, also known as *Bride reflected in a creek*, comes in the middle of the series. It was painted in Melbourne in early 1958, the year Boyd's second daughter Lucy was born, and when he represented Australia at the Venice Biennale. It is a remarkable and memorable image, reminiscent of the story of Narcissus, condemned to fall in love with his own reflection.

Boyd was certainly aware of Marc Chagall's haunting and beautiful paintings of a levitating bride and groom. Chagall's bridegroom also had a green jacket with brass buttons and dark trousers. Boyd's paintings are not pretty, however, and carry a pervasive magical and somewhat menacing atmosphere. It is as if the figures and the landscape are one. The bride rises from the stream, an Ophelia caught by a groom whose foot hooks a tree. The bride is staring at an absurd mask-like white bride's head which appears to glow out of the forest. This is a surreal wilderness, a strange place of nightmarish dreams.

Boyd's painting responds to a contemporary trend among artists and writers who argued in favour of improved conditions for Australian Indigenous people. Yosl Bergner, Noel Counihan, James Wigley, Peter Graham, Russell Drysdale and Boyd's brother David, among others, sought to make a moral issue of the desperate plight of Indigenous people. Boyd may have been influenced by the feature-length movie of Charles Chauvel, *Jedda*, released in January 1955. The film was the first to feature Indigenous people in the leading roles. It told the story of an Indigenous girl reared by a white family who is wooed by an Indigenous outcast, Marluk. The film ends tragically after the couple are chased by the white police. Sidney Nolan's series of paintings about Eliza Fraser, a white woman who was shipwrecked and lived with Indigenous people, and Patrick White's powerful book *Voss* about the relationship between the title character and an Indigenous boy, were also prominent culturally at the time.

In 1975, Arthur Boyd made an extraordinary gift to the fledgling Australian National Gallery, now the National Gallery of Australia. He and his wife, Yvonne, gifted almost their entire personal collection of his work numbering hundreds of drawings, pastels, prints, paintings, sculptures and ceramics – some 40 years of art making.

The collection did not, however, include an example of Boyd's most famous and arguably his best works from the 'Bride' series. In 1999, the National Gallery of Australia was able to remedy this omission when the splendid *Reflected bride 1* was acquired.

The 'Bride' paintings are among the greatest expressions of conscience by an Australian artist. Brilliantly executed and of sustained quality, *Reflected bride 1* speaks to contemporary Australia, beseeching reconciliation, understanding and a tolerant, compassionate meeting of old and new cultures.

Arthur Boyd had his own idea for a new Australian flag: 'It would be nice to have a flag with two lovers. They needn't be lying down, they can stand up – and they'd be rather good. When it blew in the wind, they'd wiggle, hopefully a lot … I think that would be a wonderful flag, I mean it. I'd have a black man and a white woman entwined on a flag'.[141]

Brian Kennedy

Yvonne Audette b.1930

Cantata no. 8 1957–58
oil on composition board 128.5 x 100.0 cm
purchased 1993 93.6

When I went to Europe in the mid-50s … my work
responded to the layering of society itself – the remnants
of murals on walls, the frescoes, the whole antiquity of
the civilisation. *Yvonne Audette*[142]

The deliberate and careful layering of marks, signs and colours in
Yvonne Audette's lyrical and evocative paintings clearly reflects
the influence of Europe's multi-layered histories on the artist after
living for more than a decade away from Australia. Audette was
27 years of age and living in Italy when she painted *Cantata no.8*,
a highly sophisticated and intensely worked canvas that glows
with an indecipherable and private language.

While *Cantata no.8* is an early example from this artist's
oeuvre, the painting clearly demonstrates Audette's working
method – one of controlled and analytical mark-making where
each line or brush stroke is considered and individual. On
analysing this work, one can see how Audette has sparingly
dragged transparent layers of paint over the canvas, working
from a restricted palette of warm hues of yellow and gold,
overlaid with contrasting shades of blue. She worked energetic
square brush marks across the surface, only to scrape them back
and cover them with another thin layer – appearing then
disappearing – as if distant memories, reminiscent of the rich
cultural histories that surrounded her, were simultaneously
enlivened and modernised by Audette's unique painterly syntax.

Kelly Squires

Godfrey Miller 1893–1964

Still life, fruit and flower (Day and night) c.1959

oil, pen and ink, pencil on canvas 40.8 x 62.5 cm

purchased 1977 77.334

Still life, fruit and flower (Day and night) presents the throbbing life force in everyday things. It depicts still, quiet objects – a vase of flowers and a bowl of fruit – but it shows them through a shimmering prism, so that the objects appear to dissolve into the space around them – the hard edges of the vase and bowl seem to merge into the background, or into the web-like grid of the whole. We perceive the things as shapes, fragments of colour, patterns on a canvas – a flat, painted image. But so strong is our desire to make sense of what we see, that we soon begin to understand it as a world viewed through a pane of diamond glass; we translate it into a way of seeing that we know and understand.

Then, as we stand back and observe from our point of comfort, we notice that the picture is divided into two, into the warm, yellow side on the left and the colder blue side on the right. We notice the upright vase and the horizontal bowl. We see it as a contrast of sunlight and shadow, of day and night, of the active and the contemplative mind.

The artist, Godfrey Miller, played a dominant role in the Sydney art scene in the 1950s, teaching drawing at the National Art School. He portrayed simple subjects – still lifes, landscapes and the human figure – but his content was always philosophical. He was impressed by the ideas of Indian philosophy and by Wassily Kandinsky's book, *Concerning the Spiritual in Art* (1912). He painted with a geometric precision to create mosaic-like images with a pulsating sense of life, to suggest that everything in the universe coexists or interconnects.

Anne Gray

Justin O'Brien 1917–96

Miraculous draught of the fishes c.1958

pen and ink and watercolour on three sheets of paper

104.8 x 41.5 cm (overall)

purchased 2000 2000.460.A-C

reproduced by permission of the artist's estate

In 1954, three years after winning the first Blake Prize for Religious Art, Justin O'Brien renounced Catholicism in favour of agnosticism. Yet, religion and the spiritual continued to be amongst the great themes in his art. They held a fascination for O'Brien from the early 1940s when, as a prisoner of war in Poland and Athens, he developed a passion for Greek Byzantine art.

After the war, O'Brien returned to Australia and between 1945 and 1947 lived at 'Merioola', a boarding house in Sydney, with other artists, including Donald Friend and Loudon Sainthill. This house became a kind of bohemian centre, with its tenants made up of artists, writers, actors and photographers. During 1948 and 1949, he returned to Europe, where he toured the great museums and absorbed the works of the Italian and Spanish masters.

Duccio was perhaps the most influential on O'Brien's triptychs of the 1950s. The compositional structure of *Miraculous draught of the fishes* shows direct reference to the Italian master, as do the detailed landscape elements, flat picture plane and rigid, detached figures in an apparent state of langour. Gestural elements are also very similar to those in Duccio's works. Although there is an underlying sense of the drama and importance of the moment, it also possesses the same quiet stillness as in the works of Piero della Francesca.

Miraculous draught of the fishes, an ink and watercolour triptych, is typical of the detailed compositional drawings O'Brien prepared for his paintings. As an art teacher at Cranbrook School in Sydney for many years, he developed the strict attention to detail which is evident in much of his work. The theme of young, seemingly ageless fishermen is also one that reappears in O'Brien's work throughout his career.

Anne McDonald

David Moore b.1927

Lifesavers at Manly 1959
gelatin silver photograph 30.2 x 60.4 cm
gift of David Moore 1983 83.3554

In 1951, David Moore worked his passage to London on board the *Oronsay* as a shipboard photographer. He spent seven years overseas, fulfilling his ambition to become a photojournalist for the major picture magazines. While Moore was overseas, he adopted the small 35mm reflex camera instead of the older large format studio and press cameras. The experience was liberating and, with his training in shooting for the 'decisive moment' as needed in photojournalism, the 35mm camera allowed him to capture and express fluidity.

On his return to Australia in 1958, Moore brought new skills and a new eye to his Australian images. Where his 1940s work had a framework of strong geometric shapes and clearly defined spaces, the 1950s images show sensuous free flowing lines, arcs and arabesques which interweave and lift off from fixed base lines on the ground.

Moore's picture of the lifesavers at a surf carnival at Manly in 1959 was made for *Ambassador* magazine for an assignment on New South Wales. There is something quite sensuous in the way the men feed out the lines in unison. The image has an introspective, almost cinematic quality, as if the anonymous figures are moving in slow motion with all the grace of a shoal of fish. The feel of the image is quite different from the striding, bulky bronzed lifesavers of the 1930s tourist posters, or the protective heroes of the 'swim between the flags' campaigns.

Gael Newton

Abstraction and Social Change

1960—1974

Leonard French b.1928

In the beginning 1960

enamel, gold paint, synthetic polymer resin and oil on hessian

on composition board 137.7 x 122.3 cm

from the collection of James Fairfax, AO; gift of Bridgestar Pty Ltd

1995 95.350

© Leonard French, 1960. Licensed by VISCOPY, 2002

Leonard French's *In the beginning* is a painting which simultaneously appears as abstract and visually engaging, whilst at the same time relating to a traditional narrative and to medieval conventions of art.

The title alludes to the opening words of the Book of Genesis in the Bible, when God created heaven and earth. The artist himself refers to quite specific imagery in this work and notes: 'The symbols grow on the earth – the fish move vigorously alive – the sun a cross – the sun bursts its grave-cloth, exposing its newborn self – a miracle of renewed life'.[143]

French's actual technique of painting is unique in Australian art. He often starts with a phrase which may drift into his mind. He converts this into cut-out shapes and resolves them into a harmonious compositional arrangement. Then he builds up a relief ground in gesso, mixes dry pigments with clear enamel paint and superimposes layers of colours. Gilt may be applied to some areas, followed by several layers of glazes to create an immaculate, brilliant and luminous surface. While the mixing of colours, the gilding and the use of stencil shapes may relate to techniques associated with the signwriting trade in which French served as an apprentice from the age of 14, their combination and use in modern art have few parallels.

In an original manner, French creates an art charged with a spirituality which has a discernible narrative aspect and a spectacular decorative quality, but he has achieved all of this within an aesthetic framework which is recognisably of its time.

Sasha Grishin

Janet Dawson b.1935

Vers l'ombre (Towards the shadow) 1960
lithograph, printed in colour, from three stones on cream paper
38.6 x 44.2 cm
purchased 1966 66.57
© Janet Dawson, 1960. Licensed by VISCOPY, 2002

Vers l'ombre seems too fancy a name for this lithograph
and I prefer 'towards the shadow' – but the print was made
at Atelier Patris, Paris, a registered French atelier, and so it had
a French title.

In 1960, after two years study of lithography at the Slade
School of Fine Art, London, I arrived at Atelier Patris, keen to
learn the ways of a French lithographic workshop.

I was taken on as an unpaid helper. I worked for the love of
the job and the fun and excitement of being part of a busy centre
of art production in Paris, so very different from the 1950s
Melbourne of my student days. The situation blossomed and
soon I was a full-time proof printer for artists, mainly those
of the 'Paris School', who came to have their works printed there.

Before an edition of prints was made at the Atelier, the proof
printer and the artist would collaborate to make a set of five
artist's proofs signed by the artist, one of which would be labelled
the 'master' proof. The stones would then be passed to the
edition printer who would refer to the master proof as a standard
of quality during the printing of the edition.

Vers l'ombre is one of a group of prints I made and proofed
for myself towards the end of my time at Atelier Patris. They
were editioned by the workshop as a reward for the months
of unpaid labour.

Janet Dawson, 2002

Mike Brown 1938–97
Ross Crothall b.1934
Colin Lanceley b. 1938

Byzantium 1961–62

oil, synthetic polymer paint, collage of found objects on plywood

183.0 x 122.0 cm

purchased 1988 88.645

© Colin Lanceley, 1961–62. Licensed by VISCOPY, 2002

Byzantium is a collaborative work that encapsulates the freewheeling, experimental spirit of the early 1960s. It was created by Mike Brown, Ross Crothall and Colin Lanceley, who were known at the time as the Annandale Imitation Realists. The name of the group came in part from the Sydney suburb of Annandale where the artists worked in a ramshackle Victorian house, while the idea of 'Imitation Realists' was deliberately playful, irreverent and nonsensical – debunking pretensions of 'high art'.

Byzantium is certainly one of the most striking examples of the short-lived Annandale Imitation Realists' collaborations. Every part of the surface is covered with dense, intricate patterning and imagery. The artists were particularly interested in the images and intense presence of Melanesian masks and shields, and the way New Guinean artists collaged the debris of an introduced culture, such as bottletops, nails and tin cans, into their works.

The central figure in the composition, with outstretched cardboard arms, incorporates paint-tin lids (Lanceley worked for Dulux at the time) and a wide range of found materials. There are inferences in some of the figures and heads to Dubuffet and outsider art, and also to popular culture. In the Australian context, the artist who was most significant to them at the time was John Olsen, who had recently returned from Europe. As Lanceley said of Olsen's art: 'Its appeal for me was that it seemed a very inventive approach to painting – it looked as though there could be an enormous vocabulary, a great fund of imagery to be discovered'.[144]

Although Sydney based, the Annandale Imitation Realists had their first exhibition in Melbourne. Of this show Geoffrey Dutton wrote: 'The exhibition, in 1962, was at John Reed's Museum of Modern Art. It was as much a happening as an exhibition, and scandalized and delighted Melbourne'.[145]

Deborah Hart

Stanislaus Rapotec 1911–97

Experience in the far west 1961

synthetic polymer paint on composition board 135.5 x 184.0 cm

purchased 1963 63.23

Stanislaus Rapotec's rough, explosive series of 'Tension' and 'Disturbance' paintings were, provocatively, pure abstract gestures from an uneasy, poison-coloured subconscious. His parallel 'Experience' series is marginally less disturbing, since horizontal format and earth colours imply the repose of landscape. An *Experience in Broken Hill* 1962 was a token of the newest art being produced in Australia at the time but its title, referring to a famous mining-town source of wealth, also made it a particularly calculated choice for an exhibition prepared that year for the Tate Gallery, London.

Experience in the far west is a similar evocation of red-ochre, semi-desert country in the same part of the Australian outback, and was recommended for the National Collection by Commonwealth Art Advisory Board member Russell Drysdale because it was the same kind of work that the Board had sent to the Tate. Drysdale's own most disturbing images of drought and soil erosion had been painted after a visit in 1944 to the Western Division of New South Wales, south of Broken Hill.

A Yugoslavian, Rapotec served with the Allied Forces in the Middle East desert zones during the Second World War. He then emigrated to Australia and began to paint in Adelaide. He was fascinated by emptiness, and the accessible outback provided him with subjects for a stylised realism. Moving to Sydney in 1955, he caught the first wave of Abstract Expressionism and shifted to a large scale, working quickly and directly: 'The more you can pull out of your subconscious the closer you'll come to the quality which we call fluency, spontaneity, sincerity'.[146]

In 1959, an alarmed group of Australianist 'Antipodeans' denounced the generational swing to international non-objective art: 'Today *tachistes*, action painters, geometric abstractionists, abstract expressionists and their … camp followers threaten to benumb the intellect and wit of art with their bland and pretentious mysteries'.[147] The Abstractionists, mostly based in Sydney, responded to the mostly Melbourne Antipodeans with an exhibition called *9 Sydney 1961*, shown in both cities. Although it included pure gestural abstraction by Rapotec, Peter Upward and others, many of the works, for example those by John Olsen, were also landscape-based and thus fulfilled, in a challenging manner, the Antipodean 'duty [to draw] upon our experience both of society and nature in Australia'.[148]

Daniel Thomas

Henry Salkauskas 1925–79

Serigraph 1963
screenprint, printed in black ink, from one screen on paper
53.8 x 72.4 cm
purchased 1964 64.80
© Eva Kubbos

My work from about 1955 I would say is going in two parallel directions all the time. One direction in my forms and my work is based on a landscape or nature ... where the thing is deriving from nature or environment. The second ... is going where the elements and the forms are definitely free, non-objective, I would say, created completely without any connection with any environment or landscape or nature.
Henry Salkauskas[149]

Henry Salkauskas made a major contribution to printmaking and watercolour in Australia. At the age of 15 he saw his father, a Lithuanian patriot, arrested by the Russians and taken to a concentration camp in Siberia, where he later died. Fleeing Lithuania with his mother, Salkauskas studied art in Freiburg, Germany, where he specialised in the graphic arts.

A post-war immigrant to Australia in 1949, Salkauskas worked in a stone quarry in Canberra before settling in Sydney. It was there that he championed graphic arts in Australia.

Together with other 'new Australians', he organised the *First Australia-Wide Graphic Art Exhibition* in 1960, for the Contemporary Art Society of Australia (the Lithuanian Society of Sydney sponsoring a prize).

Salkauskas initially worked in wood and linocuts but, in 1958, was inspired to take up screenprinting. In 1963 his bold gestural screenprint, *Serigraph,* was awarded the Grand Prize at the Mirror Waratah Festival Art Competition, Sydney. The judge, Daniel Thomas, noted that this was the first time that a print had been awarded the prize in preference to a painting or sculpture. In the public's eye it legitimised the print as a work of art in its own right.

The first works that Salkauskas produced in Australia were figurative, referring to physical and cultural dislocation, while later images were expressionist landscapes using symbolic references to the sun and seasonal change. He constantly simplified his images to create bold compositions with dense black forms, but these never lost their reference to nature to become completely abstract. He admired the work of the Abstract Expressionists such as Kline, Motherwell and Soulages, but his own art was more a product of his European heritage and personality than the direct influence of these artists.

Roger Butler and Anne Gray

Peter Upward 1932–83

June celebration 1961
synthetic polymer paint on composition board; three panels
213.5 x 411.5 cm (overall)
purchased 1972 72.476.A-C

Peter Upward's *June celebration* is big, a pre-metric seven feet high. So, like any upright abstract painting of that height, it is an object that reflects the observer's human scale. John Olsen said 'it is impossible to look at [his paintings] without thinking of a man working, acting and moving behind them'.[150] Others thought of dance. James Gleeson said:

> There is a certain kind of dancing in which the conscious mind surrenders its vigilance and the body becomes a vehicle for the transmission of emotion … energy that finds release in spontaneous action [bearing] an intimate relationship with the mood or mental state of the moment. Peter Upward's paintings are like the movements of such a dancer.[151]

Upward himself spoke of Japanese Zen calligraphy, American Beat poetry, and jazz: 'Everything is done in one movement … with musical impulse, the same impulse as musicians when they improvise. My paintings are a series of chords and notes'. But also of the physical: 'Like the moment when a high diver cleanly enters the water'.[152]

The title refers to the month in which it was painted – on the studio floor with broom-sized brushes in a single uninterrupted campaign – especially for the manifesto exhibition of Abstract Expressionism, *9 Sydney 1961*. It was the largest work and the most characteristic of the new movement.

The previous year, Olsen's *Spanish encounter*, nearly as large, mostly black and almost abstract, had been the great art sensation in Sydney and *June celebration* is in fact an abstract paraphrase of a similar painting, *The procession*, given to Upward by Olsen.

Daniel Thomas

Dawidi Djulwarak 1921–70

Liyagalawumirr clan
Wagilag Creation Story 1963
natural pigments on eucalyptus bark 110.0 x 50.0 cm
purchased pre-1970 00.162

In the 1960s, the Liyagalawumirr artist Dawidi Djulwarak held the supreme authority for painting the story of the climactic events of the encounter between the Wagilag Sisters and Wititj the Olive Python. In this ancestral story, events take place through which key elements of the cosmology of the Yolngu, the inhabitants of Arnhem Land, are set in place. The story of the Sisters and the consequences of their exploits is owned by six clans of Eastern and Central Arnhem Land (the Galpu, Rirratjingu, Marrakulu, Wagilag, Liyagalawumirr and Golumala).

Through Dawidi's authority comes the capacity to paint encyclopedic paintings like *Wagilag Creation Story*, in which the artist condensed as many of the details of the narrative as possible into one painting. From his grandfather, Yilkari (1891–1956), Dawidi inherited a painting tradition which enabled him to represent the multiple events of the story in a uniquely complex manner. The ancestral story sets the rules for the social and natural world, and is represented by the consequences of a series of transgressions – by the Sisters – and by the ancestral snake who is shamed when he eats the Sisters, his relatives. Using a distinctive painterly perspective, in which space and time appear to be warped and condensed, Dawidi depicted the elements of the story simultaneously and sequentially, both literally and abstractly, as a key to the artist's deep knowledge and as a score for ritual performance.

The key to this painting is the semicircular waterhole at the bottom of the painting. It is conceptually the centre of the cosmos, from which the figures depicting the events of the story radiate. Being the artist's conception site, it is also a representation of Dawidi himself. The mystery in this figure is explained by the fact that the sacred waterhole is also, visually, a mirror. As in all self-portraits, we are invited to see the vantage point from which he experiences his knowledge of the world, as if looking through the artist's own eyes.

Nigel Lendon

Roger Kemp 1908–87

Equilibrium c.1965

synthetic polymer paint on composition board 122.0 x 183.0 cm

purchased 1978 78.548

Roger Kemp was a mystic, who developed in his art a form of emblematic symbolism which has no close parallels in the art of either his native Victoria or elsewhere in Australia. Early in his career, he rejected figurative naturalism and embraced the idea of Modernism, but this for him dealt less with the rejection of reality and more with a liberation from the tyranny of imitating a literal reality.

Kemp worked in a carefully controlled palette of singing vivid blues, reds and white, but it is also one which glows with an inner luminosity. A tight ambiguous space contains the composition, establishing a relativity between one form and the next and creating an endlessly expanding vision. In *Equilibrium*, a black armature surrounds the colours, bringing to mind the great rose window of Chartres Cathedral and the paintings of Rouault. Working in synthetic polymer paint on a hardboard surface, the gestural sweep of the marks is proportional to the scale of his own body, giving the painting a human dimension. He created a dense pattern of symbolic forms built around what he termed the square of the masculine and the circle of the feminine, all of them pulsating and drifting within the surface film of the paint. Although the painting is primarily non-figurative, it is possible to interpret some of the imagery as a reference to a cruciform shape dynamically cast and rotating in space.

Kemp's painting, both in its execution and its perception, is an intuitive, spiritual and meditative experience.

Sasha Grishin

Grace Cossington Smith 1892–1984

Interior in yellow 1962, 64

oil on composition board 121.7 x 90.2 cm

purchased 1965 65.160

It is the artist's bedroom, formerly her parents', in the house that had been her home for 50 years. She loved the place whose name she also bore, but as a young Post-Impressionist she usually painted more public domains, Sydney city streets, construction sites, theatres. Eventually, however, her art came home to concentrate on Cossington, in the highland suburb of Turramurra.

Parents long dead, three siblings gone and only invalid sister Charlotte left to share the house, Grace had turned 60 and was less out-and-about. Her easel strayed from the studio to various indoor rooms. In the first of the late, great paintings of Cossington, *Interior with verandah doors*, 1954 (also in the National Gallery's collection), we look from the other side of this same bed to two glass doors, open to morning light.

She answered a questionnaire. Personal art philosophy? 'Art is the expression of "whatsoever things are lovely", at the same time expressing things unseen – the golden thread running through time.'[153] So to say 'I sit here a lot; you get to know it', implied memories and emotions as well as things seen.[154]

Immediately before beginning the golden interiors she had sent *'I Looked, and Behold, a Door was opened in Heaven'* to the new Blake Prize for religious art. Through a homely door exactly like the one in *Interior in yellow*, we see a vision revealed to St John. The artist liked finding 'a lot of different "visions"'[155] of doors seen through doors, and liked to remember that before the Smiths lived here the house had been a Quaker meeting place, designed in the 1890s as a dwelling that could become a kind of church.

An early sketchbook drawing of a figure raising her arms in the kitchen doorway, seen from the garden at dusk, called up another memory. 'I was taken by the lighting, dark out, light inside; I'm sorry I didn't do a painting. A nice feeling, the end of day, going inside. What Dad used to say – "The Smile of Home".'[156]

It was the time when she transcribed a text about 'The psychic and philosophical messages of colour'[157] and when the writer Ethel Anderson first thrilled Grace with art talk. 'The exciting new concept of space composition … a perspective beyond the boundaries of the frame. The subject … could expand inwardly or outwardly … in the cube, not merely on the surface … With your unique brush stroke, with your grasp of colour … *You* may find a fourth-dimensional emotion as yet unfound, un-named.'[158]

Of *Interior in yellow* the artist said: 'The chief thing to me was the yellow walls ... It was a very exciting thing to do … express an interior with light … the sunlight did not come in in a definite way but the whole room seemed to be full of light'.[159]

Vibrations from the square touches of yellow paint – her favourite colour, 'The colour of the sun!' – certainly express a refulgence of indirect sunlight, but there is much more.[160] Tennis on the lawn and tea on the verandah, memorised in the wardrobe mirror. Dresses on hangers waiting to be warmed by sunlight when the mirror-door opens (as in a marvellous coloured-pencil sketchbook drawing in the National Gallery collection). Artist colleague Roland Wakelin, whose painting hangs above the bookshelves. The door to the heart of Cossington. The other Cosssingtons, her own birthplace in Neutral Bay, Sydney, her mother's rectory home in England. Dad's 'Smile of Home'. Mother, another Grace, who had languished here with cancer. The yellow wall beyond which favourite sister Charlotte lingered for six years – a hospital bed installed in the family dining room – and where she died just before *Interior in yellow* began. Grace's broken hip from a fall, alone in the house, causing this to be the only painting set aside nearly completed, and finished two years later. The bed was the unfinished part, and crucial.

Like the ecstatic, abstract draperies that fill old master religious paintings, the rumpled bed cover and clothes are devices that connect the spectator to a surge of visual and emotional energy. Across a contemplative place of solitary sleep and dreams and maybe death, the wrinkle-lines and the touches of colour drag us deep through the sun-filled looking-glass, which in turn throws us back to a place of once and future outdoor activity. We and other things outside the painting are embraced by the radiant forms and colours. Space and time fulfil the prediction: a sacred place, fourth-dimensional. As Ethel Anderson said after her encounter with Grace Cossington Smith in 1925, 'there were truly great artists in Australia, and she had just met one of them'.[161]

Daniel Thomas

257

Keith Looby b.1940

Resurrection 1964
oil on canvas 263.7 x 391.7 cm
gift of James Fairfax, AO, 2000 2000.343

Resurrection is the second in a sequence of canvases from Looby's years in Italy (1960–64) that plays on religious, personal and artistic concerns. *Resurrection* is a young artist's work, its mural scale demanding stamina and ambition to incorporate the universe of ideas and visual sources from the early Renaissance and Byzantine era. Though not devotional, and indeed doctrinally naïve, 24-year-old Looby had been excited by Pope John XXIII's initiation of Christian–Marxist dialogues.

The painting allowed for hope, even if it displayed the faith of a doubting Thomas. The *momento mori* in the top right-hand corner shows the skull of the ape, a Darwinian more than a Christian comment. Perhaps the key is the figure on the left who carries a candle as if seeking the truth, but who has turned his back to the scene.

As in frescos and icons, the structure involves a hierarchy of power, with cardinals on the top and holy clowns along the bottom. The crucified and resurrected Christs merge in a central double-headed, mask-like image, which is tied to the Pieta beneath. Vertical lines of limbs and faces are set against horizontal and diagonal sticks to establish the design, in which sculptural figuration and repetitive physiognomies blend into a cartooning style peculiar to Looby. The crowded feel is relieved by the play of light and colour.

As Jeffrey Smart wrote at the time, *Resurrection*'s place as an Australian masterpiece comes from Looby's control of its contraries, from the achievement of stillness despite its busyness.

Humphrey McQueen

Justin O'Brien 1917–96

Man in a red jacket c.1960

oil on canvas 60.5 x 50.4 cm

purchased 2000 2000.1005

reproduced by permission of the artist's estate

The young man leans forward in a relaxed pose, but he is lost in his own thoughts. His large eyes stare, as though he is observing us. Introspection not scrutiny, however, is the theme.

There is a delightful elegance to Justin O'Brien's use of contour and colour. He loves his paints and holds them to their place by a strong sense of pattern making and decoration. The young man sits next to a famous Russian icon, symbolic of religious tradition, Andrei Rublev's *The Old Testament Trinity* c.1408. His elongated face and hands, the folds of his jacket and trousers, are fixed in time, suspended without motion, a static image, an icon.

Justin O'Brien produced a series of portraits of boys and young men while he was Art Master at Cranbrook School in Sydney from 1946 to 1967. They are among his best works, peculiarly detached, his sitters objectified in eye-catching colours.

O'Brien had visited Europe and feasted on its galleries, especially the National Gallery, London. Traditions of religious painting inform *Man in a red jacket*. O'Brien was fascinated by the still, elegant precision displayed in the work of masters of Flemish art, Dieric Bouts and Gerard David, and also by the Italian Renaissance masters. He also had a close eye on his own century. *Man in a red jacket* is redolent of Modigliani, Brancusi and Balthus in its simplified realism.

Given his fascination with Italy and classical tradition, it is no surprise that O'Brien settled in Rome, spending time also in Greece. He had exhibitions regularly in Australia and he died in Rome in January 1996. Often under-appreciated, O'Brien's work is unusual in Australian art, and evidence of a profound religious artistic sensibility.

Brian Kennedy

Ian Fairweather 1891–1974

Turtle and temple gong 1965

synthetic polymer paint and gouache on cardboard on composition board 144.5 x 188.5 cm

from the collection of James Fairfax, AO; gift of Bridgestar Pty Ltd 1999 99.95

© Ian Fairweather, 1965/DACS. Licensed by VISCOPY, 2002

Ian Fairweather began his artistic career in the early 1920s at the Slade School of Fine Art in London, but his long career took him far from England and English art. Not long after finishing at the Slade, he travelled steerage to China in search of adventure and this was to be the beginning of over 20 years of nomadic life, moving through the Orient and the islands of the Pacific.

While in China, he realised the expressive power of the great calligraphers and perfected his own skills as a scholar of Chinese language. He said of the calligraphies, 'there was about them a severity, a chaste beauty that made me dissatisfied with everything I had done'.[162] From this time on, Fairweather always worked on paper or cardboard, and line became his principal means of expression. By working on paper with quick-drying acrylic paint or gouache, he could expand or contract the composition according to the needs of the picture as it developed. If the picture needed to grow, he simply joined on more sheets until the picture was big enough to hold his idea.

In Bali, he found a subject matter that was in perfect tune with his creative bent. He said, 'The whole island glowed. It was a painter's paradise'.[163] He was able to live there with only the basics of existence – he had always longed for a simple life.

Ian Fairweather painted *Turtle and temple gong* in 1965, in the Malay-style thatched hut that he had built for himself on Bribie Island in the mouth of the Brisbane River – but he was drawing on his earlier memory of Bali.

He had expressed a desire to go to Australia two years before his move to Bali in 1933. He wrote: 'and then Australia, the never-never land – so lies the trail, for I have another intimation – never to go back on the way I have come'.[164] Nevertheless, it was not until 1952 that he finally came to rest on Bribie Island in a grove of native pines. Here he felt safe and able to live close to nature, in absolute harmony with his environment, and here he found the silence that he wanted. He was by nature a hermit.

Fairweather was almost 75 when he painted *Turtle and temple gong* on four sheets of cardboard, creating a masterpiece of linear construction and demonstrating the full impact of his sustained study of Chinese calligraphy.

Fairweather's method of painting was a matter of endless additions and subtractions, building a complex web of lines that gradually took shape. In this picture, he worked on a memory of a temple courtyard in Bali; the court is surrounded by rest-houses and, in the centre of the courtyard, there is the temple gong – and of course the turtle. Perhaps the turtle and gong are part of a Balinese or Buddhist tale, or perhaps it is something remembered from a Chinese text. The construction of the picture is so open-ended that, while you can make out the flimsy structures of the temple buildings, only the turtle and gong alert you to the subject. Yellow and black are the main building blocks of the composition but you can see the intricate web of grey and white lines that underlie it. It would be a mistake to see this as an abstract picture; Ian Fairweather always hotly denied that his paintings were abstract. 'Abstraction doesn't suit me', he said. 'I will always put into my paintings some representation.'[165]

It is tempting to see these late works as being influenced by his landscape environment on Bribie Island. In the midst of his grove of pines, the dappled sunlight fell as patches of shifting shapes on the white sand. This delicate tracery of light and shade seems to have infiltrated *Turtle and temple gong*. Fairweather was drawing on over 20 years of memory when he conjured up this image of a temple in Bali, but his sensibility was alive to what he saw each day in his island home. Although some element of his English training remained with him to the end, it was the expressive beauty of Chinese calligraphy and the dappled light of Bribie that shaped his later works.

Fairweather had exhibited with the Macquarie Galleries annually until his death in early 1974. The Directors of the Macquarie Galleries tried from time to time to encourage him to paint on something more robust – more permanent – and on one occasion sent him a roll of top quality linen canvas: he used it to patch the holes in his thatched roof! He said, 'To hell with posterity! It'll take what it wants, and can look after itself'.[166]

Betty Churcher

261

Colin Lanceley b.1938

Pianist, pianist where are you? 1964–65

stained and painted wood, enamel, polychrome piano keyboard and

sounding board 183.5 x 248.5 x 30.0 cm

purchased 1976 76.165

© Colin Lanceley, 1964–65. Licensed by VISCOPY, 2002

Pianist, pianist where are you? was completed in early 1965 and almost immediately exhibited at the newly-opened Gallery A in Paddington. I was about to sail to Europe aboard the *Fairstar*, having won the Helena Rubinstein travelling art scholarship the previous year. This work is the second piece to use a musical instrument theme. 1964 also saw the creation of *Kindly shoot the piano player* and *Gemini*; all employed piano parts and *Gemini* was one of my panel of five works in the Rubinstein scholarship exhibition at the Art Gallery of New South Wales in Sydney that year.

I had been working with collage since the early 1960s, extending my painterly language by adding found objects collected mostly in Sydney's streets and lanes, all broken and discarded – torn posters, broken furniture pieces, crushed and rusted tin and bits of plastic kitsch. I have always collected objects and surrounded myself with them as a source of visual stimulus. The unexpected relationships between disparate objects often form a poetic thread of creative possibility. The meanings that cling to the edges of battered objects, often poignant and evoking powerful emotions shaped by the imagination, are both what these works are about, and the manner of their making.

Pieces of a small organ and the innards of a Bluthner piano dumped in the bush could be, in themselves, the subject for a work, but at the time it was the excitement of finding the materials and of re-constructing them after an imagined model that interested me. The transformation of materials, the metamorphosis, informed by a poetic sensibility, is the key to creativity.

Colin Lanceley, 2002

Martin Sharp b.1942

Mister Tambourine Man 1966
screenprint, printed in colour, from multiple stencils on gold foil paper
76.1 x 50.8 cm
purchased 1972 72.12.4

This poster is one of my first published works after my arrival in London in 1966. I can remember my dear friend Eifa Vehka-aho creating all the beautiful circles that make up Bob Dylan's hair and which contribute so much to the work. The photograph, which forms the main image, was enlarged from a small photo in a book. The central image in the hair is a knot design, possibly by Leonardo da Vinci.

Aubrey Beardsley's work was enjoying a revival at the time and there were many posters being produced from many sources and periods, as well as by the young artists of the day. There is certainly a Beardsley flavour. The lettering is by me and all these elements were collaged together to make the complete image.

Bob Dylan's 'Mister Tambourine Man' was a favourite song of mine. My poster is really just a tribute to Bob Dylan, a songwriter and singer I have greatly admired since first hearing him in 1964. The poster was printed by Peter Ledoboer, who was the printer of *OZ Magazine*, and he also distributed it to the numerous poster shops and stalls. It was sold for £1, in an unlimited edition, and was very much a part of the times in London in the late 1960s: a decoration.

Martin Sharp, 2002

Lenton Parr b.1924

Agamemnon 1965
welded steel, enamel paint 106.0 x 218.0 x 94.0 cm
purchased 1968 68.93

In Greek mythology, Agamemnon was the warrior King of
Mycenae who led the Greek armies in the destruction of Troy.
For the viewer, Lenton Parr's title encourages associations with
the armour and weapons of ancient combat, such as might be
unearthed during an archaeological excavation. The blackened
and blistered 'body', with its tripod of spindly legs, stands
directly on the floor, without a plinth, and inhabits the same
space as the viewer. When approached, the sculpture seemingly
metamorphoses into an armoured crab-like creature and a
menacing adversary.

Agamemnon encapsulates the stylistic precedents and the
personal innovations made by the sculptor in his work during
the 1950s and early 1960s. Parr studied sculpture at the Royal
Melbourne Technical College before travelling to England in 1955,
where he worked as an assistant to the internationally acclaimed
sculptor Henry Moore. During this time, Parr became acquainted
with younger artists such as Reg Butler and Eduardo Paolozzi,
whose abstracted welded-metal sculptures were seen by the
English art critic Herbert Read as embodying a so-called post-war
'geometry of fear'.[167] Parr returned to Melbourne in 1957 and
embarked on a long and distinguished career in art education,
which culminated in his appointment as Director of the Victorian
College of the Arts from 1974 to 1984.

In the 1960s, Parr exhibited with the group *Centre Five*, which
had formed in Melbourne to foster and promote the public
appreciation of sculpture in Australia. Other members included
Vincas Jomantas, Julius Kane, Inge King, Clifford Last, Norma
Redpath and Teisutis Zikaras. The group sought to facilitate
closer working ties with architects, to expand the role of sculpture
as public art, and to increase the representation of sculpture in
public collections. Perhaps as fitting recognition of this last
endeavour, Parr's welded steel sculpture *Agamemnon* was one
of the first works of contemporary Australian sculpture bought for
the National Collection in 1968.

Steven Tonkin

Clifford Last 1918–91

Forms in majesty 1964, 1966
carved Tasmanian oak 172.0 x 56.8 x 38.8 cm
purchased 1966 66.128

Rosemary Madigan b.1926

Eingana 1968
carved English limewood 61.0 x 364.8 x 30.4 cm
purchased 1980 80.8
© Rosemary Madigan, 1968. Licensed by VISCOPY, Sydney 2002.

In the first half of the 20th century, the practice of 'direct carving' into wood or stone was seen as a modern, indeed authentic, means of translating an artist's inspiration into material form. Indebted to this idea, Clifford Last developed an approach by which he would allow a work to evolve almost organically through an understanding of, and 'truth to', the materials. He was particularly inspired by the work of British sculptors Henry Moore and Barbara Hepworth, which he encountered in London before arriving in Australia as a post-war migrant in 1947.

In *Forms in majesty*, Last created a skilful interplay of smooth and rough textures, with 'cloaked' exterior surfaces complemented by interior spaces hewn out of solid wood. His two anthropomorphic forms are the same height as that of a human figure. Orignally part of a three-figure 'holy' family group carved in 1964, the two adult figures were reworked as *Forms in majesty* in 1966, and draw an analogy with Adam and Eve.

Last's sculpture can be considered 'materially' Australian because of his primary choice of local timbers such as jarrah, blackwood, or Tasmanian oak. In *Eingana*, a carved relief in English limewood, Rosemary Madigan has produced a distinctly Australian work by synthesising two visual traditions and two creation stories. By drawing on motifs from both Indigenous art and the tradition of western art, this work reflects a personal journey of reconciliation that recognises a wider obligation. Madigan began to receive due recognition in the 1970s following the National Gallery of Australia's acquisition of her work.

Steven Tonkin

John Olsen b.1928

Sydney sun 1965

oil on three plywood panels 305.0 x 412.5 cm (overall)

purchased with funds from the Nerissa Johnson Bequest 2000

2000.342.A-C © John Olsen, 1965. Licensed by VISCOPY, 2002

I recall coming into the Harbour in the early morning after being in Europe for several years, the surrounding hills seemed to cradle the sun's light – like a benevolent bath, bubbling and effervescent. [There was] the image of things growing, pullulating from the sun's source. *John Olsen*[168]

Sydney sun reveals John Olsen's innovative approach to painting and his imaginative response to place that came to the fore in the 1960s. Compared with his earlier more intimate work, *The bicycle boys*, here he demonstrates a much greater confidence not only in painting what is seen but also what is felt and experienced.

During the mid-to-late 1950s, Olsen was endeavouring to discover what he described as 'a new kind of figuration'.[169] In essence, he wanted to go beyond literal representation without abandoning imagery and content. In the 1956 catalogue for the *Contemporary Australian Paintings: Pacific Loans Exhibition*, Olsen noted that his painting took on a particular abstract quality because he was seeking a 'direct mystical experience'. 'The thing which I always endeavour to express is an animistic quality – a certain mystical throbbing throughout nature.'[170]

Of particular significance to Olsen's efforts to bridge the gap between abstraction and figuration was his interest in Zen Buddhism. As he noted in his 1958 journal, 'Zen realises that our nature is at one with objective nature … in the sense that we live in nature and nature lives in us'.[171] For Olsen, texts such as D.T. Suzuki's *Zen and Japanese Culture* and Eugen Herrigel's *Zen in the*

Art of Archery allied this idea with an intuitive response in painting process, 'attuning the mind to the utmost fluidity or mobility to acquire the spontaneity of natural growth'.[172] In the early 1960s, Olsen became interested in the notion of our interdependence with the natural world and this became central to his art.

In 1960, Olsen returned to Australia after three years in Europe, spent predominantly in Spain. Along with a range of artistic sources which he had encountered in Europe, the environment of Sydney provided a rich basis of inspiration. After his experience of living in an old Mediterranean culture, he found the local environment magically vibrant and alive. He was struck by the brightness of the light, the fluctuating topography of the harbour and the robust energy of urban life. In the ensuing period, Olsen became closely identified with the city. As Laurie Thomas wrote in the introduction to Olsen's Opera House journal, *Salute to Five Bells*, Olsen 'has created Sydney – its harbour, life, vulgarity, beauty, movement – in the way that Drysdale created the outback'.[173]

As opposed to the Renaissance conception of perspectival space, Olsen wanted to create 'an all-at-once world'.[174] As he later wrote in his Opera House journal: 'I like to be in the middle of a buzzing honey pot of images changing and evolving … I like painting to have a human unpredictability'.[175] In works such as *Sydney sun*, the use of multiple viewpoints – incorporating what is above and below, inside and outside, the microcosm and macrocosm – also has affinities with Indigenous art which Olsen greatly admired.

Sydney sun was originally conceived as a ceiling painting. This is one of the most significant examples of the small number of ceiling paintings that Olsen created in the 1960s. The first public viewing of the ceilings occurred in exhibitions in Sydney and Melbourne in 1965. Bernard Smith wrote:

> At South Yarra Gallery [Olsen's] sumptuous and refulgent colour pours down upon us from the ceilings and walls, a resplendent exhibition which takes vitalism and colouristic exuberance about as far as it can go.[176]

Sydney Sun is an optimistic, life-enhancing work that encompasses the exuberant vitality of place. Beyond specificities of location, the painting also has universal implications. It conveys the artist's passionate, imaginative response to the natural world. From the powerful life-giving energy of the golden orb, the rays become exploratory, meandering tentacles, at one with the plant forms and ecstatic scatter of pollen, at one with the various irrational creatures that have come under its pulsating spell.

Deborah Hart

Vivienne Binns b.1940

Vag Dens 1967
synthetic polymer paint and enamel on composition board
122.0 x 91.5 cm
purchased in 1978 78.1302
© Vivienne Binns

I made *Vag Dens* when I was a young artist, only a few years out of art school. It is one of a pair of paintings with sexual themes which arose out of a desire to represent male and female sexuality through images. I woke up one morning with the images in my head, and felt it imperative that I make these paintings.

I was very interested in the Surrealists and Dadaists; their emphasis on dreams, the unconscious and sexuality was very powerful for me. There was a fair amount of tension about sexual matters at the time, especially for young people growing up. In the arts and literature and amongst those who were concerned for personal and civil freedoms, censorship was a major issue.

The name *Vag Dens* did not occur to me until after the painting was finished. A friend who was a psychologist told me that the image of the toothed vagina appeared in many cultures over many centuries; it was called *Vagina Dentata*. I was amazed, I had no knowledge of this.

The teeth had not been in my mind at all, initially. When they occurred I resisted as it seemed too strong an image They continued to insist in my mind as I struggled to bring the painting to a conclusion. Eventually I thought, 'what the heck', and put the teeth in. To my surprise the whole thing came together and was done.

I've often puzzled over the teeth. It's never simply been an image of castration to me, I think of it as a symbol of legitimate power. Just as the beautiful rose with its sweet smell has thorns and the tigress has teeth which can both rip animals apart and gently carry her cubs, so this imaginary form represents the power of the feminine.

Vivienne Binns, 2002

Henry Talbot 1920–99

Fibremakers Australia fashion study c.1964
gelatin silver photograph 23.8 x 18.9 cm
purchased 1989 1989.1436

Born Heinz Tichauer in Germany, Henry Talbot as a Jew had to escape the Nazis by fleeing in 1939 to England, where he was interned and later shipped to Australia on the now infamous voyage of the *Dunera*. Talbot later served in the Australian army until the war's end. While visiting his parents in Bolivia after the war, Talbot revived his pre-war interest in photography. He returned to Australia in 1950 and worked as a photographer; in 1956, he set up a joint studio specialising in fashion and advertising in Melbourne with fellow *Dunera* internee Helmut Newton. By 1958, Talbot was named Fashion Photographer of the Year by *Australian Fashion New*s, while Newton had established himself in Europe.

Talbot revelled in the high times and youth culture of the 1960s, when fashion was aimed at young people and sought a 'funky' look. For an assignment for Fibremakers Australia,

Talbot photographed Jackie Holme, one of the models who was the new face of the 1960s, against a backdrop of the radio telescope at Parkes, New South Wales. She is the new 1960s woman, always on the move. Talbot's description of his approach to a shoot expresses the free-wheeling times:

> I'm not one of those machine-gun shooters, you know. I would always set up a mirror beside me and the lady would move, watching herself. When the moment hit, I would take the shot. It would always depend on the model, that moment, and I had to be ready for it.[177]

Space exploration and travel permeated popular culture in the 1960s, following Yuri Gagarin's orbit around the earth in 1961 and culminating in Apollo 11 in 1969. In fashion, Pierre Cardin launched his Space Age Collection in 1964. The Australian fabric designer Bruce Finlayson set the mood for the shoot at Parkes by his use of modern synthetic materials to create fashions for the new age.

Anne O'Hehir

Brett Whiteley 1939–92

Fidgeting with infinity 1966
oil, collage, pencil, photographs and fibreglass on three panels
244.0 x 382.0 cm (overall)
gift of Philip Bacon, AM, 2000 2000.13 A–C

When I first saw *Fidgeting with infinity*, it had a profound effect on me. It derived from old master tradition, yet incorporated photography and collage. In a visual melange, my eyes absorbed dead bodies, tiny writing, a blank word balloon, a swirling road, vultures, protruding breasts, vulva, the forbidden fruit of Eden and a blank-faced Christ. The painting was on a side wall in the main entrance area of Philip Bacon's home in Brisbane. I am sure that Brett Whiteley would have been pleased by my reaction. Here was a painting like few others in Australian art, a flirtation with blasphemy, challenging religion and high art simultaneously. It was so over-the-top in its intensity.

Some years later, when I was visiting the Brett Whiteley studio in Raper Street, Surry Hills, Sydney, there were many photographs and postcards pinned to the wall. There were three images of one famous work, Piero della Francesca's *Baptism of Christ* c.1450, which is held in the National Gallery, London. Whiteley had obviously remained fascinated by this wonderful early Italian Renaissance painting, which he saw in London in mid-1966, a few days after he had arrived there from Calcutta.

During ten days in Calcutta, Whiteley had come face to face with the extremes of poverty and deprivation. This had a significant impact on him and he made two paintings as a result. The first, called *Calcutta*, showed a sitar and a beggar with outstretched hand, a blunt statement about the impoverished country of celebrated musician Ravi Shankar.

The second painting, *Fidgeting with infinity* was more complex, overblown and in every way evidence of Whiteley's extreme

personality. He explained: 'It's strange how an addictive personality like myself, born with a gift, has this compulsion to test the gift, challenge it, push it to the edge, almost self-murder it, to see if it is still there and you are in control'.[178]

Whiteley wrote of his astonishment that the Piero painting was so small, and determined to respond to it with a picture of his own:

> I was amazed at the tinyness of its space and scale. The actual Christ in it was only the size of a doll. I had always imagined the painting in my mind as being nearly life-size. I had seen how Christ's feet were placed firmly on the ground, and that there was this lettuce-green, crisp, optimistic landscape behind it. In my mind I had always seen the picture as being almost mural size. I was absolutely shocked, appalled to see this European space, this tiny picture. So much so that it launched me on this idea of painting a picture, a version closer to what I had in mind. I put two predellas [panels], of the road and the photograph of the vultures on it … I was trying to show two sides of the coin in the one picture – great beauty, great optimism and the best of human values, combined with evil, bleak, ultimate destruction and death.[179]

In this painting, Whiteley references the Piero only in part of the central section, but even here he absurdly adds a languid, sexually provocative nude. It is a mark of Whiteley's humanism and compassion, but also his capacity for bombastic self-delusion, that *Fidgeting with infinity* negotiates between sincere manifesto and empty rhetoric. It is a compelling but alienating image, with a similar effect as that on a theatre-goer attending Beckett's *Waiting for Godot*. This is either its success or its failure and people tend to love or loathe the painting. Is this a highway to heaven, the road to hell or to nowhere, or the route that circumvents religion and hope, passing Golgotha and a road strewn with victims of famine?

Fidgeting with infinity was a feature work in Whiteley's September 1967 exhibition at Marlborough Gallery in London. The show failed and Whiteley's British career crashed, leaving him to journey in the next few years from New York to Fiji to Sydney, where he was embraced as Australia's first superstar artist. He became resigned to stop tormenting himself 'over how much the world is stuffed up'[180] and to stop painting didactic works. 'There is too much pollution and pain in the world already. I just want to add some beauty',[181] he declared, and went on to paint works such as *Interior with time past*.

Brian Kennedy

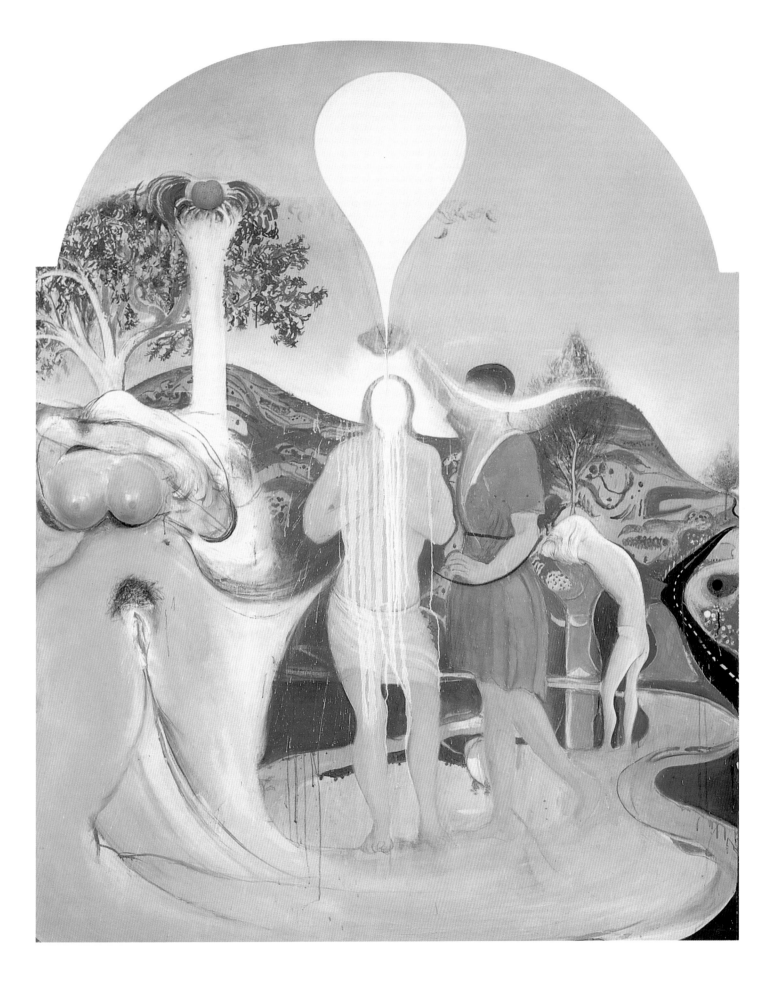

Michael Johnson b.1938

Emperor 1965
synthetic polymer paint on unprimed canvas 177.0 x 180.0 cm
purchased 1969 69.84
© Michael Johnson

The choice of colour is an emotional decision that is hard to
account for, but it's related to a physical phenomenon, to a canvas
or a piece of paper. For me there's an unstable, personal, open
way of claiming colour. The colour has to occupy or hold the
action of the horizontal and vertical framework of the human
body, the up and down and sideways.

Putting down a colour, the first thing you do is oppose it with
another colour or give it some kind of sympathy. There's one
thing I'm super-aware of right through the 1960s–70s period:

at all costs to avoid conventional modelling through chiaroscuro.
I wanted to evoke space through the tension between forms,
using the energy of colour virtually straight from the
manufacturer – without mixing, but in the right proportions.

You start with the experience of bare gesso, the primed canvas,
and that is sublime. That is meditation in itself. As soon as you
make a mark on it you set up a focus. In my 1960s paintings I felt
very awkward about the business of putting a mark in space,
because I always actually think of the whole area having a mood.

I don't see any difference between the spirit of music and the
spirit of painting. Not so much painting, but colours. Colour has
the same difficulty of floating on airwaves.

Michael Johnson, 1988[182]

Ian Burn 1939–93

Mirror piece 1967 (detail)
13 sheets of photocopied text and framed mirror
52.8 x 330.7 cm (overall)
purchased 1978 78.844.A-B

Ian Burn spent more than one third of his 30-year career overseas, where he was to have a key role in the development of international Conceptual Art. Often referred to as Idea Art, the emphasis was not on the work of art, but what it seems in the experience of the viewer.

Through *Mirror piece*, produced in New York in 1967, Burn explored the idea of looking and seeing, and demanded a new kind of attention and mental participation from the viewer. He purposely used common materials in this work to copy a household bathroom mirror. Burn felt that if the subject matter is familiar, then the familiar object, in this case the mirror, is seen but not looked at. This is further complicated as the reflective quality of the mirror actually denies the surface any observable substance. Instead the viewer, immediately confronted with his or her own image, cannot look past the reflection. To do so would require an ability to look at oneself seeing, thereby presenting a visual paradox.

What is it that we are looking at? By placing glass over the mirror Burn fragmented the image, the qualities of which he explored in the 13 photocopied pages mounted on card and framed alongside the mirror. Burn also included instructions on how to make the mirror piece as he felt that, once the structure of the work of art was established, the idea could be repeated at random outside the artist's involvement.

From 1965 to 1970, Burn produced a series of mirror and glass pieces as he continued to explore how we see things. The growth of Conceptual Art in Australia benefited greatly through the direct link created by Australian artists like Burn, working in New York.

Barbara Poliness

Paul Partos b.1943

Yellow screen with yellow and *Black garden* 1968–69
painted nylon and wood 274.0 x 107.5 x 31.0 cm (each screen)
purchased 1972 72.315.A-B purchased 1973 73.28.A-B
© Paul Partos, 1968–69. Licensed by VISCOPY, 2002

In 1968, the National Gallery of Victoria in Melbourne held an exhibition of work, *The Field*, by the new wave of artists working in a colour-field or hard-edge style. In the late 1960s, colour-field paintings were often characterised by flat, uninflected areas of colour in abstract and generally austere designs, sometimes in three dimensions. In his two related works, *Yellow screen with yellow* and *Black garden*, Paul Partos played with the boundaries between painting and sculpture. He took the painting off the wall completely, to stand it upright in space.

Partos replaced the canvas with nylon mesh and applied colour with a spray gun. The superimposition and transparency of the mesh effected moiré patterns, articulating the surface of the works. The tall and narrow structures lacked the substance of sculpture, and colour and surface were dealt with as they are in painting. Partos's solution produced neither sculpture nor painting but a curious and graceful hybrid.

In the 1960s, sculptors experimented with materials not previously used in art, especially those devised for industrial and technological uses. *Yellow screen with yellow* is made of the most banal components, the painted wood and nylon used to make flyscreen doors, yet it is an elegant work of art, with physical beauty and commanding presence.

Christine Dixon[183]

Dale Hickey b.1937

Atlantis wall 1969

synthetic polymer paint on two canvases 213.7 x 427.4 cm (overall)

purchased 1979 79.2546

Atlantis wall, despite its overt appearance of geometrical abstraction, also refers to the repetitive patterns of modern urban construction and industrial materials. The plastic or glass-brick walls seen in Melbourne's buildings form a grid of seemingly identical forms, modulated only by the changing effects of light falling on the translucent units. The title refers to a commercial product, which the Atlantis Water Management company calls a 'cellular wall drainage system … perfect for underground car parks, basements, retaining walls, bridge abutments, civil structures'.[184] It also has a more poetic resonance however, recalling an underwater kingdom, the city of Atlantis lost under the glass-green sea.

The late 1960s was the time of Minimal Art and hard-edge or colour-field painting. In 1967, both Melbourne and Sydney saw the hugely influential exhibition, *Two Decades of American Painting*. The American critic, Clement Greenberg, said any pictorial subject was unsuitable for abstract art, and lauded the flatness of pure painting. Dale Hickey's immaculately smooth surface and crisp edges are part of this style, but the muted yet intense colour and equivocal subject deny the conventions of the day. As Margaret Plant pointed out, the artist had 'an interest in motifs creating an illusionistic ambiguity, effecting a play between flat surfaces and the third dimension and in fact contradicting a straight abstract reading'.[185]

Christine Dixon

Fred Williams 1927–82

Landscape '69 triptych 1969
oil on three canvases 198.2 x 91.5 cm (overall)
gift of Mrs Lyn Williams 1989 89.1875

Yellow landscape '74 1974
engraving and drypoint, printed in black ink 25.3 x 55.0 cm
gift of James Mollison 1984 84.81

Hang the painting … up in the house and it is going to be one
of my better works! … I am getting more and more interested
in the size, hue and shape of a painting. *Fred Williams*[186]

Fred Williams's *Landscape '69 triptych* is a masterpiece of
understatement. Its apparent simplicity reveals the hand of a
pracitioner so accomplished that he makes it look easy. It appears
to have been painted rapidly, spontaneously, with the greatest of
ease, but each brushstroke has been carefully placed to create an
interconnecting rhythmic pattern – like nature itself.

Around 1963, Williams created a new way of looking at the
Australian landscape, placing dabs of heavy impasto onto a
textured ground to portray the space of the Australian
countryside dotted with scrubby trees. He observed that there
was no focal point in the Australian landscape and that this had
to be built into the paint.

Williams merged a contemporary concern with abstraction,
flat surfaces and gesture with an ongoing interest in figuration.
He commented:

I'm basically an artist who sees things in terms of paint …
I always make sure … that … the tension [in] the picture
emanates from the middle going out … I suppose the more
successful ones are where I've sort of been able to … work
freely, when I haven't been trying to impose anything on the
landscape … simply letting the landscape come to me as it
were.[187]

He absorbed himself in the landscape and translated this
into paint.

Williams said he was thinking of Frederick McCubbin's
The Pioneer 1904 when he painted *Landscape '69 triptych*.

As James Mollison remarked, 'The Pioneer, for all its overt narrative, is a painting born out of a love of the bush; Williams's triptych is about the detail of the bush'.[188] But whereas McCubbin depicted a foreground, middle ground and distance, and showed the earth and sky, Williams created an image that is more closely focused, more intense, more absorbed into the bush. In looking at this triptych, our eyes slip from one dimension to another – from the flat grey surface of the canvas to the world of living forms. A few strokes of coloured paint suggest the trunks of tall saplings, the curl of a fern, delicate plants in flower, rocks and cut logs; the things that might draw our attention if we were to sit and immerse ourselves in the bush. The more we look at the painting, the more we imagine – we can almost hear the wind ripple in the trees, a bird warble, or a goanna slither in the undergrowth. The liveliness of the sparsely placed gestures against the ethereal grey surface takes us into another realm.

Williams's triptych is like a meditation on the bush. It shares something with the late work of Monet and with Japanese screens – in the way the image totally consumes the canvas and in the manner in which the painterly gesture dominates. More especially, it shares something with the work of these artists in the manner in which spatial ambiguity replaces the ordinary pictorial concepts of up and down, back and front, depth and surface – in the way it allows our consciousnesses to dissolve into visual space.

Although in 1968 Williams broke from his long established pattern and began to use oils on his outdoor excursions, he based Landscape '69 triptych, as he had many of his earlier works, on notes, drawings and gouaches made on sketching trips. He also painted regularly from his etchings, as well as reworking paintings into etchings – finding equivalents in the different mediums. He commented:

> I never really know what is going to happen with an etching. I start off with an idea but it often turns out to be quite the opposite to what I started out [to do], so really it takes shape while I'm doing it … I can get an organic shape on the plate or on the print, and this helps me with the landscapes, particularly with my idea of the trees … I can refer to the etchings so that the paintings never really are of any particular spot but I try to evoke the feeling of a district.[189]

Williams made the engraving and drypoint Yellow landscape '74 while working on a painting, Landscape '74 (see p.18) after a visit to Preston Gorge, a relatively inaccessible site on the outskirts of Melbourne. He initially intended the painting to become one of a suite of canvases on the scale of Monet's waterlily series, but he never realised these plans.

Williams did not seek merely to create an impression of a particular place, the surface appearance, but sought instead to convey something about the character of the bush, honing his images into a kind of spiritual essence of the landscape – absolute and enduring.

Anne Gray

Lawrence Daws b.1927

Omen bird 1970
screenprint, printed in colour, from multiple stencils on paper
53.0 x 53.0 cm
purchased 1972 72.151

Lawrence Daws travelled to the outback areas of Australia on geological surveys and, inspired by these visits, painted works with dark troubled skies, limitless flat sandy plains and a one-point perspective. In 1956, he turned towards a kind of symbolic abstraction, creating images with totem-like figures over vast plains conveying a sense of space and time, change and destruction. In his screenprints, Daws created a system of personal motifs, repeating icons in several images, like running lines of communication between one work and another. In his book on the artist, Neville Weston discussed Daw's use of the bird motif:

The omen bird is a recurrent image … and, somehow, seems to have always been waiting to glide disturbingly and majestically across the skies. This is no migratory visitor or harbinger of spring, but a dark presager of doom. It is a beautiful and fearful image and, like the burning forms, it casts no shadow and seems a totally silent intrusion, a passing threat. The bird shape, as it develops during the 1971 'Omen Bird' series, is actually based on a seagull seen illustrated in a magazine, and subsequently painted black: it seemed almost timeless in the way it moved with a smooth flow of menace. The shape of this powerfully moving threat is not unlike the form of a manta ray gliding through the murky medium of underwater film spectaculars.[190]

Lawrence Daws continues to work in a distinctive semi-abstract approach, using a symbolic language.

Neville Weston and Anne Gray

Elwyn Lynn 1917–97

Chums 1970–71

lithograph, printed in black ink, from one stone; collage of handmade
paper, newspaper, string and wax seals on paper 45.0 x 58.0 cm
purchased through the Gordon Darling Australasian Print Fund 2002
© Elwyn Lynn, 1970–71. Licensed by VISCOPY, 2002

Dundoo Hills 1977

oil paint, brush and ink, crayon, watercolour, pencil, chalk, collage
of cut paper and photograph on paper 56.1 x 78.0 cm
purchased 1979 79.1599
© Elwyn Lynn, 1977. Licensed by VISCOPY, 2002

The aim is not to shock or amuse in the spirit of Dada, but to
avoid stereotyped associational evocations in making an art
from 'anti-art' materials; if art is concerned with the symbolic
expression of feelings and not mere visual appearance, these
works may realise emotions unattainable in other media.
Elwyn Lynn[191]

From the 1970s, Elwyn Lynn made collages and assemblages
out of everyday objects. He took advantage of the associated
overtones of the various items within the collage to create
suggestive images and juxtaposed unlikely objects in an ironic
fashion. He did so in see-through pieces in which he squeezed a
patchwork of fragments together between two sheets of perspex,
in lithographic prints like *Chums*, in his heavily textured
paintings, and in paper constructions such as *Dundoo Hills*.

In *Dundoo Hills*, the photograph of the tin shed and large tank
looks recognisable; it could be at Dundoo Station in northern
Queensland, but it could also be found at many other places in
Australia. The manuscripts also seem to resemble things we
know – but do they? One is in English, but folded so that it is
only possible to read snatches of sentences; while the other is in a
foreign script. The outline drawing of trees, house and hills that
runs across the bottom of the image provides a kind of echo of the
scene in the photo – and yet in the simple, childlike way in which
it is drawn it recalls the landscape of our childhood imaginings.

Lynn is known for his expressive and evocative treatment of
surface and texture. He played a major role in fostering
contemporary art in Australia as Curator of the Power Gallery
of Contemporary Art, University of Sydney. In the 1970s, when
collage began to be widely used in Australia, Lynn turned to this
medium, creating images such as *Chums* and *Dundoo Hills*. He
believed that 'life is a collage, and tailor it as we will, it will not
come out a whole, well-fitting suit, because the materials of this
collage-view of reality are diverse and distinct'.[192]

Anne Gray

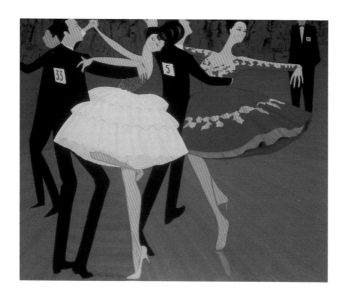

John Brack 1920–99

Latin American Grand Final 1969
oil on canvas 167.5 x 205.0 cm
purchased 1981 81.11

At the end of 1968, John Brack resigned as Head of the National Gallery School in Melbourne, where he had studied some 20 years earlier, to devote himself to full-time painting.

With paintings such as *Collins Street, 5 p.m.*1955, he had established a reputation as an urban realist and social commentator, one who employed irony to make penetrating comments concerning the human condition. Now, however, he was seeking an artistic form which would remain faithful to the local reality, to the here and now of immediate experience, but one which could also be interpreted on a more universal level. Throughout the 1960s, he experimented with different subject matter which he generally developed as series of paintings and drawings; these included the schoolyard series, the wedding series and shop front series. In each instance, he added further levels of meaning to the imagery.

Another series which preoccupied Brack in the 1960s was that of professional ballroom dancing. The theme initially appealed to him for its absurdity: people who converted a natural activity, such as dance, into a demanding and challenging ritual. It was also a continuation of the theme of precariousness of being, where couples are thrown together within a competitive environment, where all is set against them: the floors are tilted, slippery and polished, the glare of the spotlights is merciless, the crowd and the judges appear hostile.

It is possible to interpret the major painting from this series, *Latin American Grand Final*, on a number of levels. On one level it is an illustration of an actual event – the World Ballroom Dancing Championships, which were held at Melbourne's Festival Hall in 1967. Brack attended the championships and acquired a considerable number of photographs for use as source material. The painting is also about masks and facades – the costumes, the hair and the smiles are all deliberate disguises used by the competing couples, who have to face the crowd and the judge. The couples, thrown together, whether in a dance, marriage or relationship, cling to one another in gestures of simultaneous attraction and rejection, yet persist with the ritual and the farce. Unlike some of his earlier paintings where there is a clear judgemental message, here there is no judgement; Brack does not stand in front of his subject to denounce the foibles of human behaviour but instead, in the top left-hand corner, more vulnerable than the rest, dancing alone without a partner, is a self-portrait of the artist. So if this dance is a farce, a dance of life where we perform our hour upon the stage and are heard no more, assuming deliberate disguises, but alone, even when in company, then the artist is part of this ritual. He does not judge and condemn, but suffers with the rest of us.

The painting, with its blaze of neon pinks, stinging reds and sharp thrusts of black, is full of sexual symbolism set within a very formalised choreographed ritual. The generous billowing and bulbous ballroom dresses are frequently shown encroached upon by a dancer's leg, either bold and erect or curved and limp. There is a constant play between what is revealed and what is possibly implied in the imagery.

Brack employed photographs as source material for this painting; they were not copied, but used as a departure point to allow the development of a formal design. The photograph is a touchstone on the here and now, the visible, tangible Australian reality. The painting itself is a much broader comment on society, social behaviour and the tragedy of the human condition. If the *Collins Street, 5 p.m.* painting provided a very localised, close-up view of humanity, composed of observed, sketched individuals and in its title already signifying a specific time and space, then with *Latin American Grand Final* the imagery is a little withdrawn; the dancers, while based on specific photographic models, are now more symbolic, more allegoric – they are commenting about all of us, the dance of life and the ritual of being. The problem which increasingly started to preoccupy the artist was not only how to make a statement about the specific, but also how to make it in such a way as to have a universal meaning. As Brack commented later:

> I considered I had made at last a significant advance on the superficiality of the Collins Street picture, while at the same time, not making the picture look over complicated. You see, the problem was to make it operate on different levels of meaning, but to make it look perhaps deceptively simple.[193]

Sasha Grishin

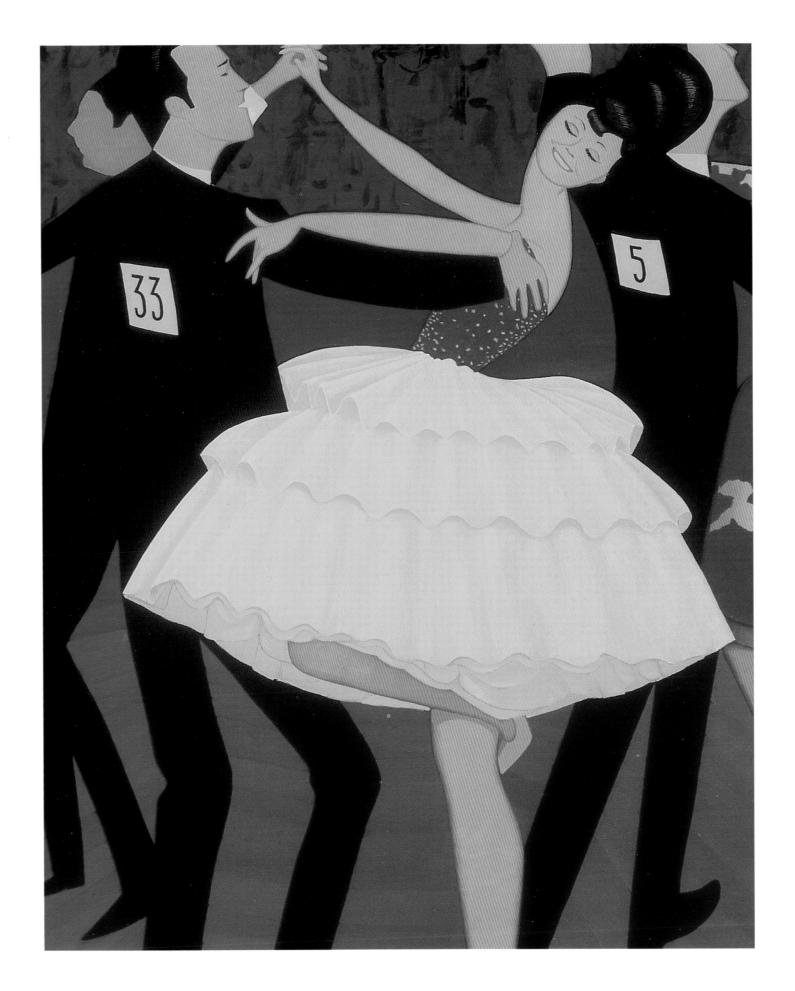

Robert Rooney b.1937

Superknit 5 1970

synthetic polymer paint on canvas 152.5 x 244.0 cm

purchased 1979 79.2548

reproduced courtesy of Tolarno Galleries

Having slowly and systematically eliminated the figure from my paintings between 1961 and 1966, it suddenly occurred to me that the material I had been collecting for my own amusement, some of which I compiled into handmade illustrated booklets for a couple of ex-art school friends, Rosemary and John Adam, could be the basis for 'serious' art.

The collage elements in these 'entertainments', as I called them, were culled from the extraordinary range of objects that people left in second-hand books – ranging from a bookmark in the shape of a woman's stockinged leg to poems and drawings. I also collected illustrated publications on Swedish club swinging, exercising in the bath and other curious activities. But I was particularly interested in pictures or diagrams that resembled abstract art.

Included in this mass of material were two books on knitting. Looking through them, I realised that the various knitting patterns could be reduced to a basic curve and straight lines.

The pencil drawings that I did for the 'Superknits' series of paintings were plotted on $1/_4$-inch graph paper using a cardboard template for the repeated curves. The negative outlines in the paintings were the result of 'drawing' the patterns on raw canvas with $1/_4$-inch masking tape.

As with the serial/cereal paintings that preceded them – the 'Slippery seal' (1967) and 'Canine capers' (1969) series, in which I used brightly coloured cut-outs on the back of Kelloggs boxes as stencils – I regarded the 'Superknits' as serious hard-edged abstractions, while recognising the absurdity of basing them on knitting patterns.

Robert Rooney, 2002

Robert Hunter b.1947

Untitled 1970–76

synthetic polymer paint, cotton thread and pencil on canvas

158.5 x 158.5 cm

purchased 1976 76.344

© Robert Hunter, 1970–76. Licensed by VISCOPY, 2002

Robert Owen b.1937

Terminus #2 1970

aluminium, perspex and oroglass 182.4 x 182.4 x 13.0 cm

gift of the Philip Morris Arts Grant 1982 83.1623

Since his first white on white paintings of the late 1960s, Robert Hunter has revealed the subtle nuances and almost infinite variations that are achievable within a minimal-conceptual framework. In *Untitled*, for example, Hunter imposed a predetermined geometric scheme on the canvas, which was systematically realised by attaching a grid of cotton threads and applying a thin layer of light grey house paint, before finally drafting a regular matrix of horizontal, vertical and diagonal pencil lines.

Yet, what at first glance may appear strictly regimented, on closer inspection reveals a multitude of irregularities in the execution. As the direction of the light shifts, so do the pencil-like shadows cast by the slightly straying threads. The small variations in each hand-drawn line gradually aggregate so that the initial perception of uniformity and rigidity collapses as the viewer's eye moves back and forth across the painting's resonating surface.

In his work, Hunter drew impetus from critical developments in American art of the 1960s, whereas Robert Owen associated with the British Constructionists when he lived in London in the late 1960s. As their name suggests, the Constructionists pursued a European tradition of abstract art established in the early 20th century by Constructivism. A favoured object was the wall relief sculpture, mathematically conceived and fabricated from materials such as aluminium and perspex. Owen aligned himself with the group's endeavours in his 'kinetic reliefs' and in his major piece, *Terminus #2*.

Owen initially exhibited this work with the title *Homage to Mondrian*, a reference to the pioneering Dutch painter and member of the avant-garde group *De Stijl*. This early title suggests a debt to Mondrian's grid compositions and diamond-shaped canvases and more broadly to the history of Modernism. Soon afterwards, however, Owen changed the title to *Terminus #2*. In erasing the original title and all its historical associations, Owen can be seen to have repudiated a simple narrative of modern art and acknowledged the diversity of contemporary practice in the 1970s.

Steven Tonkin

Ron Robertson-Swann b.1941

Australia 1969

welded steel, synthetic polymer paint 152.5 x 152.5 x 452.0 cm

purchased 1969 69.99.A-D

Traditional art is mostly representational and, particularly with sculpture, predominantly figurative. Some of the properties concomitant with that tradition are that sculpture is monolithic, has an implied core, displaces space and stands on a pedestal. It is also carved in stone or wood or modelled and cast in bronze.

My ambition with *Australia* was to reverse some of those properties. It encloses and shapes space, stands on the same level as the viewer and thus takes in the space surrounding it.

The sculpture is predominantly horizontal, not vertical, and it is constructed in steel, a material with the tensile strength to be able to draw in space and have it hold. Colour is applied to neutralise unnecessary associations with the raw steel and to reinforce the unity and mood of the work. Geometry is employed to distinguish it in the landscape while at the same time embracing and framing the landscape.

This sculpture was made in 1969, on my return to Australia after almost a decade in Europe, and is a response to the wonderful horizontal expansiveness of the Australian landscape, which could only be expressed through the development of these new means in sculpture.

Ron Robertson-Swann, 2002

John Firth-Smith b.1943

Across no.7 1972
synthetic polymer paint on canvas 132.3 x 244.2 cm
gift of the Phillip Morris Arts Grant 1982 83.1539
reproduced courtesy of the artist and Roslyn Oxley9 Gallery, Sydney

John Firth-Smith's *Across no.7* is an arresting abstract image with
bold forms and dynamic contrasting colours – a dramatic
diagonal line slashed against a flat green surface, grounded by
a strong slab of textured paint, red and black, haloed with blue.
In much of Firth-Smith's work, line has played a major role as an
organisational element. At the time of this work, immediately
following a period in New York, he painted a series of abstract
compositions in which he used fields of intense colour with
uniform flat surfaces bisected by long diagonal lines. The New
York art scene had impressed Firth-Smith, but it didn't make him
want to change to performance or Pop Art; rather it confirmed
his belief in painting for its own sake. He commented:

> When I finally arrived in New York in 1971 it wasn't what
> I expected. The glory days of post-war painting were over.
> The avant-garde was no longer painting … I saw the first
> show of people like Gilbert and George, the living, singing
> sculptures … and a naked man chopping up live goats in his
> loft with a machete spraying blood over the onlookers …

and there was other performance art, video art, earthworks,
community art, arte povera and so on. This is when I made the
decision to remain a painter – I suppose in a more traditional
classic way shunning the Warhol-Pop thing – the avant-garde.
I began trying to do something new and relevant with my
paintings – getting influences from more esoteric sources.
My decision was to keep painting relevant as painting.[194]

In the 'Diagonal' series the diagonal 'evolved after cancelling out
a picture with a big slash of paint'.[195] Firth-Smith was concerned
with space, mass and movement, and with paint and colour as
expressive elements. As he notes:

> The diagonal often became a bar floating above the ground
> of the painting; held in a vice-like grip at the bottom of the
> picture plane and free to move at the top, this tended to move
> and alter the space and kind of twist the flat surface of the
> painting. It also acted like a crowbar, levering the blocks out of
> the corners. Sometimes, depending on the colour relationships,
> the diagonal became a slot that you could see through. It also
> worked like a pole – propping up the top corner of the
> rectangular picture. The bars never bisected the rectangle of
> the canvas to create two triangles, always stopping short in the
> corners. I always felt that these paintings were kind of
> paintings of sculptures.[196]

John Firth-Smith (2002) and Anne Gray

Clement Meadmore b.1929

Virginia 1970 fabricated 1973
welded cor-ten steel 365.0 x 1402.0 x 609.0 cm
purchased 1973 73.656
© Clement Meadmore, 1970/1973/VAGA.
 Licensed by VISCOPY, 2002

Cross c.1961
welded steel, patinated 92.0 x 107.0 x 47.5 cm
purchased 1962 62.50
© Clement Meadmore, c.1961/VAGA. Licensed by VISCOPY, 2002

Clement Meadmore began a career as an industrial designer in Melbourne, before starting to exhibit non-figurative metal sculpture in the mid-1950s. At first glance, *Cross* appears to be fashioned from precariously balanced heavy slabs of iron or bronze. Yet, what look like solid blocks are in reality hollow, like empty boxes with an exterior shell constructed from thin sheets of welded steel. The dark rough texture of the surfaces is a deliberate effect, an expressive gesture of being wrought by the hand of the artist.

Meadmore moved to Sydney in 1960, left for New York in 1963 and became an American citizen in 1976. He remains Australia's most prominent expatriate sculptor with major public sculptures in Australia and numerous commissions abroad. *Virginia*, dedicated to a fellow expatriate, the painter Virginia Cuppaidge, was commissioned for the National Gallery of Australia's Sculpture Garden, where it is now located with the work of other notable international sculptors.

In the late 1960s, working in the United States provided Meadmore with opportunities to produce sculpture on an increasingly ambitious and monumental scale. There is an apparent effortlessness with which the single massive form of *Virginia* has been twisted in the centre so that its ends float above the ground in defiance of gravity. The genesis for the creation of this visual perception of weightlessness can be seen in Meadmore's earlier work such as *Cross*. In fact, *Virginia* weighs over 8000 kilograms, or eight tonnes, and was fabricated at the pioneering Lippincott factory for large-scale sculpture in the United States, before being shipped to Australia in four parts and reassembled in Canberra.

Virginia is made from a particular brand of steel, known as cor-ten, which the artist has intentionally allowed to weather on the surface to a warm earthy rust-red. As is the case with most successful outdoor sculptures, *Virginia* engages in a sympathetic dialogue with the environment it inhabits.

Steven Tonkin

Richard Larter b.1929

Cream filling; phew, finger ring 1971
synthetic polymer paint on canvas 178.0 x 366.0 cm
purchased 1975 75.113

Timeline: 1971, war in Vietnam – the Liberal Government runs
a lucky dip lottery to choose who will be conscripted. I teach at
a New South Wales high school, painting at night and in the
holidays. Half my work is figurative, the rest abstract.

This is an atypical work for the period – less protest than usual.
The method relates to collage and montage – a melange of heads
and bodies in differing scales, yet unity of design is achieved.
The size of the work is large but, during the 1970s, I did two
50-feet-long paintings called *Wall reviews* (one hangs in the
Art Gallery of Western Australia, Perth), plus a 15-feet-long
The bleeding eye of K. Marx in 1973.

The personages portrayed are Elvis Presley, Mick Jagger and
other pop stars, Nietzsche (who said 'God is dead' and predicted
führers and wars almost beyond comprehension), Verouschka
the Russian Samidzat Queen who, unlike Wonder Woman,
wore thigh-length boots for kicking commissars and was
distinctly unpatriotic: an underground Russian anti-communist
protest super hero. Also depicted are an ape, a skull and a
screaming man.

Claes Oldenburg wrote in 1967: 'I am for an art that is
political–erotical–mystical, that does something other than sit on
its ass in a museum'. This just about sums up my attitude at the
time. There was virtually no competition in Australia from fellow
artists in this area of expression. So I had a select band of
supporters and was neither rich nor famous, much as I am today.

Richard Larter, 2002

Aleks Danko b.1950

to picket 1972
glazed earthenware, wood, steel 119.8 x 369.8 x 26.0 cm (overall)
purchased 1973 73.307.A-V

to picket (some reflections)
The work is from a 1972 solo exhibition entitled *ideas, words, processes* that consisted of a range of objects and installations made by hand from two tons of clay.

reflection (1973)
As a student at the South Australian School of Art I was told that one could make anything in clay … and with that workshop statement I pushed and extended the possibilities of the medium into sculpture rather than pottery.

reflection (2001)
A place called Adelaide where I grew up, a place of darkness and silence. Every night at 1am the streetlights were turned off. This was a physical and psychic space that was going (to) … *limit, bound, confine, restrict, enclose, surround, imprison, restrain, hedge, wall, rail-in, fence* and (to) *picket*. Imagine picketing outside one's own home in protest of one's own re-entry.

reflection (1991)
As you know, we are pensioners, day in day out, 24 hours closer to death. (Russian humour)
 Aleksander Danko senior, Melrose Park, Adelaide.

reflection (1974)
'Let us return to our friend Danko (junior) and take some soundings in his early work. At a glance, most of them seem demonstrative in intent: they have the rectangularity or visual simplicity of the late 1960s styles, while the concern for "Aesthetics" as a subject almost places Danko as a wacky sort of Conceptualist. But only almost: they draw on these features, but his purpose is to parody and to undermine. Leech-like … The comedy is serious, the skimpiness severe.'
 Gary Catalano, *Art and Australia*, July–September 1974.

reflection (2001)
Fondly remembered and acknowledged for their inspiration are teachers Bill Gregory, Bill Clements and Milton Moon; fellow students Nigel Lendon, Peter D. Cole and Tony Millowick; ceramic artists Margaret Dodd, Olive Bishop and (in Sydney) Joan Grounds.

Aleks Danko, 2001

Timmy Payungka Tjapangarti 1937–2000

Pintupi people

Secret sandhills 1972

synthetic polymer paint on composition board 76.0 x 52.0 cm

purchased 1998 98.107

The Peter Fannin Collection of Early Western Desert Paintings

Payungka was one of the very first Pintupi people to live at the newly-established government settlement of Papunya, west of Alice Springs, in about 1960. His traditional country lay far to the west near the Western Australian border. Payungka was also among the first artists to take up painting at Papunya in 1971. For the artists of the community, this was the first time their work was to be viewed by the public at large. Previously, artists were accustomed to painting in ceremonial circumstances where the audience was restricted in the main to initiated people.

The first years of the painting movement at Papunya went through a number of stylistic phases, from the use of naturalistic images to conventional designs such as concentric circles and meandering lines. Some artists employed fields of dotted paint, in imitation of the technique of applying paint to the large ritual ground mosaics, sometimes to disguise the more sacred or secret design elements. The technique flourished during the time Peter Fannin was the manager of the Papunya Tula Artists Cooperative, from 1972 to 1975. It is taken to an eloquent extreme in this work, which depicts horizontal ridges of sandhills covered by fields of vegetation. This painting was in fact collected by Fannin.

Wally Caruana

Tony Tuckson 1921–73

White over red on blue c.1971
synthetic polymer paint on two composition boards
213.4 x 244.0 cm (overall)
purchased 1978 78.1033
© Tony Tuckson, c.1971. Licensed by VISCOPY, 2002

[this painting brought] us back to something more important: nerves, flesh, blood and bones, the human body and its ways of making contact. *Daniel Thomas*[197]

White over red on blue exudes a passionate energy and vigour, resonating through colour, structure and gesture, yet Tuckson called himself 'just a Sunday painter'.[198] He was unencumbered by an extensive palette, using only a translucent lapis-blue ground partly obscured by an opaque layer of 'ox-blood' red, and lusciously applied strokes of brilliant white. One can almost see him sweeping paint energetically across the surface of the masonite in dramatic and confident brushstrokes, each layer established in just enough time for the next.

This sense of the artist's presence parallels Tuckson's interest in, and connection to, the mark-making and underlying spirituality of Indigenous art, especially that of the Melville Island burial poles he saw on his travels to northern Australia. Combined with his formative art studies in London and East Sydney Technical College under artists such as Ralph Balson and Grace Crowley, Tuckson also drew inspiration from Cézanne, Ian Fairweather and Matisse. Without becoming derivative, he distilled their work and developed a unique style. His friend and colleague, Daniel Thomas wrote:

> He [Tuckson] was in fact a very pure and very fine Abstract Expressionist, probably Australia's best. He was passionately convinced of the humanity communicated by gesture, he spoke of himself as an action painter and I can't think of any artist's brushmarks whose scale and pace so clearly reveal generosity, modesty, courage and freshness: every mark is exploratory, not once is there any descent into formula, into the deadness of habit.[199]

Belinda Cotton

Marea Gazzard b.1928

Kamares VII 1972

stoneware 67.0 x 26.6 x 74.0 cm

Crafts Board of the Australia Council Collection gift 1982 82.1521

© Marea Gazzard, 1972. Licensed by VISCOPY, 2002

Artists usually name their work when it is finished, ready for exhibition. The title *Kamares* is from Greek objects I have admired over the years. My father was Greek and I am familiar with Greek culture.

Kamares VII formed part of a prestigious exhibition, *Clay & Fibre*, which the noted fibre artist Mona Hessing and I were invited to stage at the National Gallery of Victoria, Melbourne, in 1973. I say 'stage' because we saw the huge special exhibition space as a design challenge! Mona chose fibre colours from beige to earth red in tone, and I chose white as a jewel-like contrast. It was gratifying for Mona and me, after two and a half years work, to know that thousands of people saw the exhibition. (Even now, 30 years later, I meet people who remember it!) *Kamares VII* is handbuilt (coiled and flattened). I worked on a kiln shelf which, later on, slides into a kiln for firing. I enjoy working in clay – whether it is to be cast in bronze, or fired as clay.

To develop an *idea* (the difficult bit) I do many full size sketches on paper and then small maquettes and full size clay pieces to see if it 'works'. Having resolved technical problems, as well as the aesthetic, I do some variations on the theme, to make a family (or group) of several pieces. *Kamares VII* is the last of the Kamares group. The idea behind the Kamares group came from looking at everything – artefacts from museums all over the world (museums are a passion of mine) as well as natural objects: shells, seedpods, stones, the ears of elephants, and manta rays. In *Kamares VII*, I wanted to give a *feeling* of free movement to the work.

Marea Gazzard, 2002

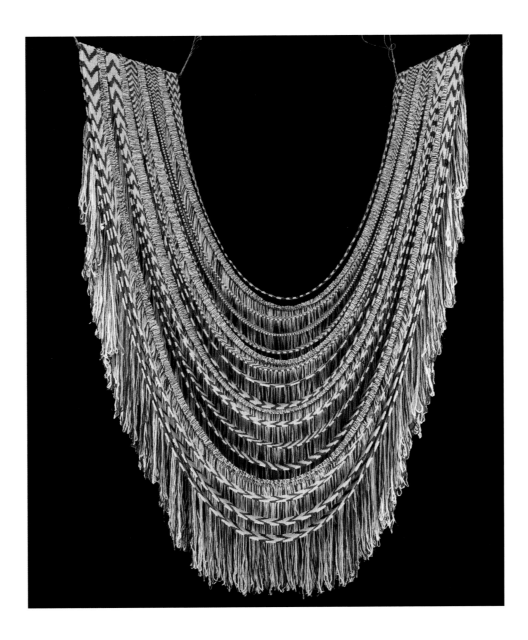

Mona Hessing 1933–2001

Scoop 1972
woven wool and cotton 275.0 x 175.0 x 85.0 cm
purchased 1973 73.278.1-11

Textile artist Mona Hessing was born in Sydney and trained in design before working as a design consultant from 1953 to 1965. She lived in India during 1967–68, designing and weaving a large tapestry in New Delhi, a commission that extended her technical and design vocabulary and gave her experience in large-scale textile work. Her subsequent work in Australia placed her in the forefront of innovative textile practice, particularly in the area of interior design and architectural work. Using a vivid colour palette, inspired by her experience with Indian textiles, she combined flat and textured knotted weaves in large tapestries that complemented the bold geometry and texture of Australian public architecture of the 1970s. Her smaller works were in perfect harmony with the revolution in domestic architecture of the period, particularly those designed in the romantic and open style of the Sydney school.

Hessing's work was in the vanguard of those who showed the possibilities for the inclusion of modern crafts in architecture, a trend that had been popularised through post-war Scandinavian and American design, but which had been undeveloped in Australia until the late 1960s. This work is freed from the traditional wall placement of tapestry and slices in arcs through open space and onto the floor. Its sense of movement is enhanced by its bold chevron patterning, reminiscent of traffic direction markers and the graphic Op Art of the period.

Robert Bell

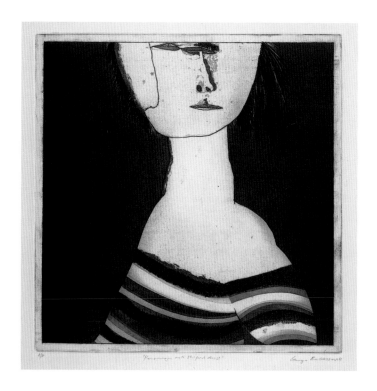

George Baldessin 1939–78

Personage with striped dress 1969
etching and aquatint, printed in black ink 50.7 x 50.6 cm
gift of George Baldessin 1975 75.544

Pear – version number 2 1973
cor-ten steel; seven forms 228.0 x 99.0 cm (each)
purchased 1973 73.559.A-G

For Baldessin, sculpture and printmaking were ideal studio companions and seeing them side by side led the artist to appropriate materials and ideas from one for the other. Every major series of etchings was summarised by a sculpture in which the artist undertook to express in three dimensions what before had been carried out on the etching plate.
Memory Jockisch Holloway[200]

Personage with striped dress juxtaposes the dark velvety tone of the aquatint with the brutal nature of the etching marks, to highlight inherent sexuality; it also demonstrates Baldessin's technical mastery. Impressed into a thick rag paper, the deeply etched lines and the rich aquatint add texture to the contorted yet appealing image, which echoes a recurring motif in many of the sculptures and prints in Baldessin's oeuvre – the amorphous figure.

Monumental and yet intimately sensuous, *Pear – version number 2* is a series of seven sculptures cast in cor-ten steel. The sculptures were cast horizontally in two parts and were mounted individually on pipes beneath the ground. Playfully leaning toward each other as though engaged in conversation, the elegant shapes reflect light by day and cast intriguing shadows by night.

George Baldessin arrived in Australia from Italy in 1949. He attended the Royal Melbourne Institute of Technology from 1958 until 1961, studying painting and later printmaking and sculpture. In 1962, he travelled to London to study at the Chelsea Art School, and studied under Marino Marini at the Academy of Fine Arts in Milan. In 1967, he travelled to Japan on a scholarship and renewed his interest in Japanese *Ukiyo-e* coloured woodblock prints which had influenced the feeling and format of his art.

Baldessin, regarded as highly professional, complex and enigmatic, won numerous prizes and participated in many major exhibitions, including a retrospective in 1977. Leaving an impressive legacy through his body of work, George Baldessin was tragically killed in 1978 in a car accident at the age of 39.

Susan Herbert

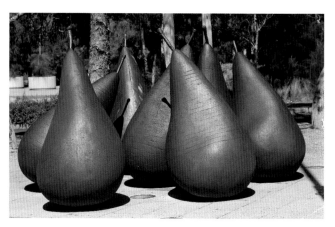

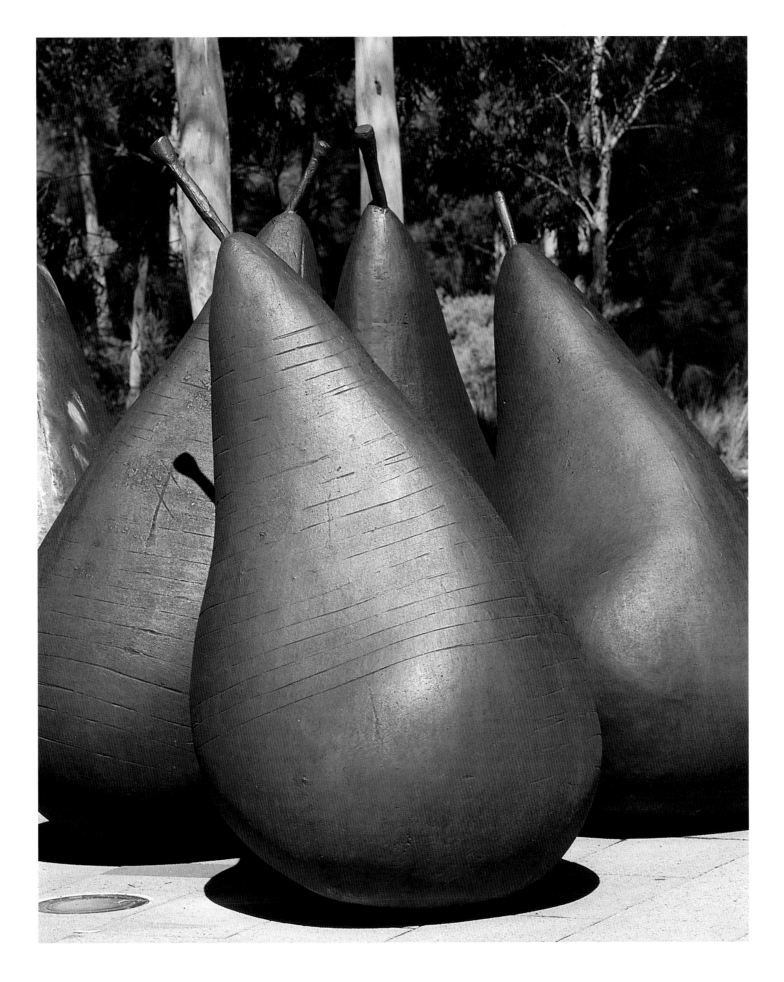

Ken Whisson b.1927

Jean's farm 1972
oil on composition board 81.0 x 109.3 cm
gift of the Philip Morris Arts Grant 1982 83.1595

Looking back, I find that for me the conscious methods I continually evolve are aimed at eliminating all kinds of cleverness and skill, for the reason that these signify and cause the blocking and petrification of the creative impulse.

The seeds – the beginnings – from which my approach is pretty clearly derived are first my teacher for 18 months, Danila Vassilieff, who told me to start at one side of the paper and just paint across to the other side – then stop. Once the other side of the paper is reached, the work is finished and one puts it aside and starts another. The other was a visit not long after to the studio of Albert Tucker. I picked up a book on Rodin and read that Rodin did the drawings on the accompanying pages with his eyes closed. I said to Tucker, 'Why did he do these drawings with his eyes closed?' And Tucker replied without hesitation: 'So that the consciousness of the lines already made will not influence or delimit the work as it proceeds'.

More directly in relation to where art comes from, I have a distinct impression when working that the painting takes place at the point where the brush touches the canvas, and I believe that art is a result of a direct line of communication between the act of creation and a level of our being which is neither the conscious nor the famous subconscious, but which could be called the intuitive faculty, and which has to function without interference from the conscious thinking process. Our rational and conscious mind looks on and even criticises what is happening, but in the moment of creation at its fullest realisation, one's own eyes and mind, one's own self looking on is caught totally by surprise.

Ken Whisson, 1994[201]

Fred Williams 1927–82

Beachscape, Erith Island 1 1974

gouache and sand on paper 55.4 x 77.4 cm

purchased from Gallery admission charges 1983 83.2989.95

I do 'strip' paintings of the beach using sand glued on – but the wind has worn me to a 'frazzle' … My final half doz. strip paintings are my best. *Fred Williams*[202]

In *Beachscape, Erith Island 1*, Fred Williams portrayed the changing faces of the shore at the point where the sea meets the land. He depicted the scene as if looking down from above, taking four slices, as it were, of a walk along a beach (soft yellow sand, grassed areas, more rocky ground and hard crunchy sand; an aqua sea, a shallower more sandy pastel blue sea, deeper darker blue shoals, as well as areas full of living things). He painted it with sure rapid strokes, full of a vitality that conveys the living energy of the scene. He used delicious, sensuous colours, rich blues and greens, purples and yellows, that sparkle together.

In the late 1960s, Williams began to divide a sheet of paper into several horizontal strips in order to present different aspects of one scene on the same page. He conveyed the complexity of perception, the way we rarely focus on just one thing (in a tunnelled vision), but take quick grabs from various viewpoints to gather information and combine these together to comprehend what we see. He captured the way that looking takes place over a period, and encouraged us to take time to 'read' his strips, step by step. But he presented the strips together, with the colours, the gestures, interrelating so that we see the image as a whole as well as in separate parts.

With the historians, Stephen Murray-Smith and Ian Turner, and fellow painter Clifton Pugh, Williams travelled to Erith Island in Bass Strait in March 1974. Because of poor weather, Williams and his friends were unable to leave the island when they intended. After days of strong winds the weather broke and Williams painted some of his finest gouaches, including *Beachscape, Erith Island 1*.

Anne Gray

Arthur Boyd 1920–99

Paintings in the studio: 'Figure supporting back legs' and 'Interior with black rabbit' 1973–74

oil on canvas 313.5 x 433.2 cm

the Arthur Boyd Gift 1975 75.3.188

Arthur Boyd's work reproduced with permission of Bundanon Trust

In the 1970s, critical opinion was predicting that painting was dead, superseded by performance art, situation art, video art and assemblage. Arthur Boyd's answer was to paint furiously, like one possessed, and he turned out some of the most memorable images of his long career. His huge canvas, *Paintings in the studio: 'Figure supporting back legs' and 'Interior with black rabbit'*, is one of a series of pictures painted in 1973–74 and is the key work of the series. Indeed, it is one of the great Australian pictures of the 20th century and could hold its own in any company.

Boyd, painting in his Suffolk studio in England after a short stint in Australia when he had seen and fallen in love with the Shoalhaven River and Bundanon, was in the grip of a dark dilemma. He was not only the victim of fashionable art scholarship but he was also the victim of his own necessity. His predicament was the need to walk the fine line between his deep inner impulses and popular opinion – no amount of acclaim could protect him from this.

In the picture, the artist is trapped in his dark studio and, through the open window, we see the enticing blaze of an Australian summer – but the artist is cut off from this and the outside world by a screen of chicken-wire tacked across the window frame. Look at the effortless freedom with which Boyd painted the chicken-wire; he handled the brush like a Zen master, weaving the skeins of paint in and out without a falter of the hand.

In his studio, the artist is surrounded by painted canvases stacked against the wall. Boyd once said that, when he realised what it was to be a truly dedicated artist, he felt like a dog on a chain and, from that moment on, he felt chained to the studio and to the profession that he loved. It was not only an all-demanding vocation, but was also how he must earn his living. He could not allow full reign to his deepest instincts because he had an audience looking over his shoulder.

Throughout Boyd's life, certain images and themes recurred. One such image is of a figure supporting another by the legs. It is a bizarre sight, but it had its origins in a humorous memory from his youth. When he was living in Fitzroy in Melbourne during the war years, his elderly neighbour would take her crippled dog for a walk by supporting its paralysed hind legs and giving it a 'wheel barrow' around the block! This comical four legged creature – half human and half animal – resurfaces here as a ferocious and demonic fury.

It is the artist who is the cripple now. His legs are being supported by the devil of necessity, which is intent on castration and intent on robbing the artist of his deepest feelings, leaving him impotent and vulnerable.

Poised over his canvas, he has one hand sheltering a pile of gold, a symbol of betrayal and sell-out for financial gain. The accumulation of money and the achievement of professional reputation are not the ultimate goal, but the artist is helpless; he is grasping his brushes in his left hand with the bristles pointing up. This way they are useless – like a pistol without bullets.

The small canvas, with which the artist struggles, is within a larger canvas of a nocturnal landscape with a high horizon on which you can just make out a thin scatter of Australian bush – in the foreground a billy boils. It, in turn, is within the still larger canvas, each canvas slightly overlapping into the space of the other. This 'overlapping' emphasises that the painted image always overlaps human experience and human emotions, and that one pictorial image generally feeds into the next.

For example, one of the pictures in his studio was *Interior with black rabbit*. It also shows the dark interior of the artist's studio, with a chicken-wired window. The rabbit sits on an open book beneath a naked electric light bulb – one of the terror tactics of the torturer/inquisitor – we cannot see this side of the canvas as it is hidden by the landscape, but the open window of *Interior with black rabbit* becomes the open window of the big picture. *Figure supporting back legs* overlaps all three images – the fiend steps in from the real world, into the large canvas and across the smaller two.

It is a cathartic painting in which Arthur Boyd lays bare his deepest insecurities and stands naked before us. The view from the window is almost euphoric. The sun stands directly overhead, casting small ultramarine splashes of shadow at the base of each tree. The heat crackles and bleaches the colour out of the landscape, while two snow-white clouds mushroom into a clear blue sky. The progression is from black studio to the muted nocturnal landscape to the brilliant light of a Bundanon summer. The view out the window is of pure, untrammelled nature, yet nature, the artist warns us, is not necessarily all that one needs for happiness; it can be another prison, fit only for those without dreams and desires.

In the space of just one year, Arthur Boyd painted this series of pictures of unprecedented intensity, depicting himself as an alienated individual in a society that no longer regarded his work as of contemporary relevance. It was in this same year that Boyd purchased 'Riversdale' on the Shoalhaven River, and re-established his roots in his country of origin. Boyd the 'Prodigal Son' had returned, and his return stimulated a fresh burst of creative energy.

Betty Churcher

Michael Taylor b.1933

Pink and silver 1974
oil and enamel on canvas 244.0 x 172.5 cm
gift of the Philip Morris Arts Grant 1982 83.1584
© Michael Taylor

Bredbo studio. A wooden shed delivered in one piece from the 'Snowy' by truck. Bredbo paintings were landscape: *Pink and silver*, *Snowline*, *Winter*, *Flying insect painting*.

Now I drive near that yellow shed every week. No one has used it since.

Some collaged works were purchased with *Pink and silver*; these make the landscape connection.

1973, 1974 exhibitions selling; canvases 244 x 174 cm purchased.

Roof too low for *Pink and silver* and *Great Dividing Range* to stand upright. Painted on floor or propped diagonal, then exhibited. Some went to Europe. *Dix Artistes Australiens Contemporains*. Banners unfurled across the Milan streets. Raining in Stuttgart. An umbrella hole in one of mine. Restoration: 600 deutschmarks.

Back 40 years. Living in Sydney on the Lane Cove River. *Black wattle* exhibited in Wynne Prize. Cadmium dots. Invisible black snake.

Stipple, spatter, spots recur in Bredbo pictures. Mere raised dots in *Pink and silver*. Other pictures, the 17-foot *September*, have grids of spots, waves of stippling, spore.

Diaphanous mists suspended in the air, the range was cloud-capped. Country clouds unlike those of the coast. Sometimes snow on the Bredbo sheds.

Some influences: handscrolls from China, Fairweather, Bonnard, Constable, Turner.

Michael Taylor, 2002

Gunter Christmann b.1936

Red, silver, black 1974
synthetic polymer paint on canvas 218.5 x 167.7 cm
purchased 1974 74.529

In the late 1960s and 1970s, many artists began to pare down their materials and processes in reaction against the expressionist art of the previous generation.

Gunter Christmann's painting of 1974 is about the art of painting. Red, silver and black, of which only red is considered a colour, have been used in abstract shapes that echo the rectangle of the canvas. However, the painting's sensual surface and the soft, sometime dribbled edges of the shapes subvert the abstract intention. Most of all, the brilliant speckled red, the most emotive of all colours, although contained by its frames of silver and black, has a strong emotional effect upon the viewer. In this way the artist, without a subject and employing his skills as a painter, has been able to call upon the experience of the viewer to create a strong and lasting impression.

Christmann established a reputation in the late 1960s for his abstract spatter paintings in which colours are juxtaposed to create a sense of optical vibration. During the 1980s, he returned to figurative painting using an expressive gestural approach. He has commented: 'I go on painting because that way I can express myself in a concentrated essence. Rather than write, I put it all in a painting'.[203]

John McPhee[204]

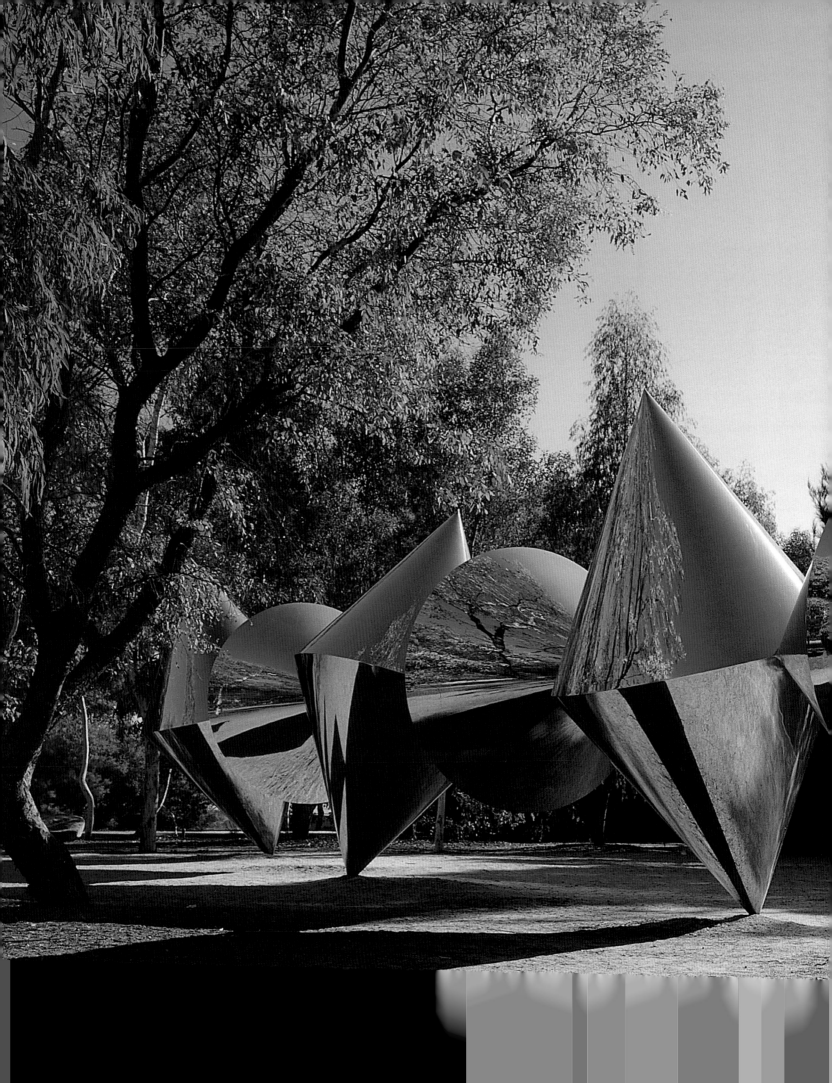

Anything Goes

1975—1989

Roger Scott b.1944

Australia Day celebration 1972
gelatin silver photograph 23.9 x 36.2 cm
gift of the Philip Morris Arts Grant 1982 83.2691

A new generation of young photographers came to prominence in the 1970s and with them came a new attitude to photography. The first photography departments were established at the art museums in Sydney, Melbourne and Canberra and, in 1973, the Australian Centre for Photography opened its doors. Attending the first courses in photography to be offered at art schools, the new generation turned away from ambitions to become photojournalists or commercial photographers and focused instead on an unglamorous, often gritty, portrayal of their own lives and those of their contemporaries. It was an exhilarating time; Roger Scott, then in his twenties, was caught up in the excitement. He concentrated on street photography:

> It [the early 1970s] was a time of political and cultural change. For some, this meant a feeling of freedom from the more conservative elements of the past. The electricity and energy bursting from this group was like a magnet. Street photographers don't have time to ponder a scene. To capture the spontaneity of a street scene you work in 100ths of a second. This was a time of hope, these people were free spirits, and to me, a joy.[205]

Roger Scott (2002) and Anne O'Hehir

Carol Jerrems 1949–80

Vale Street 1975

gelatin silver photograph 20.2 x 30.3 cm

gift of the Philip Morris Arts Grant 1982 83.2407

Carol Jerrems was one of the most acclaimed figures of the 1970s (she died aged 31, following an illness). *Vale street*, her most famous image, appears spontaneous, capturing youth culture and the spirit of the times. Yet it was staged by Jerrems using Catriona Brown, an actor friend, and two photography students. It is a complex, enigmatic image whose meaning has never been determined. For many, the image seemed to be a perfect illustration of the best-selling Helen Reddy song 'I am Woman' and a symbol of the freedom and power gained through women's liberation. To the model's distress, others read the image as an image of free love, crudely equated with sexual excess.

Anne O'Hehir

Ken Unsworth b.1931

Suspended stone wallpiece 1976
river stones, annealed steel wire 215.0 x 140.0 x 104.0 cm
purchased 1976 76.23

The series of variously suspended, propped or heaped-up river stone works, all conceived and set down as drawings and maquettes during the period 1974–77, reflects a personal response to the potential of natural materials (in previous work: earth, water, light, fire and timber) and forces, to adapt their inner qualities and energies – their inner music – with as little interference as possible, as discrete serial elements in an object; it is a structured system of rigorous clarity which seems and is, in fact, visually self-evident yet perceptually ambiguous and puzzling. The eye is not altogether convinced, so there is a sense of mystery and uncertainty.

Suspended stone wallpiece continued the idea in which the stones were introduced to the wall, either propped with eucalypt sticks or hung with wires, as distinct from those exploiting a free-standing in the round format.

In the case of *Suspended stone wallpiece* 1976 (its exhibition date), a semi-circle of modest size river stones was held horizontally above the floor by a cone of soft-annealed black wires, individually attached to a central point, at a proportionally appropriate distance on the wall above the stones. The visual effect is at once and convincingly one of aesthetic formal connections – of a structural clarity of line, form, texture and colour, and a palpable equilibrium between weight/mass, weightlessness and gravity, implied movement and rest – a tensioned yet gentle response.

The unfettered imagination could complete the full circle of stone merging with its other half through the wall, to see or be reminded perhaps of ancient associations, of some taken-up stony landscape or raised-up altars for ritual enactments. Circles, wells, platforms commemorating forgotten cruelties, triggers for spiritual regeneration or mirrors of darkest introspection?

Ken Unsworth, 2002

William Delafield Cook b.1936

A haystack 1976
synthetic polymer paint on canvas 198.0 x 274.5 cm
purchased 1977 77.515

William Delafield Cook's paintings of haystacks reveal the extraordinary in the seemingly ordinary aspects of reality, as a humble structure made of straw takes on the appearance of a classical temple set in an open landscape. The works relate to the artist's early appreciation of Greek temples and ruins, as well as his fascination with William Henry Fox Talbot's early photograph, *A haystack* 1844.

Delafield Cook understood the 'magic' that early photographers felt about being able to hold or fix an image in time. He was also inspired by the films of Michelangelo Antonioni and Joseph Losey – particularly the effect of the intense, protracted scrutiny of the camera's 'gaze' on a seemingly inconsequential aspect of reality, disrupting our normal consciousness and creating a bristling tension.

Delafield Cook painted several haystacks at intervals from 1976 through the 1980s. This was his first major painting on the theme, inspired by his impressions of one of these structures on a hill, encountered in the countryside around Geelong in Victoria:

It was one of those parched dry hills in summer and this golden shimmering thing, this structure, was sitting up there. It reminded me so much of being in Greece and coming across temple sites ... of travelling in a landscape that every now and then would resonate with a monumental kind of statement.[206] Delafield Cook set the temple-like structure in the centre of the painting, which he worked on in his studio at the University of Melbourne where he was artist-in-residence. The image has an architectonic feel. The artist built up the surface in delicate layers; working from a dark ground to the light sky, gradually painting minute strands of dry grass and straw with fine sable brushes. The palette is deliberately limited, the raking light at one with the golden, parched straw of summer. The atmosphere is eerily motionless, as though physical and mental space are as one.

While Delafield Cook was working on *A haystack* in Melbourne, Fred Williams came to his studio and admired the painting, later recommending it for acquisition by the National Gallery of Australia. The haystack remains an enduring image: an ephemeral 'house of straw' rendered monumental and held forever on the canvas.

Deborah Hart

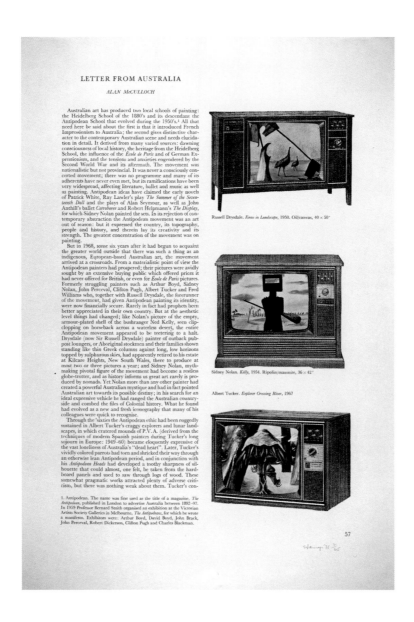

Miriam Stannage b.1939

Letter from Australia 1976
offset lithograph, printed in black ink, from one plate on paper
64.0 x 43.8 cm
purchased 1976 76.1232

The print, *Letter from Australia*, was one of a series done in 1976 using pages from newspapers, international art journals (some from the 1930s) and popular magazines. I wanted to juxtapose art images (including Australian artists' paintings) within an everyday public context such as newspaper television-sale advertisements. In 1976, these had no images framed in the empty screens. In later versions I collaged the emu, bushranger Ned Kelly and the explorer onto different paintings by Joan Miró, Kenneth Noland and Jackson Pollock, and in different locations such as China, Ireland and Canada respectively. Today, through computer technology, similar collage manipulations are commonplace in advertising and works of art. I have used this new artist's medium since 1995.

As a visual artist, sight and what is seen and unseen is a central concern. To explore this theme, I transform literature, art criticism, words (including braille) and letters (public or private) into photographs, paintings or mixed media works of art. The unique Australian landscape is often contrasted with city and suburban imagery, the life of our consumer society and man-made objects.

Time is a recurring motif. Past, present and future intertwine in subjects relating to nature, religion, war, sex and sexuality: all concerning life and death. However serious the ideas and images are, my work is often lightened in a classical minimalist style by wit and irony – wit (not cleverness) implying constant introspection and perception of life's experiences both physical and spiritual.

Miriam Stannage, 2002

Jenny Watson b.1951

Windsor (small version) 1975–76
oil on canvas 91.0 x 106.3 cm
gift of the Philip Morris Arts Grant 1982 83.1594

Windsor (large version) 1977
oil on canvas 177.6 x 213.8 cm
gift of the Philip Morris Arts Grant 1982 83.1593

In 1975, I executed a series of double paintings of the suburban houses that I had lived in whilst growing up around Melbourne. I wanted to explore beyond the single contemplative painting. At this time I was interested in the question of the original. Each house was painted in a large and a small version. The small version was painted from a photograph. The large version was painted from the small version.

The small version of each house was painted on a canvas 3 x 3½ feet from an 8 x 10-inch black-and-white photograph overlaid with a grid and carefully transposed.

The address of the house was incorporated into the painting. It's important to say that this text was not painted over the image afterwards. The letters were marked out in lead pencil on the canvas with the grid. I was interested in what happened when the letters were located in the paint. The genesis for this idea came from observations of credits over images at the end of television shows.

On completion, a photograph of the small painting was gridded up in approximately 1-inch squares and a much larger painting was done from that. The brush marks became more abstract. Although the personal meaning for me was essential as a motivation, the concerns behind the painting were located with artists such as Joseph Kosuth, Malcolm Morley, Jasper Johns and some of the American super-realists. The 'permission' to use such personal imagery was connected to arts feminism discourse I was engaged with at the time generated from the United States.

It is interesting to look back now, 25 years on, to see that working with text and image continues to be what interests me, even though my work has taken various forms since.

Jenny Watson, 2002

310

Jeffrey Smart b.1921

Corrugated Gioconda 1976
oil on canvas 80.8 x 116.6 cm
purchased 1976 76.1065

The subject matter is only the hinge that opens the door, the hook on which one hangs the coat ... My main concern always is the geometry, the structure of the painting ... Most pictures I paint stay broadly painted while I move them about, doing sketches, small studies, overpainting again and again. Only when I have the shapes in the right places do I then 'paint it realistically'. *Jeffrey Smart*[207]

The witty *Corrugated Gioconda* – a series of visual attention grabbers – shows tower blocks and palm trees fronted by a corrugated galvanised iron fence, worse-for-wear, multi-coloured and poster-laden, with the *Mona Lisa*'s enigmatic smile advertising a new publication about Leonardo by the Italian publishers Fabbri Editori.

All Jeffrey Smart's paintings are made with exemplary care and craftsmanship and he produces only four or five each year. He is concerned with 'putting the right shapes in the right colours in the right places'.[208] In *Corrugated Gioconda,* the impeccable use of lines in the floors of the apartment building echoes the reverberations of the corrugated fence. The division of the pictorial space into defined sections has mathematical precision. The diagonal from the lower left to upper right discreetly carries La Gioconda's smile.

We are offered the most celebrated of old master paintings amid contemporary banality. This is the world in which we live, where we see much but understand little, one promotional poster upon another, obscuring meaning. Smart's paintings offer opportunities for interpretation. He sees beauty, not in a flower or a garden, but in airports, roads, fences and tower blocks, and from them he makes mysterious compositions. As his fellow artist James Gleeson remarked: 'He is a narrative painter who deliberately refrains from telling a story'.[209]

When *Corrugated Gioconda* was first exhibited in 1976, a reviewer in the *Australian* picked it out from among 17 paintings and 18 studies, as the 'most powerful painting in the exhibition, and the most technically exciting'.[210] Smart, the master of composition, the technical virtuoso of Australian art, is the painter of urban landscapes who reveres the traditional skills of his profession. Having lived in Italy since 1965, Smart has described himself as 'a European with an Australian passport'.[211] He visits Australia, exhibiting regularly, and has an enviable status as an artist attracting public and critical appeal. *Corrugated Gioconda* is a particularly strong painting, in Edmund Capon's words 'a classic Smart composition'.[212] Smart can take months to find 'the germ of a picture'[213] but, when he does, he pursues it systematically with an elaborate series of drawings and oil studies before the final composition is addressed. *Corrugated Gioconda* began when Smart saw an image in a 1973 calendar for the Banca Monte dei Paschi di Siena. He noted:

The base colour of the calendar was deep blue. It seemed that it could be a wall of many colours with a white building block in the middle distance. To begin with I painted acrylic over the actual calendar. The part of the wall or fence below the building was of course, in shadow. To make it look like a fence I drew vertical lines on it. These became corrugations.[214]

The first two studies for *Corrugated Gioconda* are also in the National Gallery of Australia's collection.

Brian Kennedy

Margaret Olley b.1923

Katie's quinces 1976

oil on composition board 91.5 x 122.0 cm

purchased 1976 76.563

reproduced by permission of the artist

I have many ways of working. One is working directly from a model or from using still life; this I don't arrange and then [I] paint it immediately. I always have a very definite idea of what I want to do. Sometimes it doesn't come off immediately, sometimes it does, and this is a very satisfying thing. Other times I paint for a whole day, and then leave it for several weeks; it might go on for a month or even six weeks, taking out something, repainting again.

I very rarely make a detailed sketch, I mean a completed sketch, a detailed sketch of what I intend to do: I might make little thumbnail notes but never very detailed, because I feel you kill the painting you want to do … painting to me is like drawing, you draw with your brush or your palette knife, so whether one is using a paintbrush or water-colour or a pen, it is all creative, and I never mind which medium I'm using.

I prefer to work direct from models or still life, have an actual thing there, and then change it afterwards, because I find I am far more stimulated by having the actual thing there than relying on one's memory which is a sort of a risky thing. You can be more interested in the actual painting of whatever you are doing.

I never like to work directly on to a white ground. I might spend weeks building up a surface. As a matter of fact, anybody coming in could take it as an abstract painting, but I find this – it is really actually the bone of a painting – I must have this, before I really start on a painting.

Margaret Olley, 1963[215]

Brett Whiteley 1939–92

Interior with time past 1976

oil, charcoal and ink on canvas 182.0 x 200.0 cm

purchased 1978 79.795

A painting is a record of the extremely intensified moments of
life ... where the emotional forces seem to be propelling one to
a dangerous limit, where reason and explanations become too
enfeebled or too speeded-up to matter. _Brett Whiteley_[216]

Interior with time past is a bold, vibrant expression of Whiteley's
life. Against a lush orange background, he conjured up his studio
at Lavender Bay, with its vast expansive view across Sydney
Harbour. Into this space he scattered images of his own paintings
and sculptures, and in the foreground he placed a still life with
cherries, avocados and a vase of flowers. From the copulating
couple in the drawing on the easel to the sparkling harbour view,
to the cigarettes and smoke, he evoked his own seductive,
sensuous life. He conveyed a taste of high summer, luxurious
Sydney, the Pacific Eden.

However, Whiteley was also interested in painterly matters.
He was concerned with colour and with balancing large areas of
colour against strongly linear elements.

Interior with time past is an expression of Whiteley at peace
with himself, in harmony with his environment, and lauded in
the art community. (This painting was awarded the 1976 Sulman
Prize.) He had returned to Sydney in 1969 after almost ten years
in Europe and America. He turned from his earlier views of art as
a reforming medium or as presenting the struggle between good
and evil, and began to paint a series of sumptuous images. He
described these as 'points of optical ecstasy, where romanticism
and optimism overshadow any form of menace or foreboding'.[217]

Anne Gray

Barbara Hanrahan 1939–91

Wedding night 1977

screenprint, printed in colour, from four stencils on paper 64.0 x 46.2 cm

purchased through the Gordon Darling Australasian Print Fund 1984

84.507

Barbara Hanrahan's subject here is the uneasiness of marriage, the personal and social expectations and fantasies it produces, and the gap between these fantasies and reality. The couple, so newly united, are separated and alone in their conjugal bed, despite the decorative flowered pillows and borders. Their flesh consists of pink bricks, perhaps a symbol of the suburban house in which they seem likely to live, or of the barrier between them.

Hanrahan, printmaker and novelist, made three versions of her image *Wedding night* between 1964 and 1977, reusing the elements to different effect. The first is an etching printed in red and black, the second a linocut and the third variation is a colour screenprint. All three share the same simple compositional elements, an overhead view of two naked figures in a divided bed, with the title 'Wedding night' above and the labels 'husband' and 'wife' below them. In the 1977 screenprint, the wife's torso is also branded with the word 'virgin'. In this version, Hanrahan also added underwear to the figures, but she subverted the concealing quality of the underpants by the addition of bright yellow pubic hair, which frames the genitals and draws attention to the sexual activity to come.

By the late 1970s, the assumption that girls would be virgins on their wedding night had largely disappeared from Australian society. Hanrahan's crudely outlined figures, labelled for our inspection, seem to recall a past age of conformism and sexual ignorance. The universal theme of alienation, the essential unknowability of other people, remains as valid now as then.

Christine Dixon

Toni Robertson b.1953
Chips Mackinolty b.1954

Daddy what did you do in the nuclear war? 1977
screenprint, printed in colour, from multiple stencils on paper
73.4 x 48.2 cm printed by Earthworks Poster Collective
given in memory of Mitch Johnson 1988 88.549

Ann Newmarch b.1945

For John Lennon and my two sons 1981
screenprint, printed in colour, from multiple stencils on paper
85.8 x 59.8 cm
gift of the artist 1988 88.1205.A-B

The political poster movement in Australia was at its height in the 1970s, supporting anti-war, anti-uranium, pro-land rights and pro-feminist causes. Members of the Earthworks Poster Collective, opposed to the egotism of individual artistic fame, worked from the Tin Sheds (University of Sydney Art Workshop). In *Daddy what did you do in the nuclear war?* Toni Robertson and Chips Mackinolty appropriated a British recruiting poster from the First World War, adapting the children's bodies to reflect the genetic consequences of radiation.

Ann Newmarch reacted to the fatal shooting of John Lennon in New York in 1980 in her screenprint diptych, *For John Lennon and my two sons*. The gun dominates as the icon of a violent society which teaches young boys about guns through toys. More photo-collages – of a pistol on a key-ring, an arm with a toothbrush gun, press reports, comics and advertisements – are scattered on the blood-red ground. Julie Robinson comments: 'Most unsettling is the image of her young son holding the gun-shaped "Baby Care Wild West Toothbrush" to his mouth, a toothbrush which Newmarch had repeatedly protested to store managers about'.[218] The artist inscribed a text below: 'homicide, genocide become household words ... news becomes entertainment and toys teach a disrespect for humankind'.

Christine Dixon

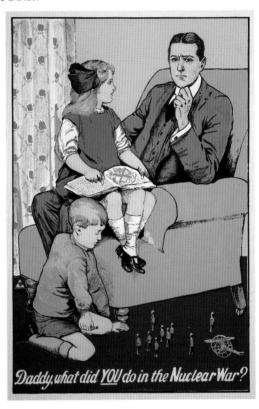

Wolfgang Sievers b.1913

Escalator site at Parliament Station, Melbourne 1977 printed 1988

Type C colour photograph 50.5 x 40.5 cm

purchased 1989 89.1422

© Wolfgang Sievers, 1977. Licensed by VISCOPY, 2002

Although he regards photography in black and white as more creative and demanding, Wolfgang Sievers's first major body of work in colour set new directions for industrial photography in Australia. He was commissioned to do the photographs for *The Fabulous Hill*, a lavish 1960 publication on the Broken Hill Associated Smelters plant and activities across Australia. To overcome the greyness of the underground locations, Sievers turned to using colour foils over his lights. He felt the colour symbolised the rich hues of the minerals which were being extracted. The use of colour foils can also be seen in his 1977 view of the construction of the elevator shaft for Parliament Station.

The image shows two tiny figures calmly conversing at the top edge of what looks like a hot cauldron; but the discrepancy in scale generates a fantastic element, suggestive of Jules Verne's 19th-century fantasy story, *Journey to the Centre of the Earth*.

The image is more than a glamorous corporate Public Relations image; it speaks also of the irony that such tiny 'ants' can create and control huge engineering complexes. Or does the image also introduce a query about the monsters that humans create? Through the 1970s to 1990s, Sievers was concerned by the decline in the role of the workers as corporations became all powerful, and by the role industry had in the polluting of the environment. As a young man, Sievers fled from the Nazi regime in his homeland to come to Australia in 1939. He has strong political and aesthetic views and his images reflect his ideas on the human condition.

Gael Newton

Bert Flugelman b.1923

Cones 1982
polished stainless steel 450.0 x 2050.0 x 450.0 cm
commissioned 1976, purchased 1982 82.2142
© Bert Flugelman

Stretching across more than 20 metres of ground in the Sculpture Garden of the National Gallery of Australia, Bert Flugelman's reflective steel *Cones* has assumed an iconic presence. Over the years, the work has become a favourite backdrop and interactive site for taking photographs to commemorate a special occasion or to record a visit with family and friends to the Gallery.

Over more than three decades of work, including numerous public commissions, Flugelman has become one of Australia's best-known sculptors. In the 1970s, after experimenting with a wide range of materials, he discovered stainless steel. In a conceptual sense, he also found himself wanting to turn away from 'self-indulgence', to engage with the outside world. Following *The Field* exhibition of contemporary abstraction at the National Gallery of Victoria, Melbourne, in 1968, the artist found a clear sense of direction.

> At that time, my work suddenly started to make real sense ...
> I wanted something that was immensely precise and minimal
> like a cube, but I also wanted to distort the planes and
> somehow deny the information that the edges gave ...
> as though there were things trying to get out.[219]

As Ian North has pointed out, Flugelman's works differ from Minimalism in that they are not only about the qualities of surface and volume, but also consistently 'had the public and the site very much in mind'.[220] This is certainly true of *Cones*. While on one level the impression is of brilliant clarity and geometry, the whole is energised by dynamic interactions of the forms across the space; they reflect sky, ground and eucalypt trees, involving the visitor as an active participant, enmeshed temporarily in the flow of constantly changing possibilities.

Deborah Hart

Mick Namarari Tjapaltjarri c.1926–98

Pintupi people

Sunrise chasing away the night 1977–78

synthetic polymer paint on composition board 40.0 x 60.0 cm

purchased 1997 97.110

The painting reflects the night's phases and the sunrise over the landscape. The usual depiction of the landscape in desert paintings is in plan view, as though the viewer were looking down from above onto the land. Here, Namarari takes this way of representation to extraordinary lengths, demonstrating the Pintupi sense of perspective, where the point of view incorporates a larger cosmology – looking down from the heavens through the stars, past the rising sun and the night onto the campfires burning on the plain below. As the night fades from the left of the picture, the sun on the right casts the dawn light over the landscape. The white dots are painted stones, whilst the central roundel represents a ceremonial ground.

This work is a part of a series of paintings about the artist's

Moon Dreaming, which he produced for the 1978 film, *Mick and the Moon*. One of the key early members of the painting movement which commenced in the early 1970s at Papunya, west of Alice Springs, Namarari went on to paint impressive larger works on canvas in the ensuing decades and was represented in numerous Australian and international collections.

Works made at Papunya challenged public perceptions of contemporary Indigenous art. For the first time, the rich visual languages of the desert were painted in synthetic paints on flat, portable boards and made available to the general public. Today, art from numerous communities in the Western Desert region is renowned throughout Australia and internationally.

This small work is an excellent example of early Papunya painting on boards and a precursor to larger, more recent works on canvas. It was commissioned by Geoffrey Bardon who, as a teacher at the Papunya school, was a catalyst in the painting movement in the early 1970s.

Susan Jenkins

Narritjin Maymuru 1922–81

Manggalili can/Yolngu people

Nyapililngu ancestors at Djarrakpi c.1978

natural pigments on eucalyptus bark 158.0 x 60.0 cm

purchased from Gallery admission charges 1986 86.1130

Narritjin Maymuru's homeland of Djarrakpi provided the central focus of his art. His paintings explore the spiritual and emotional dimensions of Yolngu (Indigenous people from Arnhem Land) life, from spirit conception, through engagement with the landscape and its history, to death and the reincorporation of the person in the spiritual dimension.

This painting combines a representation of the form of the landscape at Djarrakpi with the story of its creation in the *Wangarr*, or ancestral past. In the centre is the lake, with anvil-shaped clouds rising at either end. The dunes that separate the lake from the sea are marked by irregular triangular shapes along the left-hand border. The head and elongated body of the *Guwak* (koel cuckoo), which stretch along the right side of the painting, mark the edge of the lake. The two figures on either side of the lake represent the ancestral Nyapililngu women who, together with the *Guwak*, created much of the landscape. The forms of the women's bodies are interwoven with the events that shaped their lives.

The Nyapililngu lived in the dunes and on the lakeshore. Their bodies are represented by the sticks that they used in walking the sand dunes, digging into the ground and collecting wild plums. Their heads are the baskets into which the plums were placed. The sticks were also used to cut the women's heads when mourning close relatives. The cross motif, recurring throughout the painting, represents the breast girdles of the women and also signifies the billowing wet season clouds. The cross, too, is a sign of mourning, since clouds rising over distant lands are a portent of death. In the women's faces, the crosses mark their cheeks and allude to the grief they felt as they cut themselves in mourning and tears poured down their faces. The painting is a supreme illustration of the complex symbolism of Narritjin's art and the way in which meaning is interwoven with expressive form.

Howard Morphy

Peter Tyndall b.1951

detail

A Person Looks At A Work of Art

someone looks at something ... 1978–79

synthetic polymer paint on canvas 278.0 x 138.3 cm

purchased 1983 83.1168

Much of Peter Tyndall's prolific output is concerned with the process of looking at art. Tyndall employs a range of symbols to highlight the relationship between the viewer and a work of art within the broader context of culture and history.

A frame suspended by two strings is a recurring symbol in Tyndall's work. It appears as the central panel in *detail/ A Person Looks At A Work Of Art/ someone looks at something.* For Tyndall, the frame signifies 'something' that we recognise and can name. The strings are like physical and metaphorical supports that connect the 'thing' to the world outside the frame. The outline of a figure refers to a viewer looking. The viewer in front of a suspended frame is echoed when we look at this work. Two strings are attached to the frame of the picture; we take on the role of the outlined viewer.

Symbols, referring to the influences which affect our view of works of art, surround the central panel of the painting. A map of Australia, a dollar sign, a ladder, a cross, a skull and a question mark suggest that our process of looking at works of art is shaped by a number of cultural and historic forces. Combining these well-known graphics with his personal vocabulary of symbols, Tyndall creates a rich visual language which articulates the complex context within which we look at art.

David Sequeira

John Nixon b.1949

Eleven heads 1978

(clockwise spiral from top) *Discontinuous, or Kino; The agitator; Black diamond; Urgent; PO! PO! Manifesto/Surf, surf, surf, surf, surf; Uncomfortable audacity, or Dissident outburst; The peril; Red megaphone; Red square, or The Dialecticians apprentice; 'B'; The insult*

plastic, paint, cardboard packaging dimensions variable (with 11 audiocassette tapes)

purchased 1984 84.1266.A-K

Since 1968, John Nixon has questioned the nature of art through a widely diverse practice informed by Minimalism and Conceptual Art. His simple yet richly diverse geometric paintings show an inventive and resourceful use of ready-made objects and basic materials such as cardboard, newspaper, hessian, masonite and felt. Nixon's continuing use of geometric forms – crosses and other minimalist shapes – was originally inspired by the work of the early 20th-century Russian Constructivist artists and 1960s Abstractionists such as Barnett Newman and Ad Reinhardt. His everyday, non-art materials express an affinity with Vladimir Tatlin's creed of a 'culture of

materials' and also with the poetics of 1960s *arte povera*.

The radical impetus of the modernist tradition is an enduring source of inspiration for Nixon; it is the premise upon which he has developed his own contemporary approach to abstraction and exhibition making. Through a lively, ongoing process of experimentation (with materials, methods and approaches to display), Nixon continually tests definitions of painting and the form of the exhibition.

The work pictured here, *Eleven heads,* is from the period of Conceptual Art and typifies the declarative, language-based forms Nixon used at that time. Each of the individual 'heads' (cardboard constructions suggestive of the shape of a head with megaphone) is accompanied by a spoken audiotape of the artist's voice. When originally exhibited, a single 'head' was shown by itself in an otherwise empty room. It was simply attached to the wall with the sound seeming to come from the megaphone form. Each work was considered by the artist to be an exhibition in itself. When the heads are shown as a group, the work becomes like a store or archive of the individual pieces.

Sue Cramer

Inge King b.1918

Temple gate 1976–77
painted steel and aluminium 477.0 x 238.0 x 238.0 cm
purchased 1977 77.178

Temple gate was inspired by my first visit to Japan in 1974. Among the many treasures, I was fascinated by the various archways to Shinto shrines – wooden structures painted in bright colours, predominantly red with gold and white decorations. They are called *Torii*. It was not until 1976 that I started to develop my own interpretations of archways. My archways were conceived as part of the 'Australian landscape' which has gripped my imagination since I arrived here in 1951.

I try to measure work against the vast spaces of this country. It is not the size of the sculpture but simplicity and clarity of form, expressing inner strength and tension, that is the motivating force.

Temple gate was completed in 1977 and exhibited the same year in a solo exhibition at Realities Gallery in Melbourne. James Mollison, the first Director of the National Gallery of Australia, purchased the work from this exhibition. It remained in storage until the Gallery opened its doors in 1983 when it was installed in the Sculpture Garden at its present site.

Temple gate is a 'walk-through' sculpture, thus encouraging the spectator to explore its many facets. It was the first in a series of suspended works that try to create a feeling of flight which almost denies the gravitational pressure of the material.

I look at the art of sculpture as 'vision in motion'. I have used metal, predominantly steel, to express my ideas. I envisage my monumental sculptures as part of the environment.

Inge King, 2002

Frank Bauer b.1942

Pendant 1979

18 carat gold 21.0 x 13.0 x 1.5 cm

Crafts Board of Australia Council Collection gift 1980 84.3209

German-born Frank Bauer is one of a group of European metalsmiths whose emigration to Australia in the 1960s and 1970s enriched and influenced Australia's nascent jewellery movement. At the time this pendant was made, contemporary jewellers were interested in pushing the boundaries of their medium, questioning the conventional social meaning of jewellery (especially as it related to wealth, status and ornament) and experimenting with new, more sculptural forms and alternative materials.

At this time, Bauer challenged the traditional forms, materials and social language of jewellery by making reference to a range of structures and objects found in everyday life such as buildings, tools and domestic house fittings, reworking them into wearable forms. He also made a series of works in which he explored the grid form, of which this pendant is an important example.

In this pendant, Bauer used gold in an unconventional way, building a three-dimensional grid, a form more usually associated with minimalist sculpture and modernist architecture than with jewellery. At the same time, gold's ductility and strength allowed him to make his structure of thin wires, building up a form which has all the delicacy of jewellery.

The pendant is imposing in its scale, lending it the quality of a piece of formal regalia; its delicacy and rigorous lines, however, set it apart from the excesses of such traditional wear, inviting the viewer and wearer to recognise the sculptural potential of jewellery and to appreciate the formal qualities of its materials independent of their social status or value.

Anne Brennan

Rosalie Gascoigne 1917–99

Feathered fence 1979

white swan feathers, galvanised wire netting, synthetic polymer paint on wood 64.0 x 750.0 x 45.0 cm

gift of the artist 1994 94.256.A-R

© Rosalie Gascoigne, 1979. Licensed by VISCOPY, 2002

They were very good quality glossy feathers picked up at Lake George from the swans there ... People think it's cockatoos, but it isn't. It's the disappearing fence and the birds and the Zen look of it. Marvellous. You can't beat those level landscapes. *Rosalie Gascoigne*[221]

Rosalie Gascoigne has played a significant role in redefining the Australian landscape through her inventive application of found materials to create a poetic vision of place. The strength of Gascoigne's art emerges in part from her precise powers of observation and her capacity to distil deeply-felt experiences of natural phenomena encountered in her local environs around Canberra. Among the places she frequented was the flat, luminous environment of Lake George where she found hundreds of white swan feathers which she incorporated in her evocative, sculptural floor-installation, *Feathered fence*.

In each of the seven main components in *Feathered fence*, densely packed feathers are held together in the slats of bee-boxes attached to circular constructions made out of fine wire netting. The placement of the components across the floor in a horizontal trajectory alludes to the stretch of the vast, level landscape; the intervals between them suggest the way that fences become submerged in shallow water in alternating patterns of appearance and disappearance. The repetitions and subtle variations are characteristic of Gascoigne's approach, in this instance evoking the mirage-like nature of Lake George. A sense of luminosity pervades the whole and also a feeling of air circulating around the beautiful, tall feathers that arc in different directions to convey flight.

Gascoigne said that she wanted to capture her feelings for country – the emotional upsurge that she felt in the presence of the landscape scoured by sun, frost and wind. In the minimalism, subtle colouration and floating, flying nature of *Feathered fence*, she reveals her remarkable capacity to evoke an expansive sense of place – to be suggestive and lyrical, 'to make air visible'.[222]

Deborah Hart

John Wolseley b.1938

A journey near Ormiston Gorge in search of rare grasshoppers
1978–80
watercolour, pencil and gouache on paper on canvas
183.0 x 294.5 cm
purchased 1980 80.2173
© John Wolseley, 1978–80. Licensed by VISCOPY, 2002

John Wolseley is an artist who has concerned himself with the broader questions of the landscape and the environment for most of his life. He is an unusual artist whom Australians at times describe as a 'pommy eccentric', a 19th-century gentleman naturalist and obsessive watercolourist, while Europeans tend to see him as being preoccupied with lines of mystic energy in the land and with various forms of Asian Zen mysticism. He is unconventional, his work does not fit neatly into any pre-established school of art or pattern of thinking, yet his sprawling map-like paintings have always been highly regarded and, as a draughtsman and watercolourist, he is a consummate technician.

A journey near Ormiston Gorge in search of rare grasshoppers appears as a cross between a cartographic depiction – a journey through time and space – and an intimate visual and verbal journal of exploration. It involves both the artist and his viewer on a journey through texts and systems of visualisation, where chance and accident combine with some of the more deliberate strategies of art making. All of this is employed in pursuit of the elusive grasshopper. The viewer is not an objective witness but is an active participant in this intricate, elaborate treasure map of exploration. The little squares of the surface grid relate to pages from the artist's journal, the subdued colours reflect the actual tonality of the landscape around the gorge, while detailed draughtsmanship describes insect life, like tiny pockets of life energy.

Sasha Grishin

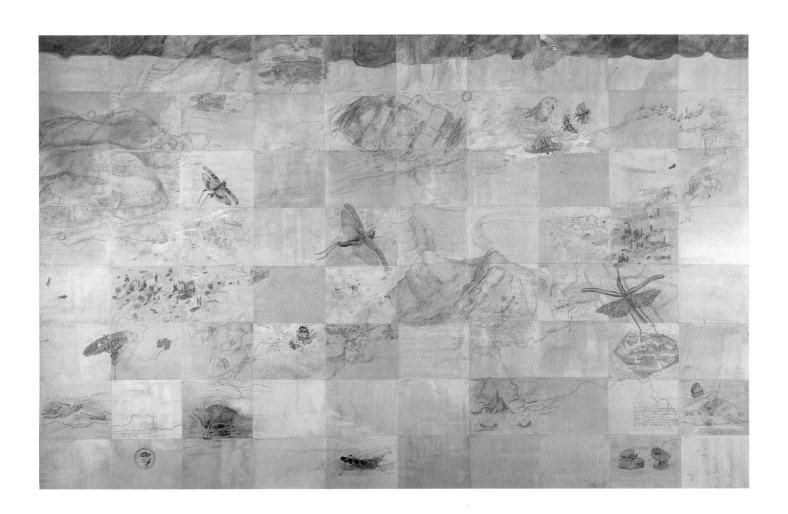

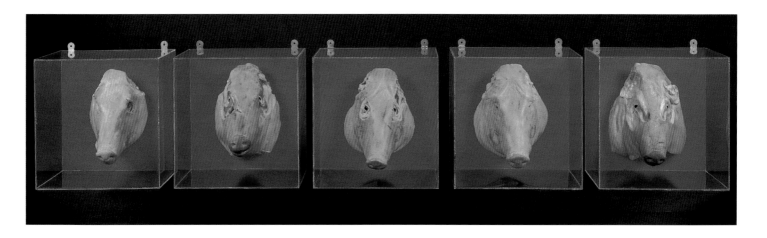

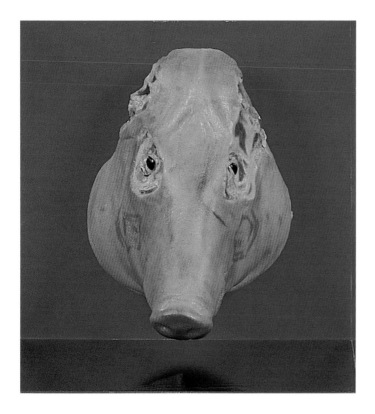

Ivan Durrant b.1947

Five pigs' heads 1978–79
synthetic polymer resin, oil enamel, perspex, brass
five elements 33.0 x 30.0 x 26.0 cm (each)
gift of the Philip Morris Arts Grant 1982 83.1605.A-E

In 1975 I had a burning ambition: to take hundreds of viewers to an abattoir to witness cows being killed. That was to be my exhibition.

Absolute realism seemed the most powerful way of viewing things. I was then, and still am, deeply concerned about the real world around us – our politics and behaviour.

To view first-hand the slaughter of a cow immediately forces you to be part of the activity of killing. You cannot avoid the connections with the eating of meat and your part in the animal's destruction. There seems to be something fundamentally understood by us all when we view life-taking first hand. I believe it's the switch-on key to get us all to feel responsible for our actions from then on.

The *Five pigs' heads* was a way of bringing the abattoir visit to the onlooker in a context that demanded reflection and questioning. The live, almost human eyes and almost human flesh of the severed pigs' heads brought the emotional response to the death closer than probably any other animal head would. The glossy, blood-red background emphasised the blood-letting.

Since the mid-1970s, all my work has dealt with super-real images in an attempt to develop a visual dictionary where I know the viewer cannot avoid seeing exactly what I am talking about. There is no attempt to disguise my images in an acceptable painterly or stylised way. The onlooker has no way out. They cannot hide their emotions under the excuse of 'it's only art'. I take great pride when people say my paintings are not art but 'copied photographs' and, likewise, my sculpture is 'just pigs' heads'.

Ivan Durrant, 2002

Jill Orr performance artist b.1952
Elizabeth Campbell photographer b.1959

image from the performance ***Bleeding trees*** 1979 printed 1990

Type C colour photograph 34.2 x 22.3 cm

purchased through the Kodak (Australasia) Pty Ltd Fund 1996 96.666

Stelarc performance artist b.1946
Norman Ainsworth photographer b.1942

image from the performance ***Prepared tree suspension event for obsolete body number six*** 1982

gelatin silver photograph 60.0 x 45.8 cm

purchased 1984 84.443.3

reproduced courtesy of the artist, Stelarc and Sherman Galleries

Performance art flourished in the 1970s and 1980s as artists sought to redefine art as more than precious items in museums. Many performances involved the artists undergoing almost ritualistic self-scourging. Events can be staged in front of an audience or as a solitary production but, by its nature, performance art is temporal. Though often no more than a basic documentary device, photographs of performance art are all that remain of many events and can stand on their own as works of art in varying degrees. Jill Orr and Stelarc have worked with a number of photographers over the years.

Jill Orr 's *Bleeding trees* was performed during the Third Biennale of Sydney in 1979 and reflects environmental concerns. During the performance, Orr was strung up in a dead tree and also half buried in the earth. In this image, her mouth is a gaping wound, 'an opening, through which fear can pass'.[223] Orr becomes the mouthpiece of desecrated nature.

Stelarc (born Stelios Arcadiou) has consistently addressed issues of the body and technology. In the late 1960s, he made a suspension work in which he was hung in a harness, but in the mid-1970s he achieved his suspension works by means of fine meat hooks inserted through his body. The event shown here took place on 10 October 1982 in Canberra. Stelarc has suspended himself in around 25 performance pieces between 1976 and 1992 in a myriad of locations – over the ocean, in warehouses, between two buildings in New York. They are explorations into determining the limits of the body in relation to forces of nature, particularly the law of gravity. Stelarc has gone on to develop advanced prosthetic devices, such as a robotic third arm, by which he extends his actions as an artist.

Anne O'Hehir

Sandra Taylor b.1942

Identification crisis 1978
glazed stoneware, three sections
32.5 x 63.0 x 55.0 cm (overall)
gift of the Philip Morris Arts Grant 1982 83.2850

Identification crisis reveals Sandra Taylor's acerbic wit coupled with an underlying seriousness. She said of this piece: 'It has the biting edge that separated it from the zany, humorous, lyrical qualities of previous works … it was a very personal story disguised as social commentary'.[224]

Taylor was attracted to American funk ceramics of the mid-1970s. After she graduated from the now National Art School at Sydney, she produced domestic ware and more specialised pieces. Once she realised that the more individual pieces sold more quickly, even though they were more expensive, she gave up making domestic ware.

Identification crisis evokes a theatrical stage set, with three different settings for her domesticated animals. The sides of these pieces gave her many options, such as covering the walls and having the palm trees visible behind them.

Through her sculptural ceramic works, Taylor lays bare the frailties and foibles of our everyday lives and tries to make sense of them. Her early work, such as *Identification crisis*, uses animals as metaphors for humans. In 1995, she began using human figures and her ideas, unfiltered through satire, are direct and therefore quite confronting.

Taylor's work may be read on two levels: it is fun and humorous, but it always looks at the more serious aspects of life. She believes that ultimately nature is the great leveller.

Meredith Hinchliffe

Robyn Stacey b.1952

Queensland – out west 1982

gelatin silver photograph, colour pencils, colour dyes, watercolour

11.2 x 17.8 cm

purchased through the Kodak (Australasia) Pty Ltd Fund 1983

83.3390.3

I made a series of 13 photographs on my first trip back to Queensland after three years living interstate. The trip was partly nostalgic, revisiting the hot and quintessentially Queensland lifestyle of timber houses, subtropical plants, and laconic locals. The tiny towns were my focus, not the great inland vistas or fabulous coastlines. It was really a road trip with my mother, driving from Brisbane out to small communities like Monto, Murgon, Gayndah and Kingaroy. The final prints are small, personal postcards, souvenirs or mementos of the trip.

At the time I was interested in hand-colouring photographs, a technique associated with women's work and craft. This approach seemed a good way to visually re-enforce the personal and intimate quality of the prints, as well as being sympathetic to the subject matter. In *Queensland – out west*, the hand-colouring also plays with the promotional notion of the postcard, being reminiscent of those 1950s and 1960s scenes of iconic Queensland tourist spots like the Gold Coast or the Great Barrier Reef.

Currently I am artist-in-residence at the Royal Botanic Gardens, Sydney, working with the one million specimens in the National Herbarium. The Herbarium images are more refined and sophisticated than those in *Queensland – out west*, and the computer and cross processing have replaced hand-colouring, but the desire to experiment with traditional forms and my interest in popular culture remains. Photography and digital processes are tools that enable me to explore aesthetic, social and historic attributes of Australian culture and lifestyle.

Robyn Stacey, 2002

Alex Mingelmanganu died 1981

Kulari/Wunambal people

Wandjina c.1980

natural pigments and oil on canvas 159.0 x 135.5 cm

purchased 1990 90.1086

In many parts of the Kimberley in Western Australia, the Wandjina ancestral beings established the laws of social behaviour. The Wandjina are associated with the life-giving properties of water. They bring the monsoonal rains and distribute the spirits of the unborn to their eventual parents.

Images of the great creator Wandjina appear on the walls of caves and rock shelters of the Kimberley. People say that the Wandjina themselves left their images on the rock surfaces after they had completed their creative actions. In more recent times, images of Wandjina have appeared painted onto sheets of bark, utilitarian objects and canvas.

To safeguard the continuation of the cycles of nature, it is the duty of the Wandjina's human descendants to conserve these images. Mingelmanganu was the first artist in the region to continue the tradition on canvas. To convey the scale of the rock paintings, he used the possibilities presented by the size of canvas as opposed to the smaller sheets of eucalyptus bark which artists in the area were used to painting on.

The layers of dots that cover the body create a glistening effect for the viewer. They have a number of associations: they recreate the presence of ancestral power in the figure and, by extension, within the painting itself. This shimmering effect, much the same as that seen in the lustrous surface of pearlshells, is also associated with health and wellbeing.

The dark shape on the figure's breast represents a pearlshell pendant worn by initiates in the Kimberley. While such pendants are made on the western coast of the Kimberley, they are traded widely and have been found as far east as western New South Wales and Queensland. The pendants are suspended from a cord made of human hair.

Wally Caruana

Anatjari Tjampitjinpa *c.1927–99*

Pintupi people
Ceremonial ground 1981
synthetic polymer paint on canvas 182.5 x 182.0 cm
purchased 1992 92.1397

This painting celebrates events connected with the ancestral Tingari beings. Tingari is the ancient and secret knowledge transmitted to Aboriginal men in ceremony as a form of post-initiatory higher education. Much of the knowledge and activities of the Tingari lawmakers is reserved for the initiated. The Tingari, however, are often also described as two major figures of varying identities who travelled through the vast Western Deserts with a large group of people. They created country and laid down the law as they went.

The painting shows a ceremonial ground where the participants sit around camps. The large circles represent older men who are decorating the younger ones (small circles) with Tingari designs. The large circle, made up of yellow dots rather than white, just to the upper left of the very centre of the painting, indicates the focal point of the ceremony. The ceremonial site is surrounded by water.

Anatjari evokes the spiritual powers that are summoned during the ceremonies and which imbue the participants through the use of visually mesmerising patterns of finely dotted concentric circles. The painting is characteristic of the minimal esoteric images produced by the Pintupi: apart from the repeated patterns of circles, there are none of the other designs, such as U-shapes and arcs, wavy or straight lines, common to the paintings by artists belonging to other language groups across the desert.

Wally Caruana

Ragnar Hansen b.1945

Tea service 1982

sterling silver and ebony teapot: 15.1 x 22.9 x 12.0 cm; jug: 10.6 x 17.0 x
8.8 cm; sugar bowl: 6.8 x 11.1 x 10.7 cm; spoon: 14.7 x 4.7 cm
purchased 1982 82.995.1-4

Helmut Lueckenhausen b.1950

Table 1982

teak 70.8 x 61.4 x 39.5 cm
purchased from Gallery admission charges 1983 83.3232

Ragnar Hansen was born in Frederikstad, Norway and trained as
a silversmith from 1961 to 1967, before emigrating to Australia in
1972. His work is grounded in the Scandinavian modernist craft
tradition, with its emphasis on fluid form, unadorned surfaces
and functionalism. The reflective nature of polished metal is an
important quality in Norwegian design, suggesting the value of
light in this region. Hansen's transference of this quality to the
Australian context has been one of his major successes, achieved
by relaxing the formal rigour of Norwegian functionalism while
reinterpreting its traditions of romanticism to reflect design
imagery influenced by Australia's natural environment. In this
tea service, the utensils become as fluid as the liquid they contain,
suggestive of the refractions of water flowing over rocks and
inviting the touch of the hand.

Hansen moved to Canberra in 1981 to teach gold and silver-
smithing at the Canberra School of Art.

Helmut Lueckenhausen was born in Germany and arrived in
Australia in 1959. He trained as an industrial designer, but his
unique furniture draws its inspiration from the natural world
and the relationship between scientific inquiry and human
experience. In this early small table, he has given the basic
elements of its design – the legs and top – animal-like forms,
suggesting a tautness and energy quite unexpected in such a
small piece of furniture, while his use of unadorned, carved teak
adds a further exoticism to this object. Lueckenhausen's interest
in such zoomorphic traditions in design has continued to inform
his work, as has his research into the culture of ceremonial
furniture.

Robert Bell

Raymond Arnold b.19

Imaginary landscape – eighteen months in Tasmania 1984
etching and aquatint, printed in black ink, each from one plate on
eight sheets of paper 120.0 x 437.6 cm (overall) printed with
assistance from Frieda Beukenkamp, Chameleon
purchased 1986 86.533.A-H

Imaginary landscape – eighteen months in Tasmania has as its
inspiration the panoramic view from the final ridge on the walk
to the summit of Frenchmans Cap. The rock is quartz and the
abrupt and swirling patterns of bright white crystal are frozen
liquid in appearance: a function of volcanos and glaciers. Wind
and rain combined to carve and scour the stone gullies that drop
down into the Franklin river, which flows around the base of the
Frenchman Range. The Franklin was to become the central
element in the well-known development/conservation clash in
1982 and it was against this background of social and political
discord that I made *Imaginary landscape*.

It took 18 months of considerable plotting to bring the image

together. I had moved to Tasmania in 1983, to bring my work
closer to important conservation issues and *Imaginary landscape*
marked the beginning of another phase of my life. The print's
title refers in one sense to this new beginning and I approached it
in a diaristic manner, working at the kitchen table on the grounded
zinc plates. Each day I would map out a small area and 'draw' the
rocky forms into the hard/soft ground surface. What began as a
sweep of gritty geological fragments built up over time into eight
segments of liquid atmosphere – rock/cloud metamorphosis.

A quote describing the work of the 17th-century Dutch artist
Hercules Seghers refers to his 'bleak hallucinatory vistas of great
power, in which the thick lines forming the rocky structures
actually seem to be eroding before our eyes'. The apocalyptical
nature of the Seghers print has an equivalent for me in the
dissolving geometry of *Imaginary landscape*. The hardground/
softground process metaphor also reinforces the idea of the
vulnerability of the landscape in the face of technological change.

Raymond Arnold, 1992[225]

Mandy Martin b.1952

Pink break 1984

oil on canvas 173.2 x 244.3 cm

gift of the Philip Morris Arts Grant 1988 88.35

© Mandy Martin, 1984. Licensed by VISCOPY, 2002

This painting belonged to a series that I painted from drawings made at a number of sites including Lake George or Weerewa, near Canberra. Some of these drawings and paintings drew on the archaeological dig of ancient Indigenous sites in this area. In this work, 'break' not only refers to the geographical gap in the hills but also to my concern at that time with the hole in the ozone layer, and this is why there are other violent atmospheric events occurring in the painting. Other themes, such as the despoliation and degradation of landscape through the industrial colonisation of Indigenous lands had, and still have in 2002, a consistent presence in my work.

In the same manner in which I still work, I combined images from drawings I had made at far-flung places like the Salt Mines in Salzburg, the petrified fossil forest at Cervantes in Western Australia and the saw-tooth wool mills in the South of New Zealand/Aotearoa (interlocked with the truncated spurs of ancient hills), with images of Lake George. I was aware of Colin McCahon's paintings, and it was possibly his work which inspired my response to Lake George. Simultaneously I was responding to 1980s Neo-expressionism, which was primarily a male domain and therefore a challenge to a feminist in terms of my critical engagement with its aesthetic influences.

Mandy Martin, 2002

Peter Rushforth b.1920

Blossom jar 1984
wood fired stoneware, chun blue glaze 28.6 x 24.1 x 24.1 cm
purchased 1984 84.1423

Peter Rushforth's *Blossom jar* is typical of the work of one of Australia's major ceramic artists, showing his fine and educated sensibility as a potter, with the expressive quality of his work unfolding in the process of making. This almost spherical jar with its small flared lip has been shaped on the potter's wheel and produced in a two chamber wood-fired kiln from which comes the chun glaze with its rich opalescence and extraordinary depths of optical blue. Accidental surface variations and breaks and trickles in the glaze, caused by the high temperature of the kiln and its swirling flames, enhance the classic simplicity.

The blossom jar reflects a life and spirit where Chinese and Japanese influences underlie the artist's own distinctive personality. Peter Rushforth's real inspirations are the working environment, the seasons, affinity with inherent qualities in clay, local materials, the mercurial actions of the kiln flame and a search for beauty.

Rushforth commenced training as a potter at the Royal Melbourne Institute of Technology and continued his studies at the National Gallery School in Melbourne and the National Art School in Sydney. A former Head of Ceramics at the latter, a member of the Crafts Board of the Australia Council, a foundation member and past President of the Potters Society of New South Wales and patron of the Ceramics Study Group of New South Wales, Peter Rushforth is regarded as a fine mentor and a master of ceramic art and education. Since the 1950s he has travelled extensively in the United Kingdom, Denmark, the United States of America and worked in Japan. He now works as a full-time potter at 'Le Var', Shipley, overlooking the beautiful Kanimbla Valley in New South Wales. Here, the natural bushland setting and spectacular Blue Mountains shape the vigour, colour and feeling of his ceramic forms.

David Williams

Klaus Moje b.1936

Uriarra Crossing 1985
glass 6.2 x 57.4 x 44.3 cm
purchased 1988 88.1987

Glass – the material of my choice – is extremely resistant towards any handling. Therefore, glass sets boundaries that are difficult to overcome. Forty years of working with glass have taught me that, in order to push back my limitations, I have to extend my skills. The journey of learning will never end. The result is ease in the realisation of the creative ideas, ease that is reflected in the finished objects.

Only on very rare occasions do I title my work. I believe that the viewer must find his/her interpretation, must find a bond with the work based on what the work is passing on to him/her. What I feel or express at the moment of creating is only secondary. When titles appear, like *Uriarra Crossing*, they are a reference to specific moments, to specific issues. Here I am paying respect to the Indigenous people, using in the work particulars that I transformed from 'theirs' to 'mine'.

Colour is the only true international language. With colour we bridge the barriers that exist within and between nations. The universal understanding of the reds, the blues and the yellows is making art the ambassador, the ombudsman, the arbitrator.

I have now spent half of my working life in Australia. During these years I have experienced a considerable growth in the studio glass scene. Australian glass has made a strong impact nationally and internationally. Australian glass artists are equally sought as teachers at home and overseas. A material which only 40 years ago was discovered as suitable for use in the expression of artistic inspiration, has established itself as a medium taught in art schools and used by an ever-growing arts community.

Klaus Moje, 2002

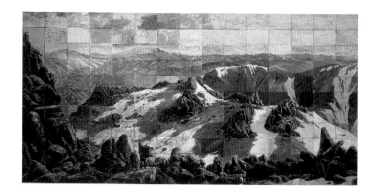

Imants Tillers b.1950

Mount Analogue 1985
oil, oil stick, synthetic polymer paint on 165 prepared canvas boards
279.0 x 571.0 cm (overall)
purchased 1987 87.1128

Mount Analogue is the title of an unfinished book by René Daumal which he worked on from 1939 until his death, mid-sentence, in 1944. It describes an expedition in search of a symbolic mountain – a mountain that will 'play the role of Mount Analogue':

> Its summit must be *inaccessible*, but its base *accessible* to human beings as nature made them. It must be *unique* and it must exist *geographically*. The door to the invisible must be visible.[226]

René Daumal was a member of the Simplist group in Paris (1928–32), a pataphysician, a Sanskrit scholar and, later, a disciple of the occultist Gurdjieff. *Mount Analogue* was a parable of the spiritual journey of the Self.

Mount Analogue is also the title of my painting on 165 canvas-board panels, painted in Sydney in 1985 after a reproduction of Eugene von Guérard's majestic landscape *North-east view from the northern top of Mount Kosciusko*. I'd often been drawn to the Snowy Mountains as a destination for summer walking and, for anyone who has climbed Mount Kosciuszko, Australia's highest point, there is something distinctly odd about von Guérard's mis-named painting. From my recollection, the real Mount Kosciuszko is bereft of rocks at its summit and has the gentle rounded aspect which had strongly reminded Edmund Strezelecki in 1840 of the 'tumulus elevated in Krakow over the tomb of the patriot Kosciusko'. Could it be that von Guérard's expedition of 1862 had mistakenly climbed the adjoining, more spectacular and rugged (though lower), peak of Mount Townsend and his painting depicts the view from there?

In 1984, my friend Evelyn Juers passed on to me a xerox of a reproduction of a painting by the Mexican Surrealist Remedios Varo. Her painting depicted a key moment in Daumal's book, the *Ascension to Mount Analogue*. It was the first (and only) time I had come across a reference to Daumal's *Mount Analogue* in the

work of any artist, so, intrigued, I found a copy of Janet Kaplan's book on Varo's life and art, entitled *Unexpected Journeys*. Varo, who was Spanish-born, had been deeply involved with the Surrealist movement in Paris but, through a series of coincidences, ended up in Mexico City where she remained until her death.

Soon after, I began my own unexpected journeys – firstly by moving from Sydney to live in Cooma, the small country town which is the 'gateway to the Snowy Mountains' and thus not far from Mount Kosciuszko. Not long after arriving in Cooma, my attention was drawn to an old homoclimatic map (1945) of the Monaro–South Coast region of New South Wales, which compared locations in terms of their micro-climate to places all over the world. Thus Bombala was linked to London, Candelo to Johannesburg, Nimmitabel to Nairn in Scotland and Cooma with a 'Guerrero City' in Mexico. Although I could not find this place on any map of Mexico I had to hand, within a year or so I had been to Mexico twice and two of the most comprehensive manifestations (installations and exhibitions) of my work ever had been mounted in Mexico City and then in Monterrey in Mexico's north!

How does this all relate to the painting, *Mount Analogue*? Could it be in the origin of my source, my model? For it is a little known fact that von Guérard's *Mount Kosciusko* languished for many years in Mexico City (of all places!) in the collection of Señor Alfonso Ortega Urgaoe, until Daniel Thomas discovered it there in 1973 and brought it back to Australia for the collection of the National Gallery of Australia, and thus triggered von Guérard's spectacular ascension within the pantheon of Australian art.

In the words of the late, narcoleptic poet John Anderson:

The world cannot be overcome by the analogue 'I'.

Imants Tillers, 2002

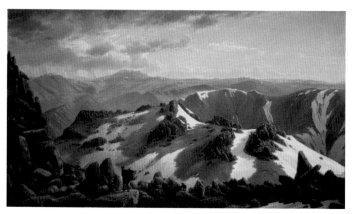

Eugene von Guérard 1811–1901 *North-east view from the northern top of Mount Kosciusko* 1863 oil on canvas 66.5 x 116.8 cm
purchased 1973 73.645

Robert Jacks b.1943

Metropolis no.14 1985

oil on canvas 183.0 x 152.5 cm

purchased 1986 86.1

© Robert Jacks, 1985. Licensed by VISCOPY, 2002

Lesley Dumbrell b.1941

Last light 1985

synthetic polymer paint on canvas 183.0 x 274.5 cm

purchased 1985 85.1882

In the mid-1980s, Robert Jacks undertook a series of paintings that took their cue from the hectic dynamism of the modern city. *Metropolis no.14*, one of his later and more austere works from the series, draws on the artist's personal experiences of downtown New York and Sydney's central business district. The title is also a reference to Fritz Lang's 1926 black-and-white film, *Metropolis*.

The dominant geometric shapes in *Metropolis no.14* suggest the severity of mid-century modernist architecture, with narrow colonnades formed by high-rise office towers. The piercing wedge that cuts through the dark central field recalls the perspective of the reflective markings on the highway being chased into night. Yet, as the viewer is deceived by this allusion to pictorial or illusionistic depth within the picture, the surface of the work is forcibly restated by the artist's painterly technique. Jacks's use of the palette knife mimics the texture of concrete manually levelled with a trowel. As a critique of the history of art, Jacks has set up a deliberate tension between the western tradition of painting as an illusion of reality, of looking *into* a picture, and the 20th-century preoccupation with the physical act of painting and the inherent flatness of the picture surface.

Whereas *Metropolis no.14* recalls the man-made, Lesley Dumbrell's *Last light* draws inspiration from the natural world. It is a decorative mosaic of angular pieces, each one unique, whilst the painting is unified as a whole by the deliberately limited palette of colours. The gentle flickering of individual elements draws the viewer's attention back and forth across the surface of the work, punctuated at points by fragments of bright blue. *Last light* is evocative of an approaching summer evening, with glimpses of the fading sky through the rustling foliage. The leaves are, however, not those of a native gum but rather of a mature maple or oak tree, perhaps in a private garden or quiet city park; a peaceful and contemplative sanctuary from the constant bustle of the metropolis.

Steven Tonkin

Liddy Napanangka Walker b.1930
Topsy Napanangka b.1924
Judy Nampijinpa Granites b.1934

Warlpiri people

Wakirlpiri Jukurrpa (Dogwood Dreaming) 1985

synthetic polymer paint on canvas; 124.6 x 123.8 cm

purchased 1986 86.1799

© Liddy Napanangka Walker, Topsy Napanangka,

Judy Nampijinpa Granites, 1985. Licensed by VISCOPY, 2002.

Paddy Jupurrurla Nelson b.1919
Paddy Japaljarri Sims b.1916
Larry Jungarrayi Spencer 1912–90

Warlpiri people

Yanjilypiri Jukurrpa (Star Dreaming) 1985

synthetic polymer paint on canvas 372.0 x 171.4 cm

purchased 1986 86.1798

© Paddy Jupurrurla Nelson, Paddy Japaljarri Sims, Larry Jungarrayi

Spencer, 1985. Licensed by VISCOPY, 2002

Yuendumu community is best known for the production of large collaborative works involving several artists. Contributors are involved as either *kirda* (managers/owners through the patrilineal line) or as *kurdungurlu* (managers/owners through the matrilineal line). The use of a vivid palette is also an identifying feature of work emanating from Yuendumu. The expression of the narrative is akin to the approach by desert painters generally, where an aerial view of the landscape and the events that took place in ancestral times is expressed through a painted language of signs and icons.

Three Warlpiri women from Yuendumu collaborated to paint *Wakirlpiri Jukurrpa*. This dynamic painting expresses well the fertile aspects of the land, an element typically found in *yawulyu* (women's design), and depicts the Dogwood Dreaming site. Women collecting and winnowing dogwood seeds are represented by the small U-shapes in the lower centre of the image. The dominant images are three clusters of seedpods. Partially cooked seeds are washed in *parraja* (carrying dish) then ground to a paste for making damper. *Kurdungurlu* of the Dreaming, Liddy Napanangka, painted the most prominent designs with Topsy, the *kirda* of the Dreaming. Younger artist Judy Nampijinpa assisted as *kurdungurlu*.

One of the first large-scale canvases to emerge from Yuendumu, *Yanjilypiri Jukurrpa (Star Dreaming)* is the work of three Warlpiri men. This magnificent work pertains to the fire ceremony of the Warlpiri people, associated with the creation of the constellations. Further information about this work is restricted, the owners of the image preferring not to divulge a full description. The collaboration of several artists reflects how ceremonial ground drawings are made, on which this work is based. Whilst Jimmy Jungarrayi Spencer, *kirda* of the Dreaming, supervised the painting, he did not participate. The main painter was Paddy Jupurrurla Nelson, a leading artist in the community who has matrilineally inherited rights to the Dreaming. Paddy Japaljarri Sims and Larry Jungarrayi Spencer assisted.

Susan Jenkins

James Gleeson b.1915

Conference at the caldera 1984
oil on canvas 152.5 x 204.0 cm
purchased 1985 85.505

Surrealism had always made use of the irrational as a method of evaluating the nature of reality. The unexpected combination of unrelated things shakes up our habitual ways of thinking about visual experiences.

Why hold a meeting at the edge of a volcanic caldera? Why have the delegates arrived in such biomorphic disguises? Why paint as accurately as possible the things one cannot see except with the eye of the imagination?

There are no logical answers to these sorts of questions. The purpose of the painting is to suggest to the viewer the idea of an alternative reality – of something hovering on the edge of identity yet still unnameable – a constituency freed from the cage of fact, a thought sprung from the compost of forgotten memories, fed from darkness yet held in stasis as something that had not been before.

Reality has not been completely overthrown but has been subverted by inner experiences into a landscape that has no exact parallel in nature. The normal elements are reshaped as living tissues with an independent life of their own – landscape as a vital organism intent upon its own secret purposes.

The Surrealist proposes that there is no such thing as a universally held reality. Individual experiences constantly shift the point of view as life itself unfolds its patterns on us.

James Gleeson, 2002

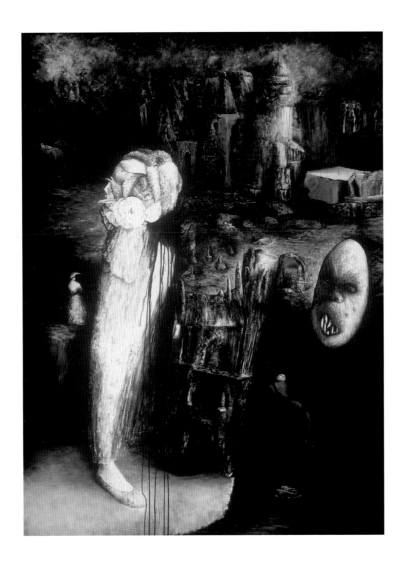

Susan Norrie b.1953

The sublime and the ridiculous 1986
oil on marine plywood 239.5 x 179.5 cm
purchased 1986 86.1131

Susan Norrie uses both classical and modern senses of memory in her work. In earlier paintings, there is a fascination with memory as repressed presence. Fantastic and grotesque figures are featured; landscape is used as spatial metaphor of psychic states in which the order of conscious logic is disbanded; a personal symbolism is overlayed on historical forms, such as the Gothic or, in a more sustained way, the Baroque. In *The sublime and the ridiculous*, Norrie was working on a larger scale with some of the ideas which appeared as violent visual notes in *Determined*, a work of disturbingly visceral immediacy – a highly personal work of memory on the death of the artist's mother.

The sublime and the ridiculous extended the technical concerns and the intensity of effect achieved in *Determined* by creating an imaginary landscape which, in its darkness and suggestions of Gothic horror, reflected internal states of confusion and fear. A dark, menacing sea in which small boats register the vulnerability of the subject in a landscape of uncertainty, Gothic ruins, mysterious figures emerging from the shadows or remaining half-light – these are all details which show the painter's desire to perversely explore corporeal space. The central figure in the painting is a monstrously feminine but headless body, draped in pink lace which is besmirched with red paint, dripping messily down the length of the canvas; the space of the head and upper body is replaced with amorphous shapes, suggesting shells or amoebic protoplasmic substance. The feminine dissolves into the indeterminate matter without boundaries and the subject itself becomes a kind of oceanic void. There is no narrative here which might be referenced, except for one of unimaginable horror and the aftermath of murderous desire.

Helen Grace[227]

Ken Orchard b.1959

Three textures 1986

woodcut, printed in black ink, from one block;

hand-coloured on three sheets of paper 244.0 x 366.0 cm (overall)

purchased through the Gordon Darling Australasian Print Fund 1992

92.106.A-C

Three textures, a large hand-coloured woodblock, comprises three abutting panels. In the left-hand panel, a boy and his dog dive from the top left corner down towards the rippling surface of water. In the right-hand panel, a girl with her eyes closed leans forward, clutching a wrap that is draped over her shoulder. In the centre, a figure whose body has been cropped from the frame supports a steaming cup with his raised arm. The cup and the arm provide the focal point for the other two adjacent panels. Through juxtaposition, the content of the three sections becomes bonded into one whole, each element making pictorial and metaphorical references to one another.

In 1985, I produced a series of collaged engravings entitled 'Disorient world'. Some of the original steel engravings, which formed the narrative material for these collages, illustrated a 1911 *Chatterbox Annual*, a compendium of children's adventure stories. The female figure derived from an engraving of a small oil painting by William Mulready (1786–1863), now in the Victoria and Albert Museum, London. Its title, *Open your mouth and shut your eyes* 1838, is the first half of the popular catch phrase ending 'and see what tomorrow may bring'. I then created the woodcut *Three textures*, using fragments of images taken from these collages, experimenting with appropriation to create subconscious recognition, and allowing me formal control over types of image reproduction.

The title *Three textures* alludes to the techniques used by wood engravers in the 19th century to produce different tones. The images were further distorted through the process of photocopying, enlargement, and cutting the woodblocks.

Ken Orchard, 2002

Tony Coleing b.1942

Battlefield 1986

linocut, printed in black ink, each from one block on 12 sheets of paper
294.3 x 542.0 cm (overall) printed by John Loane and Lesley Duxbury,
Australian Print Workshop
purchased through the Gordon Darling Australasian Print Fund 1989
89.1982

Tony Coleing's giant linocut, *Battlefield*, boldly assumes the preposterous scale his science fiction scenario demands, paying no heed to usual conventions about materials and 'appropriate' framing. He writes:

> We know that our galaxy, the Milky Way galaxy, is only one of some hundred thousand million that can be seen using modern telescopes, each galaxy itself containing some hundred million stars.
> *'How's the game going?'*
> We live in a galaxy that is about 100,000 light years across (light travels at 300,000 kilometres per second). There are 31,536,000 seconds in one year, multiply that by 300,000 and then multiply again by 100,000 – that tells you how far across our galaxy is.

> *'Who's winning?'*
> Our sun is just an ordinary, average-sized, yellow star near the inner edge of one of the spiral arms.
> *'Where's your house?'*
> It's always at the edges that uncertainty lies.
> The contestants go on blindly oblivious to the edges, not playing within the boundaries. The cockies look on … take no notice, it doesn't mean anything to them, except maybe a meal. The spectators, always at the edges, only hang on for the ride, caught between desire and death (with a bit of religion thrown in).
> *'Where's God?'*

Tony Coleing (2002) and Julie Ewington[228]

David Larwill

Adventure playground 1986
oil on two canvases 223.1 x 405.2 cm (overall)
purchased 1987 87.1.A-B

I'm thinking about working out a sensible image of what I've
put down in front of me. Finding what I can recognize and
bringing that out. The painting's what's important, not the
thought of executing a masterpiece ... the act of painting.
David Larwill[229]

Arresting in colour and overwhelming in size, *Adventure
playground* is a painting which commands attention. The surface
of the two canvases is treated as one flat, broad plane. A totemic
figure hovers in space, a dog's head rests on a bird's body, and a
mask-like face floats as if in a dream state. The vitality of this
work is emphasised by David Larwill's treatment of the paint:
short direct brushstrokes of colour layered over each other and
scraped back, revealing fragments of words and shapes. Binding
this is a tight compositional structure, a limited palette and a
strong graphic element. It is as if the work is contained by a net

of yellow paint, by black lines and strips of green. The energy
of *Adventure playground* is one of ordered chaos, of noise and the
bustle of urban living. Larwill explores a greater metaphor of
being – that life is constantly evolving, a continuous adventure.

Larwill's works of art are reflections on the adventures of life,
of stories and events frozen in time. Larwill's art became known
in the early 1980s through his association with the Melbourne
group *Roar Studios*. This collective independently administered
and funded a gallery and studio space, beginning in 1982 in
Melbourne's Green Street, Prahran and later moving to an old
shoe factory in Brunswick Street, in the inner suburb of Fitzroy.
Roar became a symbol of dynamism and self-determination, of
energy, youth and a spirited sense of achievement which was
self-consciously anti-establishment.

Over the past two decades, Larwill has continued to refine
and rework his visual language – a familiar set of motifs, figures
and shapes. His subject matter incorporates the everyday yet is
presented in an unexpected and uncanny manner, layered with
wit and whimsy.

Beatrice Gralton

Bruce Armstrong b.1957

Head 1986
carved red gum 155.0 x 90.5 x 239.5 cm
purchased 1988 88.2092

I remember very clearly the day that the log from which *Head* is made arrived in my studio; the tree had been felled in a suburban backyard earlier in the day, and came via crane truck. We had a good deal of trouble getting the log in, and l sat down exhausted when it was in far enough to be able to shut the door. I sat staring at it and the image of a kind of animal's head appeared, and I decided that I would make that the subject. I didn't 'think it up', it just happened. Looking back now at it, and the other works from around that time, I would say that my favourites are those which I didn't contrive but rather just facilitated. I was trying then, and still do try, to work quickly and directly, letting my imagination go in any direction it will.

At the time this was the largest sculpture I had made, though perhaps not the tallest. I would guess that I removed about one fifth of the bulk of the log to reveal the image, trying to retain as much of the main shape as possible, a bit like peeling a piece of fruit or removing clothes. I would say that my 'raison d'être' in relation to sculpture at that time was that I craved a kind of immediacy which painting or music has, but which sculpture traditionally has lacked in the western tradition, due to an excessive concern with technical virtuosity. In the 15 or so years since the work was made, many people have rubbed and stroked it, which has 'finished' the work with a lustrous patina unachievable in my studio. I love the idea that a work can go on developing in the years after my involvement is finished.

Bruce Armstrong, 2002

Gareth Sansom b.1939

Bright eyes 1986
oil, enamel and alkyd resin on linen 182.5 x 213.0 cm
purchased 1986 86.2291

The iconography within *Bright eyes* pretty much summed up what was going on in my art at that time – garish and extremely complicated background images, pinned down by some iconographic image. In this case it is a hatted figure with bright cat's eyes – eyes with voodoo connotations. Or black magic. The painting is obviously about the juxtaposition of the large head with the interplay of tiny figures dancing and cavorting, as if in ecstatic ritualistic homage to the head. (The head was inscribed on top with alkyd paint much later.)

The strips of railroad track striking up from the bottom left corner are not only homage to my innocent boyhood love of playing with my Hornby Dublo train set, and to Duchamp's use of connected plumbing as a stylistic device, but also to the early French abstract painting that I had seen in books when I was 16. Of course, those strips are pivotal to the painting's final structure, in that I finally needed something to animate in some way the relationship between the large head and the buzzing ground.

Gareth Sansom, 2002

After the Second World War, Australia was promoted as a dream location for migrants. Yet Nicholas Nedelkopoulos, the son of Greek migrants, discerns another life behind the suburban dream – a world of claustrophobic anxiety and everyday anarchy.

The billboard reads as a warning in multiple languages. The scene is one of a grand multicultural barbecue, set against Melbourne's bridges and buildings which shimmer on the horizon. People dressed in national costume are gathered in a backyard, complete with Hills Hoist clothesline. The mood, however, is disconcerting, being one of isolation, dislocation and containment. The figures are bound by suburbia, by their vegetable patches, garden sheds, fences and houses. Domesticity appears in the form of a pyramid, a backyard tomb, studded with worldly possessions: whitegoods, toilet, television. Nicholas Nedelkopoulos is challenging Australians to observe their habitat from beyond the boundaries of the backyards and fences that contain us and our neighbours.

Vera Zulumovski was also the child of migrants and she grew up with an acute awareness of her parents' Macedonian cultural origins and the difficulties of life in a new country. Her first language was that of her parents and she did not learn English until she started school.

In Zulumovski's art there is an unexpected fusion between Macedonian rituals and Australian settings. The backdrop for many of her prints is Newcastle, an industrial city north of Sydney, where she now lives. This union gives the prints their potency, offering the possibility of speaking to two cultures. Zulumovski comments:

> Newcastle's Macedonian Community celebrates Epiphany at the Bogie Hole, a convict-built rock pool at Newcastle Beach … So, Epiphany at the Bogie Hole is the practice of an ancient orthodox service at a site which reflects the beginnings of white Australian history, by people who are relatively recent Australians.[230]

Nicholas Nedelkopoulos b.1955

'That great Australian dream' 1987

etching and aquatint, printed in black ink with plate tone, from one
plate on paper 100.4 x 50.3 cm printed by Bill Young
dedicated by the artist to his parents, Dosta and the late
Christos Nedelkopoulos
purchased through Gordon Darling Australasian Print Fund 1990 90.20

Vera Zulumovski b.1962

Epiphany at the Bogie Hole 1991

linocut, printed in black ink, from one block on paper 81.0 x 117.2 cm
purchased through Gordon Darling Australasian Print Fund 1992
92.780

Beatrice Gralton and Roger Butler

Bea Maddock b.1934

We live in the meanings we are able to discern 1987
pigment wash, charcoal, encaustic on canvas and cibachrome
photographs within wooden framework; seven parts
115.2 x 527.1 cm (overall)
gift from the ANZ Group to the Australian National Gallery
on the occasion of Australia's Bicentenary 1988 88.378.A-G

Bea Maddock's work has ranged across printmaking,
photography, sculpture and painting, often merging these
disciplines in ways that are subtle and uncontrived. An important
aspect of Maddock's work is her interest in the written word,
drawing upon diaristic references and extracts of poetry, prose
and philosophical texts. Implicit in her adaptation of language
is the suggestiveness of the sounds and the multiple meanings
of words, often questioning the nature of human existence.

We live in the meanings we are able to discern came out of a
journey that Maddock made to Antarctica in 1987, at the
invitation of the Artists in Antarctica Program. It is the first of her
Heard Island Trilogy paintings that developed from numerous
delicate sketchbook drawings tracing the topography of Heard
Island. The painting extends across seven panels that are in turn
divided into three distinct layers. The top half reveals a
panoramic vista, referring to the traces of human occupation

and the sparse expanse of a glacial wilderness. Inspired by the idea put forward by Australian anthropologist, Dr Rhys Jones, that 'Heard Island today must be like Tasmania was in the last Ice Age', Maddock incorporated Aboriginal place names from south-west Tasmania through the centre of the composition.[231] Stretching across the base are compartments containing 21 repetitions of a single photograph of a glacier in subtle, shifting tones. This repetition of elements has a filmic, hypnotic quality, in parallel with the words that are like an incantation.

The combination of elements reveals a physical and an introspective journey relating to environment and history. As Roger Butler writes:

> The blues and greys are the colour of ice and water, but also the colour of ash – ash from Aboriginal campfires and bushfires – references to destruction in the past and in the present.[232]

In the mutability of references across time and place, Maddock evokes absence and presence – a sense of loss, isolation and the reclamation of memory – of images and words inscribed and recalled in the consciousness that informs this intensely poetic, meditative work.

Deborah Hart

Dennis Del Favero b.1953

Linea di fuoco 1987

4 slide projector/audiotape installation, 15 mins duration

500.0 x 600.0 x 300.0 cm

purchased through the Kodak (Australasia) Pty Ltd Fund 1994

94.994.36

© Dennis Del Favero

Linea di fuoco [*Line of fire*] was created during the 1980s, at a time when forces which have now taken hold were clearly emergent: the molecularisation of violence, the paranoia between communities and nations, the growing fault line between the culture of men and that of women and the establishment of new social relations by means of digital media networks. Australia seemed a haven, separated from the old continents of conflict by a sea of blind good fortune. However, as Terry Smith noted in a review of this work in the *Times on Sunday*, 'the rest of the world is already here'.[233] Unfortunately, as a nation, we were still in hibernation.

Set during a Sydney summer in 1987, *Linea di fuoco*'s multimedia surveillance of a love affair between a suspected terrorist and an airforce pilot, from the perspective of an obsessive undercover agent, seemed like science fiction at the time. Looking back, it is no longer clear when reality overtook fiction.

Dennis Del Favero, 2002

Ian Howard b.1947

Sleep of dreams 1987
synthetic polymer paint on 20 shaped composition boards
300.0 x 300.0 cm (overall)
purchased 1988 88.2257.A-T

Like many of my works, *Sleep of dreams* attempts to make what is otherwise just a nagging feeling into a real and perceptible, even concrete, image. The nagging feeling behind this work is that, regardless of a particular stance one might take towards the militarisation of planet earth, all individuals are inevitably swept up in the world as it is. Therefore, by default or otherwise, we become complicit in the real and what might be termed economic violence of the arms trade. Hence the sleeping everyman on the couch becomes a submarine, aircraft carrier, fighter bomber, missile, bomb and tank and then slips again into his old self. Alternatively, the seated figure may not be sleeping but rather dozing off in front of a television, where events of the world are paraded before him in an endless cycle of overlapping very bad dreams.

If this work is 'successful' and moves our perception from nagging feeling to demonstrated idea – that there is unwitting complicity in institutional violence from everyman (and woman) – then what is a viewer to conclude or do next?

Hopefully, by showing that which is not obvious, by proposing that this is what the world is really like, the viewer can then consider their position in this cycle. Is it a vicious circle, or are there particular categories of players not as stereotyped as my everyman, who can be outside the ring playing independent and influential roles?

Original drawings for the work were created on an overnight bus trip from Sydney to Melbourne in 1987, taking approximately 11 hours and 900kms to produce!

Ian Howard, 2002

Anne Zahalka b.1957

Die Putzfrau (The cleaner) 1987
direct positive colour photograph 80.0 x 80.0 cm
purchased through the Kodak (Australasia) Pty Ltd Fund 1988 88.322
© Anne Zahalka, 1987. Licensed by VISCOPY, 2002

Having grown up in Australia with reproductions of European old masters deeply etched in my memory, it was with familiarity that I viewed the originals in Berlin during a residency. *Die Putzfrau (The cleaner)* was produced for my exhibition at the Künstlerhaus Bethanien in 1986–87.

With the developing discourse around Postmodernism and its strategies of appropriation, these works soon became part of the vernacular. Underlying these concerns was a desire to deconstruct the old masters and reproduce them within a contemporary context using a contemporary medium.

Die Putzfrau (The cleaner) is portrayed by a performance artist who was living and working as a cleaner in Berlin at the time. As she was originally from New Zealand, the kiwi fruit on the table is a reference to her homeland. The Walkman she wears is an anachronistic element used to disrupt a nostalgic reading of the image. The peeled lemon within Dutch still life is a symbol for deceptive appearance; it is beautiful to look at yet sour to taste. The images are deceptive, they play the game of artifice and resemblance where the models play themselves performing a role and where photography resembles painting. The pulled-back drape provides a space for the viewer to contemplate the distance that separates us from our past. All these devices enable the viewer to question and understand the influence of European culture and the nature of its encumbent value system.

Anne Zahalka, 2002

Catherine Truman

Fish neckpiece no.2 1987

wood, nylon, paint, waxed flax, iron wire, acrylic steel

29.0 x 21.2 x 2.0 cm

purchased 1988 88.1416

The work shown in this book is from my solo exhibition entitled *Fish Carvings: by Catherine Truman*, held in 1987 at the Contemporary Jewellery Gallery in Sydney. The collection of wearable carvings was centred around the theme of ageing, in particular the way age is perceived by western society. Fish were used as a metaphor for the part of us that continues to grow whilst our physical exterior deteriorates.

Fish neckpiece no. 2 is accompanied by a quote from Barbara McDonald from her book, *Look Me in the Eye*, published in 1983: 'We never really know the beginning or the middle, until we have lived out an ending and lived on beyond it'. A photograph of the two generations of women from my father's side (my great-grandmother and my grandmother) also accompanies the work. Repeated images of the carving are superimposed around their necks.

The fish is carved from mangrove wood and left dry and untreated. The grey of the wood denotes age. The fins have been replaced with fresh green grass (painted nylon), to indicate life beyond, and life from within. This separation of the physical from the spiritual or other parts of us, and how the life of one affects the life of the other, continued to dominate the conceptual content of my work for a number of years. The representation of the physical versus the non-physical body was later manifested in other symbols of boats and water surfaces.

From 1996 onwards I have continued a personal investigation into human anatomy and movement.

Catherine Truman, 2002

Ramingining Artists

The Aboriginal Memorial 1987–88
Ramingining, Central Arnhem Land
wood and natural pigments max. height 327.0 cm
purchased with the assistance of Gallery admission charges
commissioned in 1987 87.2240.1-200

The Aboriginal Memorial is without doubt one of the icons of Australian art. Made in 1988 it commemorates all the Indigenous people who, since 1788, have lost their lives defending their land.

The Aboriginal Memorial was inspired by the political climate of 1988. That year marked the Bicentenary of Australia – a celebration of two centuries of European settlement – yet many Indigenous people felt there was little to celebrate.

At the time, Djon Mundine, now a freelance curator, was Art Advisor in the small community of Ramingining in Central Arnhem Land. Mundine initiated *The Aboriginal Memorial* project – an installation of 200 hollow log coffins, one for each year of European settlement, representing a forest of souls, a war cemetery and the final rites for all Indigenous people who have been denied a proper burial. Mundine approached a small group of senior Ramingining artists, including Paddy Dhathangu, George Malibirr, Jimmy Wululu and David Daymirringu, who decided to mark the event with a memorial to Indigenous people, for all Australians, past, present and future. The project grew to include 43 artists, both male and female, from Ramingining and its surrounds.

In 1987 the National Gallery of Australia agreed, under the initiative of curator Wally Caruana, to commission the installation to enable the artists – most of whom are professional bark painters, sculptors and weavers – to complete the project.

The Aboriginal Memorial installation is inspired by the hollow log coffin mortuary ceremony of Central Arnhem Land. The purpose of the ceremony is to ensure the safe arrival of the spirit of the deceased on its perilous journey from the earth to the land of the dead. A tree, naturally hollowed out by termites, is cut down, cleaned and, in a ceremonial camp, is painted with the clan's totemic designs. The bones of the deceased are painted with red ochre and, during special dances, placed inside the log which is then left to the elements. Many of the hollow logs have a small hole either carved or painted towards the top. Yolngu (Indigenous people from Arnhem Land) believe that this provides the soul of the deceased with a viewing hole to look out through and survey the land.

Whilst the function and purpose of the ceremony is intact, to an extent mortuary practices increasingly adapt to contemporary realities. At no time did the log coffins in *The Aboriginal Memorial* contain bones, nor were they used in a mortuary ceremony. Like sculptures from Indigenous Australia in galleries, they were made as works of art for public display.

The path through *The Aboriginal Memorial* imitates the course of the Glyde River estuary, which flows through the Arafura Swamp to the sea. The hollow logs are situated broadly according to where the artists' clans live along the river and its tributaries. The different styles apparent in groupings are related to the artists' social groups (sometimes described as clans) which link people by or to a common ancestor, land, language and strict social affiliations. As you move through *The Aboriginal Memorial*, you will witness the imagery from changing environments – from the lands of the saltwater people, further inland to the country of the freshwater people. The natural environment and its phenomena are vital to the Yolngu's clan identity.

Yolngu believe that to achieve a shimmering brilliance in painting through crosshatching and line work – giving a 'singing' quality to the imagery – is to evoke ancestral power. Artists from nine groups worked on *The Aboriginal Memorial* and, whilst clan designs follow strict conventions ruling subject matter, each individual artist's hand is apparent.

The work is unified by an array of common themes: celebration of life, respect for the dead and mortuary traditions and a people's connection with ancestral beings. Themes of transition and regeneration within Indigenous culture pervade *The Aboriginal Memorial*. On a wider scale, it also marked a watershed in the history of Australian society. Whilst it is intended as a war memorial, and is a historical statement, its relevance, however, does not rest with the past. It symbolises a period of transition in Australian society and speaks of life, continuity and a new beginning: a testimony to the resilience of Indigenous people and culture in the face of great odds and a legacy for future generations of Australians.

Susan Jenkins

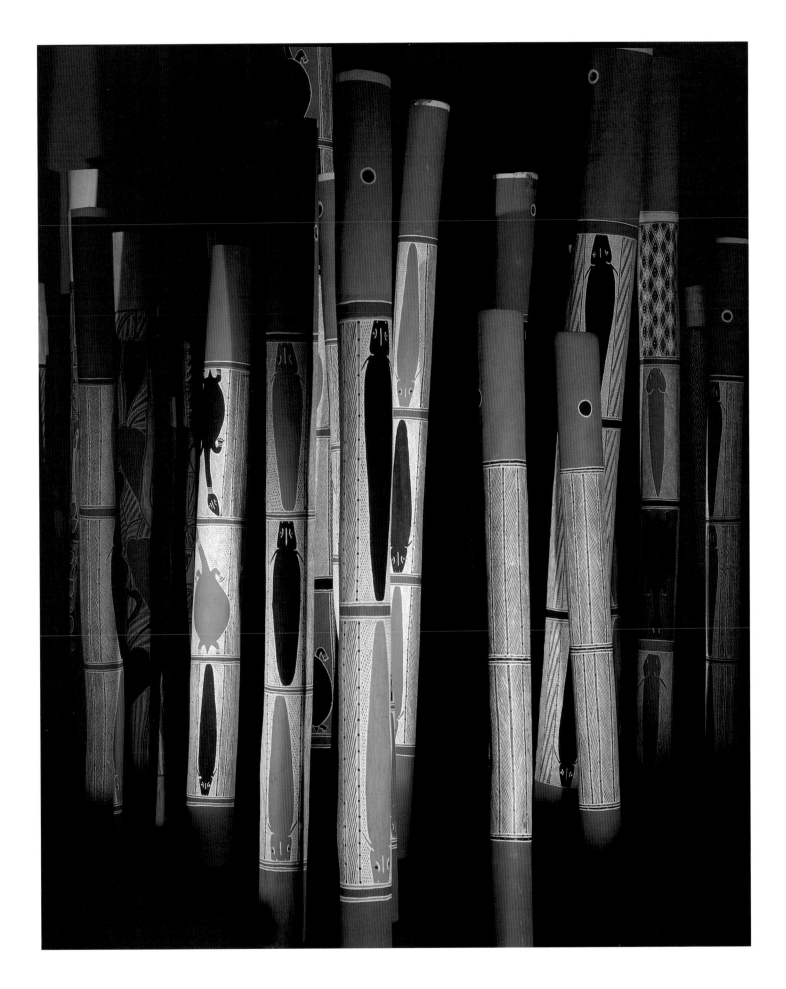

Robert Campbell Junior 1944–93

Dhanghutti/Ngaku people
Abo history (facts) 1988
synthetic polymer paint on canvas 130.0 x 200.0 cm
purchased 1988 88.1535
courtesy Roslyn Oxley9 Gallery

Abo history (facts) depicts a series of scenes related to Indigenous life, facts and myths. Although the term 'Abo' is derogatory and no longer used, the title was ascribed by the artist, whose life experience included racism and oppression. Robert Campbell Junior painted this work during 1988, the bicentennial year since colonisation, when he was appointed artist-in-residence at the University of Sydney Tin Sheds centre. At that time, he was commissioned to paint the poster for the National Aboriginal Art Award.

The year 1988 was a catalytic one for many Indigenous artists: there were strong political moves on Indigenous issues and the search for recognition of the role of Indigenous Australia in building the nation. In this painting, Robert Campbell Junior challenged the non-Indigenous accounts of history by portraying two confronting realities of Indigenous peoples: traditional life versus colonisation, assimilation versus the destruction of Indigenous culture.

Abo history (facts) is painted in the artist's unique way, with stylised images using clear and bright colours, the human figures painted X-ray style with the oesophagus revealed. The painting shows a narrative through cartoon-like vignettes, with native animals painted over the background. The intensely decorated images are full of life and meaning; they represent the official and unofficial history, the myths and reality of Indigenous life since 1788.

Gloria Morales

Jan Senbergs b.1939

Antarctic night 1989

synthetic polymer paint and collage on canvas 202.0 x 292.0 cm

purchased 1990 90.1213

© Jan Senbergs, 1989. Licensed by VISCOPY, 2002

The painting *Antarctic night* is a result of my journey to Antarctica in 1987 [at the invitation of the Artists in Antarctica Program] with the Antarctic Division on their re-supply voyage aboard the *M.V. Icebird.*

As in previous settlements in history, in Antarctica we are again squatting on the edge of yet another continent and bringing our cultural baggage with us. Already there is a sense of history there: architectural, social and visual. This painting shows an aspect of this 'historical sequence' in the decorations in the huts and workshops across the bases.

In a 'cut-away' view, it shows the interior of a winterer's hut with its walls covered in a 'tapestry' of pin-up images – from the earliest 'pin-up', the Venus of Willendorf, to the Playboy centrefolds of the 1950s and 1960s, through to the Penthouse models of the 1970s and beyond. The more you saw of it, the more it seemed like an Antarctic Pop Art movement – not unlike the New York Pop Art of the 1960s and 1970s – except certainly not cool like Andy Warhol …

However, as happens with all art movements, it also began to wane in the 1980s when more women came to Antarctica and created a more rounded atmosphere and society.

The painting in this context attempts to show an aspect of an Antarctic winterer's existence through the long and dark nights of close-quarter living in extreme isolation. As with a lot of my other work, it is meant as a detached statement of observation: an empty stage, where the actors have left, but you know what happened …

Jan Senbergs, 2002

Tracey Moffatt b.1960

Something more 1989

one of nine direct positive colour photographs 100.6 x 127.0 cm

commissioned by the Albury Regional Museum and Art Gallery with assistance from the Visual Arts/Crafts Board of the Australia Council and the Exhibitions Development Fund of the Regional Galleries Association of New South Wales

purchased 1989 89.1705.1-9

courtesy Roslyn Oxley9 Gallery

In September 1986, a dynamic wave of urban Indigenous artists gave notice of their ambitions and style by staging the first contemporary art exhibition by Aboriginal and Torres Strait Islander photographers. Their exhibition was mounted by the Aboriginal Artists Gallery in Sydney from 8–23 September as part of National Aborigines' Week 1986 and included over 60 images by ten photographers: Mervyn Bishop, Brenda L. Croft, Tony Davis, Ellen José, Daryn Kemp, Tracey Moffatt, Michael Riley, Chris Robinson, Terry Shewring, and Ros Sultan.

The Indigenous photographers' exhibition was clearly breaking new ground but received little press coverage, with only Moffatt being interviewed by Anne Howell in the *Sydney Morning Herald*. It was her first public write-up and, later, in 1998 Moffatt was the first Indigenous photographer to exhibit at the Australian Centre for Photography and enter museum collections in Australia.

A highly receptive child of the 1960s, Tracey Moffatt grew up in Brisbane avidly consuming images from magazines, films and television. The media fascinated her with its random and emotional mix – images of fantasy and other realities from across the world combined with the evening news. Film sequences were filed in her personal 'memory theatre'. But Moffatt did not dream of being the helpless object of the hero's gaze – she wanted to direct the film.

Moffatt speaks 'around' rather than 'about' her work – to her, wordy theoretical texts seem to 'breathe life out of' the actual experiencing of art.[234] Of the centrality of popular cinema and the mass-produced image as the gateway to imagination in her youth, Moffatt has said:

Cinema outings were rare. The first film I saw in a cinema was *Mary Poppins* at age five. I remember the outing vividly. To this day I still believe *Mary Poppins* to be a cinematic masterpiece. Those 1960s big budget Disney technicolor works of art remain a yardstick on which I judge almost all films, and possibly all other art ... I'm always hungry for an image. All over the world I find myself drawn to bookshops. Even in art museums I prefer to visit the bookshop first. I want to see the artwork in reproduction before I see the real thing on the wall. I can stand in a bookshop and easily scan an art magazine or book in five seconds flat – computer-like, taking in, discarding, or storing for later use, for later (so people tell me) 'appropriation'.[235]

In the photoseries for which she has become internationally renowned, Moffatt sets up clearly staged tableau images which have a narrative thread but in which many stories are being told. Themes with violence and sentiment mingle, past and present times are combined through flashbacks and the supernatural forever invades the familiar world. To this mix Moffatt brings her perspective on identity in local terms of her Aboriginality and femininity, but she also carefully styles her narratives to allow multiple readings beyond the specific politics of Australian identity.

Something more looks like a still for a film about the trials of a poor but restless 'coloured' girl in rural Australia who wants 'something more' out of life than her lot in the back-blocks. In the opening shot, the would-be heroine wears an exotic Asian dress and later steals an old evening gown in her quest for a new identity. After various fragmented images of her encounters and adventures, the heroine's ambitions to cross into the world of glamour and luxury are thwarted and she dies on the road which promised escape from her origins. Moffatt's images are tuned to an agenda in which dress and undress, language and labels are paramount issues in an identity dependent on inserting the unfamiliar dark face in a white scene. They also fulfil a quite straight forward love of dressing up and directing which Moffatt had begun as a teenager. One of her earliest efforts was when she directed her playmates to pose in nativity scenes in the backyard of her house in Brisbane.

Gael Newton

Judy Watson b.1959

sacred ground 1989

lithograph, printed in black ink, from one stone on cream paper

27.0 x 32.0 cm

purchased through the Gordon Darling Australasian Print Fund 1990

90.7-1

sacred ground was one of a series of small lithographs that I made during 1989 when I was artist-in-residence at Griffith Artworks, Griffith University, Brisbane. The printmaking facilities were well equipped and I spent long hours in the lithographic studio, which was set in a beautiful bush environment. At the end of the residency I had an exhibition, *a sacred place for these bones*. This piece relates to connections with country, particularly my grandmother's country in north-west Queensland. At the bottom there is a rectangular black shape holding a spear. The spear is from Riversleigh Station where my grandmother was born.

I made a drawing of the stone-headed spear at the Queensland Museum, where it is housed in the collections. The black rectangle surrounding the spear represents a fictitious velvet-lined case. I felt a strange contradiction seeing the spear from my grandmother's birthplace in an alien environment where it becomes a collector's item, carefully preserved. Yet I also appreciate that I can access this material that connects me back with my grandmother and with country.

There is a central form illuminated by a scatter of light in which I was trying to evoke the presence of my grandmother, the matrilineal link I have with my Indigenous heritage, my ancestors, our country. The spiralling patterns evoke dust storms, energy, heat, haze, change. The intimacy of the scale of the work was dictated by the series of small lithographic stones on which I drew. The uneven outside shape of the image echoes the edge of the stone.

Judy Watson, 2002

Lin Onus 1948–96

Yorta Yorta people

Anal fetish from the 'Dingoes' series 1989
synthetic polymer paint on fibreglass (whole series: wire, metal)
71.0 x 74.0 x 50.0 cm (curved dog) 51.0 x 21.0 x 20.0 cm (straight dog)
90.1085.C-D
© Lin Onus, 1989. Licensed by VISCOPY, 2002

Through a sense of humour and empathy, these works
challenge perceptions of fear and distaste about this often
maligned Australian animal. *Wally Caruana*[236]

Anal fetish is one of a group of six sculptures of dingoes by
Lin Onus. While at Lake Eyre, Lin Onus discovered the dingoes:
animals with strong survival instincts, skill and dignity. He saw
strong parallels between the dingoes and Indigenous people
– the fight against extinction, the survival of a race, the
adaptation to new and imposed environments. The dingoes
became like a totem in his life and art and he made them
uniquely Indigenous by painting stripes along their bodies in the
four colours traditionally created from natural pigments (white,
ochre, red and black).

Anal fetish is the second of the series of dingoes created by
Lin Onus; he started with birth and finished the series with death.
He wanted to represent the full extent of life from the beginning
to the sometimes-cruel ending (such as the trap). In this work
there is a game played; as the sculpture is beautiful and
expressive, it also conveys a dramatic story with strong
association to Indigenous life.

'Dingoes' were the first sculptures made by Lin Onus using
fibreglass, and his dog Mirrigarn was the model for the series.

Gloria Morales

LITORIA CHLORIS
UPEROLEIA RUGOSA
ADELOTUS BREVIS
LITORIA LATOPALMATA
LITORIA LESUEURI
LITORIA DENTATA
LITORIA FREYCINETI
LIMNODYNASTES TERRAEREGINAE
LITORIA PHYLLOCHROA
LITORIA NASUTA
LITORIA GRACILENTA
LITORIA VERREAUXI VERREAUXI
LITORIA CAERULEA
LITORIA FALLAX
LITORIA RUBELLA

Robert MacPherson b.1937

"15 Frog Poems: Double Drummer (Creek Song), for Bob Brosnan"
1986–90

Metl-stik aluminium lettering on wooden boards, corrugated galvanised iron canoe with wooden bracing, rope 300.0 x 210 .0 x 85.0 cm (overall)
purchased 1990 90.1406
© Robert MacPherson

A child's canoe, homemade for a muddy dam, now floats beneath sleek blond boards and black-on-gold lettering fresh from a hardware store. The words are from a strange, specialist language of hybrid Latin names used in the natural sciences.

We respond to the innocent boat-building child, the confident tradesman and the scholar wordsmith behind what we see. The art-maker also assumes at least two specialist art-viewers' responses: we should recognise references to the Surrealists' favourite simile, 'Beautiful as the chance encounter of a sewing machine and an umbrella on an operating table' and to the look of Robert MacPherson's own formative moment in 1960s New York Modernism. Greenbergian theory emphasised the specificities of good painting, such as flatness, opticality, edge-consciousness, objecthood, presence, so here a fastidiously proportioned upright rectangle generates a minimalist composition of horizontal stripes, in elegant tones of silver and grey, black and gold. Its descent to a same-width *objet trouvé* offers a satiric comparison with Mark Rothko's smouldering paintings in which a colour-cloud cushions the bottom of the field.

The title, *"15 Frog Poems: Double Drummer (Creek Song), for Bob Brosnan"*, is not as unhelpful as it seems. Count the boards: 15. The natural-science names must be frogs' names. And the name at the centre, *…TERRAEREGINAE (…of Queensland)*, is easy enough to interpret. If we hadn't guessed already that MacPherson was making art out of his own life in his own place as well as out of international Modernism, here we leap from New York art theory to a small-town childhood at Nambour in subtropical Queensland.

The quotation marks are a literary convention for indicating a poem title. Also, in Japanese poetry there is a particular tradition of frog poems, for example:

Breaking the silence
Of an ancient pond,
A frog jumps in —
Plop![237]

For ten years almost all of MacPherson's works were 'Frog Poems'. This is one of several that hold conversations between wall-hung words and floor-based folkcraft objects, and the artist volunteers they are 'like haiku poems, the floorpiece being the cushion line'.[238]

As to their content, MacPherson said of a Frog Poem containing an obsolescent low-life vocabulary: 'This jargon I find beautifully descriptive, rich, wonderful metaphorically, poetry'. These Latin names, taken from old sources and many now obsolete, silently assert the mutability of 'truth' – facts are as slippery as frogs. And: 'The childhood experience of talking to two bagmen camped under a local bridge … I've always associated … with *Litoria caerulia* the green tree frog and its abode'.[239] The Frog Poems are about childhood ease with underdog humans and shy animals, and delight in the whole natural world.

"15 Frog Poems: Double Drummer (Creek Song), for Bob Brosnan" is the first in a 'trilogy'. The corrugated galvanised-iron canoe was made at Mullumbimby in the 1970s by a child relation of MacPherson's, and the artist had once made similar corrugated canoes for the tranquil creek at Nambour. (In 1931, the 15-year-old who would become the artist Donald Friend told his diary that he flattened the corrugations for his inland river canoes.) The material is ubiquitous in Australian life, light and flexible for long-distance transport and inexperienced tinsmiths.

The other two works in the trilogy incorporate home-made boxcarts. In *"Tree Rain: 16 Frog Poems (Yellow Monday), for J. C."*, 1989–90, there is a pushcart for errands to woodshed or shops. The most personal is *"Frog Poem: Hill Song (Floury Baker), for G. B."*, 1989–92, which displays a fake found object, labelled as Robert Pene's championship billycart that raced on the steep slopes of Reilly Road, Nambour. Pene is MacPherson's ten-year-old persona.[240]

Hill Song, *Creek Song* and *Tree Rain* evoke sounds to reinforce the physical bliss of engulfment in air and water. *Double Drummer*, *Yellow Monday* and *Floury Baker* further evoke ecstatic sound; they are cicadas, shrilling insects that schoolchildren collect. The adult MacPherson continued collecting childhood creativities for his *"Green Singer: 58 Frog Poems, for J. S. N."*, 1987–97, an artist's book of 58 cicada names.

Finally, we are not expected to identify the dedications 'for Bob Brosnan', 'for J. C.' or 'for G. B'. Most dedicatees are outsiders, MacPherson's proletarian mates whose 'secular' creativity he wishes to honour within the 'sanctified'[241] institutions of high art but without exploiting or embarrassing them. Nothing if not considerate, this satirical, funny, warm-hearted master of Conceptualism, characterised by European and American critics as a Marxist heir to the dandyish Marcel Duchamp and maybe as significant as Jeff Koons,[242] insists his low-life Australians can sing as well as any high-art insider. 1960s Abstractionists said that, for artists, aesthetics, art history and theory were like 'Ornithology for the birds'.[243]

Daniel Thomas

Narelle Jubelin b.1960

A fallen monarch 1987
cotton thread, found wood mount and frame, perspex
73.2 x 63.2 cm
gift of the Philip Morris Arts Grant 1988 88.279

Displayed in a wide, hand-carved oval frame, the subject of this image is a large fallen tree (a king or queen of the forest – a monarch) on top of which are two men. They are not woodcutters but well-dressed tourists, one holding a walking stick and the other a tree fern frond, both men positioned carefully to provide a sense of dimension to the once tall timber. The original reference for the work is a black-and-white photograph of the Victorian rainforest taken by Nicholas Caire around 1887.

A century after the original photograph, Narelle Jubelin transformed the image using her signature petit point embroidery to include this work in an exhibition entitled *The Crossing*. The 1987 exhibition included works with references to popular tourist locations from the Dandenongs to the Blue Mountains. Jubelin has also transformed the intent of the original image from a moment of heroic pride – man felling a giant – to one representing a sad loss, the destruction of the natural environment.

The decorative frames and detailed embroidery of Jubelin's work draw the viewer in to share a closeness and intimacy with the image. The frames, carved by amateur craftspeople, were often the pastime of Victorian and Edwardian ladies as was the use of petit point.

Jubelin's subtle colour interpretation of the original black-and-white photographic image is carefully considered. Jubelin explains her use of DMC mercerised cotton thread:

> The threads are almost all variated in colour – in these works I use 4 strands of cotton, blended as I see fit to produce a varied colour. Thus any stitch may be from 4 different shades through 3 strands of one blended with one other or simply 4 strands of a pure colour.[244]

At the time of purchasing this work, the National Gallery of Australia also commissioned Jubelin to produce two accompanying works. Entitled *A dangerous position* and *A Box Brownie*, both refer to a similar Victorian tourist theme as *The fallen monarch* and are also derived from early photographs.

Ron Ramsey

Fiona Hall b.1953

daffodil: (Narcissus x odorus) from the *'Paradisus Terrestris'* series
1989–90
aluminium and tin 24.5 x 11.0 x 1.5 cm
purchased 1994 94.244.P

Fiona Hall's inventive works in her *'Paradisus Terrestris'* series are honed with a jeweller's precision, with the acute observation of a botanical draftswoman and with the audacious imagination of the poet's 'wild eye'. A sense of the fantastic is apparent in the erotic, fertile associations between particular plants and aspects of human sexual anatomy, revealed in her finely worked imagery emerging from the intimate containers of sardine tins.

The series is rich in implication. It is informed in part by the artist's extensive research into botanical depictions. While the title is based on John Parkinson's florilegium *Paradisi in Sole, Paradisus Terrestris* (1629), Hall was drawn to other examples such as Robert John Thornton's *The Temple of Flora* (1807). She was also fascinated by the history of ideas around plants, including systems of classification first devised by scholars such as

Carl Linnaeus in the 1700s and based upon looking at the male and female components of each plant.

> At the time of his findings ... people still believed that the Garden of Eden existed somewhere on earth. So they were shocked when he talked about plants in overtly sexual terms because their view had always been that plants were benign, innocent; they didn't have a sex life.[245]

From a current standpoint, the artist recognises that we share many characteristics with plants and use them frequently as erotic metaphors. Along with the lively provocative humour suggesting temptation in the Garden of Eden, and the exquisite craftsmanship in these works, there is an underlying philosophical awareness that informs much of Hall's art around the theme of coexistence. As she has said:

> The basis of our shared existence is something that, scientifically, we are now more fully able and obliged to acknowledge ... There are more genetic similarities between us and the plant world than there are differences. These are mind-blowing concepts that should make us take notice.[246]

Deborah Hart

Sally Smart b.1960

Spider Artist (sew me) 1989

oil and enamel on canvas 188.0 x 132.5 cm

purchased 1989 89.1516

© Sally Smart, 1989. Licensed by VISCOPY, 2002

Spider Artist (sew me) is a painting belonging to the series titled 'X-Ray Vanitas', made in Melbourne in 1988–90.

This work referenced historical and contemporary persons as models to investigate notions of the ways feminine identity has been constructed. The paintings used the portrait genre as a model with literal reference to size, pose and installation.

Spider Artist (sew me) developed from ideas about Emily Dickinson and her poetry. I was interested in the metaphor Dickinson used to describe herself, as a 'literary seamstress', stitching words together to create meaning in her poetry, and her construction of her persona around the white dress. For Dickinson, the spider artist stratagem is a paradigm of the female artist: lone, private, isolated, secret; this, of course, is a fable of modernist art, which includes luring the desire of the gaze by just this making-art performance.

This painting presents an image of a particular single female figure, who is sewing fragments of clothing onto her body into a fractured unified self, and the various garments indicate fragmentary details of identities.

Sally Smart, 2002

Mike Parr b.1945

Language and chaos I 1989–90
drypoint and electric grinder, printed in black ink, each from one plate
on 12 sheets of paper 214.0 x 468.0 cm (overall)
printed by John Loane, Viridian Press
purchased through the Gordon Darling Australasian Print Fund 1991
91.362.1-12

I have now reached the point where large drawings on paper are being produced in tandem with large drypoints and etchings. Energy and ideas are continually flowing between one medium and the other. Across the paper I work at great speed, which facilitates a particular kind of resolution as well as a particular kind of content.

Drypoints are made directly onto metal plates with a carborundum-tipped stylus or a diamond point for fine work. The line cut into the copper raises a burr and it is the burr (rather than the groove, as in etching) that carries the ink. I also use other tools such as an angle grinder, sandpaper, nails and old wood chisels for cutting and scumbling the surface of the metal plate.

In contrast to the mobility of the work on paper, copper or zinc plates are a mass of resistance. The key, though, is to understand how this extreme contrast facilitates my work, because I find the difficulty of 'seeing' the image to be particularly stimulating, as accurate contours in the mind are defeated by the process of drypoint drawing. Lines continually skid into one another, agglutinate and form patches of graphic turbulence and the surface becomes greasy, opaque. The sheer physicality of the process and the characteristic 'damage' of the drypoint lines and, in the large works, the overdrawing across images and plates, are also all in direct contrast to work on paper. It is as though at every instant I am breaking down my facility as a draftsman.

What I am really talking about is the meaning of difficulty, how images are formed, what is left out in the process and how 'skill' glosses over or conceals the artist's understanding of his own work.

Mike Parr, 1990[247]

Robert Klippel 1920–2001

Number 250 Metal Construction 1970
brazed and welded steel, found objects 64.7 x 31.2 x 26.0 cm
purchased 1977 77.335

Number 751 1989 cast 1997
bronze 160.0 x 149.0 x 61.0 cm
purchased in memory of Michael Lloyd, with the assistance of his
friends and colleagues 1997 97.1294

I am slowly going ahead with the machine-organic form relationship piece. I feel that it symbolizes that inter-relationship of all nature and the material aspect of this age – the cog wheel is but an abstract section of a plant (or flower, roots of trees like pipes etc.). For the machine form I am drawing on … all the things I have absorbed in our machine age and machine exhibitions I have been visiting.
Robert Klippel[248]

With these comments written by Robert Klippel in London 1948 it was as though he was both taking stock and setting down a template for much of what was to follow in his later development. The interest he expressed in the inter-relationships between the structures of mechanical and organic forms – intensely observed, distilled and transformed – is as relevant to the works of the 1940s when he was on the threshold of his artistic journey, as it is to those undertaken decades later.

From the start, Klippel set himself high standards. Intensely self-critical, he was constantly pushing beyond the boundaries of the mediocre and parochial. His inquiring mind was like a radar, seeking out ideas from a range of sources; art from different cultures, the natural world, forms observed under a microscope and the variations of machine parts. Although he never set out to create surrealist sculptures he met many of the Surrealists in Paris and was clearly aware of the significance of the unconscious and subconscious in relation to the creative imagination. He was also intent on developing a philosophical basis in his art, inspired in part by Hindu mysticism and Zen Buddhism. Ultimately he was interested in the profound inter-connectedness of things – in the integration of seemingly disparate aspects of the world and in the paradoxical complementary nature of opposites.

Several important shifts took place in Klippel's work between the late 1940s and 1970. His sculptures gradually evolved away from the human form and from carving in stone and wood to more abstracted, open-ended configurations in metal and assemblages of found materials. During the 1960s, first in America and then in Sydney, Klippel accumulated stockpiles of discarded machine-parts to incorporate into his sculptures. A vital aspect of the process was the *transformation* that occurred within the sculptures. As James Gleeson wrote: 'Machine parts ... have been sifted through the artist's creative imagination ... and from this metamorphosis has emerged, like a butterfly from a dull chrysalis, a dazzling work of art'.[249]

Klippel's *Number 250 Metal Construction* represents the culmination of a phase in his development. After creating sculptures of considerable complexity, he moved towards a greater sense of distillation, exemplified in this remarkably precise, intricate sculpture. On one level the spiky forms suggest a certain danger - a quality apparent in earlier works encompassing a sense of threatening aspects of machines and nature (with titles such as *Electric germinator* and *Lethal machine monster*). Along with a certain stillness in his own work, there is also a sense of the internal rhythms, of potential energy, as though at any moment the forms might become kinetic and rotate and spin on their axis, cutting into the air.

The extent of Klippel's inventive spirit of inquiry is revealed in a substantial body of work, including thousands of works on paper and a monumental series of assemblages from the mid-1980s into the 1990s. In *Number 751*, a work cast in bronze for the Sculpture Garden of the Gallery, the careful selection and placement of elements are 'arranged into a study of brooding monumentality, like a mantlepiece of odd unusable machines'.[250] Along with *Number 250 Metal Construction*, this thoughtfully conceived work provides clear evidence of an artist who continually developed, honed and tested his skills and inventive ideas, and who, through his depth of commitment and achievement, earned the reputation of being one of the pre-eminent sculptors of the 20th century.

Deborah Hart

Art Now

1990–2002

Bill Henson b.1955

Untitled 1990/91

Type C colour photograph 12.0 x 125.0 cm
purchased 1991 91.395
courtesy Roslyn Oxley9 Gallery

Bill Henson's art is some distance from the association of the camera with the literal world. He is known for a succession of moody photographic series, in which figures move seemingly out of normal time and space within strange unhomely places and spaces. Each series is usually identified only by the year of making.

Henson's world is one created with light and shadow; the elements may be staged or may be fragments of scenes extracted from 'real life' as recorded by his camera. Each series raises immediate questions about where it is going, at the same time as leading the viewer down a personal path of reverie. Henson's characteristic saturated but subdued palette has an other-worldly character and also a sense of a grandiose art and culture now vacated by its original inhabitants and wanly occupied by others. Henson's printmaking involves complex use of different film stock, colour processing of black-and-white film, and intervention in the development and exposure of the prints. The resulting prints have their colour and mood precisely orchestrated by Henson, for whom classical music is a passion.

In 1990, Henson was approached to be part of the ongoing program of commissions to artists by the management of the Paris Opera. The commissions are open-ended and Henson made several visits over a year to the three Paris opera houses. Having determined that he would look at the idea of the audience rather than buildings or performances, Henson made his photographic 'sketches' in Paris. On returning home, he put these aside, feeling the photographs he had made were too documentary. Instead, he directed a new series of tableaux in which the Paris Opera building does not appear; indeed, the landscape images were shot in America. Within the 50 images of the series, there re-occurs a pale bejewelled girl-child. The figures do not thrill or emote or call for an encore from the invisible performers. They are passive but, in losing themselves, seem to live more intensely.

Gael Newton

Hossein Valamanesh b.1949

Falling 1990

wood, bamboo, sand, steel, black granite 390.0 x 55.0 x 50.0 cm

purchased 2002 2002.26

The image of the human body, in the form of an outline of my own body and shadows, appeared in my work from the mid-1980s. It was as if I was entering the work but, in so doing, I was leaving behind recognisable personal features and filling the outline of the body with new images and ideas.

Falling is the first in a small group of works in which the figure is inverted, as if it is heading back to earth.

In his book *The Satanic Verses*, Salman Rushdie describes the mid-air explosion of a passenger airliner on its way from India to England. He describes vividly bodies and debris falling towards the ocean beneath. Gibreel Farishta happens to be on this flight and, as everything around him falls apart, he gracefully falls, lands on the surface of the ocean and walks to the beach. *Falling* was my reading of this soft landing.

Leaving behind the narrative of the book, it stands for itself and it is more like falling with grace.

In 1991 I made *Falling breeze*, for which I used the outline of the body of my son, Nassiem (meaning breeze in Farsi). In this work, falling was like growing up or coming down to earth. The falling boy meets up with a branch of a tree. With traces of fire, it is heading in the opposite direction. In both of these works only the head and shoulders are recognisable and the rest of the body is transformed into linear forms. Like the tail of a comet, they suggest the direction of the fall.

Falling is constructed from carved wood and bamboo. The head and shoulders are surfaced with red sand which gradually blends to the colour and structure of bamboo. It sits on a piece of polished black granite, reflective like the surface of water.

Hossein Valamanesh, 2002

Rover Thomas c.1926–98
Kukatja/Wangakajunga people
All that big rain coming from top side 1991
natural pigments and gum on canvas 180.0 x 120.0 cm
purchased 2001 2001.128

All that big rain coming from top side – one two three four five six [channels in top half of painting]. That waterfall came over the rock, see that rock. Across [the picture] – that [is] road way. But people top way, they [are] falling down from top, from that thing now. Some of them gone inside way, in that rock you know, in that cliff [some people have gone into the caves in the cliff to shelter].

That [is] the big cliff going to road you know – where [the] people going to [the] rock [cliff/cave] you know, flat rock. That is Nasang Gani – Dreamtime – [at] Texas.

Waterfalls used [to be there, where] people come down there, living there. [Hunting], killing crocodile, barramundi, catfish – everything. [A] camping area that way, see that road going up there – that's where they're living, living area you know. Every holiday in Texas, in Texas country – [people would visit] waterfall. *Rover Thomas*[251]

The painting portrays a waterfall on Texas Downs Station in the eastern Kimberley, where Rover Thomas once worked as a stockman. The upper half shows channels of water running to the cliff's edge and then cascading down the side of the cliff. The horizontal line across the middle of the painting indicates the cliff edge along which a road runs.

Thomas's experience of growing up in the region was common to the vast majority of Indigenous people of the Kimberley and adjacent areas. Europeans colonised the region late in the 19th century, first to mine gold and then to raise cattle. Relationships between the Indigenous inhabitants and the new settlers were uneven and in many cases there were years of conflict, usually over the newly introduced livestock which polluted the freshwater sources and drove away the game on which Indigenous people relied. Eventually, most Indigenous people in the area were forced to work for the recently arrived ranch owners. These circumstances had at least one positive outcome: the locals could retain their connection with their ancestral lands, where they were able to conduct ceremonies and continue traditional beliefs, although they were paid a pittance for their considerable contributions.

Thomas's family came from the Great Sandy Desert. By the time he was ten, his family had followed the trail north to work on cattle stations in the Kimberley. He grew up on several stations, including Texas Downs, working as a fencer and stockman.

In some ways the painting is nostalgic, looking back to days when Thomas was young and he and his co-workers would seek shelter and refuge from the long hot and humid days of hard mustering in the wet season to 'holiday' at this waterfall. Native game and fish were plentiful. Caves in the cliff face also provided shelter from the heat and cool air to breathe.

Unfortunately, the place is also the site of a tragedy that occurred in the early years of the 20th century. Thomas tells of an occasion when a group of people sought refuge from a violent thunderstorm in one of the caves at the waterfall. A bolt of lighting struck the cave and the roof collapsed on top of the people, killing everyone.

In his paintings, Thomas characteristically overlaid the more recent European history of the Kimberley with the older ancestral history, attempting very rarely to represent the landscape in a naturalistic way in terms of recording the visible sensation. This work is, however, an outstanding example of Thomas's painterly attitude; the brushy application of the pigment and the varying thickness of the paint produce a sense of light shining through the cascading torrents of water.

Wally Caruana

Brian Blanchflower b.1939

Canopy XXVI – Talisman (Solar vessel) 1991
oil, synthetic polymer paint, sand, pumice powder on jute sackcloth;
two panels 200.0 x 202.0 cm (overall)
purchased with the assistance of Annandale Galleries 1993 93.4.A-B
© Brian Blanchflower, 1991

The main title of this painting, *Talisman*, suggests a ritual object created for the purpose of concentrating beneficial energies and, in so doing, warding off harmful forces.

The subtitle, *Solar vessel*, refers not only to a container for something (in this case colour), but also to a means of travel in the imagination. It is a vessel of discovery. The repeated discs can be seen as sun symbols – the sun's relentless movement across the sky, or as lenses of perception, a means of gaining insights into the life-generating forces of the universe.

In the 'Canopy' series (begun in 1985), I have chosen to make free-hanging paintings which are simply pinned to the wall. This freeing of painting from the stretcher and the frame enables the work to float as a coloured/textured form in space. I have a strong preference for humble, coarsely-woven fabrics like hessian and jute sackcloth: materials which have a pronounced horizontal/vertical structure. I like to mix sand or powdered pumice with the paint to give it more body and grittiness. This also enhances its light-reflecting properties. Only a layer of 'coloured mud spread over rough cloth' hangs between the viewer and that which I am pointing towards.

In *Talisman (Solar vessel)* I wanted to create an intense feeling of yellowness, a sensation that would burn into the mind and remain as a glowing after-image.

Brian Blanchflower, 2002

David Daymirringu 1927–99

Djinang language group/Manyarrngu people

Gamarrang sub-section (Dhuwa moiety)

Dhamala story 1993

natural pigments on eucalyptus bark 180.0 x 100.0 cm

purchased 1994 94.226

© David Daymirringu, 1993. Licensed by VISCOPY 2002

Every Yolngu (Indigenous person from Arnhem Land) has a tract of land which contains their spiritual essence, placed there by a creative being in the ancestral past. Daymirringu was custodian of three areas inherited patrilineally, two of which are depicted here in this conceptual map of Manyarrngu country associated with two sets of creative beings.

Dhamala is an area of mud flats and mangrove swamps on the coast of Arnhem Land. The painting refers to the travels of the ancestral Djan'kawu Sisters through Manyarrngu clan country. They are creation ancestors for the Dhuwa moiety people of Arnhem Land and travelled east to west plunging digging sticks into the ground and creating waterholes and naming people, places and animals. They changed their language when they got to Dhamala.

The black bar across the bottom of the painting represents the coastal waters of the Arafura Sea and the central vertical, the Glyde River. Dhamala is on the left, western side of the river. The radiating pattern from the black circle indicates the presence of the Djan'kawu and the *Milmindjarrk* (waterhole). The *Djirrkada* (catfish) was caught and named by the Djan'kawu.

The right half of the painting shows Ngurrunyuwa on the eastern side of the river. Ngurrunyuwa is associated with the ancestral hunter Gunmirringu and Manyarrngu mortuary rites. We see here one of the foods he collected: *rakay*, the spike-rush (pointed shapes), its corms (white shapes) and the leaves.

Daymirringu was not only a senior custodian of Manyarrngu Dreamings and ceremonial leader, but he also played a leading role in relations between Yolngu people of Arnhem Land and the western world through his art. He is well known as the painter of the bark painting used on part of the one dollar note, now out of circulation.

Susan Jenkins

Dick Watkins b.1937

The key 1991
synthetic polymer paint on canvas 152.0 x 244.0 cm
purchased 1992 92.787

Dick Watkins was one of the forerunners of colour-field painting
in Australia in the late 1960s, creating works with pure colour,
using dynamic geometric shapes and limited spatial depth.
He has worked in a range of styles – figurative, hard-edge and
Pop but, from 1969, most often in a spontaneous expressive
manner. He paints directly from his inner feelings, without any
preparatory sketches, rapidly and exuberantly brushing colour
onto the canvas, creating works with immense energy
and vitality.

The key is a striking example of Watkins's expressive power.
The brightly coloured sharp-edged forms are arranged in witty
spatial patterns that can be read in a variety of ways.
Dick Watkins comments:

With not much premeditation, I move in with a few big
brushes and splash a bit of paint around – not in a linear way

– in a broad way. I get a few shapes up and then it is a matter
of slowly elaborating on that with mass and line, sort of
interchanging all the time until I arrive at a satisfactory
complexity. Every painter knows when the picture is finished.
It just gels ... The way I start a picture is purely intuitive. Each
time I have a certain optimism that this will be the ideal
painting, the masterpiece, and that is what I believe painting
should be trying to do. It should be an attempt to make
something beautiful and powerful at the same time. I think
what Pollock did is ideal. That's how an Abstract picture
should be painted ... There are all sorts of references, but with
Abstract art one uses certain devices to fill up a space. I might
start by putting a circle or a cross or some other mark. After
a while these inevitably become repetitive and have to be
discarded. There is not a great deal to work with. Only straight
lines and curved ones after all. So I have to keep working at it
all the time. To a degree, a painting is about design. It has to
assume a certain complexity.[252]

Dick Watkins (1983) and Anne Gray

Gordon Bennett b.1955

Panorama (with floating point of identification) 1993
synthetic polymer paint on canvas 137.0 x 167.0 cm
purchased 1994 94.243
reproduced courtesy of Bellas Gallery, Brisbane; Sutton Gallery,
Melbourne; Sherman Galleries, Sydney; Greenaway Art Gallery,
Adelaide and the artist

Despite first appearances, *Panorama* is not an abstract painting: the skeins of black paint reveal the silhouette of a reedy bank, set against the bright light of the sun on a quiet waterhole. In the Indigenous cultures of northern Australia, clan waterholes are the containers of souls yet to be born, and the destination of souls departing this world. By placing the Indigenous symbol, the dot-and-circle roundel (or 'point of identification'), at the centre of this pond, Gordon Bennett suggests awareness of a heritage that is indirectly his (he is of Indigenous and English descent).

Trained at the Queensland College of Art in the late 1980s, Bennett has always been alert to the artifice of visual codes in representing experience. This image reads now as a western perspective view, now as a planimetric tissue of dots, brushing against the Indigenous graphic system. The whiplash lines of glossy red, yellow and black paint were executed in the 'drip-painting' style of Jackson Pollock, for whose work (executed on the floor in a ritualistic trance, like some Indigenous painting) Bennett has an ironic affinity.

Bennett's panorama encompasses points of history, such as the long-denied facts of white violence against Indigenous Australians addressed by much of his early work. Here, rings of red blood seep from the black body of paint into the stillness of the waterhole. As the artist writes of this work: 'The points of identification are the sites of memories that flow through the conscious mind, informing and constructing our identity, our sense of self (a remembering of our experience, our history, etc)'.[253]

Roger Benjamin

Emily Kam Kngwarray c.1916–96

Anmatyerr people

The Alhalker suite 1993

synthetic polymer paint on canvas; 22 panels 90.0 x 120.0 cm (each)

purchased 1993 1993.1903.A-V

© Emily Kam Kngwarray, 1993. Licensed by VISCOPY, 2002

The Alhalker suite is a monumental installation of 22 canvases which evokes the cycles of nature and the spiritual forces that imbue the earth. It is a response to the artist's land, Alhalker, the desert country of Kngwarray's birth, on what is now the cattle-station called Utopia.

Mer Alhalkerel, ikwerel inngart. Kel akely anem apetyarr-alpek Utopia station-warl. Mern arlkwerremel akeng-akeng mwantyel itnyerremel, lyarnayt tyerrerretyart, tyap lyarnayt. Mern angwenh, ker kaperl arlkwerrek, ilpangkwer atwerrerl-anemel netyepeyel arlkwerrerl ... Mam atyenhel mern anatyarl itnyerremel, anaty itnyerremel, anaty, amern akeng-akeng lyarnayt, tyap alhankerarl utnherrerl-anem, arlkwerrerl-anemel. Ikwerel anerl-anemel, arlkwerrerl-anemel. Mern anaty mam atyenhel itnyerlenty-akngerleng artnepartnerleng, akely-akely akenh artnelh-artnelh-ilerrerleng mernek. Mern akely akelyek. Kel alperliwerl-alhemel mer-warl, mern ampernerrerl-anemel, atnwelarr ampernerrety-alpem ... T ent anetyakenhel, antywa arterretyart, antywer renh arterrerl-anemel, kel alelthipelthipek arterl-anem kwaty akenh atnyepatnyerleng. Arrwekeleny ra. Long time kwa.

I was born at the place called Alhalker, right there. When I was young we all came back to Utopia station. We used to eat bits and pieces of food, carefully digging out the grubs from Acacia bushes. We killed different sorts of lizards, such as geckos and blue-tongues, and ate them in our cubby houses ... My mother used to dig up bush potatoes, and gather grubs from different sorts of Acacia bushes to eat. That's what we used to live on. My mother would keep on digging and digging the bush potatoes, while us young ones made each other cry over the food – just over a little bit of food. Then we'd all go back to camp to cook the food, the *atnwelarr* yams ... We didn't have any tents – we lived in shelters made of grass. When it was raining the grass was roughly thrown together for shelter. That was in the olden time, a long time ago.[254]

The Alhalker suite describes the land in flood, fertilised by water; the rains and storms of early spring. The painting celebrates the coming of water after long periods of drought, as so often happens in the desert. After the rain, brilliantly coloured wildflowers carpet the landscape, and the soft-looking spinifex bushes appear beside the desert oak trees and blossoming wattle.

Moreover, Kngwarray is paying homage to the *Altyerr*, or the spiritual forces which are the legacy of the original ancestors who created the land and everything in it, and who laid down the codes of behaviour and law. The powers of the ancestors have imbued the land and have graced generation after generation of Kngwarray's people.

The work is an important benchmark in Kngwarray's career. In this major work, she revisits the themes and techniques of her earlier works: the paint is thick and juicy, areas of bold colour are juxtaposed with more muted tones, lines are defined in series of dabs of the brush. Her later canvases became more restricted in colour and sparsely painted, sometimes using only black on white to trace the patterns of the sacred *awelye* (Yam) or women's designs.

The 22 panels of the work can be displayed in any order. Kngwarray did not determine the sequence of canvases nor did

she impose any limitations on the overall configuration; they could be displayed in a horizontal line or in a grid. In many ways such freedom allowed to the exhibitor of the work flies in the face of conventional artistic practice. Kngwarray herself was anything but conventional, although her career was dogged by those over-eager to sensationalise her achievements.

It is true that Kngwarray did not begin making paintings in acrylic on canvas until she was well into her seventies, in the summer of 1988–89. The art world was amazed by this phenomenon, more so as the images she produced have been compared in quality and effect with those by some of the great painters of modern western art, from Monet to Pollock. Her gestural style was easily equated to the work of the Abstract Expressionists. In fact, Kngwarray was barely touched by the western world of art. Moreover, she had spent a long life in creating art in ritual and private circumstances, far from the gaze of the general public, making ground paintings and decorating people's bodies for ceremonies using the same techniques and designs that appear in her paintings. For Kngwarray, the late 1980s only saw a change in media, not in the visual language and meaning of her art.

The Alhalker suite is one of her crowning achievements.

Wally Caruana

Michael Riley b.1960

Wiradjuri/Kamileroi people

'Sacrifice' series 1993

gelatin silver photographs

purchased through the Kodak (Australasia) Pty Ltd Fund 1993

1993.1441.1-15

Fish: 15.6 x 22.8 cm 93.1441.7

Granules of sugar, flour and tea: 15.8 x 22.8 cm 93.1441.9

Poppies: 15.0 x 22.4 cm 93.1441.8

Cross: 22.6 x 15.6 cm 93.1441.10

Michael Riley is from central western New South Wales and has lived in Sydney since the early 1980s. A photographer, video- and film-maker, over the past two decades he has built up a steady and consistent body of work, ranging from black-and-white portraiture, film and video, conceptual work, to his most recent developments in digital media.

Riley considers 'Sacrifice' to have been his first conceptual body of work, drawing upon interwoven influences from his childhood – 'Christianity, mission life, and rationing, the photographs shift between the literal and the allegorical, exploring the experience of dispossession by replacing people with symbolic images of poppies, fish and crucifixes'.[255]

It is in this series that the symbol of the cross, that most potent of Christian icons, first appears, looming large against a turbulent sky. Riley's images reflect what he has described as the 'sacrifices Aboriginal people made to be Christian'.[256] They resonate with loss, portraying the experience of not only the individual, but also many Indigenous communities: 'loss' of culture and land in enforced, and sometimes embraced, 'exchange' for Christianity.

The granules of sugar, flour and tea echo the rations meted out to Indigenous people on missions, and hint at the struggles which present-day communities face through the onslaught of drugs.

Michael Riley says:

'Sacrifice' is a body of work that the viewer can take what they want from. It's up to the viewer to make their own connection to the works.[257]

Brenda L. Croft

Salvatore Zofrea b.1946

My mother's hands 1994–99
jetutong woodblock 40.0 x 60.0 cm
printed by Paul Smith, Sydney
gift of Peter Fay 2001 2001.135.54
© Salvatore Zofrea, 1994–99

Self-portrait 1974
oil on canvas 75.0 x 60.0 cm
gift of Peter Fay 2001 2001.264
© Salvatore Zofrea, 1974

The woodcut, *My mother's hands*, shows my mother sitting down, wearing her typical apron and with her hands folded in her lap. The first time I did my mother's hands was in 1961 when I asked her to sit for me so I could draw her hands for a drawing competition. I still have the drawings I made.

My mother's hands said a great deal to me – they did so much work, they nursed me, they gave me lots of warmth and love and comfort. I wanted to express in the hands that they would protect you and nurture you. They were strong hands, working hands, because she had worked very hard since she was a young girl.

My mother played a profound role in my life and my evolution as a painter. She had a lot of strength and I think this portrait of her hands says it all.

When I painted this early *Self-portrait*, I was going through a time of uncertainty about what lay ahead for me. I felt that I was in a desolate landscape with a building behind me with no door to enter and this made me feel reflective and melancholy. This fear of the unknown is why one hand is raised to my face.

The symbolism of the upside-down bird behind me was a reflection of my spirit and my sense of vulnerability during this phase of my life. The bird was the perfect instrument to portray this premonition of adversity.

Salvatore Zofrea, 2002

William Yang b.1943

Vigil 1994

three gelatin silver photographs 36.0 x 165.0 cm (overall)

purchased 1994 1997.1277.A-C

The modern post-Stonewall gay movement as it happened in Sydney since the early 1970s is a large subject in my collection of photographs.

In the early 1980s we heard sinister reports about AIDS coming from America. These were frightening but seemed far away. At first it seemed that only excessively promiscuous gay men were at risk. The limits of safety then were not known. When the first cases appeared in Australia a few years later there was a hysterical reaction from the press, with extremely prejudiced beat-ups of the gay community happening almost daily. This was just the beginning of a horrific time.

In the late 1980s and early 1990s, many people were getting sick and dying. Credit must be given to the gay and lesbian community which rallied to the cause, lobbied for better conditions and set up networks of help. (On a political, medical and social level, Australia has one of the best records in the world for treatment of people living with HIV.) The community had never experienced such a decimation of its numbers. Many lost all their friends. Vigils were a necessary social ritual where people could express grief and loss in a public way. The vigil I photographed in Sydney domain in 1994 was one of the biggest ever held.

In some ways with better treatments things have improved, but the epidemic is still with us. It hangs like a shadow over our lives. We who have survived have learned to live with loss.

William Yang, 2002

Guan Wei b.1957

Efficacy of medicine 1995
synthetic polymer paint on ten panels (detail) 87.0 x 46.0 cm (each)
purchased 2000 2000.340.A-J

Guan Wei has developed an idiosyncratic visual language that crosses cultural and geographical borders. Born in Beijing in 1957, he is now a permanent resident of Australia. The evolution of his work reveals a capacity to creatively distil observations and feelings relating to his past and present, while simultaneously reflecting upon the ambiguities of cross-cultural meetings shaping the future. For him, the search for home is as much an internal journey as a physical one.

With an increasing awareness of different approaches to representation, Guan Wei has been able to develop an imaginative personal style that he has described as his 'own language nest'. In his important work of the mid-1990s, *Efficacy of medicine*, he creates a theatrical stage of encounters between a range of signs, symbols and gestures, encompassing humour as well as a serious investigation into human dreams and aspirations. As he explains:

> This work explores the processes of being human in a society of mixed cultures; the subtleties and misunderstandings, the clashes and, ultimately, the shared joys.

> In the painting, the capsules are a symbol of medicine and drugs. They represent a new substance produced from ancient alchemy and modern high technology. They could save lives but could also cause death: it is up to us.

> Metaphor and symbolism are the main mechanisms of these paintings. For example, the dots on the human body are borrowed from the ancient Chinese *Book of Changes*: they symbolise our future. The objects on the tables (the drinks, the toys, the fruit etc) together form fables in each frame: stories about the yet mysterious future of multiculturalism.

> Above all, the mixing of cultures makes life exciting and novel!

Guan Wei (2002) and Deborah Hart

Rosalie Gascoigne 1917–99

Suddenly the Lake 1995

plywood formboards, galvanised iron sheeting, synthetic polymer paint on composition board; four panels 129.1 x 69.7 cm, 129.5 x 78.9 cm, 130.3 x 118.5 cm, 129.5 x 93.8 cm

given by the artist in memory of Michael Lloyd 1996 96.255.A-D

© Rosalie Gascoigne, 1995. Licensed by VISCOPY, 2002

This is not a painting. Look closely at the reproduction and you will see shadows cast by brown boards that are superimposed on each other or on galvanised iron sheeting or on boards painted blue-white. It is a sculptural wall-hung construction.

The materials retain their distinct character. Like her younger contemporary, the American Robert Rauschenberg, Rosalie Gascoigne always preferred well-used ready-made materials, as she indicated when she was interviewed by the ABC in 1997: 'They've had the sun, they've had the rain, it's real stuff, it's not like stuff you buy from a hardware shop'.[258] Here the plywood sheets had a previous life as formboard walls into which concrete was poured. The sheets of galvanised iron were found weathered in a rubbish dump. The Masonite boards, painted on by the artist, were also pre-used.

One day in 1995, as she shifted scavenged materials around on the studio floor, an elegant combination of brown boards and blue-grey galvanised iron suddenly looked like earth and water, and not just in a general way. It suddenly evoked a particular place.

Generalised landscape experience of her Canberra region is often present in Gascoigne's art. There are swooping grassland pieces and hovering cloudscapes. There had been earlier land and water pieces, but nothing made with Lysaght brand galvanised iron sheeting until 1989: 'The tin – which people thought was a lake – was the obdurate soil'. Now, six years later, in *Suddenly the*

Lake more of the 'tin' would really be a lake, specifically Lake George as suddenly seen by motorists travelling out of Canberra towards Sydney – before the present freeway flattened the journey – at a place called Geary's Gap.

The third and largest panel, instantly recognisable to Canberrans, contains the genesis of the piece; the others frame that sharp-angled flash of recognition. On its right, the lumpiest of the four panels is a suggestion of the round hills to be climbed before the surprise. On its left is only a painted board, flush with a sheet of galvanised iron, to make a calm horizon of sky and water as if seen from the road that closely hugs the shoreline after descent from the hills. Then, instead of galvanised iron for water, the remaining panel has a white-painted mid-zone, probably to suggest the dry bed of Lake George where its northern end seldom fills with water.

When read from right to left as a south-to-north motorist's drive, it is a reversal of conventional expectation. Western cultures read their images and words from left to right. As well as the usual way, this very Australian image of passage through hard-edged dry hills and along an often dry lake has to be read in the 'wrong' direction, as if it were Japanese. (Gascoigne had been a practitioner of wild, avant-garde ikebana – Japanese flower arrangement – before turning late in life to sculpture.) The two-way alternation of visual flow creates a pleasing tension, like an electric charge.

There are other tensions too, of class and gender. A female artist, whose work is highly art-literate, acknowledges that working-class men similarly love the look and feel of their materials: galvanised iron sheeting for tinsmiths to fabricate into water-related objects such as buckets and cans, roof flashings, downpipes, bathtubs; plywood for cabinetmakers or builders to transform into furniture or houses and sheds, or to hold concrete while it solidifies. We sense behind the elegant Gascoigne

product an acknowledgement of, and engagement with, a world of elegant processes, mostly male: sawing, hammering, cementing, and erecting foundations and walls.

Gascoigne and the workmen, whose cast-offs she brings into the temples of art, delight equally in the poetics of materials. Both also delight in the poetics of place, of home-making and of familiar ground.

Further, however, Gascoigne had an exceptional feeling for the tangibility of outside air and distant space, perhaps from once having lived in an astronomers' community on a Canberra mountain. Perhaps because her first motor car in 1948 was a means of liberation from Mount Stromlo, she emphasises the sensation of swooping – flying almost – along endless inland roads in one's own familiar vehicle, a particular Australian

ecstasy. No automobile is depicted in *Suddenly the Lake* but we are nevertheless cruising the old Federal Highway from a driver's seat. Those who come to Canberra by endless, open-sky road can still encounter such momentary thrills within our more general delight in cross-country driving, a feeling raised here, by Gascoigne, into something crystalline, austere and everlasting. She has converted Australian life into art.

The Canberra setting made this the perfect work to give to the National Gallery of Australia in memory of Michael Lloyd, a curator who had found for the Gallery wonderful European paintings by Miró and Magritte, and a construction by Picasso that Rosalie Gascoigne especially admired.

Daniel Thomas

Caroline Casey b.1964

Elliptical folding screen design 1994 manufacture 1996
American rock maple 200.0 x 160.0 x 3.0 cm
purchased 1996 96.1010

Caroline Casey's training in interior, fashion and textile design has given her a broad background against which to develop her work in furniture and smaller domestic objects. Designed for limited production, her furniture displays a precise logic in its use of simple materials, repetitive forms and clearly-expressed structure. The relationships between these elements of her work are subtle, allowing the eye and the hand to explore the surface and texture not only of natural materials such as wood, but also of the particular qualities of manufactured materials such as plastic and steel.

This folding screen illustrates Casey's use of a simple repetitive element – elongated ovals of wood – suggesting large overlapping plant leaves and the airiness of the traditional slatted screenwork used in traditional tropical architecture. The influence on Casey of the work of Scandinavian designers such as Alvar Aalto can be seen in its organic design elements and use of a single, unadorned material.

Robert Bell

Howard Taylor 1918–2001

No horizon 1994
synthetic polymer paint on marine plywood 183.0 x 170.0 x 0.45 cm
purchased 1997 97.605

If you work very abstractly in a minimal sort of way you are still drawing on your experience of life itself, the physical business of seeing and the more subjective one of feeling.
Howard Taylor[259]

Howard Taylor created works with an intellectual force and a subtle beauty.

In *No horizon*, he used observation to distill essential forms from nature. He created a large, abstract, three-dimensional white wall relief, shaped into a curve, which casts shadows below the form, beside the form and on the form. He was interested in the dynamics of light. Here, however, instead of representing the impact of light on the natural world – at one remove, within the picture space – Taylor used light as an active member, a dynamic living force, creating shadows on and around his constructed curved surface. His works encourage us to look, to perceive the subtleties of light as it interacts on his form and on the world around us.

Taylor was always concerned with structure in nature revealed through the changing patterns of light. He lived for many years in the Darling Ranges east of Perth and at Northcliffe, among the karri forests in the South-West. Observation and representation are central to all of his art. The portrayal and interactions of light in its most essentail – pure – form continues as the core of his achievements as an artist.

Anne Gray

Robert Baines b.1949

La Columbella tea and coffee set 1992–94
sterling silver and titanium 23.0 x 45.0 x 45.0 cm
purchased 2001 2001.132.1-6

The title of this tea and coffee set, derivative of the important Etruscan site of Columbella at Palestrina, discloses a satiric placement within the genre of post-modern 'International Italian Style'. It also points to my research into jewellery of ancient antiquity.

The multi-angled forms and geometric contrasts in each vessel achieve individuality through the differing proportions of a given set of components. This is an ongoing condition found in two previous tea sets, now in the collections of the National Gallery of Victoria, Melbourne, and the Powerhouse Museum, Sydney. The departure within this silver group is the compounding reflections from the complex polished surfaces of the silver, while the corrugated surfaces are further inclusions to the multi-sided structures.

The intricate series of fine drill holes on the black lids is reminiscent of granulation present in previous works, so influenced by the intricate techniques of Greek and Etruscan metalwork. Space-age titanium handles, with their repetitive dots, are thermally treated to produce an array of multiple colours.

Robert Baines, 2002

Howard Arkley 1951–99

Floral exterior 1996
synthetic polymer paint on canvas 174.5 x 134.5 cm
purchased 2001 2001.64

Howard Arkley is best known for his representation of the Australian suburbs; for his exuberant, theatrical paintings of suburban homes and environments. In his dramatic, hallucinatory *Floral exterior*, he creates a sense of suburban 'exotic' in order to beautify the domestic arena. It is as though so-called ordinary, everyday existence has been transmuted into the extraordinary.

Arkley has drawn upon a wide range of sources in the evolution of his vision – from an abiding fascination with Pop Art through to an avalanche of material relating to the home, including magazines, real estate brochures, and interior decoration and do-it-yourself manuals. With humour and pathos, he discovered ways of entering into and amplifying obsessions with home and garden.

Wallpaper, for example, is traditionally a means of introducing a decorative element to interior rooms, the motifs of flowers and leaves providing a way to bring nature inside. In *Floral exterior*, Arkley's reversal of the florid wallpapering in a range of vivid hues across house, sky, letterbox and lawn brilliantly conveys the merging of cultivated interior with exterior to evoke a dream-like state of mind. In contrast to the stereotype of the predictable 'suburban dream' of the 1950s, the artist appears to suggest that the self-contained exteriors of the classic suburban home might in fact mask hidden eccentricities and imaginative interior worlds.

A particularly striking aspect of this work is the cloud of bold red-on-pink motifs behind the letterbox. Certainly one of the most expressive flourishes in an Arkley painting, it is as if the stencilled wallpaper has suddenly given rise to a new language of signs and symbols that bursts forth with joyful abandon.

Deborah Hart

Kitty Kantilla (Kutuwalumi Purawarrumpatu)

born c.1928

Anjilunga clan/Tiwi people

Jurrah 1995

natural pigments and gum on canvas 149.0 x 118.0 cm

purchased 1996 96.867

Kitty Kantilla is one of the senior artists based at Jilamara Arts and Crafts on Melville Island. She employs both brushes and coconut sticks to apply natural ochres to bark, paper and linen. Her work is both subtle and strong, with intricate lines of dots, bold areas of solid ochre and sections of delicate line work. Occasionally, Kitty gives a story regarding her work but this is relatively rare, indeed her usual response to queries regarding her work is that she 'paints like her father and grandfather'.

When interviewed regarding this painting in 1995, she indicated that it depicted her country – the Tiwi name for her country is Yimpinari (sunrise) and is situated on the eastern tip of Melville Island. She said it portrayed the mangroves in the area, and the flowers and some of the crosshatched lines represented the dangerous snakes which abound in the mangroves. Country is important to the Tiwi; among other things, it represents close relationships with others from the same country, it is where the 'ancestors bones' are and it represents food to keep the living alive: 'Plenty buffalo, mud crab, fish'.[260]

Yimpinari is where Kitty grew up with her parents, siblings and many others. Here she lived a traditional life, living under paperbark shelters and eating traditional foods. She recalls these times fondly, often recounting the abundance of food in the area. Sadly, since Kitty left as a young woman she has never returned to her country. During a recent interview, she indicated that it is too far and she is now too old to undertake such a journey back to her birthplace.

Felicity Green

Fiona Foley b.1964

Badtjala people

Land deal 1995

flour, mixed media, found objects, text

202.0 x 442.0 x 442.0 cm (dimensions variable)

95.1012.1–9

courtesy Roslyn Oxley9 Gallery

Land deal is an installation consisting of flour to create a spiral shape on the floor, together with a blanket, knives, mirrors, axes, a box with beads (white and blue), scissors and a text. The text reads:

> Land deal: After a full explanation of what my object was, I purchased two large tracts of land from them – About 600,000 acres, more or less – and delivered over to them the blankets, knives, looking-glasses, tomahawks, beads, scissors, flour, etc., as payment for the land and also agreed to give them a tribute, or rent, yearly. John Batman

The objects chosen for the installation are closely associated with the words by John Batman about his purchase of the land on which the city of Melbourne now stands; they are a symbolic representation of the many Indigenous groups across Australia and the way in which their land was taken from them. The spiral shape echoes similar grooved designs drawn in the sand for Indigenous ceremonies. Objects that Batman sought to trade have been here exploited in a different sense, making this work rich in its layers of implication and irony.

Whilst the piece pertains to the purchase of Melbourne and Batman's land deal, as with much of Foley's work, it equally reflects issues of custodianship, land possession and occupation of her country, Thoorgine, and other areas of Indigenous Australia. Thoorgine was renamed Fraser Island after Eliza Fraser (wife of a British captain whose ship was wrecked on the island in 1836). In this case it was not so much the 'purchase' of the island but the forcible removal of the Indigenous owners who were dispossessed from their traditional land.

Gloria Morales

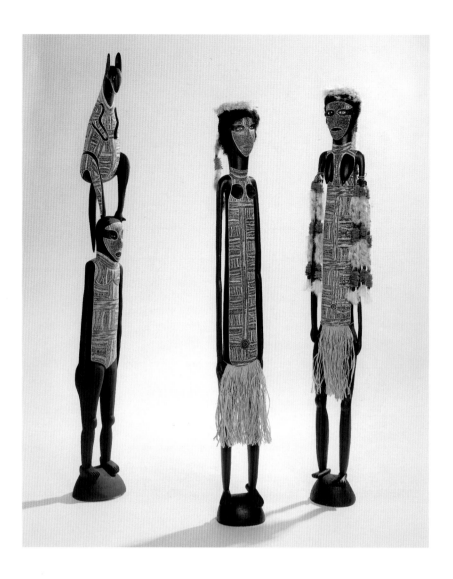

Dundiwuy Wanambi c.1936–96
Wolpa Wanambi b.1970
Marrakulu clan/Yolngu people
Motu Yunupingu b.1959
Gumatj clan/Yolngu people
Djuwany 1995–96
wood, natural pigments, feathers, hair resin, natural fibre
170.0 x 20.5 x 17.8 cm
purchased 1996 96.1.A-G

Towards the end of his life, in the scale and refinement of his works, Dundiwuy Wanambi reached the height of his powers as a sculptor. He often worked with his daughter Wolpa and his wife Motu Yunupingu, especially in the final stages of painting the bodies with intricate clan designs. The works capture in three dimensions the essence of Yolngu (Arnhem Land) art, combining the shimmering brilliance of the crosshatched design with a stark clarity of form.

These sculptures represent the Wagilag sisters and Wuyal the honey man as they travelled through Marrakulu country in the region of Trial Bay and Cape Shield in northern New South Wales. The designs on their bodies represent the rocks, creeks and waterholes of the land they crossed and where their paths sometimes intersected. Wuyal and the sisters both hunted *dhulaku* (euro) through the forests and cut down trees in search of honey.

The designs are dense with meaning and evoke the aesthetics of the landscape: the intensity of the blossom, the glistening of the honey and the energy of the bees as they move in and out of the hive. The figures are painted in the same way as people prepare themselves today for ceremonies in commemoration of the creative acts of the ancestral past; the designs capture the power of the ancestral beings and then pass it on to succeeding generations in the form of art. In ceremonies, the painted designs make the participants a part of the ancestral landscape, their faces the entrance to the hives, their bodies the flowing waters of the rivers where the ancestral beings journeyed.

Howard Morphy

Djalu Gurruwiwi b.1940
 Galpu clan/Yolngu people
Dhopia Yunupingu b.1948
 Gumatj clan/Yolngu people
Peter Adsett b.1959
Yuan Mor'O Ocampo
Ardiyanto Pranata b.1944
 Gapu, tubig, air, water 1997
 screenprint, printed in colour on cream wove paper 89.0 x 69.6 cm
 printed by Basil Hall, Northern Editions
 gift of Nigel Lendon 1999 99.126

In July 1997, five artists from Australia and the Southeast Asia region participated in a collaborative project *The Meeting of Waters*, the first Australasian Print Project, held at the Northern Territory University. As a culmination of the project the artists Djalu Gurruwiwi and his wife Dhopia Yunupingu (from north-east Arnhem Land), Ardiyanto Pranata (Indonesia), Yuan Mor'O Ocampo (the Philippines) and Peter Adsett (Northen Territory) decided to collaborate to produce this print, *Gapu, tubig, air, water*.

By the time they had agreed to work on this print, each was aware of their adopted kinship relationships to the Indigenous artists, and responded accordingly in the construction of this image.

In the bottom horizontal section, Moro'O Ocampo consulted with his classificatory mother Dhopia on the form, colour and structure of his imagery of quail and crocodile eggs. Ardiyanto's section (right-hand panel) stresses his own traditional cultural roots in batik, and the wider cultural ties within the region. Peter Adsett's section (left-hand panel) refers to the stream which flows between the two waterholes where he lived at Humpty Doo, and to the waterlily leaves Djalu had seen there. In the top horizontal section, Dhopia completed the cycle by painting her own Yirritja motifs of *larrakitj* (the hollow log coffin) with *djirrikitj* (the quail) who lays her eggs inside, and *wan'kurra* (the bandicoot) who is looking for *ngatha* (food). Djalu's central image is part of the story of his ancestor Bol'ngu, the Thunderman, who sends down *djambuwal* (the waterspout), which created a freshwater waterhole in the ocean.

Nigel Lendon

Ken Thaiday Senior b.1950

Island group: Darnley Island (Eastern Island Group), Torres Strait Islands

Language group: Meriam Mir

Hammerhead shark mask 1997

bamboo, plywood, wood, feathers, wire, synthetic cord,

enamel paint, plastic 87.0 x 60.0 x 110.0 cm

purchased 1991 91.1371

Historically, *dari* (headdresses) were worn by men during warfare; today, they are worn during dance ceremonies. Ken Thaiday Senior's *dari* reflects the social and historical influences in the Torres Strait. The shark is the artist's totem and represents an affiliation with the sea and wind. The *Hammerhead shark mask* is a moveable headdress which captures the movements of a shark with its open jaws (bottom) and natural flow of swim (top). The shark's mouth can be opened and manipulated by the dancer wearing the articulated mask. The use of contemporary materials such as fishing lines to move different parts of the headdress demonstrates an innovative approach towards Torres Strait Island art and culture, and shows how new materials and techniques have evolved in response to changes in the cultural environment. The *Hammerhead shark mask* is an example of an indigenous culture's ability to adapt and survive whilst retaining its own separate identity.

Torres Strait Islander art and culture is unique and different to that of Aboriginal Australia; the exploration and promotion of this art and culture has recently come to the forefront in Australia. The Torres Strait Islands have undergone immense social, political, religious and environmental change since contact with Europeans began in the 1800s. These major changes were accepted and adapted, resulting in an evolving culture and enhanced Torres Strait Islander identity. This has influenced the variety of material culture produced, both by artists living in the Torres Strait and by those Torres Strait artists residing on mainland Australia.

Leilani Bin-Juda

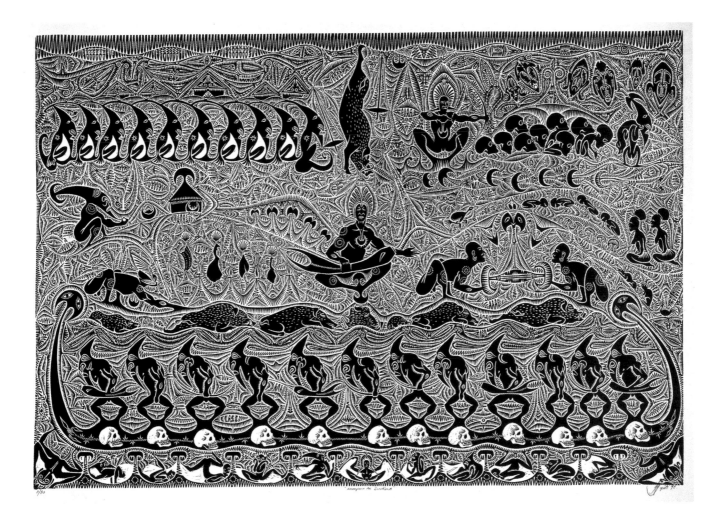

Alick Tipoti b.1975

Island group: Western Island, Torres Strait Islands

Language group: Kala Lagaw Ya

Aralpaia Ar Zenikula 1998

linocut, printed in black ink, from one block on paper 67.0 x 100.0 cm

purchased through the Gordon Darling Australasian Print Fund 1999

99.24

Over the past decade, Torres Strait Islander artists have increasingly produced many prints, especially linocuts, where the traditional carving techniques of their forefathers have been revived utilising contemporary mediums. The establishment of art centres in remote communities, and courses designed for Indigenous artists at TAFEs and universities, have encouraged this art production. Alick Tipoti followed a well-trodden route when he studied first at Tropical North Queensland Institute of TAFE and then the Canberra School of Art. In these contemporary prints, many traditional stories are being re-told, often of the period before the arrival of the Christian missionaries.

Aralpaia Ar Zenikula portrays a traditional story from Alick's home island of Badu; it tells a tale of land ownership which resulted in conflict and bloodshed. As Alick Tipoti notes:

> I get my inspiration from the ancient artefacts of the Torres Strait … and from the traditional stories handed down and recorded by my father and the recognised elders of Torres Strait.

Land ownership was of great significance to headhunters in the Torres Strait back in the old days. This story is one that occurred before the London Missionaries brought Christianity to the islands of the Torres Strait in 1871, which is known to us as the 'Coming of the Light'. Today, a pig hunter can hunt wherever he chooses on the islands without fearing to lose his life to another warrior. In the past a hunter on land would be risking his life hunting outside his boundary. This land which Aralpaia and Zenikula occupied is located on Badu (Mulgrave Island) in the Torres Strait, and the sacred location is very significant to me and my father because the name Tipoti, which we carry, is originally from Badu. Still to this day people on this island view us as one of the very few natives of this island.[261]

Alick Tipoti (2001) and Roger Butler

Kate Beynon b.1970

Excuse Me! 1997

chenille sticks 250.0 x 350.0 cm

purchased through the Rotary Collection of Australian
Art Fund 1998 98.18

reproduced courtesy Sutton Gallery, Melbourne

The work *Excuse Me!* was created for the exhibition *Blackphoenix* with Michael Pablo, at Melbourne's First Floor Artist and Writer's Space in 1997. This exhibition explored issues relating to cultural identity and 'miscegenation' – people of 'mixed race' – which referred to our own mixed heritages and migrant experiences living in Australia.

Excuse Me! is made entirely from chenille sticks, a craft material also known as pipe-cleaners. I used black chenille sticks to form the wall-drawing, which depicts a crowd of Asian cartoon-like figures standing together. Within the wall-drawing are the shapes of cartoon speech bubbles, containing Chinese calligraphic text with western punctuation such as exclamation and question marks. Here, I twisted thick red chenille sticks to

mimic inky painted brushstrokes. The wall-drawing and characters are pinned directly onto the gallery wall, creating a kind of 3D drawing effect, with the shadows adding depth.

The text in each bubble forms an expression or question from a Chinese/English travellers' phrasebook, which I had used on my trip to Beijing where I went to study language in 1995.

In *Excuse Me!* the crowd of people confronts the viewer with questions such as 'How do you do?', 'Where are you from?' and 'What is your name?' – basic phrasebook expressions which also echo cultural interrogation.

My work continues to deal with, and explore themes arising from, issues of cultural identity and politics, migration, 'multiculturalism' and racism, within an Australian context. The style of my work reflects a hybrid of influences from both eastern and western, traditional and contemporary art forms – such as Chinese calligraphy and traditional Chinese art, cartoon and comic book graphics, animation, and graffiti art.

Kate Beynon, 2002

Liu Xiao Xian b.1963

Reincarnation – Mao, Buddha & I 1998
digital image, printed in black ink, from inkjet printer on thinboard;
set of three prints each comprising 100 sheets 275.0 x 625.0 cm (overall)
purchased 1999 99.152.2 IA-10J

Reincarnation – Mao, Buddha & I is based on the core of Taoism/ Yin and Yang: the basic elements which provide the explanatory basis for the formation of the cosmos and its symbolic correlation in the corresponding human world.

The work is completed in three portraits – *Mao, Buddha & I*. Each consists of 100 panels of A4 size prints. Tiny portraits of each subject are used as 'basic elements', which in turn construct the portrait of the other, i.e. 'Mao' is made of 'I', and so on. Technically, I utilise the principle of the halftone image reproduction – the tones are broken into dots, which I have swapped for tiny images to emphasise that the universe is made up of basic elements. Such innovation has a leap effect in the process of both image formation and cognition.

The work is constructed to such huge proportions not only to meet the technical requirement, but also to allow the 108,300 small images to compete with each other outrageously for attention. Moreover, the delicacy of changes from small to the general as a whole may lead us into thoughts about micro versus macro. Hasn't it been mentioned in the Buddhist Scriptures that the immensity of the gigantic cosmos has no boundaries? Yet, it is so small that infinitude of the inside has no end.

In my work, I try to offer a new viewpoint to look at dialectical matters. After seeing the work up close and at a distance, the ambiguity of identities becomes obvious and roles are constantly changing. I try to reveal the constant rotation of Yin and Yang cosmos into different levels of life behind the scene. Hopefully, this work may provoke deeper thoughts.

Liu Xiao Xian, 2002

Dulcie Greeno b.1923

Tasmanian Aboriginal people

Shell necklace 1998

maireener shells, polyester cotton thread 195.0 cm (circumference)

purchased 1998 98.187

Valerie MacSween 1919–99

Tasmanian Aboriginal people

Shell necklace 1995

maireener, toothy, black crow shells, polyester cotton thread

186.0 cm (circumference)

purchased 1998 98.137

Lola Greeno b.1946

Tasmanian Aboriginal people

Shell necklace 1995

cockles, maireener shells, cat's teeth, buttons, polyester cotton thread

136.0 cm (circumference)

purchased 1998 98.138

Although the three named artists created their necklaces six decades after the unknown artist, the traditions that all four drew upon are connected over thousands of generations for the Palawa Aboriginal people of Tasmania. These exquisite objects convey the collective determination of the 7000-strong Indigenous community of Tasmania in overturning the long-propagated myth that all their ancestors were effectively wiped out in the 19th century.

A late 19th-century photograph of the renowned Tasmanian Aboriginal woman Trugannini [Trucaninny] – popularly and racially defined as 'the last full-blood Tasmanian Aborigine' – portrays her anguished yet dignified face, a maireener shell necklace wound round and round her neck. A similar shell necklace also appears in Benjamin Law's 19th-century portrait bust, *Trucaninny, wife of Woureddy*.

The shell necklaces made by these Tasmanian Aboriginal women represent much more than simple jewellery or decorative art. For the women who created them, the practice of collecting the shells from their traditional lands, and watching and learning from their matriarchal elders, is part of the cycle ensuring that cultural traditions are maintained and serves as links between the generations.

Artist Lola Greeno speaks of her fellow artists, her mother Valerie MacSween (née Burgess) and mother-in-law, Dulcie Greeno:

> My mother learnt about making shell necklaces from her grandmother Julia. She was one of the most important women on the island and the birthing mother [midwife] for many of the island's population. My mother remembered grandmother having a collection of shells stored in glass jars ready for 'shell stringing days'.
>
> Dulcie identifies her necklaces by the way she threads the shells to form a pattern and her method of cleaning the shells with different fluids. Dulcie shares this knowledge with her family … Maireener shells are precious to women.[262]

Lola Greeno (2000) and Brenda L. Croft

Unknown artist *Shell necklace* c.1930
shell, cotton thread 153.0 cm (circumference)
Gift of John McPhee 1988 88.373

Lena Yarinkura b.1948

Rembarrnga people
Yawkyawk Spirit 1998
pandanus, paperbark, feathers, natural pigments 200 cm height
purchased 1999 99.84
© Lena Yarinkura, 1998. Licensed by VISCOPY, 2002

Yvonne Koolmatrie b.1944

Ngarrindjeri people
Eel trap 1992
sedge grasses 44.0 x 46.0 cm
purchased 1995 95.310

Together with a small number of Ngarrindjeri weavers, Yvonne Koolmatrie has been instrumental in reviving an Indigenous cultural tradition that was in danger of disappearing altogether. *Eel trap* is a replica of a utilitarian object that countless generations of Ngarrindjeri people have made to collect eels in the Murray River. All along the river systems of the south-east, Indigenous people created similar traps, for which they collected sedge grasses (*canesens lepidosperma*). These, dried and split, they wove into marine traps in the distinctive Ngarrindjeri manner.

Yawkyawk is a word meaning 'young woman' and 'young woman spirit being'. Lena Yarinkura's life-size sculptural works are made of pandanus fibre woven casing (not dissimilar to a fish trap structure) stuffed with paperbark and decorated with natural pigments and/or feathers. They take a number of forms, often representing animals and mythical beings which exist within the clan estate.

Yvonne Koolmatrie is a member of the Ngarrindjeri nation of the Riverland region, north-west of Adelaide in South Australia; Lena Yarinkura is from the Rembarrnga people, Kune language group and Burnungku clan, living at Bolkdjam, an outstation of Maningrida, Central Arnhem Land in the Northern Territory. Although they come from different areas, their work has connections in addition to their shared Indigenous heritage. Both create wondrous sculptural objects from natural fibres with all materials collected from the artists' traditional countries. Both artists are proponents of continuous ancient weaving traditions from their respective regions, yet their singular pieces contribute critically to challenging perceptions of contemporary Indigenous art, creating new directions for fibre work in Australian art.

Brenda L. Croft

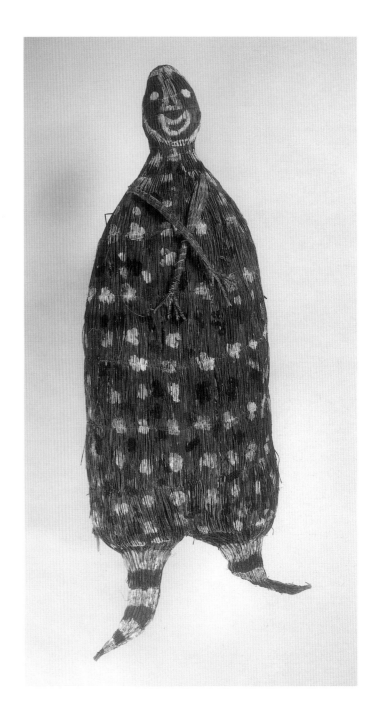

Anne Ferran b.1949

Untitled (baby's dress) 1998
gelatin silver photogram 103.8 x 81.5 cm
purchased with funds from the Moët & Chandon Australian Art
Foundation 1999 99.105

Anne Ferran has a continuing interest in historical objects; objects
which hold a physical memory. For this series of photograms,
Anne Ferran worked with clothing that had been carefully
preserved in tissue paper at 'Rouse Hill', a Sydney house that has
been in the same family since 1813 – a family that devotedly
preserved its past. Ferran spent six months on site, methodically
choosing garments that would best allow light to penetrate,
laying them on photographic paper and briefly exposing them to
light. There was no camera. The resulting ghostly shadow prints
are direct imprints in negative form, like X-rays of the garments.

Ferran chooses her words and methods with care; she seeks to
elucidate that which is usually hidden, hidden even from the
photographer herself at the moment of the making – for it is the
material closest to the paper which registers most clearly. The

photogram process also brings out old repairs to the garments;
'women's work' concealed in life, kept from the public gaze and
also from public acknowledgement.

The artist becomes the mediator, a conduit through which the
past can attempt to speak to the present:

> When I try to reflect on these images the two things I keep
> coming up with are these: on one hand the obdurate barrier,
> like a high wall or a range of distant mountains, of short
> memory/thin skin; and on the other the longing to close the
> gap, recover the past, cross touch with sight, or lose them in
> one another, to press up close to things, cloth against paper,
> skin against skin.[263]

The barriers begin to break down. The pieces of clothing take
on a life, they seem to radiate light and to take on a ghostly three-
dimensionality, as if they are still embodied. Ultimately the works
are an intimate and meditative memento mori.

Anne O'Hehir

Rosslynd Piggott b.1958

High bed 1998
wood, metal, cotton, dacron, satin, perspex, painted walls
dimensions variable
purchased 2000 2000.231.A-I

In 1994–95, I spent seven months in Paris at the Cité Internationale des Arts – living and working in the heart of Paris, in the beautiful Marais *quartier*. My studio overlooked the Seine and the Ile Saint Louis opposite.

I spent three months making drawings and destroying them. The information I collected was dense, yet confusing. One distinct thing I noticed was the bed I slept in. All the artists at the Cité are given single beds to sleep in and the studios themselves are very austere. It was a weird contrast: living in one of the most culturally and visually rich cities on earth, in domestic surroundings of institutionalised and drab austerity. When I lay in that bed during the night, my thoughts and impressions of the Parisian day would collect in my head in an intense over-abundance. Somehow, on occasion that over-abundance would transfer itself to the furniture – the bed would swell, the building would weigh itself against my chest. The relationship between mind and object was transferred, fluid and shifting.

I tried to describe these sensations in a series of watercolours, 'High bed' 1994. And several years later, in 1998, this became a large object, *High bed*. It changed a little and became its own form, but these were my initial experiences that formed the basis for the work.

I wanted to make a bed that wasn't really a bed – you couldn't sleep in this bed. It is also like a big minimalist white cube, with just enough information to think that it might be a bed. The weight of culture is recorded in that bed. This bed also registers anxiety and dislocation, its state of mind. The mercurial mirror disc registers a space above the bed so that the viewer can look upon the scene with distance.

Rosslynd Piggott, 2002

Akio Makigawa 1948–99

Recollection of memory 1 1998

cast iron; 44 panels 341.0 cm (diameter)

purchased 2000 2000.57.1–44

reproduced courtesy of Galerie Dusseldorf

photograph by Graham Sands

Akio Makigawa's contribution to Australian art is one of outstanding dedication to public education and personal progress. Much of Makigawa's work is highly restrained and meditative, a symbolic sculptural language which investigates the journey of life through the notions of time and space.

Born in Japan in 1948, Makigawa studied art at Nihon University, Tokyo, before travelling to Perth in 1974 where he trained as a sailmaker and then studied fine arts. In much of his work, Makigawa explored the relationships between humans and the natural world. The ocean is a particularly prevalent theme as the artist contemplated the fine balance between the human experience of sailing and the power of nature as demonstrated by the sea and the wind.

Made during a residency at Perth's Claremont School of Art, *Recollection of memory 1* is a contemplative work of visual subtlety. This large floor or wall piece consists of 44 cast-iron panels which, when joined together, form a circular construction almost 3 1/2 metres in diameter. Each panel is represented by a different motif, all of which belong to Makigawa's distinctive symbolic language. Some motifs resemble urban architectural patterns and shapes, recalled from a created environment of boats, bowls, buildings and gateways. Others refer to the organic and elemental: spiritual symbols for water, fire, earth and air, and symbols for life-giving seedpods and rain-sending clouds. Makigawa fused these elements with the personal construction of time; the circular shape of this work encouraging the viewer to read it as a journey, infinite and organic, yet man-made and cerebrally conceived.

Recollection of memory 1 is a sort of symbolic biography, a compendium of themes that characterise Makigawa's oeuvre. Some elements are included in previous works, including *Time watcher* 1988 and *Time and tide* 1994. This is a poignant late work, closing the circle of the artist's life.

Beatrice Gralton

Fiona Hall b.1953

Fern garden 1998
tree ferns, river pebbles, steel, granite, water, concrete, copper, wood mulch
purchased with the assistance of Friends of Tamsin and Deuchar Davy, in their memory, 1998 98.16

Fiona Hall's *Fern garden* has transformed a daunting site into a wondrous, fertile space for interaction and contemplation. Hall considers the work as garden design rather than public sculpture or 'land art', informed by historical precedents such as Japanese temple gardens and Islamic gardens. As the work was for the National Gallery of Australia, she chose the *Dicksonia antarctica* tree fern, one of this country's most ancient plants. Within the pebbled paths are pavers inscribed with Indigenous names for the tree fern, together with names of the languages or language groups from which they come, as a way of recognising the significance of Indigenous knowledge and histories.

In *Fern garden*, there are associations between regenerative plant forms and the human body, so evident in Hall's earlier *'Paradisus Terrestris'* series. There is, for example, the sense of entering a womb-like space, through curvilinear gates that represent the female reproductive system. The main path,

like a large unfurling fern frond, spirals in to the central fountain which in turn provides a shimmering, tactile and audible element in the garden.

The recurring idea of naming is a significant, often poignant, aspect of *Fern garden*, as shown in the granite tops of two facing seats inscribed with the names of Tamsin and Deuchar Davy, twins who died tragically in a light plane accident near Canberra. Friends of Tamsin and Deuchar made a significant bequest to the garden in their memory. Another bench is inscribed with the name of Koori artist Destiny Deacon, a friend of Hall's, who playfully requested her own 'Mrs Macquarie's Chair' in the garden.

Fern garden is in part a place of reconnection and remembering and, like so many great gardens around the world, it is a sanctuary for reflection. Since the garden was first established, the tree ferns have continued to develop. They will endure into the lives of future generations, reminding us of the regenerative capacities of the plant world to inform our lives: to deepen awareness, nourish our sensibilities and fill us with a sense of wonder.

Deborah Hart

Rick Amor b.1948

The call 1998–99
oil on canvas 152.0 x 183.0 cm
purchased 2000 2000.450

Is this heavy-set man making or receiving a call? Is he giving
or taking orders? His workplace seems empty and the view is
depressing, so do we feel sympathy?

As a young art student I half believed that, in offices and
government buildings around the world, implacable bureaucrats
sat and directed our lives. Of course this is only partly true and
came from my youthful reading of Kafka, Orwell and others.
Images from those formative years persist and occasionally
surface.

When planning and painting a work like this, I am preoccupied
with technical details like colour, composition and drawing. Only
later do I sometimes speculate about the meaning, which was
usually unconscious when I had the idea for the picture. The
reasons for choosing one subject over another are often rooted
in childhood. I want to understand or relive an experience, then
reconstruct it, both for myself and to communicate to others.

To return to the man in the office – things are not all that bleak,
for there is some weak sunshine coming through the window and
life goes on outside.

Rick Amor, 2002

Kevin Connor b.1932

Four figures, Stanley Street 1998
oil on canvas 198.0 x 283.0 cm
purchased with the assistance of the Breuer Family 2001 2001.172

In *Four figures, Stanley Street*, Kevin Connor focused on the
dynamics of a group of men sitting on a park bench. The figures
are physically close to each other and yet have no eye contact,
reflecting the way people in urban society can live within close
proximity to each other yet remain isolated. They are larger than
life in the way close-ups of characters appear 'larger than life' on
screen. They stare into space seeming to question – or ponder
about – the world and their existence in it.

Connor has painted many expressive figurative paintings
which have an immense power and intensity, and which convey
the humanity of his subjects. His drawings and sketchbook
studies are central to all he produces and form the departure
point from which his paintings emerge. He writes:

Drawing a lot around the city …
Out of drawing I paint gouaches on paper. With a bit of luck
 one or two of these are acceptable.
Start looking at a big canvas, 196 x 242 cm.
Go out and have coffee, read a bit, thinking.
Thinking, into fear. Thinking, into tiredness. Start.
Taking a good drawing or gouache, start drawing in charcoal
 on the canvas. A little thin paint.
Next day, a tentative overpaint. Sitting, looking, thinking,
 working.
Put it in the racks, hang on to it for a month or so.
Do a bit more work, then cut it up and bin it.
Some time on, one morning the angels sing.
I paint two large canvases in the day. One the next morning,
 too. All just right. (*Four figures, Stanley Street* is one
 of these.)

Kevin Connor (2002) and Anne Gray

Brook Andrew b.1970

Wiradjuri nation

Revolution 1999

screenprint, printed in colour, from four screens on paper

77.0 x 300.0 cm printed by Brook Andrew and Basil Hall assisted by Gilbert Herrada, Northern Editions

purchased through the Gordon Darling Australasian Print Fund 2001

2001.55

© Brook Andrew, 1999. Licensed by VISCOPY, 2002

Revolution is a work created in the early stages of my investigation of anthropological photography as a means to recirculate historical images of long forgotten, erased or amnesiac times. The subject of the portrait is identified as Cunningham, from Armadale, New South Wales, and is sourced from AIATSIS (Australian Institute of Aboriginal and Torres Strait Islander Studies), Canberra. Very few Indigenous artists choose to investigate anthropological material due to the sensitive nature of how and why the photos were taken. I believe, like many, that this recirculation is healthy for our cultural self-belief and in order to remember our ancestors. Indigenous artists' contemporary use and/or reference to this material is a way to grapple with, and participate in, a discourse which is silenced even within our own communities.

This image, presented as a poster, imitates popular cultural 'activism'. Still today, some of my work is relegated to 'political art'. In fact, some Indigenous artists' work is often relegated as such. Unfortunately for contemporary Australian identity, there is still some way to go in regard to acknowledging different views on life, art and cultural strategies other than that of the dominant lifestyle. Evidence of this type of invisible or almost amnesiac response is seen within the current Australian media and Australian government policies, and is a refusal to help heal some of the present pain within the lives of those people affected by the Aboriginal Protection Board, a creation of Australian policy.

How is 'freedom' judged within Australian popular culture today? Why the fear of discussion and action? Does hard cash lay it all on the line? For one lifestyle to thrive, must others be destroyed? *Revolution* is an artwork which reflects this Zeitgeist.

Brook Andrew, 2002

Julie Dowling b.1969

Budamia/Badamiya/Yamatji people

Her father's servant 1999

acrylic, red ochre and blood on canvas 100.0 x 120.0 cm

purchased 2000 2000.631

reproduced courtesy of Artplace

In *Her father's servant*, Julie Dowling has created a sinister atmosphere, the shadows cast by the candlelight conveying anything but gaiety. Instead, the viewer senses incest and slavery, as the central figure, Mary – the artist's great grandmother – stands emotionally alone and adrift, though surrounded by her 'family', including her father, the master of the house.

A member of the Budamia/Badamiya nation of the Yamatji people of the North-West region of Western Australia, Dowling's work draws on the traditions of oral history, and she has taken on the role of collating and documenting her family history in portraiture. A key element of her work is the portrayal of matrilineal members of her family.

Dowling has often stated the influence on her work of classical European painting in terms of perspective and light. The open door, windows and mirror hanging in the middle ground, combined with the sharp perspective of the table top and tray, allude to the Dutch school of painting in the manner of de Hooch and others.

On the back of the painting, the artist has written:

My great great grandfather's name was Edward Henry Oliver. The *Wudjula* [whitefella] wife was Amy Amelia Booth. Her half sister in the painting is Fanny, her half brother is called John. My great grandmother Mary 'Tuppance' Oliver was separated from her mother 'Melbin' and kept on as her father's servant until she was 16 years old and was taken to Kalgoorlie to work in Mining out-camps and bush motels. She was a cook. She cleaned and kept house for her father and his new wife Amy Amelia Booth until she got angry with Mary over her looking after her children one day and she was taken away.

I don't have any photos of Mary or 'little grannie' as my mum called her. So I wanted to 're-claim' this story for my family. My great grandmother was not considered an Australian 'under the act' until she married my *Wudjula* great-grandfather Francis Latham. When he divorced her in 1928 she lost all rights as a citizen and her children (my grandmother Mary [Molly] and her sister Dorothy) were taken away by their father to an orphanage instead of the government forcibly taking them to Mogumbar [mission] or Sister Kate's [children's home].

Julie Dowling (1999) and Brenda L. Croft

Rosemary Laing b.1959

flight research #6 1999

Type C colour photograph 70.0 x 141.0 cm

purchased 2001 2001.125

© Rosemary Laing, 1999. Licensed by VISCOPY, 2002

Rosemary Laing made her 'flight research' series in 1999 in the Blue Mountains near Sydney. The images from this series are disquieting in their tension, and also quite joyous – the bride is an image of fabulous freedom as she defies gravity. It was preceded by an earlier series concerned with aerospace, nature and technology. Here, a woman in a bridal gown appears to be in free fall above the landscape. In the series, for which Laing employed a stuntwoman, the bride rises, falls and floats. The image is not digitally manipulated. The viewer is asked to believe that a bride can go sailing into the clouds. When first exhibited, the wedding dress was also placed on the gallery floor, evidence perhaps that the bride had finally touched down. Laing's art is symbiotic in its melding of the sensuous, colourful world of three dimensions and the stringently conceptual and speculative world of philosophy, abstract concepts and meditation.

Laing's work reflects the omnipresence of technology in our lives and our way of interacting with it, the collision between nature and technology. Advances in technology have meant that time and space have ceased to exist in a manner that is meaningful to us in any traditional human-referenced sense. We are able to move in ways that do defy gravity and we accept this as normal. This image fulfils our fantasy of effortlessness, yet we know in the ordinary world of gravity and daily experience that we need to be wary of such seductive illusions of modern technology.

Anne O'Hehir

Louise Hearman b.1963

Untitled (739) 1999

oil on composition board 61.0 x 61.0 cm

purchased with the assistance of funds from the Moët & Chandon Australian Art Foundation 1999 99.165

Since she first began exhibiting in the 1980s, Louise Hearman has been creating images which are unsettling in their ambiguity and resistance to explanation. In *Untitled (739)*, a child sits alone in a forest clearing, a shaft of brilliant light catching the child's hair and grass beyond and intensifying the deep shadows of the surrounding trees. Hearman's dramatic use of light creates a mood of disquiet and unease by raising questions about the nature of this innocuous scene. Is it sunlight, or artificial night-time illumination? Is it hair standing up on the child's head, or are they faun-like horns? This instability of imagery, which shifts and changes with the light, challenges our own perceptions of reality and asks us to look more carefully at the world around us, and beyond the realm of appearances.

Hearman's interest in twilight and shadows, in the bizarre and fantastic, have precursors in the 18th-century Romantic movement and 19th-century fin-de-siècle Symbolism, Surrealism and film noir. Hearman's use of light emulates photography in that it fixes forever a transient moment. Paradoxically, this light does not illuminate her subjects, but renders them even more dark and mysterious.

Elena Taylor

John Mawurndjul b.1952

Kurulk clan/Kuninjku/Eastern Kunwinjku people
Mardayin at Mumeka 1999
natural pigments on eucalyptus bark 156.0 x 74.0 cm
purchased 1999 99.90
© John Mawurndjul, 1999. Licensed by VISCOPY, 2002

In *Mardayin at Mumeka*, John Mawurndjul provides a masterly example of his very particular and innovative development of Western Arnhem Land bark painting. The subject of the painting is linked to 'outside' or public representations of *Mardayin*, among the most sacred Indigenous ceremonies and now rarely performed in Arnhem Land. Mawurndjul grounds the ceremony at a particular place, Mumeka, a significant locality on the Mann River crossing on his Kurulk clan land. Mumeka today is a small outstation community; the last big *Mardayin* ceremony was performed near here by the Eastern Kuninjku speaking community in the late 1970s.

When Mawurndjul participated in this *Mardayin*, he was a young man in his early twenties, an apprentice artist, ritual novice and fine hunter. Now, some 25 years later, he has established his credentials as a senior law man and in the top echelon of bark painters; at times he is referred to, like his deceased relative Yirawala, as 'the Picasso of Arnhem Land'. It is this status that provides him with the authority to take an established art tradition onto a new plane, breaking out of a style that usually encapsulated meanings within representational borders of animals, reptiles, fish and mythological creatures, to more abstract forms within a rectangular border.

The *rarrk* (crosshatching) in this work is similar to the body paintings worn by creation ancestors and painted onto the chests of participants in *Mardayin*; the circles depict sacred pools in the ancestral landscape, as well as important sites on Kurulk land. Within the painting are broader geometric forms, stylised versions of sacred emblems from the ceremony. The exceptionally fine *rarrk* is distinctly Mawurndjul, proof, along with the subject matter, of his originality and authorship. Today, there is an emerging trend towards family collaboration among the most senior bark painters, owing not only to the work intensity of crosshatching but also in order to assist the passing of skills inter- and cross-generationally. At times, Mawurndjul works with his wife and daughter and a few panels in the lower left of *Mardayin at Mumeka* hint at such collaboration.

Jon Altman

William Robinson b.1936

Springbrook with lifting fog 1999
oil on linen 203.0 x 259.0 cm
purchased with funds from the Nerissa Johnson Bequest 1999 99.122

This painting came from one of my many walks to Goomoolahra and some of the surrounding bushland. It is a landscape based on knowledge of place, rather than specific description.

What I hope to give the viewers of this painting is the feeling that they are themselves surrounded by this light, gentle fog. If they are truly in the landscape, and not merely passers-by at a picture in a gallery, they should feel that there is a sensation of fog into which they have moved. They are then looking out of this mist to the light of the sea and sky to the left and front, to the sunlight filtering over the Tweed River to the right, and the clearing sunlit trees above and behind. I tried to reveal gentleness in the landscape, with trees emerging slowly and warmly in the sunlight. I have tried to find ways to include the viewer in the work – to live in the vision itself. In earlier paintings, where I was struggling with the composition and the construction, I did not always satisfactorily grasp the atmosphere to capture the viewer.

I worked particularly on the three-dimensional construction of the clouds and their relationship to sun and sea. This area provides a window for moving out of the forest into luminous space.

William Robinson, 2002

Peter Booth b.1940

Untitled 1999

oil on canvas 207.5 x 269.5 cm

purchased 2001 2001.173

Untitled is one of Peter Booth's most accomplished paintings, revealing the consistency of his underlying vision as well as his ability to find new ways of creating haunting landscapes of mind. The work is a clear demonstration that dark fears and insights can be expressed as powerfully in the whiteness of a bleak snow-covered landscape as in the descent into blackness.

In the 1970s, Booth worked predominantly with a dark palette, first in a more abstract way and later employing a range of apocalyptic figures and environments. As Jan Minchin wrote:

> In 1977 Booth's art became dramatically figurative. Private tensions, personal trauma and an eccentric imagination were the source for strange underworlds depicting the most aberrant human behaviour. With a dreadful immediacy and

a palette of violent reds and blacks, these works tell of private nightmares.[264]

Booth began his 'snow paintings' in 1989, while re-reading Shakespeare's *Macbeth* and contemplating the often tragic consequences of ambition and greed. The mood of *Untitled* is evoked by the restricted palette of predominant white and tones of grey, and the starkness of the partially enclosed, rocky environment with light falling snow. The world appears to have become eerily quiet, stripped of life, as indicated by bare bones discarded on the ground.

It is as though we are invited to enter an archaeological site of memory, a space for reflection and contemplation, where some primeval struggle has occurred. In tandem with the desolate, existential feel of this space, the lush, expressive painterly surface adds to a sense of the artist's profound and passionate response to recurring patterns of history and the human condition.

Deborah Hart

Aida Tomescu b.1955

Ithaca II 1999
oil on canvas 183.3 x 159.5 cm
purchased 2000 2000.16
© Aida Tomescu

Ithaca II has its origins in the religious imagery of Moldavian frescos in northern Romania. I revisited these churches in 1997 – a visit prompted mainly by an SBS film on the poet Paul Celan, which was partly shot in north Moldavia.

Ithaca II was the first, and paradoxically also the last, of the 1999 series of seven paintings (the result of my having scraped off and repainted the upper section of the canvas, after completing the rest of the series). My main concern throughout was to find a reality which I could not deny, an image with its own sense of coherence.

I kept returning to Celan as a way of discouraging a reliance on aesthetics. I needed to break through the surface illusion of paint and find an opening into the work. Painting has always been a gradual construction of something that exists independently of me, but with this series it seemed more as a slow progression towards a state of stillness. It was like painting something that I was not aware of seeing, but that I felt was there.

Despite the built-up surface of *Ithaca II*, texture is never my concern. The more fluid lower section of the canvas went through massive repainting and some of Celan's verses from *Crowned Out* are buried within the image.

As a sensation of watery green-greyness emerged, images came and went and a more subtle, unexpected presence surfaced in the work: a substance floating somewhere in this indeterminate space, independent of – and quite outside – the imagery I've been working with. A curious extra intention that I'm not responsible for, an intention by the painting itself.

Aida Tomescu, 2002

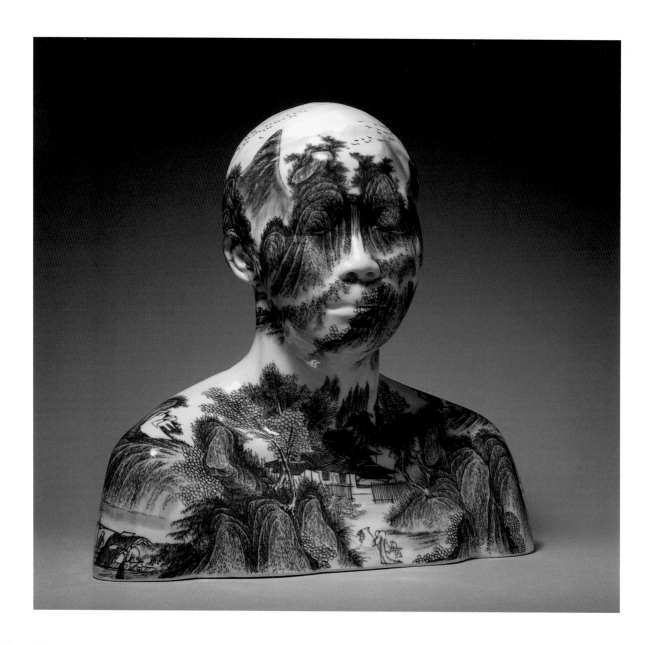

Ah Xian b.1960

China China bust 15 1999
cast porcelain, with handpainted underglaze decoration
34.8 x 36.6 x 20.0 cm
purchased 2000 2000.7

It is about a beautiful dream, it is about fancy and fantasy, and it is about human beings, the natural environment surrounding us and the civilisation we have evolved.

Other than our consciousness, we are part of nature but, as an unsolvable contradiction, it seems that the technologies we have been developing, especially in the past two centuries, are against nature and never affirm it. Did nature create our consciousness or did we, mankind, create I and WE out of it? It is one of the oldest philosophic propositions, like the chicken and the egg.

Landscape exists because we exist and vice versa. It is not just the environment reflecting on us, our surroundings and we humans grew out of each other.

It is a conscious adjustment, as I switch myself from the mainstream clamour-crowd and its followers to a solitary uncultivated field. Although this sounds like the Chinese saying, 'lifting oneself off the earth by one's own hair', it has been decisively and effectively reflected in my recent works. It is simply a conceptual attitude, which is directing my art creation.

Our ancestors have created and handed down to us a very wealthy culture and art heritage. I believe that the best place to apply (not just attach) all of such quintessential treasury heritage we possess is nowhere else but on human beings ourselves. This would be one of the dearest returns to both nature and art evolution that I could aim to achieve.

Ah Xian, 2002

Marcel Cousins b.1972

Boxes and screen 1999

woodblock, colour copy transfers and collograph on paper

63.0 x 90.0 cm

purchased through the Gordon Darling Australasian Print Fund 2000

2000.300

My method of production is archaeological in a sense. I am sifting through the visual traces (texts and images) of Japanese culture – things that are available at street level, on the surface and – reading back – tracing an origin or a prior story, to develop an insight into some of the mediated perceptions I have of Japanese life.

My primary interest in utilising printed media lies in their ability to question the idea of artworks as 'one-offs', as unique and irreplaceable. We now live in an age of mass reproduction, where original images can be duplicated with ease by digital printing and to the highest quality. Many of these reproductions are widely distributed in the form of books, posters, postcards, T-shirts, calendars, stamps and even tableware.

The reproducibility of original art must therefore have a degrading effect on 'originality' itself. In some cases, when the duplicate is the only reference, the 'mechanically reproduced original' becomes the original itself. So for most of us, the duplicate is reality as we know it. The work *Boxes and screen* is an exploration of the difference between an object and its representation, by changing scale, context and by introducing foreign materials, depicting what exists between a cultural reality and a cultural mythology. So, meaning is therefore a transient phenomenon that changes or keeps changing its meanings, rather than something that is fixed holding over time for a series of different audiences.

Marcel Cousins, 2002

Ricky Swallow b.1974

Rooftop shoot out with chimpanzee 1999

cardboard, wood, plastic model figures and portable record player

53.0 x 33.0 x 30.0 cm

gift of Peter Fay 2001 2001.160

Ricky Swallow draws upon a personal archive of experience swamped by American popular culture. His sources, from the original *Star Wars* to *Planet of the Apes*, are excavated from teenage memories or from video and late-night commercial television re-runs. His talents as a model maker are undeniable, whilst the stigma usually associated with this primarily adolescent hobby is deflected by the highly cerebral nature of his work, as well as the incisive critique of contemporary culture in his 'memories made plastic'.

Rooftop shoot out with chimpanzee was one of 20 works in the artist's installation *Even the odd orbit* 1998–99 in the 1999 Melbourne International Biennial. The shoot out is staged on a ten-storey, but half-metre tall, office block, the blank grey cardboard facade a replica of the building that housed the Biennial. An obsolete 1960s record turntable provides not only the mechanical but also the whimsical visual foundations of the work. Once activated, this low-tech kinetic contraption is reminiscent of an old-fashioned music box, the chimpanzee spinning like a prima ballerina on one foot, keeping a captive audience at bay.

The toy-like associations and diminutive scale of the architecture and cast of characters initially mitigates the sinister themes explored by the artist. The chimpanzee, the once celebrated subject of genetic experimentation, has now become a fugitive with a gun and nowhere to run. The viewer's own probing curiosity becomes a metaphor for the ever-watchful eye of Big Brother. In *Rooftop shoot out with chimpanzee*, Swallow has extrapolated from Hollywood cinema a model for a brave new world.

Steven Tonkin

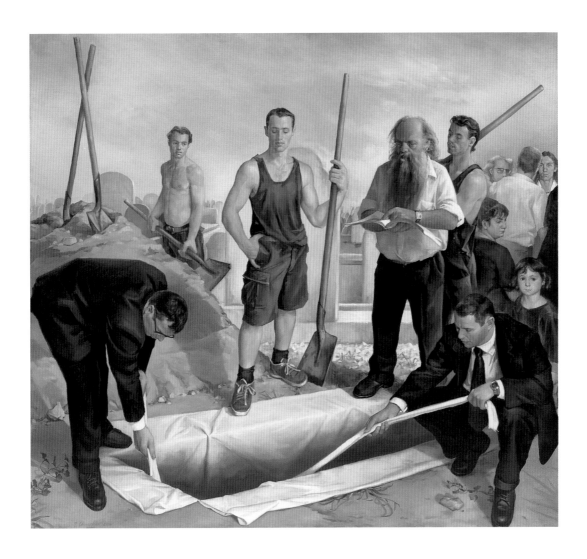

Peter Churcher b.1964

The burial 2000
oil on linen 212.0 x 235.0 cm
purchased 2000 2000.451

From the very outset I could only paint one way – directly from observation of the physical world around me. The figure, with all its humanistic and dramatic qualities, has always been a central concern of mine. As a figurative painter during the last years of the 20th century, I have been compelled to ignore modernist or 'contemporary' orthodoxies and redefine my own contemporary vision of painting by looking back to the tradition of the grand figure compositions of European painting which I have, somewhat brokenly, inherited.

From the earliest years in my painting career, I have undertaken the challenge of painting large-scale multi-figure compositions. Some of the inherent problems include: the problematic relationship between the narrative or 'story-telling' versus 'pure' painting concerns of composition and form; the technical problems of spatial relationships within the picture plane; and artifice versus realism.

My painting, *The burial,* marks for me a culmination of earlier forays into the large-scale figure composition. The starting point for this work was a personal reaction to two strongly divergent events witnessed from my own everyday world: the first, a newspaper photograph of a drive-by shooting in Wollongong; the second, my father-in-law's graveside funeral. As preliminary drawings took place, the composition quickly took on a life of its own – in no way could the picture simply be a recreation of these two events. It had to exist on its own as an 'abstract' human composition, yet, of course, still retaining narrative elements that evoked my original emotional response.

Visual elements drawn from the original two sources – the crossed shovels stuck in a pile of earth, the black-suited men against shirtless youths, the gathered huddle of observers, activity versus passive watching-by – all these became crystallised and interwoven to form the ambiguous human composition I came to call *The burial.*

Peter Churcher, 2002

Peter Atkins b.1963

Journal 1999 (Sydney, Auckland, Melbourne, Mexico City) 1999
found objects; 20 panels 30.0 x 30.0 cm (each)
purchased 2000 2000.134.A-T

Travel – the experience of other cultures and places – has been a
rich source of artistic inspiration for Peter Atkins. His most recent
works are in the form of a visual diary composed from items
collected during his travels, recalling the artist's physical,
emotional and intellectual responses to time and place.

These items are of the everyday and commonplace: plastic
tags used to tie bread bags and discarded by parents and children
feeding ducks in Centennial Park, bottle-tops from Mexico City,
and feathers, leaves and moss collected during a weekend in Eden.

Journal 1999 (Sydney, Auckland, Melbourne, Mexico City)
comprises 20 collaged panels. In each, Atkins has carefully
arranged his materials to create balanced and harmonious
compositions made up of repetitive structures. In so doing,
Atkins wittily transforms his prosaic raw materials into an
elegant poetry of the everyday.

While Atkins's *Journal 1999* is on the one hand an intimate
record of the artist's experiences, on the other it has a more
universal resonance. By creating structure and pattern, Atkins is
able to suggest the habitual and shared elements of human
activity. Similarly, the acts of selecting, discarding and arranging
elements to form the finished work echo the human compulsion
to create order and meaning out of experience.

Elena Taylor

Robert Boynes b.1942

Rendez-vous 2000
synthetic polymer paint on two canvases 120.0 x 230.0 cm (overall)
purchased 2002
2002.24.A-B

Dream-like, filmic possibilities inform Robert Boynes's paintings of urban environments. Since 1995, he has moved from depicting large overviews of cities to more close-up viewpoints incorporating figures in motion. His spaces are those of transit – crossings, walkways, escalators, stairways, subway stations – spaces that no individual owns, that everybody has a right to use. The works suggest open-ended scenarios of people coming and going, perhaps to or from a rendezvous. It is the implication of life beyond a particular 'frame' that is significant to Boynes:

> It is like [Jean-Luc] Godard's idea that what is important is what comes before and after the movie. It is the implication that this is just a slice of a continuing action ... I think this is one of the reasons I allow myself to work with moving figures – to create this implication that something has come before and something will happen after. The scene is a particular chink of the action that you look through – a privileged moment in a continuum.[265]

Rendez-vous is one of a number of works that Boynes undertook during a residency at Artspace in Sydney's bustling Woolloomooloo. To begin with, he photographed people in the city environment. He was not interested in the identity of individuals but rather in the idea of archetypal urban dwellers. After taking hundreds of photographs, which Boynes regards as sketchbook notations, he rigorously selected, edited and transformed the image – initially by scanning it into the computer, then relaying it onto a large silkscreen which he in turn manipulated in the painting process on canvas.

It is in the act of painting, of washing back and overlaying successive glazes, that Boynes attains a fugitive, mysterious aura and luminosity in his work. It is in paintings like *Rendez-vous*, of figures moving through urban spaces set alongside calligraphic neon signs, that he conveys his fragmentary 'fictional documentaries' of contemporary life to illuminate imagination.

Robert Boynes (2002) and Deborah Hart

Neil Roberts 1954–2002

Half ether, half dew mixed with sweat 2000
canvas, cotton, leather, glass, copper foil and metal
244.0 x 28.0 x 28.0 cm
purchased 2002 2002.25
© Neil Roberts, 2000. Licensed by VISCOPY, 2002

Half ether, half dew mixed with sweat is from a body of work about boxing. It is also about material memory: can substances record and transmit anything of their history through their materiality alone?

I wondered about the metaphysical visibility of all the force that had been applied to this punching bag in its time, and how such a trace might appear. The bag is an absorbent object, a kind of filter or pad that stands in for the body it resembles, and it required some form of extraction or distillation to make visible the substances imbedded within it. I found a 'formula' for that process in a line from a poem by the American artist and illustrator Raymond Pettibon: *half ether, half dew mixed with sweat.*

Like the gradual planetary transformation in J.G. Ballard's book *The Crystal World*, a crystalline carapace in copper-foil glasswork overtook the punching bag. To draw that structure, I looked to a tradition of window-making that epitomised the height of refinement: that by the famous early 20th-century American glassmaker, Louis Comfort Tiffany, whose work became synonymous in his time with good taste and class. His signature vocabulary of Arcadian wisteria and grapevines seemed to also be an evocation of crystalline growth.

The glass describes a new surface on the punching bag, one made visible from the energy and concentration applied to its canvas surface over years and years. I tried to produce a rarefied, dewy atmosphere that threw base substances like sweat and blood into sharp relief.

Neil Roberts, 2002[266]

'IMPOSSIBLE FLOWER' Helen Wright 2000

Helen Wright b.1956

Impossible flower 2000

digital print, printed in colour on paper 15.0 x 10.0 cm

purchased through the Gordon Darling Australasian Print Fund 2000

2000.297.1

My first inspiration for this suite of prints came from a newsworthy item about a triumph of genetic technology in the production of the sweetest, most luscious tomato. The 'perfect' tomato was produced by crossing a tomato gene with a salmon gene. The surreal, even absurd images that this genetic marriage inspired formed the basis for the prints in this box-set. Other influences have been Mary Shelley's Frankenstein and the great voyages of discovery which returned botanic booty to Europe during the Enlightenment and culminated in the Victorian 'rage for curiosity' and the spectacle of cabinets of curiosities.

Impossible flower is the first in a series of digital and traditional prints in this format under the title of 'The impossible'. My

interpretation of the 'impossible' is a slightly ironic one. Although the more grotesque and disturbing aspects of the impossible made possible do not appear in this suite of prints. In 1996, I produced a series of drawings called 'Impossible science' and, in 1998, I worked on a large commission at the Royal Botanic Gardens in Hobart entitled 'Nature observed'. These works inform this suite of prints. My intention in these works has been to deal with the interpretation of a Utopian nowhere place – a voyage of discovery and exploration to an imaginary continent through the use of computer technology. This is not unlike the great voyages of exploration which introduced new species through travel, trade and horticulture and marked the development of new varieties of hybrids and cultivars.

These are impossible flowers from a garden of earthly delights. Imaginative amalgams from a Golden Age. A wish fulfilment in its most positive sense.

Helen Wright, 2000[267]

Brian Hirst b.1956

Flat form – teal 2001
blown glass with gold, silver and copper foil 52.0 x 39.0 x 12.0 cm
purchased 2001 2001.46

Brian Hirst was born in Yallourn, Victoria and began working in glass in 1979. His sentinel-like vessels and panels are often made with reference to the forms of Cycladic sculpture and to the degraded iridescent surfaces that characterise classical antique Roman glass.

Manipulating blown glass vessels by flattening the form and introducing geometric bands and fields of intense colour, Hirst avoids direct historicism in his work and gives it a sense of modernity and a connection to the contemporary world of materials. This work is a development of this theme and reflects a parallel interest in the subtleties of Japanese *maki-e* ('sprinkled gold') lacquer, through the fleeting appearance of flecked gold leaf in the vase's inner surface, a form of decoration also seen in historic Venetian and contemporary Japanese glass. Hirst's articulation of gold and silver foil surfaces and his use of the blue-green teal, in almost opaque glass, also alludes to the historical use of glass in jewellery, where its brilliance and fluidity were used to suggest the arcane and the exotic. With a mastery of some of these more demanding techniques of glass, Hirst evokes its historical richness to underscore a contemporary language of form and colour.

Robert Bell

Tim Johnson b.1947

Generic painting 2000
synthetic polymer paint; five linen panels 152.0 x 380.0 cm (overall)
purchased 2001 2001.65.A-E

Tim Johnson, who has long been interested in cross-cultural ideas, considers *Generic painting* to be the culmination of a number of years working with Indigenous and Buddhist influences. He believes that his work is a way of using paint 'to document, to reflect and to create some form of narrative, referencing Modernism and Postmodernism and above all trying to represent the positive side of things'.

At the heart of Johnson's approach is meditative search and an in-depth interest in collaboration. In the 1980s, he often visited the Indigenous artists at Papunya in Central Australia where, after a time of familiarisation and establishing mutual trust, he was given permission to use dots and worked collaboratively with celebrated artists Clifford Possum Tjapaltjarri and Michael Nelson Tjakamarra.

As a practising Buddhist, he has also had various initiations, including the Kalachakra teachings from the Dalai Lama in 1996.

In the year 2000 he visited Mount Kasuga in Nara, Japan, where he was able to study Shinto and Buddhist art in detail. In *Generic painting*, across a shimmering field of tiny white dots and soft, glowing clouds of colour, Johnson has created a work that pays homage to his teachers and opens up a field of transcendent possibilities. As the artist notes:

> *Generic painting* draws on a variety of experiences and sources to create an illusory world where recognisable cultural signifiers (Buddhist imagery, Papunya dots, Shinto shrines, aliens and UFOs) combine to create a kind of generic space for the viewer. Each panel centres on a subject, the first being West Camp at Papunya in 1981, the next, the historical Buddha touching the earth, the next, Mt Meru the mythological centre of the universe, then the earth itself, then Mt Kasuga, a Shinto shrine in Japan. Interwoven with these themes are many other references and interconnections. Various landscape styles that include a contextualised use of dots and photographic and chance imagery are used to create a field of readable signs.[268]

Tim Johnson (2001) and Deborah Hart

Claudia Borella b.1971

Home journey #2 2001
fused, kiln-formed, carved and polished glass, metal stand
24.0 x 98.0 x 17.5 cm
purchased 2001 2001.43.A-B

Claudia Borella was born in Canberra and trained in glass at the Canberra School of Art. Her work is characterised by its precision and crisp geometrical form and decoration.

This elongated open bowl form, made of kiln-formed, red, black, blue and cream laminated glass, reflects Borella's industrial design background and the technical rigour developed while artist-in-residence at the American Bullseye Glass Company studio in Portland, Oregon in 1998. Its finely-balanced linear form and striking use of kiln-formed and laminated opaque glass is authoritative and confident, with a scale that brings to it an architectural presence. These qualities are enhanced through Borella's use of materials and colours, evoking the ebullience and visual drama of Italian design of the 1950s. Its interpretation in Australia symbolised post-war modernity and the influence of immigrant designers, and was expressed in the interior design of espresso bars, appliances and the colourful patterned laminates and plastics of kitchens and bathrooms of the period. These themes echo through Borella's exuberant forms, linking us to a fondly-remembered period in Australian design, yet celebrating the fluidity and precision that has made glass such a quintessential material in current design.

Robert Bell

Melinda Harper b.1965

Untitled 2001
oil on canvas 183.0 x 156.0 cm
purchased 2001 2001.138
reproduced courtesy of the artist and Anna Schwartz Gallery

One of the more powerful arguments in favour of abstract painting is that it presents us with opportunities to experience the act of looking in its purest form: our unexplained feelings of elation on seeing particular combinations of colour in the flow of daily life given a permanent form independent of the visual descriptions of objects. The rectangle and the planar line whilst in themselves the most neutral bearers of colour-cargo, through multiplication and in combination with each other, can generate a wide range of resonances. These are the elements of Harper's work. *Judith Pascal*[269]

My paintings are developed out of my own experiences of looking. They are concerned with colour and abstract form. They are a visual experience: colour, the tone of colour, its application, the form, is an act of involving a precision of thought and becomes a complex visual experience. The experience is as rich and complex in its own way as observing and being in the landscape. Abstract paintings are direct observations of life, they relate to the lived experience. The act of looking, the obvious, the precise and the precious.

purple/with light blue	smith street, collingwood
grey/yellow light grey / orange	northumberland street, collingwood
misty dark blue/ white/green	laughing waters, eltham
prussian blue/ultramarine blue	eltham

Nature/
Intersecting shapes/stripes of color, bands of color/shapes colliding into each other and through each other/agoraphobia/ discomfort/and a sense of balance.

Melinda Harper (2002)

John Young b.1956

Give and take 2001

digital scan and oil on two panels 210.0 x 264.0 cm (overall)
purchased with funds contributed by Sue Cato, Member of the
National Gallery of Australia Foundation Board 2001 2001.130.A-B

For the past decade, John Young has concentrated on a series
of paintings generically titled 'Double Ground'. *Give and take*
is from this body of work and sums up Young's concerns in
addressing issues of displacement and the plight of people in a
diaspora. Young comments:

Memories, sentiments of departure and severing from an old
culture, the denial and indifference to the loss, the anxiety
of an unknown new land, and the reality and hardship
on the new shore. Many of such memories are more than
often repressed, buried away in confusion, without the

perspicuousness of a psychic landscape which gives these
sentiments reasons or stories for their existence.[270]

In *Give and take*, Young merges memories and rites of passage in
open-ended ways to re-create this psychic landscape. The images
in the work are rich in historical and cultural references. They
include Chinese porcelain dolls, the Potola Palace in Lhasa, Tibet,
a stone archway of Yuan Ming Uyan (the Chinese Versailles),
and a male and female image in opposite corners of the painting.
The patterned background was drawn from a Tibetan tanka.
'It was my hope that some resonance or mood still remains from
the original tanka pattern.' In this way the artist creates a fiction
whereby the montaged forms in the foreground are brought into
relationship with the background, inviting the viewer to feel that
these diverse images have belonged with each other all along.

John Young (2002) and Deborah Hart

Christian Thompson b.1978

Bidjara people

Kangaroo and boomerang jumper 2002
machine knit jumper, variable dimensions
purchased 2002 2002.140

Untitled (Marcia Langton) 2002
pegasus print, 55.0 x 55.0 cm
purchased 2002 2002.141

Christian Thompson is a young Bidjara/German-Jewish-Australian artist/curator, born in South Australia, whose people are from regional Queensland, south-west of Brisbane. Relocating to Queensland in his early teens, he has been based in Melbourne since 1999, initially as an art student, more recently an artist with a number of solo exhibitions under his belt, and turning his hand to curating exhibitions of other Indigenous photomedia artists. Thompson has rapidly emerged as a force to be reckoned with in new media art and technology.

Kangaroo and boomerang jumper and *Untitled (Marcia Langton)* are both from *Blaks' Palace*, Thompson's solo exhibition held during 2002 Melbourne Fashion Week. Thompson is one of many young, emerging Indigenous artists who challenge our very understanding of Australian identity and what it means to 'be' Australian. By reappropriating kitsch imagery of bygone times and reinvesting them with his own stylised intent, he subverts the safety net of icons that non-Indigenous Australians think we all 'own' – in this case, iconic images of native fauna and Indigenous tools. The boomerang has been appropriated as a logo by national airlines, real estate companies and, most recently, the Sydney Olympic Committee for Organising the 2000 Games.

The jumper is modelled with complete confidence by renowned Indigenous academic and activist, Marcia Langton, whose heritage is shared by the artist. Machine-knitted by professional machinists, the jumper is made up of 98% polyester and 2% wool, in bilious colours, far removed from the brilliant palette of the Australian bush, which it purports to represent. The ridiculous sleeves can take on a myriad of meanings; they can be seen as constrictive, turning the item of clothing into a literal as well as a metaphorical straightjacket. The artist states:

Blaks' Palace[271] follows on from my previous work that challenges notions of Aboriginality manifested in an Anglo-Celtic or western artifice. This work speaks specifically of a particular era – the 1980s. However, the colours chosen for the jumpers reference powder pinks, sky blues and camel browns that so often decorate kitsch or tourist market objects referencing Indigenous people. I'm basically reinterpreting these 1980s items of clothing by making them in the residue of 1950s kitsch. The colours are very 1950s in terms of the Delft Blue, Australian pink and Camel. So, I'm also looking at the 1980s. People like me who grew up in the 1980s in regional Australia, well there was material like these jumpers being made – suggestive of Aboriginal culture but definitely not representative of what Aboriginal culture meant to Aboriginal people.

The title [*Blaks' Palace*] derives from my traditional country near Springsure in the Carnarvon Gorge [in Queensland]. Our traditional painting on the rock faces in the Gorge illustrates our [D]reaming and is a fertility site for women. Many blaks and whites in south-west Queensland call this place the Blaks' Palace, inferring that this site is of immense beauty – it is for me.

Christian Thompson (2002) and Brenda L. Croft

Notes

1 John Hawkesworth, *An Account of the Voyages Undertaken by the Order of His Present Majesty, for Making Discoveries in the Southern Hemisphere, and Successively Performed by Commodore Byron, Captain Wallis, Captain Carteret, and Captain Cook, in the Dolphin, the Swallow, and the Endeavour: Drawn up from the journals which were kept by the several commanders and from the papers of Joseph Banks, Esq.*, London: printed for W. Strahan and T. Cadell, 1773, vol.3 (Book 2), pp.561, 577.

2 Richard Neville, *Sotheby's Catalogue, Sale AU645, Willcox Collection*, Melbourne, 8 November 2000, Lot 4.

3 Thomas Pennant, *The Literary Life of the late Thomas Pennant Esq. by himself*, London: B. and J. White, 1793, p.25.

4 James Cook and James King, *A Voyage to the Pacific Ocean: Undertaken by the command of His Majesty, for making discoveries in the Northern Hemisphere ... performed under the direction of Captains Cook, Clerke, and Gore in his Majesty's ships the Resolution and Discovery: in the years 1776, 1777, 1778, 1779 and 1780*, London: printed by W. and A. Strahan for G. Nicol and T. Cadell, 1784, 3 vols.

5 Translation published in *Les Sauvages de la Mer Pacifique*, Canberra: National Gallery of Australia; Sydney: Art Gallery of New South Wales, 2000, p.32.

6 Compiled from Roger Butler, 'John Lewin: *Birds of New South Wales with their Natural History* (1813)' in *National Gallery of Australia: An introduction to the collection*, Canberra: National Gallery of Australia, 1998, p.2 and Andrew Sayers, *Drawing in Australia: Drawings, water-colours, pastels and collages from the 1770s to the 1980s*, Melbourne: Oxford University Press and National Gallery of Australia, 1989, p.28.

7 John Glover to George Augustus Robinson, Robinson papers, vol.37, p.430, Mitchell Library, State Library of New South Wales.

8 Daniel Thomas (ed.), *Creating Australia: 200 years of art 1788–1988*, Sydney: International Cultural Corporation of Australia, 1988, p.92.

9 ibid., p.92.

10 ibid.,p.93.

11 ibid., p.93.

12 Text edited from Daniel Thomas (ed.), *Creating Australia: 200 years of art 1788–1988*, Sydney: International Cultural Corporation of Australia, 1988, pp.92–93.

13 John Glover to George Augustus Robinson, Robinson papers, vol.37, p.430, Mitchell Library, State Library of New South Wales.

14 *John Glover: The Bath of Diana, Van Diemen's Land*, Sotheby's catalogue, Sotheby's Australia Pty Ltd, 17 April 1989, unpaginated (individual catalogue).

15 James Bonwick, *The Past of the Tasmanians*, Samson Low, Son & Marston, 1870, p.210.

16 *Hobart Town Courier*, 18 September 1835, p.3.

17 John Skinner Prout, 'The Sketcher in Tasmania', *Once a Week*, vol.6, 1 March 1862, Chapter 1, pp.275–80 (p.276).

18 *Genesis of a Gallery*, Canberra: Australian Government Publication Service for the Australian National Gallery, c.1976.

19 *South Australian Gazette & Colonial Register*, 3 November 1838, p.4.

20 Melbourne *Argus*, 4 December 1857, p.5.

21 Melbourne *Herald*, 4 February 1858, p.5.

22 *Illustrated Melbourne Post*, 18 April 1863, p.9.

23 *Eugène von Guérard's Australian Landscapes / A Series of 24 Tinted Lithographs illustrative of the most striking and picturesque features of the / Landscape scenery of Victoria, new South Wales, South Australia & Tasmania, / Drawn from Nature and Lithographed by the Artist, with Letter Press Description of each View / printed and published by / Hamel & Ferguson / Melbourne Victoria*, plate XIII [issued in six parts, 1866–68]. Also facsimile edition, Marjorie Tipping (introd.), Melbourne: Lansdowne Press, 1975, p.68.

24 ibid.

25 Tim Bonyhady, *The Colonial Earth*, Melbourne: Miegunyah Press, 2000, p.104.

26 Georg Neumayer, *Results of the Magnetic Survey of the Colony of Victoria Executed During the Years 1858–1864*, Mannheim: Schneider 1869, p.54 quoted in Tim Bonyhady, *Australian Colonial Paintings in the Australian National Gallery*, Canberra: Australian National Gallery, 1986, pp.40–1, (date mistakenly cited as 5 June 1862).

27 Text edited from James Gleeson, *Colonial Painters: 1788–1880*, Melbourne: Landsdowne, 1971; *Masterpieces of Australian Painting*, Melbourne: Lansdowne, 1969.

28 Thomas Carrington, 'Some Relics of an Australian Artist', Melbourne *Argus*, 5 June 1888, p.4.

29 John McPhee (ed.), *Australian Art in the Australian National Gallery*, Canberra: Australian National Gallery, 1988, p.15.

30 A.F. Bon, 'Barak, an Aboriginal Statesman', Melbourne *Argus*, 28 November 1931.

31 Ann Galbally, *Frederick McCubbin*, Richmond, Victoria: Hutchinson of Australia, 1981, p.56.

32 Tom Roberts, 'The Loan Collection of Victorian Artists', Melbourne *Argus*, 30 September 1893, p.14.

33 Andrew Sayers, *Aboriginal Artists of the Nineteenth Century*, Melbourne: Oxford University Press, 1994, p.51.

34 John Peter Russell to Tom Roberts, 24 September 1884, Tom Roberts (papers), State Library of New South Wales, ML MS A2479.

35 Charles Conder, letter to Tom Roberts in R.H. Croll (ed.), *Smike to Bulldog: Letters from Sir Arthur Streeton to Tom Roberts*, Sydney: Ure Smith, 1946, p.128.

36 *9 by 5: Exhibition of Impressions at Buxton's, Swanston Street, Melbourne, August 17 1889*, Melbourne: the artists, 1889, title page.

37 Mary Eagle, *The Oil Paintings of Arthur Streeton in the National Gallery of Australia*, Canberra: Australian National Gallery, 1994, p.5.

38 David Malouf, *The Conversations at Curlow Creek*, London: Chatto, 1996.

39 *Table Talk*, April 26 1889, p.5 quoted in Mary Eagle, op.cit., p.27.

40 ibid., p.43.

41 *Golden Summer, Eaglemont* sold in 1924 for 1,000 guineas, 1985 (AUD$1,075,000) and 1995 (AUD$3,500,000). Letter from *Golden Summer, Eaglemont* owner Bill Hughes to Betty Churcher, 2 February 1995 (National Gallery of Australia file), states: 'Congratulations on your persistence as that, along with your feminine charm, is what convinced me … to make the decision to sell'.

42 Mary Eagle, *The Oil Paintings of Arthur Streeton in the National Gallery of Australia*, Canberra: National Gallery of Australia, 1994, p.56.

43 Mary Eagle, *The Oil Paintings of E. Phillips Fox in the National Gallery of Australia*, Canberra: National Gallery of Australia, 1997, p.11.

44 London *Magazine of Art*, vol.17, 1894, p.70.

45 Translated from *Letters of Vincent van Gogh 1886–1890*, facsimile ed., 2 vols, London: Scolar Press, 1977.

46 Mary Eagle, *The Art of Rupert Bunny*, Canberra: Australian National Gallery, 1991, pp.22, 28–9.

47 Ernest Fysh, *Memoir of C. Douglas Richardson, Sculptor and Painter*, Melbourne: 1933, frontispiece.

48 William Rothenstein, *Men and Memories: Recollections 1872–1922*, 2nd ed., 2 vols, 1931–32, London, vol.1, 1934, p.73; cited in Ursula Hoff, *Charles Conder*, Melbourne: 1972, p.75.

49 cited in John Rothenstein, *The Life and Death of Conder*, London: Dent, 1938, pp.173–4.

50 Letter dated 24 October 1901, quoted in Patricia Fullerton, *Hugh Ramsay: His life and work*, Melbourne: Hudson, 1988, p.68.

51 Lucy Swanton, 'Memoir of Rupert Bunny', typescript, [Sydney]: Newcastle Region Art Gallery, 1968.

52 Melbourne *Argus*, 24 July 1911, p.7.

53 'Lamia' in London *Country Life*, 28 September 1907.

54 Mary Eagle, *The Art of Rupert Bunny*, Canberra: Australian National Gallery, 1991, p.64.

55 P.G. Konody, London *Observer*, 27 May 1910, p.7.

56 Blamire Young to Oscar Paul c.1923, National Library of Australia MS 1825: Dr Walter Paul, 101 letters from artists.

57 Julian Ashton, 'Blamire Young and his work', *Art in Australia*, series 1, no.3, 1917, [p.22].

58 Hans Heysen, letter to Lionel Lindsay, 3 February 1910, Lindsay Family (papers), La Trobe Australian Manuscripts Collection, State Library of Victoria, MS 9104.

59 Edited and amended from Bridget Whitelaw, *The Art of Frederick McCubbin*, Melbourne: National Gallery of Victoria, 1991, pp.108–9.

60 Florence Mary Taylor, 'Three Women of Merit, Being a Review of the Work of Rosa Langenegger, Florence Rodway and Marion Mahony Griffin', *Building*, 12 May 1914, pp.112a–m.

61 Grace Cossington Smith, letter to Mrs Cunningham, 10 August 1919, Letters to the Cunningham family, National Library of Australia.

62 Roland Wakelin, interview with Hazel de Berg, National Library of Australia Oral History Dept.

63 Roland Wakelin, 'Post-Impressionism in Sydney: Some personal recollections', *AGNSW Quarterly*, January 1962, p.91.

64 Mary Eagle, 'Roland Wakelin, The Fruitseller of Farm Cove', *Australian National Gallery Association News*, Spring 1983, pp.2–3.

65 *The Australian Worker*, 24 June 1931, p.1.

66 'Art To-day: Scathing criticism by director of art gallery', *Sydney Morning Herald*, 21 September 1929, p.16.

67 Margaret Preston, 'Wood-blocking as a Craft', *Art in Australia*, third series, no.34 (Oct–Nov 1930): pp.27–35 (p.27).

68 Lionel Lindsay, 'George Lambert – Our finest Australian master', *Art in Australia*, third series, no.36, 15 February 1931, pp.12–17 (p.16).

69 George Lambert, letter to Amy Lambert, 23 October 1921, Lambert Family (papers), State Library of New South Wales, ML MSS 97/10, p.359.

70 'A Unique Exhibition', *Advertiser*, 28 July 1924, p.10.

71 Roger Butler, submission to the Australian National Gallery Council re. purchase of *Flapper*, 8 March 1988, p.2.

72 John McPhee, *Australian Decorative Arts in the Australian National Gallery*, Canberra: Australian National Gallery, 1982, pp.60–61.

73 Illustrated in Daniel Thomas, *Grace Cossington Smith: A life, from drawings in the collection of the National Gallery of Australia*, Canberra: National Gallery of Australia, 1993, p.24.

74 ibid., p.27.

75 Stephen Coppel, *Linocuts of the Machine Age*, London: Scolar Press, 1995, p.66.

76 Stella Bowen, *Drawn from Life*, Maidstone, England: George Mann, 1974, p.192.

77 Helen Maxwell, 'Recent Aquisitions', *Australian National Gallery Association News*, January/February 1987, p.7.

78 Edited excerpts of lectures given by Sam Atyeo in Jennifer Phipps, *Atyeo*, Melbourne: Heide Park and Art Gallery, 1983, 32, 34–5, [32, 34].

79 Lloyd Rees, *Peaks and Valleys: An autobiography*, Sydney: Collins, 1988, pp.166, 189, 193.

80 John Brackenreg in conversation with Mary Eagle, October 1982.

81 Kenneth Macqueen, 'Adventure in Watercolour' in Kenneth Macqueen, *Adventure in Watercolour*, Sydney: Legend Press, 1948, p.8.

82 Kenneth Macqueen, 'An Explanation of Technique' in ibid., p.2.

83 Editorial, *Art in Australia*, third series, no.17, September 1926, p.2.

84 Adapted from Mary Eagle, National Gallery of Australia Acquisition Submission, 1995.

85 William Blake, 'And Did Those Feet' in *Milton, a Poem*, 1804, (line 8).

86 Roy de Maistre, Extract from lecture on 'Colour in Relation to Painting' in Gayfield Shaw, 'The Art Salon' *Colour in Art*, Sydney, 1919.

87 Edited text from John McPhee, *Australian Decorative Arts in the Australian National Gallery*, Canberra: Australian National Gallery, 1982, pp.78–79.

88 Gael Newton, 'The Sunbaker', in Jill White (ed.), *Dupain's Beaches*, Sydney: Chapter & Verse, 2000, pp.68–73; Max Dupain, *Max Dupain Photographs*, Sydney: Ure Smith, 1948, p.12.

89 Hendrik Kolenberg and Barry Pearce, *Francis Lymburner*, Sydney: Art Gallery of New South Wales, 1992, p.10 (introduction).

90 James Gleeson, *William Dobell*, London: Thames and Hudson, 1964, p.20.

91 Brian Adams, *Portrait of an Artist*, Melbourne: Hutchinson, 1983, p.78.

92 Eleonore Lange, *Exhibition 1, Paintings and Sculptures*, David Jones' Exhibition Galleries, 17 August–2 September 1939 (foreword to exhibition catalogue).

93 Elise Blumann quoted in Anne Gray, 'Elise Blumann', *Art and Australia*, vol.16, no.4, June 1979, pp.369–71 (p.369).

94 Helen Ennis, *Olive Cotton: Photographer*, Canberra: National Library of Australia, 1995, reprinted 1996, p.54.

95 ibid.

96 Olive Cotton interview with Diana Rich, 11 May 1988, National Library of Australia, ORAL TRC 2413.

97 Margaret Preston, 'The Orientation of Art in the Post-War Pacific', Sydney: Society of Artists, 1942, p.7–9.

98 Roger Butler, *The Prints of Margaret Preston*, Canberra: Australian National Gallery, 1987, p.46.

99 Margaret Preston, op.cit., p.9.

100 Margaret Preston (notes for a lecture), inscribed in a notebook, a photocopy of which is included in the Margaret Preston Papers, Art Gallery of New South Wales.

101 Lin Yutang, *The Chinese Theory of Art*, London: Panther Art, 1969, p.156.

102 Traudi Allen, *John Perceval*, Melbourne: Melbourne University Press, 1992, p.58

103 James Mollison and Nicholas Bonham, *Albert Tucker*, Melbourne: Macmillan, 1982, pp.37–38.

104 Robert Tonkinson, *The Mardu Aborigines*, 2nd ed., Fort Worth: Holt, Rinehart & Winston, 1991, p.123.

105 Wally Caruana, notes for National Gallery of Australia, 2002.

106 Ola Cohn, 'My Interpretation of Sculpture', H.Tatlock Miller, (ed.), *Manuscripts: The book nook miscellany*, Geelong, no.1, [November] 1931, pp.15–17 (p.16).

107 *Sydney Morning Herald*, 23 January 1948, p.2.

108 Russell Drysdale, *Catalogue of an Exhibition of Paintings and Drawings by Russell Drysdale*, Leicester Galleries, London: 1965, p.[5].

109 Robert Klippel, letter to Jack Giles, January 1947.

110 James Gleeson, *Robert Klippel*, Sydney: Bay Books, 1983, p.23.

111 Sidney Nolan quoted in Kenneth Clark et al, *Sidney Nolan*, London: Thames and Hudson, 1961, p.30.

112 Sidney Nolan, 'The "Kelly" paintings by Sidney Nolan' in *The Australian Artist,* vol.1, pt.4, July 1948, p.20.

113 Cynthia Nolan, *A Bride for St Thomas,* quoted in M.E. McGuire, *All Things Opposite: Essays on Australian Art,* Prahran: Champion, 1995, p.23.

114 Albert Tucker, in conversation with James Mollison and Nicholas Bonham in James Mollison and Nicholas Bonham, *Albert Tucker,* Melbourne: Macmillan, 1982, p.42.

115 Sali Herman, quoted in the *Bulletin,* 20 December 1948.

116 Sali Herman, quoted in 'New Art and Old Sydney', *Nation,* 8 November 1958.

117 Sali Herman, interveiw with Hazel de Berg, 3 November 1965, Hazel de Berg Collection, National Library of Australia.

118 Maisie Drysdale, letter to Felicity St John Moore dated 27 July 1991, quoted in Felicity St John Moore, *Classical Modernism: The George Bell circle,* Melbourne: National Gallery of Victoria, 1992, p.124.

119 Mary Eagle, *Peter Purves Smith: A painter in peace and war,* Sydney: The Beagle Press, 2000, p.168.

120 Janet Hawley, *Encounters with Australian Artists,* St Lucia, Queensland: University of Queensland Press, 1993, pp.94–96.

121 James Gleeson, *The Drawings of William Dobell in the Australian National Gallery,* Canberra: Australian National Gallery, 1992, p.54.

122 Tim Fisher, 'Horace Trennery', *Australian National Gallery Association News,* January/February 1987, p.5.

123 Guy Grey-Smith, interview with Hazel de Berg, 29 May 1965, Hazel de Berg Collection, National Library of Australia, ORAL DeB97, (transcript of sound recording, p.4).

124 David Strachan, interview with Hazel de Berg, 1962, Hazel de Berg Collection, National Library of Australia.

125 Jean Bellette, quoted in Ursula Hoff, 'The Art of Jean Bellette', *Meanjin,* no.51, summer 1952, pp.358–66 (p.359).

126 Jean Bellette, 'Piero della Francesca 1416–1492', *Art in Australia,* 1 March 1942, pp.28–36 (p.36).

127 Lloyd Rees, interview with James Gleeson, 18 August 1978, National Gallery of Australia (transcript p.26).

128 ibid.(transcript p.27).

129 ibid.

130 Sidney Nolan, letter to Geoffrey Dutton quoted in Geoffrey Dutton, 'Sidney Nolan's Burke and Wills Series', *Art and Australia,* vol.5, no.2, September 1967, pp.455–59 (p.459).

131 Herbert Badham, *A Study of Australian Art,* Sydney: Currawong Publishing Co., 1949, p.146.

132 See discussions in John Reed, 'A Statement on Bob Dickerson: Painter', *Ern Malley's Journal,* vol.2, no.2, November 1955, pp.15–17; John Hetherington, 'Robert Dickerson: Life-class (with a difference)' in *Australian Painters: Forty profiles,* Melbourne: F.W. Cheshire, 1963, pp. 211–216. In the past, this work was also known as *A Straight left by Griffo.*

133 M.M. Bakhtin, *The Dialogic Imagination,* Austin: University of Texas Press, 1981.

134 Banjo Patterson, *Clancy of the Overflow,* line 15.

135 John Olsen, *Drawn from Life,* Sydney: Duffy and Snellgrove, 1997, p.7.

136 John Olsen, interview with James Gleeson, Australian National Gallery, 9 April 1979 (transcript p.1).

137 Mark Strizic and Terence Lane, *Schulim Krimper: Cabinet-maker,* Melbourne: Gryphon Books, 1987, p.26.

138 Janine Burke (ed.), *Dear Sun: The letters of Joy Hester and Sunday Reed,* Melbourne: Heinemann Australia, 1995, p.103.

139 James Gleeson, 'Seeking Refuge in Sculpture', *Sun* (Sydney), 10 April 1957, p.36.

140 Grazia Gunn, *Arthur Boyd: Seven persistent images,* Canberra: Australian National Gallery, 1985, p.56.

141 Arthur Boyd, *7.30 Report* ABC TV, January 1995, quoted in *Arthur Boyd: Brides, myths and landscapes,* Sydney: Savill Galleries, 23 March to 29 April 1995 (exhibition catalogue).

142 Yvonne Audette, quoted in S. McCulloch-Uehlin, 'Abstraction's Forgotten Generation', *Australian,* 23 April 1999, p.9.

143 Vincent Buckley, *Leonard French: The Campion Paintings,* Melbourne: Grayflower Publications, 1962, p.86.

144 Colin Lanceley in conversation with William Wright, *Colin Lanceley,* Sydney: Craftsman House, 1987, p.8.

145 Geoffrey Dutton, *The Innovators: The Sydney alternatives in the rise of modern art, literature and ideas,* Melbourne: Macmillan, 1986, p. 219.

146 Stanislaus Rapotec, quoted in Laurie Thomas, *The Most Noble Art of Them All: The selected writings of Laurie Thomas,* Brisbane: University of Queensland Press, 1976, p.155.

147 *The Antipodean Manifesto* printed in full in Steve Tonkin and Deborah Clark, *The Antipodeans: Challenge and response in Australian art 1955–1965,* Canberra: National Gallery of Australia, 1999, pp.42–43.

148 ibid.

149 Henry Salkauskas, interview with Hazel de Berg, 1962, Hazel de Berg Collection, National Library of Australia, (transcript of sound recording, [p.3]).

150 'John Olsen's Picture of the Week', unidentified Sydney newspaper, 1961, quoted in [Charles Nodrum], *Peter Upward: The subject of art,* Melbourne: Charles Nodrum Gallery, 7 March 2000 (exhibition catalogue).

151 James Gleeson, 'Painting in Australia Since 1945', *Art and Australia,* vol.1, no.1, May 1963, pp.2–19 (reprinted, 21st Anniversary issue, vol. 21, no.1, spring 1983, p.48).

152 Irene Buschtedt, 'Home from London – with Tropical Touch', unidentified Sydney newspaper 1972, quoted in *Peter Upward,* exhibition catalogue, University of New South Wales Union, 23 May–1 June 1973.

153 Daniel Thomas, *Grace Cossington Smith,* Sydney: Art Gallery of New South Wales, 1973, p.6 (exhibition catalogue); from a 1971 questionnaire for a proposed education book.

154 ibid., p.8.

155 Daniel Thomas, *Grace Cossington Smith: A life: From drawings in the collection of the National Gallery of Australia,* Canberra: National Gallery of Australia, 1993, p.10.

156 ibid., p.29.

157 Bruce James, *Grace Cossington Smith,* Sydney: Craftsman House, 1990, p.67; transcribed 1924 from Beatrice Irwin, The New Science of Colour, London: William Rider & Sons, 1918.

158 Bethia Foott, *Ethel and the Governors' General: A biography of Ethel Anderson (1883–1958) and Brigadier-General A. T. Anderson (1868–1949),* Sydney: Rainforest Publishing, 1992, p.129–30; this first meeting was March 1925.

159 Thomas 1973, p.6; from tape-recorded interview 16 August 1965 with Hazel de Berg, Canberra: National Library of Australia, transcript p.2.

160 ibid., p.7.

161 Foott, p. 130.

162 Ian Fairweather in Nourma Abbott-Smith, *Ian Fairweather: Profile of a painter,* Brisbane: University of Queensland Press, 1978, p.63.

163 ibid., p.49.

164 Ian Fairweather, letter to Jim Ede, Shanghai 24 May 1931 in ibid., p.44.

165 Ian Fairweather in ibid., p.130.

166 ibid., p.144.

167 The phrase 'geometry of fear' was used to describe the post-war British sculpture exhibited in the British Pavilion at the XXVI Venice Biennale in 1952. See Herbert Read, 'New Aspects of British Sculpture' in *Exhibition of Works by Sutherland, Wadsworth, Adams, Armitage, Butler, Chadwick, Clarke, Meadows, Moore, Paolozzi, Turnbull,* London: British Council, 1952.

168 John Olsen 2000, letter sent to National Gallery of Australia.

169 Comments by John Olsen, 2 November 1986 in Barry Pearce, 'Direction 1' in *Art and Australia*, vol.24, no.4, 1987, pp.497–504 (p.503).

170 John Olsen in *Contemporary Australian Paintings: Pacific Loans Exhibition on board Orient Line S.S. Orcades*, Sydney: Orient Line, 1956, p.[17].

171 John Olsen journal, 1958 (as cited in Deborah Hart, *John Olsen*, Sydney: Craftsman House, 2000).

172 ibid.

173 John Olsen, *Salute to Five Bells: John Olsen's Opera House Journal*, Angus and Robertson, Sydney, 1973, [pp.1–4, p.3]

174 John Olsen in Deborah Hart, *John Olsen*, Sydney: Craftsman House, 2000, p.50.

175 John Olsen, *Salute to Five Bells: John Olsen's Opera House Journal*, Angus and Robertson, Sydney, 1973, [p.47].

176 Melbourne *Age*, 16 June 1965.

177 Sheryn George, 'Visions Splendid', *Australian Magazine*, April 25–26 1998, p.57.

178 Janet Hawley, *Encounters with Australian Artists*, St Lucia, Queensland: University of Queensland Press, 1993, p.37.

179 Sandra McGrath, *Brett Whiteley*, Sydney: publisher, 1979, p.78–9.

180 Hawley, op.cit., p.41.

181 ibid.

182 Michael Johnson, interview by Terence Maloon, in *Michael Johnson: Paintings 1968–1988*, Sydney: Art Gallery of New South Wales, 1988.

183 Adapted from Michael Desmond and Christine Dixon, *1968*, Canberra: National Gallery of Australia, 1995, pp.53, 55.

184 Atlantis Water Management web site at www.atlantiscorp.com.au/applications/wall_drainage.html.

185 Margaret Plant, *Dale Hickey: A retrospective exhibition*, Ballarat: City of Ballarat Fine Art Gallery, 1988, pp.1–2.

186 Fred Williams diaries, 11 May 1969.

187 Fred Williams, talking to James Gleeson, Melbourne, 3 October 1978, National Gallery of Australia Library, tape recording.

188 James Mollison, *A Singular Vision: The art of Fred Williams*, Canberra: Australian National Gallery, 1989, p.139.

189 Fred Williams, interview with Hazel de Berg, 8 December 1965, National Library of Australia, tape 155.

190 Neville Weston, *Lawrence Daws*, Sydney: Reed, 1982, p.99.

191 Elwyn Lynn, quoted in *Elwyn Lynn and Carl Plate*, Melbourne: Museum of Modern Art of Australia, 1960.

192 Elwyn Lynn and Sidney Nolan, *Sidney Nolan – Australia*, Sydney: Bay Books, 1979, p.12.

193 Sasha Grishin, *The Art of John Brack*, Melbourne: Oxford University Press, vol.1, 1990, p.115.

194 John Firth-Smith, correspondence with Gavin Wilson, 25 March 1999 in Gavin Wilson, *John Firth-Smith: A voyage that never ends*, Sydney: Craftsman House, 2000, p.74.

195 ibid.

196 John Firth-Smith, 2002, from notes in the early 1970s.

197 Daniel Thomas, notes, National Gallery of Australia, 1993.

198 *Sydney Morning Herald*, 28 August 1975.

199 ibid.

200 Memory Jockisch Holloway in 'Venus in Sackcloth: Eroticism and ritual in the work of George Baldessin' in Robert Lindsay and Memory Jockisch Holloway, *George Baldessin: Sculpture and etchings*, Melbourne: National Gallery of Victoria, 1983, p.25.

201 From Ken Whisson, 'Talk 1994: Technique and intuition' in *Ken Whisson: Paintings 1947–1999*, Melbourne: Niagara Publishing, 2001, pp.141–44.

202 Fred Williams's diaries, 27–28 March 1974.

203 Gunter Christmann, 'The Medium, the Message and the Marketplace', *Aspect*, vol.1, 1975, pp.9–12 (p.12).

204 Edited text from John McPhee, *Australian Art in the Collection of the Australian National Gallery*, Canberra: Australian National Gallery, 1988, p.54

205 Letter from Roger Scott to the National Gallery of Australia, 2002.

206 William Delafield Cook, interview for the William Delafield Cook video, Brisbane: Queensland Art Gallery, 1987 in Deborah Hart, *William Delafield Cook*, Sydney: Craftsman House, 1998, p.156.

207 Jeffrey Smart in Sandra McGrath, 'Jeffrey Smart', *Art International*, Jan–Feb 1977, pp.17–19, 25 (p.17) quoted in John McDonald, *Jeffrey Smart: Paintings of the 70s and 80s*, Roseville: Craftsman House, 1990, p.34.

208 ibid., p.23.

209 James Gleeson, *Modern Painters 1931–1970*, Melbourne: Lansdowne Press, 1971, p.98.

210 Sandra McGrath in the *Australian*, 23 November 1976, p.10.

211 Quoted in *Jeffrey Smart: Drawings and studies 1942–2001*, Sydney: Australian Galleries, 2001, p.32.

212 Edmund Capon, *Jeffrey Smart Retrospective*, Sydney: Art Gallery of New South Wales, 1999, p.2.

213 Jeffrey Smart in ibid.

214 Jeffrey Smart in Peter Quartermaine, *Jeffrey Smart*, Melbourne: Gryphon Books, 1983, p. 89.

215 Margaret Olley, interview with Hazel de Berg, 8 October 1963, Hazel de Berg Collection, National Library of Australia (transcript 101, p.1–2).

216 Brett Whiteley, 'Notes and thoughts taken at random from the artist's notebooks', in Sandra McGrath, *Brett Whiteley*, Sydney: Bay Books, 1979, pp.214–19 (p.216).

217 McGrath, ibid., p.168.

218 Julie Robinson, *Ann Newmarch: The personal is political*, Adelaide: Art Gallery of South Australia, 1997, p.14.

219 Bert Flugelman, private interview, Adelaide, 29 June 1974 quoted in Ian North, 'Bert Flugelman, from Heroism to Reflection', *Bulletin of the Art Gallery of South Australia*, vol.36, 1978, pp.2–15 (p.6).

220 North, ibid., p.9.

221 Rosalie Gascoigne, quoted in Vici MacDonald, *Rosalie Gascoigne*, Sydney: Regaro Pty Ltd, 1998, p.47.

222 Rosalie Gascoigne interviewed by James Mollison and Steven Heath in *Rosalie Gascoigne: Material as landscape*, catalogue for an exhibition curated by Deborah Edwards, Sydney: Art Gallery of New South Wales, 14 November–11 January 1998, p.7.

223 Jill Orr, artist's statement in *Act 3: Ten Australian performance artists*, Canberra: Canberra School of Art, 1982.

224 Sandra Taylor, quoted in Grace Cochrane, *The Crafts Movement in Australia: A history*, Sydney: University of New South Wales Press, 1992, plate 12.

225 Raymond Arnold, 'Notes to *Imaginary landscape*' sent to Roger Butler, National Gallery of Australia, 20 July 1992.

226 René Daumal, *Mount Analogue: A novel of symbolically authentic non-Euclidean adventures in mountain climbing*, Boston: Shambhala, 1992, p.8–9.

227 Edited text from *Through a Glass Darkly*, Sydney: Art Gallery of New South Wales, 1995.

228 Julie Ewington in *My Head is a Map: A decade of Australian prints*, Canberra: National Gallery of Australia, 1992, p.14.

229 David Larwill in 'The Expressionist: David Larwill talks to Tiriel Mora', *Follow Me Gentlemen*, May 1985, pp.119–22 (p.122).

230 Vera Zulumovski, January 1992 in Roger Butler, *My Head is a Map: A decade of Australian prints*, Canberra: Australian National Gallery, 1992, p.44.

231 Bea Maddock quoted in Anne Kirker and Roger Butler, *Being and Nothingness: Bea Maddock*, 1992, Canberra: National Gallery of Australia, 1992, p.105.

232 Roger Butler, ibid., p.33.

233 Terry Smith, 'The Rest of the World is Already Here', *Times on Sunday*, 6 September 1987.

234 Tracey Moffatt in *Tracey Moffatt: Fever Pitch*, Sydney: Piper Press, 1995 p.5.

235 ibid., p.6.

236 Wally Caruana, *National Gallery of Australia: An introduction to the collection*, Canberra: National Gallery of Australia, 1998, p.34.

237 Trevor Smith, *Robert MacPherson*, Perth: Art Gallery of Western Australia, 2001 (exhibition book), p. 71 quotes this poem by Basho.

238 Daniel Thomas, 'Everybody Sing: The art of Robert MacPherson', *Art and Australia*, vol. 33, no.4, winter 1996, p.494.

239 Smith, op.cit., p.119, 'MacPherson's *White Angel… A primer*', also published in Mary Eagle (curator), *Virtual Reality*, Canberra: National Gallery of Australia, 1994, p.26 (in both places with different punctuation from that given here and confirmed by the artist).

240 Smith, op.cit., p.153, reproduces a detail of the billycart labels, and reproduces the billycart piece. Ingrid Periz, *Robert MacPherson: The described the undescribed*, Sydney: Art Gallery of New South Wales, 1994 (exhibition catalogue), reproduces the labels detail and, pp. 38–39, all three works of the trilogy.

241 Thomas, op.cit., p.487.

242 Smith, op.cit., pp.133–34; Thomas, p.486, referring to René Block and Dan Cameron.

243 Variations of the wisecrack were heard by the present writer in New York in 1966, sometimes attributed to Barnett Newman, and can be found in the literature of Abstract Expressionism as 'Art history [or Aesthetics] is for artists as ornithology for the birds'.

244 Narelle Jubelin, letter to Darryl Collins, Australian National Gallery, February 1988.

245 Fiona Hall interviewed by Deborah Hart in 'Fertile ineractions: Fiona Hall's garden', *Art and Australia*, Sydney: Fine Arts Press Pty Ltd, vol.36, no.2, 1998, pp.202–11 (p.206).

246 ibid., p.206.

247 Edited from *Prints by Mike Parr*, Canberra: Gordon Darling Australasian Print Fund for the Australian National Gallery, 1990, [p.4].

248 Robert Klippel, quoted in James Gleeson, *Robert Klippel*, Sydney: Bay Books, p.49.

249 James Gleeson, ibid., p.228.

250 *An Introduction to the Collection*, Canberra: National Gallery of Australia, 1998, p.19.

251 Rover Thomas speaking in 1992. Recorded by Mary Macha, transcribed by Kim Akerman.

252 Dick Watkins, interview with Grazia Gunn, 30 May 1981, quoted in Grazia Gunn, 'Dick Watkins', *Art and Australia*, vol.21, no.2, 1983, pp.210–16 (pp.210–11).

253 Gordon Bennett, artist's statement given to the National Gallery of Australia, 1994.

254 Interview recorded and transcribed by Jenny Green, 'The Enigma of Emily Kngwarray', *World of Dreamings*, at: www.nga.gov.au/Dreaming/ Index.cfm?Refrnc

255 Brad Webb in *Oxford Companion to Aboriginal and Torres Strait Islander Art*, Melbourne: Oxford University Press, 2000, p.687.

256 Michael Riley in Avril Quaill, *Marking our Times: Selected works of art from the Aboriginal and Torres Strait Islander Collection at the National Gallery of Australia*, Canberra: National Gallery of Australia, 1996, p.66.

257 Michael Riley, telephone conversation with Brenda L. Croft, 2002.

258 Rosalie Gascoigne, interview with Stephen Feneley, ABC *Express*, 4 December 1997 (transcribed at: www.abc.net.au/express/ stories/rose.htm).

259 Howard Taylor, interview with Ted Snell, 16 May 1993, in Ted Snell, *Howard Taylor: Forest figure*, Fremantle: Fremantle Arts Centre Press, 1995, p.101.

260 Kitty Kantilla, quoted in *The Third National Aboriginal and Torres Strait Islander Heritage Art Award: The art of place*, Canberra: Australian Heritage Commission, 1996, p.20.

261 Alick Tipoti, in Roger Butler (ed.), *Islands in the Sun: Prints by Indigenous artists of Australia and the Australasian region*, Canberra: National Gallery of Australia, 2001, pp.33, 36.

262 Lola Greeno in *Keeping Culture: Aboriginal art to keeping places and cultural centres*, Canberra: National Gallery of Australia, 2000, p.9.

263 Anne Ferran, quoted in Geoffrey Batchen 'History Remains: The photographs of Anne Ferran', *Art on Paper*, vol.4, no.3, January/February 2000, pp.46–50 (p.50).

264 Jan Minchin, 'Peter Booth' in *From the Southern Cross, A View of World Art c.1940–1988, Australian Biennale 1988*, Sydney: The Australian Broadcasting Corporation and The Biennale of Sydney, 1988, p.82.

265 Robert Boynes interview with Deborah Hart, 5 February 2002.

266 This statement was submitted to the National Gallery on 28 February 2002, three weeks before Neil Roberts's tragic death.

267 Helen Wright, text accompanying *Impossible Flower*, boxed set of 10 digital prints, Hobart: 2000.

268 Tim Johnson letter to Deborah Hart 2001.

269 Judith Pascal, in *Melinda Harper*, Brisbane: David Pestorius Gallery, 1994 [p.4] (exhibition catalogue).

270 John Young, notes on the painting, National Gallery of Australia file 01/0330 f3.

271 A term originally coined in the late 1980s by Indigenous artist Destiny Deacon.

Select Bibliography

Books published by the National Gallery of Australia appear in bold type.

Abbott-Smith, Nourma. *Ian Fairweather.* Brisbane: University of Queensland Press, 1978.

Adams, Brian. *Portrait of an Artist: A biography of William Dobell.* Melbourne: Hutchinson, 1983.

Adams, Brian. *Sidney Nolan: Such is life.* Melbourne: Hutchinson, 1987.

Adams, Bruce. *Ralph Balson: A retrospective.* Melbourne: Heide Park and Art Gallery, 1989.

Alexander, Catherine. *Ambrose McCarthy Patterson (1877–1966): His early years and the development of his art and career (1877–1917).* Melbourne: Monash University, 1991 (unpublished thesis).

Allen, Christopher. *Art in Australia: From colonization to postmodernism.* London: Thames and Hudson, c.1997.

Allen, Christopher. 'The Lonely but Familiar Places of Clarice Beckett', *Art Monthly Australia,* no.120, June 1999.

Allen, Traudi. *Clifton Pugh: Patterns of a lifetime.* Melbourne: Thomas Nelson, 1981.

Allen, Traudi. *John Perceval.* Melbourne: Melbourne University Press, 1992.

Amadio, Nadine. *John Coburn: Paintings.* Sydney: Craftsman House, 1988.

Anderson, Patricia. *Contemporary Jewellery in Australia and New Zealand.* Singapore: Craftsman House, 1998.

Anderson, Patricia. *Contemporary Jewellery: The Australian experience 1977–1987.* Sydney: Millennium, 1988.

Ashton, Julian. *Now Came Still Evening On.* Sydney: Angus and Robertson, 1941.

Astbury, Leigh. *Sunlight and Shadow: Australian impressionist painting 1880–1900.* Sydney: Bay Books, 1989.

Bail, Murray. *Ian Fairweather.* Sydney: Bay Books, 1981.

Bail, Murray et al. *Fairweather.* Brisbane: Queensland Art Gallery, 1994.

Bakhtin, M.M. *The Dialogic Imagination: Four essays.* Austin: University of Texas Press, 1981.

Bauer, Frank. *Frank Bauer.* Adelaide: Frank Bauer, 2000.

Bell, Robert. 'Designing the Australian Experience' in John McDonald, *Federation: Australian art and society 1901–2001.* Canberra: National Gallery of Australia, 2000.

Bell, Robert. *Material Culture: Aspects of contemporary Australian craft and design.* Canberra: National Gallery of Australia, 2002.

Bell, Robert. *Nature As Object: Craft and design from Japan, Finland and Australia: The Third Australian International Crafts Triennial.* Perth: Art Gallery of Western Australia, 1998.

Bennett, Jill. 'Dennis Del Favero and the Traumatophilia of Video Installation' in Ben Genocchio and Adam Geczy (eds), *Installation Art in Australia.* Sydney: Power Publications, 2001.

Bogle, Michael and Landman, Peta. *Modern Australian Furniture: Profiles of contemporary designer–makers.* Singapore: Craftsman House, 1989.

Bogle, Michael. *Design in Australia 1880–1970.* Sydney: Craftsman House, 1998.

Bonyhady, Tim. *Australian Colonial Paintings in the Australian National Gallery.* Canberra: Austalian National Gallery, 1986.

Bonyhady, Tim. *Images in Opposition: Australian landscape painting, 1801–1890.* Melbourne: Oxford University Press, 1985.

Bonyhady, Tim. *The Colonial Earth.* Melbourne: Miegunyah Press, 2000.

Bonyhady, Tim. *The Colonial Image: Australian painting 1800–1880.* Sydney: Ellsyd, 1987.

Bowen, Stella. *Drawn from Life.* Sydney: Pan Macmillan, 1999 (reprint of 1941).

Bradley, Anthony. *The Art of Justin O'Brien.* Sydney: Craftsman House, 1982.

Broadfoot, Keith and Butler, Rex. *Objective gesture: John Young, selected works 1986–97.* Sydney: 1987.

Bromfield, David. *Akio Makigawa.* Sydney: Craftsman House, 1995.

Bromfield, David. *Brian Blanchflower: Works 1961–1989.* Perth: Department of Fine Arts, University of Western Australia, 1989.

Bromfield, David. *Elise Blumann: Paintings & drawings 1918–1984.* Perth: Centre for Fine Arts, University of Western Australia, 1984.

Brown, Tony and Kolenberg, Hendrik. *Skinner Prout in Australia 1840–48.* Hobart: Tasmanian Museum and Art Gallery, 1986.

Bruce, Candice. *Eugen von Guérard.* Canberra: Australian National Gallery, 1980.

Bruce, Candice et al. *Eugene von Guerard 1811–1901: A German romantic in the Antipodes.* Martinborough, New Zealand: Alistair Taylor, 1982.

Bruce, Candice. *Ian Fairweather.* Brisbane: Queensland Art Gallery.

Buckley, Vincent. *Leonard French: The Campion Paintings.* Melbourne: Grayflower Publications, 1962.

Bull, Gordon. 'Yosl Bergner' in Charles Merewether, *Art and Social Commitment.* Sydney: Art Gallery of New South Wales, 1984.

Burke, Janine (ed.). *Dear Sun: The letters of Joy Hester and Sunday Reed.* Melbourne: William Heinemann, 1995.

Burke, Keast. *Gold and Silver: Photographs of Australian goldfields from the Holtermann Collection.* Melbourne: Penguin, 1973.

Burn, Ian. *Artists Think: The late works of Ian Burn.* Melbourne: Monash University Press, 1996.

Burn, Ian. *Dialogue: Writings in art history.* Sydney: Allen and Unwin, 1991.

Burn, Ian. *National Life and Landscapes; Australian painting 1900–1940.* Sydney: Bay Books, 1990.

Butler, Roger. *Australian Prints in the Australian National Gallery.* Canberra, Australian National Gallery, 1985.

Butler, Roger (ed.). *Islands in the Sun: Prints by Indigenous artists of Australia and the Australasian region.* Canberra: National Gallery of Australia, 2001.

Butler, Roger. 'John William Lewin' in *The National Gallery of Australia: An introduction to the collection.* Canberra: National Gallery of Australia, 1998.

Butler, Roger. *My Head is a Map: A decade of Australian prints.* Canberra: National Gallery of Australia, 1992.

Butler, Roger. *Sydney by Design.* Canberra: Australian National Gallery, 1987.

Butler, Roger. *The Europeans: Émigre artists in Australia 1930–1960.* Canberra: National Gallery of Australia, 1997.

Butler, Roger. *The Europeans: Émigré artists in Australia 1930–1960,* travelling exhibition brochure, Canberra: National Gallery of Australia, 1999.

Butler, Roger. *The Prints of Margaret Preston: A catalogue raisoneé.* Canberra: Australian National Gallery, 1987.

Calado, Jorge. *Linha da vida: a fotografia de Wolfgang Sievers 1933–1993* [*Life Line: The photography of Wolfgang Sievers 1933–1993*]. Lisbon: Camara Municipal Cultura, 2000.

Capon, Edmund. *Jeffrey Smart.* Sydney: Art Gallery of New South Wales, 1999.

Carroll, Alison. *Barbara Hanrahan: Printmaker.* Netley: Wakefield Press, 1986.

Caruana, Wally and Lendon, Nigel (eds). *The Painters of the Wagilag Sisters Story, 1937–1997.* Canberra: National Gallery of Australia, 1997.

Caruana, Wally. *Aboriginal Art.* New York: Thames and Hudson, 1993.

Caruana, Wally. *Roads Cross: The paintings of Rover Thomas.* Canberra. National Gallery of Australia, 1994.

Caruana, Wally (ed.). *Windows on the Dreaming.* Canberra: Australian National Gallery, 1989.

Catalano, Gary. *The Solitary Watcher: Rick Amor and his art.* Melbourne: Miegunyah Press, 2001.

Catalano, Gary. *The Years of Hope: Australian art and criticism 1959–1968.* Melbourne: Oxford University Press, 1981.

Chapman, Christopher. *Surrealism in Australia* Canberra: National Gallery of Australia, 1993.

Churcher, Betty. *Molvig: The lost Antipodean.* Melbourne: Penguin, 1984.

Clark, Jane and Druce, Felicity (eds). *Violet Teague.* Sydney: Beagle Press, 1999.

Clark, Jane and Whitelaw, Bridget. *Golden Summers: Heidelberg and beyond.* Melbourne: National Gallery of Victoria, 1985.

Clark, Jane. *Nolan: Sidney Nolan landscapes & legends: A retrospective exhibition: 1937–1987.* Melbourne, National Gallery of Victoria, 1987.

Clark, Kenneth et al. *Sidney Nolan.* London: Thames and Hudson, 1961.

Cochrane, Grace. *The Crafts Movement in Australia: A history.* Sydney: New South Wales University Press, 1992.

Cooke, Glenn and Edwards, Deborah. *L.J. Harvey and his school.* Brisbane: Queensland Art Gallery, 1983.

Coppel, Stephen. *Linocuts of the Machine Age: Claude Flight and the Grovesnor School.* London: Scholar Press, 1995.

Craig, Clifford, Fahy, Kevin and Robertson, E. Graeme. *Early Colonial Furniture in New South Wales and Van Diemen's Land.* Melbourne: Georgian House, 1972.

Cramer, Sue. *Guan Wei: Nesting, or the art of idleness, 1989–1999.* Sydney: Museum of Contemporary Art, 1999.

Crawford, Ashley and Edgar, Ray. *Spray: The work of Howard Arkley.* Sydney: Craftsman House, 2001.

Cree, Laura Murray (ed.). *Australian Painting Now.* Sydney: Craftsman House, 2000.

Croft, Brenda L. *Beyond the Pale: Contemporary Indigenous art.* Adelaide: Art Gallery of South Australia, 2000.

Croft, Brenda L. *Indigenous Art: Art Gallery of Western Australia.* Perth: Art Gallery of Western Australia, 2001.

Crombie, Isobel. 'Louisa How: Pioneer photographer', *Australian Business Collectors' Annual,* 1982.

Curnow, Wystan. *Imants Tillers and the 'Book of Power'.* Sydney: Craftsman House, c.1998.

Czernis-Ryl, Eva. *Australian Gold and Silver 1851–1900.* Sydney: Powerhouse Publishing, 1995.

Davis, Alan and Stanbury, Peter. *The Mechanical Eye in Australia: Photography 1841–1900.* Melbourne: Oxford University Press, 1985.

Davis, Annette. *Guy Grey-Smith's Landscapes of Western Australia.* Perth: Edith Cowan University, c.1996

de Berg, Hazel. *Conversation with Arnold Shore, 14 August 1962.* Hazel de Berg Collection of Tape Recordings, Canberra: National Library of Australia, 1962.

de Berg, Hazel. *Conversation with Arthur Murch.* Hazel de Berg Collection of Tape Recordings, Canberra: National Library of Australia, 1962.

de Berg, Hazel. *Conversation with Frank Hinder* [Transcript of interview, 20th July, 1963]. Hazel de Berg Collection of Tape Recordings, Canberra: National Library of Australia, 1963.

de Berg, Hazel. *Conversation with Jean Bellete.* Hazel de Berg Collection of Tape Recordings, Canberra: National Library of Australia, 1976.

de Berg, Hazel. *Conversation with Kathleen O'Connor.* Hazel de Berg Collection of Tape Recordings, Canberra: National Library of Australia, 1965.

de Vries, Susanna. *Ethel Carrick Fox: Travels and triumphs of a Post-Impressionist.* Brisbane: Pandanus Press, 1997.

Desmond, Michael and Dixon, Christine. *1968.* Canberra: National Gallery of Australia, 1995.

Dickerson, Jennifer. *Robert Dickerson: Against the tide.* Brisbane: Pandanus Press, 1994.

Dimmack, Max. *Noel Counihan.* Melbourne: Melbourne University Press, 1974.

Docking, Gil. *Henry Salkauskas 1925–1979.* Sydney: Art Gallery of New South Wales, 1981.

Dufour, Gary. *Howard Taylor: Sculptures, paintings, drawings 1942–1984.* Perth: Art Gallery of Western Australia, 1985.

Dumbrell, Lesley. *Shades of Light: Lesley Dumbrell 1971–1999.* Melbourne: Ian Potter Museum of Art, University of Melbourne, 1999.

Dunbar, Diane (ed.). *Thomas Bock, Convict Engraver, Society Portraitist.* Launceston: Queen Victoria Museum and Art Gallery, 1991.

Dunlop, Ian and Deveson, Pip. *Conversations with Dundiwuy Wanami.* [videorecording]. Sydney: Film Australia, 1995.

Dysart, Dinah. *Julian Ashton sketchbook.* Canberra: Australian National Gallery, 1981.

Eagle, Mary and Minchin, Jan. *The George Bell School: Students, friends, influences.* Melbourne: Deutscher Art Publications, 1981.

Eagle, Mary and Jones, John. *A Story of Australian Painting.* Sydney: Macmillan, 1994.

Eagle, Mary. *A Tribute to William Dobell.* Canberra: Drill Hall Gallery, Australian National University, 1999.

Eagle, Mary. *Australian Modern Painting between the Wars 1914–1939.* Sydney: Bay Books, 1990.

Eagle, Mary. *Peter Purves Smith: A painter in peace and war.* Sydney: Beagle Press, 2000.

Eagle, Mary. 'Roland Wakelin: The fruit seller of Farm Cove', *Australian National Gallery News,* Spring 1983.

Eagle, Mary. *The Art of Rupert Bunny in the Australian National Gallery*. Canberra: Australian National Gallery, 1991.

Eagle, Mary. *The Oil Paintings of Arthur Streeton in the National Gallery of Australia*. Canberra: National Gallery of Australia, 1994.

Eagle, Mary. *The Oil Paintings of Charles Conder in the National Gallery of Australia*. Canberra: National Gallery of Australia, 1997.

Eagle, Mary. *The Oil Paintings of E. Phillips Fox in the National Gallery of Australia*. Canberra: National Gallery of Australia, 1997.

Eagle, Mary. *The Oil Paintings of Tom Roberts in the National Gallery of Australia*. Canberra: National Gallery of Australia, 1997.

Edwards, Deborah. *Godfrey Miller: 1893–1964*. Sydney: Art Gallery of New South Wales, 1996.

Edwards, Deborah. *Rosalie Gascoigne: Material as landscape*. Sydney: Art Gallery of New South Wales, 1997.

Edwards, Deborah. *Stampede of the Lower Gods: Classical mythology in Australian art 1890s–1930s*. Sydney: Art Gallery of New South Wales, 1989.

Edwards, Geoffrey. *Clifford Last Sculpture: A retrospective exhibition*. Melbourne: National Gallery of Victoria, 1989.

Edwards, Geoffrey. *Klaus Moje Glass: A retrospective exhibition*. Melbourne: National Gallery of Victoria, 1995.

Edwards, Geoffrey. *The Painter as Potter: Decorated ceramics of the Murrumbeena Circle*. Melbourne: National Gallery of Victoria, 1982.

Ennis, Helen and Crombie, Isobel. *Australian Photographs: A souvenir book of Australian photography in the Australian National Gallery*. Canberra: Australian National Gallery, 1988.

Ennis, Helen and Jerryms, Bob. *Living in the Seventies: Photographs by Carol Jerrems*. Hobart: Art Exhibitions Committee, University of Tasmania, 1990.

Ennis, Helen. *Cazneaux: The quiet observer*. Canberra: National Library of Australia, 1997, 1994.

Ennis, Helen. *Olive Cotton: Photographer*. Canberra: National Library of Australia, 1995.

Ennis, Helen. *Wolfgang Sievers*. Sydney: WriteLight, 1998.

Ewington, Julie and Seear, Lynn (eds). *Brought to Light: Australian Art 1850–1965 from the Queensland Art Gallery Collection*. Brisbane: Queensland Art Gallery, 1998.

Fahy, Kevin, Simpson, Christina and Simpson, Andrew. *Nineteenth Century Australian Furniture*. Sydney: David Ell Press, 1985.

Fink, Elly. *The Art of Blamire Young*. Sydney: Golden Press, 1983.

Fink, Hannah, Lynn, Victoria and Perkins, Hetti. *Judy Watson*. Epernay: Moet and Chandon, c.1996.

Fisher, Tim. *Painting Forever: Tony Tuckson*. Canberra: National Gallery of Australia, 2000.

Forwood, Gillian. *The Babe is Wise: Lina Bryans and her portraits*. Melbourne: University of Melbourne Museum of Art, 1995.

France, Christine. *Justin O'Brien*. Sydney: Craftsman House, 1997 (revised ed.).

France, Christine. *Marea Gazzard: Form and clay*. Sydney: Craftsman House, c.1994.

Frangos, Seva and Moore, Margaret. *Miriam Stannage: Perception 1969–1989*. Perth: Art Gallery of Western Australia, 1989.

Free, Renée. *James Gleeson: Images from the shadows*. Sydney: Craftsman House, 1993.

Free, Renée. *Lloyd Rees*. Melbourne: Landsdowne Press, 1972.

Friend, Donald. *Gunner's Diary*. Sydney: Ure Smith, 1943.

Friend, Donald. *Painter's Journal*. Sydney: Ure Smith, 1946.

Fullerton, Patricia. *Hugh Ramsay: His life and work*. Melbourne: Hudson Publishing, 1988.

Fullerton, Patricia. *Hugh Ramsay 1877–1906*. Melbourne: National Gallery of Victoria, 1992.

Galbally, Ann and Gray, Anne (eds). *Letters from Smike. The letters of Arthur Streeton 1890–1943*. Melbourne: Oxford, 1989.

Galbally, Ann. *Frederick McCubbin*. Melbourne: Hutchinson, 1981.

Galbally, Ann. *John Peter Russell*. Melbourne: Sun Books, 1977.

Galbally, Ann. *The Art of Arthur Streeton*. Melbourne: Lansdowne Press, 1969.

Gellatly, Kelly. *Leave No Space for Yearning: The art of Joy Hester*. Melbourne: Heide Museum of Modern Art, 2001.

Gibson, Eric. *The Sculpture of Clement Meadmore*. New York: Hudson Hill Press, 1994.

Gleeson, James. *Aspects of Australian Art 1900–1940*. Canberra: Australian National Gallery, 1978.

Gleeson, James. *Colonial Painters, 1788–1880*. Melbourne: Lansdowne Press, 1971.

Gleeson, James. *Interview with John Olsen*. National Gallery of Australia Research Library, 9 April 1979.

Gleeson, James. *Masterpieces of Australian Painting*. Melbourne: Lansdowne Press, 1969.

Gleeson, James. *Robert Klippel*. Sydney: Bay Books, 1983.

Gleeson, James. *The Drawings of William Dobell in the Australian National Gallery*. Canberra: Australian National Gallery, 1992.

Gleeson, James. *William Dobell*. London: Thames and Hudson, 1964.

Gooding, Janda. *Chasing Shadows: The art of Kathleen O'Connor*. Perth: *Art and Australia* in association with the Art Gallery of Western Australia, 1996.

Gray Street Workshop–Celebrating 15 Years: An anthology. Sydney: Object, Australian Centre for Craft and Design, with Gray Street Workshop, 2000.

Gray, Anne. 'A. Henry Fullwood: Recording Australia's first 100 years', *The Australian Antique Collector*, January–June 1984.

Gray, Anne. *A. Henry Fullwood: War Paintings*. Canberra: Australian War Memorial, 1983.

Gray, Anne. *Art and Artifice: George Lambert 1873–1930*. Sydney: Craftsman House, 1996.

Gray, Anne (ed.). *The Diaries of Donald Friend*. Canberra: National Library of Australia, 2001.

Gray, Anne. *Line, Light and Shadow, James W. R. Linton: Painter, craftsman, teacher*. Fremantle: Fremantle Arts Centre Press, 1986.

Gray, Anne. *Painted Women: Australian Artists in Europe at the turn of the century*. Perth: Lawrence Wilson Art Gallery, University of Western Australia, 1998.

Gray, Anne. *Swingtime: East Coast–West Coast*. Perth: Lawrence Wilson Art Gallery, University of Western Australia, 1998.

Gray, Anne. *The Way We Were: 1940s–1950s*. Perth: Lawrence Wilson Art Gallery, University of Western Australia, 1996.

Grishin, Sasha. *Australian Printmaking in the 1990s: Artist printmakers 1990–95.* Sydney: Craftsman House, 1997.

Grishin, Sasha. *Contemporary Australian Printmaking: An intepretative history.* Sydney: Craftsman House, 1994.

Grishin, Sasha. *John Wolseley: Land marks.* Sydney: Craftsman House, 1998.

Grishin, Sasha. *Leonard French.* Sydney: Craftsman House, 1995.

Grishin, Sasha. *The Art of John Brack.* Melbourne: Oxford University Press, 1990.

Guan Wei. Sydney: Sherman Galleries, 1995.

Gunn, Grazia. *Arthur Boyd: Seven persistent images.* Canberra: Australian National Gallery, 1985.

Hackforth Jones, Jocelyn. *Augustus Earle, Travel Artist: Paintings and drawings in the Rex Nan Kivell Collection.* Canberra: National Library of Australia, 1980.

Haese, Richard. *Rebels and Precursors: The revolutionary years of Australian art.* Melbourne: Allen Lane, 1981.

Haese, Richard. *Yosl Bergner.* Melbourne, National Gallery of Victoria, 1985.

Hall, Adrian. *Looking: Prints by Tony Coleing.* Brisbane: Museum of Contemporary Art, 1988.

Hall, Barbara and Mather, Jenni. *Australian Women Photographers 1840–1960.* Melbourne: Greenhouse Publications, 1986.

Hall, Fiona. *Subject to Change.* Adelaide: Experimental Art Foundation, 1995.

Hammond, Victoria. *Merric Boyd: Studio potter 1888–1959.* Melbourne: National Gallery of Victoria, 1990.

Hammond, Victoria and Peers, Julia. *Completing the Picture: Women artists and the Heidelberg era.* Melbourne: Artmoves, 1992.

Hansford, Pamela. *Peter Tyndall: Dagger definitions.* Melbourne: Greenhouse Publications, 1987.

Harris, Wendy and Roslyn Kay. *Aboriginal and Torres Strait Islander Studies: Book 1.* Australia: Learning Solutions, 1994.

Hart, Deborah. *John Olsen.* Sydney: Craftsman House, 1991.

Hart, Deborah. *Joy Hester and Friends.* Canberra: National Gallery of Australia, 2001.

Hart, Deborah. *Tales of the Unexpected.* Canberra: National Gallery of Australia, 2002.

Hart, Deborah (ed.). *Uncommon World.* Canberra: National Gallery of Australia, 2000.

Hart, Deborah. *William Delafield Cook.* Sydney: Craftsman House, 1998.

Hawkins, J.B. *Australian Silver 1800–1900.* Sydney: National Trust of Australia (NSW), 1973.

Hawkins, J.B. *19th Century Australian Silver.* Woodbridge, England: Antique Collectors' Club, 1990.

Haynes, Peter. *Robert Boynes 3 decades.* Canberra: Nolan Gallery, 1995.

Heathcote, Christopher. *A Quiet Revolution: The rise of Australian art 1946–1968.* Melbourne: Text Publishing, 1995.

Helmer, June. *George Bell: The art of influence.* Melbourne: Greenhouse, 1985.

Henson, Bill. *Photographs.* Sydney: Pan Books, 1988.

Hoff, Ursula. *Charles Conder.* Melbourne: Lansdowne Press, 1972.

Hoff, Ursula. *The Art of Arthur Boyd.* London: André Deutsch, 1986.

Hoff, Ursula. 'The Art of Jean Bellette', *Meanjin*, no.51, vol.11 no.4, summer 1952.

Hollinrake, Rosalind. *Clarice Beckett: Politically incorrect.* Melbourne: Ian Potter Museum of Art, University of Melbourne, 1999.

Holmes, Jonathan. *Les Blakebrough – Potter.* Sydney: Bay Books, 1988.

Hood, Robert. *Merrang and the Hood Family.* Warrnambool: Deakin University Press, 1991.

Horton, David (ed.). *The Encyclopaedia of Aboriginal Australia: Aboriginal and Torres Strait Islander history, society and culture* Canberra: Aboriginal Studies Press for the Australian Institute of Aboriginal and Torres Strait Islander Studies, 1994, 2 vols.

Howard, Ian. *Foreign Bodies. Ian Howard: Survey exhibition 1967–1997.* Canberra: Drill Hall Gallery, Australian National University, 1997.

Hughes, Robert. *Colin Lanceley.* Sydney: Craftsman House, 1993.

Hughes, Robert. *Donald Friend.* Sydney: Edwards and Shaw, 1965.

Hughes, Robert. *The Art of Australia.* Hammondsworth: Penguin, 1970.

Hunter, Robert. *Robert Hunter Paintings 1966–1988.* Clayton: Monash University Gallery, 1989.

Hutchings, Patrick E. and Lewis, Julie. *Kathleen O'Connor: Artist in exile.* Fremantle: Fremantle Arts Centre Press, 1987.

Hylton, Jane. *Colonial Sisters: Martha Berkeley & Theresa Walker: South Australia's first professional artists.* Adelaide: Art Gallery of South Australia, 1994.

Hylton, Jane. *Modern Australian Women: Paintings & prints 1925–1945.* Adelaide: Art Gallery of South Australia, 2000.

Ioannou, Noris. *Australian Studio Glass: The movement, its makers and their art.* Sydney: Craftsman House, 1995.

Ioannou, Noris. *Masters of Their Craft: Tradition and innovation in the Australian contemporary decorative arts.* Sydney: Craftsman House, 1997.

Isaacs, Jennifer. *The Gentle Arts: 200 years of Australian women's domestic & decorative arts.* Sydney: Lansdowne Press, 1987.

James, Rodney. *Fred Williams, Coastal Strip.* Mornington: Mornington Peninsular Regional Gallery, 2001.

Jenkins, Susan. *Ramingining Artists: The Aboriginal Memorial 1987–88.* Canberra: National Gallery of Australia, 1997.

Johannes, Christa E. *W.C. Piguenit 1836–1914: Retrospective.* Hobart: Tasmanian Museum and Gallery, 1992.

Johns, Elizabeth, Sayers, Andrew, Kornhauser, Mankin, Elizabeth, Ellis Amy et al. *New Worlds from Old: 19th century Australian and American Landscapes.* Canberra: National Gallery of Australia, 1998.

Johnson, Heather. *Roy de Maistre: The Australian years 1894–1930.* Sydney: Craftsman House, 1988.

Johnson, Heather. *Roy de Maistre: The English years 1930–1968.* Sydney: Craftsman House, 1995.

Kent, Rachel. *Swallowswenson: An exhibition of sculptural works by Ricky Swallow and Erick Swenson.* Sydney: Museum of Contemporary Art, 2001.

Kerr, Joan (ed.). *Heritage: The National Women's Art Book.* Sydney: Craftsman House, 1995.

Kerr, Joan (ed.). *The Dictionary of Australian Artists: Painters, sketchers, photographers and engravers to 1870*. Melbourne: Oxford University Press, 1992.

Kirker, Anne and Butler, Roger. *Being and Nothingness: Bea Maddock – work from three decades.* Canberra: National Gallery of Australia, 1992.

Kleinert, Sylvia and Neale, Margo (eds.). *The Oxford Companion to Aboriginal Art and Culture*. Melbourne: Oxford University Press, 2000.

Klepac, Lou. *Guy Grey-Smith Retrospective*. Perth: Western Australian Art Gallery, 1976.

Klepac, Lou. *Horace Trenerry*. Adelaide: Art Gallery of South Australia, 1970.

Klepac, Lou. *Nora Heysen*. Sydney: Beagle Press, 1989.

Klepac, Lou. *Nora Heysen*. Canberra: National Library of Australia, 2000.

Klepac Lou. *The Genius of Donald Friend*. Canberra: National Library of Australia, 2000.

Klepac, Lou. *The Life and Work of Russell Drysdale*. Sydney: Bay Books, 1983.

Klepac, Lou, Pearce, Barry and McDonald, John. *David Strachan*. Sydney: Beagle Press, 1993.

Kolenberg, Hendrik and Pearce, Barry. *Francis Lymburner*. Sydney: Art Gallery of New South Wales, 1992.

Kolenberg, Hendrick. *Australian Watercolours*. Sydney: Art Gallery of New South Wales, 1996.

Kolenberg, Hendrick. *Jan Senbergs: Imagined sites, imagined reality*. Melbourne: Museum of Modern Art at Heide, 1994.

Kolenberg, Hendrick. *Lloyd Rees in Europe: Selected drawings from his sketchbooks in the Gallery's collection*. Sydney: Art Gallery of New South Wales, 2002.

Kolenberg, Hendrick. *Tasmanian Vision*. Hobart: Tasmanian Museum and Art Gallery, 1987.

Lane, Terence and Serle, Jessie. *Australians at Home: A documentary history of Australian domestic interiors from 1788 to 1914*. Melbourne: Oxford University Press, 1990.

Lane, Terence and Strizic, Mark. *Schulim Krimper – Cabinet-maker: A tribute by Marc Strizic and Terence Lane*. Melbourne: Gryphon Books, 1987.

Lane, Terence. *Robert Prenzel 1866–1941: His life and work*. Melbourne: National Gallery of Victoria, 1994.

Larkin, Annette. *Peter Atkins "world journal"*. Melbourne: Australian Exhibitions Touring Agency, 1997.

Le Memorial: un chef-d'ouvre d'art aborigene/ The Memorial: a masterpiece of aboriginal art. Lausanne: Musée Olympique, 1999.

Lindsay, Elaine (ed.). *The Diaries of Barbara Hanrahan*. Brisbane: University of Queensland Press, 1998.

Lindsay, Lionel. *Comedy of Life*. Sydney: Angus and Robertson, 1967.

Lindsay, Robert and Holloway, Memory Jockisch. *George Baldessin: Sculpture and etchings, a memorial exhibition*. Melbourne: National Gallery of Victoria, 1983.

Lindsay, Robert. *John Brack: A retrospective*. Melbourne: National Gallery of Victoria, 1987.

Lindsay, Robert. *The Seventies: Australian painting and tapestries from the collection of the National Australia Bank*. Melbourne: National Australia Bank, 1982.

MacDonald, Vici. *Rosalie Gascoigne*. Sydney: Regaro, 1997.

Macqueen, Kenneth. *Adventure in Watercolour: An artist's story*. Sydney: Legend Press, 1948.

Maloon, Terence and Lynn, Victoria. *Michael Johnson: Paintings 1968–1988*. Sydney: Art Gallery of New South Wales, 1988.

Mansfield, Janet. *A Collectors' Guide to Modern Australian Ceramics*. Sydney: Craftsman House, 1988.

Mansfield, Janet. *Contemporary Ceramic Art in Australia and New Zealand*. Sydney: Craftsman House, 1995.

McCaughey, Patrick. *Fred Williams*. Sydney: Bay Books, 1980.

McCaughey, Patrick. *Roger Kemp: Cycles and directions 1935–1975*. Melbourne: Monash University, 1978.

McCulloch, Alan and McCulloch, Susan. *The Encyclopedia of Australian Art*. 3rd Edition. Sydney: Allen and Unwin, 1994.

McCulloch-Uehlin, Susan. 'Abstraction's forgotten generation', *The Australian*, 23 April 1999.

McDonald, Anne. *Douglas Annand: The art of life*. Canberra: National Gallery of Australia, 2001.

McDonald, Anne. 'Mary Cockburn Mercer: The epitome of the modern Australian woman', *Artonview*, no.26, winter 2001.

McDonald, John (ed.). *Federation: Australian art and society 1901–2001*, Canberra: National Gallery of Australia, 2000.

McGrath, Sandra. *Brett Whiteley*. Sydney: Angus and Robertson, 1992.

McGregor, Ken and Thomson, Elizabeth. *David Larwill*. Sydney: Craftsman House, c.1997.

McGregor, Ken. *Robert Jacks: Past unfolded*. Sydney: Craftsman House, 2001.

McKay, Judith. *Harold Parker: Sculptor*. Brisbane: Queensland Art Gallery, 1993.

McLean, Ian. *The Art of Gordon Bennett*. Sydney: Craftsman House, 1996.

McPhee, John. *Australian Art in the Collection of the Australian National Gallery*. Canberra: Australian National Gallery, 1988.

McPhee, John. *Australian Decorative Arts in the Australian National Gallery*. Canberra: Australian National Gallery, 1982.

McPhee, John. *The Art of John Glover*. Melbourne: Macmillan, 1980.

McQueen, Humphrey. *Suburbs of the Sacred*. Melbourne: Penguin, 1988.

McQueen, Humphrey. *Tom Roberts*. Sydney: Macmillan, 1996.

Mendelssohn, Joanna. *Lionel Lindsay: An artist and his family*. London: Chatto and Windus, 1998.

Mendelssohn, Joanna. *The Life and Work of Sydney Long*. Sydney: McGraw-Hill, 1979. Menz, Christopher. *Australian Decorative Arts, 1820s-1990s: Art Gallery of South Australia*. Adelaide: Art Gallery of South Australia, 1996.

Menz, Christopher. *Milton Moon Retrospective*. Adelaide: Art Gallery of South Australia, 1991.

Merewether, Charles. *Art and Social Commitment: An end to the city of dreams 1931–48*. Sydney: Art Gallery of New South Wales, 1984.

Miller, Ronald. *John Brack*. Melbourne: Landsdowne Press, 1971.

Minchin, Jan and Butler, Roger. *Thea Proctor: The prints*. Sydney: Resolution Press, 1980.

Modjeska, Drusilla. *Stravinsky's Lunch*. Sydney: Picador, 1999.

Moffatt, Tracey. *Tracey Moffatt: Fever Pitch*. Sydney: Piper Press, 1995.

Mollison, James and Bonham Nicholas. *Albert Tucker*. Melbourne: Macmillan, 1982.

Mollison, James and Minchin, Jan. *Albert Tucker: A retrospective*. Melbourne: National Gallery of Victoria, 1990.

Mollison, James. *A Singular Vision: The art of Fred Williams*. Canberra: Australian National Gallery, 1989.

Mollison, James. *Fred Williams. A souvenir book of the artist's work in the Australian National Gallery*. Canberra: Australian National Gallery, 1987.

Mollison, James. *Genesis of a Gallery*. Canberra: Australian National Gallery, 1976.

Mollison, James. *Genesis of a Gallery part 2*. Canberra: Australian National Gallery, 1978.

Mollison, James. *The Phillip Morris Art Grant: Australian art of the last ten years*. Canberra: Australian National Gallery, c.1982.

Montana, Andrew. *The Art Movement in Australia*. Melbourne: Miegunyah Press, 2000.

Moore, David, *David Moore, Australian Photographer*. Sydney: Chapter and Verse, 1988.

Moore, Felicity St John. 'Force of Nature, Danila Vassilieff's *Stenka Razin*' in *Creating Australia: 200 years of art 1788–1988*. Adelaide: Art Gallery of South Australia,1988.

Moore, Felicity St John. *Charles Blackman: Schoolgirls and angels*. Melbourne: National Gallery of Victoria, 1993.

Moore, Felicity St John. *Classical Modernism: The George Bell circle*. Melbourne: National Gallery of Victoria, 1992.

Moore, Felicity St John. *Vassilieff and his Art*. Melbourne: Oxford University Press, 1982.

Morphy, Howard. *Aboriginal Art*. London: Phaidon, 1998.

Morphy, Howard. *Ancestral Connections: Art and an Aboriginal system of knowledge*. Chicago: University of Chicago Press, 1991.

Mosby, Tom (ed.). *Ilan Pasin (this is our way)*. Cairns: Cairns Regional Gallery, 1998.

Mountford, C. P. and Tonkinson, Robert. 'Carved and Engraved Human Figures from North Western Australia', *Anthropological Forum* 2(3):1969.

Murch, Ria. *Arthur Murch: An artist's life 1902–1989*. Sydney: Ruskin Rowe Press, 1997.

NAIDOC 86 Exhibition of Aboriginal and Islander Photographers. Sydney: Aboriginal Artists Gallery, 1986.

National Gallery of Australia: An introduction to the collection. Canberra: National Gallery of Australia, 1998.

Neale, Margo. *Urban Dingo: The art and life of Lin Onus, 1948–1996*. Sydney: Craftsman House; Brisbane: Queensland Art Gallery, 2000.

New Directions 1952–1962: Lewers Bequest and Penrith Regional Art Gallery, 1991.

Newton, Gael. *Axel Poignant: Photographs 1922–1980*. Sydney: Art Gallery of New South Wales, 1982.

Newton, Gael. *John Kauffmann: Art photographer*. Canberra: National Gallery of Australia, 1996.

Newton, Gael. *Shades of Light: Photography and Australia 1839–1988*. Canberra: Australian National Gallery, 1982.

Newton, Gael. 'The Perfect Picture: James Francis Hurley' in *South with Endurance: Shackleton's Antarctic Expedition 1914–1917, the photographs of Frank Hurley*. Melbourne: Viking Penguin, 2001.

Newton, Gael. 'The Sunbaker' in White, Jill (ed.), *Dupain's Beaches*. Sydney: Chapter and Verse, 2000.

Nixon, John. *Thesis: selected works from 1968–1993*. Melbourne: Australian Centre for Contemporary Art, 1994.

North, Ian (ed). *Heysen*. Melbourne: Macmillan, 1979.

North, Ian et al. *Hans Heysen Centenary Retrospective, 1877–1977*. Adelaide: Art Gallery of South Australia, 1977.

North, Ian. *The Art of Dorrit Black*. Adelaide: Art Gallery of South Australia, 1979.

Norrie, Susan. *Susan Norrie*. Perth: Art Gallery of Western Australia, 1999.

O'Callaghan, Judith. *Helge Larsen & Darani Lewers: A retrospective*. Melbourne: National Gallery of Victoria, 1986.

O'Callaghan, Judith. *The Australian Dream: Design of the fifties*. Sydney: Powerhouse Publishing, 1993.

Olsen, John. *Drawn from Life*. Sydney: Duffy and Snellgrove, 1997.

Olsen, John. *Salute to Five Bells: John Olsen's Opera House journal*. Sydney: Angus and Robertson, 1973.

Orchard, Ken, 'J.W. Lindt's Australian Aboriginals (1873–74)', *History of Photography,* vol. 23, no.2, summer 1999.

Parr, Lenton. *Lenton Parr: Vital presences*. Sydney: Beagle Press, 1999.

Pascal, Judith. *Melinda Harper*. Brisbane: David Pestorius Gallery, 1994.

Pascoe, Joe (ed.). *Delinquent Angel: Australian historical, Aboriginal and contemporary ceramics*. Florence: Centro Di, 1995.

Pearce, Barry and Kolenberg, Hendrick. *William Dobell 1899–1970: The painters progress*. Sydney: Art Gallery of New South Wales, 1997.

Pearce, Barry. *Arthur Boyd Retrospective*. Sydney: Art Gallery of New South Wales, 1993.

Pearce Barry. *Brett Whiteley: Art and life*. Sydney: Art Gallery of New South Wales, 1995.

Pearce, Barry. *Donald Friend, 1915–1989: retrospective*. Sydney: Art Gallery of New South Wales, 1990.

Pearce, Barry. *Elioth Gruner, 1882–1939*. Sydney: Art Gallery of New South Wales, 1983.

Pearce, Barry. *John Passmore 1904–84: Retrospective*. Sydney: Art Gallery of New South Wales, 1984.

Pearce, Barry. *Kevin Connor*. Sydney: Craftsman House, 1989.

Pearce, Barry. *Margaret Olley*. Sydney: Art Gallery of New South Wales, 1996.

Pearce, Barry. *Sali Herman Retrospective*. Sydney: Art Gallery of New South Wales, 1981.

Perkins, Hetti and Fink, Hannah. *Papunya Tula: Genesis and genius*. Sydney: Art Gallery of New South Wales, 2000.

Philipp, Franz. *Arthur Boyd*. London: Thames and Hudson, 1967.

Phipps, Jennifer. *Atyeo*. Melbourne: Heide Park and Art Gallery, 1982.

Phipps, Jennifer. *I Had a Dream: Australian art in the 1960s*. Melbourne: National Gallery of Victoria, 1997.

Photo/History: Margaret Dawson, Tracey Moffatt. Victoria: Australian Centre for Contemporary Photography, 1998, 1999.

Pigot, John. *Hilda Rix Nicholas: Her life and art*. Melbourne: Miegunyah Press, 2000.

Pinson, Peter. *Elwyn Lynn Retrospective 1956–1990*. Sydney: Art Gallery of New South Wales, 1991.

Pinson, Peter. *Elwyn Lynn: Two decades*. Sydney: Ivan Dougherty Gallery, Alexander Mackie College of Advanced Education, 1977.

Plant, Margaret. *Dale Hickey*. Ballarat: City of Ballarat Fine Art Gallery, 1988.

Plant, Margaret. *John Perceval*. Melbourne: Landsdowne Press, 1971.

Poignant, Roslyn. 'The Swagman's After Image', *Photofile, 35*, May 1992.

Polizzotto, Carolyn. *Approaching Elise*. Fremantle: Fremantle Arts Centre Press, 1988.

Poulton, Jill. *Adelaide Ironside: The pilgrim of art*. Sydney: Hale and Iremonger, 1987.

Puvogel, Renate, Reinhardt, Brigitte and Stegmayer, Hanna. *Jenny Watson*. Ulm, Germay: Ulmer Museum, 1996.

Quaill, Avril. *Marking our Times: Selected works of art from the Aboriginal and Torres Strait Islander Collection at the National Gallery of Australia*. Canberra: National Gallery of Australia, 1996.

Quinlan, Karen. *In a Picture Land Over the Sea: Agnes Goodsir 1864–1939*. Bendigo: Bendigo Art Gallery, 1998.

Quartermaine, Peter. *Jeffrey Smart*. Melbourne: Gryphon Books, 1983.

Radford, Ron (ed.). *Tom Roberts*. Adelaide: Art Gallery of South Australia, 1996.

Rainbird, Stephen. *Kenneth Macqueen*. Brisbane: University Art Museum, University of Queensland, 1981.

Real Visions: The life and work of F.A. Joyner, South Australian photographer 1863–1945, Adelaide: Art Gallery of South Australia, 1981.

Research report series 1/Aboriginal and Torres Strait Islander Studies Unit. Brisbane: Aboriginal and Torres Strait Islander Studies Unit, University of Queensland, 1994.

Robert Owen: Between shadow and light: London works 1966–1975 and new directions. Melbourne: Monash University Gallery, 1999.

Robinson, Julie. *Ann Newmarch: The personal is political*. Adelaide: Art Gallery of South Australia, 1997.

Rod Ritchie. *Seeing the Rainforests in 19th-century Australia*. Sydney: Rainforest Publishing, 1989.

Roger Kemp: Cycles and directions 1935–1975. Melbourne: Exhibition Gallery, Monash University, 1978.

Rose, Margaret A. *Victorian Artists: Margaret Baskerville (1861–1930) and C. Douglas Richardson (1853–1932)*. Melbourne, 1988.

Rozen, Alan. *The Art of John Coburn*. Sydney: Hamlyn, 1980.

Ryan, Judith. *Images of Power: Aboriginal Art of the Kimberley*. Melbourne: National Gallery Victoria.

Salter, Elizabeth. *The Lost Impressionist: A biography of John Peter Russell*. London: Angus and Robertson, 1976.

Savage, Paula & Strongman, Lara (eds). *Tracey Moffat*. Wellington, New Zealand: City Gallery Wellington, 2002.

Sayers, Andrew. *Aboriginal Artists of the Nineteenth Century*. Melbourne: Oxford University Press, 1994.

Sayers, Andrew. *Australian Art*. Oxford: Oxford University Press, 2001.

Sayers, Andrew. *Australian Drawings and Watercolours: A souvenir book from the Australian National Gallery*. Canberra: Australian National Gallery, 1988.

Sayers, Andrew. *Drawing in Australia: Drawings, watercolours, pastels and collages from the 1770s to the 1980s*. Melbourne: Oxford University Press, 1989.

Sayers, Andrew. *Eric Wilson*. Newcastle: Newcastle Region Art Gallery, 1983.

Sayers, Andrew (with essay by Murray Bail). *Sidney Nolan's Ned Kelly: The Ned Kelly paintings in the National Gallery of Australia*. Canberra: National Gallery of Australia, 2002.

Scarlett, Ken. *Australian Sculptors*. Melbourne: Thomas Nelson Australia, 1980.

Schofield, Anne and Fahy, Kevin. *Australian Jewellery: 19th and early 20th century*. Sydney: David Ell Press, 1990.

Seear, Lynne. *Darkness & Light: The art of William Robinson*. Brisbane: Queensland Art Gallery, 2002.

Seear, Lynne and Ewington, Julie. *Brought to Light: Australian art 1850–1965*. Brisbane: Queensland Art Gallery, 1998.

Senbergs, Jan. *Voyage Six – Antarctica*. Melbourne: Powell Street Gallery, 1988.

Shore, Arnold. *40 Years Seek and Find*. Melbourne: 1957.

Smart, Jeffrey. *Not Quite Straight*. Melbourne: William Heinemann, 1996.

Smart, Sally. *Sally Smart: The unhomely body series, femmage, shadow and symptoms series*. Melbourne: 1999.

Smith, Bernard. *Australian Painting 1788–1960*. Melbourne: Oxford University Press, 1962.

Smith, Bernard. *Documents on Art and Taste in Australia 1770–1914*. Melbourne: Oxford University Press, 1975.

Smith, Bernard. *Place, Taste and Tradition: A study of Australian art since 1788*. Sydney: Ure Smith, 1945.

Smith, Bernard. *The Antipodean Manifesto: Essays in art and history*. Melbourne: Oxford University Press, 1976.

Smith, Geoffrey. *Arthur Streeton 1867–1943*. Melbourne: National Gallery of Victoria, 1995.

Smith, Geoffrey. *Russell Drysdale: 1912–81*. Melbourne: National Gallery Victoria, 1997.

Smith, Trevor. *Robert MacPherson / Trevor Smith: with an essay by John O'Brian*. Perth: Art Gallery of Western Australia, 2001.

Snell, Ted. *Howard Taylor: Forest figure*. Fremantle: Fremantle Arts Centre Press, 1995.

Sparks, Cameron. *David Davies 1864–1939*. Ballarat: Ballarat Fine Art Gallery, 1984.

Sturgeon, Graeme. *The Development of Australian Sculpture 1788–1975*. London: Thames and Hudson, 1978.

Swallow, Ricky. *Memories Made Plastic: Ricky Swallow*. Sydney: Darren Knight Gallery, 1999.

Sydney Long 1871–1955. Sydney: S.H. Ervin Gallery, 1979.

Taylor, Elena, (ed.). *National Sculpture Prize & Exhibition 2001*. Canberra: National Gallery of Australia, 2001.

Taylor, Luke. *Seeing the Inside: Bark painting in Western Arnhem Land*. Oxford: Clarendon Press, 1996.

Taylor, Paul (ed.). *Anything Goes: Art in Australia 1970–1980*. Melbourne: Art and Text, 1984.

The Aboriginal Memorial, National Gallery of Australia website: www. nga.gov.au/ memorial

Thiele, Colin. *Heysen of Hahndorf*. Adelaide: Rigby, 1968.

Thomas, Daniel, Free Renée and Legge, Geoffrey. *Tony Tuckson*. Sydney: Craftsman House, 1982.

Thomas, Daniel. *Australian Print Survey 1963/4*. Sydney: Art Gallery of New South Wales, 1963.

Thomas, Daniel (ed.). *Creating Australia: 200 years of art 1788–1988*. Adelaide: Art Gallery of South Australia, 1988.

Thomas Daniel. *Grace Cossington Smith, a Life: From drawings in the collection of the National Gallery of Australia*. Canberra: National Gallery of Australia, 1993.

Thomas, Daniel. *Outlines of Australian Art: The Joseph Brown Collection*. Melbourne: Macmillan, 1973.

Thomas, Daniel. *Sali Herman*. Melbourne: Georgian House, 1962.

Thomas, David. *Rupert Bunny 1864–1947*. Melbourne: Lansdowne Press, 1970.

Thomas, David (ed.). *The Art of Christian Waller*. Bendigo: Bendigo Art Gallery, 1992.

Through a Glass Darkly. Sydney: Art Gallery of New South Wales, 1995 (inaugural Guinness Contemporary Art Project).

Timms, Peter. *Australian Studio Pottery and China Painting*. Melbourne: Oxford University Press, 1986.

Tipping, Marjorie. *An Artist on the Goldfields: The diary of Eugène von Guérard*. Melbourne: Currey O'Neil, 1982.

Tipping, Marjorie. *Eugène von Guérard's Australian Landscapes*. Melbourne: Lansdowne Press, 1975.

Tonkin, Steven and Clark, Deborah. *The Antipodeans: Challenge and response in Australian Art 1955–1965*. Canberra: National Gallery of Australia, 1999.

Topliss, Helen. *The Artists' Camps: Plein air painting in Melbourne 1885–1898*. Melbourne: Monash University Gallery, 1984.

Tranter, Robin. *Betram Mackennal: A career*. Sydney: University of Sydney, 1990 (unpublished thesis).

Turnbull, Clive, Young, Elizabeth and Thomas, Daniel (commentaries). *Antipodean Vision: Australian Painting: Colonial, Impressionist, Contemporary*. Melbourne: F. W. Cheshire, 1962.

Tyndall, Peter. *Double Crossed Again: Death to all mirrors!* Berlin: Daadgalerie, c.1992.

Uhl, Christopher. *Albert Tucker*. Melbourne: Landsdowne Press, 1969.

Weston, Neville. *Lawrence Daws*. Sydney: Reed, 1982.

Whisson, Ken. *Ken Whisson: Paintings 1947–1999*. Melbourne: Niagara Publishing, 2001.

Whitelaw, Bridget. *The Art of Frederick McCubbin*. Melbourne: National Gallery of Victoria, 1991.

Wilkins, Lola. *Stella Bowen: Art, love & war*. Canberra: Australian War Memorial, 2002.

Wilson, Gavin. *John Firth-Smith: A voyage that never ends*. Sydney: Craftsman House, 2000.

Wittman, Richard. *William Frater: A life with colour*. Melbourne: Miegunyah Press, 2000.

Yang, William. *Australian Chinese*. Canberra: National Portrait Gallery, 2001.

Yang, William. *Diaries: A retrospective exhibition*. Sydney: State Library of New South Wales, 1998

Zdanowicz, Irena. *Colour and transparency: The watercolours of Lesley Dumbrell, Robert Jacks, Victor Majzner*. Melbourne: National Gallery of Victoria, 1986.

Zubans, Ruth. *E. Phillips Fox 1865–1915*. Melbourne: National Gallery of Victoria, 1994.

Zubans, Ruth. *E. Phillips Fox: His life and art*. Melbourne: Meigunyah Press, 1995.

Text Authors

Ah Xian
Practising artist currently living in New South Wales

Jon Altman
Director, Centre for Aboriginal Economic Policy Research, Australian National University

Rick Amor
Practising artist currently living in Victoria

Brook Andrew
Practising artist currently living in New South Wales

Bruce Armstrong
Practising artist currently living in Victoria

Raymond Arnold
Practising artist currently living in Tasmania

Peter Atkins
Practising artist currently living in New South Wales

Robert Baines
Practising artist currently living in Victoria

Eugenie Keefer Bell
Lecturer in Architecture, University of Canberra

Robert Bell
Senior Curator, Decorative Arts, National Gallery of Australia, Canberra

Roger Benjamin
Senior Lecturer in Art Theory, School of Art, Institute of the Arts, Australian National University, Canberra

Kate Beynon
Practising artist currently living in Victoria

Vivienne Binns OAM
Practising artist currently living in Canberra

Leilani Bin-Juda
Curator, Aboriginal and Torres Strait Islander Program, National Museum of Australia, Canberra

Brian Blanchflower
Practising artist currently living in Western Australia

Tim Bonyhady
Centre for Cross Cultural Research & Humanities Research Centre, Australian National University

Robert Boynes
Practising artist currently living in Australian National Territory

Anne Brennan
Lecturer, Art Theory, School of Art, National Institute of the Arts, Australian National University, Canberra

Barbara Brinton
Manager, Education, National Gallery of Australia, Canberra

Roger Butler
Senior Curator, Australian Prints and Drawings, National Gallery of Australia, Canberra

Wally Caruana
Former Curator, Aboriginal and Torres Strait Islander Art , National Gallery of Australia. Currently freelance curator, consultant and art writer

Betty Churcher AO, AM
Former Director of the National Gallery of Australia, currently Adjunct Professor, Centre for Cross Cultural Research and Humanities Research Centre, Australian National University, Canberra

Peter Churcher
Practising artist currently living in Victoria

Jane Clark
Deputy Chairman, Sotheby's Australia

John Coburn AM
Practising artist currently living in New South Wales

Tony Coleing
Practising artist currently living in New South Wales

Kevin Connor
Practising artist currently living in New South Wales

Lyn Conybeare
Development Manager, National Gallery of Australia, Canberra

Stephen Coppel
Assistant Keeper, Prints, British Museum, London

Belinda Cotton
Manager, Travelling Exhibitions, National Gallery of Australia, Canberra

Marcel Cousins
Practising artist currently living in New South Wales

Sue Cramer
Former Director, Institute of Modern Art, Brisbane and Curator, Museum of Contemporary Art, Sydney. Now an independent curator and writer based in Melbourne

Brenda L. Croft
Senior Curator, Aboriginal and Torres Strait Islander Art, National Gallery of Australia, Canberra

Aleks Danko
Practising artist currently living in Victoria

Janet Dawson OBE
Practising artist currently living in New South Wales

Dennis Del Favero
Practising artist, Australian Research Council Post-Doctoral Research Fellow and Co-Director of the Centre for Interactive Cinema at the University of New South Wales, Sydney

Christine Dixon
Senior Curator, Research, National Gallery of Australia, Canberra

Julie Dowling
Practising artist currently living in Western Australia

Ivan Durrant
Practising artist currently living in Victoria

Mary Eagle
Former Senior Curator National Gallery of Australia, then Visiting Fellow, Centre for Cross Cultural Research, Australian National University, Canberra. Currently working as a freelance art historian and curator

Helen Ennis
Lecturer, School of Art, National Institute of the Arts, Australian National University, Canberra

Julie Ewington
Head of Australian Art, Queensland Art Gallery

John Firth-Smith
Practising artist currently living in New South Wales

Tim Fisher
Former Assistant Curator and Curator, National Gallery of Australia, Canberra. Currently Exhibitions Curator at the National Library of Australia, Canberra

Emma Fowler-Thomason
Gordon Darling Graduate Intern, Australian Prints, National Gallery of Australia, Canberra

Marea Gazzard AM
Practising artist currently living in New South Wales

James Gleeson AO, AM
Practising artist and arts writer currently living in New South Wales and former Visiting Curator of Australian Art, National Gallery of Australia, Canberra

Helen Grace
Senior Lecturer, Art History and Screen Studies Program, School of Humanities, University of Sydney

Beatrice Gralton
Australian Art Project Officer, Exhibitions, National Gallery of Australia, Canberra

Anne Gray
Assistant Director, Australian Art, National Gallery of Australia, Canberra

Felicity Green
Lecturer, Arts and Crafts, Bachelor Institute of Indigenous Tertiary Education, Northern Territory

Lola Greeno
Practising artist currently living in Tasmania

Sasha Grishin
Associate Professor and Head, Art History Department, Australian National University

Fiona Hall
Practising artist currently living in South Australia

Susan Hall
Freelance writer and editorial consultant

Melinda Harper
Practising artist currently living in Victoria

Deborah Hart
Senior Curator, Australian Painting and Sculpture, National Gallery of Australia, Canberra

Susan Herbert
Head, Education and Public Programs, National Gallery of Australia, Canberra

Michelle Hetherington
Acquisitions, Pictorial, National Library of Australia, Canberra

Meredith Hinchliffe
Freelance arts advocate and arts writer based in Canberra

Ian Howard
Practising artist and Dean of the College of Fine Arts, University of New South Wales, Sydney

Susan Jenkins
Assistant Curator, Aboriginal and Torres Strait Islander Art, National Gallery of Australia, Canberra

Michael Johnson
Practising artist currently living in New South Wales

Tim Johnson
Practising artist currently living in New South Wales

John Jones
Former Curator, Australian Paintings and Sculpture, National Gallery of Australia, currently freelance writer and curator living in Castlemaine

Magda Keaney
Art Curator, National Portrait Gallery, Canberra

Philippa Kelly
Freelance writer and curator, former Editor of Arts Monthly Australia

Brian Kennedy
Director, National Gallery of Australia, Canberra

Inge King AM
Practising artist currently living in Victoria

Lee Kinsella
Assistant Curator of Art, Australian War Memorial, Canberra

Colin Lanceley AO
Practising artist currently living in New South Wales

Richard Larter
Practising artist currently living in Australian Capital Territory

Nigel Lendon
Deputy Director, School of Art, National Institute of the Arts, Australian National University, Canberra

Liu Xiao Xian
Practising artist currently living in New South Wales

Robert MacPherson
Practising artist currently living in Queensland

Anne McDonald
Senior Assistant Curator, Australian Prints and Drawings, National Gallery of Australia, Canberra

John McPhee
Former Curator of Australian Decorative Arts and Senior Curator of Australian Art, National Gallery of Australia, Canberra, now an art consultant living in Sydney

Humphrey McQueen
Freelance art writer currently living in Canberra

Jenny Manning
Project Coordinator, Education, National Gallery of Australia, Canberra

Mandy Martin
Practising artist currently living in New South Wales

Helen Maxwell
Gallery owner and freelance art writer currently living in Australian Capital Territory

Klaus Moje
Practising artist currently living in New South Wales

Gloria Morales
Conservator, Objects, National Gallery of Australia, Canberra

Howard Morphy
Director, Centre for Cross Cultural Research, Australian National University, Canberra

Gael Newton
Senior Curator, Photography, National Gallery of Australia, Canberra

Anne O'Hehir
Assistant Curator, Photography, National Gallery of Australia, Canberra

Margaret Olley AO
Practising artist currently living in New South Wales

Ken Orchard
Practising artist currently living in New South Wales

Mike Parr
Practising artist currently living in New South Wales

Roslynd Piggott
Practising artist currently living in Victoria

Roslyn Poignant
Australian writer from an anthropological perspective, based in London

Barbara Poliness
Project Coordinator, Travelling Exhibitions, National Gallery of Australia, Canberra

Ron Ramsey
Assistant Director, Access Services, National Gallery of Australia, Canberra

Robert Reason
Assistant Curator, European and Australian Decorative Arts, Art Gallery of South Australia, Adelaide

Neil Roberts
Artist who died tragically during the production of this publication

Ron Robertson-Swann OAM
Practising artist currently living in New South Wales

William Robinson
Practising artist currently living in New South Wales

Robert Rooney
Practising artist currently living in Victoria

Felicity St John Moore
Former Principal Lecturer, Education, National Gallery of Australia, Canberra. Currently freelance art historian and curator

Gareth Sansom
Practising artist currently living in Victoria

Jude Savage
Manager, Travelling Exhibitions, Australian War Memorial, Canberra

Andrew Sayers
Director, National Portrait Gallery, Canberra

Roger Scott
Practising artist currently living in New South Wales

Jan Senbergs
Practising artist currently living in Victoria

David Sequeira
Public Programs Coordinator, National Gallery of Australia, Canberra

Martin Sharp
Practising artist currently living in New South Wales

Sally Smart
Practising artist currently living in Victoria

Betty Snowden
Assistant Curator of Art, Australian War Memorial, Canberra

Kelly Squires
Art Specialist, Deutscher- Menzies, Melbourne

Robyn Stacey
Practising artist currently living in New South Wales

Miriam Stannage
Practising artist currently living in Western Australia

Jacqui Strecker
Senior Curator, Art Section, Australian War Memorial, Canberra

Elena Taylor
Senior Assistant Curator, Australian Painting and Sculpture, National Gallery of Australia, Canberra

Michael Taylor
Practising artist currently living in New South Wales

Daniel Thomas AM
Inaugural Senior Curator of Australian Art at the National Gallery of Australia, Canberra, former Director of the Art Gallery of South Australia, Adelaide, currently living in Tasmania

Christian Thompson
Practising artist currently living in Victoria

Imants Tillers
Practising artist currently living in New South Wales

Alick Tipoti
Practising artist currently living in Queensland

Aida Tomescu
Practising artist currently living in New South Wales

Steven Tonkin
Assistant Curator, Research, National Gallery of Australia, Canberra

Robert Tonkinson
Professor, Department of Anthropology, The University of Western Australia

Catherine Truman
Practising artist currently living in South Australia

Ken Unsworth AM
Practising artist currently living in New South Wales

Hossein Valamanesh
Practising artist currently living in South Australia

Debbie Ward
Senior Textile Conservator, National Gallery of Australia, Canberra

Dick Watkins
Practising artist currently living in New South Wales

Jenny Watson
Practising artist currently living in Queensland

Judy Watson
Practising artist currently living in the Northern Territory

Guan Wei
Practising artist currently living in New South Wales

Neville Weston
Adjunct Professor, Research Institute for Cultural Heritage, Curtin University of Technology

Ken Whisson
Practising artist currently living in Italy

Bridget Whitelaw
Former Curator of 19th-century Australian Art, National Gallery of Victoria, Melbourne

David Williams
Director, School of Art, National Institute of the Arts, Australian National University, Canberra

Lola Wilkins
Head, Art Section, Australian War Memorial, Canberra

Helen Wright
Practising artist currently living in Tasmania

William Yang
Practising artist currently living in New South Wales

John Young
Practising artist currently living in Victoria

Anne Zahalka
Practising artist currently living in New South Wales

Salvatore Zofrea
Practising artist currently living in New South Wales

INDEX

Main entries are indicated by numbers in bold, illustrations by numbers under artist in italics.

Acknowledgements

My sincere thanks to all the artists for creating so many wonderful works, and to the Board members, Directors, Curators and Donors who ensured they were in the collection of the National Gallery of Australia. Thanks to each and every one of the authors (including artists) for their clear and concise essays, in which they have shared their enthusiasms for the works – without their contributions this book would have been a very different one indeed.

At the National Gallery: in publications, I cannot thank Susan Hall enough for her editorial intelligence, her enthusiasm for the project, her patience and care and her unwavering support and proficiency in undertaking her share in managing this sizeable collaborative publication. I am also indebted to Kirsty Morrison, for her exemplary design and the uncompromising concern for quality that distinguishes her publications.

In Australian art, I am immensely grateful to all the curatorial staff for their advice on the selection of works, and for providing support in so many and various ways – you are a great team to work with. Special thanks to Roger Butler and Deborah Hart who read and provided advice on many essays and who checked all the transparencies to ensure they were of the best quality. Thanks especially to Elena Taylor and Anne MacDonald who researched all the captions for paintings, sculpture, prints and drawings and uncovered many important details, and also to Daniel Thomas for his insightful caption information on the works he wrote about. Thanks also to Brenda L. Croft for her guidance on Indigenous matters. Thanks, too, to Kelly Squires who provided invaluable assistance in the early days of the preparation of this book and to Anne Chivas, Tonya Jefferis, Kate Manning and Caroline Squires for their administrative support.

Thank you to Leanne Handreck and to the copyright holders for their cooperation in obtaining copyright clearance. Thanks to Amber Cameron and Diana Hall for proofreading and to Hilary Kent for providing the index.

Thanks also to Margaret Shaw, Gillian Currie and Helen Hyland from the Gallery library for their assistance with reference material. To Bruce Moore, Eleni Kypridis and Wilhelmina Kemperman for their assistance with photography. To Beatrice Gralton, Ben Taylor, Caitlin Perriman, Derek O'Connor, Geoff Newton, Joel Bliss, Lloyd Hurrell, Valerie Alfonzi, Sam Bottari, Jeremy Russell and Fiona Bolton for assisting with moving the works so that they could be photographed. Thanks to all in the conservation department for preparing works for photographing and display.

My immense gratitude to Humphrey McQueen for his sound advice. Finally, my sincere thanks to the Director, Brian Kennedy, for his vision and encouragement, and to Ruth Patterson, Assistant Director, Marketing and Merchandising, who provided the ways and means. Last but not least, thankyou to Gordon Darling for officially launching this book.

Anne Gray